SAUL STEINBERG

ALSO BY DEIRDRE BAIR

Calling It Quits: Late-Life Divorce and Starting Over
Jung: A Biography
Anaïs Nin: A Biography
Simone de Beauvoir
Samuel Beckett: A Biography

SAUL
STEINBERG A BIOGRAPHY

Deirdre Bair

Nan A. Talese | DOUBLEDAY
NEW YORK LONDON TORONTO SYDNEY AUCKLAND

All rights reserved. Published in the United States by Nan A. Talese / Doubleday, a division of Random House, Inc., New York, and in Canada by Random House of Canada Limited, Toronto.

www.nanatalese.com

DOUBLEDAY is a registered trademark of Random House, Inc. Nan A. Talese and the colophon are trademarks of Random House, Inc.

Book design by Pei Loi Koay
Jacket art: Untitled (from the Mask Series with Saul Steinberg), 1962. Photograph by Inge Morath © The Inge Morath Foundation/ MAGNUM PHOTOS. Mask by Saul Steinberg © The Saul Steinberg Foundation/ARS, NY
Jacket design by Emily Mahon

LIBRARY OF CONGRESS CATALOGING-IN-PUBLICATION DATA
Bair, Deirdre.
Saul Steinberg : a biography / Deirdre Bair.—First edition.
pages cm
Includes bibliographical references and index.
1. Steinberg, Saul. 2. Artists—United States—Biography. I. Title.
N6537.S7B35 2012
741.092—dc23
[B]
2011050601

ISBN 978-0-385-52448-3

MANUFACTURED IN THE UNITED STATES OF AMERICA

10 9 8 7 6 5 4 3 2 1

First Edition

FRONTISPIECE: Saul Steinberg, *Self-Portrait with Hat*, c. 1946.

For Aldo L. Bartolotta

(who never had a bad day)

I don't quite belong to the art, cartoon, or magazine world . . .

they just say "the hell with him." They feel that he who has wings

should lay eggs.

CONTENTS

Like many other Americans in the last half of the twentieth century, I grew up eagerly awaiting the arrival of *The New Yorker* each week. Back when there was no table of contents, I think a lot of people must have done as I did, flipping through the pages to scan the titles of articles and glance at the end to see who wrote them while reserving my initial attention for the drawings and cartoons. And from the quantity of fan mail the magazine received, I don't think I was the only one who stopped fanning the pages to study whatever Saul Steinberg contributed to an issue. His work always got my attention, and nine times out of ten, my first response was the same puzzled question: Just what did he mean by *that*? All those numbers, letters, squiggles, and curlicues; those funny animals and ferocious figures; the brutalist buildings, tranquil landscapes, and chaotic street scenes—what was he getting at? And as for *that* poster, the iconic "View of the World from 9th Avenue," dubbed by me and countless others "The New Yorker's View of the World," I am sure I was among the first delighted buyers who rushed to the store on Madison Avenue for a copy, which has hung in every house I've lived in since then.

When I became a university professor, my office bulletin board was festooned with Steinberg's covers, most of them the ones containing words that I used to try to inspire my students to think. There was the one that showed a man standing between two signs, one pointing to "before" and the other to "after." There was the one with all versions of the verb *to be*, and the one that proclaimed "I do," "I have," and "I am." And whenever assignments were due

and I knew I'd be deluged by requests for extensions, I'd send my students a message by posting one of my favorite cartoons on the office door, of a man who sits behind a desk beaming as the word *NO* floats above his head and over to the deflated supplicant who sits in front of him.

In my home office, ever since I was a graduate student in Paris years ago and I went without lunches to buy it, a Steinberg print has hung on the wall where my eyes naturally gravitate when I raise them from my work. It has floated above every desk since the days when my ancient typewriter gave way to a succession of computers, because I always found something soothing in it during my daily search for whatever words or thoughts were eluding me. I still don't know what there is about this print, one of his landscapes from the era of *The Passport,* that is endlessly fascinating. It just is.

That vague generality pretty much characterized my overall response to Saul Steinberg's art until early 2007, when I saw two exhibitions of his work, at the Morgan Library and Museum and the Museum of the City of New York. I spent so much time studying the drawings and trying to puzzle out what inspired him to create them that the friends who were with me grew tired of waiting and were about to leave without me when I rushed to tell them how I thought I'd found what I'd been missing all those years. I had just read a caption that quoted Steinberg as having said, "I am a writer who draws." That was it, of course, the elusive key that opened the first of the many doors that led me to spend three magical years searching for an understanding of his oeuvre.

On my way out of the Morgan Museum, I bought the book that accompanied the exhibition, and when I got home, I put it beside the four books of his drawings that were already on my library shelves. One by one I took them down again, once more finding puzzle and pleasure in equal part. Several months later, when I was packing books and files for a household move, I came across a huge folder left over from my teaching days that contained all the Steinbergiana that had adorned the walls and bulletin boards of my various offices. For the first time I was aware of the variety of his output, from *New Yorker* covers to product advertisements. I had saved an old Hallmark calendar and one leftover Christmas card from those he drew for the Museum of Modern Art. There was even a photo of a funny-looking fellow with a mustache and black-framed glasses holding a tiny brown paper mask over his nose, who I now knew was Saul Steinberg himself. How many years had I saved all this? It was hard to remember when I started, or even why. I knew nothing about the artist's life when I collected all these things and until that moment had never considered finding out who he was, where he came from, or why he made such an impact on his culture and society. At that time I really believed that I would

never write another biography, but thoughts about Saul Steinberg persisted, and almost before I could verbalize what they were, I knew that I wanted to write about him. One thing led to another, and that was the start of this biography. Four years later, the end result is here.

2007–2011
New Haven, Connecticut

SAUL STEINBERG

THE AMERICANIZATION OF SAUL STEINBERG

S aul Steinberg's Italian diploma in architecture stated clearly that he was "of the Hebrew Race," which meant he was forbidden to work in Milan in 1940. He was a Romanian citizen, but his passport had been canceled, making him a stateless person bound to be rounded up by Mussolini's Fascist police and sent to an internment facility, the Italian version of a concentration camp. Although he was well known for his satirical drawings and cartoons in two of Milan's leading humor newspapers, he lived for several months as a hunted man and never stayed long in any one place.

His Italian girlfriend hid him in her room and her friends hid him in theirs; his classmates from school did the same. But Milan was really a small town and difficult to hide in for long. It was only a matter of time until he would oversleep and be arrested in one of the daily 6 a.m. sweeps through the poorer parts of town, then be loaded onto a train with others who had run afoul of the Fascisti and sent to an internment facility. Those on the run heard rumors that suspects who surrendered voluntarily were treated better than those who were caught in the daily raids, and so, on the advice of his friends, Steinberg turned himself in at the neighborhood police station. Shortly after, he was indeed shipped off to an internment facility, Tortoreto.

The train ride to Tortoreto was the start of a long series of peregrinations that eventually took him from Milan by plane to Lisbon (twice), to Rome by train, to New York via ship, and then to four days in a holding pen on Ellis Island until the ship that took him to exile in the Dominican Republic was ready to sail. A year later, through the intercession of everyone from Commodore Cornelius Vanderbilt to his American uncles and cousins, to several

international publishers and agents and the editors of *The New Yorker*, he was finally admitted to the United States. He took his first legal footsteps on American soil in Miami and from there he took a Greyhound bus (one of his favorite modes of travel) to New York.

Several months later, in one single day, Saul Steinberg became a United States citizen, a commissioned officer in the United States Naval Reserve, and, via the Office of Naval Intelligence, a member of the fledgling OSS (later the CIA) under the auspices of Wild Bill Donovan, who wanted him despite the fact that navy doctors who had examined him declared him both physically and psychologically unfit for service.

Ensign Saul Steinberg, USNR, was sent to Washington, D.C., for a brief period of training in psychological warfare to prepare for an overseas posting where his considerable knowledge of languages would complement his artistic abilities. Fluent in his native Romanian and Italian, with excellent French and good German, able to get by in Spanish, and with a smattering of Portuguese and comprehensible English, he was sent by his superiors to be a spy in inland China.

And that, as he was fond of remembering, was the start of the Americanization of Saul Steinberg, and of his lifelong love affair with all things American.

A DECIDEDLY PECULIAR PLACE

Romania, a half civilized, semi-oriental,
self-indulgent country

Saul Steinberg always thought of his native country as a decidedly peculiar place, but he was convinced that the little town of Râmnicul-Sărat had been specifically invented for him to be born there. Even his birth date had a slightly surrealist tinge, for it changed according to which calendar was in use: it was June 15, 1914, in the Julian (then being phased out) but June 28 in the Gregorian (adopted piecemeal by different regions of Romania until 1920). His parents celebrated June 14, either because the calendar change confused them or because they simply lumped his birthday in with other historical events that happened on this internationally important political day. When he was an adult, his wife and friends often had to ask which day he preferred, as he kept changing his mind. For years he chose not to celebrate either one, preferring "Bloomsday," June 16, the day James Joyce chose for the peregrinations of Leopold Bloom, the hero of *Ulysses*, one of his favorite novels, and a displaced Jewish wanderer like himself.

Political events shaped many crucial developments in Steinberg's life, which in later years he described as a parallel to the history of the twentieth century, an immense prank played not only on him but on all of humanity. On the birthday his parents celebrated, June 14 (June 28 in the modern calendar), 1914, Archduke Franz Ferdinand and his wife were assassinated in Sarajevo, and in August World War I began. Exactly five years later and again on June 14, the Treaty of Versailles, which ended the war, was signed; it was a punitive agreement that had much to do with the instigation of the Second World War, the annihilation of European Jews, and Steinberg's forced emigration to the United States.

War, and particularly the two world wars, affected Steinberg's life drastically, but even before the first one began, fractious politics caused major changes in his family's life. Romania, then known to the world as Roumania, had been a country only since 1861, when the principalities of Walachia and Moldavia voted to unite and selected Colonel Alexander Ioan Cuza to lead them. Cuza proclaimed the founding of the "Roumanian nation," adding that he feared the new country would not long be satisfied with him. He was right, and by 1866 the government was in such disarray that a delegation was sent to search for a foreign prince who could be persuaded to accept the newly created and highly unstable throne of a constitutional monarchy. They had no one specific in mind when the search began, but the main attribute they sought was a large private fortune, which they hoped would guarantee independence and distance from the many intrigues of the competing clans, political parties, and ruling classes.

The younger brother of the king of Belgium was the Roumanians' first choice, but he was so frightened by the internal politics of the country that he declined the offer. The committee moved on to Germany and another younger brother, Prince Karl of the Prussian royal house of Hohenzollern-Sigmaringen. Karl was not exceptionally bright, but he liked the idea of having his own country and became the first prince of Roumania, crowned as King Carol I in 1881 when Romania became a monarchy. His reign lasted until his death in 1914 and was punctuated periodically by the same sort of boundary disputes and regional wars that had been fought ever since the Roman conquerors withdrew around A.D. 271–74, leaving behind their name and their language superimposed on that of the native Dacians, the indigenous tribe they had conquered.

AN ETHNIC STEW OF A NATION began to bubble as soon as the Romans left. The Dacians were overrun consecutively by tribes of Goths, Huns, Avars, Bulgars, and Magyars; in the Middle Ages Mongols arrived, only to be supplanted by Turks, who incorporated Romania into the Ottoman Empire. Russia and Austria challenged Turkey during the eighteenth century, as did the Greeks, whom the Romanians disliked more than the Turks but with whom they allied themselves until Turkey was in turn marginalized by the Russo-Turkish war of 1828–29. All through these regional wars, certain parts of the country were spoils passed back and forth between neighboring Hungary, Bulgaria, and Russia. And just as the country's boundaries were in constant flux, so too was the language. Based originally on the Latin overlay on Dacian, the Romanian language swelled with additions from every conquerer, invader, and even the vanquished.

Politics and language made it difficult to forge a Romanian identity, and that did not begin until Ioan Cuza united the two principal territories, Walachia and Moldavia (now Moldova) into what were essentially Russian protectorates. By the reign of Carol I, the country was dominated by nationalists, and Jews became scapegoats and victims. Christians (both Catholic and Orthodox) blamed the Jews for violence and turmoil but ignored the way the ruling classes plundered and pillaged the peasants. The upper classes benefited from anti-Semitic demonstrations and did nothing to rein in the violence.

In 1907 the peasants were starving, and a revolt erupted that threatened to paralyze, if not destroy, the entire country. The Christian population looked for a scapegoat and found it in the Jews who acted as agents for the mostly absentee landlords, collecting rent and taxes and gouging the peasants in every possible way. Despite the 1878 Treaty of Berlin, when world opinion forced the Romanian government to give the Jews full rights of citizenship, successive governments ignored the treaty and persecution continued. Jews were not legal citizens of Romania and were therefore forbidden to engage in legitimate occupations, trades, or professions, so many learned to survive as moneylenders or stewards of the nobility's extensive land holdings. The situation was so desperate in the last years of the nineteenth century that it led to what was later described as the forced emigration of Romanian Jews to the United States, and three of the six sons of Saul Steinberg's paternal grandfather were among them.

1907 to 1912 were the years in which the political became personal for the Steinberg family. Shortly after the first Balkan war erupted in 1907, Saul's father, Moritz (sometimes called Moise), served two terms in an artillery regiment in the Romanian army. The first time he had to impersonate his brother Martin, who had gone to Denver, so that penalties or punishment would not be inflicted on the family still in Romania; the second was under his own name. Moritz was called sporadically to postings in other parts of the country until World War I began in 1914, but he was mostly at home until Romania entered the conflict in 1916; after that, his regiment was officially mobilized and he was largely absent until 1917.

Moritz, born in the town of Huşi on September 7, 1877, was the second son of Nathan (also known as Nachman) Steinberg and his second wife, Clara (sometimes called Henka or Hinke), whose patronymic was never recorded. Nathan had one child from his first marriage, Berl, who became the first of the three sons who went to the United States to settle in Arizona. He was followed by two of Moritz's brothers, who would play important roles in Saul's Americanization: Aaron, a younger brother who took the name Harry when he

settled in New York and became a printer, and Moitel, an older brother who called himself Martin after he moved to Denver and became a businessman. Despite the several migrations that pogroms had forced on the Steinberg family, Moritz had a cautious and timid nature and never gave serious thought to following his brothers to America; he stayed in Romania, preferring the devil he knew to the one he did not.

Both Saul's parents came from families of Russian origin. The Steinbergs had been Romanian for only two generations, having migrated westward from Sevastopol to Odessa, then to Tiraspol before they eventually crossed the border to settle in the northeastern principality of Moldavia. Saul's mother, Roza (she later changed the spelling to Rosa), was also born to ethnic Russians who had fled pogroms, but they had done so much earlier and had been living in Walachia for at least six generations.

As a boy, Saul remembered hearing his mother claim that her side of the family had the higher status; as an adult, he had his own distinct perception of where both sides of his family ranked on the social scale. By the generation of his maternal grandfather, born Iancu Itic, the family had taken the name Jacobson, totally forgotten its Russian origin, and been assimilated into Romanian culture and tradition. Iancu Itic was a well-off wine merchant who was also married twice and who fathered a great number of children, by some accounts as many as sixteen. Many of his children were also wanderers, and both sons and daughters emigrated to France, the United States, and Palestine (now Israel). Six of his sons and five of his six attractive and highly eligible daughters played roles of varying importance in Saul's life, but Iancu Itic was memorable as "a peculiar sort of Romanian . . . almost absorbed by the peasants and the local color" with "a talent for making good wine." Saul appreciated the old man's earthy qualities but was far more attracted by the glamour of his paternal grandfather, Nathan Steinberg, who began his career as a sergeant-major in the Romanian army.

Grandfather Steinberg was a man who took pride in all things military and whose martial bearing helped him prosper after he opened a military tailor shop in Buzău, a garrison town sixty miles from Bucharest. Romanian officers were his best clients, and as was typical of the age, he "trussed [them] up in corsets under brightly sashed tunics . . . every shining perfumed hair in place, an occasional monocle fixed immovably in the eye, cigarettes dangling from their lips." They were truly "Ruritanian dandies" whose elaborate getup stole the scene from their ladies, so much so that when World War I began, an order forbidding junior officers to wear eye shadow had to be issued. Nathan Steinberg was renowned for the fancy uniforms he created, all festooned

with elaborate gold braid, and he liked to wear some of them himself. His formidable mustached likeness as well as his resplendent sartorial creations became familiar totems for the military figures that later populated his grandson's art.

It was in Buzău that the boy Saul first cast his artistic eye on the cityscape, which he saw as one of empty streets because all the citizens were in the cafés. This was when he first became aware of the pleasure of looking at girls, as they seemed to be the only people on the sidewalks, all of them splendidly dark-haired and decked out in school uniforms. When he wrote down one of his favorite recurring adolescent dreams, it became a paean of four-letter words about how all his neighbors were parents of dying girls begging him to fuck them, as that was the only way they could be cured.

Buzău was where his mother's family had been comfortably settled for several generations and where she was working as a seamstress on the trousseaus of rich girls when she met Moritz Steinberg. He and Roza Iancu Itic Jacobson were married there on December 6, 1911. Moritz was then working as a printer and bookbinder in Râmnicul-Sărat, about thirty miles north of Buzău, and he took Rosa there to her first home as a married woman, away from her five sisters, to whom she was close. Rosa became pregnant in Râmnicul-Sărat and suffered at least one miscarriage, possibly more, before she gave birth to a daughter, on April 9, 1913. Raschela (Rasela or Rachel, always called by the diminutive Lica or Licuta), was born prematurely and grew into a delicate child who was a puzzle to her large and robust mother.

Rosa was strong and outspoken and, depending on her mood of the moment, did not hesitate to erupt in joy or rage. The household was dominated by her swift mood changes, but Lica floated through these episodes seemingly unfazed, growing into a thin, quiet, thoughtful little girl, seldom crying or asking for attention and appearing mature far beyond her years. Family lore had it that she was a twin, but the other fetus did not develop and instead became a dermoid cyst in Lica's neck, which troubled her all her life and may have been responsible for various complications that led to her relatively early death at the age of sixty-three.

Such a lump was troubling to a mother reared in a culture where superstition and folklore reigned supreme, but what was even more upsetting in a country with a large Muslim population was Lica's left-handedness. Rosa subjected the child to a "very dramatic" campaign to force her to use her right hand, and what Lica had to endure before she was "broken" made her awkward, hesitant, and terrified forever that she might inadvertently do something with her left hand. Rosa was proud that she succeeded in breaking Lica's natu-

ral affinity and, in this as in all things concerning her family, bragged about imposing her formidable will.

There were many other instances of Rosa bullying Lica as a child, about everything from correcting her posture to prodding her to be more outgoing as a teenager. In her mind, she did these things because she loved her daughter, and in her overbearing way she did, even as she alternated bullying with trying to coddle and protect Lica. She treated Lica this way even after she had become a responsible and self-sufficient adult with a husband and two children. Lica was not joking when she claimed to be forever grateful to Saul for being born thirteen months after she was, because she was no longer an only child and he diffused their mother's meddling behavior. Lica attributed whatever shred of independence she managed to gain to the fact that after Saul's birth, as a son, he became the primary focus of Rosa's attention.

Rosa carried Saul to full term, but he too was a delicate baby, and he became a spindly boy, thoughtful, introspective, and plagued by childhood diseases and vague illnesses. When he was twelve going on thirteen, he contacted something mysterious that was thought to be rheumatic fever, and Rosa kept him bedridden for six months. Caring for Saul distracted her from totally dominating Lica's formative years, which gave the girl just enough freedom to grow up with a strong sense of self. Lica adored Saul and he returned her sentiment, so brother and sister shared an attitude of quiet conspiracy toward their increasingly domineering and powerful mother, who was known to them in private as "the General."

The quiet Moritz remained slim and slight throughout his life, but Rosa packed on enough weight to give the appearance of a dreadnaught in full sail as she slashed and battled her way to primacy in all things connected with her family. No one addressed the subject directly when Saul's earliest published drawings began to feature Zia Elena, a huge battle-ax of a woman with a body like Rosa's and a face like Mussolini's, or later, when he drew couples with formidable, oversized women and cowering little men. Not until he was nearing the end of his life did he venture to describe his initial interpretation of the phrase *sub rosa*, remembering the shock of recognition he felt when he admitted to himself that he, his sister, and his father were powerless under Rosa's domination. Her two children and two grandchildren never openly discussed her character and personality while she was alive; only after her death did they feel free enough to call her a "horror" and a "terrorist" and admit that her "selfish and authoritarian" manner had brought them emotional pain.

From the day Rosa accepted Moritz's proposal, she set the terms for who would be in charge within the marriage. Her first rebellion against the status

quo came when she refused to accept a situation most Romanian women of her generation always agreed to unquestioningly: to take in a child their husband had fathered out of wedlock. Moritz told Rosa he had a daughter, Sophia, born in Galest in September 1911, whose mother had died giving birth and to whom he proved his devotion by giving her the Steinberg name. Rosa knew that Moritz loved the little girl and wanted her to be raised as their own, and when she refused, he told her he wanted to continue to provide for the child's upkeep, which she also refused to let him do. Saul's memory of this family drama was of how Rosa threw hysterical, mean-spirited tantrums whenever Moritz raised the subject. And so Sophia remained in Galest with her mother's family, and if Moritz sent money or exchanged letters with this daughter, he kept it to himself. Sophia kept the Steinberg name, and Lica and Saul were fascinated, if not haunted, by the rumor of a half-sister and by their father having another, totally private life. However, they knew better than to speak of it to Rosa.

Rosa did many things that embarrassed them—for instance, the way she behaved on their holiday excursions to the Black Sea resorts, where they stayed in genteel hotels. Although she claimed to be an observant Jewish matron, she did not follow Jewish dictary laws at home. The only time she did so was when she took her own food to hotels that boasted of their cuisine and insisted that the chef's cook her food under her direction and to her satisfaction. There were many things she thought were her due; she would rudely spear choice morsels

Saul Steinberg, his parents, and his sister. Black Sea, 1926.

from Moritz's plate, or brag that she could overcome her insomnia only by reaching over to pull his pillow out from under his sleeping head and add it to her own pile, even if she woke him in the process.

One day at dinner she told Moritz and the children the story of how she had taken a seat on a park bench to rest her feet while out shopping. At the other end of the bench sat an old Jewish couple, the woman bedecked in jewels and snoring loudly. When the woman woke up, she told Rosa proudly that she had ordered her husband to stay awake and guard her jewelry while she napped. Rosa related the story as a fine example of a perfect husband's perfectly obedient behavior. No one commented, especially her children, who accepted such stories quietly.

Even in their teenage years, the last they lived at home together, the brother and sister were often too shy and embarrassed to discuss their mother with each other. As two middle-aged adults, Saul and Lica tried to analyze their mother's character and decided that Rosa's method of controlling her family was to play the role of the chronic victim. Saul knew how intelligent she was and how she was probably frustrated by all the political and social events in the larger world that had conspired to disrupt her well-being so many times. He festered, while Lica was better able to shrug off the way Rosa managed to turn worldwide catastrophes into events whose only meaning was that they upended her personal life. Even more, Saul hated himself for what he called his "radar with mother," a love-hate affinity that dominated the household and created distance and formality between him and his gentle father, who learned to fear his stern adult son almost as much as he feared his formidable wife.

While Saul was growing up and forever after when it came to his family, the only person he loved without reservation was Lica. She was "the only taboo, the untouchable." He adored her with "the perfect intangibility of love."

SAUL STEINBERG DID NOT have many memories of his first four years of life. He was between six and eight months old when they left Râmnicul-Sărat to live in Buzău and be near Rosa's family while Moritz came and went according to his army

Steinberg and his sister as schoolchildren.

postings. Moritz, unlike his staunchly military father, who was celebrated for his leadership abilities, was a lowly soldier in the artillery, charged with grooming the enormous workhorses that dragged the caissons and cannons. Even though he hated horses and was often frightened of them, he put up with the work for a time, but the beatings he endured because he did not do the job properly led him to desert before the war was officially over. He went into hiding in his father's attic, where he stayed until all Romanian conscripts were decommissioned and it was safe to come out. While living in the attic, he disguised himself by growing a beard and wearing peasant's clothing, topping it off with the towering lambskin headgear called the *caciula*, which the infant Saul thought made him look like a prehistoric monster. Saul's strongest memory was of being caught up in his father's arms and scratched by his beard.

MORITZ WENT INTO THE ATTIC WHEN Saul was three and emerged when Saul was five, in 1919. He thought it safe to move his family to Bucharest, and there Saul's lasting memories of his native country began. After the war, Jews were finally given full citizenship and permitted to engage in various businesses. Goaded by Rosa, Moritz did not resume his job as a printer and bookbinder in Râmnicul-Sărat but instead allowed her and her brothers to convince him that he could make a better living in Bucharest if he followed them there and set up a business that would mesh with some of theirs. They were sign painters and shopkeepers, and they told him of machinery he could buy at bargain prices to establish a *fabrica de cartonaje*, a firm that he named Victoria and that specialized in the manufacture of cardboard boxes of all sizes and shapes. It was a profession Moritz did not like in a place he disliked even more, on the misnamed Street of the Sun, the Strada Soarelui, where a nondescript flower market provided the only spot of color in an alley where rats prowled like cats and horses struggled to pull carts perilously overloaded with boxes up a steep hill through what seemed a never-ending tunnel of wind.

The boxes ranged in size from the tiny ones that held lipstick to the massive crates that held individual boxes of matzos for Passover, which became a huge moneymaker and the major source of income. Moritz taught himself to design specialty boxes for everything from cigars to candy, and with two of his brothers-in-law who were sign painters made magisterial cardboard wreaths for wedding decorations and funeral services. The brothers took on many other forms of advertising that required Moritz's collaboration, all of which distinguished his work and made him a respected craftsman rather than a simple manufacturer, a profession of lesser status.

Moritz designed and manufactured bright blue canvas bags in which children carried their books and lunches, the 1920s version of the status bag that all schoolchildren wanted, with its manufacturer's label, "Atelier Steinberg," prominently displayed on the back. When Saul began elementary school, he was the envy of all the other children because his name was on the schoolbag and the bag was his father's creation. It brought him a high degree of respect, not to mention the admiration of all the little girls, and he strutted proudly whenever he carried it.

Saul had few of the usual toys that children cherish, because there were very few toys in Romania, which had been so ravaged by World War I and postwar reparations that until the mid-1920s its people survived on clothing and foodstuffs distributed through international relief organizations. This was yet another of the many "humiliations" that Rosa (enjoying her role of chronic victim) railed against when Moritz's brother Harry sent much-needed boxes of food and clothing from the Bronx. There were times when the family could not have survived without these care packages, but Rosa always managed to find fault with something or other—a coat that was too thin or too heavy, packets of food that were too savory or too stale.

Despite the lack of ordinary toys, to Saul, his father's factory was a wonderland. His favorite toys were scraps of embossed paper, colored cardboard, and rubber stamps, but most of all he liked the large wooden blocks of type used to create letters for posters. When his adult drawings began to feature personified letters and numbers, he disagreed with critics who thought it revolutionary and said it was "not such a great invention—it was something always known to me." He spent long days playing on the factory floor, "extremely high on elementary things, like the luminosity of the day and the smell of everything—mud, earth, humidity, the delicious smells of cellars and mold, grocers' shops." Throughout his life he filled his art with visual descriptions of smells, and the occasional jottings in his diary and much of his correspondence describe various smells that gave him pleasure or brought back memories of pleasures past. Smell was the sensation that evoked memory, and he likened everything in the factory to "the smell of an artist's studio, of collages." There were great vats of glue and pots of ink, wood being cut and shaved into standards for holding the hand-lettered signs or type for printing the words that decorated the large funeral wreaths. Vast stacks of paper had their own smells, some of which he later associated with their colors and textures.

There were visual images as well. When the workers (mostly women and girls) made candy boxes, they used glossy paper on which they glued a chromolithography of a famous painting. Saul liked to watch them make lipstick

holders, the first group of workers deftly twisting cardboard cylinders onto which others further down the line glued gold and silver foil, while still others awaited their turn to apply sequins and sparkles as the finishing touch. Early on, even before he reached puberty, he liked to watch the girls who worked on the factory floor line up before his father for their pay packets on payday. His observant eye noted the strutting boyfriends, fathers, and pimps who waited with outstretched hands to take their women's wages and head for the nearest tavern to drink them away.

At school he spoke Romanian and French, but at home and with his aunts and uncles he spoke "the secret language of my parents, Yiddish." He remembered going into his uncles' businesses, which were as magical as his father's factory. Rosa's family provided most of these fascinating uncles. Her brother Josef Jacobson and one brother-in-law, Moritz Grinberg, were both sign painters. Her sister Sali's husband, Simon Marcovic (Marcovici after they moved to Israel), was a shopkeeper who specialized in stationery, textbooks, and popular novels. In his store Saul read tales of Alexander the Great and adventures, as well as the book he liked best and read repeatedly, "the *Thousand and One Nights*, with those Oriental women wearing nothing but a few veils."

Two other uncles began as watchmakers but branched out in different directions: Rosa's brother Isac took the name Jacques and became the richest of them all when he added expensive jewelry to the watches he sold and repaired. Saul liked the smell of watchmaker's oil that permeated his shop but did not go there often because he was not allowed to get too close to the table where Uncle Jacques bent over a watch's innards; the slightest movement or the least little sneeze would send the tiny springs flying and bring down Jacques's formidable wrath.

Rosa's brother-in-law Jack Kramer sold musical instruments, gramophones, and phonograph records. Saul liked his shop better than Uncle Jacques's, because many of the clocks Uncle Jack sold played the stirring Romanian national anthem, "Réveille-toi, Roumain, du sommeil de la mort." In the window there was an automaton in the shape of a clown that moved its head and rolled its eyes, put there deliberately to entice the peasants in the Crucea de Piatra (the Stone Cross district), poor people just arriving from country villages who had never seen such a marvel.

Mostly, however, the Crucea de Piatra was home to prostitutes, who filled street after street in one of the largest red-light districts in all of Europe. The boy Saul learned early on that there were elegant bordellos reserved for the rich, but the ones nearest his uncle's shop were "run-of-the-mill where . . . these poor little whores mingled with the children, dogs, hens, roosters, ducks, a small

garden, the flowers they were growing, the ripe tomatoes." He was entranced by all the activity, which "as is almost always the case in Romania, took place in the courtyard." The activity was especially fascinating on Saturdays, when the farmers' wives would come down from the country villages, not to sell their foodstuffs but to sell themselves. Young girls and older matrons came dressed in their everyday work dresses, aprons, and muddy boots, to stake out their places and wait for resident men and boys to claim them. Housewives stayed inside and shooed their daughters away from the windows but had no control over their young sons, who raced around teasing "the whores" and jousting with each other to see who could cause the most mischief and gain the best view of the goings-on. Saul was very young when the older boys in his building on the Strada Palas told him about sex, but he preferred to watch quietly from the sidelines rather than join in their teasing. For him, it was not the most fortunate introduction to the intricacies of human sexual relationships; he had no interest in the farmwomen, who were unwashed and smelly.

Adolf was the uncle Saul liked least, the one he denoted with just his first name after he married the only plain Jacobson sister. This was probably not so unusual, because no one else in the family ever called Adolf anything but "the other bookseller." To young Saul, he was merely "a fat lame man." The most romantic of all was another uncle by marriage, Micu Cohen, a croupier who worked the gambling tables in a Black Sea resort town. Saul liked to watch Uncle Micu at work whenever his parents took him there on holidays, and insisted that his adult penchant for casino gambling started with the thrill he got from watching Uncle Micu's sleight of hand.

Saul was closest to his Aunt Sali's husband, Simon Marcovic. He was happy when Rosa sent him to the shop at Christmastime to help sell German toys and glass tree ornaments, but mostly to help Uncle Simon by watching the customers, "almost all of them thieves." The store was a wonderland of pens, pencils, and ink; of notebooks filled with ruled and graph paper; of sponges for cleaning slates and powder-blue paper to cover textbooks; of labels on which the pupil could write his name and the name of the school. Being in Uncle Simon's shop was almost as good as being in his father's factory, and both places provided memories and sensations that found their way into his adult art.

Another of his favorite schoolboy pastimes was to visit the widowed Mme. Stibal and her paralytic son, who lived several houses away from his own on the Strada Palas. Mme. Stibal collected postcards to entertain her child, and she always welcomed Saul because he was content to pore over them for hours on end, putting them in various arrangements that would allow him to comment and create stories for his own amusement as well as the boy's.

What with all these outlets for his imagination, it was not unusual that Saul would develop a natural proclivity toward the visual arts, and so too did Lica. One of their first exposures came though the chromolithographies of famous paintings that Moritz chose to decorate the candy boxes and other specialty boxes. He selected the ones he wanted to use from a collection of reproductions he kept at home, fat bound volumes that contained everything from Renaissance madonnas to what constituted modern art before 1920 that was deemed suitable for Romanian consumption. Moritz often spent his evenings looking at the books, and Lica and Saul liked to sit beside him. It marked the first time that the children saw such paintings as Raphael's Dresden Madonna, with what they called the "thinking angel," or Millet's *Angelus,* which was to become another of the many totems Saul used in his mature drawings and painting.

Lica's interests were more specialized than Saul's: she was fascinated by process, by such formal, rule-bound expressions of creativity as etching and engraving. She wanted to understand *how* art was done, whereas Saul was more interested in *what* the artist was thinking when he created it. As an adult, when Lica strove to master the techniques of printmaking and etching, he called her actions a preference for a "suffering profession." From childhood he preferred to draw freehand, and one of his earliest images became one of his most varied and lasting, repeated in many different versions and guises in his adult art. This he called simply "a man on horseback," and the first time he drew it was after he saw King Ferdinand I in a parade with Queen Marie and their children, the king decked out in the finery of a fairy tale and riding a sweaty black horse, followed by the royal carriage drawn by six white horses with white-and-purple plumes on their heads. Inside the carriage sat the queen and other members of the royal family, all of them heavily made up, all the males dressed in military uniforms loaded down with decorations, all the women glittering with jewels and crowns and tiaras on their heads. "Remember," he instructed himself many years later, recalling how the streets were covered with fresh sand for the parade; how policemen stood alert, ready to blow shrill whistles at the crowd that was bursting against ropes and barricades as people strained to see; and especially the dog, for there was always a mangy cur who wandered onto the street just before the king's carriage passed by, to everyone's consternation. Steinberg heard his mother and aunts discussing for days afterward the details of the queen's dress, and how one of the princesses was getting fat, and how the king was so old he must be dead, embalmed, and stuffed with straw to keep him upright.

These were all images that Steinberg used in many different forms through-

out his mature career, and there were many times after he became a celebrated artist that he was asked—or even that he asked himself—about the origins of such childlike simplicity. Critics compared him to everyone from Picasso to Joyce, Mozart, and Kafka, but most often comparisons were made to Paul Klee. It seemed as if, no matter who or where, an interviewer or a critic could not ask Steinberg about the sources of his art without facilely invoking Klee's name, which was unfailingly irritating. "Too many geniuses—Steinberg claims only his own," declared an Italian television interviewer, one of the many who tried but could not slot him into a particular category or ism.

"To solve once and for all the problem of Klee," Steinberg told the art critic Grace Glueck, "I want to say this, that Klee did not influence me. The relation- ship between Klee and myself is that we are both children who never stopped drawing." Steinberg believed that he and Klee both derived ideas from the original source of children's art. He insisted that every sort of spontaneous or stylized drawing, such as the folk art of primitive peoples, originated there, and he placed himself and Klee among the primitives: "They are the ones who truly used the line in order to say something—it's a form of writing—so this is the relation between Klee and myself, this love of graphology, popular graphology, children's graphology, and so on." And as far as he was concerned, that was it; there would be no further comment about Paul Klee's influence coming from him, because "every explanation is an over-explanation."

He did, however, speak more kindly and fully of Klee's influence in private conversations with friends, but only when he was the one to introduce the topic, usually with a particular remark of Klee's that he never tired of misquot- ing. Klee said "a line is a dot that went for a walk," but Steinberg changed it to "a line is a thought that went for a walk." This, he told his avid audiences, was well worth pondering.

Probably the closest he got to a thoughtful and truthful response to ques- tions of origin and influence came during the 1970s, when he engaged in rambling conversations with his trusted friend Aldo Buzzi, which were pub- lished as the book *Reflections and Shadows*. Steinberg volunteered that he had once asked himself "how children and lunatics used to draw" and described himself as an "illustrator" whose style had not changed since he was a small child, when he drifted through his father's factory and his uncles' shops and tried to re-create what he saw there. He believed that this was what made him different from other artists, who often encountered problems when they approached maturity, because all too often their tendency was "to stop drawing in a childish manner—or to stop [drawing] entirely, or to begin drawing in an academic style." That had not happened to him, he insisted, because he had

trained himself to retain the attitude of a child who looks at the external world and sees things as if for the first time. Equally important, he had not changed what he called his way of describing what he saw. He used the term *line* loosely, to describe both his technique and how he chose to portray his subjects and express his ideas, and insisted for the rest of his life that the most important thing about his line was that it was "the same one I acquired back then."

Steinberg's earliest extant drawing is one he made at age eleven and dated October 24, 1925, on the back of a photograph of his kindergarten class. It appears to be of an authority figure, a bearded man in a high-collared jacket and uniform cap with a visor. Two other drawings exist from his schooldays, probably done when he was fifteen or sixteen. Both are charcoal and show his awareness of and attempts to create line and shadow, an indication that they were exercises done for a high school art class. One is a six-sided pyramid, both shaded and with its own shadow; the other is a profile portrait of his father's head. Despite being the rendering of a beginning artist, the drawing portrays a good man beset by the cares and woes of daily life and shows the artist's early ability to convey emotional complexity.

There is an aura about the portrait that, with hindsight, conveys sadness, probably because the adult Steinberg believed that his father had had a sad life and he himself had been a sad little boy. He said it was not until he became a teenager that he understood why he was sad, and how, in order to survive, he had to become an observer of rather than a participant in his daily life. When his friend the critic Dore Ashton told Steinberg that she thought the mature drawings he made of his Bucharest childhood mimicked the style of some Middle European children's book illustrations, he said he made them with an air of incredulity, because he could not believe that he had originated in such a land of "pure Dada," a "masquerade country," an "Art Deco World peopled by Byzantium man." Being Romanian was a complicated matter, Steinberg told Ashton, for it didn't matter how long a Jew had lived in Romania, he was still a foreigner.

A WUNDERKIND WITHOUT KNOWING IT

Saul liked to tell the story about how a Romanian man was sent by his family to the U.S. on a ship, with everything they thought he should have from his homeland: pots, pans, pillows, mattresses. This was his entire luggage, and when he left the ship, somebody stole it all. There was nothing left to remind him of Romania, and he was gloriously happy.

Steinberg described himself as "a culturally born Levantine [whose] country goes from a little east of Milan, all the way to Afghanistan." His reflections on being brought up Romanian were surreal enough to convince him that Dada could not have been invented anywhere else, and that was why everyone from Tristan Tzara to Eugène Ionesco had to come *from* Romania, the implication being that like so many other compatriots who later became his friends—Mircea Eliade, Emil Cioran, Norman Manea, and especially Ionesco—he too had to get out. From his earliest schoolboy memories, he thought of himself as an outsider and an observer who looked at his *"patria"* from a distanced perspective. Like most children, he wanted to fit in and be like everyone else, but he found it impossible. He received no feeling of normality from interacting with his peers; that came only when he was drawing.

When he reflected upon how his *patria* influenced his art, he tried to recall his earliest childhood so that he could assign blame to his circumstances, but almost every time he did, his account conflicted with similar ones. In some he thought he had probably been happy because he was simply too young to recognize the deep-seated anti-Semitism that permeated his "sewer" of a country. He was happy at Christmas, for example, when he joined neighborhood children of all religious persuasions to make bouquets of artificial flowers out of filmy pink and mauve paper, all highlighted with gold sparkles and tied with wire to wooden wands that they waved as they went through the streets singing Christmas carols and touching people on the shoulders to wish them a good year. He thought the flower wands were "the most beautiful colors" he had ever

seen, and when he was an old man, they remained one of his "most important and strongest memories" of childhood. And yet in other accounts he insisted that his sadness had begun in infancy and by the age of ten had become his dominant emotion, even though he did not understand what caused it until he was a teenager. It was only then that he learned through personal experiences how restricted daily life was for Romanian Jews, and when he began to seek what he thought of as normalcy, he found it only through drawing and reading.

The society into which he was born was a complex one, especially for a transplanted Jew of Russian origin whose family spoke Yiddish as their common language. Romania had been a Turkish colony and part of the Ottoman Empire for several centuries, during which it became home to what Steinberg called "Levantine people—Lebanese, Turks, Persians, Egyptians, not to mention Greeks." His compatriots were an ethnic blend of peoples who looked not to Western Europe but to the East and to Asia for cultural sophistication, even as they conducted themselves according to the rigid Austro-Hungarian code of manners, beliefs, and behavior that had been superimposed by the ruling Hapsburgs. And yet despite the cultural mishmash of all these conflicting "Levantine" cultures, Bucharest took so much pride in patterning itself after all things French that it was known as the "Paris of the Balkans."

The physical city of Steinberg's childhood was one of contrasts and contradictions, of huge villas lining broad avenues that bore the grand French name *chausées* even though they were really dirt roads, obstacle courses marred by piles of horse dung and scoured and rutted by the wheels of carriages. The mansions were patterned after the imposing homes in the faubourgs of Paris from which they took their French names, with the most imposing lining the Calea Victoriei, the only street with a Romanian name because it was home to the king's palace and the most important government buildings. It too was a study in contrasts, rutted with cobblestones that did not deter luxury cars such as Lagondas and Hispano-Suizas from hurtling along, forced to swerve often to avoid hitting oxcarts or clusters of Gypsies who were cooking their dinners over patches of burning tar in the middle. Steinberg called such visions "a mixture of honey and shit, from which, as in real life, only happy memories remain."

YOUNG SAUL LOVED THE HOUSE WHERE he grew up. His happiest memories were connected with life at Strada Palas 9, a one-story house built into an interior courtyard of apartment buildings, much like all the others in the Antem and Uranus neighborhoods. It was "a society with no mysteries, where daily life was conducted in the courtyard and where doors were always open and anyone could look in the windows." Trees surrounded the house, and in the daytime,

the light coming into the courtyard was "luminous." He was "charmed . . . by sundown reflected on walls, colors," and as an elderly man was moved when certain colors gave him momentary pangs of happiness because he remembered them from childhood. There were vegetable and rose gardens that created "all sorts of smelly perfumed places." Children played on roofs or in attics, and there was a constant parade of noises, friends, and neighbors. Animals roamed freely; chickens were treated as domestic animals and were permitted to wander in and out of houses as easily as dogs and cats; ferocious geese could also go wherever they wanted, but local lore considered it outrageous to have a duck inside a house.

No domestic animals dared to enter the impeccable Steinberg kitchen or the heavily furnished, ornately wallpapered dining and living rooms. "Everything had to appear nice," and the house was layered with embroideries, curtains, drapes, and antimacassars. Rosa dressed Saul and Lica "like cabbages"; Lica wore fussy dresses with big collars and huge hair bows that held back her straight bobbed hair, while Saul was stuffed into stiff white shirts and fawn-colored suits with short pants. Even as a child he recognized that in comparison with Rosa and her immaculate household, her house-proud sisters "lived like pigs." The Steinbergs were prosperous and could afford a servant, so Rosa engaged one of the many Romany girls who came down from the dirt-poor mountain villages. Rosa was a tough and frequently abusive taskmaster, but despite occasional shouting matches and hurled crockery, the girl stayed with her for all the years they lived on the Strada Palas.

When Lica was old enough for kindergarten, Saul tagged along with her, so they were in the same class and often the same classroom for most of their early education. Boys were not separated from girls until secondary education, and in keeping with the Romanian love of costume, they had to wear uniforms. Saul donned a lesser version of something military, a dark blue suit and cap, highly polished black boots, and a lighter blue scarf whose color signified his school. He also wore a sleeve patch with a number that denoted both him and his school: LMB, for the Liceul Matei Basarab, and 586, for his "identification and denunciation."

The Liceul Matei Basarab, more commonly called by the French name, Lycée Basarab, was a highly competitive secondary state school for which students had to pass a rigorous entrance examination and where Saul learned a hard lesson: that in every single class, Jews were always outcasts, outsiders, or pariahs. He had not encountered this in his elementary school, in a neighborhood where the other students came from backgrounds similar to his. Those children were a hodgepodge of native and transplanted Jews from many

nations, all of whom accepted each other and wanted only to meld into Romanian nationality.

As an adult, Saul Steinberg described himself as a "wunderkind . . . without knowing it," for he did not realize until he was no longer there that it was the only way for a young Jewish boy to survive, let alone prosper, in Romania. Education offered the way up and out, and he was one of the students who did well in most subjects. He had not yet encountered overt anti-Semitism when he entered the Lycée Basarab—that only happened once he was there—and he began his studies as "a true native, proud of my country, seriously involved in loving it, thinking this was my life, my future and my pride."

Just getting to school every day was quite an adventure, because it was on the opposite side of Bucharest from home, far from the secure homogeneity of his own district. He commuted on a decrepit American streetcar, where he had the experiences that led to his discovery of how deeply anti-Semitism permeated everything. It suffused him with shame at the time and imbued him with lifelong rage as an adult, when he became deeply embarrassed whenever he had to admit he had been born in Romania.

Nonetheless, being admitted to the Lycée Basarab and wearing its uniform put him into an elite class and offered his first opportunity to forge relationships with non-Jews even as such daily contact brought the horrific realization that "people literally showed hatred." As an adult, Steinberg liked to use the word *divorce* to characterize ending everything from a friendship to a business agreement, and in this instance he said he "divorced" the entire country when he discovered the shame of not being wanted. He remembered the school as "an inferno of screams, slaps, toilets!" where only the French professor, who sometimes told bawdy stories, offered rare gestures of friendship and kindness that he remembered for the rest of his life.

Within the lycée, the enrollment was more than half Jewish, so he learned to avoid the classes and places where he encountered discrimination and tried to befriend Jewish boys who were like him. There was a clear division within the school that placed the students into three categories, and all the boys were aware of it. The first and highest comprised the "extremely sophisticated aristocratic Romanians," who were in a social class all their own and who socialized only with each other. The lowest cluster was "for the peasants, the troglodytes, the simple ones who . . . were in contact with primitive culture," whom he avoided. The remaining category was made up of the boys with whom he could interact, or, more accurately, those with whom he was socially comfortable and wanted to interact—other Jewish boys who were also cognizant of where they fit into the school's scheme of things. Such an understanding meant that they

accepted the role of wunderkind by studying hard in the hope that good grades would admit them into a desired way of life, which, depending on the student's degree of intelligence, could range from a profession to the military, government service, or a satisfactory trade.

The problem for a young Romanian Jewish boy like Saul Steinberg in the 1920s was that he was "part of a civilization that had to be improvised." The country was so new that there were few models to emulate: "We had no model in literature. We had no tradition of character." Even more poignant was how difficult it was to find "an adult, a respectable adult" on whom to model himself: "Of course one has in the family an adult, a father, et cetera, but these are adults that one loves and one doesn't quite respect them sufficiently to want to be like them." In his case, this was especially true.

External politics were tremendously influential in determining how the teenage Saul regarded his elders and how he and his father related to each other when he became an adult. It was grim to be a Jew in Romania in the 1920s and 1930s, and it was especially grim for the men of Moritz's generation. The end of World War I did not bring peace, as Romania's armies kept fighting Russia and Hungary in order to protect the four territories they had been awarded by treaty: Transylvania, Bessarabia, Bukovina, and Dobruja. Acquiring these lands doubled the country in size just when its resources had been so plundered and devastated that the original population could not survive without great infusions of foreign aid, which came only in sporadic dribbles. The future American president Herbert Hoover was shocked by "the minuteness of the German despoliation," as the departing occupiers stole anything that could be carried or shipped home and destroyed everything that could not.

The American ambassador, Charles J. Vopicka, told his government that the country had been stripped and looted first by the Germans and then by the Russians, who followed them, and he "urged and begged in the name of humanity . . . that relief be sent as soon as possible." Romanian famine was not a priority among Western leaders, noted the biographer of Queen Marie, who herself bemoaned that medals were being stamped in honor of Woodrow Wilson "whilst one cannot obtain a single engine that would help us to feed our starving population." Steinberg's memory of wartime hunger stemmed from the time when he was four or five and Rosa trained him and Lica to say "No thanks, we have that at home" whenever they visited neighbors and were offered cookies or cakes. They were allowed to take one only if the neighbor insisted.

By 1919 the situation of Romania, but most particularly of its Jews, was one of the most heated topics at the Paris Peace Conference. A fiery argument

broke out between Queen Marie and Woodrow Wilson over which country's minority population was treated worse, American Negroes or Romanian Jews. Wilson appeared to win when he provided evidence that Jews were removed from their usual battlefield stations and placed at the front of the front lines to be the first killed in the fighting with Hungary and Russia. Things worsened until July, when the Romanian prime minister walked out of the Paris negotiations, inspiring King Ferdinand to put the blame on "American Jews, bankers, and big businessmen" for trying to exploit Romania's natural resources for their own corrupt ends. He further inflamed his citizens when he blamed the Romanian Jewish community for contributing to "the cause of the economical and financial crisis." A year later, the usually tolerant Queen Marie echoed his sentiments when she said she tried "hard to feel towards [Romanian Jews] as I do to other nationalities, but ever again I am appalled by their extraordinary physical hideousness."

Thus by the late 1920s, when Saul was making his daily trek to the lycée, the country was in disarray and the climate was ripe for the rise of an ultra-right political movement fervently dedicated to the tenets of the Romanian Orthodox religion and just as fervently obsessed with anti-communism and anti-Semitism. This was the Iron Guard, whose official name was the Legion of the Archangel Michael, organized in 1927 by the charismatic mystic Corneliu Zelea Codreanu, who found his most willing volunteers among peasants, young and idealistic intellectuals, and disaffected shopkeepers and civil servants. Not everyone who wanted to join the Iron Guard was accepted: the fanatical thugs who followed Codreanu were an elite group who had to prove themselves in a three-year apprenticeship, during which they were imbued with the ideologies of violent action in the name of religion, sacrificial death, and, if necessary, political suicide. By the time they finished training, they were ruthless terrorists, and they were the ones who patrolled and menaced the route to school that Saul took every day.

THIS WAS THE POLITICAL CLIMATE IN which Moritz Steinberg, his brothers, and his brothers-in-law tried to remain as unobtrusive as possible while they worked hard to make their businesses prosper and provide stable homes for their families. They kept their heads down and tried to avoid those who demanded bribes, and they learned how to placate them if they could not avoid having to pay. They learned not to engage with those who taunted them and to fade quietly away from those who made actual threats to their livelihood. Even though their sons were just as powerless, they rankled at such caution, which they perceived as a lack of backbone. It was hard for Saul in particular, who saw

himself as participating in "a social class revolution . . . definitely going ahead and taking part in a cultural world that was remote and more advanced than the one of our parents." For him, Moritz was "the weak part of my family. He has not courage or will." Even worse, "he has always been absentminded," a quality Saul detested.

The immersion at school in a culture different from the one his father lived in at home instilled a degree of bravado in Saul, but it also induced rage and frustration. Many years later he said that his childhood and adolescence in Romania were "a little like being a black in the state of Mississippi." His exposure to the larger culture introduced another puzzle for a young Jewish boy in a segregated society to solve: how to use his education as a process of self-invention and how to search for role models within it. One of the ways he did this was through a literary circle that one of his friends, Eugen Campus, organized at his home. Steinberg, Campus, and the few others whom the rest of their classmates dismissed as the "serious boys" did not think of themselves as budding writers or artists but rather as idealists who wanted to examine moral values through their readings.

With his friends, but mostly on his own, Steinberg created a code of conduct and found reassurance in what he called "my real world, my real friends, in books." At the age of ten, which he realized was "much too early," he read Maxim Gorky, whose story "Alone in the World" became an important metaphor for his personal feelings. At twelve he was poring over Dostoevsky's *Crime and Punishment*, while Jules Verne provided "complete anaesthesia," which he had to regulate with heavy doses of Emile Zola and Anatole France. Like many other precocious adolescents, he found the idea of "the artist as orphan" appealing, and like his fictional heroes, he had to invent his own scenarios through his readings; also like them, he "*makes* [his emphasis] himself by education, by survival, by constantly paying attention to himself, but also by creating an exterior world that had not existed before."

At the Lycée Basarab, Saul was subjected to an entirely different kind of education. The rigorous curriculum consisted of courses in philosophy, foreign literature (with emphasis on highly sanitized Russian and French authors), history (primarily of Romania), Romanian language and literature, and foreign languages. He took two years of classical Greek, four of Latin, French, and German, and one year of Italian. Also required were courses in geography, mathematics, and sciences, including chemistry, the natural sciences, and hygiene. Students were required to take religion in each of the four years, but for some reason Steinberg was exempted in his first and last years. When he graduated, his diploma officially classified him as a Romanian citizen of Jewish

nationality and the "Mosaic" religion, "Mosaic" most likely being an administrative term dating from the Ottoman Empire, which may have been why he was excused from religion classes for two years.

Music was one of his two best subjects (at home, Saul took violin lessons and Lica played the piano); not surprisingly, drawing was his best (grade 9 out of 10). Despite his high grades in music and drawing, his was otherwise a decidedly mediocre record that placed him exactly in the middle of his class, with grades ranging from 5 (almost failing) to 7 (good), with only German higher at 8 (very good). In conduct (general deportment), his attitude and behavior were good, but overall his record was not good enough for him to be listed among the *elevi celebri* of today's Matei Basarab Institute.

He graduated in June 1932, and although he did not focus on preparing for any specific career during his lycée years, his favorite courses were in literature. He read avidly in Romanian translations all those Russian novelists who were approved by his teachers because the school required them: Babel, Zoscenko, Avercenko, and Korolenko. On his own, in both Romanian and French translations, he read Chekhov, Gogol, and Dostoevsky, and they became his lifelong favorites. After reading the Russians, he turned to French novels in their original language, but later, when he became proficient in Italian, he read some of them again in translation and liked them best in that language. He read voraciously during his lycée years, when constantly having to translate foreign literatures into Romanian was irritating and disturbing for reasons he could not quite pin down until he became fluent in Italian and then in English, when he understood how poor the Romanian translations were. From then on, he concluded that his native Romanian was "a language of beggars and policemen" which he had to ignore.

His embarrassment at the recognition of having been born into "a primitive civilization" may have begun shortly before, when he was ten and his uncle Harry visited from New York with his wife and two teenage daughters, Henrietta and Gertrude. Saul was "electrified by the beauty of my cousins and also by the smell of America, chewing gum, shampoo." Everything about America was grist for his imagination, especially the postmarks on the letters his family received from his uncle Martin in Denver and uncle Harry in the Bronx. The word *Bronx* itself was "especially magic, an explosive place, a fantastic name. Imagine—to live in Bronx!" America was "the constant hope of the oppressed," from which a steady stream of things came to the Steinberg family via the Hoover Relief: coats, woolen underwear, knickerbockers, and toys such as a double-decker bus and a sailboat. He called them "things to revere, not for play." Although he was fascinated by all things American, he made no mention

of trying to emigrate there, but he did make a solemn pledge to escape from the claustrophobia of Romania at the first opportunity.

By the time he was a teenager, he had decided that everyone around him, from his parents and relatives to most of his classmates, were living a life that disgusted him and espousing principles that he disdained. "I was different," he recalled, but at the time he could not find the courage to behave in ways unlike theirs. The literary circle showed him that it was possible to have intellectual preoccupations and high values, but it also showed him that he needed to be careful about how he expressed them.

Steinberg's jaded view of his native country influenced his work in courses that focused on Romanian history and literature. One essay he wrote during his junior year is notable for a light touch that falls somewhere between simple observation and outright sarcasm. He was seventeen when he was assigned to compare and contrast two Romanian writers, Miron Costin and Dimitrie Cantemir. His teacher's few corrections shed interesting light on Steinberg's attitude when he wrote the essay. He had just become fully disillusioned by the realization that his entire secondary education had consisted of "a fictitious history made by, adopted by, politicians . . . where a great number of kings and kinglets and royal bores and princes succeeded one another, absurd people who most of the time were front men of the Turkish Empire, princes elected for the political convenience of the monarch, decapitated six months later and substituted by somebody else." This jaded attitude permeates the essay, in which he called Cantemir and Costin the "two *aces* of old historical literature," which his teacher (no doubt horrified by such flippancy) changed to "two *leaders*." Steinberg sided with Cantemir, whose education and outlook were international. He praised Cantemir for his study of foreign languages and cultures, for the books he published in other languages, his contact with "distinguished [international] personages," and his membership in the Berlin Academy. He was careful not to denigrate Costin, but neither did he praise him, writing of how Costin studied "briefly" in Poland (which even in Romania was considered a cultural backwater) before returning to Moldova (then a primitive country), where he spent the rest of his dull life as a court functionary. The essay was not what a student who wanted to go places within his insular native land should have written; it was not politically expedient in the Romania of the late 1920s to prefer a writer who went out into the great world and made an impact on it to one who stayed at home and followed the party line.

Reading Cantemir was part of Steinberg's discovery of "the true history of other nations" just as he was preparing to enter the university. He had been force-fed a history that was small-minded and regional rather than interna-

tional, "made by—adopted by—politicians to cause us to be patriotic and hate the Hungarians." He was shocked by things he had not been taught about the true histories of other eastern European nations, above all "the influence of the Slavic world, the Russian Empire, the Russian civilization." He did not mention the most shattering event of recent history—World War I—or the major countries that fought in it, because nothing about the war or its aftermath was then taught in Romania.

Steinberg's years in the lycée, 1928 to 1932, coincided with the start of the Great Depression, during which Romania became even more cloistered and isolated by extreme poverty. From the start, every segment of society suffered, including Moritz Steinberg's factory, where manufacturing contracts for specialty boxes dwindled and the business was reduced mostly to bookbinding. It was what Moritz liked best, because it was a sedentary pursuit that left him alone in peace and quiet. However, it did not pay well, and at the end of 1929, when Saul was fifteen and finishing his first year at the lycée, Moritz had to move both his family and his factory to Strada Justitie (Justice Street). The "workshop," which had been a good-sized Romanian *fabrica*, was now known by the French term *atelier* to denote its greatly reduced size and staff. The Steinbergs lived in a small house next door to the atelier, and in these years they were often "without [electric] current, heat, bathroom, lights."

IF THERE WAS EVER ANY THOUGHT that Saul might enter the business and someday take it over, it does not appear in any of the many letters Moritz and Rosa wrote to their various family members, nor did Saul ever mention it in his correspondence or other written reflections. He was the family's wunderkind, and even in such dire economic times he was destined for the university, although there was no mention of what he would study or what profession he intended to follow.

He grew up to become an independent individual within a tightly knit family group, a beloved member who deliberately placed himself in the position of the outsider and observer of the domestic scene. In 1942, in one of the earliest of his many attempts to recapture and re-create the memories and images of his first eighteen years—the only years he lived in Romania—he painted a telling portrait of daily life in Strada Palas 9, before the family had to move. His mother, father, and sister are seated at the breakfast table as the Romany servant girl walks toward them carrying a platter of food. Rosa sits close to Lica and hovers over her, while Moritz sits apart from them at the far end of the table, upright and crisply dressed for business, drinking his coffee with perfect rectitude. Behind Moritz, sheer curtains blow in a window open to the

courtyard, where other life is under way, separate from the life in the Steinberg dining room. This domestic scene fills the top half of the page, while in the bottom right-hand corner Steinberg depicted himself in his schoolboy uniform, "wearing a name plate with a number, like an automobile." It is a strong statement of his place within the family, for he stands away from the cozy domestic scene at the table, carrying his bookbag and ready to depart. He observes his family as they go about their daily business, but they do not observe him. He is separate and distanced; he has presented a happy and peaceful domesticity, but he is not a part of it.

By the time he was eighteen, he was indeed a separate entity. Moritz and Rosa respected him, mainly for his intelligence and success at school, and so they deferred to him because he brought home to them his knowledge of the outside world and the wisdom to interpret it. They were both innately intelligent and intellectually curious, but they were not formally educated, so they appreciated the new knowledge their son imparted. They knew what a good education could do for an ambitious Jewish boy, and they wanted something better for their son than a life like theirs, subject to the whims of those in power and the vagaries of fortune and finance that dominated their business dealings. It was important for their only son to better himself and, by extension, to better their own position in the world. They allowed Saul, even encouraged him to pursue what interested him most, but the underlying message was that it should lead to a solid and secure career.

And so he entered the University of Bucharest in 1932, unsure of what it might lead to but imbued with a questing intelligence and an eagerness to find out. He lasted exactly one year, a restless year in which he read a great deal, wrote only what his courses required, spent time with his lycée friends, and did not seem to make new ones. He might have worried about what would become of him, but if he did, he never said so, and no one else did either. At the end of that year of drifting, through a series of happenstances and compromises he decided to become an architect.

A SECURE TRADE

I accepted a kind of compromise. If I had declared that I wanted
to dedicate myself to art, my parents would not have supported
me in school. So I declared that I wanted to study architec-
ture . . . [a] serious and prestigious profession, almost on the
same level with medicine.

Moritz and Rosa Steinberg would have been alarmed if they had
known Saul was flirting with the idea of becoming a writer, but they
would have been terrified if they had known he was also considering
a career as an artist. When he applied for admission to the university,
they were overjoyed with his decision to become an architect and broadcast
it to their entire community. The local custom was for Jewish matchmakers
(*shadchanim*) to visit the aspiring student's house, bringing offers from rich
practitioners in the chosen field to sponsor the student and pay for his educa-
tion if he would agree to work for them after graduation. Unfortunately, Saul
was rejected when the admissions committee for the school of architecture
pronounced him deficient in the two most important criteria for an architect:
mathematical ability and skill in drawing. They deemed him far more talented
in languages and shunted his admission to the university's liberal arts division,
the Faculty of Arts and Letters.

This was the first-ever rejection in all Steinberg's years as a Jewish wun-
derkind, which may have been why he spent his only year at the University
of Bucharest lackadaisically reading philosophy and literature, pursuing sev-
eral girls, and occasionally worrying, along with his parents, that he was not
preparing for a profession that would enable him to become self-supporting.
Throughout his life, he was asked many times what had led him to become an
architect, and as he did with so many other questions, he invented a variety of
answers. Probably one of his most truthful came when he told a friend that "for
a young Romanian Jew, construction was a secure trade."

In 1932, when Steinberg began his university studies, architecture was a

sound career choice for the son of a Jewish small-business owner in search of a more secure profession. By the 1930s, building was a booming enterprise in Bucharest, as Romania was rebounding from the years of deprivation imposed on it at the end of World War I. Literally overnight the country doubled in size, when the provinces of Transylvania-Banat and Bessarabia-Bukovina were ceded to the "Old Kingdom," and became known as the kingdom of Romania, home to seventeen million people of disparate ethnic backgrounds spread over 295,000 square kilometers. It was "an interesting, animated time," especially in Bucharest, as Aron Sigalu, who changed his name to Arthur Segal when he moved to Germany to become a painter, described it. Suddenly there were all sorts of possibilities in a new country "where the capital does everything possible to look like Paris though the king is a prince of the house of Hohenzollern and the nobility a carryover from the Ottoman [Empire]."

People poured into what had been a sleepy country town of rutted and unpaved streets with run-down houses that were now being demolished and replaced by huge barracklike buildings on broad thoroughfares. Everything was done in the name of modernism and "the new Romanian architecture." No matter how ugly the building or inappropriate the setting, everything was touted as "progressive." And there were not enough architects to design all the new government offices and apartment blocks, which could not be built fast enough.

The sudden need for skilled builders forced those in authority to turn architecture into a profession open to anyone who could qualify, one that all but guaranteed wealth, prestige, and high social status. The profession became both honored and rigorously structured after 1921, when the Corpul Tehnic al Arhitectilor (Architects' Technical Association) was created, and by the time Steinberg applied to the university's Scoala Superiora de Arhitectura (Upper School of Architecture), all architects were required to pass a rigid system of testing and professional registration. Throughout the 1930s, diplomas granted by the Bucharest School of Architecture were recognized in Europe as being on a par with those granted in Paris, Zurich, Milan, and Berlin. Many young Romanian sons of wealthy parents chose to study abroad, but those who came from the working classes stayed at home to earn diplomas that were accorded equal respect. Thus, for a student like Saul Steinberg, whose family could not provide the financial wherewithal for him to go abroad, rejection at home was especially stinging.

The year he spent reading literature and philosophy unfolded easily enough but without much to engage him. The curriculum concentrated on everything local and patriotic, and every field within the humanities was filtered through

the lives and works of exemplary Romanian personalities. Among those espe-cially revered was George Matei Cantacuzino (1899–1960), a prominent architect who had begun his professional life as an artist and writer. Known as the "chronicler of Romanian spirituality" and praised for insisting on the interlinked totality of all forms of art, Cantacuzino promoted the German idea of *Gesamtkunstwerk*, which held that architecture must be closely related to every other artistic expression and that its relevance must be central to any study of a given culture.

Cantacuzino's first and most important architectural commission was the restoration of the Byzantine ruins at the Palace of Mogoşoaia, which he worked on from 1920 to 1931. Just outside Budapest, it was a popular destination for students on hiking trips, and Steinberg went there with three of his lycée class-mates in April 1932, more for the fun of the outing than for architectural edi-fication. He also joined them to hike on Omu and Caraiman mountains, an activity he immediately disliked and never engaged in again.

Steinberg enjoyed these three friends: Eugen Campus, Bruno Leventi, and one known only by his surname, Pascharides, whom he described as "rich Jews and Greeks, swift, happy, the aristocracy of the class." He always insisted that he made few, if any, close friends during his school years in Bucharest and described himself as awkward and clumsy in social settings, constantly fearful of making a fool of himself and unable to interact naturally with people his own age. There is a contradiction in this description of himself, for fifty years after their schooldays ended, he rekindled a warm friendship with Leventi and actively sought to reconnect with Campus, who was living in Israel and writing for Romanian-language publications there and elsewhere.

Campus was the one who initiated the literary circle and dubbed them "the serious boys." It was an unusual group in that its members were not inter-ested in becoming poets or novelists but rather "wanted to explore the world of cultural values together." This was where Steinberg first understood how essential the study of literature and literary criticism were to the acquisition of knowledge. However, such study would not lead directly to the lucrative profession his parents expected, and so architecture offered the perfect com-promise, particularly after he learned of the Iancu brothers, the success story held up for their own sons by every Jewish parent of Steinberg's generation.

Steinberg and his school friends were a decade younger than most of the prominent Jewish men who were luminaries of architecture in Romania, par-ticularly the Iancu brothers (who changed their name to Janco to make it easier to pronounce when they went to France to practice in 1920). Steinberg did not even know of Marcel and Iuliu (later Jules or Julius) Janco until he went

to the university and heard their names bandied about. Their father was so wealthy that the brothers were accepted as assimilated Jews who were able to move so freely throughout Bucharest's upper-class society that they attended the extremely prestigious Liceul Gheorghe Lazar, which had very few Jewish students. Steinberg's father and uncles were well aware of these architects and hoped that their own sons might achieve the same professional success and emulate the lifestyle of their social superiors.

Marcel and Jules Janco were among those who were wealthy enough to study abroad. With a third brother, George, they went to Zurich in 1915 and enrolled in the Eidgenössische Technische Hochschule, the Swiss Federal Institute of Technology, but instead of concentrating on their studies, they spent the better part of the next five years involved with another Romanian Jew who had been their lycée classmate, Samuel Rosenstock, who changed his name to Tristan Tzara and became one of the founders of Dada at the famed Cabaret Voltaire in 1919. By 1932, when Steinberg was studying literature, the Janco brothers had long given up Dada and were living in Bucharest, welcomed as respected members of the local intelligentsia. Instead of coming home with them, Tristan Tzara went to Paris and was being cited by Steinberg's professors as an example of the "Judeo-Bolsheviks" whose "literary anarchism" was corrupting Romanian culture.

Steinberg and his classmates were too respectful of authority to contradict their professors, but they were always aware of Jewish inroads in local society, and Tzara and his ilk represented the burgeoning number of "young emancipated Jewish writers" who encouraged "the openness of Romanian environments toward artistic modernity." They knew that the very modernity their professors touted in all things Romanian was a predominantly Jewish phenomenon, a fact that those in authority carefully ignored. The professors did not tell their students that within a country of six million people, 300,000 of whom were Jews, the vast majority of the avant-garde had been born into and grown up in a Jewish culture and tradition.

The eighteen-year-old Steinberg was vaguely aware that something interesting was going on in Bucharest's artistic circles. A lot of names he remembered hearing were figuring in what later became known as the beginning of Balkan absurdist writing, but with the exception of the literary circle at Campus's house, his youth and personal circumstances left him far removed from any direct contact with it. He and his few friends had little opportunity to socialize with these writers and were too shy to seek them out.

They were also too shy to pursue girls, and there was almost no chance to meet them through their school. Even so, girls had been capturing Steinberg's

fancy for several years. In Buzău, for example, on visits to his grandfather, he "took pleasure from a city full of young girls . . . on the sidewalk, a few magnificent brunettes in school uniforms." In Bucharest, the only girls he knew were those who lived on his street or were the sisters of his friends, and there was no opportunity for anything but casual conversation in awkward chance meetings. Like other adolescent boys, he kept these encounters and everything else about girls to himself.

He wondered how he was going to promote himself as an architect when he looked at himself in photographs and saw a shy, skinny fellow with a "gigantic head," a dandy in spats and a well-worn suit, topped off with a "George Raft and Ronald Colman hat." Campus described him as having a "timid and taciturn" personality and a "thin bony body . . . elongated face . . . and prominent nose." Steinberg may well have wondered how far such looks were going to get him in business, let alone in life.

He recognized that there was a strong contrast between himself and the Romanian Jews who had succeeded in gaining the right to study for a secure profession. His father was still struggling to keep the *fabrica* going, while on the other side of town, Hermann Iancu, father of the architects, was a prosperous *commerciant,* or merchant, another of the few occupations open to Jews. Hermann Iancu was so successful that his family lived on one of Bucharest's finest streets in an architect-designed villa surrounded by several thousand square meters of private gardens. The house they lived in and the life they led was light-years removed from the overcrowded Jewish quarter where the Steinberg family and all their relatives congregated. Nevertheless, the Steinbergs were all well aware of this other, magical way of life. Everyone in Steinberg's extended family knew that when the Janco brothers went abroad, they were supported in grand style by their father, and when he abruptly summoned them home in 1921, it was because they were "needed," as so many building projects had begun and each one was "bigger than the next." Money and social standing begat success, and when Saul Steinberg was considering architecture as his profession, the Janco brothers were at the pinnacle.

Steinberg was one of four in his neighborhood who wanted to become architects. Jacques Ghelber, who later became his cousin by marriage, passed the Bucharest entrance exam and was admitted, while Steinberg and two of his friends from the lycée, Bruno Leventi (whom Steinberg now called Leventer), and Mihail "Ciucu" Perlmutter, were not. All three were left with two options: either to look for a job or study something else. Because they had no other option that year, they all enrolled in the university's liberal arts division, but while Steinberg was drifting along studying philosophy and literature and

wondering what to do next, Leventer had not given up on architecture and was earnestly investigating foreign possibilities.

On the one hand, it was depressing to hear Ghelber's enthusiastic reports about his architectural studies, but on the other, because Steinberg and Leventer were neighbors as well as friends who saw each other almost every day, it was much more intriguing to hear him describe his foreign research. Steinberg began to think that going abroad to study architecture would get him out of what had become a stultifying home life and a dismal educational experience and would be far more exciting than the uncertain future he faced if he stayed in Bucharest.

The first foreign school Leventer looked into was the Ecole des Beaux Arts in Paris, simply because Romanians looked to Paris as the epitome of superiority and perfection. The Beaux Arts was quickly ruled out because living in Paris was too expensive, as were Zurich and Berlin shortly after. London was also a respected destination after the war, but it was too far away as well as too expensive. That left only Milan, but even so, it was not a destination of last resort. Romanians prided themselves on a shared history with Italy because of the roots of their language and many other similarities, from the way family entities related to similar diets and pleasant vacation destinations. These were not as superficial as they might seem at first glance; Italy was a popular choice for Romanians because it was so close, so similar, and so safe.

Steinberg's argument for going to the Regio Politecnico was bolstered because Leventer, whose family was so like his, enjoyed the full support of his parents. When Saul first told his parents that he wanted to join his friend, Rosa was aghast, and as always turned the situation into one wherein she played the dominant role. What would happen to her, she wailed, if "Sauly," her beloved only son, left her? She would never have a moment's peace, worrying about him, so far away from the family nest and her loving ministrations. Her outbursts could be heard throughout the courtyard, but they had no effect on Saul, who had adopted the attitude that would govern his behavior toward his family for the rest of his life. Nothing Rosa did could make a dent in his determination, his rigid fixation on what he wanted, and what he needed to do to get it. He would not give in to his mother's manipulative tears, fainting, and heart palpitations. He remained the polite, devoted, and obedient son on all other fronts, but when it came to Milan, he intended to go if accepted.

Moritz too played his typical role in this new family drama. He did not engage with Rosa in her bouts of histrionics, nor did he try to dissuade Saul. He shouldered his new task, which was to reorganize the family's finances so

that Saul could pay his tuition and have an extremely modest amount left over for room and board. In his usual quiet and thorough way, Moritz arranged it, and when the letter of admission came, he was prepared for Saul's departure. Leventer and Perlmutter were also accepted by the Politecnico, and they and Saul set off together for Milan.

THE PLACE TO GO

As far as I could ever see, Saul never did anything to bring about his success. It just fell into his lap. All he ever did was draw, and the rest came by itself.

Saul Steinberg and his friends, Leventer and Perlmutter, arrived in Milan in the fall of 1933 to begin their architecture studies at the Regio Politecnico. Three penurious students, they moved from student housing into one furnished room after another until they found something fairly decent and affordable at Viale Lombardia 21. The bathroom was a shared toilet at the end of a long hallway, but the room was on the top floor and filled with light from a window that opened onto a tiny balcony just big enough to

Steinberg in Milan with an unidentified classmate at the Politecnico.

hold a potted plant, which they jokingly called a "terrazzo." They were thrilled to have the room, although they were not so thrilled with its only decoration, the *testa di cavallo,* an embalmed horse's head that hung directly above Leventer's bed. The roommates agreed that it ranked somewhere between frightening and disgusting, but they were too cowed to ask the landlord to take it down.

Saul Steinberg's official registration in the school of architecture was dated November 17, 1933, and on December 16 he was officially enrolled as a first-year student in the Regio Politecnico, ID number 33–34/81. His actual entry to the school had come in September with the convocation that signaled the start of the semester, on the day before classes began. After the ceremony, the "skinny little fellow with the big nose and heavy glasses" was noticed by another student who was also loitering in front of the building on the Piazza Leonardo da Vinci. This was Aldo Buzzi, a native of nearby Bergamo, who had enrolled in the Politecnico after a lackluster year in a music conservatory because "the architecture department was the place to go if you were not sure about what you wanted to do with yourself." Steinberg initially attracted Buzzi's attention because "there were so few foreigners in the school and everything about this one seemed different and out of place." Something told Buzzi that this other student was a kindred spirit, since they were both behaving as if they had nothing else to do and nowhere to go while everyone else had rushed out of the convocation intent on last-minute preparations—first for lunch, then for classes.

Steinberg and Buzzi fell into step and began to talk, and as one subject led to another, they found themselves deep into a philosophical discussion of what would happen if an artist drew a single line and allowed it to evolve into a drawing. When Steinberg became so excited by the subject that his Italian faltered, they switched to French, a language they both knew well enough for a spirited conversation. This became the first of many during the next seventy years and the basis for a rich correspondence when they were not together. Despite the ease with which their friendship began, Aldo was aware from the start that Saul was a very private person who kept most of what he thought or did to himself. At first Aldo thought of him as a poseur who was merely trying to keep his insecurities from being seen by others, but as time went on, he realized that this was Saul's true personality, and he learned to respect it.

Becoming Aldo's friend was exceedingly helpful to Saul as he sought to blend into a life far different from what he had known in Bucharest. The Poli, as the students called it, was both bohemian and sophisticated, and by studying everything Aldo did or said, what he wore, how he interacted with the other

students, and even how he smoked his cigarettes, Saul was able to avoid most of the gaffes a foreigner would unwittingly make. Aldo's self-confident descriptions of his native Bergamo seemed the epitome of refinement to the "nervous Romanian boy in the ill-fitting, mismatched jacket and trousers." Saul was impressed when Aldo told him that his second cousin, Tommaso Buzzi, was on the Politecnico faculty and would be their instructor for *disegno dal vero* (drawing from life); he was even more impressed when he learned of Tommaso Buzzi's distinguished reputation as one of Italy's foremost designers.

Aldo was the son of a widowed mother, and like Saul, he had to count every penny. He was a font of information about bargains, the most important being where to find the most food for the least money. At the top of the list was the local *latteria,* a "milk shop" that went by the improbable name of Bar del Grillo, famous among poor students for serving heaping plates of rice lavished with butter. Years later Saul still savored the memory of "gigantic portions of *rigatoni al sugo* with sage twigs and all the bread you could eat, followed by goulash or stew drowned in red sauce, which you mopped up with the endless bread." But he could not afford even that during his first year, 1933–34, when the Romanian leu was weak against the Italian lira. He could afford to eat once a day, and he had that meal at noon in the student restaurant, where he could take as much pasta or risotto as he could load onto his plate, always topping it with a fried egg if eggs were on the menu. In the evenings he ate surreptitiously in his room, having smuggled out at lunchtime a Milanese panini, which he covered with butter and gorgonzola or a smattering of peach jam—for as long as the supply he brought from home lasted. He drank water and went to bed hungry, consoling himself with food fantasies as he recalled his mother's enormous meals of "terrible Jewish-Romanian cuisine."

By his second year in Milan, he had overcome his shame and shyness to join his classmates regularly at the Bar del Grillo, where students could nurse a single coffee for hours and buy cigarettes and postage stamps. Shortly after, when the shabby hangout became the first commission of Ernesto Rogers and his newly founded architectural firm, BBPR, what had been a mismatched collection of cheap wooden tables and chairs was turned into a sleek example of modern Italian design, all black lacquer, shiny chrome, and stainless steel. However, despite its gleaming splendor, the bar's location just down the piazza from the Politecnico guaranteed that it would remain the same old neighborhood fixture it had been during its incarnation as a *latteria*. It was Saul's local throughout the 1930s, and for a few years it became his address, Via Pascoli 64, when he rented a room above the bar; for the rest of his life, it became an iconic talisman for triggering happy memories. Even after it was long gone,

he praised the Bar del Grillo as "the best kind of propaganda for a modern architecture."

He never forgot the four Cavazza sisters, who had inherited the bar from their father, an old man who dozed away his days in a chair near the sunny front window. His was "the face of a Roman senator which had been passed on to his daughters with disastrous results." Angela, "the oldest and most ferocious," presided over the cash register. Saul was amused by her name, "given her face, a real Leonardoesque caricature of a warrior in the act of killing somebody." The next daughter, Natalina, was the waitress, "a real spinster, less ferocious, even a bit more maternal." She served the food cooked by Maria, "enormously fat, of whom one saw only her bust" as she passed the dishes through a little window that separated the kitchen from the restaurant proper. Saul noticed that the fourth sister, Carla, was "not bad looking," but he never made a pass at her because she had a fiancé "and would vanish every now and then for a day or so."

Student gossip held that the Bar del Grillo got its name from the trigger on a pistol, or *grilletto*, which the students insisted was also the most common slang word for the clitoris. It might have been, in some obscure dialect other than Milanese, but Saul knew that the name was bestowed by the original proprietor, an Italian who came home from America and garbled the English words *bar and grill*. To him, it was "the most perfect name for a restaurant with dancing and rooms for rent by the hour," and he quickly became a fixture among the students who gathered there. Having such a comfortable hangout was one of the reasons that, after his first poverty-stricken year, he never ventured out to see much of the city that lay beyond the bar, but the chief reason he stayed there was because he had so little money: after he paid for the bare necessities of survival, there was not much left for public transport and entertainment.

Milan was cosmopolitan in every way, a "laboratory for modernity," internationally respected for art and architecture, graphic design, industrial development, fashion, and every form of culture from opera to literature. Although he lived in the city's intellectual epicenter for more than eight years, Steinberg always insisted that his "autobiography" of that time was more of an "autogeography." His entire world was bounded by the few streets located midway between the Metro stops of Piola and Lambrate and consisted only of "a particular neighborhood," the working-class district surrounding the academic institutions that made up the Città degli Studi. His world became even smaller when Ciucu Perlmutter moved elsewhere and he and Bruno Leventer were left alone to settle in under the dreadful *testa di cavallo*. Living so close to the

Poli, Saul needed only to make a short walk for morning coffee at the Bar del Grillo before heading up the piazza to classes. Then it was back to the Grillo to hang out.

Saul insisted that the strongest memory of his early years in Milan was of "solitude," that he was never at home and always out, unable to make himself study, concentrate, or read. He "marched around like a soldier for hour after hour," returning to his room only when he was "exhausted, falling asleep hungry but sufficiently happy." When he walked the streets, it was in a daze as he stopped to read the menus and stare at the abundance of foods displayed in grocery windows. He looked with yearning at antipastos, pastas, roasts, and sweets, until he became so faint that he had to cross the street to get away from the sight and also from the reflected images of the girls who passed by on the sidewalk behind him. When he turned to look at them directly, their legs in sharp heels left him so dizzy with longing that his food fantasies had to compete with sexual fantasies in which he imagined himself taking part in all things witty, from conversations to courtships. If asked what he saw on his peregrinations, he could only describe the "abundance" of women and the "luxury to observe them in their infinite variety." Food and sex were unreal dreams, out of touch and reach behind thick glass windows but nevertheless contributing to the artistic vision he was formulating: the plate-glass window was a barrier, but even so, it represented two important and useful qualities: transparency (the food) and reflection (the girls), both of which became the "symbol of reality becoming my art, my condition, my life."

As an architecture student, Saul was aware of the new buildings that were springing up all over the city, but he never commented on them. Nor did he remember visiting the art museums and monuments that international visitors flocked to all year long, and he never mentioned politics, although Milan was a hotbed of Fascist intrigue from the beginning of Mussolini's reign in 1922. His experiences in Romania had taught him how expedient it was for foreigners, particularly Jews, not to call attention to themselves. Having witnessed at first hand political persecution in Bucharest, he knew the wisest behavior in Milan was to fade into the background and become "the first-class noticer" that he was from those years onward.

However, Steinberg's contention that he was always solitary and alone during his first two years in Milan (and even after) does not ring entirely true. His room became an informal gathering place for other students, and there were frequent parties. Every morning that the weather permitted, he went out onto what Leventer ironically dubbed "the terrace of our villa, in the shade of the dwarf palms," where he would draw for hours. As soon as he met

Aldo Buzzi he became part of a group of fellow students, mostly Italian and most of whom became lifelong friends as they went on to establish brilliant and distinguished careers. Among them were two who became luminaries in the Italian film industry, Alberto Lattuada, the writer-director who was later Aldo Buzzi's brother-in-law; and the famed director Luigi Comencini. Sandro Angelini became a respected architect in Bergamo, and Erberto Carboni was already making a name for himself while still a student when he contributed to the internationally acclaimed avant-garde graphic design firm Studio Boggeri. Steinberg saw these friends every day in the classroom and the hallways, and the ones as poor as he and Buzzi often joined them for meals at the Grillo, while the ones who had a bit more money often stood drinks at the bar. Every day he had conversation and conviviality whenever he wanted it and companionship for anything social he chose to do. If and when he was alone, it was because he chose to be.

Saul had two major preoccupations during his early years in Milan, drawing and girls, and he indulged in both every day, most of the time managing to sketch and ogle in concert. Aldo joked that the notebooks he carried everywhere seemed to be "attached directly to his hand and pen," but even though Saul insisted that the only thing he took notice of was "the luxury of women," his notebooks attest that he saw much more. From his youth in Bucharest, when he first attempted to paint with oils on canvas, the smell of turpentine made him ill, so he concluded that he was probably allergic to it and tried never to use it. Instead of joining classmates who copied the paintings in museums, he chose to draw the life of the streets, rendering everything he saw with his characteristic firm black line and giving everything a touch of the whimsical and imaginative that was uniquely his own. He drew street scenes and buildings, especially churches such as the lofty San Lorenzo, and the glass-domed interior of the Galleria Victor Emmanuel II with its Café Biffi, which, as soon as he earned enough money to afford it, became one of his favorite destinations.

As for women, whenever he wanted to do more than look at them, he had several options, and he exercised them all. The skinny Romanian boy in the ill-fitting clothes very quickly became proficient in the Italian language and particularly the Milanese dialect, and in the process he discovered that women found his easy manner attractive. If he wanted to talk, plenty of young girls went to the Bar del Grillo to flirt with students, who could be counted on to buy them drinks, after which the girls might occasionally be persuaded to go upstairs to one of the rooms that could be rented by the hour. There were also nearby brothels on unobtrusive side streets, known to students and tolerated

by neighbors, just so long as everyone was quiet and discreet. Later in life, when Saul joked that a friend's red velvet furniture looked like something out of a Milanese brothel and she asked how he would know about such things, he only laughed and shrugged. His sole problem with women in those years was one of money, and sometimes, when he had to choose between entertaining a woman and buying a meal, he chose to go hungry—if no friend was around to float a small loan.

ALTHOUGH STEINBERG INSISTED THAT HIS "chief interest . . . was in girls, and he was hoping "to find [himself] through love," he had not gone to Milan to pursue women but to become an architect. As soon as his studies began, he became as sardonic about his profession as he was about his personal life. He thought the curriculum at the Poli was "marvelous training for anything but architecture" and joked that it was so "frightening" to think that one of his drawings might eventually become a building that he always took care to draw "reasoned lines."

In the years that Steinberg was a student, the educational philosophy of the Politecnico lay somewhere between "cribbed Bauhaus" and "the influence of Cubism," but the one certainty about the curriculum was that it was "comfortable" rather than demanding. Students often postponed final exams until long after they completed the courses—in some cases for years—and that is what Steinberg did. This casual attitude gave him all the freedom he needed to keep on with the style he had adopted when young, of "continuing and perfecting childhood drawing—without the interruption of academic training." In later years he insisted that the Poli had exerted little, if any, influence on his mature drawing. What remained strong from these years were the memories of "places that don't belong to geography but to time."

In the first year of classes, the Politecnico students took courses that were divided almost equally between the rigidity of mathematics and science and the fluidity of art and the humanities. Analytical mathematics and advanced geometry were balanced by the history of art and architecture. Steinberg took two language courses as electives: German (then the language of science and necessary to understand technical publications) and English (the lingua franca for general international discourse). Students were required to study elements of construction, mineralogy, applied geology, and elementary architectural composition and drawing, but he also studied *disegno dal vero*, or drawing from life. The life-drawing courses were held at the Poli, but the student body was enlarged by groups from other area schools, such as the prominent Accademia di Brera, where painting and art history were the primary subjects. It

made for an interesting mix of styles and opinions, and provided broader cultural insight into contemporary Italian art.

In *dal vero*, Tomasso Buzzi taught students how to see everything with a new and discerning vision, from human models to inanimate objects and still life assemblages. He would point to a view or an object and tell the students to draw it quickly, which brought a "revelation" to Saul, who told Aldo that until he took this course, he had only drawn from "fantasy" or "imagination." Now he was finding both "surprise" and "passion" in everything he saw and drew, because of his teacher's unorthodox way of exploring and explaining the world around him. The work he did in Tomasso Buzzi's class had a special meaning for Steinberg; throughout his life he always threw away drawings that displeased him, "but rarely drawings *dal vero*."

Tomasso Buzzi was not only Aldo's cousin but also the friend and collaborator of Giò Ponti, another of Steinberg's professors, and he was the first of several (Ponti was later among them) who told Steinberg that he had the makings of an artist as well as of an architect—heady praise for a first-year student. Toward the end of the course, Tomasso Buzzi shifted the course content away from what the Brera students called "pure art" and toward what he called "documentary" drawings. In the days of the T-square and slide rule, these included the architectural segments and components of buildings that students drew by hand before computer programs rendered such drawings obsolete. Steinberg's versions of some of the "documentary" drawings were of interiors as grand as the Galleria, simple layouts of living rooms and bedrooms, and building facades and decorative columns. Here again, in pencil and ink lines of varying blackness and width, he subjected such concepts as distance and perspective to his particular vision. Straight walls appear slanted and off-kilter, furnishings are distorted, and hallways and corridors are either foreshortened or made to loom unnaturally large. He tried to explain what he did by saying that his work always said "something about something else" and that his intention was always to show "something more than what the eye sees."

Interestingly, the nuts-and-bolts courses that formed the greater part of the curriculum offered other ways for him to use what he saw to represent and describe something else entirely. Arturo Danusso, already respected for an important series of published papers on the use of reinforced concrete slabs, taught a structural engineering course that was pure mathematics combined with solid geometry. Ambrogio Annoni, a distinguished architect who specialized in architectural restoration, taught "drawing from nature" in a course titled "organisms and forms of architecture." The student body for this course was a combined group of architecture students from the Poli and art histo-

rians and restoration specialists from the Brera, and the mix made for some exciting discussions. The eclectic Piero Portaluppi, considered one of the main protagonists of architectural culture in Milan, used his courses to provide students with practical work experience for the many important commissions he executed between the 1920s and the 1950s. Giò Ponti, in an interior design course, taught Steinberg to see every object in a room with the same sense of astonishment that Tomasso Buzzi inspired, and to commit it to paper with the refreshing originality that became a hallmark of Steinberg's vision.

Despite Steinberg's insistence that the Poli had little influence on the development of his style, it is not too far-fetched to find traces of what he learned in these courses in the later drawings that puzzled and delighted legions of admirers. The classes sparked his initial knowledge of and lifelong interest in the history of art and architecture, but just by being in Milan he gained the confidence to be a snob about art and architecture, to know what was good and dismiss what was not.

His courses fed his imagination but did not become illuminating experiences until he began to take the required field trips that complemented classroom instruction. Students went to several factories throughout the Piedmont region that specialized in manufacturing various materials used in construction, among them a cement factory in Ferrara where they saw the practical application of Danusso's research. One of the best trips was Steinberg's first to Rome, where the students were taken to monuments, ruins, and buildings old and new, then left free to let their imaginations carry them on waves of creativity. Steinberg became "a very, very precise observer of the world, a profound and precise draftsman" as he drew the required "documentary" drawings. His line became firmer, more assured, and to his surprise his personal sketchbooks filled far faster than those that were required. His creativity overwhelmed his course work, and because he was not concentrating on class preparation but was branching out into other, more artistic areas, he was not prepared for most of his examinations and delayed them.

He thought he had plenty of time to deal with bureaucracy whenever he was ready to confront it, even though the years from 1933 to 1936 passed with astonishing speed. He worked hard during term time but was still relieved when he went home to Bucharest every summer to satisfy his parents' questions with vague replies that he was making progress toward his degree and everything was proceeding smoothly and on schedule. He usually traveled by ships that sailed from Genoa or Venice, sometimes up the Danube, other times via the Black Sea. Occasionally he wended his way to Vinkovich in Yugoslavia, where he transferred to the Orient Express, which came from Istanbul. He

didn't work to earn money during his vacations, so when he returned to Milan, the over-solicitous Rosa usually stuffed his suitcase full of salami, halva, peach preserves, and cakes. His friends were happy to share the "pink, green, and blue box of sugary treats" that was usually piled on top of what Saul dismissed as merely "some drawings." He filled sketchbook after sketchbook as a way of coping with his family and a way of life that had become foreign and distasteful. He saw himself becoming more Italian than Romanian, and just as he postponed his exams, it was easier to evade thoughts of having to return to Bucharest.

ONE OF THE THINGS SAUL CHAFED at during his early years in Milan was the constant lack of money, a problem that was partially solved one day at the end of 1936 when a brittle, fast-talking woman "just sort of appeared" in the Bar del Grillo, gave a hard, appraising look at all the men, and took a seat by herself at the bar. Ada Cassola had blue eyes and dark blond hair and wore her skirts a fair bit shorter than modesty required. Aldo remembered her as "tall, thin, angular, and not really a beauty; many would say she was not even pretty, but there was something striking about her, and her personality fused with what Saul was looking for in a woman." Like Saul, Ada was an exceedingly private person. She allowed the habitués at the Grillo to believe that she had come to Milan from a small town somewhere to the west or south, perhaps in Liguria, but she had no trace of an accent and did not speak a dialect native to that region or any other. She spoke Italian with a cultivated accent that sounded both practiced and acquired, and when she did lapse into the Milanese dialect, she was able to speak it fluently. She evaded Saul's questions, especially about her age, but he eventually discovered that she had been born in 1908, which made her six years older than he. She told him she had no family and stuck to the story that she had come alone from an unnamed small town to seek her fortune in the big city. She never spoke of how much education she had or whether she was prepared for anything other than menial work.

Ada Cassola Ongari, Steinberg's "beloved Adina."

In the beginning, Ada helped out as a waitress at the Grillo and as a cleaning woman for the rooms above, but she had bigger dreams and did not do such work for long.

Her mysterious comings and goings provided irresistible gossip for all the regulars at the bar, but neither Saul nor Aldo could get a straight answer about how she suddenly seemed to have all the money she needed without ever appearing to do any work. Aldo thought she might be a fence for stolen goods or a smuggler. Both possibilities gained credence when she gave Saul a cigarette case and wristwatch and shortly afterward was arrested for smuggling contraband cigarettes. A bribe to a local official got her off that time, but she did have to lie low for a while, and Saul and Aldo had to pitch in to help cover her expenses. Nothing daunted Ada: she was fearless, always up for a dare, and after World War II began, she smuggled contraband right under the noses of the Nazis.

Ada remained a major presence in both men's lives until her death at age eighty-nine in 1997. For Aldo and later for his wife, Bianca Lattuada, she was a "mystery to the very end: never once did she speak of her family or her origins; never once did she reveal anything personal about herself." Saul was utterly besotted with Ada; she was the first woman to captivate him totally. He begged her repeatedly to marry him, but time after time she stalled, giving one reason or another. She was so elusive that when he was not drawing or going to classes, he was almost always trying to track her down so that he could be with her. However, fidelity was never his strong suit, and there were other female diversions at the Grillo. The regulars did not hesitate to let Ada know that Saul had gone off with "the little red-haired girl," and she was furious when she went to mail a package to him and the postal clerk smirked, saying that she "knew" him. "Naturally you will say you don't know her [but] I know you have a soft spot for fat blondes and unfortunately I am not one," Ada wrote to him. She didn't like it when he went off with other women, but as she had her own reasons for secrecy, she seldom complained; however, in this case she was so angry she said she could not write to him again until she "cooled down."

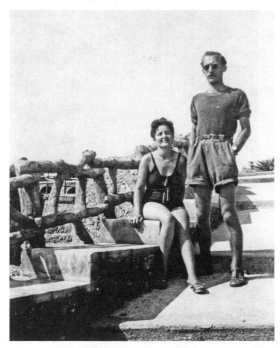

Ada and Saul before the war.

Ada may have been a fearless and independent woman, but in Mussolini's Italy she had to practice discretion. Saul did eventually spend nights in her room, although for a long time he had to pretend to be visiting her at various girlfriends' apartments, from which the girlfriends would then conveniently absent themselves. For the most part, Ada quietly arranged their assignations for somewhere other than Milan. She liked the tourist towns in Liguria, and Varazze was a favorite destination. She would stop there on her way back to Milan after one of her mysterious absences—usually to Genoa—and send telegrams and letters asking Saul to meet her in a certain boardinghouse where she had reserved a room in his name. She cautioned him not to tell anyone where he was going and to avoid being seen by anyone who might recognize him when he walked from the train station. What she didn't tell him, in these letters or in person, was the primary reason for her discretion: that she had a fiancé—if not actually a husband—Vincenzo Ongari, who lived in a nearby town in Liguria that she regularly visited.

The relationship between Saul and Ada was intense from the beginning; it developed in fits and starts all rife with passion and was punctuated by drama, fueled by both their deceptions, large and small. Meanwhile, Saul's money problems continued, until Bruno Leventer grew tired of listening to his woes and gave him a push to do something about selling his drawings.

WHILE SAUL AND HIS FRIENDS WERE spending the 1936 summer vacation in Bucharest, a new satirical newspaper called *Bertoldo* made its Milan debut, on July 14. The publisher, Angelo Rizzoli, thought there would be a market for a paper that toed the Fascist line but occasionally flirted with censorship by poking fun at the regime and making people laugh. It was patterned after a similar paper in Rome, *Marc'Aurelio*, but instead of pitching it toward the working class, Rizzoli aimed for a solidly bourgeois readership. Leventer was a fan of *Marc'Aurelio*, and one morning shortly after the fall term started, he was lazing about and reading *Bertoldo*. After listening yet again to Saul bemoaning his poverty, Leventer forced his reluctant roommate to gather up some of his drawings and take them to one of *Bertoldo*'s two editors, Giovanni Mosca. "I remember how stubborn you were and how you were firmly against going to Mosca, but fortunately, you eventually gave in," he later recalled during a conversation with Steinberg.

Giovannino Guareschi was the managing editor and Carlo Manzoni a staff writer, and both were in the office on the day Steinberg walked in. Manzoni saw "a young man with a blond mustache and glasses" who stepped up to Guareschi's desk carrying a large portfolio: "He puts the portfolio on the table

and pulls out a paper with a drawing of a little man, a cartoon cloud exiting from his mouth: 'I would like to illustrate a short story by [Giovanni] Mosca,' says the cloud."

Guareschi barely glanced at the artist or his submissions as he gave Steinberg his standard answer for would-be contributors: to leave the drawings along with his name and address, and he would show them to Mosca when he arrived. Manzoni overheard "the young blond man" say his name was Saul Steinberg and he was an architecture student living in the student residence.

Mosca liked what he saw, and on October 27, 1936, a Steinberg drawing under the pseudonym Xavier (chosen for the "absurdity of the initial") appeared in *Bertoldo*. The reader response was immediate and positive, and the editors asked for more, telling Steinberg to sign his own name from then on. Steinberg was astonished by his success: "I only discovered my talent when my first drawing was published . . . It took me ten minutes to do, but when it appeared in the paper, I looked at it for hours and was mesmerized."

In the cartoon entitled "Barbe" ("Beard"), a dandy who wears a top hat, carries a cane, and sports an enormous black beard is leaning against a Corinthian column. Behind him is a similar male figure, disproportionately large compared to the small horse on which he is riding. Behind the rider are two barren twiglike trees (or perhaps flowers), stuck in urns in the middle of a small plot of grass encircled by bricks. One of the twigs sports a singing bird. The dandy leaning against the column has one hand beneath the beard that drops almost to his waist and in the caption berates himself for having forgotten to wear a tie. It was the first of more than two hundred drawings Steinberg would publish until June 1938, when the racial laws imposed by Mussolini forbade Jews, particularly foreign Jews, to work in Italy.

Steinberg and *Bertoldo* were a perfect fit. Under Mosca's editorship, the paper aimed for "a public that almost immediately was in on our game of allusions . . . once Italian readers, especially the young ones, became aware of fascist 'speech,' they saw its ridiculous side. *Bertoldo*, a mischievously comic paper, became a school for gravity." The poet and writer Attilio Bertolucci noted how Steinberg's mature "fabulous graphics that are the extreme results of the most advanced humor today" might have originated in his apprentice years at *Bertoldo* during the most troubled period of Mussolini's regime.

Almost immediately Steinberg was caught up in the excitement of journalism. The paper appeared twice each week, so two deadlines loomed, and he was expected to present a large selection of new drawings at each. The editorial committee met in one of the upstairs rooms of the Bar del Grillo, where Saul waited as they perused his drawings. They paid on the spot for those they

took. Aldo waited downstairs in the bar: "If Saul got money, we would eat. At first all the money went for food, because he was a poor student and the drawings gave us a good dinner. Sometimes he sold so many that we would take the money elsewhere and then we dined first-class." Steinberg enjoyed the life of a boulevardier. He updated his wardrobe, treated his friends to drinks and meals, and passed the time leisurely in the Galleria's restaurant, Biffi. His weekly submissions provided the rare, beautiful pleasure of "making money out of something I enjoyed doing and then spending it as soon as I made it," he recalled.

Soon after his earliest publications, Steinberg was given pride of place on what the editors called "the interior page," one devoted solely to cartoons. Not only was it the place to be, but often there were no other drawings but his. Suddenly Saul Steinberg was a recognized name and a well-known figure among the glitterati of Milan's chattering classes. He formed friendships with the *Bertoldo* writers and editors and was soon spending his days bantering with them, either in the Bar del Grillo or in their offices. He befriended Cesare Zavattini and Achille Campanile, who had come to Milan from Rome to coedit the rival humor newspaper, *Settebello*, and the designer Bruno Munari, who was their friend and frequent contributor. That led to an important friendship with Cesar Civita, who was then working as an editor for the esteemed publisher Mondadori. Steinberg became as popular among all these journalists and writers as he was among his classmates at the Poli, and he grew accustomed to being hailed by strangers in the bar or on the street who wanted to offer suggestions for drawings or cartoon captions. However, even though he had become a celebrity, success did not change his demeanor. He remained coolly polite and observant, distant and slightly detached from the banter of those around him, although he liked the attention and, even more, the security that came with being paid regularly for his work. Having money provided a kind of security he had never before enjoyed.

Steinberg still shared a room with Leventer, who was about to graduate because he had taken all his examinations in a timely fashion and who was looking forward to beginning his practice in Bucharest. Aldo often spent time in their room, where Saul had commandeered the only large wall for his *Bertoldo* drawings. Aldo studied them, "in wonder, as one idea led directly to another, and then to another, and so on, and so on. Saul liked to review the evolution of his characters, his subjects. He needed to see the chronology of what he had already drawn as his ideas unfolded. He liked to see how he changed things as he went along. No, he actually *needed* to see how he changed things as he went along."

Steinberg's rise as one of the cartoonists whose work readers could expect to see each week within *Bertoldo*'s pages coincided with the leading role the publisher's son, Andrea Rizzoli, played in its editorial direction. Rizzoli assigned most of the topics for the cartoons and the punch lines or captions, which were usually arrived at during the biweekly editorial sessions. Steinberg normally sat in a corner, quietly sketching, often ignoring the assigned theme as certain typical figures and motifs began to recur in his work.

One of his most successful creations was Zia Elena (Aunt Helen), a battle-ax of a woman who resembled a combination of Mussolini and his mother. She often appeared at the center of a topsy-turvy landscape littered with partial body parts or pieces of statuary (depending on how the viewer saw them), sporting butcher knives in her waistband, flowers and flags spewing out of her hair, and with cowering animals hiding beneath her floor-length skirts. The landscape behind her owed much to the influence of Giorgio de Chirico, whose paintings draw the eye upward and outward, to slanted horizons and vistas different from but as symbolically important as the main theme at the bottom of the canvas. Readers related to Zia Elena, as Steinberg used her to poke fun at Mussolini's edicts, family relationships, and the stresses of modern life.

Readers also learned to recognize a Steinberg cartoon at first glance because of the recurring motifs. Among them were Corinthian columns and Ionic flutes, small architectural renderings of ornate public buildings, unfurled banners of all sorts and sizes, and geometrical backgrounds that might be heavily patterned wallpaper or floor tiles. There were objects everywhere, either relating directly to the subject or else put there just for the whimsy of it. Statues and monuments were almost always objects of satire and ridicule; in Steinberg's world, horses rode men and men whose lives were not large enough to be commemorated by one grand monument were often given two tiny ones, with half their body mounted on each. He sometimes used collage, and Aldo attributed at least part of his interest in the technique to a French book that he urged on his friend, mistakenly attributing it to "the neoclassical Picasso" rather than to Picasso's various phases of cubism. It marked the beginning of Steinberg's fascination with Picasso as a draftsman-artist and would eventually lead to his assertion that he and Picasso were the two greatest artists of the twentieth century.

Flush with success, Steinberg felt that 1936 was his year of "paradise," and so too were 1937 and the beginning of 1938. Ada still came and went in her mysterious way, but there were other admiring and available women, and he kept busy socializing with his interesting new friends in journalism. He did not often go to classes, nor did he do much about taking exams. He found it far

more exciting to observe Italian attitudes and behavior and then convey them with everything from whimsy to satire in the newspaper than to seclude himself in the Poli to slog away at architectural drawings and renderings. In 1938 he was in the fifth year of a five-year program leading to his degree, but he still thought he had all the time in the world to take the qualifying exams. He thought it more important to keep his ties to *Bertoldo*, even though worrisome political pronouncements were intensifying.

In June 1936, the Italian government department that oversaw propaganda became the formal Ministry of Popular Culture, charged with regulating the media. It generally left publications alone, as long as they did not stray too far from the official Fascist line, until January 1937, when a more stringent set of "guidelines" was imposed. General news publications were directed to "satirize attitudes and political mentalities that go against Fascism, such as Bolshevism, liberalism, societarianism [that is, the League of Nations], parliamentarianism, and so on," and they were expected to express their criticisms in language the public would swallow whole. Publications that specialized in humor and satire were given greater leeway for exaggeration and were instructed to "fight racial hybridism" and "target all attitudes that do not harmonize with the way of life taught by Fascism."

Bertoldo certainly did its part to follow all the Fascist directives from the very first issue—so closely, in fact, that it "carried errors, bad taste, venial and mortal sins" throughout the two years before the 1938 racial laws were enacted. The editors freely chose to print cartoons that featured anti-Semitic stereotypes until 1938, after which reporters and columnists regularly wrote strident articles and short stories that mocked or defamed Jews. Still, in the paper's defense, the editors did print far more material that managed "to walk the thin line between compliance and satire" and to assert that it was not "a pedantic Fascist newspaper, nor, least of all, anti-Fascist. It was an Italian newspaper for young and not so young people, in an era where Italians had much to cry about, and for this very reason needed a good laugh." Like so many other individuals or entities in the prewar years, *Bertoldo* never fully compromised its integrity, but neither was it entirely unimpaired.

Saul Steinberg never commented publicly on his association with *Bertoldo* or with its chief competitor, *Settebello*, which he started working for in 1938. His cartoons were mostly apolitical, and on the rare occasion when they did touch on politics, it was usually to mock Mussolini, his minions, or one of his directives vaguely and indirectly. However, almost half a century later, when the son of his friend Sandro Angelini wanted to publish a doctoral thesis that dealt with Steinberg's creative output during his Italian years, he prevailed

on the young man not to do so. Steinberg called it "a terrible idea, blackmail, revelations . . . who knows what dark horrors will surface?" It would have been embarrassing to have to explain how, as a young Jewish artist, he had worked so successfully for newspapers in Fascist Italy. He was able to evade this question in the United States because so few Americans knew anything about Italian culture; the only reason he ever had to give for not permitting reproduction of the Italian cartoons (and one that was easily accepted) was that they were juvenilia and unworthy of notice.

However, as 1938 unfolded, Steinberg would have continued to draw cartoons for *Bertoldo* if a better offer had not come his way. When the publisher Alberto Mondadori bought *Settebello* and appointed Steinberg's friends Cesare Zavattini and Achille Campanile as coeditors, they invited him to join the board of directors. It was an excellent offer and he was happy to take it, especially after they dangled the plum of a feature in every issue. It meant a larger income and greater exposure to bolster his growing reputation. Once again he planned to let his examinations wait for another year. Bruno Leventer had just graduated and like Perlmutter (who was there only briefly) had gone home to Bucharest, so Steinberg was totally without Romanian support for the first time since 1933. His original reason for leaving Romania was that he feared he could not "accomplish anything extraordinary," and it certainly seemed that he had been right to do so, as he was now well on his way to becoming enormously successful in Milan. He had become settled in Italy, at ease with the language and culture, and was sure his future lay there. He was confident that he would eventually finish his studies, gain his degree, and forge a prosperous career that would allow him to combine art with architecture. And then, in the space of a few months, everything changed, when Mussolini set forth a series of decrees that forbade Jews, Italian or foreign, to work in Italy.

THE BETRAYAL

I didn't want to accept the reality, the betrayal, the way dearest Italy turned into Romania, hellish homeland. How lucky I was to be saved!

Until late 1937, Mussolini mocked the German idea of racial purity and held a "sovereign contempt for Nazi racial doctrines." It was not until after the conquest of Ethiopia, when his military forces were burdened with obsolete arms and equipment and his currency and foreign exchange severely straitened, that he discovered what a useful political tool anti-Semitism could be to persuade ordinary citizens to accept a severe austerity program that would let him prepare for war.

Starting in 1938, new laws came thundering down upon the heads of the 40,000 to 70,000 Jews who had lived in Italy since the Roman Empire. Early that year, the Ministry of Popular Culture began a harsh campaign instructing the press to publish articles about how Jews had insinuated themselves into influential positions and professions at every level of public life, thus destroying the purity of traditional Italian life and work. The general public did not pay much attention to this campaign, because Jews in Italy had been highly assimilated for several centuries. Thus, when the *Manifesto della Razza* (Manifesto of Race) was proclaimed in July and state-sponsored anti-Semitism began, most Italians were at first puzzled, then dumbfounded by all the new laws.

Intermarriage between Jews and "Aryans" (as Mussolini now proclaimed Italians to be) had long been commonplace, but henceforth such marriages were forbidden. Jews who had become citizens after 1919 were stripped of citizenship. Jews could not own land or hold property above a certain value and could not employ Aryan domestic help. All foreign Jews except those over sixty-five or those already married to an Aryan Italian had to leave the country within the next four months or face expulsion by force, and this included foreign students like Saul Steinberg.

The educational system was in chaos as Jewish faculty members were fired, Jewish students were forbidden to attend public schools, and textbooks by Jewish authors were banned. Jews were expelled from the military and forbidden to practice professions unless their clients and patients were also Jews. In November, Jews were banned from membership in the Fascist party, and the following year they were forbidden to work in journalism. Widespread puzzlement gave way to panic as one confusing and contradictory edict followed another, and Steinberg was caught in the thick of it.

On August 6, 1938, the Ministry of National Education declared that, starting in September of the academic year 1938–39, all Jewish students, even those previously enrolled in universities, would be forbidden to attend classes. One month later, the Ministry of Foreign Affairs partially reversed the decision, decreeing that foreign Jewish students who had been enrolled for the previous academic year could continue their studies until they earned their degrees. There were several months of confusion until January 1939, when the Ministry of National Education took charge once again and amended the law to allow foreign students to stay in Italy until they completed their degrees; the hitch was that those who were behind would not only have to catch up, they would have to finish by the end of that academic year. For Steinberg, it was a staggering problem of nearly insurmountable proportion.

Since 1936, when he began to draw for *Bertoldo*, he had done what Ada called "the usual: delaying until the future." He had stopped studying and going to any classes that were not required and had taken (and passed) only one of the seventeen necessary examinations, which meant that if the government enforced the most recent law, rather than allowing it to be ignored, as so many of the previous ones had been, he had exactly one year to take and pass sixteen examinations, get his degree, and get out of Italy. Coupled with the problem of earning the degree was the impossibility of earning money: his last signed cartoon appeared in *Settebello* in September 1938, just after Jews were forbidden to work in journalism. Once again, except for the occasional loan of a few lire from Aldo, an infusion of cash from Ada, or an under-the-table commission sent his way by friends, he was almost entirely dependent on his parents.

The grit, determination, and overdeveloped sense of personal responsibility that was characteristic of the adult Saul Steinberg began during this year, as he focused all his energy and attention on two major tasks: attaining his degree and supporting himself. His friends were not about to let him go under, and they gave him work when they could. The aristocratic Erberto Carboni set him to making preliminary sketches for the Studio Boggieri design staff, sometimes preparing finished presentation drawings for clients, sometimes making pre-

cise mechanicals for printers. One project that survives is an advertisement for "Dynamin [gasoline], the Super Shell," in the newspaper *La Stampa*.

Steinberg's friends at *Bertoldo* and *Settebello* did not desert him either, as unsigned drawings and cartoons that appeared in both papers during the next several years bear his signature totems and subjects. He tried to draw constantly and studied only when not working to earn money. Even though he knew from the beginning that he "could never become an architect because of the horror of dealing with people that architecture involves," he still felt the moral obligation to complete the degree, partly not to disappoint his parents but also because of his sense of responsibility about finishing whatever task he started. Steinberg took his exams at the last possible moment he could, and by the spring of 1939 he had taken and passed all sixteen. In the Italian university system during his student years, the highest passing grade was 30 and the lowest was 18. Steinberg's grades were surprisingly good when the subjects centered on drawing, as in courses like Giò Ponte's interior design and decoration (27) and scenography (26), but he barely passed when the courses were mathematical or scientific, and those grades lowered his final average to 20.5. It was the same when he took the *esame di laurea*, the qualifying exam before the doctoral thesis: he barely passed, with 65 out of 100.

The *esame* was a special project that had to be designed and built in four days, during which students were confined to a sequestered area of the school to live and work. If accepted, the *esame* became the basis of the *tesi*, or thesis. Steinberg's subject was "Architectural and urbanistic organization of an urban center; Development of a representative building." He designed and built a theater, but even for such a rigidly delineated academic endeavor with strict rules about what could be done, he could not resist adding a touch of the comic: on the drawing that showed the building's entrance, he added a stick figure straddling a cow and holding in his outstretched hand a lance pointing to the building. When his examiners asked why it was there, he claimed he needed it to "indicate the proportions." They accepted the project, stick figure and all, but his whimsy did not stop there. He made an even more grandiose—and illegal—gesture when he signed the official document declaring that he was now a doctor of architecture; instead of writing his full name, as required by law, he printed his last name only in large block capital letters, the signature he had used for all his cartoons. No doubt he was letting his professors know that the name they had seen many times in *Bertoldo* or *Settebello* was all he thought necessary for identification.

On March 1, 1940, he sent an exultant telegram to his parents: "I did well. I am an architect." On March 5 he told them he was "officially and in the name

of the King proclaimed a doctor in architecture." He did not tell them how angry and upset he was to find that he had been given "a diploma of discrimination and prejudice." Saul Steinberg, son of Moritz and born in Romania, was officially proclaimed *di razza Ebraica* ("of the Jewish race"), which rendered his diploma as worthless as "the fake Bodoni" typeface used to print "the fake parchment." No matter that his degree was certified by Vittorio Emanuele III, "King of Italy and Albania, Emperor of Ethiopia"; as long as it said "of the Hebrew race," he could not practice his profession in Italy even if he wanted to.

The insult rankled for the rest of his life. In 1985 he exchanged copies of their diplomas with Primo Levi, who said his own was "symmetrical to yours and just as anachronistic." Steinberg told Levi that he had never, ever used the title doctor of architecture and had been lucky not to have worked in the profession: "The Kingdom of Italy? Finished! Albania? What a joke! Emperor of Ethiopia! What cruel and stupid times. All vanished." Even "the doctor of architecture has vanished," he concluded. "Only Saul remains, son of Moritz, of the Jewish race."

THERE WERE "CRUEL AND STUPID TIMES" in 1940, but Saul still had to make a living while he plotted how to escape from Italy. "Dad writes that I'm avoiding his question, about what I will do after I receive my diploma," he wrote to his parents, trying to evade a direct response to their uneasiness. However, he had to tell them at least part of the truth: "There is nothing certain and it's hard to do what I would prefer," which was to resume the life he had enjoyed as a successful cartoonist. After the ordeal of getting the degree, all he could do to recover was "to sleep and eat a lot," but he could not afford to relax for long, because he had to pay the taxes that universities charged on top of tuition, as well as other taxes imposed directly by the Italian government. Moritz and Rosa sent one thousand lire, which was supposed to cover the taxes and leave enough for his living expenses until he found work, but he was still short and had to add the rest from his earnings. It was "pretty painful to have to part with 2,000 lire." Still, he was blithe: "I have no money but I'll get out of it." Several weeks passed before he wrote to his parents again, saying he was still unsure about work and did not rule out returning to Bucharest. Whether he was telling the truth or providing a sop for their fears, he was never serious about returning to Bucharest, especially after he started to work again in Milan—surreptitiously, to be sure, but steadily.

He kept a partial list of the work he did between the spring of 1940 and the end of 1941, and it showed a variety of projects, including five cartoons sold

to "other newspapers or magazines," plus the "useless and ridiculous work" of submitting cartoons and captions directly to *Bertoldo* even though he was convinced the authorities would shut it down (which they did) after "one more issue and then that's it." Pietro Chiesa of the design firm Fontana Arte threw a commission his way to design something to ornament a piece of furniture, and he made "a nice drawing with bottles and flowers." His friend Vito Latis, another Jewish architect constrained by the racial laws to work only for Jewish clients, was commissioned by a family named Sacerdotti to design a villa in Rapallo, which Steinberg dubbed "Milanese Bauhaus." The commission Latis gave him was far more remunerative: to make a painting for a large wall in the house, of a typical Ligurian beachfront complete with restaurants and stores, strolling couples, and swimmers.

While Steinberg was working diligently to survive in Milan, he was also investigating various options for where to go when he could no longer stay in Italy. The country did not officially enter the war until June 10, 1940, and as his Romanian passport was not due to expire until November 29 of that year, he counted on having a brief margin of safety during which he would try to renew it. He never imagined that he would become officially stateless, but several weeks after Italy entered the war, Romania was sliced apart as Soviet forces occupied the Bessarabia region, Hungary tried to grab Transylvania, and Bulgaria wanted Dobruja. In September, King Carol II abdicated and fled, leaving his nineteen-year-old son, Michael, as king. That same month Michael was deposed when the Iron Guard, led by General Ion Antonescu, established the ultra-right National Legionary State and Antonescu declared himself *conducător* (Romanian for *duce* or *führer*). Antonescu ordered the guard to destroy opposing political parties, murder dissenting intellectuals, and launch punitive assaults against Romanian Jews. Praised by Hitler for his "glowing fanaticism," Antonescu allied the country firmly with Nazi Germany, leaving Steinberg to fear that he was about to become both stateless and trapped.

He was frustrated and angry with himself for not leaving "a year, two ago, when everything was simpler," and berated himself for the "big mistake" of not getting his degree sooner. His "biggest anguish" was that if he had taken the degree on time, he could have repaid his parents' sacrifices by settling them in "a comfortable life, without worries or woe." Another possibly dangerous complication arose when it appeared that he would have to return to Bucharest to serve in the Romanian army. His original military classification was with the "1914 contingent," which until now had always been exempted from the draft, but with Germany dictating Romanian policy, there was some internal confusion about whether this ruling still held. A letter to his parents spelled out his

hope of deferring military service as a means of prolonging his passport until February 1941, but he did not explain how he planned to do this, and there is no record that he ever tried. Instead he concentrated all his energies on getting out of Italy and started to think seriously about the United States.

The first person who encouraged him to make the move was his friend Cesar Civita, who worked for the publisher Arnaldo Mondadori throughout the 1930s as the editor of a literary magazine, *Le Grandi Firme*. Steinberg met him through two of Civita's colleagues who were his friends, Cesare Zavattini and Gino Boccasile, the designer responsible for much of the magazine's distinctive art. Cesar and his brother, Victor, were born into a wealthy Jewish family that had been in Milan for generations, and both wisely recognized the need to flee to Paris as soon as the racial laws were passed. They urged Steinberg to do the same, but he told them he was content in Italy and hoped to remain there.

The two Civita brothers soon realized that Paris was no safer than Milan, so they left for New York in 1939. Cesar stayed until 1941, when he went to Buenos Aires to become Walt Disney's representative for all South America and later the founder and successful publisher of Editorial Abril in Buenos Aires and in São Paulo, Brazil. Although Cesar Civita's name was on their firm's New York letterhead, it was Victor who remained there as a talent agent for international artists and writers, Steinberg prominent among them. Well before they got to the United States, the Civita brothers began to sell Steinberg's drawings to magazines as varied as *Life*, *Mademoiselle*, and *Town & Country*. Julian Bach, later a distinguished literary agent, was then a young editor at *Life*, and it was he who made the proud claim that he was Steinberg's first American publisher, "in terrible times, 1940." Bach wanted drawings of France's Maginot Line, which Steinberg provided from his imagination, as he had never seen photographs, and which (as Bach remembered) "to our mutual horror, collapsed between the time the drawings went to press and were published in the magazine."

Steinberg's luck was better with *Town & Country*, where the editors raved about his drawings, and he received further encouragement when Cesar Civita wrote from South America that Brazilian publishers were interested in his work. This was very good news, because they accepted almost everything he submitted and then paid promptly. Despite the perilous political circumstances, Steinberg was earning at least part of his keep, and as long as there was transatlantic traffic, he thought he could count on checks arriving from time to time.

Meanwhile, Saul's American relatives had been corresponding with Moritz

and Rosa about sponsoring his immigration to the United States. Moritz's brothers, Harry in New York and Martin in Denver, both agreed to sponsor him and contribute money toward his passage. Soon after Cesar Civita arrived in New York, armed with the address given by Saul, he visited Harry Steinberg to plot strategy. Cesar described the bureaucratic flood of paperwork they would have to navigate in order to bring Saul to New York, but Harry, on behalf of his entire extended family, was willing to do what needed to be done, not only for Saul but also to help Moritz, Rosa, and Lica to immigrate. This plan was short-lived because the Romanian political situation made it impossible for them to leave, but there were still possibilities for Saul to travel through neutral countries, so they continued their efforts.

Harry was fortunate that his daughter Henrietta, the charming thirteen-year-old who posed next to Saul in family pictures when she visited Romania, was now well connected in terms of bureaucratic niceties. She was married to Harold Danson, an employee of Paramount Pictures, who was familiar with all sorts of international avenues of communication, and she was also private secretary to Cornelius Vanderbilt, Jr., a man-about-town related to the original commodore of the same name, a relationship he used often to further his career. He made contacts with all the right people and published a newsletter, *Vagabonding with Vanderbilt*, that fell somewhere between a travelogue, a political tip sheet, and a gossip column. This well-connected Vanderbilt had influential contacts in Washington as well as New York, and he agreed to use them on Saul's behalf.

The Dominican minister plenipotentiary in Washington told Vanderbilt to contact James N. Rosenberg, who was president of an organization called the Dominican Republican Settlement Association, headquartered in New York and working with the approval of the dictator Rafael Trujillo to grant asylum to European Jews. Rosenberg put Vanderbilt in direct contact with his colleague Mrs. Rebecca Hourwich Reyher, who had seen and liked Steinberg's work in *Life* and was eager to help her friend, "dear Neil" (as she called Vanderbilt), get him on a ship as soon as possible. There was, however, one major obstacle to overcome: Jews were most welcome in Santo Domingo as long as they paid the Trujillo regime $1,000 for each immigrant's first year in the country and $500 for every year thereafter. The Denver and New York Steinbergs pooled their money and raised much of the necessary sum, while Harold Danson gathered letters from various banks for the U.S. Department of State to certify and forward to the Dominican authorities.

As the extended family geared up to expedite Saul's transit, he was working his way through his own bureaucratic nightmare, his fears intensified by

the Italian government's rush to round up all civilians who were considered a danger to the Fascist regime. This category ranged from political dissidents to harmless foreign students like Steinberg, who, through no fault of their own, found themselves trapped.

Daily police roundups became standard operating procedure on weekdays (but not weekends, when the relevant branch of the government did not work). Steinberg was sure he would be arrested after the Ministry of Foreign Affairs singled out Hungarian and Romanian Jews as particular undesirables who had to be "expelled from the Kingdom." He had been living in a room above the Bar del Grillo, but he often slept somewhere else, sometimes at the studio Aldo shared with Luciano Pozzo. Ada and her girlfriends had apartments throughout the city, and various friends from the publishing and design worlds allowed him to sleep at their homes. Andrea Rizzoli let him hide out in the *Bertoldo* offices, Arnoldo Mondadori took him into his family's capacious apartment, and Giovanni Guareschi loaned him a bicycle to use for quick getaways.

Steinberg knew that the roundups always took place between six and seven in the morning, so he got up early, washed and dressed quickly, and hopped on the bike to ride around town as if he were an ordinary Milanese citizen going to work. Even in such perilous times, he saw the city with an artist's eye: "The air in Milan was excellent . . . the light was beautiful, and I saw something I had never seen before, the calm and silent awakening of a city." He usually returned to Bar del Grillo a little after seven, knowing that if the police had not come by, he was safe for another day. He had breakfast and went back to bed for a nap, satisfied to have "a whole free day ahead of me, more than a vacation, almost a life gained." He did this for the better part of a year, sneaking out through the back courtyard when the police came early and he could hear them coming up the front stairs. Carla, the youngest of the four Cavazza sisters who owned the bar, laughed as she told him how one of the policeman, "like a real Sherlock Holmes," felt the bed and declared it "still warm."

While Steinberg was on the lam, he was working hard to secure both the necessary travel documents and the money to pay for his voyage. Harry and Martin Steinberg and Harold Danson all contributed; Aldo gave what he could, as did Cesare Zavattini, and Cesar Civita gave advances against earnings and made sure that money owed from various publications arrived promptly. Still, he was dealt a crushing setback in the spring of 1940: with most of the money in hand, and despite a letter from Cornelius Vanderbilt, Jr., to the American consul in Naples requesting a U.S. visa, his application was rejected because the Romanian quota had already been filled. Cesar Civita tried briefly to obtain

a visa for Ecuador but gave it up when someone—Henrietta Danson, Vanderbilt, or perhaps Steinberg himself—came up with the idea of using the Dominican Republic as a temporary haven until he could get to New York.

Steinberg knew of other Romanian Jews who had been granted asylum in Santo Domingo, and he had already gone to Genoa to put in his application at the consulate. It was on file there when a letter, perhaps composed by Henrietta but signed by Vanderbilt on June 1, 1940, arrived in the office of "The Minister of the Dominican Republic" in Washington, D.C. Vanderbilt asked the Dominican consul to cable his Genoa counterpart to ask him to secure an entry visa for "a very talented and worthwhile resident" whose agents and editors guaranteed that he would earn "a considerable amount of money in the United States, which he will, naturally, spend in the Dominican Republic." The Washington consul's reply was a curt rebuke, saying it was "out of the question" for him to contact his Genoa colleague, as he had "no jurisdiction over any European consul."

A period of wild uncertainty, confusion, and travel followed, as Steinberg tried to get the transit visas that would permit him to board a ship of the American Export Lines. Harry and Martin Steinberg and Cesar Civita gathered the money in New York to purchase a ticket in his name on a U.S.-line ship, and it was being held for him in the Lisbon office. All he had to do was get to Lisbon. From July 26 until November 27, 1940, Steinberg raced back and forth across several countries, trying to put his travel papers in order. He did acquire a visa from the Dominican Republic in Genoa, which enabled him to obtain a tourist visa from the Portuguese consulate in Milan; he went to Rome several times to secure a transit visa from the Spanish consulate to use on his way to Lisbon; and he had to secure a second Spanish transit visa as well, specifically for the brief time he was in the Barcelona airport. He also needed a letter from an American consul (which he got on another trip to Rome) that guaranteed an "affidavit of travel" so that he could book passage on a ship that docked in New York, where he would transfer to another, which would take him to Santo Domingo. And after all that racing around, just when it seemed that everything was in order and he could depart, none of these documents mattered, because the Portuguese government denied his tourist visa.

Portugal was being flooded with Romanian Jewish refugees, and the Salazar government was worried that there were not enough ships to carry them to other countries even if they had the necessary money and documents. With everything else in order, Steinberg was shocked when stony-faced customs police would tell him only the official reason, that his application had expired. He never learned the real reason, that "Romania is facing a serious

problem . . . of disposing of an undesirable, numerous and mounting population of the Jewish race."

All Steinberg knew of these political machinations was that he had been denied a visa in Lisbon. Undeterred, he contacted the Portuguese consul in Milan again, and on August 29, 1940, that consulate disregarded a new secret memorandum that had been issued in Lisbon and granted him a transit visa. What the Milan officials ignored and Steinberg did not know was that Salazar's government was so alarmed by the huge influx of European Jews from many countries that they had issued a secret directive closing the border entry points. Thus Steinberg became an unwitting victim of police secrecy and silence: when he landed at Sintra airport on Friday, September 7, after a flight from Milan, he was told to take the next flight back, and no reason was given.

As if being sent back to Italy were not bad enough, he was convinced that the Lisbon authorities had confused him with "another Steinberg, a Communist Steinberg, on their list." Being labeled a Communist was a red flag in every country he needed to pass through on his way to immigration, and once labeled as such, he would find it nearly impossible to have the stigma removed. Even though such a mix-up was never proven, it made a convenient excuse as he headed back to Milan in abject despair.

Steinberg never learned about the secret directive of Salazar's secret police and spent the rest of his life thinking that he had somehow lacked one or more of the proper travel affidavits for the United States. As soon as he returned to Milan, he started all over again to round up a new set of documents, casting widely for help. He even enlisted the aid of the Panamanian consul, who told him to go to Rome and deal directly with the Romanian legation. He took the overnight train and spent three hours in the waiting room the next day, but when his turn came, his passport was not renewed and he was not told why. The most likely reason was that without it, he would have to find his way back to Bucharest, where he could be drafted. That was never an option for Steinberg, but as long as he had to stay in Rome overnight, he went sightseeing.

When he returned to Milan he had further bad news from the Spanish consulate. His transit visa through Spain had been revoked because he no longer had a valid Romanian passport. Now he was not only stateless but also unable to leave Italy. To deal with the misery, he began to keep a cryptic diary-journal of his travails, something he would do off and on for the rest of his life when he needed to think things through and sort out how to deal with them. On December 6, 1940, he noted that it was almost three months since he had been sent back from Lisbon on that dreadful Friday, September 7. He remembered this date for the rest of his life as his "most dramatic disaster, my Black

Friday." He also remembered the "other Steinberg," who might have kept him from leaving; what hurt most about this confusion was what he decided was an "accusation of bad faith," that is, that he had not been honest. But he refused to dwell on it: "enough" was his last written word on the subject.

His natural tendency toward superstition now became focused on Friday as the day that "more and more often brings me bad luck." He had gone to Rome for the Spanish transit visa on a Friday and to Lisbon hoping to board a ship on a Friday, and both times he had been turned back. However, when December 6 arrived, it was "a really black day Friday." He had never been religious, but uncharacteristically he prayed: "God will help me get through these years."

There was unrelieved misery on every front. On November 10, Romania was devastated by an earthquake so severe that it caused damage as far away as Hungary, Bulgaria, and Ukraine. Bucharest was less badly damaged than other Romanian cities, and the homes and shops of the Steinbergs and their relatives were relatively unscathed. They were terrified for Saul's safety when they listened to Romanian radio and heard reports of the air raids and bombings in Milan, while he tried to convince them that he was in good health, had enough work, and was not in any real danger. It was still hard to write cheerful letters when he was feeling far from optimistic. He told the diary, "I am anxious right now, as I always am when something eludes me and my desire for it grows stronger."

The ship he hoped to sail on, the *Siboney*, was due to leave Lisbon for New York in twelve days, and he had to face up to the fact that he would not be on it. The police roundups had become infrequent, and in depression he began to sleep until noon. When he woke up he read, first, Manzoni's *I Promessi Sposi* (The Betrothed), "a great and fine book," and then *The Autobiography of Benvenuto Cellini*. He felt "more and more empty in the head," and when he finally roused himself to wakefulness, daily life was all "malaise."

Money was getting tight again, so he could not afford to indulge in self-pity for long. He courted Giovanni Mosca at *Bertoldo* with an early Christmas gift of painted wood blocks, possibly one of the earliest examples of the wooden books, pens, tables, and boxes for which he would become famous later in his career. Unfortunately, when Mosca was unable to send much work his way, Steinberg's general financial strain resulted in a brief falling-out with Aldo Buzzi. He was now sharing a design studio with Luciano Pozzo, but they did not have enough work for themselves and were too poor to be able to pass any along to Saul. He found this difficult to accept and told the diary, "I would not treat a friend this way."

To further complicate his life, there was Ada. They fought, they argued, they made up. They spent entire days in bed while he sated himself, then he pouted because she preferred to spend evenings with her girlfriends rather than with him. He was irritated while they lolled in bed because she spent too much time chattering about silly, ordinary things he didn't want to hear about. In a better mood, they met in restaurants for tea and went to movies, which he adored, particularly American films like *Stagecoach*, with John Wayne, and *Jamaica Inn*, with Charles Laughton. By the end of April 1941, he referred to Ada as his "dear girl" and didn't know how he could function without her radiant presence in his life.

And then, just before her birthday at Christmastime in 1940, Rosa threatened to complicate his life even further. She pretended to be worried about how he was scrambling to survive in Milan, but in truth she was more worried about his possible emigration. Rosa was determined to get to Milan so she could "take care of him," probably a euphemism for persuading him not to go. He tried to calm her down with a letter full of repetitive statements about how well he lived and worked and how he always "tried to do everything in the best way possible." He assured her that he had many friends and was "not really alone and without any support."

Saul was never a diligent correspondent, but when he did write to his parents, he was always careful to give only as much information about his attempts to leave Italy as he thought they could handle; otherwise, he assured them repeatedly that even though the winter was cold, he had enough warm clothes; he ate regular, healthy meals; and his work brought in enough money to keep him going. Moritz and Rosa wrote far more frequently, and the letters (particularly hers) were filled with flowery complaints of sleepless nights, panic attacks, "fears and woes." When Moritz wrote, it was to beg Saul to write more frequently so Rosa would calm down. Fortunately for Saul, if Rosa did make any concerted effort to get to Milan, it came to naught. The exchange of letters during these years set the pattern for how Saul and his parents would relate to each other for the rest of their lives, with Rosa imploring him to write, Moritz begging him to do so to placate her, and Saul responding only when he could no longer avoid it.

POGROMS BEGAN IN EARNEST THROUGHOUT ROMANIA shortly after the New Year in 1941. Thugs rampaged through the Jewish quarter of Bucharest, but Moritz's shop was in a courtyard and not as badly damaged as those that fronted the street. Moritz kept the girls who worked in his factory inside until the attacks were over, so nobody was injured and nothing was lost. The

Olteni (Christian natives of southwestern Romania) who kept the dairy store on the corner surprised the Steinbergs by aiding them with much-appreciated "Gentile kindness." The attacks, however, were merely the start of sustained persecution. Mail censorship had already begun, so communication even with another Axis country like Italy was slow and sporadic. Jews were still allowed to read newspapers, but soon their radios were confiscated, and shortly after, deportations began.

Meanwhile, in Milan there was a genuine possibility that Steinberg would be sent to prison. Even though his Romanian passport had expired in December, he was more or less ignored by the various ministries that monitored the status of foreign students. The local police knew he was still around, but no higher authority told them to arrest him, so he was left alone. He actually formed cordial relations with some of them, particularly "a certain Captain Vernetti," who arranged for him to have "postponements" from arrest or deportation. It also helped that everyone from Buzzi to his colleagues from the Politecnico and his friends in the publishing world had influential friends or relatives who worked within various government agencies and were eager to help him. He wrote in his diary that 1940 had been the worst year of his life, but even so, he was proud of having earned his degree, taught himself enough English to make out what a newspaper article was about, and had his drawings published in distinguished American periodicals. Despite these triumphs, he was still certain that 1941 was going to be a bad year, at least at the beginning.

He was not surprised when a telegram from the prefect of Milan arrived at the Grillo on February 21, 1941, stating that the Ministry of the Interior had been informed that the former student Steinberg who had been "warned to leave the Kingdom" was still there. Steinberg went to the ministry to affirm that he would be more than happy to leave the kingdom, but even though a "tight-lipped" American vice consul had granted him a transit visa to pass through the United States, he had not yet been able to secure the new ones that would allow him to pass through Spain en route to Portugal. He was in the frustrating position of trying to line up a stack of legal dominos in order to make them fall in order, but on every occasion the one he needed to start the tumble was missing.

There must have been other former foreign students who fell into this curious Catch-22 situation, but a specific file was compiled in Rome devoted to resolving the situation of the *"Ebrei stranierei,"* the foreign Jew "Steinberg Saul, di Moritz." His case created such a bureaucratic muddle that the prefect of the ministry in Milan did not know how to resolve it and had to cable the head office in Rome to ask for "directives." Rome told Milan to "formulate

concrete proposals," and two weeks later the prefect decided that, as "the foreigner in question is unable to leave the Kingdom, he should be assigned to a concentration camp." By the time Steinberg received this decree on April 16, he had resigned himself to going.

THE SYMPATHETIC CAPTAIN VERNETTI WAS THE officer who arranged the details of his arrest. On April 17 he told Steinberg to put his affairs in order and to report back in one week, prepared to be sent immediately to a detention center, most likely Tortoreto, a small town in the province of Teramo on the Adriatic coast. Steinberg spent a frenetic week trying to clean up all the loose ends connected with his various projects. He rushed to put final touches on the panel for the Sacerdotti villa in Rapallo, submitted cartoon captions for *Bertoldo*, drew one "vignette" for *Settebello* and two for the magazine *Tempo*. He presented himself as scheduled to Captain Vernetti on April 24, only to be told that the police were not ready to receive him and he could have two more days of freedom. He spent them with Ada, mostly in bed, rousing only to take her to the movies and eat at the Bar del Grillo.

On Sunday morning, April 27, promptly at 10 a.m. he presented himself to Captain Vernetti in the local police station, San Fedele, and one hour later they were on their way by taxi to San Vittore al Centro, the main prison in Milan. Steinberg was placed in a holding cell with thirty-six other prisoners, all of whom slept on the floor. The next day he was transferred to the second floor of San Vittore and placed in a cell with a Soviet Russian named Zessevich, who had already been incarcerated for fifty-six days, and a Hungarian named Erdos, who had been there for fifty. Both were being held "under suspicion," a vague generality that meant their papers were not in order, but they were in no hurry to be repatriated or to fight in the war. They were content to pass their time in what was, for them, the relative comfort of a Milanese prison, even though they were housed among common criminals who lived there under the most primitive, unsanitary, and unhealthy conditions.

Steinberg helped them pass the time by creating a deck of playing cards "with tobacco papers, bread crumbs and soup . . . all drawn with a copying pencil." For the red ink needed for hearts and diamonds, they pricked their fingers and used blood. When they tired of cards, they had tobacco and other entertainment, such as a variety of daily and Sunday newspapers, a sports journal, and one devoted solely to comic strips. They could buy jam, chocolate, dried figs, walnuts, beer, wine, cheeses, bread, and warm milk. They had cigarettes, but matches were chancy; they had soap and were permitted showers every other day or so. Cells were inspected around 3 p.m., and there were

three nighttime checks. Soup was served at eleven, with two small loaves of bread for each prisoner, and from nine to ten they were permitted to walk in the prison grounds. All in all, it wasn't so bad. Steinberg knew he would not be in San Vittore for long so he did not try to settle in, spending his days instead in genuine terror that he would be sent not to Tortoreto but to Ferramonte di Tarsia, a far harsher camp in the southern province of Cosenza, Calabria.

ALTHOUGH BOTH ITALIAN AND GERMAN CAMPS were called concentration camps, the main difference between them was that the Italians interned but did not exterminate. Those confined to Italian camps ranged from persons deemed dangerous to the Fascist regime to citizens of enemy states and everyone else who fell between the cracks of official bureaucratic rulings, including foreign students who overstayed their welcome. The two major categories of detainees, however, were Jews (both Italian and foreign) and political dissidents who were outspoken in their distaste for fascism.

There were also two different classes of internment. "Free" meant that the person was sent to a small village or town and had to find a way to live there at his own expense. Spouses or family members could join the offender, who had to report for curfews and roll calls but was otherwise free to go about his business. Steinberg was in the other class, the one sent to the so-called concentration camps, where prisoners were segregated by sex, lived in collective housing, and were permitted only limited contact with outsiders. Most of these camps were in the isolated mountainous regions of central Italy or in the even harsher mountains of the most backward provinces in the extreme south. He was greatly relieved when he was finally told that he was going to Tortoreto, one of the better camps, in east-central Italy. It was near enough to Milan that Ada, Aldo, and some of his other friends would have a fairly easy time trying to visit and packages sent by mail were more than likely to be delivered.

On May 1 at 9 a.m., he was taken down to the main floor at San Vittore, where he was allowed to telephone Ada and tell her where he was going. In her inimitable fashion, his "dear girl" already knew it and had gone to Ferraro's, the shop near the Grillo where they usually bought food and other provisions. Steinberg was put into a taxi with two policemen as escorts and taken to the railroad station, where a small group of friends gathered to see him off. Aldo was waiting with his luggage and their friend Dr. Pino Donizetti, who brought a large sack full of various medicines, especially quinine against the rampant malaria that plagued the camp. Ada was there too, her eyes nervously scanning the crowd for a glimpse of him, and she made "a little jump" when she saw him. He noted, as he always did, what she was wearing: "gray overcoat, black

dress with her aunt's brooch." He kissed her "lightly, wet mouth, she cries. I won't see her anymore. Dear Adina."

Escorted by policemen from Sicily, he and the other prisoners were put on board a train for the relatively short but roundabout journey to the Abruzzi, which would take several days. They went from Bologna to Rimini, where they were taken off the train long enough to eat lunch in a workers' café, then ushered back on to ride until midnight, when they arrived in Ancona. The prisoners were herded into the railway station waiting room and told to sleep as best they could, but Steinberg managed to get out long enough to buy a stamp and a postcard to send to his parents. He told them he was "constantly on the road in my attempt to leave [Italy]," but he didn't tell them he was writing while on his way to an internment camp. At 6:30 a.m., another train took the prisoners to Tortoreto, and Steinberg caught a brief glimpse of the sea before he was taken to his final destination.

THERE WERE ACTUALLY TWO SEPARATE CAMPS in Tortoreto; Steinberg was in the one called Tortoreto Alto, and the other was Tortoreto Stazione. Each camp had its own separate governance and police security, and supervision was, to say the least, casual. At Tortoreto Stazione, a corporal and four other patrolmen from the local station occasionally patrolled the grounds or made roll calls at the Villa Tonelli, where the prisoners lived. It was a large, ramshackle building built in the Moorish style and represented a castle. Steinberg called it "a truly romantic prison," consisting of ten rooms on the first floor, ten on the second, and nine other supposedly habitable rooms. The authorities deemed it suitable to hold a maximum of 115 inmates, but conditions were so primitive and unhealthy that when Steinberg arrived it was overcrowded with just 79. Most of the prisoners were officially labeled German Jews, and twenty-four had already been interned for two years.

In 1940 the Villa Tonelli's sewage system, bathing, and toilet facilities were supposedly improved, but in 1941, while Steinberg was there, the building had no running water owing to a lack of water pressure; inmates were permitted to shower once every week to ten days, using buckets of cold water raised from the well that also provided their drinking water. Sewage was still disposed of in nearby cesspits. There was an infirmary of sorts consisting of three cots, supervised by the local "health officer," whom everyone took care to avoid. A primitive kitchen provided meals that prisoners ate in a refectory, and those who had friends or family to bring them extra food were exceedingly grateful and considered themselves lucky. The government allowed a daily stipend of a few lire to prisoners who had no family to bring them food or money. In later years

Steinberg liked to tell friends that the pope supplemented the stipend with an extra six lire every day "as an allowance, and for his own peace of mind." They needed this money because they had to buy so much of their food in order to survive.

"There was quite a traffic in bread," Steinberg remembered, "fresh bread, dry bread, all kinds of bread. Grass and herbs, a bit of onion," all were scrounged to make "bread soup, bread pies." He thought himself lucky to be sent there in May, when it was warm and easy to forage.

The main problem for the detainees was how to pass the time. There was a large garden in front of the house, and prisoners were permitted to walk in it. They could see the townspeople through the fence, particularly the women, "virgins full of passion . . . all those bulging curves ready to explode: bosoms, backsides, and so forth." Apparently some of the girls looked back at the prisoners. Many years later, one who lived next door to the Villa Tonelli remembered the "romantic young man who fascinated all the girls on account of his good looks." They flirted through the fence, calling for Paulo, the Italianization of Saulo, the nickname Steinberg was given by his friends in Milan, or Saulino, as Ada had called him before she coined the lover's nickname Olino, or *"mi Olino caro."* The "enforced abstinence" within the camp made Saul pine for Ada: "Adina, always thinking of her. At nights I put my head under the covers and start to think. I greet her, Hi Adina . . . poor dear Adina, I love her very much."

There was an interesting collection of fellow prisoners, and intellectual and cultural life flourished as well as it could under such circumstances. Steinberg befriended two of the prisoners who were Austrian Jews: the violinist Alois Gogg, who became a professor of music and director of a symphony orchestra in Wisconsin under the name of Milton Weber, and Walter Frankl, the architect and elder brother of the famed neurologist/psychiatrist Dr. Victor Frankl. When the inmates came up with the idea to send something sarcastic to Mussolini to "thank" him for the minuscule daily food allowance, Frankl made a tongue-in-cheek drawing that showed the Villa Tonelli surrounded by small blocked-in spaces where each prisoner could write his name. They intended sarcasm with a proclamation of the word *Duce!* at the top of the page in large block capitals, followed by a statement that the detainees were profoundly grateful for the stipend and wished to offer their stupendous thanks for such a magnanimous gesture of "human treatment." Their sarcasm continued as they saluted Mussolini again at the end with another large block of capitals: "Viva l'Italia!"

Steinberg spent his first few days reading books that others had brought

with them, especially those he found in the English language. He liked *Huck-leberry Finn*, particularly the part where "Tom Sawyer takes off his hat as if taking the lid off a box of sleepy butterflies." It may have been one of the earliest images that sparked his imagination for so many of the drawings that showed startling objects erupting from inside a person's head. But he soon tired of reading, and when he became acquainted with a number of prisoners who had worked in journalism or the arts and who were still trying to practice their professions from prison, he knew he needed to follow their lead and get to work. He was beginning to settle into the place, even getting used to smoking Popolari, a coarse brand of Italian cigarettes. He bought a brush and some paints and within ten days had finished a "still life on a table in the foreground, in the background, rooms, families, the usual things. The self-portrait on the table, not bad, all a little messy and confusing in color."

He had begun to draw *dal vero* whatever he saw in San Vittore, and he continued with passionate intensity in Tortoreto. At San Vittore, to conserve paper, he had put three drawings on one page. On the left was his cell, number 111 on the second floor of San Vittore, with everything in the room carefully labeled and explained. He wrote the names of his cellmates on the mattresses on the floor, noting that two were made of straw but his was not. In the center on the cell floor was the carefully labeled water jug, washbowl, soup dish, and wine carafe. In the middle drawing, a shadowy outline of a man stares wistfully up at a large barred window, and in the right-hand drawing Steinberg surrounded a barred cell seen from the exterior with writing that depicts the hours when everything happens in the prison: milk at eight, soup at eleven, and three bed checks at night. At Tortoreto he was in Room No. 2, a large dormitory with ten other prisoners. He drew it in stark black outline, depicting dejected male figures sitting on beds with their few belongings hanging limply on the walls behind them. Here and there, several desk tables and chairs are scattered. The aura is one of nothing to do but kill time, and there is an intense impression of tired, bored men, waiting for something to happen. By May 28, Saul noted in his diary that he had sent two tempera drawings to Aldo and if he did not soon leave, he would "die of heartbreak."

Actually, heartbreak or toothache—he was not sure which would get him first. He had suffered, and would continue to suffer throughout his life, from every sort of problem with his teeth. When the pain was too severe to endure, prisoners were allowed to go to the dentist in Tortoreto Alto. Steinberg had had several cavities filled by this dentist, but the pain persisted, and a week later he was convinced it might kill him. Naturally, this was the exact moment when his travel dominos all lined up perfectly and were ready to fall.

———

HIS AMERICAN RELATIVES HAD PREVIOUSLY MADE contact with an Italian group known by the acronym DELASEM (Delegazione per l'Assistenza degli Emigranti Ebrei, the Delegation for the Assistance of Jewish Emigrants) and were hopeful that an on-site Italian organization could assist them. DELASEM, created by the Union of Italian Jewish Communities in 1939, carried official government authorization for the purpose of assisting Jews in Italy (whether Italian or foreign) to leave the country. Neither Steinberg nor his relatives ever mentioned that he received financial help from DELASEM, but he did receive the group's advice and assistance throughout the time he tried to leave. Nothing much came of it before he went to Tortoreto, and he had all but given up on it.

Suddenly, on May 30—and on his unlucky day, a Friday—he received a telegram from DELASEM telling him that his Portuguese visa had arrived. There was no mention of a transit visa for Spain (although it came a few days later), and he had just twenty days to get himself to Lisbon before everything expired. It meant that he had to fly, and a week of confusion followed until another Friday, June 6, when a letter from DELASEM in Rome led him to believe there was some question about his plane ticket. Steinberg was sure that, as it was Friday, there was still time for something bad to happen.

He was calmer the next morning when he heard someone shouting his name from the street. It was his fellow prisoner Alois Gogg, joyous because they would both be allowed to leave for Rome the next day. That night their fellow prisoners gave them a royal send-off. First there was dinner, for which they pooled all their resources. Then they presented Steinberg with another of Walter Frankl's drawings of the Villa Tonelli, signed by all his fellow internees. After that, Gogg gave them a muted violin concert—in the dark, as lights were turned off at nine o'clock, after which prisoners were supposed to be quiet.

In his little book of reminiscences, *Reflections and Shadows*, Steinberg wrote that everyone walked with him and Gogg and their police guard as far as they were allowed, to the edge of the station, where the two were escorted onto a train bound for Rome. As it passed by the villa, all those left behind were up on the roof or at the windows, waving everything white they could find, including sheets and towels. In the wartime "Journal, 1940–42," however, he tells a different story.

Instead of going directly *to* Rome with Gogg, Steinberg got off at the next station and boarded the night train coming *from* Rome and went to Milan to spend a day with Ada. He made the trip "seated with all the perils, police, documents," but arrived without incident and went directly to the Grillo. While

he was in bed with Ada, Natalina Cavazza did his laundry, scolding him for taking such shabby clothes and worn-out socks to America in his one small suitcase. The next night he got back on the train, and this time he did go to Rome, to "a crowded train, a nameless hotel . . . saved from minute to minute by a miracle." He stayed at the Hotel Pomezia on the Via dei Chiavari near the gate to the old Jewish Ghetto, in a room he shared with Gogg, where he drew another of his stark pencil drawings, as if he needed to fix every feature of it firmly in his mind so it would stay there forever.

In later years Steinberg liked to tell a more dramatic story about how he fled—that he had no exit visas and "slightly falsified" them with a rubber stamp of his own making. In truth he had all the proper travel documents, affidavits, and visas that were required, and thanks to his Italian friends, he was flush with money. On June 16 he and Gogg were allowed to board the Ala Littoria flight that took them to Lisbon via Barcelona and Madrid. They stayed in Lisbon until June 20, at the Hotel Tivoli on the appropriately named Avenida Liberdade. Gogg, who was sailing on a later ship, came to the pier with another released internee named Isler, and they waved goodbye to Steinberg as he boarded the *Excalibur*, a ship of the American Export Line, with his small suitcase and two dollars in American money.

On June 21, Hitler declared war on Russia; on June 22, the ship picked up fourteen Dutch sailors who had been in a lifeboat for fifteen days after their ship had been torpedoed; on June 23, they stopped in the Azores to allow "eight clandestine passengers" to disembark. After that it was a straight shot to New York on rough seas, and on July 1 the *Excalibur* sailed into New York Harbor. Cesar Civita was there with the New York Steinberg family, but they were not able to do more than greet Saul briefly. Henrietta Danson noticed sadly that his little valise contained only an extra shirt, a pair of socks, and an apple he had taken from the ship's dining room.

Despite Harry Steinberg's plea to Mrs. Reyher of the Dominican Settlement Association that Saul be allowed to stay with his relatives until his departure, they were not even allowed to take him into Manhattan for an afternoon of sightseeing. He could only greet them before customs guards hustled him off to the barracks on Ellis Island, where he was interned until the ship for the Dominican Republic was ready to sail. He spent his first American Fourth of July there, so close to the New York he had dreamed of but still so far away that he could not even see the famed Manhattan skyline. By the time he sailed, Civita had joined the Dansons and Steinbergs to outfit him with everything he might need, including lightweight clothing and leather oxfords, the first he had ever worn. They also supplied him with an English dictionary, writing

and drawing supplies, and, most important of all, various unguents and insect repellents to ward off tropical diseases.

"They've brought me everything," he wrote to his parents. "They are all very nice and polite and very attentive." He told Rosa and Moritz that he wanted to start working as soon as he landed, as he believed he had the "hope and potential to succeed." It was a brave boast made just before he boarded a ship on July 5, to sail off to a life he could not even begin to fathom.

TO ANSWER IN ENGLISH—A HEROIC DECISION

*He is now in the Dominican Republic. He has no passport . . . it is
very much to our interest that he come to New York . . . The ques-
tion is, can we do anything to help things along.*

T he voyage took eight hot and fretful days because the ship was delayed
for three in Puerto Rico. When it finally docked at a small port on the
north coast of the Dominican Republic, no explanation was given for
why they were not going to Ciudad Trujillo, as planned, and everyone
was ordered off. Steinberg discovered that Spanish was an easy language to
learn for one who knew Italian, and he was able to speak enough to hire a car
that drove him to the capital city through the inferno of midsummer heat. He
arrived on July 13 and immediately became aware of how bribery and cor-
ruption fueled the government of the megalomaniac dictator, General Rafael
Trujillo, who had even renamed the venerable city of Santo Domingo after
himself. Steinberg was struck by the kaleidoscopic profusion of color in the
local landscape, the abundance of tropical foods, and the bustle and fervor of
the people who crowded the streets. But the strongest impression for a Euro-
pean coming from a colder clime was the intense and suffocating heat, and
within days he was sick.

He spent most of his first month in bed under a canopy of heavy netting,
felled by malaria and trying to fend off voracious mosquitoes with a variety of
the medicines and spray guns of Flit insect repellent his cousins had provided.
He was in a pleasant enough hotel room, paid for by Cesar Civita, who sent
fifty dollars every month as an advance against future earnings, and he still had
a little left from the funds his friends had contributed before he left Italy, sup-
plemented by what his uncle and cousins had given before he left New York.
He drew his room in a letter to Henrietta Danson, complete with an arrow
pointing to the green lizard on the floor beside his bed, which ate all the flies,

roaches, and gnats who tried to invade it. "I shall try to answer in English—is an heroic decision," he told her in his still imperfect command of the language, and he followed the declaration with an arrow pointing to a squib of his sweating self sitting at a desk with a large dictionary open in front of him. By October he had still not recovered from the malaria, but he tried to work, even though it was "impossible to be very well" in such a dreadful climate.

Cesar Civita had arranged for him to draw daily comic strips for Dominican newspapers, which he did because the pay was decent, even though none of them engaged his interest. He told Henrietta Danson that he had generated more good ideas for cartoons in a single afternoon in Milan than he did in an entire month in Santo Domingo. Otherwise, daily life was dull and he did little. He managed a daily ocean swim but was too lethargic to practice English; he thought the Dominican people "much primitive" and socialized only with other Romanian refugees, befriending an architect from Bucharest, Paul Rossin, and his wife, Tina, and brother, Pierre. He went to their home for meals or to pass evenings with them and other Romanian refugees, particularly a family named Godesteanu. They all knew each other from Bucharest, and talked frequently of Leventer, who had returned home hoping to work as an architect, and the peripatetic Perlmutter, who was rumored to be in Hollywood but was actually in Algiers. All the reminiscences overwhelmed Steinberg with a sense of what he had lost, as they brought back memories of other Romanian friends and summer outings in the countryside.

By the end of his first month in Santo Domingo, he realized that he was getting a lot of good news, all coming steadily from the Civitas' New York office. Gertrude Einstein, the woman who ran their office with the utmost efficiency, told Steinberg that Cesar had sold some drawings to various American publications, but the real excitement came when *The New Yorker* bought one and wanted more and *Mademoiselle* bought "four or five" for a double page in the Christmas issue and wanted another double-page spread for Valentine's Day. He told his Danson cousins (still in imperfect English) that he knew of "the very goods English like *Punch* and *Humorist*, but I think *The New Yorker* is the top. Is very flattery for me." Then *The New Yorker* asked for more drawings, and suddenly he had so many commissions that even doing work he loved became almost more than he could handle.

He thought his malaria was cured, but by mid-October he was ill again and described himself as looking "like a x-ray picture full with quinine, fever, etc." He was in bed during another heat wave, which lasted through November and made him even more "ill and furious." He had been in Santo Domingo for four months, and for more than two he had been bedridden and often unable

to work. That was his chief frustration, but there was a long litany of others, starting with parcels of clothing the Steinbergs and Dansons sent from New York. Customs officials expected bribes, so they refused to give him a package containing trousers and shoes valued at $25 until he paid an unofficial "tax" of $19. Since he was against it in principle and short of money besides, he asked a Dominican acquaintance who knew the customs officials to offer a smaller bribe, which was successful.

NO MATTER HOW SICK, TIRED, OR DEPRESSED Steinberg was, he always forced himself to write relentlessly cheerful letters to his parents, even to the point of stretching the truth by exaggerating how much money he was making and how, if his good fortune continued, he would be able to bring them "over here soon." Hoping to placate Rosa, he adopted his Aunt Mina's flowery style of letter writing and used her religious exhortations to preface almost every statement. His letters were full of expressions asking for God's help or hoping that God would bless his various undertakings. The only unvarnished truth he told was to describe how his good fortune in escaping from Italy had made him so aware of his Jewish heritage that he fasted on Yom Kippur, not only for himself but also to honor his parents. And yet no matter what he wrote, it was not enough to calm his mother, who was convinced that her twenty-seven-year-old son was dejected and depressed and his spirits would rise only from being in her presence.

After the United States entered the war, Rosa insisted that Saul was in greater danger in Santo Domingo than he had ever been in in Italy. She chose this moment to write hysterical letters to Harry Steinberg, alarming him and irritating Saul when he learned of them. Harry tried to pacify her by telling Moritz that "the main thing is to calm Rosa." Patiently, and "especially for Rosa," he described the peril Saul had faced in Italy, but she was still determined that he must return to Bucharest. Harry tried repeatedly to tell her that her wish for him to return was unrealistic, and he begged her to have faith that Saul would be successful and bring her "great naches," using the Yiddish expression for the pride or pleasure a Jewish parent gets from a child. Rosa ignored everything he said, including his careful descriptions of how much Saul was earning, of his excellent diet amid the abundance of food, and of his pleasant life in a paradise that tourists paid handsomely to visit. She ignored everything, insisting that Saul was in danger, and at that point Harry lost patience, writing, "You don't help him by being upset . . . on the contrary, you discourage him, and he has to be encouraged." Whether Harry ever persuaded Rosa to calm down became a moot point, because mail service to and

from Romania was severed, and for the next several years only an occasional cryptic message sent through the auspices of the National Society Red Cross of Romania reached any of them.

ROSA'S OUTBURST PALED BEFORE THE WORST blow of all, which came just when Saul was weakest from malaria. Aldo sent a letter saying he could no longer keep it secret that he and Ada had had an affair. The letter was Saul's first real contact with either of them since he arrived in Santo Domingo, and it left him reeling. They had written to him in Tortoreto and Lisbon, but mail delivery was sporadic, and for every letter he received, many others were either delayed or lost. One of the first things he did after landing on Ellis Island in July was to write a letter to Aldo begging for news. Aldo did reply in August, but Saul did not receive that letter until October, and the only news it contained was of the affair. Aldo said he needed to tell Saul because their friendship meant everything to him, and he begged Saul not to end it. Even though Saul was stunned by the confession, he did not wait to hear Ada's side of the story before taking Aldo's: "He makes it clear that she is the guilty one . . . that the thing lasted for a while, that it was he who ended it when he received the letter from me from Ellis Island. She had wanted to keep it secret." In a fit of self pity, he added "poor me."

Several days later he received two letters from Ada with her version of the affair. "She writes bullshit," he decided. In her usual blunt manner, Ada was brutally frank about what had happened between her and Aldo. She took full responsibility, asking Saul not to "feel rancor toward Aldo because he certainly regrets it greatly." She told him her "heart had nothing to do with it" and the encounter was purely physical. She insisted that she had controlled it and if she had not wanted Aldo, or anyone else for that matter, "no one would have touched me." Ada was especially angry with Saul for believing that the only reason she had told him was that Aldo and perhaps some of his other friends had already done so. She insisted that she would have told him herself, probably sooner rather than later, but as he had done throughout their relationship, he needed to invent some reason to doubt her. She said that she had told him because she needed to get it into the open, but "as usual I did the wrong thing."

In response to Saul's continuing criticism, Ada wrote several more letters trying to explain how little the affair mattered. He dismissed them as further attempts to justify herself, and he worked himself into melodramas as each one made him "suffer anew" and relive the shock and anguish of his first awareness of it. In these letters Ada tried to explain how it happened by describing how she had been thrown into constant contact with Aldo during the months when

the two of them were working frantically to secure the money and transit visas Saul needed. She reminded him again of how she had written over and over to him in Tortoreto, begging him to write directly to her rather than addressing letters meant for the two of them to Aldo so that he could read them first. Ada claimed that Aldo had an irrational need to hoard Saul's letters; he would not even tell her when he received them and would let her read them only if she found out from others that they had arrived. Aldo never volunteered that letters had come; even worse, he would not let her see the pages but would read them aloud and keep them for himself. Often, to find out if Aldo had received a letter, she had to go around asking other friends if they had heard news of Saul. If they had, she then had to track down Aldo, and that was never easy. She usually began at the Grillo, and if he was not there she went to his studio or various workplaces. Once she trekked to a nearby village where he was visiting his mother, and another time to a village where his sister lived. Ada tried to make a joke of it, albeit a grim one, when she told Saul how she had to involve Aldo's entire family in order to get news of him.

For whatever reason, Aldo did not like Ada, perhaps because he did not trust her. She hinted at Aldo's resentment in almost every letter that reached Saul in Tortoreto, as if she hoped he would do something to resolve the situation. Usually she began positively, by describing the frenzy with which Aldo was working to establish helpful contacts within the bureaucracy, how he was raising money to pay "small fees" (that is, bribes), and how he would send her to Genoa while he went to Rome so they could save time and cut through red tape by pleading with separate ministries. It was not until after she praised Aldo's efforts that she told Saul the truth about how they related to each other. Ada seemed puzzled by how cryptic and cold Aldo was to her, and how he was so uncomfortable in her presence that he would sometimes walk away abruptly in the middle of a conversation, leaving her to worry about what, if anything, he knew about Saul's incarceration that he was not telling her.

All that changed after Saul was safely on board ship for the Americas. As neither Ada nor Aldo was receiving mail from him, each contacted the other routinely to see if anything had arrived. Gradually strained conversation led to easy conviviality and then to unexpected intimacy. Ada told all this to Saul in the hope that it would be the end of his endless demands for her to rehash the details of the affair. She hoped he would soon tire of brooding so they could put it behind them, but his very next letter asked her to describe yet again every intimacy that had transpired. She begged Saul to realize how lonely she had been after he left and how she simply lost control of herself momentarily. She was not seeking to absolve herself of blame, but she wanted him to stop picking

at the scab of something that should be allowed to heal: "You are making a big deal out of it, and you hurt me by dwelling on it." Still, he was unable to let it go; "I have to vent," he declared. Whatever he did to assuage his anger seems to have worked: several days later, when Ada sent a photo from Genoa of herself with her husband and dog, he merely commented that he had received it.

The photo did not come as a surprise, for Saul had known since the early days of their relationship that Ada was married. He simply didn't care, and apparently neither did she. From then on her letters referred casually to her husband, never by name but always as *he* or *him*, and how *he* was waiting for mobilization, and how she would sell *his* house to finance her move to the United States once Saul was safely ensconced there. At one point she even told him of an abortion—cryptically, because censors read the mail: "That which we had hoped for when you were here has happened, but now was not a good time."

Saul's thinking about Ada fluctuated daily, if not hourly. On any particular "today" he was seriously thinking of marrying his beloved Adina, whereas on various "yesterdays" he never wanted to see her again. He went back and forth in this fashion for the remainder of his stay in Santo Domingo, but most of the time he yearned for her and she was his "poor dear Adina" who "writes beautiful things, she loves me, my dear Adina." When he wrote in his diary that "I really am thinking of marrying Adina," it was one of the very few times that he ever made such an admission. After the Pearl Harbor attack, when it seemed likely that mail service to Europe would be suspended, he had the recurring dream that he lost her somewhere in Milan and was chasing through the streets looking for her: "Dear Adina, poor little thing. The good times are over, Adina, dear and good with me."

He may have been pining for his lost love, but that didn't keep him from being with other women. When he wasn't sitting in the dentist's chair for the escalating problems with his teeth, he had to find another doctor, "in great fear because of a pimple near my dick. Fortunately, it was nothing."

ONCE HE HAD MOSTLY RECOVERED FROM the malaria and a head cold that hung on for weeks, he moved from the hotel to his first set of furnished rooms. A child next door cried so constantly that he could neither sleep nor work, so he moved again several months later to an apartment where things were more tranquil. He had been on the island for a little over six months and was desperately trying to recover from the topsy-turvy life his illness had foisted upon him, realizing that he needed to focus on the two things that mattered: trying to work, and finding a way to get himself to the United States. The Civi-

tas were continuing to send commissions his way, one of them being a book jacket for Simon & Schuster. He was also finishing the Valentine's Day spread for *Mademoiselle*, but otherwise there was ominous "silence from New York," much of it due to the interruption of mail service after most of the Americas entered the war. The Civitas had raised his monthly stipend to $70, but it was often delayed. "I continue confusedly my work . . . because I'm almost penniless now," he told the Dansons, and he was grateful for the three pairs of shoes and the $50 they sent at Christmas. To keep himself busy, he began to paint and entered three pictures in the annual exhibition sponsored by the local Museum of Fine Arts. He was pleased with his success but somewhat puzzled to find out that he had been labeled "a surrealist."

Things picked up after the New Year, as Civita sold drawings and cartoons to the newspaper *PM*, the magazines *Liberty* and *The American Mercury*, and once again to *The New Yorker*. In January 1942, Steinberg told the Dansons, "Is a pity I'm not in New York. I have a lot of goods ideas for cartoon, but when they arrive at New York they are too old or not interesting yet." By March his frustration was mounting: "It's a pity I'm not in America now, it's the moment all magazines and papers needs cartoons." He was not working well "without stimulant [stimulation] . . . day after day I'm waiting for some good news, with little hope." His attitude had changed since he first arrived, when he was "so happy to be free here, after Italy and so on, but now I really need New York."

Enough time had passed that he could start the New Year by trying to get a place in the Romanian quota, but once again, just as in Lisbon, he feared the specter of the "other, Communist" Steinberg. Saul Steinberg was afraid to go to the U.S. consulate in Ciudad Trujillo because he feared the authorities might ask him if he had ever been deported from the United States. While he was being held in Ellis Island, his English was so poor that an Italian interpreter was assigned to take his information for immigration officials. In the process, the interpreter asked a routine question about why he had been sent back from Lisbon, and Steinberg thought he had to explain about the confusion with the "Communist Steinberg" that had sent him back to Italy, which he equated with deportation. The interpreter stressed that if he had indeed been deported, he could not apply to reenter the United States for a full year. Somehow Steinberg confused this conversation with a deportation from the United States, and after so many months he could not remember how he had answered the interpreter's question. All he remembered was that when the ship bringing him to Santo Domingo had docked in Puerto Rico, the crew had confined him to his cabin and he had overheard the guards outside his door describing him as a "dangerous deportee." He was convinced it had something

to do with the Ellis Island questioning, which might have raised red flags in his immigration file. Now that he could speak passable English, he wanted to know if he should try to explain the situation to the U.S. consul or just keep quiet and worry about what to answer if anyone asked the question.

Also, his application for the Romanian quota required that he submit forms in both Washington and Ciudad Trujillo. Since he could not go himself, he painstakingly prepared an English curriculum vitae in a letter to Harold and Henrietta Danson, which listed his birth date, residences, and education for Harry Steinberg to use when he made the trek to D.C. on Steinberg's behalf. Steinberg described his work experience first as an "architect designer" and then as a "publicist" for *Bertoldo* and *Settebello*, but he cautioned the Dansons to tell his uncle "is better don't mention any my work in a wartime Italy." He did say, however, that when anti-Semitic laws prohibited him from working after 1939, "I published [just] the same without signature."

Another possible glitch arose when he tried to obtain the Dominican certificate attesting that he had been in residence there. To get it, he had to provide his "born certificate" and two police certificates—one from Romania, the other from Italy—establishing that he did not have a criminal record. He could not attain any of them, and his only hope was to garner enough positive testimonials from United States citizens that consular officials might say "Never mind."

Indeed, many people were working diligently and were eager to testify on his behalf. Cesar and Victor Civita collected letters from editors at *Esquire*, *The American Mercury*, *Mademoiselle*, *The New Yorker*, and *PM*, all affirming that they had bought his work in the past, assumed that he would continue to do good, if not better, work in the future, and believed that he possessed admirable personal qualities. Civita also furnished a statement of Steinberg's earnings as proof that he had every likelihood of continuing to support himself, and handsomely at that.

Cornelius Vanderbilt, Jr., who was now a major in military intelligence stationed at the Metropolitan Military District in New York, directed his letter to a high-level contact in the Department of Justice's Immigration and Naturalization Service. Vanderbilt pulled out all the stops as he described Steinberg's "considerable reputation" in Europe and then went on to speak of how *Life* called him "one of the foremost European caricaturists." Vanderbilt described how "partly through my interest," Steinberg was able to get to the Dominican Republic and submit work to other American publications: "I have seen his work on the editorial pages of *PM*, where on many Sundays he has had cartoons that satirically struck at our enemies . . . [Others] have been accepted by *Liberty*, *The New Yorker*, *Mademoiselle*, *Harper's Bazaar*, and *The American*

Mercury." Vanderbilt concluded with a statement that showed how remarkable Steinberg's nine-month sojourn in the Dominican Republic truly had been: "This is an extraordinary record for an artist who has not yet seen our country and yet has captured the interest of the editors of these great magazines."

Indeed, before Steinberg ever set foot on American soil, his particular vision was capturing the tenor of the times in oblique and offbeat ways, so much so that James Geraghty, the art editor of *The New Yorker*, who had seen his work in other magazines, persuaded the magazine's legendary editor, Harold Ross, that it was "very much to our interest that he come to New York, [where he would] become a major artist almost at once. I'm told he's in his twenties, and a man of ideas." Even better was the agreement Civita arranged on May 14 that *The New Yorker* would have the right of first refusal for all of Steinberg's cartoons and other drawings.

These testimonials paid off at the end of April, when Steinberg's visa was finally granted. "I'm so happy, I can't tell you!" he wrote to his Danson cousins. His application had been approved and he would soon be given his quota number, so that within two to three weeks at the most, he could leave for the United States: "New York at the end of May—I cannot believe it!" He had his visa in hand on May 16, but it arrived just in time for another round of worry and frustration.

Civita and his relatives in New York decided that Steinberg should fly to Miami and could make his way to New York as he pleased, most likely by train. Gertrude Einstein ("Miss Einstein" to Steinberg then and for several years after) was put in charge of making the plane reservation for an open date, meaning that he could fly whenever a seat was available. The problem was that flights were limited and there was a long line of people with higher priority. With the open ticket, he assumed that all he had to do was go to the airport and wait for his name to be called, but he still had the nagging worry that when his turn to board the plane finally came, the confusion with the "other, Communist" Steinberg might keep him from realizing his dream "to be in New York, to work really." He begged his uncle and cousins to tell him what he needed to do so there would be no trouble about what he had begun to call "my matter."

By the end of May, even though Harold Danson and Gertrude Einstein assured him that his ticket was on its way, it had not yet arrived via the mail. And even as he admitted that it was "stupid" to bore Harold Danson with more questions about "my matter," he could not resist doing so. Danson seldom lost patience with anyone in the fairly emotional family he had married into, but he did so after one too many letters about "my matter." He turned it over to Miss Einstein, who told Steinberg she was conveying a message from Danson

"which sounds very sensible: he is a bit angry with you for talking so insistently about 'your matter.' There is no special 'matter.' You are just a normal immigrant and should not behave as if you were not, lest people start wondering."

After telling him that Civita had rounded up an Italian refugee to meet his plane and help him on his way, and that the *New Yorker* editors were also enlisting their own connections to help him, Miss Einstein ended her letter sweetly: "Don't you think you should have sweet dreams now and stop worrying about self-made spectres?" But this wasn't soothing enough for Steinberg, and she had to write again: "There is not the slightest danger that the events of Lisbon will again take place. I repeat what I said in previous letters: stop worrying, take the plane whenever Pan American Airlines will have a seat for you and come. You will see that everything is very easy with a regular immigration visa in your pocket."

AND SO, ONCE HIS TICKET WAS in hand, he spent the month of June going to the airport every day and returning to his furnished room every night. He was utterly frustrated: "I'm wasting my time here, I cannot even work, my baggages are made, ready to leave every day. I cannot say how much [longer] I'll have to stay here waiting."

Every day he chatted with others who were standing in line and sweating in the summer heat. More people were leaving every day, but on flights to Haiti or to Maracaibo and other South American cities, where they hoped to find easier connections for Miami. Steinberg was being advised by them and by some of his American contacts to take his chances and go to Port-au-Prince, but he was afraid to do it for fear that by leaving the comparative safety of the Dominican Republic, he could land in a country where untold new troubles might arise to impede him. He apologized for complaining, but every day seemed to be forty-eight hours long: "Now I cannot do nothing but wait and smoke bad cigarettes."

Finally, on June 28, 1942, the long wait ended and his turn came to board a Pan American Airlines flight to Miami. Vittorio Nahum, the Italian refugee enlisted by Civita, met him at the airport and took him to the Embassy Hotel in Miami Beach. Steinberg spent one night in the hotel and the next morning went to the Greyhound bus station, where he bought a one-way ticket to New York.

"Traveling by bus, if you manage to sit in the first row, you enjoy the ideal view, the rarest and most noble one," he later said. And that was how he got his first view of the American Dream as the bus wended its way up the Atlantic seacoast.

CHAPTER 8

IN A STATE OF UTTER DELIGHT

*Who the hell knows where my home is . . . I didn't have the time
to know New York and love it.*

The first thing Steinberg noticed about New York was its architecture,
particularly the impact of cubism. He trained his European eye on
the urban landscape and decided that the dominant influences were
"Constructivism," "Cubism," and "Fernandlégerism." Despite wartime
rationing, restrictions, and blackouts, everything he saw or experienced left
him "in a state of utter delight." The "Cubist elements" that became his life-
long totems assaulted his eye everywhere he looked, and everything he saw
became grist for his artistic mill, from the gleaming Chrysler Building, where
"Art Deco was merely . . . Cubism turned decorative," to the sensuous plastic
curves and neon-bright colors of larger-than-life jukeboxes, to women's dresses
(short, to conserve fabric), shoes (usually high, with platforms and stilettos for
heels), hairdos (upswept into elaborate rolls and curls), to men's neckties (large
and bright, splashed on colorful zoot suits in rebellion against drab khaki uni-
forms). Taxis provided fascinating bursts of color in shiny enamel, particularly
the sleek flowing lines of the Pontiac sedans, which sported a hood ornament
that he thought resembled "a flying Indian that derived directly from Bran-
cusi and his flying birds." He marveled particularly at "the sort of red that is
obtained only on metal, many coats & laquer, the illuminated taxi sign on top
rendered even more clearly the jukebox origin of the car." Billboards were a
revelation in text and type. English as spoken by "Noo Yawkahs" was a foreign
language. The noise, dirt, traffic, confusion—everything that jumped out at his
senses in the New York of 1942 was part of "a very American world," and in his
opinion, one that was so "very optimistic" that he had trouble assimilating it. In
later years, he regretted that he had only sketched and not made "large paint-

ings" of all that he saw then, of "diners, girls, cars, an America I believe myself the first to have discovered, or at least to have sketched." To him, America was "disarming," always looking for "gimmicks," and with "amusement park qualities" defining its skyscrapers."

He went about the business of observing daily life in New York with what others thought was quiet reserve and dignity but in reality was the shy silence of someone whose English was not very good and who preferred not to expose himself to embarrassment or ridicule by trying to speak it: "Speaking primitive English was not my style." It was also a cover-up for the depression caused by feelings of confusion and displacement, an ambivalence inspired by the city he had yearned to live in for so long. "Who the hell knows where my home is?" Steinberg wrote a year later as he reflected on his earliest days in the city and "the empty stupid life" he led there. "I hated New York. I didn't have anything to do with that place, and I still hate to think of Times Square like a Luna Park, and Sixth Avenue busy and strange."

The Steinbergs, Dansons, and Civitas (via Miss Einstein) eased his entry into city life by having a room waiting for him in a Greenwich Village hotel, the Adams, on the corner of 11th Street and Sixth Avenue (now the Avenue of the Americas), the first street he knew in the United States. "Sixth Avenue was very luminous then," he recalled years later: "mostly brownstones, cheap jewelry, army & navy stores, used books, loans for guitars and cameras. Joke stores (rubber fried eggs, etc) . . . In summer Sixth Avenue had the looks of a Canaletto, the pink gold brown the even light of the houses bordering the Gran Canal." He was captivated by "the great American aroma in summer— a combination of Cuban tropical and drugstore, chewing gum spearmint, Soap, the new and rare smell of air conditioning, healthy and clean sweat." It was a relief after the "Dominican street smell [of] sweat, starched suits, waxed tiles, carrots, Cremas [strong Dominican cigarettes]."

His neighbors were Ruth and Constantino Nivola, who had also escaped from Italy and were living in a one-room sixth-floor walk-up on Fifth Avenue between 14th and 15th Streets. He had known them in Milan before they fled, first to Paris, because Ruth was Jewish, and they were the first people he looked up in New York. Tino was filled with a zest for life, and when he suggested on the spur of the moment that he and Steinberg should go to see Niagara Falls, off they went. Tino was the art director for *Interiors* magazine and therefore high on the list of exiled artists and writers, who went to him in search of work as well as friendship. Through him Steinberg was introduced to other Italian refugees who spoke the same polyglot he did and who gave him the same sort of companionship and camaraderie he had enjoyed in Milan. It

was an insular little group, whose members were as unsettled and disoriented as he was. There was no particular bar or café to gather in, as Il Grillo had been, but rather, in the New York way of the young and poor, they socialized over potluck dinners or drinks, usually in the Nivola apartment. Ruth Nivola remembered how "everybody brought something, food, drink, because no one had money enough to entertain a group."

Many of the Italians were anarchists who congregated around Carlo Tresca, the socialist who was later assassinated in front of the building where the Nivolas lived. All were intellectuals and avid collectors of every rumor and scrap of information about what was happening in Italy, for they thought of their time in New York as "a brief exile" and had "no curiosity about the USA." They stayed late, talking into the night as they exchanged news and rumors and compared the horrors they had gone through, with everyone expressing "such a feeling of wanting to create a better world." To the Nivolas, Steinberg "was then the way he was even later, quietly observant and saying little but very troubled by the persecution of the Jews."

Steinberg made many friends among artists, musicians, actors, and writers, initially through the Nivolas. Among those he cherished were the artists Alexander Calder and Philip Guston, the journalist Ugo Stille, the author and illustrator Leo Lionni, the violinist Alexander Schneider, and the critics Bernard Rudofsky and Harold Rosenberg. Despite such lasting friendships, he still believed that "true friendship, which is a provincial art, doesn't exist in New York. It's more a matter of seeing each other at parties and other daily, dissolute, alcoholic festivities." He may have disparaged such socializing, but he gave good value to his hosts and became a sought-after dinner guest who dined out almost every night for the rest of his life. As his English became fluent, he preferred his own witticisms and entertained with monologues instead of engaging in actual conversations with other guests and for the most part held his audiences enraptured. He was quick to perceive what was missing in a host's house or apartment and made something artistic to fill the space. In the Nivola flat, for example, he painted a mural on a wall that expanded their "one beautiful room with big windows but no kitchen and bath down the hall [into] an apartment with many rooms and much beautiful furniture."

WHILE STEINBERG WAS STILL IN SANTO DOMINGO, Cesar Civita, as his "attorney or agent," paved the way for the start of his financial security by negotiating a contract with *The New Yorker*. It was signed by Ik Schuman, the managing editor, who became Steinberg's friend and benefactor, and it gave the magazine the right of first refusal of all his drawings. As soon as Steinberg

was safely in the city, Civita prepared another document that spelled out the terms of their agent-client agreement, giving him "exclusive right to place and sell, in all countries of the world," any drawing that Steinberg made on his own "initiative and idea" or on Civita's "special order." The agreement unfairly gave Civita an unusually high 30 percent of all monies received, leaving 70 percent for Steinberg. It was valid for two years, beginning on July 1, 1942, and would be automatically renewed for another year on July 1, 1944. Civita also prepared a complementary document that named Victor and Charles Civita (his brother and father, respectively) as Steinberg's "true and lawful attorneys." It gave them power of attorney to make all decisions relating to Steinberg's work, because of the likelihood that he would be drafted into the army as soon as he became a naturalized U.S. citizen.

More work soon followed, including an invitation from the Office of War Information for Steinberg to join other artists who were interested in contributing whatever work the government required "to help win the war," despite the fact that he was still a man without a country. By November he was a consultant to the OWI's Graphics Division and was being paid up to $10 a day by the Overseas Operations Bureau. He also responded to *The New Yorker's* memo to its artists about the "important and immediate need for vacation art" that would ease "wartime vacations in the darkened city" for people "swelter[ing] in dim apartments or sunny penthouses." The magazine was especially interested in cartoons pertaining to gas rationing and travel restrictions, which contributed to the "shortage of men [for] young women from Manhattan." Several weeks later a second memo arrived, asking artists to disregard the August heat wave and start thinking about the Christmas issues, and Steinberg responded to that request as well.

Now that work and a steady stream of income appeared to be assured, his immediate concern was to become an American citizen, although he knew he might be drafted as soon as he was naturalized, if not before. Thanks to Civita, he had been able to repay most of the money that had helped him leave Italy, and now that he was safely settled in New York, he wanted to see the Pacific Ocean. He took advances against future earnings from Civita and *The New Yorker* and prepared to set off by train for the West Coast. He was especially eager to get to California and see Hollywood, and here he was helped by Harold Ross, who told him that the first person to see was Joe Reddy, the publicity director of the Disney Studios, who would give him useful introductions. Even more important, Ross insisted, was to go to Chasen's restaurant and introduce himself to the fabled owner, Dave Chasen. Another *New Yorker* editor, Ted Cook, also wrote to Reddy to ask him to show Steinberg "the works," but espe-

cially to have him meet Walt Disney in person. Steinberg was already "famous in Europe," Cook added, and was now "on a swing around the U.S." Ross showed the high regard in which he held Steinberg when he sent four copies of a letter of introduction to him in care of general delivery at the main Los Angeles post office. Each carried the personal notation that Ross didn't know Steinberg was really going to make the trip until the last minute or he would have done even more to try to help him.

Steinberg took the southern route to Los Angeles and the northern route back to New York through Chicago. He went in style, in a one-bedroom room-ette, "one wall a window speeding night and day. 4 days!" When he woke up in Gallup, New Mexico, and raised the shade, he saw "a large redskin face looking at me. Paradise!" The desert scenes he knew only from black-and-white movies were brilliant "red, orange, and Japanese sunsets." The dining car was "splen-did," filled with old-fashioned Americans who looked like Herbert Hoover. He saw the Pacific Ocean for the first time at Santa Monica and thought, "Now I could die happy. I saw the two oceans."

This was the beginning of Steinberg's inveterate traveling, which he had dreamed about since boyhood. From his earliest days as a schoolboy, no one was more aware of geography or more fascinated by maps than he was, even though geography was a subject poorly taught and badly explained in Roma-nian schools. In later years, after he had taken to drawing his own maps, he created mythical depictions of what he thought landscapes should reveal and what the people who lived there should represent. They became one of the most beloved categories within his artistic expression, bringing fan mail to *The New Yorker* in record number whenever one appeared.

Before he owned a car, in order to experience the climate and culture of a place as directly as possible, he preferred to take buses, always heading for the front seat; he took trains only if there were no buses, because trains traveled through "the back side of cities" and he didn't like what he saw there. Time was limited on this trip, so he had to take the train, and once he arrived at his destination, he could not stay for long. He did not use most of the letters of introduction or take any exceptional memories away except for one: Mickey Mouse as a cultural icon.

The talking rodent had intrigued him since his student days in Milan, when he decided that it represented something special about American society, although at the time he did not know what. When he got to Santo Domingo, he was struck by what he saw as the Mickey Mouse proclivities of a country with lush, overblown, blowsy feminine characteristics superimposed on a macho culture. As he was crossing the United States, he thought a lot about Mickey

Mouse and decided that he was a negative "character . . . with a lot of influence on the street." Steinberg, who was brought up in a country where Jews had no rights and were not even considered citizens until he was five, believed that Walt Disney had created Mickey Mouse out of his own prejudice.

Steinberg was quick to recognize the situation of African-Americans in a segregated culture and to sympathize with the indignities society inflicted on them. He was convinced that "in Walt Disney's head, Mickey Mouse was black . . . half-human, comic, even in the physical way he was represented with big white eyes . . . Comic and moving, but only human in some aspects." In his own drawings, whenever Mickey Mouse appears, the figure is threatening, negative, or at the very least unsettling.

ONCE BACK IN NEW YORK, STEINBERG was waiting for something to happen as the year ended. "Damn!" he wrote. "The New Year begins on a Friday," always a bad sign. Nor was he pleased about spending "the stupid New Year's Eve [at a Spanish restaurant] with Spaniards, Nivola, Calder." Despite the companionship of cheerful good friends who always made him laugh, he insisted that he was "sad and alone as always since I left Adina." He was despondent that the cross-country trip had been so rushed that it was unsatisfying and so depressed that he did not honor the Romanian custom of paying a New Year's Day visit to his relatives at Harry Steinberg's apartment. As always, work was his solace, and as there was nothing he could do to hurry events along, he got back to it and focused on passing his citizenship exam, which he fully expected he would have to take.

He was still thinking of himself as alone, lonely, and pining for Ada when he received an invitation that literally changed his life. On the first Sunday in February, the Romanian painter Hedda Sterne "invited him to lunch and he stayed six weeks."

All she knew about him was that he too was a Romanian Jew in exile. She had no interest in him personally, as she was trying to put the earlier years of her life behind her and had little interest in anything or anyone Romanian. She was "familiar here and there" with Steinberg's work in magazines, and she simply wanted to see more of it. He, on the other hand, was smitten from the moment she opened the door to let him into her apartment. The first time he saw her, he knew he wanted to marry her.

She was born Hedwig Lindenberg and came to New York from Bucharest in 1941, after barely escaping a Nazi roundup of the Jews in her apartment building. She was a breathtakingly beautiful woman, with honey-blond hair piled high on her head, prominent cheekbones, and disarming periwinkle-blue

eyes. There was only one impediment to Saul's courtship of Hedda: half an hour into his first visit, she told him in her honest and forthright manner that she had been married since 1932 to a childhood friend, Frederick Stern, a wealthy Romanian businessman and financier. Hedda explained that hers was an "unorthodox union," and told Saul how they had lived apart since 1938, when she chose to remain in their Paris apartment while Fred went to live in London for business purposes. She explained how she knew from the beginning that it would always be "an open marriage, a *marriage blanc*, because Fred Stern had a Madonna/Whore attitude toward women and could not distinguish between them." Hedda was his wife and he treated her "with adoration and reverence" while he openly consorted with other women for sex. At the end of 1938, Fred recognized that war was inevitable and moved to New York to begin the process of bringing Hedda and his extended family to the United States.

Frederick Stern changed his name to Fred Stafford when he moved to New York. He was one of six brothers who were "all energetic [over]achievers." After graduating from the University of Bucharest, he had taken a law degree at the Sorbonne, then stayed in Paris long enough to amass a respected collection of classical and impressionist paintings and objects of ancient and Oriental art. Hedda married him when he returned to Bucharest, during the years when he was "a reader, an intellectual." This changed shortly after the marriage, when he went to work for a financier and "learned how to deal with money, and became very, very successful." He rose quickly to become head of the Romanian textile industry at Buhuşi and a major stockholder in the company. At the end of 1938, when he knew the time had come to relocate his family and his art collection to New York, Hedda chose to stay in Bucharest with her mother and brother. Fred assembled the necessary documents anyway, and like Saul before her, Hedda had her own adventure stories to tell about how she had made her way to Lisbon, luckily missing her confirmed passage on a boat that was torpedoed shortly after it left the harbor, and how she had to bide her time and wait for space on another one before finally sailing. When she arrived in October 1941, Fred and his family were on the dock to greet her.

Fred had great respect for Hedda's talent and agreed to let her live separately in New York. Her ostensible reason was to concentrate on her painting, but she had already asked for a divorce when they first lived separately in Europe. Because of his "old world background," Fred insisted that "there could never be a divorce," and Hedda contented herself with this "limbo." She asked again when she arrived in New York, and again he said no. She did

not protest that time either, because her marital status was irrelevant to her; the only thing that mattered was the thrill of having the freedom to paint all day long. In the years of their separation, she had taken the occasional lover, but she was one of those rare (for that time) women who could form genuine friendships with men without the specter of sex rearing between them, and she much preferred friendship to love. As one example among many, when she met the writer Antoine de Saint-Exupéry through another refugee who had sailed on the same boat, he and Hedda established an "instant friendship" that she described as "entirely private, out of the ordinary world, soul-to-soul" and he as one of "spiritual assistance."

Hedda rented an apartment on the fifth floor of a walk-up building at 410 East 50th Street and settled down to work. To enhance her feeling of independence, she changed her first name from Hedwig to Hedda and added an *e* to Stern to make it entirely her own name and not Fred's. Still, she could not make up her mind about how she wanted to be known, so the name on her doorbell when Saul Steinberg came to call read "Hedwig Stafford," a combination of her legal first name and the new name Fred Stern took to make himself seem more American. For the next several years she caused confusion for herself and Saul by using Hedwig Stafford interchangeably with Hedda Sterne and Hedda Stafford.

Despite their separate residences and separate lives, Fred was a loving and generous benefactor. To Hedda, he was always "an extraordinary, true, loyal friend," and throughout her long life, he made sure she never had to worry about financial security. She always described herself without irony or embarrassment as a "kept woman" who never had to concern herself with money because Fred gave her every form of support she needed or wanted. Such economic well-being allowed her to live free of the pressures faced by other artists and to say of her career, "I was what I became before I knew it was something to be."

By the time she extended her invitation to Saul Steinberg, she had become an unorthodox independent woman with a huge network of friends and (some would say) several intriguing lovers. She took no part in the fractious political maneuvering that went along with selling or exhibiting her work and was content to paint for ten to twelve hours every day, keeping quietly aloof from what then constituted the places in the art world to see and be seen. When she invited Saul to visit, it was because of genuine interest in his work and not in his person.

Saul had never met a woman like Hedda, and the memory of their first meeting was so deeply etched in his mind that for years afterward the first

Sunday in February was a sacred day in his personal calendar. A year after their first meeting, in one of the daily letters he wrote during his military service, he re-created the day in what Hedda called "those charming letters that boy-friends write to girlfriends."

He began at the beginning: "You explained me by phone how to arrive there by two buses so I said yes and took a taxi." He told how the taxi let him off at the wrong end of 50th Street and how he walked the length of it to the East River before finding her building. When he read the name Hedwig Stafford on the mailbox, he decided that she must have a roommate. He had such trouble opening the door that he "ringed twice the buzzer." Before he had gone to see her, he knew that she was a successful painter in Europe who was fast building a reputation in New York, but what he saw of her work was not what he expected: "I thought your paintings are around flow-ers and landscapes and groups of children. Maybe that's the kind of art I was expecting from a girl from my native town. Instead it was different and it was confusing."

Hedda greeted her guest casually and asked him to entertain himself while she went to her studio to finish a painting. It gave Saul "time to look around and see the happiest room in the world, light and warm and strange objects on the wall and strange paintings (I felt inferior always because I didn't under-stand some of your stuff and I still feel that way)." When he recollected the emotions that swirled in his mind, he described himself as "a good friend of yours before I saw you just in the few minutes I spent looking around with you drawing in the other room." When she finished and came in to be with him, he realized that he may have been looking at her work, but he had really not seen it and certainly had not assimilated it. However, instead of talking about her work or his, which was the reason Hedda invited him, Saul asked question after question about her life, as he wanted to know everything there was to know about her.

She told him she had been born in Bucharest in 1910, which made her four years older than he, but for the rest of his life he never allowed her to admit her true age; he made her tell people she was born in 1916 and was therefore two years younger. From their first meeting, he insisted they speak only in English, because he still thought the Romanian language should be spoken only by "beggars and policemen." Hedda recalled that "he had school English, the kind Eastern Europeans learn in school. He really didn't know the language to speak it, he couldn't properly order a dinner in a restaurant and if we walked down the street and people greeted him, he could not answer because he didn't understand what they said." Nevertheless, even when his

command of the language failed him, he insisted that they must speak English, and Hedda complied, as she did with everything Saul wanted.

Saul tried to say it offhandedly when he told people that Hedda came from a family "socially on a higher level" than his, but he said it with pride rather than resentment. It pleased him that the "son of shopkeepers could be desired by such a sophisticated and cultured woman." Her father, Simon Lindenberg, had been a high school teacher of languages before he inherited the pharmaceutical fortune of a brother who died at an early age. When Simon first took over, money poured in from the commercial laboratories, where cosmetics and drugs were invented and researched, but unfortunately he did not have his brother's business acumen, and before long there was "a great family show over his lack of success." Shortly after World War I began, Simon also died young, and his widow, Eugenie Wexler Lindenberg, took over the business. She ran it with Leonida Cioara, who had been Simon's partner and became her second husband, and under their direction it prospered and they became wealthy.

Hedda had a brother almost three years older, Edouard Lindenberg, who graduated from Bucharest University, took his doctorate in Berlin, and became a prominent conductor throughout Europe. Hedda and Edouard grew up in luxury in "a big house, a happy home, dogs in the back yard, and travels to Paris and Vienna." Because "with the Romanian language, you couldn't go anywhere in the world," both were taught French, German, and English and were fluent from childhood. Edouard was sent to private schools, but Hedda was homeschooled until she was eleven, after which she attended the Institute Française-Romanienne, the best school for wealthy young Jewish girls whose families did not want them exposed to public education. She enrolled in the University of Bucharest to study philosophy and art history but soon realized the limitations of the curriculum and dropped out after two years, preferring to study and read on her own, which she did all her life. Many of her friends thought she was better informed in philosophy and art history than their professors, and her views were respectfully considered by the Bucharest intelligentsia.

The Lindenberg home was filled with music because Edouard played the violin and the widowed aunt who lived with them was a gifted singer. Hedda was assigned to take piano lessons in the hope that the family would have its own trio, but as a "small but rather articulate child" she rebelled and demanded that her mother let her study what she really loved, drawing and painting. Several days later she was presented with an easel and paper and vividly remembered that "to this day, it was and is the happiest moment of my life." By the time she was in high school she was taking classes in Marcel Janco's atelier and had

become the protégée of a family friend, the distinguished surrealist painter Victor Brauner. She was a teenager when she formed her first close friendship with men, Victor Brauner and his younger brother, Theodore.

Victor Brauner was the first to recognize Hedda's talent, and when she was just fourteen, he honored her by making a linocut portrait, *Hedei* (To Hedda), which was used in the single issue of *75HP*, the avant-garde magazine he cofounded. Later that year he used the linocut on the poster announcing a major exhibition of his work. Brauner's linocut was done in a style "advocating a synthesis between literature and the visual arts . . . a hybrid of Constructivist, Cubist, and Futurist styles with rebellious Dada overtones." He passed along all his knowledge of these subjects to Hedda Sterne, and their influence was present in the early work that so baffled and intimidated Saul Steinberg, who came from the "world of the comic press, a world all its own"—comic/satiric journalism that was grounded in the immediate social and political reality. His art education was based on commerce and utility and was totally unlike hers, which was based on a solid knowledge of the history of painting, literature, and philosophy.

During her teen years, Hedda spent the summers in Vienna with an aunt who lived there, taking art classes at the Kunsthistorisches Museum, where she concentrated on ceramics in the mornings and visited other museums to look at paintings every afternoon. She made trips to England, where the Chelsea Flower Show left her imbued with a desire for color in her work, and she accompanied her mother and brother to Greece, where she was mesmerized with the fluid lines of classical sculpture and the forms of architecture. When she was seventeen, her parents sent her alone to Paris to enroll in Fernand Léger's classes and attend André Lhote's as a visitor in his Montparnasse atelier.

It was highly unusual for a girl from Hedda's background to be allowed to live on her own, but her mother recognized her maturity and dedication to art and honored her independence. Hedda lived in a student hotel in Montparnasse, the section of Paris she liked best because "it was the place of strangers, and I was a stranger." She did not, however, become a part of the bohemian influx that filled the quarter between the two world wars: "I was like a real good little Jewish girl. I could have been as free as possible, but I behaved all the time exactly as if my mother and my father, my aunt, all my relatives were right around there watching me." It was as "a good little Jewish girl" that she married Fred Stern in 1932 and then returned without him to Bucharest in 1938, because she "could not think of anything else to do."

She was just in time to see Romania becoming "super-primitive and

anti-Semitic, like Poland but without the pogroms." By the late 1930s, the entire country was "contaminated by Germany with a fascist contour to the whole of society." Like Saul, Hedda always felt that "being Jewish was being an outsider, and an outsider was the normal thing to be." The difference between her attitude's and Saul's was that she considered herself "an outsider by circumstances [of birth]," whereas he thought of himself as "an outsider by attitude [of an artist]." She believed that he was "a 100% original because of his approach to humor, which his audience did not know they needed it until he came along." She marveled at his ability to make ideas concrete with a symbol, whereas she saw herself as merely the repository of a long tradition of art and ideas that she could only hope to express as intelligently as possible.

Everything about the two of them was different, even though there were so many similarities in their backgrounds, interests, and the facts and events of their lives. She was as entranced by him as he was with her, and later that first afternoon, when he kissed her for the first time, she asked why he had done it. He told her it was because he liked her "as a girl, a woman, a lover, and a very decent person." A year later, when he wrote the "boy friend-girl friend" letter, he tried to explain it better: "I'm not like you. You are friendly and cooperative with people you barely know and you say open what you think. I'm different, new people are strangers for me and I have to spend a long time before I lose my self conscience [sic], the idea of hearing myself talking or seeing myself acting . . . I don't know why I'm this way, maybe I didn't have always around the right people, and making silly conversation for the hell of being normal when I feel myself losing vitamins in the effort I have to make." He knew that none of this was news to her, but he wanted to tell her anyway because "I like much to write you and I'm much in love with you."

Saul Steinberg pursued Hedda Sterne for the next eighteen months before he convinced her to accept his many and repeated marriage proposals. Throughout that time, theirs was a relationship dominated on his part by passion and on hers by the desire to make physical passion coexist with a deep and important friendship that would not result in marriage. She was afraid that he was confusing passion and friendship with love because he and she were both "the products of refusals. We both refused what Romania had to offer. We didn't want it, but we had no other comparison." Despite the fact that they had both lived for more than a decade outside their native country, Hedda was convinced they were still "insular, provincial. How did we know to refuse what we had when we didn't really know what else was out there?" She believed they had to find out what else was "out there" before they could begin to be serious about marriage. Other men before Saul had been infatuated with her,

and she expected that his interest would wane over time, as theirs had. Hedda was always the sensible one where passion was involved, so she stalled. She told Saul they should enjoy whatever time they might have together because the moment he became an American citizen, he would surely be drafted. And, who knew what would happen after that?

GOING OFF TO THE OSS

*This applicant has about everything disqualifying that could
exist. However an officer went from here [D.C.] to get him. He is
physically disqualified and not a citizen. Is urgently wanted by
VCNO for special duty in conjunction with activities of a schizo-
phrenist, and being the pick of New York, is eminently qualified
for duties for which wanted.*

> *Very nice fellow. Quiet and shy in appearance. Looks older
> than age . . . The man will never be a leader and is rated satisfac-
> tory only because his services are apparently urgently needed by
> the Navy Department.*

William J. "Wild Bill" Donovan, the head of the OSS, confided to
his close friend the *New Yorker* editor Harold Ross that the mili-
tary had an urgent need for skilled artists and cartoonists who
could perform a variety of services. The most basic need was
for artists who could draw simple pictures that explained various aspects of
military life for soldiers who could not read or understand simple texts. The
services also needed pamphlets, booklets, and flyers that could be used to com-
municate with the native population in countries where no Americans could
speak the language. The OSS itself wanted to make propaganda to distribute
behind enemy lines and needed natives of other languages and cultures to cre-
ate it. Steinberg fit Donovan's requisites on all fronts: he spoke Romanian and
Italian fluently, French and Spanish decently, and English haltingly. He had
lived in Italy and knew it well, and he could do his work with a few ordinary
materials: all he needed to make simple and expressive drawings was a pencil
or a bottle of India ink and a pen and whatever paper was at hand. Steinberg
also filled a need for the canny Harold Ross: he could send drawings back from
the front so that the folks at home would have a bird's-eye view of what their
boys faced every day.

Several weeks before that momentous first Sunday in February 1943
when Saul Steinberg met Hedda Sterne, paperwork of all kinds was zooming
through bureaucratic channels on his behalf. Efforts were under way either to

make him a naturalized American citizen or to waive the requirement so that he could be sworn directly into the navy as a commissioned officer as swiftly as possible. Other requirements, such as graduation from Officer Candidate School and fluency in English, were also waived so that he could be rushed into an assignment under the aegis of Naval Intelligence. He found all this activity slightly puzzling, because he had spent the last months of 1942 and the beginning of 1943 waiting to be drafted by the army as an "acceptable alien"; watching as his Selective Service classification changed from 4F (unsuitable) to 1A when his local draft board decided that even though he was a resident alien whose command of English was poor, he was "otherwise qualified for service in the Armed Forces." He thought his destiny was to be a foot soldier in the infantry, and he had been waiting every day for his call-up, but once again influential friends were working on his behalf.

Everything in his prior life made him a prime candidate for the OSS Morale Operations (MO) Branch, the organization's propaganda arm in the European theater. However, in its unfathomable bureaucratic omniscience, someone in Washington decided that Saul Steinberg was better suited to the navy than the army and that his talents could best be put to use with a landlocked naval unit in western China. He was assigned to the Sino-American Cooperative Organization, a group known by the acronym SACO, ostensibly a division of the OSS but one that worked mostly independently of it. As Steinberg knew nothing about SACO, he told Hedda Sterne that he was "going off to the OSS, to teach Chinese people, explaining things with drawing." He was as bewildered by the assignment as she was.

Donovan wanted Steinberg so badly that he began the complicated vetting process that would lead to his commission by carefully looking for an evaluating officer with significant clout who would be willing to overlook Steinberg's only dubious qualification: his complete ignorance of anything connected with the navy, from leadership to seamanship. Donovan made a highly unusual arrangement for the assistant chief of staff for readiness, on the staff of Admiral Ernest J. King, the CNO (chief of naval personnel), to send an officer to New York for the sole purpose of testing Steinberg. The officer gave Donovan the report he wanted, writing that "Mr. Saul Steinberg of New York city" was the "artist and cartoonist needed for a special project . . . the most suitable available individual." The officer also agreed that Steinberg's "completion of naturalization be waived," as should the need for fluency in spoken and written English.

Despite the officer's positive report, Steinberg's appointment appeared to be jeopardized because he spent the next several weeks undergoing a series of mental and physical examinations by various navy doctors who found "every-

thing disqualifying that could exist." Mentally, they diagnosed him as having, in navy parlance, "PSN-mild-ND," a mild psychoneurosis that had never before been diagnosed. Physically, the first doctors who examined him found "valvular [sic] heart disease, mitral systolic murmur," and "visual defects" (he wore glasses for nearsightedness). These were disqualifications and obviously would not do; when Donovan read the report, he told the doctors to schedule a second exam. Several weeks later a new group of physicians pronounced Steinberg's heart normal and his eyesight within accepted parameters. There was no mention of any mental disorder, and the original diagnosis was dismissed as nervousness over the exam and frustration at his inability to express himself in English. After all this, there was another hurdle: the director of naval officer procurement in New York, well aware of "the special circumstances surrounding the case," ruled that Steinberg was not qualified to become a naval officer and therefore "prefer[red] to make no recommendation."

Much debate and discussion followed between the New York procurement office and the several offices in the Washington Navy Department who were vetting Steinberg's case, until everyone agreed to override the evidence and induct him. The rush was on to have all documentation finalized by the week of February 18, 1943. Everything was crammed into the same day, February 19, and in one swearing-in ceremony after another, Saul Steinberg took the oath to become a U.S. citizen, was commissioned as an ensign in the Naval Reserve, was assigned to the Morale Operations Branch of the OSS, and received orders to report for duty at the landlocked naval base in Chungking, China. Everyone was astounded but James Geraghty, the art director at *The New Yorker*, who expressed what they all thought: "God knows how your knowledge of the Italian people will benefit you in China, but perhaps the Navy knows best."

Not knowing how to transport its new recruit to China, the navy covered all possibilities by requesting a special passport from the State Department, which included visas for Trinidad, Venezuela, Brazil, the continent of Africa, Egypt, the Sinai, Trans-Jordan, Arabia, Iraq, Iran, India, and his ultimate destination, China. He was in a frenzy to put his life and work in order, starting with updating the life insurance policy he had prudently bought several months earlier when he had registered for the draft. He was working in his steady and methodical manner to finish all his outstanding commitments to magazines when an entirely new set of orders arrived: the navy was not sending him to China immediately, but to Washington for "temporary active duty under instruction." He thought he was going to Officer Candidate School after all, to become a "ninety-day wonder," but first he was ordered to outfit himself with uniforms and wear them in public.

All his life, Steinberg was meticulous about the quality of his clothes and how they were tailored, and his uniforms were no exception. He had them fitted to his slim figure and was careful to keep the brass buttons polished and the shoes spit-shined. The first time he felt ready to be seen in public, he dressed nervously at Hedda's apartment and together they took a walk through midtown Manhattan. Whenever they passed sailors on one of the avenues, Saul noted that they were raising their hands to their caps, but he was not sure what, if anything, he was supposed to do. Hedda stopped the next sailor they saw to ask him, and he explained how enlisted men were required to salute officers, who were supposed to return it. She asked him to go around the corner onto a quiet street with her and Saul, where he instructed the brand-new Ensign Steinberg, USNR, in the proper way to receive and return a salute. After a short practice session, Steinberg shook the puzzled sailor's hand. He and Hedda continued on their walk, but they were disappointed not to pass another person in uniform he could salute for the rest of the afternoon.

THERE WAS A LOT OF WORK to finish before he went to Washington, and he concentrated on getting it all done. He also concentrated on teaching Hedda as much as he could about his personal relationships and business affairs so that she could intercede for him whenever it became necessary. He introduced her to Victor Civita, who had landed a prestigious and remunerative commission

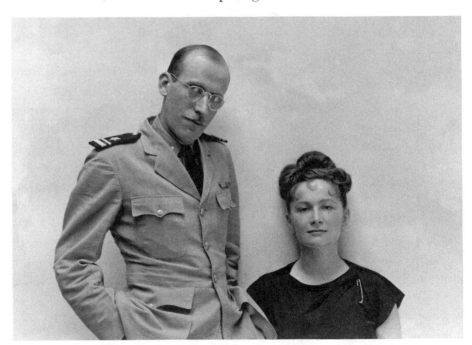

Steinberg and Sterne before he was sent to China.

for Steinberg to design the jacket and create the illustrations for *Chucklebait: Funny Stories for Everyone*, a children's book by the noted author Margaret C. Scoggin. Steinberg had commissions to fulfill for *PM* and *The New Yorker*, and he made a list for Hedda of the portfolio of cartoons he had amassed for them and other publications to draw on while he was away. Their editors liked the way he ridiculed bombast and gave a comic twist to the seriousness of war, as in his cartoon of an easily recognizable Hermann Göring, festooned in full Nazi regalia and covered with glitz that included flashing rhinestone swastikas on each epaulette. He was also preparing for the first American exhibition of his work, in April at the Wakefield Gallery on 55th Street in New York, where a young woman named Betty Parsons had taken an interest in his work.

As with so many other introductions to people with whom Steinberg formed meaningful friendships, the one with Betty Parsons came through Constantino Nivola. Steinberg was so close to the Nivolas that they were the first friends to whom he introduced Hedda Sterne, taking her to their apartment four days after he met her and urging her to value their friendship as much as he did. Hedda took to them at once and they became friends for life. Tino was the art director of *Interiors*, and through their welcoming hospitality at home, he and his artist wife, Ruth, were responsible for what would in later years be called networking. artists dropped in informally, as did gallery owners, museum curators, magazine editors, art historians, and book publishers. The New York art scene during World War II and the decade that followed was small enough that everyone knew everyone else, and the Nivolas could always be counted on to make something happen. Betty Parsons championed Steinberg and Nivola by giving them a dual show, and the reviews for "Drawings in Color by Steinberg, Paintings by Nivola" were favorable. Hedda was miffed that Betty took Saul's work "more seriously" than her own, but not for long, because she recognized why: "Each week he was in *The New Yorker* brought him more fame. His rise was extraordinary."

Saul introduced Hedda to Betty, and when Betty opened her own gallery, they both became her devoted clients. Through her they formed indi-

Steinberg and Betty Parsons with two unidentified guests at the opening of his first gallery exhibition.

vidual friendships with the glittering litany of painters whose work defined postwar American art, particularly Robert Motherwell, James Brooks, Jimmy Ernst, Ad Reinhardt, William Baziotes, Barnett Newman, Mark Rothko, Clyfford Still, Adolph Gottlieb, Theodore Stamos, Wilfred Zogbaum, and John Graham. John Graham introduced them to Elaine and Willem de Kooning, but Hedda and Saul soon had to limit their socializing: "Bill and Elaine lived at night and we lived in the daytime, so we had to stop seeing them. We didn't have the stamina." As for the other artists, they saw them on their own terms but "never at the Cedar Tavern. They were all changing partners down there and we never went in for that."

Hedda already had her own friendships among artists and took care to share them with Saul before he went overseas. She had known Peggy Guggenheim since the late 1930s, when Hans Arp saw her work in Paris and urged Victor Brauner to send it to Galerie Guggenheim Jeune in London. The war forced Peggy Guggenheim to relocate to New York, where she renamed the gallery Art of This Century. When Hedda arrived, she reintroduced herself, and Peggy became her "first friend" and included her in several important group shows. Like all the other "recent Americans, refugees all," Hedda found herself swept into the whirl of parties that Peggy held every night in her large house on Beekman Place. There she formed friendships with other émigré artists, among them Piet Mondrian, Marcel Duchamp, and André Breton. By the time she took Steinberg to meet them, "all these male artists were calling me 'one of us.'" She made the mistake of taking him to the kind of party he detested, one of Peggy's bashes, where at least "four hundred to five hundred people, all the European intelligentsia, wandered through the house during the night." Saul went with her to several more before he refused to go again. He disliked the large drunken crowds and particularly the French refugees, who he thought had no interest in anything American and were only in the United States until the war was safely over and they could go back to France. He, who had no real sense of himself as belonging to any *patria*, found that "back home for me is not very clear [because] I have many backhomes." He was keen to understand his adopted country, particularly now that he was about to fight and perhaps die for it.

AS SAUL'S RUSH TO TIE UP loose ends before leaving New York intensified, Hedda played an increasingly important role in his life. Remembering Saul at that time, she reflected that he always required someone to look after him, and "there was always someone, always lots of people who took care of Saul, helped him out, made things easy for him." She listed all those in Italy who

had helped him escape, all the Romanian refugees in Santo Domingo whom he had known from childhood and who made him part of their families, all the relatives who pooled their money and influence to get him to New York, and all the professional contacts who kept him out of the army infantry and saw to it that he was a commissioned naval officer in the fortunate position of being able to continue to practice his civilian profession while serving in the military. She was impatient whenever she listed this huge collection of people who loved and cared for Saul only to have him reject it and insist that he had no one to catch him when he fell through the cracks, as he was sure he would do at any given moment. He became angry when Hedda passed this off as his "Jewish fatalism, Romanian superstition," and he refused to accept her rational dismissal of feelings that were deeply imbued in him.

He needed someone to provide a buffer and support, and he decided that Hedda was the one to do it. He reflected upon his relationship with Ada, who had done all sorts of favors and services for him despite her mysterious comings and goings, especially in helping him to leave Italy, but he insisted that she had never been "truly there" in the sense of devoting her life to fulfilling his needs and wants. Saul believed that Hedda could do this, and that her most important quality was to make him feel solidly grounded for the first time in his life. It was something she found both puzzling and amusing for the rest of hers.

"I was always overly protected," Hedda remembered. "Someone always took care of me. I never did a tax return, paid a bill. I suppose I was able to take care of Saul because Fred [Fritz Stern] Stafford took care of me." The security that her marriage to Fritz provided allowed her to keep "Saul's neurotic needs" in perspective, but more important, permitted her to keep an emotional distance from him and from them: "When he was in the navy and before we were married, there were no promises between us. I was still married. We were not engaged. And I had a big affair while he was away."

Despite Hedda's extremely independent lifestyle, which she never tried to modulate or hide, Saul convinced himself that she was as besotted with him as he was with her and that she would give up her independence in a minute to take care of him. Without asking, he put her in charge of everything he wanted or needed, from shopping trips to buy more India ink and drawing tablets to preparing herself to take over all his dealings with Victor Civita and various magazine publishers. There was also a new possibility in the works when the publisher Duell, Sloan and Pearce wanted to collect all Steinberg's drawings and cartoons for a book because of the success it had just had in publishing a work by another *New Yorker* cartoonist, William Steig's *The Lonely Ones*. Steinberg had never heard of the publisher, but in early March he told Civita

to proceed with negotiations but to confer with Hedda in every instance. He prepared to leave for Washington, thinking that the contract would be settled before he finished Officer Candidate School and pleased that everything was in Hedda's capable hands. This led to their first major quarrel, during which they sat in silence over cocktails at the Beekman Tower Terrace on a dreary Sunday afternoon. She objected to the way he was using her, and he agreed that she was right to blame him, but as usual he had an excuse: it was the beginning of springtime and he was always unhappy at that time of year, and besides, he "was leaving and didn't know how to take it, things were happening too fast."

IN WASHINGTON, HE DID NOT GO through OCS as he had expected, because the length of time it would take for "such training would hamper and restrict the war effort." He remained as uninformed about and unfamiliar with naval practices and procedures as he was in New York when he had to ask the sailor to teach him to salute. He was assigned instead to a "specialized billet" at the Interior Control Board, where he was supposed to use his "specialized skill or knowledge" to "prepare equipment needed for artwork on psychological warfare." He was billeted in a hotel apartment, where the other residents were as closemouthed as he was about what they were doing, so he made no friends and was often lonely. Every day he reported for duty at Morale Operations, much as if he were going to work in a nine-to-five civilian business office. His training consisted of learning about different kinds of propaganda and different kinds and qualities of paper and ink, and listening to general lectures on the psychology of the native populations and occupying armies in the different theaters of war. Mostly he learned about the kinds of printing facilities he could expect to find, supply links for products he needed, and how his group was to communicate and cooperate with other MO facilities.

Much of the time he spent sitting in the corridor outside the office of Kay Halle, who worked in Morale Operations and thought Donovan must have forgotten all about Steinberg moments after he recruited him. "What are you doing?" she asked him one day. "Nothing," he replied, so she put him to work creating cartoons that were subsequently distributed in Germany and Italy. When he drew a uniformed Nazi, it was with the head of an animal with a pointed snout and lizardlike tongue, and his Japanese soldier's head was a crocodile with vicious teeth who wore a baseball cap and little round eyeglasses. It was one of his earliest drawings of what became a totemic animal.

On weekends he took the train to New York, passing the time by reading magazines and making his own drawings on top of articles and pictures in *Life*, *Time*, or the *Saturday Evening Post*, his favorite because of its many illustra-

tions. Sometimes Hedda went to Washington to spend a week. During the day, while he went to the office, she went to museums or spent rainy afternoons tucked up in bed drawing or reading. When he came home, there was always "scotch & wine & apple pie," foods he remembered while he was overseas and which for the rest of his life always made him think of her.

The spring passed pleasantly enough, and the work he was doing made the war seem far away and distant. One of his most enjoyable assignments was illustrating a pamphlet the OSS distributed to all new recruits. The pamphlet covered everything from how candidates were chosen to what they should take with them to foreign lands, how they should expect to live while there, and, most of all, how they should keep their mouths shut about the work they did and where they did it. Steinberg created an homage to Hedda with his illustrations. For the first one, "You Are Chosen," he drew easily recognizable cartoons of the two of them preparing to throw objects at maps of Germany and Japan, he a book titled *Background and Research* and she a larger-than-life fountain pen with a wickedly sharp point. Under "Packing and Shipping," he has them up to their necks in boxes festooned with shipping labels, and under "Learning to Live with Next to Nothing," he drew their heads emerging from thimbles.

Saul thought of Hedda always, and it gave him pleasure to insert something of her into his work. Having her in his life, the routine of his weekday work, and the weekend train trips back to his old life in New York all lulled him into a false sense of complacency. If this was war, it was not so bad. Thus on April 18, he was completely unprepared for the change-of-duty orders that fatally disrupted his easy life. He was given eight days to prepare to fly to San Francisco, where he would board a ship that would not be identified until the proper time came for him to depart for the long, roundabout journey to China.

The pamphlet he illustrated with drawings of him and Hedda took on fresh new meaning, not just to remind him of her but also to help him get through the bureaucratic rigmarole that was about to begin. The pamphlet advised:

> *Let this be your stock answer to any leading questions:*
> *I haven't any idea where I will be stationed.*
> *I am going to be doing some background and research work for the*
> *war effort. I understand, but I don't know anything about the details.*
> *I haven't the faintest idea where I am going.*

MY HAND IS ITCHING FOR DRAWINGS

Lt. Steinberg states that MO personnel were completely misunderstood and misemployed by commanding officers who could see no direct use for their work. Therefore they were assigned all sorts of tasks for which they were not particularly suited, and in fact some of the Colonels seemed to think that Lt. Steinberg's function was merely to draw dirty pictures which they could put up in the villas.

Steinberg flew to San Francisco on May 1, 1943, and reported directly to the Twelfth Naval District headquarters, where he was told that the Dutch ocean liner *Nieuw Amsterdam*, commandeered as a troop ship, was leaving the next day and he would be one of the seven thousand men on it. He thought himself fortunate to share a cabin with only five roommates, especially during the first few days, when he was felled by "a very unromantic sickness." The *Nieuw Amsterdam* was big and slow and lumbered across the equator twice without encountering the enemy. Some of the officers passed the time by creating a shipboard newspaper, for which Steinberg drew the "funnies on Sundays." They stopped in Wellington, New Zealand, long enough to parade "with music and people cheering and old ladies crying" and then did the same in Perth and Freemantle, Western Australia. By the time Steinberg left the ship on June 4 at Colombo, Ceylon, he had lost all his money playing cards and gambling. He partied there for several days and thought it was a paradise compared to his next stop, Calcutta, India, which he reached on June 11 after five days on a small and dirty train; he was distressed by the poverty and filth he saw at first hand. By the eighteenth he was moving from one base to another toward his eventual destination, Chungking, but he was still in India on the twenty-ninth. He compared being stuck there to being in a doctor's waiting room, passing the time reading old, bedraggled magazines and hoping his turn would soon come.

Ostensibly he was to show other MO divisions how to set up and operate printing equipment, but in reality he did next to nothing because equipment was either hard to come by or lacking, and no one seemed to have any clear

idea of what MO officers were expected to do even if the presses were up and running. The weather was hotter and more humid than in Santo Domingo, and left him too enervated to pass the time by making his own drawings. He thought Calcutta was "not a good place to live in, really too hot and too many people around." He did have a private room in the officers' quarters, but a continuous procession of cleaners, barbers, and salesmen invaded it, clamoring for attention, and there was no respite when he left because more vendors besieged him. In haste to elude them, he often stumbled and fell over sleeping bodies on the street. He did get to see several temples and was intrigued by the many monkeys and the overwhelming number of sacred cows, all of which he drew.

A monthlong circuitous train journey finally ended at the air base in Chabua, north Assam, when he boarded a cargo plane on July 16 for the three-hour flight over the Hump to Kunming, China, not minding the extreme cold because of the clear sight of the Himalayas. He went directly to his base camp on the northeastern outskirts of Chungking, dubbed "Happy Valley" by those stationed there. It took him four days to adjust to the heat, which sometimes reached 106 degrees and left him "perspiring like a waterfall" and gobbling salt pills and vitamins as if they were candy.

Happy Valley was a small village surrounded by even smaller ones clinging to the hillsides that cradled it. All about the place there was "heat, dirt, discomfort, and discouragement," but he liked China better than the "chic and comfort" of Calcutta.

He was billeted in quarters that were more like Chinese houses than navy barracks. The furniture was primitive, but food was plentiful, even though there were only chopsticks with which to eat it. Water had to be boiled and drunk when still hot and tasted "like the rice paddy from which it comes." Not surprisingly, all the sailors were felled from time to time by "the extraordinary Chinese diarrhea, a national malady that is cured with a medicine called 'the cement.'" Malaria was rampant, and the mosquitoes were "like dive bombers asking for blood." He was glad that he brought the extra netting Hedda had insisted on, even though the navy routinely equipped every bed with it. He was also grateful for her many gifts, for he would have been lost without the big black portfolio for

Steinberg in China at his first wartime duty station.

drawings and the mirrored shaving kit that enabled him to be the only officer with a decent shave.

He was among "some very nice fellows" who were billeted two or three to a room, and he drew his for Hedda, showing the mosquito netting enclosing the bed he had learned to make with navy-style square corners. He drew his desk, which held his framed photo of her and some of the decorative ivories and other small objects he had begun to buy on trips into town. One afternoon his roommate returned after an hour away and was surprised to find that Steinberg had covered one full wall with a mural of Manhattan featuring "a table, two chairs, a bottle of whiskey and two glasses, [positioned] near a window which looked down upon Times Square." He also drew his commanding officer as he walked back to his quarters from the shower hut in his underwear, returning the salute of a Chinese soldier in full uniform. He made many more drawings of his fellow officers, but the one they liked best and remembered more than forty years later showed them relaxing in deck chairs all in a row, with their feet on the porch railing in front of them. They all stared off into the distance at the hillside villages with undulating rice paddies above and below them, while the little English bulldog one of them brought from Australia snored contentedly on the floor behind them. There was even a library of sorts, where Steinberg found and reread one of his favorites, Voltaire's *Candide*. He told Hedda he had everything he desired but her and something he wanted even more: cold water.

The rainy season started in August, but the heat continued. His commanding officer gave him permission to make drawings for any New York publication that wanted them, but between the heat and the lack of letters from Hedda, who did not write every day as he did (sometimes several times), he was despondent. His main concern was that he had nothing suitable for the magazine that meant the most to him, *The New Yorker*, because he refused to submit anything but his very best to its editors. He had to be in "a special mood" to draw for them, and inspiration was sorely lacking in his little village, permeated as it was by the stench of human waste, with which the peasants fertilized every inch of cultivated soil. He thought there was nothing he could draw in such a place, where "the atmosphere is quite different from anything sophisticated or anyway respectable the way *The New Yorker* is."

In actuality, his impressions of daily GI life in China turned out to be the first of a series of highly successful drawing-essays he sent to the magazine from his various postings, which totaled sixty-nine drawings filling twenty pages throughout 1944 and 1945. Many were originally drawn as illustrations for naval information and propaganda pamphlets, and all of them were so suc-

cessful that both his supervising officers and the censors agreed they could do the second and equally important job of lifting the morale of the folks back home by showing their GIs' daily life. Not only did they help boost the magazine's sales, they also helped to solidify Steinberg's reputation.

Steinberg's work in China, like everything else about his military service, was far from ordinary or routine. Despite Wild Bill Donovan's insistence that he was needed by the OSS, the navy assigned him to the Sino-American Cooperative Organization, affectionately dubbed by those who served in it as "the Rice Paddy Navy." Intelligence-gathering had not yet coalesced into the unified entity it became under the CIA, and each of the services had its own official spying apparatus. The Chief of Naval Operations recognized the need for such a group in China shortly after the attack on Pearl Harbor and ordered the formation of the top-secret Naval Group China. Its mission was to gather intelligence about the weather and transmit it to air bases and ships patrolling the coastal waters, to infiltrate behind Japanese lines and monitor all activity on shore and at sea, and to prepare information that would be useful for an Allied invasion. Within SACO, Steinberg was attached to a sabotage training center where his official title was "psychological warfare artist," and his work was deliberately described vaguely: "to prepare background for future PW [psychological warfare] operations in China."

The officer in charge was Commander (later Rear Admiral) Milton E. Miles, an old China hand (as officers who had served in the Far East before the war were called). Miles was a graduate of the Naval Academy, where his fellow midshipmen gave him the affectionate nickname Mary after the movie star Mary Miles, and it stuck. He ran his command at Happy Valley on an informal first-name basis, which was awkward for the somewhat puzzled Saul, who stuttered at calling him Mary and whose only prior knowledge of anything military was the pomp and circumstance of his grandfather's uniform shop in Buzău. Mary Miles ran a military camp that operated on very unmilitary principles: there were no ceremonial flag raisings or bugles playing reveille or taps, the men did not salute, and the uniforms were whatever the men found handy. Surprisingly, it worked.

At the inception of his China command, Mary Miles was the official coordinator of the OSS in the Far East as well as the founder of SACO. His counterpart was the shadowy General Tai Li, "one of China's most mysterious, most respected and most dreaded men." Tai Li commanded the Chinese version of the OSS in Chiang Kai-shek's Nationalist Army, and he and Miles forged such a deep personal friendship that they sometimes merged their soldiers and sailors for the infiltration and sabotage of enemy encampments. Miles was a fervent

supporter of Chiang Kai-shek and an adversary of General Joseph "Vinegar Joe" Stilwell, the commander of the China-Burma-India theater (CBI), who was not. Eventually, long after Steinberg had been transferred to other duty stations, Miles was effectively marginalized by Donovan, Stilwell, and others in various commands as they enfolded some of SACO's operations into their own intelligence groups and shut down the rest entirely.

However, during the brief time Steinberg served under Miles's command, one of his major tasks was to assess whatever information the front-line spies gave him and, along with the rest of his psychological warfare cohorts, to prepare everything from leaflets that were dropped behind enemy lines to brochures that instructed both American and Chinese soldiers in how to engage with the maximum respect for each other's culture. He also drew derogatory cartoons of Japanese leaders that were dropped from planes or that showed up mysteriously in cities and towns deep in enemy-held territory. One of his most important assignments was to analyze data gathered by agents and draw precise maps of the South China coast that would guide downed airmen to safe passage outside Japanese-held territories. His work required precision and discipline and was often top secret, but there was another part that was strictly fun.

A group such as SACO needed something visual to tie its disparate divisions and individual members together, and as Miles rejected Tai Li's offer to bring in "politically checked [that is, disease-free] women," insignias, pennants, flags, and emblems had to suffice. Steinberg contributed one of the best known and loved when he drew a poster that also became a sleeve patch. It showed one of his long-nosed cartoon characters, a flat-footed, heavyset man wearing a pith helmet and Lone Ranger mask, outfitted in a coolie uniform, carrying every weapon from a hatchet to a handgun and about to insert chopsticks into his open mouth. He is surrounded by a tent made of mosquito netting with anchors extending out on either side and a rakish American eagle, also wearing a Lone Ranger mask and a pith helmet, upon which two tiny birds perch. Two banners stream down from the eagle, one saying "What the hell" and the other "E pluribus per diem." A third banner at the bottom of the drawing completes it, this one saying "Confidential."

Miles considered Steinberg a valued member of his team and wanted to keep him in China, but the OSS still wanted him and finally succeeded in having him transferred in December 1943. His official orders detailed a journey that would eventually deposit him in Algiers, Algeria, on "temporary duty." It would start as soon as he reported to the area's chief army OSS officer in China, who would issue orders instructing him to return to Calcutta. The orders were

confusing, not only because they were issued by the army rather than the navy, but also because once the temporary duty in Algeria ended, he was to receive a new set that would send him back to his official posting with SACO in Happy Valley.

On December 8 he told Hedda that the "news" he had hinted about in previous letters was finally happening, for, apropos of nothing definite, he had convinced himself that Algiers was only a way station and his eventual destination would be Rome. The night before he was to leave Happy Valley, he was deeply touched by the farewell party his fellow officers gave him, especially when one of them opened a bottle of scotch he had been saving for six months. He was sorry to leave his friends but eager to start for where he hoped to end up—Europe—and he chafed at one delay after another as he experienced firsthand the military complaint "Hurry up and wait." There was no transportation available until December 19, and he had nothing to do until then.

THIS TIME THE FLIGHT OVER THE Hump encountered "some excitement with [Japanese] Zeros" before the plane landed safely in Chabua, Assam. Steinberg left for Agra on December 23 en route to Karachi, where he stayed until December 26. On Christmas day he was in a navy liaison house, "very chic and formal" and a bewildering contrast to Happy Valley's informality. Unused to the spit and polish of dress uniforms and silver flatware at table, he drank so much of the local Manhattan cocktail that he was sick for two days. On the twenty-seventh he boarded another plane, which made several stops in India and Africa before dropping him at Khartoum, Sudan, where he stayed until the twenty-ninth. He was in Cairo on New Year's Day 1944, still in transit and miserable at having to sleep in a barracks with fifty other men. He tried to see the places Hedda had seen on a trip with her mother and brother before the war, but Egypt filled him with a curiously different sensation, and he described himself as akin to a horse that senses his stable is near and wants to get there. The smells reminded him of Romania and the Levant but mostly reminded him of Italy, the place he still thought of as his real home, and of how close he was to it, and yet so far away.

HE ARRIVED AT WHAT WAS SUPPOSED to be his final destination, Algiers, on January 2, but for the next four days he had to fly from one unnamed place to another, which he described with deliberate vagueness as "somewhere in West North Africa." He was assigned to a "curious outfit" that left him feeling "kind of lost and sad," and in each place the local Morale Operations unit put him to work setting up printing presses and doing other mechanical work for

which he had no prior experience and no aptitude. There was so little work that he feared he would be sent back to China. Also, he was the only naval officer in an army unit, which was strange in itself and made even stranger because, after the informality of Happy Valley, he had "to be now all the time well dressed, regulation uniform and so on." His army colleagues remembered him fifty years later because he was the only naval officer among them, but they also remembered how private he was, and how "taciturn." He was even more noticeable because all his luggage was lost somewhere in China and he had to wear his only uniform every day, which made keeping it clean and pressed difficult. His erratic wanderings never took him to a naval base where he could buy new uniforms, and because it was cold, he had to borrow a non-regulation army overcoat. He grew tired of having to explain to superior officers why he was out of uniform.

At work, he had problems with a number of high-ranking officers who had no understanding of the local culture. The OSS often sent out officers who were native-born Americans from the business world and who spoke only English, so these men handled agents as if they were managing a sales force. Most of the agents were like Steinberg, transplanted Europeans who were fluent in several languages and cultures, so they simply ignored their bosses and did what they thought needed doing. Steinberg, for example, was enlisted to make cartoons that were "dropped in millions of copies over the occupied territories."

But he still had too much time to pass, so he drew a letter in the form of a newspaper for Hedda, listing himself as "publisher, editor, and lover of Hedda." Once again her letters had not caught up with him, so he filled the paper with his news: his uncle Harry Steinberg had received a letter from Saul's sister, Lica, via the Red Cross, and she was now married and living on a street he did not remember; the barber had shaved off his mustache and he was lost without it; he was smoking between forty and fifty cigarettes a day; most of all, he wanted to go home and get married. Preparing this newsletter was such a happy diversion that he planned another one to be illustrated by "the famous Ensign," which was to be "The Anniversary Issue!" because it would soon be the first Sunday in February 1944, one year to the day since he had met Hedda. He ended by begging her to marry him: "Heddina, a no from you will kill me. Please say yes and be my wife. I need you and it'll be good for you. Send me a telegram with a yes, a kiss for you, I love you a lot." Several days later, he was "happy happy happy" because she sent a telegram in which she did say yes. "God bless you for that," he replied, adding several gushing paragraphs to tell her again and again just how happy she made him.

———

HEDDA'S ACCEPTANCE OF HIS PROPOSAL WAS the only settled thing in his life. The good cheer he had worked hard to convey in every letter to her dissipated in an explosion of negativity on January 24. He was "sick of being attached to the Army," tired of flying all over Northwest Africa and having little to do, of the navy sending him to temporary duty with the army and the army sending him right back to the navy. By Valentine's Day, he concluded that "this war is a war of pants sometimes, pants destroyed by sitting down on hard chairs and waiting."

Finally, on February 23, 1944, the orders he had been hoping for arrived from the Allied Force Headquarters. Stamped MOST SECRET, they ordered him to proceed "on or about February 24 from this station to Naples, in order to carry out an assigned mission and upon completion of temporary duty return to proper station." He hoped that "proper station" meant Washington, because all military personnel were entitled to home leave after eighteen months of service, and his temporary duty in Naples might last long enough for him to reach the magic number. There was the fear, however, that he would be in Naples such a short time that he would be sent back to China without reconnecting with any of his Italian friends.

On February 24, after a rough flight in heavy rain, fog, and wind, he reached the southern Italian province of Calabria. "I was really scared," he admitted to Hedda. He was on special detachment to the Fifth Army Headquarters of the OSS-AAI (Allied Armies in Italy), but he was not allowed to tell her his exact location or what work he was doing. Most likely he was in Bari or Caserta, where the 2677th Regiment, to which his MO unit was attached, made its headquarters at various times before moving on to Rome. All he could say was "I'm finally here and I'm very much confused. Things have so much changed . . . poverty, confusion, I'm upset by things I've seen."

For the next month he was moving constantly from place to place and finally seeing "some of the real war." He wanted to find enough time to draw what he had seen, "the convoys, trucks, guns, tanks, rolling in a long snake line up in the mountains, all mixed with refugee vehicles and bicycles and just people in a wonderful place, towns and hills with every top of hill covered right on top by a village of small houses and in the center a baroque church with tower." But then he thought perhaps he should not draw it, because (as he tried to explain in his still imperfect English) "this sort of scenery, which is beautiful in reality but which usually turned out to be corny in a drawing, too much like cheap style, imagination."

Being in Italy was frustrating in so many ways, starting with the impossi-

bility of communicating with any of his friends in Milan. The 2677th MO was charged with installing printing presses in Naples to create and distribute propaganda throughout as much of the country as the Allies had penetrated, but the commanding officer instituted a logistical nightmare when he stubbornly insisted that the staff had to be billeted in Caserta, headquarters of the Allied Command in Europe and more than an hour's ride from Naples if the trains were running, even longer if the men had to cadge rides on roads clogged with military traffic. Steinberg and his army counterparts never knew when or where they would work from one day to the next, and the constant moving around induced another sad and unsettling experience: "In Italy, I used to be just one of them and feel at home but now because of the uniform I'm for them just another sucker, another tourist easy to fool and belonging to a strange superior class." His feelings of displacement were heightened when he listened to Radio Bucharest and felt "silly and sad. I never been in years so near to that place." Hearing his native language raised another bittersweet emotion: he was so close to his family, so eager to have news of them and even to see them, yet he was reluctant to do anything that might make his superiors think about sending him to Bucharest, even if only for temporary duty.

By mid-April 1944 he was more or less in a routine as he went back and forth between Naples, Caserta, and several other southern Italian towns. He had now been overseas for a year, and he thought it was time to take an inventory of how much he had changed. First he listed his one bad habit: he thought he smoked far too much, at least three packs a day. Then he listed what had happened to him: he had finally finished the required inoculations, which made him sick in bed for a week, and he was fascinated when he read Italian magazines to see how those he had worked for had changed or evolved in the three years since he left. He was happy to see that he still had "a few imitators" who were imitating his style of drawing from three to five years before. He sent these observations to Hedda, accompanied by some drawings made by his imitators, including one of a tiny man on a huge rearing horse.

TIME STILL HUNG HEAVY OVER HIS DAYS, and mail delays so he did not receive Hedda's letters made them heavier. He was sure the slowness of the mail was all due to "coming attractions" (that is, the D-Day invasion), so he spent most of his time shopping for things for his and Hedda's future home. He loved to shop and told Hedda proudly that he had collected a lot of "junck [sic], and you know how I like junck." He played tourist by visiting local southern Italian ruins, but the incompetent guide and the ignorant tourists depressed him. He preferred to go off by himself to buy postcards to add to the collection

he was amassing. It was lonely and frustrating to be stationed in a backwater where nothing ever happened, especially after he was put in charge: "I'm the commanding officer of this place because I'm the only officer and the only sort of fun is to play cards with the sergeants." By May 10 there had been so many last-minute changes to his orders that he "almost cried for days."

Then suddenly everything became a frenzy of activity. On May 11, 1944, an offensive began that had him moving toward Rome with one of the convoys. For five days there was "lots of excitement," including the death of one of his roommates. Then just as suddenly everything changed: troops were on the move to Rome, but Steinberg was sent back on the "dead road" to North Africa. He gave up on reaching Rome and also Bucharest, to whose radio broadcasts of lies and propaganda he had become addicted.

"I don't know what's wrong with me, but as soon as I get used to one place I have to move," he wrote from North Africa, as once again he was sent from one small town near Algiers to another. Hedda teased him that he always needed a list of things to worry about, and he admitted it was true, but now he had something genuine: he should have been promoted to lieutenant JG (junior grade) several months earlier, but he was so far from his original unit in China that no one there remembered to submit the required paperwork. He didn't care about the rank, but he wanted the salary increase, so he started the process himself, as it seemed likely he would be in North Africa for the duration of the war.

Once again he was in debilitating heat and unable to work. Algiers was a "stupid city," and he was sharing "a dark dirty room with another fellow" without even a drawing table. Even worse, he was required to spend the equivalent of business hours sitting in an office in full uniform, to take his turn as officer of the day, to supervise all administrative activity, to sleep in his uniform at night, and to be ready to assume command on the off chance of enemy action. He also had to censor the enlisted men's mail and supervise the collection and burning of confidential trash every day at five o'clock. He hated it.

D-Day, June 6, 1944, initiated several days of excitement as news of the Normandy invasion filtered down the continent to Africa, but Steinberg's morale remained low. By June 11 things had returned to the boringly normal, and he continued his daily routine, spending evenings glumly alone in his office making drawings for *The New Yorker*. His hands were "itching for drawings" as he was itching for any sort of action, no matter what kind. His uncle Harry wrote to say that he had received two telegrams from Moritz and Rosa sent via the Red Cross, and they were well. It was the first news Steinberg had had of his family for over a year. His birthday was June 15, but having ruined

his stomach on Spam and army rations, he could only watch as his army colleagues drank the whiskey he bought for them at the navy exchange. Now his unit was working around the clock and he was "running around and busy as hell, extremely unusual for me." By the end of the month, his unit was on the move back to Italy. Only one thing made him sad to leave Algeria: the pet baby goat they had to leave behind, in the care of "a bastard who ate him."

THIS TIME HE WAS JOINING THE push to Rome via Sicily and up the coastal roads of southern Italy, where he saw nothing but "destruction . . . an extraordinary tragic thing." He kept a small black pocket notebook in which he drew "frightened villages." He saw "entire cities completely forever destroyed where people still wandered looking for things and living in what little is left out of the walls, bewildered and hungry." One of the "most pitiful" sights was burning palm trees; one of the most tragic was tailor-made for his ironic sensibility: a German tank that exploded after colliding with a monument of "the usual horseback Garibaldi or somebody you'll always find in the piazza of an Italian town."

By mid-June the paperwork for his promotion was complete and he became a lieutenant JG. He bought the gold braid and had it sewn onto the

Saul Steinberg, *Cassino,* 1945.

summer uniforms he had finally managed to buy, only to find that the navy had changed them from khaki to blue-gray and once again he was out of uniform. By July 22 he had been moving around in such confusion that he had not had time to unpack the small amount of baggage he had carried from Algeria in early June. He compared his morale to his dirty laundry, "accumulated for days and days, and I buy new shirts instead of washing the old ones." He was billeted in a series of elegant houses that had formerly belonged to high-ranking Fascist followers of Mussolini, all of whom were now on the run. Local people had looted the places, but he managed to sleep in "fancy beds in fancy houses" without running water or electricity, where he wrote or drew by candlelight.

Because he could keep clean and had enough to eat, he felt guilty: his life was so comfortable compared to that of the "hungry population who don't realize they've lost the war." After so many years of identifying himself with Italy and all things Italian, he now observed the local population from an American perspective and thought he had made a big mistake by angling so hard to return there: "I'm very much disgusted about the whole business, the atmosphere of little misery and intrigue and other European tricks I forgot about in the last three years. Now I see it again with new eyes and I'm very much homesick for the big generous America."

If he saw nothing but the ugly side of things in Naples, Rome was far worse. Quite by accident he ran into some "so-called" friends he had known there and in Milan. After the first "enthusiastics and cheerings," he found them like "ghosts and shadows" who were difficult to talk to: "I changed in many ways or rather I think I found myself better in the past 4–5 years." When friends who remembered his drawings from the 1930s said they were surprised to see how much his style had changed, he was glad, "because I always suspected my old drawings of being just silly (and they indeed used to be enjoyed by silly or snobs)."

One old friend he met by happenstance was the journalist Mikhail Kamenetzki, who had taken the name Ugo Stille after he endured many of the same tribulations as Steinberg during his quest to immigrate to the United States. Stille was working for *Corriere della Sera* and wanted to write an article about Steinberg for the newspaper, but nothing came of it. Steinberg was unable to reestablish contact with Aldo or get news of him and Ada until after the war ended, but he did meet several other friends from the Politecnico who were in Rome. Steinberg's uniform made Alberto Lattuada uneasy, so their meeting was strained and uncomfortable. It was even more awkward with two of his *Bertoldo* friends, Mario Ortensi and Mario Brancacci. After that, he stopped

seeking out Italian friends and, unless they sought him out, limited his socializing to American colleagues.

HE BEGAN TO DROP CLUES TO Hedda about what he had done and where he wanted to go that he hoped would pass the censors. He wrote that he hoped to see his father on his father's birthday, July 15, a hint that he was angling for a furlough to Bucharest. He said that when he looked at magazine photos of Italian women in bathing suits, his "Sicilian heart" was jealous not to be at the beach with them, a way of letting her know that he had been in Sicily and was on the move again. His next letter was more straightforward, as he said that he was sick and tired of moving constantly and was "again in a bad place, hot and flies and uncomfortable, I'm dirty and my eyes burn." That meant Algiers. To let her know when he was back in Rome, he described himself as one of the sloppiest naval officers "in a neighborhood where regulations and etiquette dominated, as was usual with outfits far from the front lines."

Two things were uppermost in his mind: returning to the United States, and having a furlough in Bucharest. By mid-August 1944, because of "the exciting news about landings all over the place," he was so sure that his orders to go home were on their way that he told Hedda he would not write as often because he would soon be with her in person. He was shocked and dismayed when his orders came and instead of going to Washington, he was assigned for "two weeks or less" to temporary duty in Toulon, France, where his assignment was to deliver "certain classified materials" to the OSS regiment somewhere in Provence. His selection as a courier was nothing out of the ordinary, for some of the most important information that guided sabotage operations and propaganda campaigns on the French Riviera originated in OSS field offices in Caserta and Algiers and was then funneled into France by whoever was available to carry it. Steinberg was probably chosen because he had previously made a number of similar trips between Italy and North Africa. However, the Toulon assignment was dangerous, because it came just after the Allied invasion of southern France, when the country appeared poised for civil war between Resistance fighters and collaborators. For someone who had not seen actual combat, it was particularly nerve-racking, and he was glad when it was over and he was once again back in Italy.

ON AUGUST 23, 1944, KING MICHAEL of Romania staged a royal coup, dismissing the military commander, Ion Antonescu, withdrawing his country's allegiance to Germany, and capitulating to the Allies. In early September, Steinberg learned that an American plane was being sent to Bucharest to

recover two important prisoners of war and that he could be on it. His orders were to fly from Rome to Bari and then on to "such other points in Italy as may be directed" before landing in Bucharest. By mid-September he was back in the homeland he had previously wanted to be free of forever.

Bucharest had been hit hard by bombings once Allied planes stopped targeting the Ploesti oil fields, and Steinberg found devastation everywhere. He knew that his parents were still living on the street where the workshop was, Rahova Road, and he decided to go there first, even though Lica was the person he most wanted to see. He knew she had been married in April 1942 and was living with her husband, Ilie "Rica" Roman, in a neighborhood whose name Steinberg neither recognized nor remembered.

Before he left Italy, he raided the PX for everything he could take to his family, from canned rations to candy bars, but once he got there, the visit was traumatic. During the war, he did not write of it to Hedda, who was the only person to whom he confided his innermost thoughts. After the war, when he resumed contact with Aldo Buzzi, he merely said that he had managed to get to Bucharest and found it unchanged. The only time he described in detail what he saw in 1944 came fifty years later, during a reunion in Israel with his old high school friend Eugene Campus.

He told Campus that when he got out of the jeep that took him to his parents' house, he was shocked to see how it and all the others on the street looked abandoned and were boarded up. As he stood there gazing up and down the bomb-damaged street, a curious child who had never seen a navy uniform began to wave American flags and dance around him and then around the jeep. Steinberg asked in Romanian what had become of his family and all the neighbors. The child told him everyone still lived there, but they had all gone to the synagogue because it was Yom Kippur. Steinberg surprised his parents when they returned from the services, but the visit was disturbing and he left as soon as he could get away. With the jeep outside and all the PX loot dumped on the table, he felt like a "caricature of Prince Charming returning home on his fiery steed, he's incapable of performing any miracles. He can't even justly punish the criminals."

If photos are any indication, the reunion was far from joyous. Steinberg is in uniform, his face serious to the point of being grim. He stands next to his parents, who are seated at what appears to be a kitchen table, and they appear to be uneasy, regarding him warily, as if he were a stranger who dropped down from an unknown world and whose language they can neither speak nor understand. This visit marked the only time he had returned to Romania since he spent his summer vacation there in 1937. From then on, the Romania of his

Steinberg on his last visit to his family in Bucharest: his parents, his sister, and her husband, Ilie Roman.

youth became "a closed chapter" he never wanted to open. He was "afraid [of having] a brutally emotional response to the old childhood places" where he had "suffered . . . felt miserable and humiliated . . . Like in a prison." In his old age, he reminisced about the "disasters of a visit to the tribe" and wondered why, ever since childhood, he had always "looked for ways to escape and avoid families." In his last decade he often revisited the facts and events of his life in Romania, but only long enough to use his hand to transpose some of them into art.

AFTER THE LIBERATION OF ROME ON June 4, 1944, Steinberg's unit, the 2677th MO, was among the first to enter the city and set up operations. By his June 15 birthday, a printing plant had been commandeered, and the work Steinberg did from then on was probably the most sustained and valuable contribution he made toward helping to win the war. The MO unit was a team of twenty-two men and one woman who were "straight out of [journalism's] Central Casting." Among them were Eugene Warner, who directed the operations; Norman Newhouse, of the newspaper publishing family (and later the owners of *The New Yorker*); William T. Dewart, Jr., the publisher of the original *New York Sun* newspaper; Temple Fielding, the travel writer whose guidebooks created his financial empire; and, most important of all, a forty-five-year-old cor-

poral from Chicago, Egidio Clemente, an Italian-American printer in civilian life who kept the presses up and running. The only woman was a Czech-born American WAC, Barbara Lauwers (later Podoski), who was fluent in German and several central European languages.

The unit worked out of a safe house where the staff gathered daily for brainstorming sessions, during which they thought up hilariously funny projects that were seldom executed and others that were deadly serious and resulted in significant successes in ending the fighting and reaching the civilian population. The MO unit conceived a newspaper called *Das Neue Deutschland*, which was allegedly printed and distributed in Germany by anti-Nazi resistance groups united under the auspices of a fake peace party supposedly operating inside the country, but actually originated in Rome. The deception succeeded so well that Heinrich Himmler went to great lengths to see that the paper was exposed and denounced as an OSS ploy. To create it, the staff had to find paper and typefaces of a quality that would have been used within Germany, no small feat in war-ravaged Italy. They had to depend on agents planted in Germany to get the newsprint to Rome, so publication was sporadic. There was no problem finding native German-speakers to write the articles, because one of the main tasks of the three colleagues who had spoken the language since birth was to interrogate German prisoners of war and determine which could be persuaded to assist the Allies. In many of the MO brainstorming sessions, Steinberg's colleagues who spoke German were struck by his replies: despite his fluency in the language, he always replied in Yiddish.

Steinberg's drawings filled each issue of *Das Neue Deutschland*, and here again, since the goal was to make people read the paper rather than avoid it for fear of Nazi reprisals if they were caught with it, his cartoons were more whimsical and laugh-provoking than frightening or off-putting. His Hitler was befuddled, his face a sort of figure eight with a long nose, drooping mustache, and downturned mouth. To poke fun at the Volkssturm, the home defense army composed of those either too old or too young to fight in battle, Steinberg resurrected the Zia Elena figures from his *Bertoldo* days, this time as two fat German housewives on roller skates, wearing Nazi armbands and wielding brooms and umbrellas instead of guns.

Much of what Steinberg drew was distributed widely within Germany as well as Italy. One of his more imaginative creations was rolls of toilet paper that bore the visage of a downcast Hitler and the instruction to use it "this side up." He created the "entwined heart" button that decorated the propaganda folder of a fictitious "League of Lonely War Women." The folders were dropped behind German lines and urged soldiers to wear the button when home on

leave, as it would attract hordes of women eager to provide sex beyond their wildest dreams. The subterfuge was so credible that it even fooled the *Washington Post*.

In his work, Steinberg was able to indulge in one of his lifelong passions: postcards. He created both pictures and messages that were supposedly written by members of the German underground as well as ordinary citizens, all urging the population to rise up and overthrow the Nazi tyrants. The postcards provided some of his earliest practice at the different kinds of handwriting that filled so many of his drawings after the war, particularly the fake diplomas that he created for friends. He also created official-looking rubber stamps and certificates for the postcards, and they too prefigured many of his later ones. Some of the postcards were comic, such as the ones where little men shot bows and arrows at Allied planes from sagging hot-air balloons that bore the inscription "Luftwaffe." When MO created a phony German "League of War Mothers," whose members were allegedly urging their sons to surrender to the Allies, Steinberg's postcard showed dejected and embattled soldiers under the heading "Our Sons in Foreign Lands."

The MO used an ingenious distribution method to get the postcards into Germany, loading them into official mail sacks that had been stolen by operatives and smuggled into Italy. Air force planes then dropped the filled sacks of phony mail onto trains during bombing and strafing raids, and once the raids were over, railroad personnel unknowingly unloaded them along with the genuine mail. Here again, official German newspapers and radio stations had to warn citizens to beware of American fakes.

Most of the MO staff called Steinberg their official art director because of the variety of his work. When Edward Lindner wrote a song along the lines of Kurt Weill's "Wie lange noch?" (How Much Longer?), Steinberg created the cover illustration for the sheet music, which was printed as a lithograph and became a popular sensation when distributed behind enemy lines. And when Barbara Lauwers learned that several hundred Czech and Slovak soldiers had been conscripted into the German army, she created the text for a small white folder that Steinberg designed, inviting the soldiers to cross over to the Allied side, waving the folder as they came. More than six hundred soldiers did as the folder directed, and Lauwers won the Bronze Star for it.

For all of these projects in 1944, Steinberg drew his creations on shoddy paper that came from Germany, paper so scarce that much of what he used was the blank back side of official military forms. He did MO work on the blank side, but he also embellished and embroidered the official side with his own fanciful creations, all of which showed the new turn his work had taken since

he joined the 2677th MO: he had completely stopped drawing with pencil and now used only pen and India ink. There was a crisis when he lost the fountain pen Hedda had given him, which he had carried everywhere from China to Italy, but she sent a variety of others to replace it, and he liked and used them all.

Around this time, he began to decorate his letters to her with some of the rubber stamps that became one of his favorite postwar devices, among them the fingerprint and the pointing finger with various admonitions ("rush," "secret," "confidential," etc.). After the war he took delight in telling the apocryphal tale of how he used the pointing finger marked "secret" to identify his underwear when he lost the laundry marker that bore his name: "Then, when I was suddenly assigned home . . . I got all my laundry except the underwear marked *Secret*. I kept imagining this long grey underwear . . . wrapped up in a safe somewhere and guarded by MPs." It made a whimsical story that he liked to tell to distract overzealous reporters who wanted to hear about his wartime adventures, but it wasn't true.

STEINBERG HAD SEEN MANY THINGS IN wartime that raised conflicting emotions, and he often could not decide whether to try to forget them or to immortalize them through drawing. One event that came to the forefront of his memory every time it rained was of a group execution he had witnessed in Kunming. Nine Chinese men on their way to be shot for theft were marched in a line with a rope around their necks tying them to each other, all of them goaded and prodded by Chinese soldiers holding rifles. Incongruously, the prisoners were allowed to carry umbrellas to protect them from the rain. Five of the nine were "real robbers," but the other four were paid replacements for the actual thieves: "This is a law in Yunan province. A man condemned to jail or death can buy a poor man to die in his place. The poor man has reasons, he has a farm to buy for his family, or wants to improve life conditions for his father, so he cashes the money and goes to die happy. Life doesn't mean much anyway."

In Italy, Steinberg saw a convoy of German prisoners, "just kids 16, 17 years old and as a group they don't look at all like superior beings." He, who had only experienced air raids or listened to the stories of soldiers returning from the front about the violence of battle, wondered how he could convey what they had experienced to a civilian population that had no comprehension of total destruction and annihilation. In the cities he saw crowds of many nationalities who had supported the Axis cause—all of whom were suddenly in crisp American uniforms bought on the black market and professing fidelity to the Allies. Even though he could appreciate the desire for survival at any

cost, the cynicism of the turncoats was deeply upsetting. All the adult Italians he talked to were depressed; their only ambition was to get to America, and nobody wanted to stay and rebuild the country. He feared there would be a violent internal struggle once peace was declared, and indeed there was. When the Psychological Warfare Branch enlisted his services as an interpreter, he was dismayed by the attitude of a handsome and healthy boy of nineteen who told him that England and America had started the war and Mussolini was a great man who was betrayed by the traitors around him. Democracy may be all right in America, the boy said, but Italy needed order and somebody to give the orders. Steinberg feared that the Italy he knew and loved was lost forever.

After the war, Steinberg wanted to draw this and the other things he had witnessed in the form of visual stories. While he was stationed in China, he had devised classes in which he tried to persuade some of the sailors to draw, because "everybody should know how, every child makes drawings." The trouble with drawing, as he saw it, was that people grew up and thought they had to copy photographs, "with real proportions and prospective," and he thought this was wrong because these "grown-up drawings were just science, a trick." He would tell the sailors, "Take it easy, here's a sheet of paper and a pencil. Don't worry about reality, make it wrong, make from memory a scene that impressed you and you remember well. Make details and keep working." The sailors usually drew something about their hometown, their families, or events that had meaning for them, such as holiday parades and high school football games. Steinberg thought they were all "excellent" and "beautiful." After the war he wanted to do more along these lines, "to pick up people and give them paper pencil colors and being my guests for a week or so with the obligation to work a few hours a day for me turning out artwork."

He wanted to write about all these things as well as to draw them, but he worried that whatever form his effort took, the result would be "too simple." He poured out his emotional reactions to the war in letters to Hedda and found it "curious, how no ideas remain in my mind but only facts, only things connected with life and especially my life. My memory simply refuses to take care of general truth found now and then in people's words."

The memories of Steinberg kept by those who served with him covered a range of emotions. Barbara Lauwers remembered how much fun he was; he would sneak up behind her and put his hands on her hips, calling her by her nickname, Zuska, drawing it out in his pronunciation as "Zoooshka!" "Give me all your Tootsie Rolls for my hot date tonight," he would cajole, and of course she would. He was always ready to take her and anyone who wanted to join them to see "the real Rome, off the beaten track." Lauwers never got over his

"off-the-center vision." After the war she lived in Greenwich Village for a few years, during which she saw him fairly often. One night at dinner in an Italian restaurant, a man came to the table soliciting donations for charity. Those who gave dropped their money into the slit in an empty can of peaches. "Now how the hell did he get the peaches out?" Steinberg wanted to know. Lauwers cited it as an example of "the kind of thing he was always wondering about in Italy."

Peter Sichel was the MO financial officer, and because of his job was the recipient of much of the group's personal and privileged information. He thought Steinberg was "a strange and private man" who went out of his way to avoid telling even the most ordinary fact about himself. Sichel wondered how much of his behavior was due to Steinberg being a naval officer bewildered by being plunked down in the midst of an army unit, never mind that he was also a foreigner who had to learn all things American by instinct.

Others, such as Edward Lindner, thought that his behavior might have had something to do with his being anti-military in general. Lindner remembered how Steinberg hid under a desk when an admiral came to visit the unit so he would not have to salute him. Lindner also saw Steinberg in New York for the first few years after the war and corresponded with him in the last decade of his life. His lasting impression was that Steinberg "had a lot of *Weltschmerz*" and was "bitter about the purpose and result of the war," with "an acute sense of futility about it all." He quoted a phrase Steinberg repeated many times after the war, that "it was all for nothing. Everything we did was worth nothing." Steinberg reserved his particular bitterness for the Holocaust and how little was done to prevent or stop the murder of six million Jews. For him, everything about the war was "too little, too late."

The colleagues who retained the happiest memories of their friendship with Steinberg were the men who served with him in China, where he seems to have formed his deepest friendships and his own happiest memories. After he left China for Italy, he corresponded with most of them, nostalgic for the work of "the Miles organization," which he found as dangerous and fascinating as ever. The affection he felt for the men with whom he served in China is evident in the drawings he chose to include in his first book, *All in Line*, published the year after he returned to civilian life. Under the section titled "War," Steinberg included vignettes from each of the theaters in which he served, but only China has groups of sailors engaging in communal activities, from buying souvenirs in village stores to eating with chopsticks in a Chinese restaurant (this became his first cover for *The New Yorker*). Sailors have smiles on their faces when mail call brings them letters and they sit dejectedly when none come for them. Steinberg treats the Chinese with affectionate respect, even

Steinberg wore his Navy uniform after the war. Shown here with Tino Nivola and Aldo Bruzzichelli in Springs, New York.

those who have to carry the heavy Americans in sedan chairs. All the other wartime theaters—India, North Africa, Italy—depict scenes a tourist might see with only a solitary soldier or two, or occasionally a WAC, sitting bored and tired in front of them. In Italy he tried to draw convoys scaling hillsides in preparation for battle or village squares with their ubiquitous monuments, but these drawings are ordinary and without the wit and bite of most of his others.

STEINBERG LIKED THE NAVY AND WAS proud to be in "the society service." After the war, even though he was earning good money and could afford to buy the finest civilian clothes, when he dressed casually he continued to wear his navy-issue khaki trousers, shirts, and web belt with the brass buckle (which he kept polished). As for the army (especially the units with which he served), that was quite another matter. On November 8, 1944, several days before Steinberg received orders to return to Washington and was released by the 2677th MO, he was interviewed by an intelligence officer in the OSS. He began the interview by saying he did not think it was "fair play" to discuss the troubles he had encountered, but he did speak briefly of being assigned to tasks for which he was unsuited, including drawing "dirty pictures" that senior officers could put

up on the walls of commandeered villas. He told the interviewing officer that he found very little tangible value in the work he did as a morale officer: "SO [Special Operations] and SI [Special Intelligence] have something to show for their work, that is, you can see a bridge before and after it is blown up, and an SI man can present a current list of intelligence reports." As for MO, "there is no way of measuring the effectiveness since the work which is accomplished is done without visible or measurable results, hence, we can never tell how much MO influenced the enemy."

The interviewing officer asked how Steinberg thought MO officers should work in future times, and his reply could have been the description of how twenty-first-century terrorist cells should operate. He thought MO workers should be "extremely intelligent and crafty minded," but they should be recruited long before any war began and sent to live in the country where they would work. They should become completely integrated into the area where they are stationed, and because their work is so dangerous, there should be no communication between the operatives and their handlers: "They have their directives and they know better than the people outside do what is going on in the region where they are working . . . They know the best way they can poison the minds of the population."

AFTER THE INTERVIEW, AND AFTER MORE than a year of being attached to the army in Europe and Africa, Steinberg was on his way back to Washington and duty with the OSS Naval Command. True to his love of "junck," he shipped boxes of it back to Hedda. Besides her letters and the books and papers he had collected, he shipped a German helmet, cap, hood, cartridges, gun holster for a Colt automatic pistol, New Testament, French horn, whisk broom, several boxes of miscellaneous souvenirs, and "one book of cartoons" that would mostly go into *All in Line*. He also shipped "drawers and undershirts, wool," and like everything else, it arrived safely at Hedda's in good time.

Steinberg may have dismissed his work as unimportant, but he kept the things he brought back from the war for the rest of his life, and he used many of them in his art. He made photocopies of his dog tags and official ID card; of the fingerprint he affixed to his commission and discharge papers (on which he embellished flourishes and fake writing); bills from the hotels he stayed in, such as the Great Eastern in Calcutta, complete with flourishes and symbols; and foreign currency, particularly Chinese. Some of the elaborate engravings of steam trains, buildings, and the people on paper currency and the pagodas, flowers, and trees on coins all found their way into his drawings in years to

come, as did a faded yellow paper entitled "Chinese Lesson," with characters, phonetic pronunciation, and English translation.

He had served in three theaters of war, the Asian Pacific, European, and American, and he was authorized to wear the appropriate medals, including the Victory Medal. These too appeared in various guises in drawings throughout his long career, but after the war he put them away, never wearing them and seldom looking at them. He was in New York on a thirty-day leave at the end of November 1944 when he received a letter from Eugene Warner, the chief MO officer, who was still in Rome, expressing his great pleasure at being able to forward a commendation from General Donovan to "Each Member of the MO Branch, 2677 Regiment, OSS." Donovan praised them all for their "splendid teamwork and high morale in the face of hardships," which he enumerated: "inadequate equipment and transportation, insufficient number of trained personnel, security restrictions, and a rapidly changing tactical situation." Steinberg filed it away with all the rest of his war souvenirs.

NAVAL OFFICERS RECEIVE PERIODIC FITNESS REPORTS from their commanding officers, and their promotion is dependent on them. Because Steinberg was attached to the army for so long, the last one he received from the navy came from Milton E. "Mary" Miles, then his commanding officer in Chungking, on May 31, 1944. Miles described Steinberg as "excellent in intelligence, judgment, initiative, cooperation and loyalty," but only "mid-range in Force and Moral Courage" and "low" in "Leadership." Commanding officers were asked to provide "commentary" on these judgments, and Miles did so: "His specialty is cartooning in which field he is outstanding. His performance of duty has been very satisfactory. He is recommended for promotion when due." But it was more difficult for the army to evaluate him a year later. At the end of 1945, he was adjudged "a difficult officer to appraise and impossible to compare with others." The evaluating officer praised his "unique qualifications . . . in the special field of sophisticated cartoon and caricature art work," dismissing it as a "talent he applies with great success in illustrating aviation training manuals." He was strongly recommended for promotion, but only if his duties were "confined to his specialty."

The navy did recommended him for promotion, and after several bureaucratic snafus he was promoted to lieutenant. He was obligated to stay in the Naval Reserve until 1954, when he was finally and officially discharged. Until then, every time he left the country, he had to secure permission to travel and inform the commandant of the Third Naval District (New York) when he returned. It was a mere formality, but he fulfilled the obligation with personal dignity and respect for the institution.

Meanwhile, in September 1944, he was terrified by the rumor that he would be given two weeks' leave and then sent back to Rome. "I don't want two weeks leave," he wrote to Hedda. "I want to go home and stay there!" He wanted to get away from the war, get married, get his first book published, and solidify his working relationship with *The New Yorker*. To prepare her for the man she would soon see, one who had lost so much weight because of malaria, chronic diarrhea, and digestive distress, he enclosed a drawing of a small dog that resembled a spaniel trying to jump a fence. "Greetings," read the caption. "This is me (I lost some weight)."

Most of all, he wanted to sit in a room side by side with Hedda. "My hand is itching for drawings," he told her. "I have a thirst for sitting on a tall chair at a drawing table covered with white-yellow paper as a background or cover, and then a book of white smooth paper, a bottle of Indian ink, colored ink, aniline, sharp pencils, small pens, brushes and quiet afternoon, and Hedda painting somewhere in the room."

He returned to New York on the first of October, and even though he had to report to Washington for duty with the OSS Naval Command when his one-month leave ended in November, his war was essentially over.

STARTING AGAIN IN THE CARTOONS RACKET

I'll have a hard time starting again in the cartoons racket
especially if The New Yorker will go ahead publishing the
old scrap of drawings made two years ago.

Many soldiers stationed far from home had only to worry about surviving the war, but Steinberg had two other concerns that occupied him almost full-time: persuading Hedda Sterne to divorce her husband and marry him and promoting his promising career.

All the while that he was being shuttled from one European posting to another, he was also fulfilling commissions generated by the Civita brothers and assuaging the astonishment and horror of his *New Yorker* editors when they discovered that his agents took 30 percent of his earnings.

When Steinberg was drafted, he packed the few belongings in his Sixth Avenue hotel room, one small suitcase of clothing and several large boxes of his work, and took them to Hedda Sterne's apartment. He had put her in charge of supervising all his affairs, particularly acting as go-between and dispensing the drawings according to his directions to Jim Geraghty, the art director at *The New Yorker*, and Victor Civita, his primary agent now that Cesar was in South America. Before he left, he introduced Hedda to everyone to make sure that they understood she would be making decisions on his behalf. At Civita's, she and Gertrude Einstein, the administrative assistant who ran the office, took an instant liking to each other and formed a friendship that smoothed all of Hedda's subsequent dealings with Victor. Saul left for China quite content that his best interests would be served by Hedwig Stafford, Hedda Stafford, or Hedwig or Hedda Sterne—whatever she was calling herself at that particular moment, to the confusion of those with whom she conducted his business.

While he left the bulk of his old work with Hedda for her to dole out whenever his military postings kept him from sending new work, he left

another bundle of drawings with Victor Civita, who quickly got most of them published. As a way of keeping his lucrative client's name in circulation, he hounded Steinberg repeatedly to send new ones, especially those he could sell to *The New Yorker*. When the mails delayed the sending or receiving, Hedda had to dig deep into her trove and Civita had to cull whatever he could find as well. Steinberg was not happy when Hedda sent him a copy of *The New Yorker* in December 1943 with "that horrible drawing of the big A letter at the optician." It was one he had made at least two years earlier, when he was trying to make the transition from his European style to *The New Yorker*'s, and to him "it sure is a very stupid drawing." However, as he did for the rest of his time in the navy, he did not blame his agents for publishing work he was not proud of; instead he made allowances for them.

Even before Steinberg left New York, Civita was courting the publisher Duell, Sloan and Pearce, whose editors had expressed serious interest in a book of drawings. Steinberg spelled out everything he wanted in minute detail before he would agree to a book: "I want [to see] the proofs or Photostats of every page and drawing before printing and [he is] to do nothing without my ok or yours. Please keep an eye on him."

He wrote this letter at the end of 1943, when *The New Yorker* had accepted some of his China drawings for publication in early 1944. He was passing through India at the time and while there made a dozen drawings for the magazine that departed from his usual style, quite pleased that he had done something he had never been able to do before: "I act like a photographer and sketch what I see." In the past, he had insisted that he could create only in solitude, and he resented it when anyone tried to watch him at work. In India there was no possibility of tranquillity or privacy, so he learned to sketch contentedly, often in the midst of crowds that thronged to look over his shoulder. He ignored the jostling, pointing, and touching and was just happy that his new technique "works."

While he busied himself creating enough drawings for a book that would tell the story of what a tourist—albeit one in the midst of a war—might see as he wended his way from China through India and Egypt to North Africa, another publisher expressed interest in a book. The initial inquiry did not come through Civita's office but in a letter directly to Steinberg from a Miss Morrison who worked for Alfred A. Knopf. Miss Morrison told him she had seen his cartoons in *The New Yorker* and wanted to publish one hundred drawings consisting of a mix of old and new work. He did not reply to her immediately but wrote first to Hedda, pleading for information about the book Civita wanted to sell to "that triple name publisher." Hedda did a little digging and discov-

ered that Miss Morrison was a good friend of Jim Geraghty's, who, because he was so frustrated by the way Civita dispensed drawings piecemeal, urged her to make an offer. When it came to Steinberg's business interests, Hedda was astute, and she told Steinberg that whatever passed between Geraghty and Civita was "of no concern to us if they [Knopf] offer a better contract."

Several months had passed since the end of 1943, when he had entrusted Hedda and Victor Civita to make selections from the drawings he left with them. It was in 1944 and just after he was sent to North Africa that he began to fear that if a book did come to pass, the publisher would send the photostats to his old APO address in China, where they might languish and never be forwarded. "Please be interested in me and my work," he begged Hedda as he explained his uneasiness that Victor might not wait for his approval and just select old, outdated material for a book, which would make it difficult for Steinberg to resume a career at *The New Yorker*: "I'll have a hard time starting again in the cartoons racket especially if *The New Yorker* will go ahead publishing the old scrap of drawings made two years ago when [Cesar] Civita was telling me that the only way of being able to publish something in New York is just lowering the standard, in other words make a vulgar 'popular' and photographic kind of drawing. I've never been able to make him happy about it but I tried anyway and I made a few very silly drawings I'm always ashamed to think about. It was the sad time of my residence in Santo Domingo and I didn't have many hopes or aspirations."

Steinberg was referring obliquely to the main feature of his work that Cesar Civita had told him he had to change when he was in the Dominican Republic, ill with malaria and too browbeaten to dispute. Cesar thought that the big bulbous noses on some of his cartoon figures were "too Jewish," and he advised Steinberg to tone them down to make them more "mainstream" and thus more likely to be accepted by a magazine that was noted for its white, suburban, upper-middle-class subscribers. Saul told Hedda about Cesar's advice shortly after they met, and how he had accepted it because "he thought he was only a greenhorn, and what did he know—what could he know, he who never set foot in New York!" She was outraged by what she insisted was Cesar's pandering to anti-Semitism and was convinced that even though he was Jewish himself, he was still a "Jew hater." This opinion caused one of Saul and Hedda's first serious arguments and became a lasting difference of opinion between them. Hedda never changed her view of Cesar and Saul continued to defend him, but shortly after this his drawings took on a newer, sharper line, as did the noses on his figures.

After the war, when he was an established figure at *The New Yorker*, Stein-

berg used to say that the "US brand of anti-Semitism is a joke, but when you least expect it people will reveal themselves." One who "startled him no end" was Harold Ross, who told him "here in the US, we don't have noses like that." Hedda said Steinberg told her he "knew anti-Semitism when he saw it, but he just bypassed it." He was already a star who could draw whatever he wanted. And he did.

WHEN CIVITA TOLD STEINBERG THAT CONTRACTS were being prepared by Duell, Sloan and Pearce and that he should allow the book to appear under their imprint, he was ready to stop dealing with Miss Morrison of Knopf. Hedda told him not to cut her off completely, because she thought he could use Knopf's interest to negotiate better terms with Civita and DSP (as they were now abbreviating the publisher's name). Because Hedda was such an independent thinker and could not be swayed when she truly believed in something, Saul trusted her judgment almost as much as he trusted his own, which was why he gave her carte blanche to make the initial decision, not only about continuing to negotiate but also about what should appear in his all-important first book. However, after she made the initial selection, he was determined to be in complete charge of the project.

Steinberg believed that anything he published had to enhance his reputation, and he did not think it was asking too much of a publisher if the vagaries of wartime mail delivery might hold up production. His main directive was that Victor Civita should have nothing to do with the book, and he told Hedda that only after he had overseen the entire production process and the pages were ready to be printed would she have his permission to show the layout to Victor. No matter what Victor thought when he saw it, Steinberg intended to remain adamant: "If I like it, if it works, ok. If not, never mind the book."

Hedda was worried about how Victor would deal with being shut out of the production process, because at the same time that negotiations for the book were under way, Steinberg had ordered her to bypass him and deliver the new drawings he was sending directly to Jim Geraghty at *The New Yorker*. Geraghty knew that Civita was Steinberg's agent of record, so, quite properly, he sent the payment for every drawing he bought to the Civita agency, even though he and the other editors were appalled by the 30 percent commission Victor took; the usual agent's fee was 10 percent, sometimes less. When the editors asked Hedda to explain why it was so high, Hedda said she couldn't speak for Saul and they must ask him, which Geraghty did. Steinberg told Geraghty that he knew the agreement made no sense but he had agreed to it when he was a confused refugee in Santo Domingo and was unwilling to change anything

while he was so far away. It was easier to be passive and follow "the policy of *mañana* and the garbage under the rug." He had another reason, an active one that exemplified his character: he told Geraghty that Cesar Civita had helped him at a time when he would have "sold [his] soul for a ticket out of Italy" and he did not begrudge him one cent of the commission. Steinberg admitted that he felt differently about Victor now, but all he wanted for the time being was to let him "just cash the 30% and that's all." His extreme loyalty to the Civita family was only one of the many examples of his behavior toward anyone who ever helped him or showed any sort of kindness throughout his life. No matter how these people may have taken advantage of his goodwill or generosity in later times, gratitude dictated his actions, and he always found a way to forgive them so that he could continue to honor their initial kindness.

THE NEW YEAR LIMPED ALONG, and in February 1944 all Steinberg knew of the book's progress came from Hedda's infrequent letters, as none of Civita's had reached him since the previous November. She relayed news of technical disputes with DSP, with whom Steinberg had now settled, and now that he wanted the book to be published, he was worried that the publisher might cancel it if he insisted during wartime on getting as close to perfection as possible. He wanted the drawings to be entirely of black ink on white paper, but the publisher wanted color, so he reluctantly agreed to it and to the eight-by-ten-inch page size DSP originally scheduled. But when the book was finally printed in 1945, he was delighted to learn that his wish for black-and-white drawings had been honored and that restrictions on paper had been lifted so that it appeared in the twelve-by-nine-inch page size he wanted. The publisher also had a title in mind, "Everybody in Line," which would have multiple meanings; all the cartoons would be arranged chronologically, and many of the wartime drawings depicted soldiers in various kinds of lines and formations. Steinberg didn't really like it but was trying to get used to it when Hedda wrote again to say that no one at DSP liked the word *everybody*, so they were still tossing ideas around.

Meanwhile, according to Civita, the cartoon Steinberg called "the horrible A drawing" was causing a flurry of fan mail at *The New Yorker*, and DSP was insistent that it had to go into the still unnamed book. Steinberg refused to believe it was anything more than a trick on Civita's part to keep him working on "the kind of silly cheap stuff easy to sell." Even if it was true that the cartoon was generating so much excitement, he refused to believe it or to churn out more of what Victor wanted, because the *New Yorker* editors were "getting madder and madder" about Civita. They had begun to send checks directly to

Steinberg because they refused to pay the exorbitant commission. Steinberg was upset and did not know what to do.

He was further distressed when he saw the second set of proofs sent by DSP, this time a selection of approximately eighty drawings on a roll of microfilm. He did not blame Hedda, saying that it had happened because she was so "nice" ("nice" or "nice girl" being his pet terms for her), that she had allowed Victor to "influence" her in choosing "the worst drawings available." He told Hedda, "I'll write and tell him I don't want the old stuff." In one of the rare instances when he expressed his true opinion of how the Civita Agency's representation had failed him, Steinberg called Victor "a bastard" who was "only interested in money." The agency did not keep a record, "not even a scrapbook," of his drawings, let alone of whether they were sold and where they were published. He blamed Victor for making a scattershot selection without thought of the book's concept, but here again he gave him the benefit of the doubt: "I can't blame him too much for that, I'll have to take care of it sometimes."

One month later, in April, there was still no contract from DSP and no response from Civita about Steinberg's objections to the book's content. The only topics Civita wrote about were offers from businesses and commercial firms to make drawings for advertisements, publicity, and promotions. At the time, this sort of work was "too far away" for Steinberg to consider.

Meanwhile, at *The New Yorker*, Harold Ross had become directly involved in the ongoing controversies with Civita, starting with the DSP book. Steinberg tried to mediate by offering a solution to the problem of how to eliminate the old drawings he no longer liked. His idea was to put together a collection of what he was loosely calling "war drawings," with a working title for the book of "Soldiers & Civilians." Of the eighty or so that Civita had chosen, Steinberg thought only twenty-six were worthy of inclusion, and he had his doubts about at least ten of those. His China drawings had been published and been so successful that despite the shortages of paper and the compressed wartime size of the magazine, Ross had them offprinted as a small booklet for Steinberg to send to friends and relatives.

After the success of the China drawings, Ross scheduled a four-page layout of North African scenes for the magazine. Steinberg also had at least fifteen more drawings from Italy that he thought were very good, and Ross took those as well. All told, Steinberg thought the three segments would provide the foundation for an excellent book: he already had twenty from China and planned to draw five or six more, he had fifteen from Algiers, thirty from Italy, and wanted to add at least a half dozen each from India and Egypt. To round

out the book, he thought of making twenty more new drawings of "caption-less stuff," because he was convinced that his work was now firmly anchored in a realm where the image was so immediate and intense that words were no longer needed.

He was indirectly hoping that by dealing directly with Ross, he would nudge Civita away from his lackadaisical attitude toward the DSP contract, which was still not finalized, so he dangled the threat that he was entrusting Ross to find a new publisher or "eventually [the] same one." When Civita did not respond, Steinberg did send the drawings to Ross—directly.

Civita did not reply to Steinberg's concerns about the book until June 1944. By then Steinberg was adamant that it should consist only of the war drawings and should have a new working title, "something like 'c/o Postmaster.'" Civita disagreed and insisted that such a book was not viable and would have to be interlarded with "the usual cartoons." Steinberg was tired of the book and ready to abandon it and Victor Civita as well. Hedda had written a letter criticizing the way Victor was handling (actually, neglecting) his affairs, and he had to agree with her: "He is what he is and you are right when you say that charity is to be done for better purposes." As Steinberg was sure that he would soon be shipped back to New York, he decided to wait until he got there to remedy the situation in person. He had signed the contract with Civita in May 1942 and it was to expire in July 1944, but he didn't know the exact dates because he never received a copy.

Steinberg was depressed by the difference in the way Geraghty and Civita handled his affairs. Geraghty was so eager for some of his wartime drawings to appear in every issue that he figured out how to send telegrams that reached Steinberg in two days, while Steinberg sometimes had to wait a month or more for Victor Civita to address a pressing problem through regular APO mail. Shortly before he was sent back to New York, his attitude hardened. He continued to express the usual sentiment, that he dealt with Victor only because of his "debt of gratitude" to Cesar, but now he let his resentment show: "Let him make the book if still actual. I don't consider him much like my agent—I never did—he's getting 30% without doing a thing." However, it was too difficult to change anything through the mail, so once again he resigned himself to the status quo until he could deal with it directly. At that point all his worries were concentrated on Hedda, who had gone to Reno in April for the required six weeks of residency before her divorce became official. He had finally convinced her to marry him, and he was eager to get home before she changed her mind.

DIVORCING FRED STAFFORD (AKA FRITZ STERN) was not a decision Hedda made easily. From her first meeting with Saul Steinberg, the woman who favored reason over emotion was embarrassed to admit that when she was around him, the objective, dispassionate, coolly appraising Hedda who saved all her feelings for her painting became a blushing schoolgirl swept away by sexual passion. When she was alone, she cringed to recall how she surrendered all judgment when he was with her. Even though she was smitten, she recognized a womanizer when she saw one, but Saul was so charming and had such charisma that she was almost able to persuade herself it didn't matter.

At one of their earliest meetings he told her about his "very lovely true girlfriend," Ada, and her unfounded jealousy. Hedda asked for examples, and Saul told her of a day they had gone to a Ligurian beach where there were many other attractive women. Hedda knew she was in for big trouble if she let the relationship continue, because "his eyes lit up thinking about the bathing beauties; he forgot that he was telling me this story in connection with Ada's jealousy and he got carried away by his memories of other women."

Hedda made no comment when Saul's Italian reverie ended and his thoughts returned to her. He mistook her composure for a lack of feeling, and her absence of jealousy drove him wild with desire and made him even more determined to marry her. She urged him to go slowly and think rationally: "When he was in the navy, there were no promises between us. I refused to become engaged to him—how could I—I was still married." But other thoughts nagged at her: "While he was away, all the while he was telling me how he loved me he was sleeping with other women whenever he could." Saul never deviated from what he told Hedda at their first meeting: "He wanted to get married, but this was not my idea. It took eighteen months before he wore me down and I said okay."

Their courtship by mail gradually eroded Hedda's "mountain of doubts." When he was sent overseas in mid-1943, her letters were more friendly than loving as she filled them with quotes from writers like Mark Twain and Oscar Wilde and long disquisitions on "the ideas of other people including [Aldous] Huxley who's too intelligent and has the right ideas always and it's true what he says." Hedda wanted to engage Saul in discussions about ideas and philosophies that might provide evidence of things they had in common, but he objected: "I want to know what *you* say or think with *your* words." All he wanted, he insisted, was "a good healthy love letter." Six months passed, and by January 1944 he was still miffed: "I never got one and I wrote you many."

Hedda wanted to be able to share her innermost thoughts with Saul, but she never succeeded in doing so. "In all the years of our relationship, we

never talked about my problems or my ideas. I was not a weeper and I never complained; I never threw tantrums or made demands, so he assumed there was nothing that ever bothered me. We only talked about him." In the beginning, that did not stop her from trying to talk about the issues and ideas that mattered to her, especially her attitude toward art in general and her own in particular. She usually tried to express her views when she wrote about current exhibitions and the people she saw when she attended openings or visited museums and galleries. She reported news, trends, and gossip in equal part, and she clipped articles from magazines such as *Art News* and *Art Digest* that she thought would interest him. In 1943, after she officially adopted Hedda Sterne as the name by which she would henceforth be known, her painting career seemed poised to put her at the forefront of modernism. She had been included in several important group shows at Peggy Guggenheim's Art of This Century gallery and was given her first solo exhibition by Betty Parsons at the Wakefield Gallery. Through them she met the artists who would become her friends (and Steinberg's), all luminaries in abstract expressionism. All this activity led to a stunning realization that she wanted to share with Saul: that she was content to sit in her studio all alone except for her cat and to paint nonstop for ten or twelve hours every day, but only for herself. She confessed that "after the show, a lot of things became clear to me, among them that there is practically no vanity left in me—and very little ambition, too."

Saul never responded to this; instead, his next several letters gave her new instructions about how to deal with Victor Civita.

Hedda was not yet ready to abandon her desire to talk about art, so she changed her focus to talking about his. She began with her thoughts about what constitutes "good" art. To her, he was a great rather than a good artist because there was a "seductive" quality to his vision that made people willing to ponder difficult concepts or spend time analyzing something ordinary that he had depicted within an extraordinary setting or in an unusual manner. She believed that he entranced people into doing so "without their even knowing it." What she was striving to do in her own work was to rid it of a "certain 'joli,' 'pleasant' [quality] I'll probably never loose [sic]—because I am nothing much really." She wanted her painting to take on attributes of Monteverdi's music, to become austere, measured, and with all emotion "sublimated and unrecognizable, humble, like the Middle Ages monks." But she was veering into dangerous territory and that was enough about her, so she returned to a discussion of his work: "You have all the qualities of the great, really great artist—I know it . . . you achieve without efforts for which others have to work years. There is a free flow between your ideas and your pen."

When Hedda wrote this, it was to encourage him to hold strong to his vision for the book. At that time she was still engaged in contractual discussions with Miss Morrison, who was now talking directly to Victor Civita, and Hedda relayed the unsettling information that Victor and Miss Morrison agreed that new drawings should be more "imitative" of the early work that Steinberg was trying to put behind him. What they really wanted was cartoons with captions, and when Hedda told him that, he channeled all his energies (and Hedda's) into a book for DSP where he would have more control over the content. At the same time, Geraghty had posed a new and fascinating idea that Hedda thought Saul should consider. Geraghty showed a great number of Steinberg's drawings to Ludwig Bemelmans, the artist-illustrator and writer who created the Madeline books for children and was a regular (and popular) cover illustrator for *The New Yorker*. Geraghty wanted to nurture and promote Steinberg's talent and sought Bemelmans's opinion of his "eventual development." Bemelmans was intrigued by Steinberg's vision, so he studied the drawings and some of the letters Steinberg wrote to describe them. He said he was sure that Steinberg would eventually become a writer, and he told Geraghty to encourage him to go in that direction. Bemelmans and Geraghty both agreed that there was "something about [Steinberg's] way of using absolutely simple daily words and giving them certain new sense and charm" in his letters, and that this, in concert with the drawings, could lead him to excel in any number of genres. Hedda said Saul probably thought this "improbable," but to her it was "just normal."

BY THE EARLY SPRING OF 1944, when she was allowing herself to be persuaded that she should go to Reno for a divorce, Hedda worried that it would be wrong to be away from New York if Saul managed to get the long-delayed furlough he thought was due. While she vacillated, he wrote letters about how he wanted to live once the war was over: "All I desire now from life is to stay with you and make drawings. Let's forget about complications, let's ask things from life and people instead of being surprised when things happen or feeling like not deserving them. The war experience made me a bit more realistic." He wanted their life to be boring, because he needed boredom "in order to make something good," and he was specific about where he wanted to make that something good: "in a studio with a big soft rug to walk around barefooted . . . we'll make a long table for drawing, about 12 ft long, with pen & ink section, tempera and watercolor section. Then we'll buy from some café or restaurant a small table with marble to make drawings on thin paper over the marble surface, the pencil is really sliding, the ideal surface for pencil drawings."

His meticulous description of how they would work was not exactly what she wanted to hear, especially when he told her that he thought she should postpone the trip to Reno and stay securely married to Fred Stafford for the indefinite future. Instead of getting his furlough, he was being shunted from one posting to another, from North Africa to southern France and Italy, so near the fighting that he worried he might be killed and she would have given up financial stability for naught. Hedda thought he might be trying to tell her that he had stopped loving her, and she tried to imagine how she would react if it were true. In an eerie prefiguration of how she actually did behave throughout the many years she was married to Saul Steinberg, she imagined herself as "trying to be very 'good and heroic' . . . I always try to be civilized and things like that make me want to convince myself that this is the way I would act." She seemed surprised by the conclusion she arrived at: "I love you. Really. I don't know very well why."

FRED STAFFORD WAS AS WORRIED ABOUT Hedda's security as Steinberg was, but by the middle of May they all three agreed that Steinberg was likely to survive the war and that Hedda should go to Reno. Fred told her that he hoped marriage to Saul would be lasting and happy but she was not to worry if it were not, because he would always provide for her. He was as generous and gracious about the divorce as he had been during the marriage, and Hedda was in Reno on May 23, assured that Fred would cover all her expenses.

The divorce was final at the end of June, and on July 5 she left by train to spend the summer painting with Betty Parsons in Provincetown, where she promptly caught the flu. The only bright spot was five letters from Saul and a photograph of him with a "too little moustache." He acknowledged receiving all her V-mail letters, but he wrote nothing about her desire to talk to him about things that really mattered to her. After reading his letters, she replied, "I feel lousy. I'll write more when I feel different." It might have been the flu speaking, but it might have been other nagging worries as well.

THE STRANGER SHE MARRIED

Steinberg arrived in New York on a parachute with no credentials but he made quite a personage of himself in a very short time. He knew how to make his way in the sophisticated world and was very good at it.

The plane that carried Saul Steinberg home was based at the Patuxent River, Maryland, naval station, and it landed there on October 4, 1944. His orders were to report directly to the OSS Naval Command in Washington, "where his services are desired in connection with the operations conducted by this agency." He reported just long enough to ensure that the paperwork for his furlough was in order and to let his superiors know that he would be back when it ended on October 25. He went to New York to make arrangements for an immediate wedding, and on October 11 he and Hedda went to City Hall to begin the process. A kindly clerk waived the waiting period and married them that very day. The marriage license was filled out by someone who was Spanish and illiterate in English and who wrote illegible English answers to the questions. Hedda called it "the first of Saul's phony documents, maybe."

The suddenness of finding themselves married was so unexpected that neither Saul nor Hedda had planned anything to do, so they bought a bottle of champagne and went home to drink it. Hedda had one glass and promptly got so sick that she vomited all night long. "Subconsciously," she recalled, "I think I knew it was not going to last. The problem was that from the first day I expected it to end."

Despite her qualms, Hedda was radiant with good health and brimming over in equal parts with relief that Saul had survived the war and happiness that they were together. Beside her he seemed wraithlike, his mustache not the only part of his body that was diminished. He was so thin as to be emaciated, his digestion ruined by so many army rations, his health depleted by months of

malaria and diarrhea. None of his clothes fit, and he had to shop for new ones in the boys' department for a child's size 14.

Harold Ross insisted on giving Saul and Hedda a wedding dinner and asked them whom to invite. Hedda left the guest list to Saul, and the single name he mentioned was S. J. Perelman, who "always made Saul weep with laughter." Even before he came to New York, Steinberg had studied Perelman's "satires of, let's say, Hollywood conversations" as a way of teaching himself how to avoid the gaffes of clichés in English. To him, Perelman was "indispensable as a teacher of pitfalls, common wisecracks, a hint of the fairly high level of popular sophistication."

Perelman and his wife, Laura, graced the dinner, as did Eva and Jim Geraghty, the *New Yorker*'s cartooning couple Alan Dunn and Mary Petty, and Carmine Peppe, the makeup editor and "de facto art director," who became one of Steinberg's best friends at the magazine. Ross was then married to his much younger third wife, Ariane Allen, whom he placed next to Saul, while he sat at Hedda's left and placed Sid Perelman on her right. When Sid learned of her friendship with Victor Brauner, he became the life of the party, and everyone hung on his tales of how he formed his surrealist underpinnings during the 1920s when he was an expatriate in Paris. The guests sat spellbound as Sid improvised examples of surrealism's influence, such as the one he swore best contrasted the American and British approaches to art: elbow patches on tweed jackets. He and Saul bonded over the shared opinion that what to the British was only a way to repair worn-out clothes and make them last longer had become in American hands a symbol of high style when Brooks Brothers sewed the patches onto brand-new and expensive tweed jackets. Quirky and offbeat, it was just the sort of story that sparked the imagination of the two men, whose friendship lasted for the rest of their lives. It was, in fact, such a deep friendship that Perelman later gave Steinberg his first-edition copy of *Ulysses*, signed by James Joyce, who was Steinberg's favorite author.

Both Hedda and Saul took another memory of lasting resonance from their wedding dinner, albeit of a different kind. All was not well in the Ross marriage, and although everyone at the table imbibed freely, the liquor affected Ariane Allen more than the other guests. She spent the whole evening caressing Saul's thigh under the table, most of the time not bothering to hide what she was doing. Hedda was aghast, but Saul enjoyed being the object of a young and attractive woman's attention. Hedda realized that what she feared most about her new husband was true: he enjoyed being "a real success with women" because "he just loved women." Hedda thought he was like a little boy

wanting any woman's praise and attention because "he thought it built him up in my eyes."

Several weeks later, the Steinbergs were still learning how to live and work together in Hedda's apartment on 50th Street when a WAC who had worked with Saul in Europe came to visit. Passing through New York on her way home, she was visibly pregnant and therefore had been discharged, as women were at the time. Hedda welcomed her, and when she went into the tiny kitchenette to prepare refreshments, she could see Saul and the WAC in a passionate, bent-over-backward kiss. Saul was not embarrassed but "rather proud of himself," even though Hedda was "heartsick. It was a disaster to have to see this after two or three weeks of marriage."

Hedda was trying to come to terms with this stranger she had married, the civilian husband who had replaced the passionate wartime lover whose every letter pledged undying love, adoration, and above all fidelity. The lover wanted nothing more than to be cloistered with her in a room where they could make art side by side. Now she found herself living with a husband whose "idea of marriage was that he should be free, free, free, and not one bit guilty because of a girlfriend, or actually, a lot of girlfriends." When they packed one small valise for an overnight outing and Hedda found inside a long, still unfinished love letter he was writing to Ada, she was terrified that she had given up a loveless but secure marriage to Fred Stafford for one that might be predicated on Saul Steinberg's whim of the moment, fraught with every kind of insecurity from emotional to financial.

Many years later, Ian Frazier, a trusted friend to both Saul and Hedda, tried to explain the complexity of their relationship as he, the outsider, observed it. "To know Hedda through Saul would be to underestimate her," he said. "She is so remarkable you have got to give him credit for having chosen her." The obverse is true as well. Both had come to the United States eager to throw off their embarrassing Romanian antecedents and to become as fully American as they could, with every nuance the adjective implied. Both were nourished by the American society that gave them refuge, and both were eager to get to work and find happiness and prosperity within it.

There were several niggling wasps in this fragrant ointment, and one of the largest was Saul's suspicion that disaster of every sort lurked just around the corner, waiting to sting him. Frazier wondered how, during the early years of his American life, he controlled the rampant paranoia that intensified as he aged. When asked if Steinberg had been this fearful and superstitious in Italy before the war, Aldo Buzzi just laughed, shrugged, and spread his hands in a gesture of hopelessness, unable to explain why his friend believed that at

any given moment he could lose everything for which he had worked so hard. Steinberg's nephew, Stéphane Roman, described it as the "ordinary superstitious Romanian fatalism that is impossible to overcome, no matter how long you are away from the country." Hedda and Saul seldom compared their adopted country to the one of their birth, and even though they had many Romanian friends, they never reminisced. But when Norman Manea came to New York, Saul told him fiercely to embrace being American and never to be frightened or ashamed of it.

IN THIS ATMOSPHERE, AND IN THE not very large apartment on 50th Street, the two people who wore so many different metaphorical hats—among them newlyweds, artists, naturalized U.S. citizens, and friends to an ever-growing number of New York's cultural elite—set up their worktables and got on with their life. For Steinberg, this meant solidifying his role at *The New Yorker* and accepting as many of the commercial commissions that were being offered as he could. He was eager to pay back everyone whose earlier generosity had helped him to leave Italy, especially the Civitas, Aldo, and Ada. After he started to work in 1945, he sent regular money and CARE packages to Aldo and Ada throughout Italy's long postwar recovery.

First and foremost, however, there was his family to support, which, besides his parents, now included Lica and her husband and their newborn son, Stéphane. It was still difficult to establish direct contact with them, and here he was helped by his uncle Harry, who diligently explored every channel through which Saul could funnel money, clothing, medicine, and anything else that the Soviet-dominated Romanian government permitted its desperate citizens to receive from foreigners. Saul had to do all this while commuting to Washington, where he was still on active duty with the OSS.

The navy authorized him to commute to New York on weekends while wearing his uniform but did not grant travel or per diem expenses, which meant he had to find more and more work to pay for everything. In Washington he did whatever the OSS assigned, but it was easily and quickly finished, leaving him lots of time to devote to his own projects. His days were uneventful until he saw his latest fitness report, with the unnerving statement that he would be "trained for a future overseas assignment." The uncertainty that such an interruption could bring to the new life he was busy crafting was a specter that haunted him until May 1945, when he was transferred permanently to New York and the Training Literature Field Unit at One Park Avenue. There he made drawings for posters and brochures until December, when he was discharged from active service. Until his final discharge from the Naval Reserve,

in 1954, his major worry was the fear of being recalled to active duty, especially during the Korean War, but fortunately he was not. His major irritation was being required to notify the Third Naval District of the dates every time he left and returned to the country, which he dutifully did.

In September 1945, he learned that Aldo Buzzi was "alive and well" and working as a writer and set designer for Alberto Lattuada and occasionally for the exciting newcomer Federico Fellini. Steinberg knew of Fellini, for they had met by chance in a restaurant in Rome where Fellini was trying to eke out a living by sketching patrons for a few lire. Aldo told Saul that Ada was in Ravenna and, as far as he knew, still married. Saul resumed contact with her, but his most intense correspondence was with Aldo. It served in lieu of a diary of his daily life, as he told Aldo everything, starting with descriptions of his life as a stateside sailor: the worst part was having to "get up every morning and go to an office" and spend most of the day "sitting still and bored." This was not entirely true, as his career had taken off like the proverbial rocket, and he spent most of every day while in the navy doing his own work.

THE FIRST MAJOR ITEM OF BUSINESS was to choose a title for the forthcoming book. Everyone he knew had a role in the debate, but for want of something better it remained "Everybody in Line." One of the first groups of friends Saul and Hedda made were some of the artists and editors at *The New Yorker*, and because Hedda was a superb cook, they had fallen into the easy camaraderie of inviting friends for casual suppers and drinks and conversation afterward. "Those were the years," Hedda recalled, "when I cooked for whoever dropped by." One evening when they were entertaining Jim and Eva Geraghty, William Steig and his wife, and Alan Dunn and Mary Petty, someone said the magic words "All in Line." They all agreed that it was a perfect title because of its many resonances, from the chronology of the drawings to the unending lines of soldiers and sailors who had to "hurry up and wait" and the truck convoys that snaked up and down winding mountain roads. Steinberg was so pleased with the title that he immortalized the tableau of all the guests as they sat around discussing it by drawing them in his daily diary for the week of April 26–May 2. He captioned it "title for book and world of future," and noted beneath it—perhaps as his way of indicating better times to come—that this was the same week when Mussolini was hanged in Milan and Hitler committed suicide in his bunker.

All in Line was a hit in bookstores, selling 20,000 copies before the summer ended and becoming a bestseller for the Book-of-the-Month Club. It hit all the right notes for a public eager to understand daily life in wartime but not

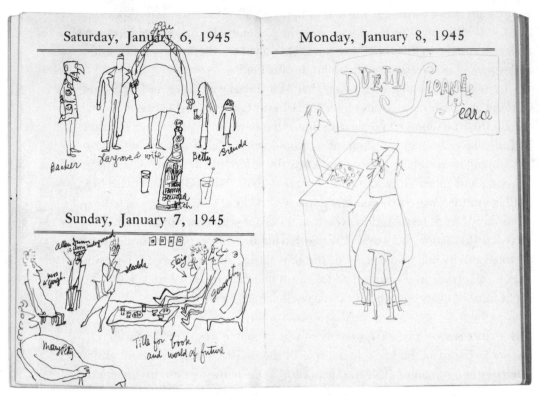

Steinberg's 1945 appointment book, pages for January 6–8.

yet ready to confront its atrocities. Steinberg's depictions of life overseas that had appeared in *The New Yorker* helped to whet the public's interest in the book; the magazine's subscription list was ten to one military to civilian, and his low-key representations of the daily life of soldiers and sailors resonated strongly with both groups. Fan mail poured in to the magazine, as readers responded to, complimented, and even corrected his drawings. In the book, Steinberg's Hitler and Mussolini appear as objects of amusement rather than fear and scorn; his civilians, officers, and bureaucrats are gently chided and ridiculed in equal part. The country was eager to get on with the business of rebuilding for peacetime, but it was not too soon for a nostalgic glance back at military life during the past few years, and Steinberg's book provided the perfect venue.

Steinberg's success coincided with an interesting moment in the publishing history of *The New Yorker*. His wartime drawings brought him to the forefront of what was then known as "the department of fact" under managing editor William Shawn, who was positioning the magazine to be an intellectual

powerhouse and a leader in various forms of investigative journalism. After the war, the reading public's insatiable desire for facts led to the rampant growth of straight newsmagazines and to *The New Yorker*'s transformation into a curious hybrid of fact and fiction. Steinberg's contributions fit right in with Shawn's plans, for they were also a hybrid, of "wordless dispatches as pictorial reportage." As such, they placed him among the other artists and cartoonists who had their fingers on the pulse of the contemporary zeitgeist, not only in the United States but in other countries as well. By 1949, Steinberg's influence in Germany was such that two relatively unknown writers who were just at the beginning of their distinguished careers, Heinrich Böll and Max Fritsch, were asked by a magazine to write stories based on Steinberg's drawing of a wife seated at one end of a long dinner table playing the violin for her dining husband. When the stories were sent to Steinberg, he put them aside without trying to get them translated into English, because he "may have been embarrassed" by all the attention.

Steinberg's art captured what his friend Harold Rosenberg called "the problem of identity as central to the work." Rosenberg, the scholar and critic with a larger-than-life personality, placed Steinberg among the American artists who began to dominate the scene in the 1940s and 1950s, among them de Kooning, Rothko, and Hans Hofmann, all of whom either immigrated to America themselves or whose parents brought them as children, giving them roots in the immigrant experience. For these artists, Rosenberg wrote, "The issue 'Who am I?' was sharpened by 'Where am I?'" Those he named as examples were different from previous generations of traditional American painters because they were not only determined to "realize" themselves, they were out "to make a name for themselves." They made their work take on a new function as they strove to create themselves socially (that is, within American society) "as well as metaphysically."

In the last decades of his life, when Steinberg was collaborating with Aldo Buzzi on editing the dialogue that became the book *Reflections and Shadows*, he looked back at the decades of the forties and fifties, the years he believed were the time when American art began to flourish after a long period of neglect. He thought that because the artists who were his friends had spent their youth "in poverty and neglect," by the time they became famous they were already "almost posthumous." That, he determined, was "the cruelty of Art History."

Steinberg was paramount among those artists in his desire to "milk that huge cow," as he described the United States. He told the French journalist Alain Jouffroy that it would be "stupid" not to want to milk this particular cow

from time to time, but the interviewer was astute enough to recognize this as a "gentle cynicism" that hid something much deeper: "What really attaches him to the United States is not its 'milk,' but the quantity of ideas and the spectacle of its streets, towns, and its contradictory customs . . . the mixture of burlesque and tragedy, false and true, old fashioned and modernism and even utopianism, which makes this country the most aberrant cultural kaleidoscope of the western world."

In the exchanges with Buzzi, Steinberg verified Jouffroy's contention when he compared the American art world to the kaleidoscopic Tokyo Ginza. Once an artist became a part of this difficult and mysterious world, he found that "it contains the two most important and poisonous things of life, fame and money. One desires them and one fears them." In his case, he had not become an artist primarily for fame and money, although "it's true. I wanted them, too." All his life he was suspicious of young artists who devoted themselves to the "nobility of art," finding it far more reasonable to consider art "as a stage for visibility." If this attitude was "cynical," he still thought it was "truthful and logical." For Steinberg, "Art with a capital A makes me suspicious."

IN STEINBERG'S CASE, AND ESPECIALLY IN the immediate postwar years, "milking the cow" was essential for reasons other than furthering his art. There had been a slight opening in communications with Romania, but it usually took as long as four months for a letter to reach Bucharest and equally long for a reply. Owing to "political circumstances" after the Soviet occupation imposed harsh restrictions and penalties on all aspects of life, it was difficult to send anything, even through legitimate channels. Neither money nor certified mail was permitted until international relief agencies such as the one known by the acronym HIAS were set up. Even then, despite the list of approved items that could be shipped, the chance that money or goods would reach the intended recipient was low. Armed with the official approved list, Hedda shopped for items that Saul paid to send every week, among them bolts of woolen or cotton material that his relatives could sew to make clothing, coats, shoes, and house-hold supplies. He wanted to send medicines, everything from cold remedies to aspirin, but initially they were not allowed. When medicines were finally approved, he sent penicillin until Moritz told him that the crooks involved kept and sold more than half of it. For Lica he sent cosmetics and dresses, and when he was permitted to funnel cash through the agency, he sent several hundred dollars both to her and to his parents several times each month. He begged for news that they had received it in every letter, but like the dresses and cosmetics he sent to Lica, they received it one time out of every three or four.

Moritz would have been content to soldier on with life in Romania, but Rosa wanted to leave. Saul investigated and found that it would be "fairly easy" to bring them to the United States, because they were his parents and therefore not subject to the quota. It would be different for Lica and her family, because they would qualify for the quota and would have to wait their turn. He filed an affidavit of support for all of them, which meant that he would assume full financial responsibility for everyone.

And then, when the reality sank in of what it would mean to his own life if his parents were in New York, Saul experienced some highly conflicting emotions until, as Hedda said, he realized that "he didn't want them here. He knew that wherever they were, if they were outside Romania they would be unhappy. So he sacrificed himself anyway: by bringing them out, he set them up to be unhappy and to blame their unhappiness on him."

The obvious choice of a place for them to settle was Israel, where more than one hundred thousand Romanian Jews had gone and where both Moritz and Rosa had siblings and other relatives as well as friends and former neighbors. Moritz wanted very much to go there, but Rosa had other ideas. Saul called her a snob when she insisted on France, preferably Paris, and as the years passed, he held her "responsible for the unhappiness" that resulted. However, "No matter how much loneliness and suffering [she had] from French xenophobia, she had the satisfaction of thinking that she was envied by her sisters and some despised [Romanian] neighbors."

Saul knew it would be an expensive process to get them resettled, and he got to work with a vengeance, taking up most of the offers of work that were made by advertising agencies representing businesses, manufacturers, and corporations and that sometimes came directly from these entities. The commercial requests intensified at the same time that his work was selected by the influential curator Dorothy Canning Miller for a group show at the Museum of Modern Art titled "Fourteen Americans." The exhibition had several far-reaching repercussions as it traveled extensively: first, it brought his work to the attention of midwestern industrialists and businesspeople, all of whom were quick to offer lucrative commissions; and second, it led to lifelong friendships with Robert Motherwell and Isamu Noguchi, who were also featured.

Miller's approach was to select artists who were just beginning to be recognized (although youth was not her primary criteria) and to present their work in depth. Of Steinberg (then thirty-two), she wrote that his work revealed "the oddities of everyday italicized with the razor's edge of humor." He, like all the artists, represented a strongly American idiom, but to Miller it was coupled

with a "profound consciousness that the world of art is one world and that it contains the Orient no less than Europe and the Americas."

Miller's editorial essay was brief and to the point, and rather than just expressing her interpretations, she allowed the artists to offer theirs in personal statements in the catalogue. Steinberg was the only one of the fourteen who did not provide one, choosing instead to let the work speak for itself through a drawing that featured the unreadable handwriting of one of his "phony documents." Miller kept it for her private collection but chose not to reproduce it in the catalogue, so his page was blank. In the years that followed, whenever he was asked to explain what his work was about or where his inspiration came from or what he was trying to convey, he did one of two things: he either made up answers on the spot (such as the ones about stamping his wartime underwear "top secret" or inventing the official-looking rubber stamps to forge the documents that let him leave Europe) or he chose not to reply at all. In 1961, when his friend Katherine Kuh asked him to sit for an interview in a series with American artists that she was conducting for the Smithsonian's Archives of American Art, he initially agreed but almost immediately changed his mind. He told Kuh he could not collaborate "to create a complicity in which I would play my part according to popular expectations." He thought it would be a "dangerous" exercise to do this: "The man involved in his own history becomes himself a work of art. And a work of art doesn't permit changes and it doesn't paint or write."

In "Fourteen Americans," Steinberg's major presentation was an ink drawing titled *The City*, executed on a scroll fifty feet long and twenty inches high. He also showed humorous images of birds in cages and a larger-than-life hen, but he faced the harrowing aspects of the war head-on as he chose to exhibit images of the destruction of Monte Cassino and the vaporization of Hiroshima. A year before the exhibition, he told an interviewer from *Newsweek* that he feared that being in the service had damaged his art: "There is an inside discipline which does not allow me to do freely what is not logical. I cannot think of what is absurd anymore." He also told Aldo Buzzi that because he had spent the past three years in uniform, all his impressions were "from the military point of view, or anyway, in uniform. I hope it influenced me."

This show was also the first time he attempted to show the public what Hedda called his "phony documents," now generally known as the "false documents," inspired by calligraphy and books about handwriting analysis (he had a large collection) and replete with official-looking rubber stamps and seals of his own creation. At various times he gave them to friends to celebrate everything from diplomas (as to Primo Levi, whose diploma from the University

of Turin also bore the detested "raza Hebraica") to travel passports (Henri Cartier-Bresson, John Hersey, and Janet Flanner), and he made two separate ones for Hedda, to celebrate her talents in cooking and dishwashing.

"Fourteen Americans" was also the first time that his place in the postwar art world was questioned. Howard Devree, reviewing the show for the *New York Times*, thought it "a safe guess he never dreamed his cartoons would someday be 'museum pieces'" and went on to list the questions he felt were bound to be asked about Steinberg's inclusion: "Why do they include him? What's that stuff got do to with art? What do they mean, art?" Actually, Devree was wrong: these questions did not end when the show was over; they plagued Steinberg for the rest of his career.

Steinberg held a curious position among such friends and luminaries as Willem de Kooning, Jackson Pollock, Mark Rothko, Phillip Guston, Alexander Calder, Barnett Newman, Ad Reinhardt, Richard Lindner, and a host of others. Milton Glaser saw him as a cartoonist "who by some extraordinary series of shifts became a major artist." Glaser thought him the only visual artist who had been able to achieve the highest status as both. And yet as one of Steinberg's close friends, the artist Mary Frank, noted, "He was somehow not treated as the great artist he was. People would say, 'Yes, he's fantastic,' but then they'd call him a cartoonist and the word *cartoonist* had a bad edge to it." As an intellectual and an artist of ideas, Steinberg was out of sync with the reigning genre of abstract expressionism, in which emotion was the primary response to the blank canvas. Frank assessed his curious position: "Here he was, in the sixties and seventies, when he was an extremely famous artist, but when there were big shows of U.S. art in Europe, he was not included. He was distinguished but not the same as people like Motherwell and de Kooning."

Frank thought this was "very hard for him," but Hedda Sterne disagreed. She thought many of the artists who befriended Steinberg "felt safe with him because they did not consider him a competitor. They looked down on him because he was a cartoonist, but what they didn't realize was that he was a genius. He knew exactly who he was, and he knew that he had to make money. He could do anything, from wallpaper to fabric design to greeting cards. He was not happy doing these things, but no matter what he did, it was always brilliant. He could not put his pen to paper without doing something marvelous every time." Still, although Hedda and other good friends sometimes expressed anger or dismay that Steinberg was somehow outside the mainstream of American art, he never commented or expressed his own frustration.

Steinberg had become an "AA" artist at *The New Yorker* ("most wanted,

highest paid"), which put him in the company of William Steig, Charles Addams, and Sam Cobean, all of whom became his friends, but it also put him a cut above them. All the artists who worked for the magazine had private agreements and contracts with "different pay scales, different arrangements," so that none knew what the others were being paid, although all were eager to find out. Steinberg was one of the two highest paid, with a "special deal" shared only by Peter Arno. When Steig learned of it, a competitive tension on his part soon disrupted their friendship. After 1950, Steig was no longer part of Saul and Hedda's "*New Yorker* circle," which had grown to include Geoffrey Hellman, A. J. Liebling, and Joseph Mitchell. Charles Addams, however, remained the artist to whom Steinberg was closest. Charlie, as Steinberg called him, was "a quiet and elegant man, in both the physical and moral sense." Steinberg's "quiet friendship" with Addams began in 1942 and ended with his death in 1988.

The ever-cheerful Addams was never bothered by discrepancies in status or pay. He was too busy enjoying the puns and practical jokes, the naughty postcards and witticisms they exchanged, but most of all their mutual love of automobiles. Addams helped Steinberg buy his first car, a 1947 gray Packard convertible with a red leather interior. Saul and Hedda drove the behemoth to Jamaica, Vermont, in the summer of 1947, where they rented the house of a painter and hoped to do work of their own. Despite the company of Ruth and Tino Nivola, the summer was not their happiest: "We went up there in complete ignorance, and you can imagine what successes we were," Hedda recalled, "what with those accents and that car."

Saul, whose only driving experience before this had been in a navy jeep, "was a bad driver who specialized in losing his way." In their many road trips, his erratic driving often resulted in detours that led to thrilling adventures, such as the one a few years later when they drove their second car, a second-hand Cadillac bought from Igor Stravinsky, to the West Coast. A wrong turn found them outside Seattle on "a remote and rarely visited Indian reservation. The road to get there was corrugated and on the sides it appeared to be decorated with empty whiskey bottles." The elders welcomed these curious strangers by inviting them to stay at a tribal motel and attend a Native American rodeo. Steinberg was delighted and "stored these images, which he used with great affection again and again."

IN THE FALL OF 1945, THE commissions were piling up to the point of threatening to engulf him, but he still described himself as "fine, fat, I eat, and create artificial difficulties for myself," no doubt referring to the undefined disasters

that he feared might strike at any moment. His drawing table was a "mountain of scrap paper" that he had to dig through in order to make room to work. He had become intrigued by the idea of "baths, bathrooms, tubs, and basins" and was deeply involved in the world of "tiles, ornamental fretwork, women bathers with little portions of their bodies sticking out of the water." He meant it all to be humorous, and whether it became beautiful or not was "incidental," but these drawings were a big hit when he included them in his second book, *The Art of Living*, in 1949.

Once his position at *The New Yorker* was firmly cemented, much of his life during the years from 1945 to 1950 was centered on proliferating com-

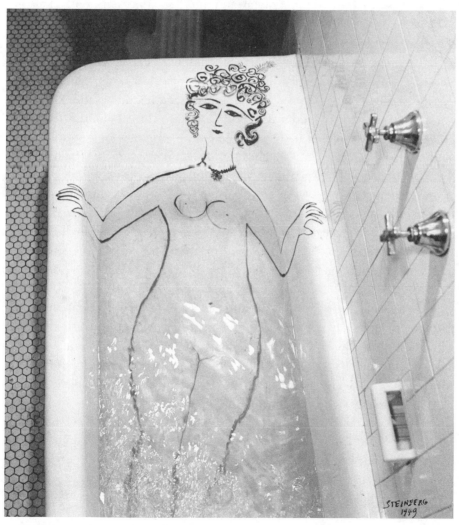

Saul Steinberg, *Woman in Tub*, 1949.

mercial work that ranged from the "highbrow to the low." He signed on in 1945 to do an annual series of Christmas cards for the Museum of Modern Art, which he ended in 1952 for a more lucrative commission that lasted for a decade, creating a series of Christmas cards, calendars, and other seasonal novelties for Hallmark. He also did drawings for the Neiman-Marcus Christmas catalogue, and in the process acquired a friend and major collector in Stanley Marcus. He did many dust jackets for books, among them the highly successful Chucklebait series for children by Margaret Scoggins. He created wallpaper and fabrics, some of which featured his representations of landmarks in Paris, Venice, Milan, and Rome. He created ads for companies that manufactured copper tubing and sheet metal, and the Noilly Pratt vermouth campaign ("Don't Stir" without it.) His drawings were in magazines such as *Life*, *Flair*, *Fortune*, *Harper's*, and *Town & Country*. *Vogue* sent him to Washington to do political drawings, and *Harper's Bazaar* sent him to Paris to cover the fashion shows. He also produced drawings for architectural journals, which he drew for the money, keeping his thoughts to himself and not telling the editors that he thought the general tendency in postwar architecture and industrial design was "toward streamlined bad taste." As for his overview of general-interest and fashion magazines, he thought them far more conservative than those in Europe, because of "advertising, which is the basis for every publication with a few exceptions." In his view, there was no "real" art magazine in the United States, only "mouthpieces for art and antique dealers." He added architecture magazines to this category, particularly *Architectural Forum*, because it was sold only by subscription and "lives on the advertising of construction companies, etc., which often control the content." The only publication he deemed "perfectly free and more intelligent than its time" was *The New Yorker*.

In the dialogues with Aldo Buzzi that took place a good twenty-five years later, Steinberg spent quite a lot of time explaining what the magazine meant to him. Drawing for it made him feel that he was doing "a useful task" that allowed him to be "an active part of society." What made him happiest was the vast number of readers who related to and appreciated his drawings, which gave him feelings of acceptance that he did not find anywhere else. Thinking about the early days of his career at *The New Yorker* brought back memories of his childhood and adolescence, when, like so many other youngsters with a creative bent, he was convinced that he was the only one beset by adults who did not understand him and who were constantly criticizing, scolding, and finding him lacking. He only felt "normal" when he retreated into the privacy of his art, and it was not until (in his exaggeration) "millions of people" responded to his cartoons and drawings that he became "an *inventor* of nor-

mality" who was able to exert a "social and political influence" that other adults willingly accepted.

For Steinberg, *The New Yorker* was an oasis: "[The editors] ask for a specific product and I give it to them. It's a clear situation and therefore my relations with the magazine are logical, stable, without doubts; also due to the *kindness* (decency, loyalty, honesty, correctness) that has always reigned over the editorial environment, from Harold Ross to Bill Shawn to Jim Geraghty. They tell you yes or no at once, without hesitation, no possibility of misunderstandings, immediate payment, publication at the right moment, the author's rights observed with meticulous care, complete protection of the artist: a marvelous *kindness*, which unfortunately is now vanishing everywhere."

When Steinberg wrote this in the late 1970s, things were rapidly changing at the magazine, and he feared that "the Levantine system [bribery and corruption] has arrived in America, the homeland of trust." He regretted the loss of what had been for him until then "an oasis, where America's ancient morality survives intact."

WHILE WORK FILLED HIS DAYS, STEINBERG was busy educating himself. He loved the movies, and after several hours at his worktable, when the pleasure of drawing threatened to become tedium, he took a walk and often ended up in a movie theater. His tastes were eclectic, ranging from *The Lost Weekend* to *Open City*, which he thought was proof that "the absence of Fascism is good for art." He went to galleries and museums but complained about crowds that behaved as if they were in the funhouse at a fair. He thought Salvador Dalí and the crowds at his exhibition were well suited to each other, as he was "a clever pirate who cheats his buyers and they get what they deserve." Always a voracious reader, he found Flaubert "better than ever" in *Three Tales*; Proust "sort of" bored him. He liked Tolstoy and often returned to *War and Peace*, as well as to Balzac, and was so fond of his *New Yorker* colleague Joseph Mitchell's writing that he considered translating some of it into Italian. Most of all when he read, he was studying the history of the United States.

Steinberg was easily bored and often restless, and he needed excitement. He was so eager to see every part of his adopted country that he would go just about anywhere he was invited. One of his first excursions came in the spring of 1946, when he went to Pittsburgh to judge a nationwide contest for children's painting at the Carnegie Institute (now Carnegie Mellon University). After wading through approximately six thousand drawings, he gave the prize to a little boy's painting of "an old woman being decapitated." In June, while spending the summer in Provincetown on Cape Cod ("a more violent place

than the Italian Riviera"), he got word that Jim Geraghty had secured a press pass for him to cover the Nuremberg War Crime Trials.

These were the years when every glittering name in New York and Europe found its way into Saul Steinberg's address book. In New York, he was a habitué at Del Pezzo, the midtown restaurant that was a hangout for artists, designers, writers, and architects, most of them an international mix of refugee "raffinati" like himself. On any given night he might share a table with Tino Nivola, Leo Lionni, Niccolò Tucci, Marcel Breuer, and Bernard Rudofsky. When Henri Cartier-Bresson was in New York, he too was a regular. Dorothy Norman and Jean Stein invited Steinberg to parties that included socialites, left-leaning intellectuals, and movie stars. Geoffrey Hellman and his wife Daphne gave soirees at their town house, where the hottest new writer or painter held court and Daphne often played her harp. Mary McCarthy, then married to Bowden Broadwater, introduced him to the crowd at *Partisan Review*; Steinberg shared her political views, and they formed a deep friendship based in later years on mutual activism. He enjoyed conversations with Joel Sayre and shared his love of postcards and exchanged them with Walker Evans; he learned a little bit about etching from Stanley William Hayter, with whom he exchanged examples of work; and he kept up his friendships with the Italian circle that included Nicola Chiaromonte, Carlo Levi, and Ugo Stille. When he and Hedda were not entertaining, he was out every night of the week, elegantly dressed in the clothing he now bought exclusively at Brooks Brothers.

HE AND HEDDA SAILED FOR ENGLAND on the *Queen Mary* in July 1946 and stayed there long enough to visit their various galleries and renew contact with friends before going on to France. In Paris they began a close friendship with Janet Flanner, *The New Yorker*'s "Genet." Through Henri Cartier-Bresson they met Giacometti, and Gjon Mili gave them an introduction to Jean-Paul Sartre and Simone de Beauvoir. Steinberg was entranced with the laconic and taciturn Giacometti after his first visit to his studio, where everything was a work of art, even the plaster-encrusted telephone. It was different with existentialism's high priest and priestess, with whom there was no rapport.

Steinberg went to Sartre's Rue Bonaparte apartment "because of my own snobbery," to draw a small portrait. Sartre's mother (with whom he lived) made him uncomfortable by watching over his shoulder as he drew. Later he drew Beauvoir, but her portrait was perfunctory and unsatisfying, as she was in a hurry for him to finish and there was no conversation between them. Neither she nor Sartre was interested in the portraits, and Steinberg never showed them his drawings. "Things never clicked for us with them," Hedda recalled.

Steinberg was furious with Sartre's contention that "the Jews had survived only *because* of their persecution—for which therefore, they should thank God"; Sartre and Beauvoir dismissed Steinberg because of his hatred of communism and his embrace of all things American. When they saw each other in the Café Flore or the bar at the Pont Royal, they always nodded politely, but that was all. Several years later, when Hedda was in Paris without Saul, he scolded her for forcing Sartre to recognize and greet her in the Bar Pont Royal. He thought she should have snubbed Sartre, as she was far too good for the likes of him.

WHEN THEY LEFT PARIS, SAUL AND Hedda headed for Monte Carlo, because he wanted to gamble. They took a scenic route that had them rambling through Angers, Auxerre, Aix, Montpellier, Albi, and Toulouse. Saul won a little at the casino, which put him in a jolly mood as they continued on to Italy, where he saw Aldo in Milan for the first time since 1941. He was so determined to get Aldo to America that he launched a number of schemes, including trying to get press credentials from *The New Yorker*, which didn't happen. He gave Aldo 50,000 lire to pay for a trip to Paris, where he wanted them to meet once his stint covering the Nuremberg trials was finished. He also promised to send more money to Aldo in regular increments.

Hedda returned to Paris to stay with her mother and brother while Saul went to Rome. He told her he was going to meetings with various friends who were interested in vague and amorphous film projects, which he mostly invented, but he didn't tell her his real reason: Ada was living there and he wanted to see her. The meeting went badly, and although he did not tell her he was married, "she figured it out." They resumed their affair, and he was relieved to find that he had no further doubts about having married Hedda instead of her. Nevertheless, when he left Ada he was "feeling guilty" for how he had treated her, which he tried to assuage by giving her 50,000 lire and promising to write and send money on a regular basis.

After he left Ada, he went to Udine, Vienna, and Munich and then on to Berlin to prepare himself to face Nuremberg. When he wrote to Aldo, he said he saw "Goring and company" but made no comment about the trials themselves. He was

Steinberg with Sterne and Aldo Buzzi in New York, early 1950s.

quartered with other American correspondents in the Faber Castle, home to the pencil-manufacturing family, sharing a room the size of a basketball court. Among them were John Stanton of *Life* and Victor Bernstein of *PM*, for whom he made his first "passport," a fanciful false document akin to the larger diplomas, this one proclaiming Bernstein a "special ambassador to the War Crimes Trials." Otherwise, everything he saw was "very depressing." He tried to make a joke of it when he wrote to his parents: "I was in Nuremberg for the end of the trial and the executions (I didn't assist in this)," but he was serious when he described to Aldo his sadness at what he saw throughout Germany. There was too much "pointless misery and destruction, especially in Berlin, where the ruins of bad architecture created ugly buildings and ugly ruins." His drawings of the devastated landscape and the wretchedness of daily life appeared in the portfolio "Berlin" in *The New Yorker* on March 29 and April 12, 1947. By that time he and Hedda had finally managed to get out of Europe and back to New York, where they made some major changes in their working lives.

THEY HAD BEEN IN EUROPE FOR six months, which was almost three months longer than they had originally intended to stay, and Saul had "loafed" and done no work. They dallied because of the pleasure of unplanned side trips, such as an extended stay on the French Riviera, but the main delay was caused by both ship and airline strikes in France. They tried from Paris to confirm departures from England or Sweden, but everything was fully booked and they were unable to leave before cold weather set in. They had only taken summer clothes, so they had to ask friends in New York to send their winter clothing, because they could not sail until the end of November. The return voyage in early December was "calm and dignified," but when compared to Paris, they thought "New York was dirty, disagreeable, and smelled bad." Nevertheless, "little by little, one falls in love with it again."

Steinberg had so many projects under way that he needed more space than the 50th Street apartment could provide, so he left it for Hedda to work in and rented a studio at 38 West 59th Street. Saul told Aldo it would solve the problem of where he would live when he came to New York, because he was determined to get him there. But even the studio space was not enough room for Steinberg's many projects, so he also rented office space at 107 East 60th Street. He liked the daily walk to the studio but did not like the feeling of leaving home each morning to go to a job—he had had enough of that in the navy. One way he thought to make himself feel more at home was to install a bed and a carpet, which he soon did, more for Aldo's future comfort than his own.

Once he had an office, his first order of business was to try to persuade Iris Barry, the founder of the film department at the Museum of Modern Art, to curate a film festival, with which he would cooperate as another of his ongoing schemes to bring Aldo to New York. Aldo had never practiced architecture, and his career in the early postwar years consisted of working on whatever tasks his Lattuada brother-in-law found for him on the sets of his films. It was Aldo's wife (as he always called Bianca) who held what Hedda called "the big job" as her brother's most trusted associate, while Aldo was "more like a nineteenth-century gentleman—a bit of a dabbler in many things." Steinberg loved the movies but was not interested in the intellectual idea of film, nor was he interested in the attention to administrative detail required to make an international documentary film festival happen, and the project soon languished.

He threw himself into socializing, and his date book grew fat with new names of people who became good friends, such as Monroe Wheeler, Russell Lynes, Herbert Berghof and Uta Hagen, Leo Lerman, and Hattie Carnegie. He was a guest at the elegant Gramercy Park mansion owned by Benjamin Sonnenberg, where he met the ten-year-old Benjamin Jr. (a good friend as an adult) for the first time. Alexander "Sasha" Schneider, the violinist famed for his excellent cooking, was then living with the actress Geraldine Page, to whom Saul paid the kind of attention that made Hedda embarrassed and sad. Schneider loved to gather friends for glittering conversation over his gourmet food, and he invited Saul and Hedda to dine with Véra and Vladimir Nabokov. At their first meeting they discussed Nabokov's study of Nikolai Gogol, which Steinberg had already reread several times. He continued to reread it frequently for the rest of his life, each time finding in it something new to pique his intellectual curiosity. It became one of his frequent references, almost a kind of symbolic shorthand for ideas of his own that he wanted to convey, particularly in the drawings that featured an enormous nose. Similarly, Nabokov's favorite artist was the "wonderful Saul Steinberg," who "could raise unexpected questions about the consequence of a style or even a single line, or could open up a metaphysical riddle with as much wit as an Escher or a Magritte and with far more economy." With Nabokov, Steinberg formed another of his lasting intellectual friendships, which were almost always with writers, Saul Bellow and William Gaddis primary among them. Other writers played important roles in Steinberg's intellectual development, but it was Nabokov who was responsible for a major impact on his life: a few years after they met, Nabokov told him how to break his daily habit of smoking three or more packs of Salem cigarettes "cold turkey." It took two

attempts, but Steinberg followed Nabokov's instructions and never smoked again.

THERE WAS ANOTHER MAJOR TRIP IN the spring, this time to Mexico City for the month of April. Hedda was already there, studying and working with Miguel Covarrubias, and Saul and Henri and Monique Cartier-Bresson joined her. They and Hedda stayed on after Saul returned to New York to finish up a mural commission for the Bonwit Teller department store. Afterward, on May 20, Saul left for Cincinnati, where he had a commission to create murals for a new restaurant, the Skyline at the Terrace Plaza Hotel. The latter mural interested him most but not for the actual work: he had been as far as Pittsburgh, and now he had the opportunity to see Cincinnati and to cross the Ohio River into Kentucky as a side trip.

He made the Bonwit Teller mural quickly but was not pleased with it. The one for the Skyline restaurant, which was "much bigger and more serious," was going to require a lot more thought before he could even begin to do the considerable work required. He made a preliminary visit to the site in May, driving along the Pennsylvania Turnpike in his big Packard convertible, thought about the mural over the summer while he and Hedda were in Vermont with the Nivolas, and then worked on it from October until the end of the year. His friend Gjon Mili offered his photography studio on the Lower East Side because Steinberg needed more space than his own small room to execute a mural whose dimensions were too large for it. He planned to make it in sections using oil on canvas, and, in yet another of his schemes to bring Aldo to New York, offered him the job of "assistant, with excellent pay." Aldo declined, so Steinberg worked alone.

Another request came in August, when he interrupted his Vermont vacation to rush to New York and supervise the installation of the Bonwit Teller mural and worry about the Cincinnati project. The industrial designer Henry Dreyfuss wanted Steinberg to execute murals for the four bars on the "Four Aces" ships of the American Export Lines. Steinberg accepted, as he did every lucrative commission, but he was growing both weary and wary of murals: "The trouble is that these things give me no pleasure; from the time the first drawing is made to when the mural is finished too much time goes by for the original drawing to go on pleasing me." Once the original was complete, he found things that he wanted to change, but by then it was too complicated to do so, "and so I say to hell with it, let's finish it as it is, get rid of it as though it were mumps or some other illness." Even worse was the process that followed the execution, when he had to deal with the architects in charge of installing

what he drew. This part of the process reminded him of the despised GUF in Mussolini's Italy—the Gruppi Universitari Fascisti—"because they have to combine art or idealism with business."

As was usual with Steinberg, however, once he got involved in the actual work, the "tribulations" turned into an appreciation of its "pleasure." He was sorry to see the Cincinnati project end because he so enjoyed painting with oils on "very fine canvas, the best Belgian linen." He was delighted that it turned out so well and was happy to have at least one bright spot in a year that was not ending on a high note.

IN ROMANIA, THE RUSSIANS WERE THREATENING to close the frontiers and cut off immigration, and Rosa was growing frantic that she and Moritz would not be able to leave. Now that the country was solidly in the Soviet bloc behind the Iron Curtain, there was no possibility of bringing them directly to New York or to France, so Steinberg began to investigate whether he could send them to a South American country for several years until they could qualify for entry into the United States. "The business of visas begins again," he noted wearily. Anything beside his work was "a bother" he did not want to deal with, nor did he have to, because Hedda took care of every detail of their daily life. She was left to plod with the mundane in order for Saul to soar. For him, "if I have to do anything beyond [work] such as life, money, supervision, strategy, then the work—quality—turns out badly."

Saul did secure South American visas for his parents, but immediately after, Hedda took charge. She was able to arrange for them to pass through France, where they would stay in Paris on an extended visa for as long as they wished as guests of her mother and brother. She went to Paris before New Year's 1948 to prepare for their arrival, which, because of Rosa's requirements, she compared to setting up a small village. Hedda left Saul to welcome the new year in yet another fit of the gloom and doom he always felt about the holiday. He was in such a bad mood that he invented a bad case of the "grippe" to escape most of the invitations from "old bores," who were actually people whose company he otherwise enjoyed.

He told Aldo that it was no small matter to have to face taking on the responsibility for five or perhaps seven new Romanian dependents, for besides his parents and his sister and her family, one of Rosa's sisters and her son also wanted to come. Since he left the navy, he had tried to set up a routine wherein he worked hard for six or seven months of the year on as many commercial commissions as he could fulfill so that he would have enough money to support his dependents and then travel and do his own work for the other five. Now

that he would be entirely responsible for the well-being of so many, he worried not only that the pleasant lifestyle he had created would be disrupted, but also that it might vanish if he was not able to earn enough to support everyone. Ever since childhood, he had "always looked for ways to escape and avoid families." Now it appeared that all his efforts were for naught, and he would never be free of the familial bosom.

SLAVING AWAY WITH PLEASURE

To work, I must isolate myself. It's a weakness of mine. I also find it very difficult to accept things from other people. I prefer to exchange gifts, or even to pay excessive sums to get exactly what I want. I realize it's a kind of arrogance: I want to be the person in charge, the person steering the car, the one in control. If anybody does something for me, I feel used, manipulated, no longer free.

Hedda was in France in the winter of 1948, ostensibly to prepare for settling Saul's parents, while he stayed in New York to work on the many commissions that had spring deadlines. That was the reason Hedda gave to friends to explain her long absence, but in reality it was one of the many times she went away to give Saul time to think about the state of their marriage and the responsibility he bore for the problems within it. From the moment she left, he missed her and reverted to the wartime lover who could not live without her and worried that she would leave him, a far cry from the dominating and domineering husband who took her for granted when she was at home. He wanted to join her in France as soon as he could get his various commissions under control, but he claimed to be afraid of commercial airliners and refused to fly, insisting that he had to sail in a first-class cabin on the best ocean liner. It was difficult to secure passage when the completion dates of so many projects (most notably of the Cincinnati murals) were indefinite.

He was surprised to find how upsetting it was to be alone in their apartment without her. At night the building was full of noises he never heard when she was with him, and sometimes he woke up in a panic when he reached for her and found her side of the bed empty. He even ate his meals in her seat at the table so that he didn't have to look at her empty chair. He wrote to her almost every day and in each letter told her how much he loved her and how she was his dearest friend and the best thing ever to happen in his life. He wrote these letters during the time that he was at the height of his philandering; Hedda was well aware of it, and it was the cause of the first and thus far most dangerous period of tension between them.

Many years later, when she was an incapacitated woman in her nineties, Hedda spent much of her time reflecting on her marriage to Saul. She described it as "highly interesting, occasionally wonderful, very often difficult. Saul was not prepared for conjugal life; he wanted total freedom from every point of view." Hedda knew from the beginning that hers would be an open marriage, with "Saul having casual affairs every two minutes if he could have managed," and she had no choice but to accept it. She did not need to read the appointment books he always left open on his desk to know when he was in the midst of an infatuation, when his only nod to discretion was to note his assignations in an easily recognizable shorthand or code with cryptic notations of single initials, room numbers, and times. Even though Hedda always considered herself unconventional, she still resented it when he casually described "interesting things" about other women's bodies, such as "her ankles as seen from the left," or "the inside of her upper arm," or her "nice earlobes." Only much later, when she forced herself to accept that his idea of marriage was "Fellini's 8½," was she able to feel more compassion than anger toward him: "In a way, sex was his life. He deprived himself of true union because he was not ever in love." It took her years to arrive at this understanding, but in the beginning it was hard.

Hedda had gone to Paris earlier than she needed to and was staying longer than she had originally planned just to give Saul time to realize what she brought to the marriage. It was the first of the many separations she instigated in order for her absence to make his heart grow fonder—a difficult course to take the first time she did it, but one she used repeatedly during the years they lived together. Indeed, as soon as she was gone, he broke off several of his more persistent liaisons with women who wanted him to commit to more than casual and occasional sex, for without the security of Hedda's presence, they frightened him. Worried that she might retaliate by initiating a relationship of her own in Paris, he told her that they should both remember that they were married to each other and should not "harm" themselves or their marriage in any way. Now that she was gone, he realized how much "self-confidence" she gave him, and the reason he missed her so much was that he truly loved her.

HE WENT OUT ALMOST EVERY NIGHT just to avoid the loneliness of being in the apartment without her, but he curtailed his womanizing and socialized mostly with male friends, particularly Richard Lindner, to whom he and Hedda had become close. Within minutes at their first meeting, they both knew that Lindner would become their lifelong friend, and he did. Like them, he was a refugee who embraced all things American from the moment he arrived in

1941. They were all approximately the same age and had many things in common, from their personal backgrounds to their political underpinnings. Lindner was born in 1901 to German Jewish parents, and his upbringing in a cultured middle-class household in Nuremberg was similar to Sterne's. Like Steinberg, he was always aware that as a Jew, he was an outsider in a precarious situation in his birth country. Lindner was educated at art academies in Nuremberg and Munich and worked for a short time in Berlin before becoming the art director of a Munich publishing house. He resigned in 1933, the day after Hitler became chancellor, and went into exile in Paris, where he became active in the Resistance, served in the French Army, and was briefly interned before he made his way to the United States. When he met Steinberg and Sterne in 1945, he was working as an illustrator for books and magazines, among them *Harper's Bazaar* and *Vogue*, but he was eager to devote himself to painting. In 1953 he put his friends into one of his most famous paintings, *The Meeting*, now in the collection of the Museum of Modern Art, and in 1954, when he had his first solo exhibition, he followed them to Betty Parsons's gallery.

They and Lindner shared the same idiosyncratic but insightful responses to much of contemporary American art and artists. Steinberg credited Lindner with a "proto-pop [art] color sense," one that he shared. They had many friends in common, both abroad and in New York, which further deepened their bond. Saul was a dedicated poker player and spent many pleasant evenings playing at Sasha Schneider's apartment with Lindner and Gjon Mili. Lindner introduced them to the set designer René Bouché, and Saul and Hedda befriended him as well.

Invitations continued to pour in while Hedda was in Paris, and Steinberg accepted most of them, but only if he was in the mood. He saw a lot of his old friends, the writer Niccolò Tucci and the photographer Dave Sherman, but he dismissed them as his "old bores" on the rare occasions when he felt like staying home alone. When Hedda was in New York, she generally accompanied him, but after she returned from the Paris sojourn, she told him she did not like the constant round of parties and dinners and preferred to spend her evenings at home reading or painting. She liked it when friends dropped in for casual suppers in her kitchen because she liked to cook and enjoyed intellectual conversations, but only one-on-one or with two or three people she knew well.

Saul, on the other hand, liked to get dressed up and go out, to places where more and more he could count on holding the floor. He liked to dine at the home of the dancer Sono Osato and her real estate developer husband, Victor Elmale, because they always deferred to him for conversation. It was always a

pleasure when the Covarrubias were visiting them from Mexico and he could steer the dinner table conversation to Hedda and her work, which they all admired. Irving Penn invited him to an opening of his photographs, where he chatted with Tatiana and Alexander Liberman about future projects he might do for *Vogue*, and soon he was one of their favorite dinner guests. These occasions soothed the paranoia that always lurked in his mind, that he would be a penniless failure because at any moment everyone might stop buying his work; in this instance, because he had just done a series of drawings for the magazine that did not "come out well" and Liberman had rejected them. No publication had done this in recent years, and the Libermans' invitations assuaged his fear that *Vogue* might become the first of many.

He was working hard every day and drawing constantly, but much of what he submitted to publications that had hitherto accepted everything he sent was now being culled, sometimes with a high percentage of rejections. When a politically themed drawing he was trying to make for a *New Yorker* cover during the forthcoming election cycle was rejected—"something corny with eagles and floating allegories"—it made him look back with the eye of a critic at the earliest drawings he had done for the magazine; he concluded that they were "mediocre," and he could not see any genuine progression or development in his work since then. He worried that he might become "forced by necessities to perfect my mediocrity." A qualified joy came when various commercial firms accepted without comment a dozen advertising drawings because they made "lots of money (no Victor [Civita] involved)."

Every morning he went to his studio and worked on commercial projects and his own drawings; each afternoon he returned to the apartment, where he took over Hedda's workspace and tried to paint with oils to amass enough canvases for a show at Betty Parsons's gallery. He told Hedda he was amazed by how much he had to learn about using oils and how difficult it was. He was pleased when he taught himself to spread color with a knife and with the tricks he picked up from studying the work of other painters in museums, particularly Matisse. When he was invited to a "private selected pre-preview" of his friend Joan Miró's show at MoMA, he went to see what techniques he might copy, but he left after ten minutes, sure that he would learn nothing while surrounded by a "sad bunch of snobs."

WITH HEDDA AWAY, HE HAD LOTS of time to worry about his general health, as he had still not fully recovered from the illnesses and bad diet of the war years. He tended naturally toward hypochondria, and so he took care to give Hedda the details of each whinge and twinge in every letter as a ploy to elicit

her sympathy and perhaps an earlier homecoming. Without her, it also seemed as if every illness that made the rounds of the city felled him, and he had various forms of "flu" or "grippe" throughout the winter. Worst of all were the problems with his teeth, which had been seriously neglected for years. He was now consulting dentists, endodontists, and dental surgeons for months on end, a situation that lasted every year for the rest of his life. Because his teeth gave him his worst "real hell," he was delighted when his primary dentist took a skiing vacation and he got a respite from the several-times-weekly sessions, which sometimes lasted several hours. When the dentist returned, his only relief came on the several occasions when he went to Cincinnati to supervise the installation of the Skyline Restaurant mural in the Terrace Plaza Hotel.

Steinberg took Constantino Nivola with him, because he needed help with the installation. He had absolute trust in Tino's vision of how it should be hung but was irritated by his old friend's devotion to his wife and children, who were the main subjects of his conversation as they worked. He believed he had to baby Tino by listening, and he found it a little boring, especially after long days of being polite to the local people, who treated him with "silence from the upper classes and big insulting laughter and scorn from the uncultured." It made him furious when they asked how much he was paid for the mural and what it represented. He told Hedda that Cincinnati was a miserable city and thanked God that they did not "have to depend on or flatter people like that . . . ruthless, fat, and strongly intent on the most modest and vulgar things of life."

Of the mural itself, he went back and forth with the usual gamut of emotions he felt during large and long projects, first liking it enormously, then wishing he could make significant changes, and finally throwing up his hands and wanting to walk away from it. Eventually he decided that he liked the way it turned out, because he could stand in the enormous room and see almost the entire length of the mural with a single sweep of the eyes, and "that's a pleasant surprise." It inspired him with new ideas about adding to and improving everything about it, but it was too late to make changes, so he left it as it was and caught the train back to New York.

It was beginning to seem as if murals were going to be the most constant form of expression in his career, as Henry Dreyfuss was pestering him to come to lunches and meetings to discuss the ones for the four ships. When Steinberg compared the murals for the ships to those for the Cincinnati restaurant, he felt more secure about the new project, because the shipboard setting was on a smaller scale. He thought he could do the full-scale drawings while he was in Europe with Hedda and have them shipped back to New York, so he

began to investigate a definite sailing reservation. Just as he started, a request for another mural came from an architect in Washington, D.C., who wanted him to make a large one for a hotel there. Even though Steinberg was worried about not having enough money to be able to spend two or three months in Europe in fairly affluent comfort, he turned down the offer.

There were, however, lucrative smaller commercial assignments that he thought he could dash off quickly before he left. *House and Garden* editors asked for twelve drawings they could use to advertise their magazine in *The New Yorker*. They told him what they wanted, but he thought their ideas were silly and convinced them to use his, which were "a lot funnier." *Holiday* magazine wanted to sign him to a contract that would guarantee him a certain amount of work each year. He wanted to do it but thought he should first consult the editors at *The New Yorker*, who let him know they disapproved of his working for any other magazine on anything but a freelance basis. He gave up the idea, but only after they gave something in return: correspondent credentials that he could use whenever he traveled.

Steinberg was unable to secure the May 7 passage he wanted and had to wait until the fourteenth, when the only space available was a cabin on the *Queen Mary* that he had to share with a quiet businessman, who used the room only to sleep and had no interest in pursuing a friendship with the famous artist. Steinberg was jubilant that the crossing would take a swift five days and put him in Cherbourg on May 19. He worked furiously to tie up all the loose ends in New York, but there was also a lot of socializing, as everyone wanted to wish him bon voyage. Monroe Wheeler invited him to dinner with two other good friends, Russell Lynes and Loren McIver, and Sasha Schneider gave a dual farewell party, because he was leaving on a concert tour. After a dinner at the home of the architect Ben Baldwin, Saul was able to give Hedda the good news from Betty Parsons, who was another guest, that two of Hedda's large paintings of agricultural machines had been selected for a national tour of museums and for the prestigious exhibition of American painting at the Carnegie Institute of Pittsburgh. "Very important," Saul declared. Parsons gave him the even better news that she had just sold one of Hedda's larger canvases for a good price. "Congrats, Pig, and worst," he wrote, using one of his pet names for her ("Rabbit" was the other) and taking care to avoid the evil eye by invoking the Romanian custom of wishing the worst of luck instead of the best. He told her he would bring her some fine brushes that Leo Lerman sent as a gift so that she could keep on working.

Hedda had been staying with her brother and his family in Paris, but once Saul arrived they wanted to rent an apartment that was big enough to work

in, and Schneider thought he had the perfect solution. He wanted them to exchange apartments with Agnes Capri, a multitalented actor, singer, and theater producer, who had a stunning duplex on the Quai Voltaire, overlooking the Seine and the Louvre. At first the idea excited Saul, but the more he thought about it, the more it upset him. He did not know Agnes Capri, and even though her apartment was spectacular and she was vouched for in the highest terms by his trusted friend, Steinberg's paranoia came to the fore and he rejected the exchange. He told Hedda he could not bear to think of a stranger prowling among their things and possibly laughing at their possessions or sneering at their way of life.

He did, however, make one significant rental when Schneider agreed to take the Packard convertible for $100 a month. Saul was ecstatic, because he loved the car and didn't want to sell it, but he was even happier when Igor Stravinsky (who had come to Schneider's dual farewell party) agreed to sell him a Cadillac convertible he no longer needed, as he and his wife were going to California. Saul couldn't wait to get to Paris, but he was already anticipating coming home and taking his first road trip in the Cadillac.

IN HIS LAST LETTER TO HEDDA before he sailed, Saul wrote that he could not bear to think of being separated from her ever again, and once they were together he was going to tell her all the intimate things he had been unable to say since they were married. He wanted to take her "on the biggest and noisiest honeymoon, in France (or maybe go somewhere else, we'll see)." The Berlin airlift had begun, and Hedda wrote back that she was terrified the Russians would start bombing and something would happen to him on the voyage to France or to her if she got on a ship to return to New York. She was sure there would be a nuclear war, but Saul told her not to worry because wars always started in the fall and they might as well enjoy a Paris honeymoon before then.

In Paris they stayed in a hotel on the Boulevard Raspail rather than an apartment, just long enough to visit the galleries, where Steinberg thought "a lot of bad art [was] running around." He called it "the famous artistic climate of Paris, shit that makes good lettuce grow." He would have stayed longer if Aldo had been able to come (he sent money for him to make the trip), but Aldo and Bianca were working in Mantua on one of Lattuada's films, so Aldo suggested that Saul visit him instead. Saul and Hedda started out in a rental car for Italy via the French Jura and Geneva, but the fog was thick and the mountains frightening, and it took them several days to get there. After a few days they left the car and took a very slow train that meandered through Provence to Toulouse and finally Biarritz, where Saul felt "indifferent and stupid." The

town and the people made him want to find someplace ugly where he could work, but first he had to go back to Paris to await his parents' arrival.

SINCE FEBRUARY HE HAD BEEN BRACING himself "for the big Romanian cloud" that he expected to envelop him and that made him, a true skeptic, think he needed to get himself "psychologized." It reassured him to think he could always talk to a psychologist for those "moments when I feel really low," but despite the worry about supporting so many people, he never fell that far down in the dumps. He told Aldo that "it's no small matter, the thought and sight of five or maybe seven new dependents arriving from Romania." Before he left New York, he had already been helping various Romanian refugees, either those he befriended in Santo Domingo or those from Bucharest who had come directly to the United States in the Romanian quota. He knew that they considered him a soft touch who could be counted on for financial help, but he never complained and gave generously, quietly, and willingly. Still, it got so that he hated to answer the phone, because so many times the caller greeted him in Romanian and he knew that a plea for money would follow. He was tired and depressed by the thought that once his family arrived, his burden of responsibilities would not only increase but also remain constant. To add to his depression, he was still tired from the frenetic work schedule he had kept in the first half of the year, and so it was probably not surprising that the joyous honeymoon he envisioned was less than satisfactory for either him or Hedda. By the time they left Biarritz, Saul was his usual intense, controlled, unemotional self, while Hedda continued to play her role of the agreeable and complacent wife. They were tanned but tired of killing time and eager to go home.

THEY RETURNED TO NEW YORK IN October, on a good ship in a calm ocean, where they "ate bad meals on massive gold plates." Using the Milanese variant of a vulgar Roman expression, Saul told Aldo that he had wasted enough time playing and if he hoped to lead a happy life next summer, he knew he had to dedicate himself to industry and commerce for the entire winter.

His parents had arrived in Paris shortly after Christmas Day, his mother's birthday. Hedda's brother and his wife were both slightly overwhelmed by Rosa's needy and demanding behavior, but they did everything possible to make her and Moritz comfortable and to keep the unpleasant details from Saul. He was relieved that their arrival, although "forced" on him, turned out to be straightforward and without complication and that all his fears were unfounded. He wanted to put off seeing them until the spring.

Once he was back in the States, his work went well; he was "slaving away at

it with pleasure," particularly three new color designs for the Patterson Fabric Company, one of the best firms in the country, with which he had an ongoing commission until the mid-1950s. He began the new year, 1949, by looking for a new and larger studio, a single space where he could combine an office and a workplace, and he found a large room on the tenth floor of a building at 38 Central Park South that had impressive views overlooking the park. He did a series of drawings in preparation for the first large-scale work, a new mural called "An Exhibition for Modern Living," curated by Alexander Girard for the Detroit Institute of Arts and later hung at the J. L. Hudson department store. As all the other architects involved in the project were exhibiting "the best design (in their opinion) of the past twenty years," Steinberg decided to depict "all the ugly or stupid things that have been done." He drew "the panorama of a whole city, with buses, stores, houses, cottages, skyscrapers, etc.," as well as cross-sections of various buildings and houses that showed the different kinds of life that went on inside them. By the time he finished, he had twenty-four drawings, which were later put into a small exhibition at the art institute, where he hoped for a good sale. The show drew record crowds, but not a single one was sold. Girard was sorry to relay the bad news that the people in Detroit did not understand "values." Steinberg decided to concentrate on the positive: he had "a bunch of cartoons" in the works, mostly for *The New Yorker*, and was beginning to collect old material and make new drawings for a still untitled book commissioned by "a rich publisher."

All these projects made Steinberg realize that work was "therapeutic" for him, "but still more therapeutic are the money and success that come with it." He told Aldo that he doubted he would have the strength to give up money and success, so what he gave up instead was the possibility of devoting himself purely to his art, especially to painting. If his own work did not actually take a back seat to commercial projects, it was certainly coequal with it until the early 1960s.

SIMON MICHAEL BESSIE WAS "the rich publisher" at Harper & Brothers who wanted a book of his drawings and cartoons, and who wooed him with fine lunches and dinners in order to persuade him to prepare one. Steinberg thought he had enough drawings among those he had published earlier, all of which he could reuse, because he always entered into the same agreement with other publications that he had insisted on from his earliest dealings with *The New Yorker*: he sold the rights for first-time reproduction but kept the originals and the right to use them as he wished. He had more than enough material ready to hand, and with some new drawings to unify them around a theme, he knew he had a book.

The new book presented the same problem he had had with *All in Line*: coming up with a title. He thought about "Wrong Century, Maybe," or simply "The Wrong Century," but he decided that this was an important title that had to be saved for a good novel, as it could be better explained through a written story. For a short time he liked "Rapid Transit," but after much "searching and indecision," he settled on *The Art of Living*, chosen because it was "an old and honored title that means nothing (it makes me laugh)."

Unlike the case of *All in Line*, the reception for *The Art of Living* was tepid. The book was published in early fall in an edition of 20,000 copies, but despite favorable reviews, by Christmas only 10,000 had been sold and Steinberg feared the book would be remaindered. All the reviews were positive and he thought some of them were "even intelligently written," but he still found it "a mystery what makes a book sell."

True to his decision to favor money over art, he spent the winter concentrating on tried-and-true projects he could fulfill without having to think too much or too hard about them. He was now hiding from new work far more than accepting it, as he was reluctant to take offers from prestigious publications for which he would have to come up with something that consumed both time and energy. Carol Janeway at *Harper's Bazaar*, Leo Lerman at *Mademoiselle*, and several editors at Knopf as well as other publishers and publications made offers. *Art News* hounded him with phone calls because he didn't answer the editors' letters, and worst of all, other artists, from college art students to wannabe illustrators, sent him their work or pounded on his door with portfolio in hand to ask for "the maestro's" opinion. He complained of having to work like a businessman for eight to ten hours every day, especially after he had to hire a Miss Elinor to take care of much of the detail. He wasn't used to having anyone in his studio while he was working, and he didn't like it. He didn't even like having to give her directions about how to respond to the many requests before sending her off to take care of them elsewhere. Miss Elinor didn't last long, and over the years there was a succession of others, who didn't last either.

One of the few professional highlights of the early spring was the visit to New York of the Italian architect Ernesto Rogers, with whom Steinberg was delighted to renew a prewar acquaintance that became an abiding friendship, although a qualified one at the start. Steinberg thought Rogers was one of the tourists who went home and wrote a book about "Me and America" after three weeks in the country. He changed his mind as their first luncheon lengthened to fill five hours. When Rogers became intrigued by Steinberg's description of Hedda's latest paintings of machines and buildings, Steinberg took him to Betty Parsons's gallery to see them. Rogers left with "great admiration" for

Hedda and invited Saul to bring her to his home in Bergamo when they went to Italy in July. Yet again Saul was pleased to be married to an intelligent, talented, and beautiful woman and proud that others recognized her extraordinary qualities. He could tell her so in letters, but unfortunately he was unable to convey these feelings when they were alone together.

She had gone to France again, and this time her reasons were far more serious. For the second year in a row, he wrote in letters what he simply could not say in person: "I made up my mind in your absence that I'm forever attached to you and all the talk about betrayal, not enough love, divorce, etc. was all nonsense, yours or mine, and it's time to stop it."

He had plans to join her in early July but something tragic happened that made him forget his fear of flying and try to book passage in June on an Air France plane: Hedda knew she was pregnant when she left New York, and her reason for going to Paris was to sort out her feelings about what to do. In Paris, she discovered that the pregnancy was ectopic and she needed abdominal surgery to repair the damage it had caused. A flurry of telegrams ensued during the ten or so days she was in a Paris hospital, and when she left to convalesce on the Riviera, Saul wrote frantic letters. He told her he had consulted their family physician in New York for reassurance that the French doctors were giving her proper treatment, while she wrote from Juan-les-Pins urging him to stay in New York and finish his work because there was nothing he could do for her. She knew how many commissions he had and how difficult it would be for him to leave them unfinished, and also she knew by now that his work always came first.

He and Hedda had never really discussed the idea of having children. It was unspoken between them that Saul was the equivalent of their child and all their energies and attentions were to be focused on him. He thought they were complete as a couple and did not need the distraction of a child, and besides, children irritated him. When he was forced to be around them, he did not know how to behave. Hedda remembered when the proud mother of a newborn took them into the nursery during a dinner party, insisting that they admire her sleeping baby. Saul rubbed his shoe back and forth on the carpet, then touched his finger to the baby's nose to produce an electric shock. The child woke up screaming, the mother was upset, and Saul (innocently and truthfully) said all he wanted to do was to create a situation where the child would always remember him. He didn't understand his friend Tino Nivola, who had bought an old farmhouse in the village of Springs in eastern Long Island, where "he works three hours a week and the rest of his time brings up his children." Saul's incomprehension of Tino's deep and loving attachment often resulted in cut-

ting remarks that were hurtful to his old friend, who always ignored them and forgave him.

Hedda was thirty-nine in 1949, a time when most women had their children in their early twenties, and thus she was more of an age to be a grandmother than a mother. She and Saul had never really discussed the possibility that they might become parents, and once the pregnancy ended and the scare over her health was gone, they treated it as if it were akin to a ruptured appendix and just got on with their lives.

STEINBERG DIDN'T WANT TO TAKE THE time to go to Europe, nor did he want to spend two or three months there. He was worried about *The Art of Living* and used it as an excuse to delay the trip and evade his real reason for not wanting to go, the first face-to-face meeting with his parents since his 1944 furlough in Bucharest. "I brace myself for seeing [my] parents," he told Hedda, knowing that no matter what he did or said, it would offend them. He was so afraid of lashing out that he told Hedda he could not see them unless she was with him to act as the go-between: "I can't talk my mind to them because they are able to understand but they'll refuse to. If I'll break down and tell them my mind it'll be a real breakdown for me." Hedda told him that every time she saw Rosa there was constant prying, as Rosa tried to find out how often Saul wrote to each of them. He replied that the best way to distract Rosa was for Hedda to buy her something, preferably a sewing machine. "If it were not for the parents," he concluded, "I'd write you to come home. I wouldn't even go to Europe."

Work was piling up to the point where he would have to take it with him, even though he badly needed a break. For the first time in his life he suffered from insomnia and found himself drinking scotch heavily in order to relax and get to sleep. The increasing amount of business-related details made him realize he would have to find a lawyer he could put on retainer, adding one more person to his professional payroll.

He wasn't thinking clearly when he decided that the best way to avoid or evade all his work and responsibility was to leave New York. "We really have to move to the country," he told Hedda, and this became a recurring theme in his letters. The Nivolas invited him to spend a weekend in their farmhouse in the Springs section of Amagansett; Saul was the only guest, and he spent the time enthralled by Claire, their "really beautiful" daughter, while ignoring her brother, Pietro, "a very dignified little child." The next day he visited Jackson Pollock and Lee Krasner in their "curious old house and a barn where he paints on the floor. She paints, too, things that look like labels on trunks that

have traveled a lot." He told Hedda that they might think of renting a house in Springs for several weeks in September but that Long Island was not for them, because there were too many artists and they needed to be "not near painters."

In a spurt of energy after his Long Island weekend, Steinberg hired Alexander Lindey as his lawyer and made an agreement with Betty Parsons that allowed her to sell his work directly from her gallery for a 25 percent commission, with the rest coming to him. There followed a "very trying evening" with Cesar Civita, who was in New York ostensibly on other business but mostly to persuade Steinberg to renew his contract. Steinberg resisted and went home dead tired to drink a lot of scotch to get to sleep.

He gave himself the brief respite of a week off by not answering the phone or the doorbell at his studio and ignoring his correspondence. He also declined all social engagements and spent his evenings in the apartment "drinking lightly and walking up and down the floor, thinking, worrying," mostly about himself and his emotional state. Even though he did little to change his behavior, his self-analysis was perceptive: he knew that being around people made him "false, scared, formal, competitive." When he was alone he was "more harmonious" and more "at peace" with himself, because he was able to assess his actions and interactions honestly and sincerely. Such thinking further convinced him that the only way to lead a peaceful and harmonious life was to leave New York entirely and get a house in the country that had two floors, one for him and one for Hedda. He wanted Hedda to help him make moving plans when they were together in Europe, so they could "do things right" when they returned.

ONE WEEK OF SOLITUDE WAS ALL he could spare and, more truthfully, all he could stand, and he jumped right back into his frenetic, activity-filled schedule. He went to Detroit and was a guest in Alexander Girard's home, "an architect's own dream house." He loved his room, with its Mexican pottery, a small Henry Moore sculpture, an Italian ex-voto, and an Eames chair. On the way home he stopped in Cincinnati to check on the murals before rushing back to New York for a flurry of appointments. In a single day he declined an unnamed department store's invitation to do its Christmas windows, then went to Harper & Brothers to "help their ignorant editors make a blurb" for his book jacket and from there to a luncheon with the businessman roommate on the *Queen Mary*, who was organizing everything from their reservations for deck chairs to dining room meal seatings. He hurried back to the studio to write the checks to pay his bills, because Miss Elinor had quit, then had to make phone calls in answer to a pile of letters from the Detroit staff because there were too many

questions and talking was faster than writing. And after he crammed all that into business hours, he had to return calls to friends such as Betty Parsons, Leo Lerman, and Hawley Truax at *The New Yorker*. It was a typical New York work-day, but it made him feel "like a parasite who hadn't manufactured anything, just blahblahblah."

Naturally—at least to him—several of his teeth chose this time to erupt in infections. The dentist prescribed penicillin, after which he would need at least one extraction, if not two. Penicillin calmed things down, but he worried constantly about a flare-up when he boarded the train for another working trip to Detroit, to stay again with the Girards. They entertained him with the most interesting guests they could gather for their elegant dinner parties, but mostly he spent several days on his own, walking around downtown Detroit because the mural needed details of the city itself.

One evening Steinberg was invited to dine at the home of "an architect called Saarinen," who wanted him to think about creating a mural for the Ford Motor Company's research institute, which he was designing and building. Steinberg was interested in principle, but for Hedda and not for himself. He left the publicity photos Betty Parsons had made of Hedda's paintings with Saarinen because he wanted him to commission her to make a mural of the machines, motors, electricity, and chemistry that she was then painting. The two men liked each other, especially after they discovered how much they had in common, starting with service in the OSS during the war. Although Hedda's part in the project never came to fruition, Steinberg and Saarinen's friendship endured.

In New York, he deliberately cultivated another new acquaintance, the journalist Ruth Gruber, who was much respected for her dedication to rescuing Jews during World War II and who had been instrumental since the war's end in helping displaced European Jews emigrate, first to Palestine and then to the new nation of Israel. Because of her connections at the highest levels of the United States government and the United Nations, the desperate Steinberg wanted to enlist her to help get his sister and her family out of Romania. Gruber was eager to help and wrote "most convincing letters" to various "big shots." She also took him to meet other influential people, and at "a big party of rich Jews," he saw "more old women and jewels than ever in my life." It was his introduction to the world of Jewish fund-raising at the highest levels, and for the rest of his life he gave as much as he could to every Jewish organization that asked. Gruber was willing to do what she could for Lica and Rica Roman, but she wanted something from Steinberg in return. He groused that he had to go to dinner with her and her publisher because it was "payback" time and she

wanted him to design the jacket for her new book. He tried to plead having too much other work before leaving for Europe, but "it's too late now and I promised I'd do it." After a "dull evening," he hastily designed a "dull" book jacket.

HE WAS TO SAIL ON THE *Queen Mary* on June 21, 1949, arriving in Cherbourg on the twenty-sixth, but his teeth threatened to derail the departure. When he saw the dentist the week before, the dentist told Steinberg to go to a surgeon that very day for an extraction. Instead he went to lunch with Jim Geraghty and got very drunk. After he drank so much liquor and became incoherent with nervousness, Geraghty could barely get him into the surgeon's office. The surgeon examined him and said there was no need for extraction, only for larger doses of penicillin. Steinberg sobered up immediately and got himself back to his office, where he fell into a deep sleep and did not wake up until late afternoon, when he heard Leo Lerman pounding on his door. Then it was back to business as usual. After Lerman there was a succession of visitors that ended with Geraghty, who wanted to make sure he was all right and, if he was, to look at the preliminary drawings of the Detroit murals, as he was interested in buying some for a spread in *The New Yorker*. Steinberg pulled out all his drawings and behaved as if this were his first meeting of the day with Geraghty, even though he wanted to go home and sleep "for about 20 hours."

In general he got little sleep, because there were too many parties and dinners he had to attend before his departure. Hedda worried about him and chastised him for behaving like "a loose man dancing with depraved de Kooning" at one of Bill and Elaine's raucous parties in their downtown apartment. He insisted that it had been a sedate evening during which he mostly chatted with Wilfredo Lam (whom he liked) and Stanley William Hayter (of whom he was wary). He liked de Kooning, who he insisted was "a nice man," and as that friendship deepened, Steinberg became convinced that through him he had found the key to understanding American abstract painters: "They're primitives."

As the date to sail approached, he was so busy that he limited his social engagements to the good friends he called his "old bores," paramount among them René Bouché and Richard Lindner (who always babysat the Steinbergs' cats). Russell Lynes gave a small dinner where Monroe Wheeler and Loren McIver were the only other guests, and Steinberg was able to enjoy the rarity of a serious conversation that was all about art. He was not so enthusiastic when Wheeler gave another dinner where two of the guests, McKnight Kaufer ("a mediocre artist of posters") and Glenway Westcott "kissed on both cheeks like girls." Rosa and Miguel Covarubbias were in town and he had to sit through

Miguel's documentary film about Bali, "very boring but grand for him." He took Mel and Mark Rothko to lunch at a neighborhood French restaurant, and to keep the conversation flowing with the taciturn Mark, he got them "happy with martinis." Isamu Noguchi, another good friend, was the honored guest at a number of parties before he left New York again "to go away forever," as he always said and never did, so Steinberg went to all his farewell parties. He cut short an evening with Bernard Rudofsky because he didn't feel up to the serious arguments over architecture and city planning that he knew would ensue.

The social encounters were interspersed with a great deal of work and intense reading, all of which combined in ways that eventually showed up in his drawings. From Melville's *Moby Dick* to Rebecca West's *Black Lamb and Grey Falcon*, he turned to Havelock Ellis and Balzac. Always searching for "the real America," he read Ring Lardner's short stories and Erskine Caldwell's *Tobacco Road*, which made him want to jump into the Stravinsky Cadillac and take to the open roads of the American Southeast in search of hillbillies and moonshine. To his great surprise (and delight), aspects of Balzac's *Comédie Humaine* made him "excited" about the Detroit murals in a way that he had not been excited about any work "in months or years."

He envisioned the murals as a panorama that began with the impression of speed, in keeping with Detroit as the Motor City, where the streets were named Packard, Ford, and Chrysler. The first image was a cluster of cars and trucks roaring off after having been stopped at a traffic light. They led the eye into several very small houses with huge billboards above and behind, all festooned with the word *EAT*. He was very pleased with "the trick" he used for the next house, "you know, the cute little whitewashed board house with a verandah and a man sitting on a rocking chair." The cute little house became a dozen when he made photostats and pasted them in a sequence so that "same house, same man" became the generic equivalent of every middle-class suburb in any American city. They led the eye to an A&P supermarket and a bank that he drew as a "classic temple." These were balanced by more photostat images of the middle-class house and man, which led directly into the industrial age. Factories were surrounded by thousands of cars that belonged to the workers inside, all of it encircled by "smoke stacks, gazometers, railways, etc. then slums." Steinberg deliberately rendered them in "bad and clumsy drawings" to show the poverty of spirit and misery of life such urbanization inspired. He insisted they had to be "bad" in the sense of sloppy and amateurish, because otherwise such misery "became cute." To enforce his point to the casual viewer, he made blotchy ink spots, left his fingerprints scattered here and there, and put some of the drawings on the floor so he could dirty them by stepping on

them and leaving the imprint of his rubber-heeled work shoes. To take this section of the mural one degree further away from reality, he did not use the original drawings but had them reproduced photographically. After this he veered back into repetitions of the "cute house" (as he was now calling it) until the viewer's eye stopped at a Moorish gas station, which Steinberg used to introduce a city that was all brownstones and shops until it came to a "6th Avenue like" center. Here, at street level he had movie theaters, drugstores, burlesque houses, and Italian restaurants, while above them were the offices of everyone from dentists and chiropodists to tree surgeons and passport photographers. This would lead to a skyscraper "with a fancy store on street level and about 500 floors of offices." He planned to exaggerate the height and to shape the building like a cathedral, with windows evenly distributed throughout and showing activity inside them. After this there would be a plaza with a World War I monument and a post office "with socialist murals, etc." He planned to complete the murals with views of the rich suburbs and cross-sections of the houses that populated them, in which the carefully measured and modulated activities of the wealthy and pampered residents could serve as a counterpoint to the frenetic activity that began the panorama.

He was so excited to have the project fully envisioned and mostly drawn that he apologized to Hedda for writing an entire letter about it without commenting on her health. While recovering from the ectopic pregnancy, Hedda fell sick again with an unnamed ailment. Saul's only comment was to say he was sorry and would phone their family physician, Dr. Hurd, to see if he had any useful advice for the French doctors.

By the time he sailed on June 21, the couple's letters had become a terse and tense exchange, with Hedda scolding him for destructive behavior, particularly heavy drinking. She accused him of using liquor as an escape from life, but he disagreed, saying that the only time he drank was to avoid the terror of the tooth extraction. He did agree with her "about the stupid boring results of drinking" and hoped that when they returned in August, everything would be conducive to "a year of good work with very little drinking or smoking."

He was so worried by the coldness of her last few letters that he proposed a new way to demonstrate how much he loved her. She should go to a European city small enough for him to run into her as if by accident, and they would pretend to be strangers meeting for the first time. He would court her for several days, until ("because I couldn't take this game [any longer]") he would end it by asking her to marry him. Even in such a love letter, he could not resist bragging about how well he had worked that day: "I made a big skyscraper with a few persons jumping from the roof. Entire families falling with dignity."

———

FAMILIES FALLING FROM ROOFS COULD WELL have been the metaphor for his meeting with his parents in Paris. Moritz was silent to the point of catatonia, overwhelmed by the variety and color of daily life in Paris after the drab monotony of Bucharest, but mostly rendered speechless by Rosa's constant litany of complaints. Nothing pleased her; she even complained about the gracious hospitality of Hedda's family in snide and oblique ways that made it all but impossible to contradict her. Saul was stunned to hear her bemoan all that she had given up and left behind in Bucharest, only to fall into such constrained circumstances in a city that was supposed to be the most comfortable and cultured in the world. Unspoken but inferred was her only son's lack of concern for her plight and his callous indifference to her needs. Hedda sensed that he was at the breaking point and quickly invented imaginary projects for which he needed to go to the South of France and Italy. Instead they hid out for a week in the studio she had been renting in one of the outer arrondissements, far from her brother's residence, and which Rosa and Moritz knew nothing about. Being there gave them time to see friends and visit galleries and for Saul to tend to details pertaining to work in New York that arose after his departure. They resurfaced long enough to take Rosa and Moritz to a spa, but it did not measure up to Rosa's memories of holidays by the Black Sea and was not successful. They knew they would have to do something drastic, because Paris as a final destination was not working out.

It was a relief to head to Milan, where they renewed acquaintances with colleagues from the Politecnico and discussed the possibility of future collaborations in architectural design and film. Ada was living alone in Milan after an "Italian divorce" in which she and her husband simply agreed to go their separate ways, since the country had no legal divorce. Saul decided that he would have to do more than send the occasional check, and he helped her financially for the rest of her life with regular contributions of money. He and Hedda left Milan for Bergamo and the first of a number of pleasant visits with Ernesto Rogers, and then they went to Venice. Saul took rooms at the Grand Hotel for himself and Hedda and also for Aldo and Bianca, who joined them for a happy reunion. Saul spent much of the reunion with Aldo sitting in the piazza throwing out various ideas and possibilities for work that Aldo could do in New York. He was determined to get Aldo a visa for a long stay, but nothing concrete came of it.

By mid-August, after a meandering journey through the Alpes-Maritimes and the Alsatian *route des vins*, Saul and Hedda were back in Paris, unsure of what to do about a permanent home for Moritz and Rosa and eager to escape

from their clutching neediness. They decided that the parents had to go to Nice, where there was a sizable contingent of Romanian Jewish refugees from their old neighborhood, who could offer companionship and, better yet, commiseration. Saul had to harden himself to overcome Rosa's initial recalcitrance, but shortly after, the senior Steinbergs made the move.

Hedda had been away from home for almost ten months, and she wanted to go back to New York and get to work. Saul was not all that eager to resume the life he led there, but now there were even more people who depended on him financially, and he knew he needed to keep the money coming in to support them.

That fall he was prone to a general malaise. He cut his three-pack-a-day nicotine habit down to almost nothing; he was not sure if he had "tobacco poisoning or mental stuff," but he was afraid to go to a doctor to find out. He was trying to amass a collection of drawings and cartoons that would assure a steady income for the better part of a year, but the work was "hard and depressing." It would have been easy and even enjoyable to do "variations on the same theme," but none of the publications who bought his work wanted what they called "repetition." Coming up with a single good idea gave him little satisfaction, because he had to change his thinking completely in order to find the next original one. He thought of himself as working and working, but "inertia" still came back, and with it insomnia. All his obligations seemed insurmountable,

Steinberg's parents in Nice.

and he had no energy to deal with them. "I'd rather lie awake at night over unanswered letters than make the effort to write," he told Aldo. Still, when he added up all he had done, a partial list showed "To *Vogue* 6 large, 8 Venice Medium, 7 Paris Color, 6 railways, 13 misc. Total 40. Gave *Glamour* 17 dr." There were even more that went to *The New Yorker*, plus designs that went to the two fabric companies, Patterson and Stehli, and a host of other smaller commissions. He had achieved his objective for the year, and there was enough money coming in to support all his obligations.

Saul and Hedda went off to celebrate Thanksgiving, Steinberg's favorite American holiday, with Sandy and Louisa Calder in their Roxbury, Connecticut, farmhouse. It was the first of many holiday invitations with the Calders that they accepted, for they loved the way Sandy and Louisa and their daughters gathered all the guests in the kitchen to eat and drink to excess, to dance, sing, and in general make merry. Steinberg loved Calder, "the dancing man," and on one of these happy occasions, when Saul could not hear what Sandy was telling him, he sat on his knee to hear him better. "I thought afterwards that I had not sat on a man's knee in sixty years! And that this was the only man so happy and so innocent to give me and everybody the simple and loving familiarity." It was exactly what he needed to get him to the end of a dispiriting year, and he returned to New York energized for the usual round of holiday festivities.

Unfortunately, there was no prospect of any new, different, and interesting work on his horizon, only more of the same for the usual publications, and the new decade seemed likely to start as the old one had ended. Several years earlier, when Steinberg first went to work for *The New Yorker*, Jim Geraghty astutely assessed his personality by saying he needed "excitement." It was never truer than it was in 1950.

THE ONLY HAPPILY MARRIED COUPLE

As artists, the Steinbergs pursue their separate ways . . . Both want to create a picture of America, but not the same picture. Says Hedda: "I am getting rid of images." Says Saul: "I am unfit to do anything not funny."

At a party one night, Saul was introduced to an awestruck young architect who told him that he and Hedda had a near mythical reputation as the only happily married couple in New York. That a total stranger could express what so many people believed showed how well the very public couple kept their personal lives private. The architect made his remark at a time when their professional reputations were in the ascendant and they were too busy dealing with them to focus on their personal differences, which were mostly due to Saul's inability to express emotion in person and his brief affairs and longer liaisons. However, whatever went on within the marriage stayed there, known only to the two of them.

The beautiful Hedda and the charismatic Saul certainly made a glamorous couple, admired and envied in equal measure. Most of the people they considered their friends were luminaries in the international worlds of high society, arts and letters, politics and culture, and increasingly within the rarefied atmosphere of the financial world, as wealthy collectors competed to buy their work. To outsiders looking in, their life was a constant round of enviable parties, dinners, country weekends, and long European holidays. With their professional reputations soaring, they were sought after for interviews by all the publications that mattered, and they were on almost every list of "promising" or "important" figures in the art world.

Much of the hoopla began when Hedda's photograph appeared in *Life* in January 1950, the only woman among fourteen male artists, all of them lumped together under the sobriquet "the Irascibles." The name was originally an adjective used to describe a disparate collection of painters and sculptors in

Saul Steinberg, *Untitled*, 1954.

an article that proclaimed them an "Irascible Group of Advanced Artists." It became, for better or worse, their trademark when the critic Emily Genauer wrote an editorial for the *New York Herald Tribune* that grouped them together as a de facto school. Actually, the Irascibles could trace their origin to the first of a series of meetings organized by Barnett Newman and Ad Reinhardt asking other artists to join in composing a letter to the president of the Metropolitan Museum protesting the conservative makeup of a jury selected to judge an

exhibition of contemporary art. The Irascibles declared the judges hostile to every form of "advanced art" but to abstract expressionism in particular.

Hedda befriended Newman and Reinhardt at Peggy Guggenheim's gallery when she first arrived in New York, and she liked and respected them both, as did Saul when she introduced him. She thought Newman was "politically savvy about publicity" and admired Reinhardt for being "an abstract artist in the 30's before everybody else, a very good political cartoonist and a . . . man with backbone." Both painters wanted to assure maximum publicity for their campaign to get the Met to open its doors to modern art, so they invited thirty artists to the round-table meetings, but only eighteen attended. Hedda, as a painter, was invited, but Saul, seen primarily as a cartoonist and draftsman, was not. If he was miffed by his exclusion, he never expressed it to her. They both agreed wholeheartedly with the "social [that is, political] agenda" espoused by Newman, Reinhardt, and Adolph Gottlieb (who wrote most of the letter), so Hedda went to the meetings on behalf of herself and Saul. She thought he should have been invited, but he was too busy with the many commissions that were bringing increasingly large sums of money. Fleur Cowles was prominent among those who wanted to buy his work, as she was eager to woo him for her new magazine, *Flair*.

Although other women attended the Irascibles' round table discussions (among them Janice Biala and Louise Bourgeois), Hedda was the only one who showed up for the photo session staged by Nina Leen, along with the fourteen male artists brave enough to sign the letter and risk being photographed. Hedda didn't hesitate to embrace the cause, because "in those days I signed any form of protest." As the only woman in the photo, and a strikingly beautiful one at that, she was from that moment on most often classified as an abstract expressionist, despite her insistence on two major points: the Irascibles in the famous photograph were "not a school and it never was," and the only thing they had in common was that most of them were represented by Betty Parsons and "were all considered avant-garde."

Leen's photograph was indeed striking, with Hedda Sterne dressed all in black and standing at the top of a pyramid formed by the fourteen artists seated below her. The photographer staged "the architecture" before the artists arrived by arranging fourteen chairs with name tags indicating where each man was to sit. Hedda arrived late, to the consternation of Leen, who thought she was not coming and did not have a chair marked for her. Hedda knew the omission "was not deliberate," as Leen quickly found something for her to stand on which posed her on an elevated platform at the center of the photo and made her the focal point. The entire session lasted about ten minutes, but

reverberations from it never ended: when Hedda first saw the picture, she said, "In terms of my career, it's probably the worst thing that ever happened to me." She never changed her mind.

Despite the fact that her method and technique were constantly changing, from then on she was branded an abstract expressionist, which meant that all too often her work was labeled and dismissed. Throughout the 1950s, when art historians looked for "sweeping trends" to define the contemporary scene and painters were embracing "signature styles, such as Pollock's drips and New-man's zips," Hedda's process was one of "uninterrupted flux." While critics often deemed her willingness to embrace new ways of creating art "inconsis-tent," Betty Parsons defended the constant change: "Hedda was always search-ing, never satisfied. She had many ways; most artists just have one way to go."

Like Saul Steinberg, Hedda Sterne was primarily interested in process. She could well have been describing how he approached a drawing when she described how she approached a painting: "Painting for me is a process of simultaneous understanding and explaining. I try to approach my subject uncluttered by esthetic prejudices. I put it on canvas in order to explain it to myself, yet the result should reveal something plus." When she did speak of Steinberg's work, she said that what she most admired about it was his "ability to make ideas concrete with a symbol." For her, the mystery hovering over his work was always "where did this come from?"

The idea of process was one they talked about constantly. Throughout the years they lived together, Sterne and Steinberg never lacked for conversation about making art, although they seldom spoke specifically about what they were working on at the time. Hedda explained how they were "filled with ideas, and even at the worst of times, when he was at his most remote, conversation about art was without end."

Both were avid readers, and writing techniques often enriched their con-versations about the process of making art. Sterne was keen on philosophy, particularly Schopenhauer and Hegel, and later Confucius, Lao-tzu, and other Eastern thinkers. She loved poetry, her favorites ranging from Rilke to Walt Whitman. She read fiction, but not to the extent that Steinberg did. His tastes were all-embracing and eclectic, veering from Stendhal and Manzoni to con-temporary Italian novelists like Carlo Gadda, who wrote in dialect, to Ameri-can regionalists such as James T. Farrell and Erskine Caldwell. He reread the Russian novelists repeatedly, from Gogol (his favorite) and Dostoevsky (whom he liked) to Lermontov and Turgenev (to whom he accorded lesser attention). He read through Balzac's *Comédie Humaine*, engrossed in the turmoil and travails of the characters, and was moved by some of Zola's novels, especially

those that dealt with social inequities, like *Germinal*. He liked to read American history, particularly of the Civil War period and after, and he was keenly interested in the sociological and cultural studies written after World War II that he thought would help him to understand his adopted country.

Hedda Sterne and Saul Steinberg worked devotedly at the visual arts every day, sometimes for ten to twelve hours at a stretch, but when they paused, words became their chosen form of communication. They were constantly seeking to enrich their art through reading, and if there was one defining quality about their work in the immediate postwar decade, it was that they strove to make others see visual truths about their subjects that were hitherto hidden or unclear.

IMMEDIATELY AFTER *LIFE* SINGLED OUT Hedda Sterne as "one of our most promising young painters," *Vogue* followed by placing her at number 11 on the magazine's list of "53 Living American Artists [to watch]." The article described her as "the 34-year-old abstractionist who has in paint some of the airy balances of Emily Dickinson's poetry." Hedda set out to read Dickinson's poetry to try to understand what the writer meant by the comparison. Another glowing review soon followed in the *New York Times*, describing her show at Betty Parsons's gallery as composed of "extremely handsome" abstractions that "constitute an authentic and impressive document of our society."

Hedda was pleased with the public response to her painting, but the attitude she expressed toward her own work during the war years had crystallized and hardened since her marriage. "Your work interests me much, much more than my own," she wrote to Saul during the war, as she described the pleasure derived from a long, ten- to fourteen-hour day spent painting for her own pleasure and with no thought of presenting it for public consumption or comment. After the war, as her reputation rose steadily, she clung even more steadfastly to the idea of art as an example of personal expression rather than as a product meant for the world of commerce. In the mid-1950s, after an evening in the company of Katherine Kuh, the influential curator of modern art at the Art Institute of Chicago; the architect-designer Frederick Kiesler; and the painter Richard Lindner, all of whom she counted among her closest friends, she told Saul that she thought their "poor little ambitions: were 'Lamentable!'" As were her own, she was quick to add, especially when she had a personal encounter with "an element of the public or of museums." Whenever "real people" or a faceless institution became involved with her painting, she believed that "all the magic disappears." She would have been content to paint quietly just for her own pleasure, and as a "kept woman" (her semi-ironic description of how

she was supported by her husbands in her two marriages) she could have done so. However, the circumstances of the early years of her marriage to Steinberg, when she was half of one of the art world's most dynamic couples, would not allow her to do so.

In 1951 she and Saul were featured together in *Life* in an article whose headline was "Steinberg and Sterne: Romanian-Born Cartoonist and Artist-Wife Ambush the World with Pen and Paintbrush." Glamorous photos of the couple highlighted a large selection of their work, and the accompanying article was built on the several fanciful myths about his life that Steinberg had earlier created. Here he claimed that his penchant for drawing had begun when, as a young child, he watched a forger who lived in his Bucharest neighborhood make official-looking stamps and labels. He repeated the story of how he stamped his underwear "secret" while in the OSS, and added the delightfully fanciful story that the only work he did in China was to teach the peasants how to wiggle their ears. Hedda did her share of mythmaking, claiming that dancing had been her first love and she had studied it in Europe, where she had also been a stage designer. She claimed to be just returning to a career as a painter. Describing where and how they worked, Steinberg told the interviewer that every morning he went to his studio, where he often spent whole days doing nothing but lying down. Sterne said she worked at home "amid pebbles and firemen's hats." The only truth in their comments came when both admitted to a fascination with the United States, "he by the habits of people, she by machines and towering structures."

The *Life* article appeared after another period of frenetic work and travel. Saul's output during the first six months of 1950 earned enough for him to follow his usual custom of taking the summer off, but then an intriguing offer came. Alan Jay Lerner and Vincente Minnelli were filming *An American in Paris*, with Gene Kelly playing an artist there on the GI Bill. Someone at Metro-Goldwyn-Mayer came up with the highly original idea of hiring Steinberg's drawing hand for close-ups of scenes featuring Kelly as he was supposedly painting, so Saul and Hedda went to Los Angeles instead of Europe. They rented the Bel Air home of Annabella, the French actress and ex-wife of actor Tyrone Power, and were eager to settle into the Hollywood film scene. Saul's hand was supposed to became a movie star, but the rest of him lasted exactly three days.

He thought it was only his hand that they wanted to film, ostensibly drawing something amorphous, unrecognizable, and mostly unfilmed, until he read the letter of agreement he was expected to sign. He was to create "certain works of art, paintings, sketches, etc.," all of which were to become the exclu-

sive property of the studio, to be used to "exploit and exhibit" the movie. He was also expected to give the rights to use his "name, voice, and likeness for advertising and exploitation," in perpetuity. And after he surrendered all rights to his own work, he was to understand and agree that the studio was giving him "special, unique, unusual, [and] extraordinary privileges," and if he breached them, he could be held liable for damages.

Saul told Aldo that, having been courted with "great promises of 'a free hand, do what you want,'" he spent his three days on the set dealing with "*gli eterni stronzi* [the usual assholes] who make Technicolor musicals, stupid stuff." He thanked the God who made it possible for him to find work elsewhere so he could refuse this contract, but he was still upset about "all those dollars I didn't pocket." It led to several gloomy days over "the conflict between money and honest work."

After that he decided that he liked California, particularly the "excellent climate" and an American landscape different from anything he had experienced in Vermont, Cape Cod, or the eastern end of Long Island. The climate was so seductive that he imagined living there forever, if not for all the "huge spiders, deadly poison" that he was sure infested the entire region. As was usual wherever he went, interesting people wanted to meet him. He met such diverse personalities as Christopher Isherwood, Don Bachardy, and the acerbic Oscar Levant and formed a lasting friendship with Billy Wilder based on their similar sardonic wit, Mittel-European sensibility, and ironic perception of American culture and society.

Ray and Charles Eames became good friends and colleagues with whom Steinberg enjoyed several collaborations. When Charles saw some of the drawings Steinberg was making of Los Angeles, he wanted them for a movie, but the idea was abandoned when other projects took precedence, particularly one that became a spoof with public repercussions. Steinberg was particularly taken with the Eameses' 1948 chrome and plastic chair, and he drew the outline of a big black cat lounging on one of them. He graced another with a naked woman's torso similar to the nudes he drew in a bathtub and on the bathroom's walls. Everyone who saw Steinberg's nude-woman chair found it amusing, so the Eameses included it in a 1951 "Design for Living" show of their work at the Long Beach Museum, where it quickly caused a local scandal. The museum had a new director, whose relationship with her staff was colored by their affection for the former director, who had curated the show. The staff rebelled when the new director declared the chair to be "vulgar" and instructed them to turn it toward the wall so that only the undecorated back was visible. Each day when the new director arrived, she turned the chair to the wall, and imme-

diately afterward someone on the staff turned it to face outward. Naturally the local papers had a field day, and the story soon became grist for regional and national amusement while viewers debated the pros and cons of obscenity and vulgarity and what constituted just plain art.

WHEN THE LEASE ON ANNABELLA'S Bel Air house ended, Hedda took the train to New York while Saul boarded a bus that took him first to Las Vegas and then across the midsection of the United States. It gave him time not only to see the vast spaces of the American Plains states and to try to fathom what influence those who lived there might bring to bear on the collective American psyche, but also to think about the series of drawings he wanted to make about his California experience. He was having trouble finishing them to his satisfaction, because capturing their "reality" was "too peculiar." When he tried to describe what he had seen on the streets and highways of Southern California, he compared it to a circus, saying it was just as difficult to draw because he had to "keep making an effort not to fall into clichés." He was eventually satisfied with the California drawings, which became a series titled "The Coast" when *The New Yorker* published them in January 1951.

Back in New York, he resumed the annual pattern of doing commercial work for the first three months of the year. One of the most lucrative but irritating commissions was a Neiman-Marcus catalogue cover and a design for the department store's wrapping paper and other packaging. When the store's art department, with the blessing of Stanley Marcus, made changes without Steinberg's approval, he was furious. After that he was careful to retain full legal control of work done for Marcus (who had become a serious collector of his work and liked to think of himself as a good friend). There were various disagreements in the years they worked together, but Steinberg's decisions about how his work would be presented were always final, even though Marcus was occasionally reluctant to accept them.

At the end of March, confident that he had earned enough to spend the next three to five months on his own work, Steinberg and Sterne boarded a transatlantic liner that took them to Italy. The filmmaker Carlo Ponti (not yet married to Sophia Loren) was on board and through a mix-up ended up having to pay for a supper eaten by the three of them. Ponti insisted on a photograph of himself with Saul and Hedda as reimbursement for their share, and they obliged. They thought that would be the end of having to deal with Ponti, but on one of their first nights in Naples they met him by accident and he insisted that they dine together. They decided that he was not one of their favorite people, nor was Naples one of their favorite cities. They thought it was all rob-

bery, graft, and "lousy food." It was all "a little too much like Romania," so they decided to head for someplace quiet where they had never been before and were unlikely to encounter anyone they knew.

Sicily offered the isolation and quiet they craved. They toured small towns and ruined temples for several days before settling in Palermo and setting up to work in a quiet hotel. For diversion they made brief forays or took longer ferry trips to the Italian mainland to explore southern Italian regions. In April they went to Florence, where their friend the American artist Richard Blow lent them the Villa Piazza Calda, a Renaissance structure he had bought and restored in 1927, where he had subsequently revived the art of *pietre dure*, the Florentine mosaic art that combined marble with colored stones. Steinberg thanked Blow for his generous hospitality with an especially fancy diploma that sported elaborate curliques and flourishes and a stylized green border similar to those that embellished stock certificates.

Steinberg and Sterne used Piazza Calda as the jumping-off point for short trips throughout central and northern Italy, often in the company of Aldo Buzzi, who was with them for several weeks. They went to Capri and San Remo, both of which were as beautiful as they had been touted, and then it was farewell to Aldo in Mantua as he changed for a train that took him home to Milan while they went on to France. Saul girded himself for visiting his parents in Nice by stopping first to gamble for several days at the casinos in Monte Carlo.

HEDDA MADE HERSELF A WILLING BUFFER in all of Saul's dealings with Rosa and Moritz. She took care of fulfilling every need or desire (usually Rosa's) conveyed in their letters. Hedda was not fond of shopping but spent countless hours and sometimes days looking for just the right winter coat or for stockings and underwear that fit Rosa's exacting specifications yet never met them. She may have chafed at having to shop and then ship to Paris whatever Rosa wanted, as often as several times each month, but she kept her feelings to herself and took care of everything so that Saul seldom had to deal directly with his parents. However, he took an active role in trying to make sure that Lica and her family had the best chance of receiving the few things she requested.

The government of the PRR (People's Republic of Romania) had instituted harsh new restrictions on gifts from relatives outside the country, so it became frustratingly difficult to help her. Each citizen was allowed to receive one package per month weighing one kilogram or less, which meant that most relatives no longer attempted to send goods but sent money instead. Funds had to be funneled through organizations that were supposed to be honest and reliable, but unfortunately, once the money crossed the Romanian border, this

was often not the case. Frequently the amount was greatly reduced or, more often, never arrived at all; medicines, such as the ones Lica was desperate to have for her husband's undiagnosed ailments and her small son's scarlet fever, were never received.

The emotional travails of Lica's family's emigration swooped up and down like a roller coaster with no end in sight. There was a brief moment of hope when Lica received notice that her house had been officially allocated to another family, which in Romanian terms meant that her family had been cleared for a departure that could come at any time. They prepared to go by packing the few possessions they would be allowed to take and giving away many of their furnishings and most of their winter clothing, for Lica was certain they would be sent to Israel. When several months passed without official notification and no one came to claim their house, once again they resigned themselves to staying. "We are extremely stressed out by this way of departing," she told her brother.

Rosa continued to make her usual peremptory requests, all conveyed in the most wheedling and irritating letters. Hedda shopped a number of times to try to find the right winter coat and then shipped several, but none pleased Rosa. Fearing her son's ire over her pickiness, she changed tack and asked first for a new house in Nice, then adjusted her sights to a new apartment, and then decided to settle for household things, starting with a new refrigerator. Saul did what he always did: he fired off a check. What he dreaded most about the coming visit was answering the questions he knew Rosa would ask about what he was doing for his many relatives, both those waiting to leave Bucharest and those already in Israel. It was already a subject of general conversation in the immediate family, with Lica stuck in Romania and worrying about how much her brother had to earn to support them and their cousins as well, who were asking for money and then complaining about the amount they received.

The pleas for help took many forms and also came from relatives who had made it to Israel. One well-off cousin hid his money in high-interest European accounts and claimed he did not want to use it because the exchange rate was unfavorable, so could Saul please send him "a donut maker, a refrigerator, and some radios"? All these were to be a loan until the exchange rate stabilized, but until then he preferred to use Saul's money rather than his own. Another cousin asked for enough to buy a truck, a taxi, or enough laundry machines to open a laundromat. Most of the others simply asked for gifts of money in heart-rending letters that described poverty, illness, and deprivation. Saul Steinberg honored every request, sending enough goods or money to fulfill each request entirely or to come as close to it as he could. And if people asked a second or third time, he sent even more than they requested.

———

HE HAD A GOOD EXCUSE NOT to stay long with his parents in Nice: he had to go to London to meet Roland Penrose for discussions about a solo exhibition of his work that was scheduled for one year later at the Institute of Contemporary Arts. Penrose had founded the ICA in 1946, along with Herbert Read and several others who wanted to offer the British public something different from the traditional kinds of art anointed by the Royal Academy. He was an early booster of Picasso and Jackson Pollock and featured both in one of the ICA's first shows; he was a friend of Max Ernst, Henry Moore, and Joan Miró, all of whom he featured soon after and whose work he collected in his own impressive private collection. Penrose was married to Lee Miller, the American model who became an avant-garde photographer before distinguishing herself as a fearless war correspondent. They had just bought Farley Farm, 120 acres in a small village in the same area of Sussex where Virginia Woolf made her last home, and they invited Steinberg to come for the weekend.

Steinberg took an immediate liking to Miller and Penrose, and they to him. Penrose could not find enough superlatives to praise Steinberg's talent and was eager to boost his reputation and make him feel welcome in England by introducing him to other artists and writers. Miller had been in Romania just after the war, and Steinberg listened avidly to the few things she told him about her experiences. Being at Farley Farm was a magical time for Steinberg. It was a house "filled with art and crammed with crazy people," where he got fresh air and exercise, drank too much liquor and ate too much food for the good of his digestion, and observed with slight puzzlement the constant parade of exotic bohemian guests who drifted casually in and out. It might have been better if he had ended his tour of the British Isles there, for then he might not have taken away such a negative impression of most of England, Scotland, and the two Irelands.

His first impression of London was from one of the city's red double-decker buses, where everything looked "trim and shining," with no remaining vestiges of the war's ravages. A side trip to Brighton and Rye reminded him of an "old fashioned Coney Island." After eight hours on a train to Edinburgh, he could not wait to leave one of the "corniest" cities he had ever seen, full of "King Arthur, legendary heroes, fake castles, etc. . . . Roman temples made out of asphalt." He promised himself to "think of the good parts of Edinburgh some other time." He took the train to Glasgow, the ferry to Larne, and the train to Belfast, which he liked best, until he realized that as it was Sunday and raining too heavily to leave the hotel, he had nothing to do because all the pubs were closed.

His next stop was Dublin, where his first night was passed at a B&B filled

with Irish Americans or the English, who came to gorge on eggs and butter. The next day he decamped for the Shelbourne, Dublin's best hotel, and the day after that he took the ferry to Liverpool and went back to London. He stayed there for several days, determined to visit London's eighteen railway stations, all of which he deemed "beautiful." He went to the theater to see *A Winter's Tale*, and although he was never a fan of Shakespeare, he was surprised by how much he liked both the play and the theatergoing experience. On his last day in London he went to the Victoria and Albert Museum, where he was entranced with the various sorts of "junque" that always appealed to him—best of all, "Queen Victoria's banquet printed and *embossed* on silk." The weather had turned so tropically hot that he drank beer to keep himself "alive." As for the food, it was "so bad I can hardly touch it." He had had enough of Anglo-Saxon attitudes, and it was time to go.

He went to Brussels for a few days, eager to put the British Isles behind him. Dublin and Belfast had reminded him of "the Eastern-type poverty" of his native Romania, and the only reason he stayed as long as he did in Edinburgh was "out of perversity . . . to see how it's possible to build in such an ugly and stupid way." The more he traveled around the British Isles, the more he realized how much he loved Italy. From then on he visited Britain only in connection with exhibitions of his work.

AFTER BRUSSELS, HE TOOK THE TRAIN to Paris, where he helped Hedda pack up for the boat trip home, including the new trove of rubber stamps he had picked up in his travels throughout Italy, France, and England. It wasn't the happiest of his transatlantic crossings, for he was despondent throughout the voyage over having surrendered the Central Park South studio as an economy measure. He and Hedda had spent more money than he expected, and he knew he had to start earning as quickly as possible, so he fretted that it would take a month or longer to find a new workspace. This worry paled the minute they landed in New York, when a threatening crisis presented itself: the navy wanted to recall him to active duty because of the Korean War, and he was ordered to go to Washington. "I'm putting up a fight," he told Aldo, and apparently he was successful, for he was not recalled, although he was not officially discharged from the Navy Reserve until three years later, on October 15, 1954.

By the end of October 1951, he had been working steadily from the apartment and was so tired that he needed another vacation, which he simply could not afford to take. One of the more intriguing invitations for commercial work came from the impresario Lincoln Kirstein, who wanted him to design sets for a ballet choreographed by George Balanchine. To prepare himself, he went to

one ballet performance after another. Otherwise, everything had fallen into its usual pattern: "I smoke, I drink and work. I don't even know if I'm happy." He got what he thought would be the vacation he needed in late December through early January 1952, when he went to Palm Beach, Florida, to make drawings for *Life* and *The New Yorker*. He thought it was "frightful in its ugliness, stupidity, and vulgarity," and disliked intensely having to draw "ugly things" that were akin to "pornography."

He was tired of the peripatetic life, and tired of living in a small apartment without enough space for either himself or Hedda to work well. Since their stay at the Villa Piazza Calda and after his visit to Farley Farm, he was more insistent than ever that they needed to set up a permanent home. He had temporarily given up the idea of moving to the country, because of the sheer impracticality of living far from his major sources of income. Perhaps in the future they could think about a place for weekends and vacations, but what they needed now was something in the city with space enough for each to work, space for them to reciprocate the hospitality of their many friends, and space to welcome particularly Aldo (although he never came), whom Saul was eager to help professionally. Also, an increasing parade of strangers were being sent their way by European friends who thought they should all know each other. Penrose and Miller sent the prickly Sonia, widow of George Orwell, who spent the evening at a posh dinner party in high dudgeon after she learned that the Saul who sat next to her was not Bellow but only an artist she had never heard of named Steinberg.

AND SO SAUL AND HEDDA BEGAN to talk seriously about how much space they would need so that both could work at home. It would take a very large apartment to accommodate them, and soon they realized they would be better off in a house. When they examined their finances, it became clear that Steinberg, with all his obligations, could not swing the deal on his own. Fred Stafford, who was still hovering over Hedda to make sure that she was financially secure, stepped in and provided the money for them to buy a four-story town house at 179 East 71st Street. Steinberg was so eager to move in on January 31, 1952, that he cut the Palm Beach stay short by several days. He was excited about settling down for the first time in his life, looking forward to becoming a solid citizen of his adopted *patria*, a landowner and payer of property taxes.

The house was one in a row of brownstones on the north side of 71st Street, a quiet, tree-lined block between Lexington and Third Avenues. The first floor became their public area, a large room that combined a kitchen, dining, and living room. The focal point was a large oval table that could seat

twelve comfortably and several more at a pinch. At the rear, French doors opened onto a walled garden. Two other points of interest were the large white porcelain sink and ruby-red enamel stove with two ovens; over each Hedda hung the two diplomas Saul made to proclaim her expertise in dishwashing and cooking. Throughout the next decade, Steinberg filled the room with the work of his friends, including a life-size white plaster nude by Tino Nivola, a Calder mobile, a painting by Josef Albers, two Giacometti drawings, a small dressmaker's dummy, and some of his own "constructions" that resembled bits

Saul Steinberg, *Diploma for Hedda (Cooking)*, 1950s.

and pieces of pianos and clocks. They installed enormous flat wooden files to hold their work in an organized manner (the first time they had enough space for such a luxury), and on them they placed mattresses and pillows so they could climb up and lie down to nap or read after eating.

Saul took over the second floor, using the larger room at the rear of the house for his studio and keeping the one at the front for overflow storage until he found a billiard table that reminded him so much of the one he had played on at Il Grillo in Milan that he had to buy it. He thought he worked better once he was able to walk back and forth between the two rooms, alternating between playing billiards and making drawings. On the top floor, they kept the larger room at the rear of the house for their bedroom, because it was quiet, while Hedda crammed all her painting equipment into the smaller room at the front. It faced the sunny south, but she managed to work all day long despite the light that streamed in.

They were both proud of the house and wanted to show it to friends, so they began to give dinner parties once or twice a week, seating a dozen or more guests around the big oval table. Although the guests were an eclectic mix, most were what Hedda called "Saul's *New Yorker* people," and they were the ones most often invited. Saul was at his most relaxed and comfortable with James Geraghty, Joseph Mitchell, Geoffrey Hellman, A. J. Liebling, Niccolò Tucci, Charles Addams, Sam Cobean, and "their wives or girl friends." Their other dinner guests were people they had known since their earliest days in New York, and unlike the glittering invitations from wealthy collectors and patrons of the arts that Saul was accepting more and more frequently, only their closest old friends were invited to sit around Hedda's kitchen table. From the performing arts, these included Sasha Schneider, Uta Hagen, and Herbert Berghof; from the art world, their closest friends were Richard Lindner and René Bouché, and after them Mark Rothko, Ad Reinhardt, and Berte and Bernard Rudofsky. Iris Barry brought them news of film, while Louisa Calder and Denise Hare listened intently as Sandy and David entranced the company with talk about sculpture. During their summers in Wellfleet, Saul and Hedda had befriended Marcel and Connie Breuer, with whom they exchanged dinners there and in New York. There was never a lack of conversation at the table, but their favorite evenings were those when everyone sat around until the wee hours listening to Harold Rosenberg declaiming while his wife, May Tabak Rosenberg, acted as moderator between him and Steinberg. May liked best the dinners when it was just the four of them and Harold and Saul pontificated like "two Irish rabbis."

Rosenberg was fast becoming the one friend whose "contagious intelligence" engaged Steinberg's completely. Steinberg was enthralled by Rosen-

berg's "rare gift for inventing and discovering ideas in your presence . . . Talking with him was always a surprise. One didn't quite know what the talk was about, but it was extremely precise and efficient." Rosenberg was a towering presence physically as well, over six feet tall and with a sweeping but awkward stride caused by "a leg that would no longer bend." Steinberg, whose height was just below Rosenberg's shoulder, would not let him begin to talk until he sat down, so they could have "a conversation of equals."

Interspersed with the New York friends were the many Europeans whose hospitality they enjoyed in Europe and were eager to return in New York. Many of Steinberg's Italian friends were becoming luminaries in the burgeoning film industry, Vittorio de Sica prominent among them. Steinberg saw him in New York for several days before he too vanished into Hollywood.

Because Hedda wanted to paint all day, her menus seldom varied. Most of the meal was improvised, based on whatever was in season and available in the market. The one constant was the meat course: large, choice roasts that she could put into the capacious ovens of her red stove in the morning and allow to cook all day long while she painted. Saul had become an aficionado of good wines, particularly dry white Italian vintages, and he took great pleasure in offering his new finds to his friends.

When "the Steinbergs," as friends had taken to calling them, were not entertaining at home, they were out somewhere being entertained. Hedda preferred to stay quietly alone at home and often did, but Saul was "a marvelous guest" who needed stimulation every night of the week. And yet, according to Hedda and the many friends who were with him, "he was just himself; he did not actually participate in the life of the party." Many of the invitations came from "people he thought were obnoxious," but he accepted them because the hosts were either collectors of his work or personally responsible for sending lucrative commercial commissions his way. Most of the time when he was a guest, he preferred to declaim rather than converse, to regale someone else's dinner table with a monologue that was so witty, erudite, and fascinating that the other guests were content to let him hold sway because he was so charming. At other times he could be exceptionally rude. Hedda did not attend the dinner given by a media mogul who was trying to persuade Steinberg to accept a commission for a drawing that he thought was in bad taste. When he came home early, he told her proudly how he was so appalled by the banality of the conversation that he caused a scene. Saying, "This can only get worse," he rose from the table, threw down his napkin in anger, and left. "He did things like this on purpose," she recalled. "He did not hesitate to offend, because he was offended if something or someone was not in perfect taste."

It was the start of the years when he loved to scandalize people. One evening he sat glowering in the corner of Priscilla Morgan's living room after what she thought had been a congenial dinner at her round table for eight. Morgan was celebrated for her ability to jolly her guests into conviviality, and indeed on this evening they were all talking and laughing except Steinberg. When she asked him why he was not having a good time, he replied loudly enough for everyone to hear, "These people are all talking!"

"Yes, Saul, and isn't it fun?" she replied.

"No," he said, "they should all be listening to me." And with that he got up and walked out.

THE ENERGY THAT STEINBERG PUT INTO his nonstop socializing was extraordinary, especially when viewed in tandem with all the commercial work he did during the same period, and all of his own work in preparation for a series of exhibitions that began in late March and took him away from home for the better part of the next two years. Two days before he finished moving into the house, on January 28, 1952, his first solo exhibition in two years opened—a major show in two galleries at the same time: with his longtime dealer, Betty Parsons, and with his new dealer in the space just across the hall from hers, Sidney Janis.

Betty Parsons had been an early champion of many of the most successful American abstract artists since her earliest years, when she worked at two successive galleries before starting her own in 1946. She showed their work during the lean years before they became famous, but in the 1950s many were wooed away by gallery owners who promised them higher prices, Sidney Janis prominent among them. Most of these artists left Parsons completely, but Steinberg, who probably needed the money Janis promised more than most of them, refused to make the move unless he could continue to show with Parsons as well. He stayed with her because of his unmitigated loyalty to people who helped him when he needed help the most, but Betty had also become a close friend. She was one of the first people he met in New York in 1942, and one of the first to support his career. He returned her generosity when she was starting her gallery in 1946 by becoming one of the four friends who each contributed $1,000 toward the $4,000 she needed to rent the space at 15 East 57th Street.

This personal quality of the friendship between Steinberg and Parsons made for a curious professional relationship, because Steinberg regarded art dealers with a somewhat jaundiced eye as "the intermediary between two of the most important things in life: money and fame." Of his two dealers, he found it easier to deal with Parsons, a "fictional character" who was so other

worldly that he thought of her as akin to Dostoevsky's Raskolnikov or Stendhal's Julien Sorel, than to deal with Janis, who was "completely brass tacks." "I liked her," he said in 1985 (she died in 1982). "I miss her, even now, very much."

STEINBERG AND STERNE LEFT FOR THE San Francisco opening of a one-month exhibition of her paintings and his drawings, March 5 to April 5, at Gump's store gallery, after which they made a quick turnaround so he could sail for England to supervise the installation of his work for the exhibition at the Institute of Contemporary Arts. He always traveled in first class, and on this voyage the one fellow passenger he wanted to meet but whom he had to eye surreptitiously was the comedian Jimmy Durante, traveling as Mr. James Durante, whose reserve did not invite familiarity. Steinberg knew two other people on board, a boring Scottish poet who alluded to previous meetings he did not remember and Hans G. Knoll of the furniture company, who was "gossipy and could be a treasure . . . but gossip needs a bit of spirit to transform it from sordid to anecdote." By the time the ship docked, he felt he had been through a "six day long bar mitzvah organized by some aunt." The crossing was tedious enough to get him over his fear of airplanes, and he vowed to fly next time to "avoid this concentration camp of pleasure."

He booked a room at the Hyde Park Hotel but stayed only long enough to do publicity before the show's official opening on May 1. It made him so nervous that he calmed himself with long walks about the city. On one of them he ran into the Irish writer James Stern and his German-born wife, Tanya, on Piccadilly, and they invited him to tea. Stern had worked in journalism as a writer for *Time* and they were hungry for news of New York; giving it relaxed Steinberg enough to think he was still there and not in London. He was convinced the show was headed for disaster, so he planned to leave before it opened, to hide out for several days in Paris, and to gird himself to go on to Nice to see his parents.

The exhibition room was smaller than he expected and disappointingly shabby. There was no room for many of the images he had planned to show, including a large photograph of the woman painted on the bathtub. He thought the eighty-eight small framed pictures were hung "all right," but he was amazed at the kinds of questions they inspired in British journalists; for instance, one of them noticed that many of his drawings slanted to the right and wondered if they represented his political leanings. It made him vow "never no more" to submit to a press conference. The last one gave him several "jittery" days as he waited for "poisonous" reviews, and he felt "like a refugee again, imagining waiters and cops looking at me with suspicion."

He was particularly fearful of the the London *Times*, because the reporter had a grudge against all things American and considered Steinberg to be representative of the worst of them. The review had not yet appeared when, to his amazement, the "very monumental looking . . . *Manchester Guardian* and *The Observer*" gave him "fan" reviews and a flattering photo, both of which he found "a bit embarrassing." And to his amazement, the *Times* review was as glowing as all the rest. The show was an enormous success, drawing unprecedented crowds every day, but it did not sell as much as he had hoped, because "people were horrified to hear of the prices." He did eventually sell "two-three pieces" at prices starting around several hundred English pounds, but even that was considered "too expensive." His consolation was that during the huge Picasso show that preceded his, not a single work was sold.

He did steal away quietly to Paris before the official May 1 opening and stayed there for several days, mostly taking care of personal business, such as making sure that gifts ordered for Hedda's mother and brother in London had been sent to them in Paris as scheduled. He lunched several times with a depressed Nicola Chiaromonte and was nonplussed to find that he had to do all the talking in order to keep the conversation going with his uncharacteristically silent friend. Steinberg's efforts were rewarded when Chiaromonte took him for a walk that led to the discovery of several arcades, covered passages that he had not seen before, which he thought of including in a new book he was in the early stages of thinking about. He wrote several times to Hedda, asking her to send her sizes so he could buy the luxury items he adored and she disdained, especially handmade shoes and slippers, but she ignored him. Also, because there were so many more antique shops in London than in Paris that specialized in things he liked to collect, particularly antique clocks and watches, and he had not resisted buying several, he did not have his usual enthusiasm for Paris shopping. And besides, there was little time, because he had to go to Nice.

HE BOUGHT A TRAIN TICKET ON May 5 for a six-day stay and took the precaution of booking a hotel room as well. He found his parents the same as always, with Rosa's "cynicism" reminding him even more of the "real Balzac" than usual. Now she wanted a fur coat to replace the heavy astrakhan she had not been permitted to take out of Romania, claiming that it was the dearest thing she had ever owned and that she could not recover from its loss. She told Saul she had been saving for years ("starving probably," he said sarcastically) to buy a "skimpy one" suitable for the Mediterranean climate, but before she would buy a coat she infuriated him by asking in false humility for his permis-

sion. Even Moritz got on his nerves this time, as he insisted on reading letters aloud from the poor cousins in Israel, "some moving, some sordid," while Rosa pressed to know exactly how much financial support Saul was giving them. He bristled when she added slyly that it was going to cost him a fortune to keep her and Moritz on the Riviera, because people could live into their nineties in such a pleasant climate. Then she made the most irritating demand of all, telling him that she had invited other Romanian émigrés for Sunday lunch because she wanted to show off how rich and successful her American son had become. He had to brace himself to go through with it, but he knew it was easier to do it than to refuse, so he gritted his teeth and allowed himself to be put on display. He knew if he didn't, her passive-aggressive behavior would make both her and Moritz "sick." It made him realize how much of a "defense" Hedda always threw up between him and his parents and how grateful he was for it.

To get away from Rosa's constant carping, he invented the myth of business in Rome and went there for an overnight visit. When he arrived, the myth became truth during a happy reunion with Cesare Zavattini, who wanted to make a movie with him. Zavattini had proposed collaborations before for an animated cartoon or a documentary, but this time he wanted to do a full-scale feature film similar to his recent hit, *Miracolo a Milano*. Steinberg agreed in principle and waited for Zavattini to come up with a concrete proposal, hoping that it would be one that enabled him and Aldo Buzzi to work together. He thought he had the answer when another friend from their Milan days, the director Luciano Emmer, proposed six films of Steinberg's drawings for both movies and television and agreed to hire Buzzi to direct at least one of them. Unfortunately, neither director's ideas ever came to fruition, even though Zavattini made sporadic attempts to work with Steinberg for many years afterward.

Otherwise, the Italian trip was disappointing on all fronts. Steinberg found Aldo depressed and living in poverty with Bianca Lattuada, who talked only of money and their lack of it. Her brother, Alberto, insisted on regarding Steinberg as "an American big shot" and conversing only in halting broken English, to which Steinberg always replied in fluent Italian. He was disgusted with how all his old friends treated him, and because he did not want to use a truly derogatory term, settled for calling them "Europeans." He was upset that "as soon as money and business appear, friendship goes down the drain," and although he hoped it would not be true in his case, he worried that it might be.

SEVERAL DAYS LATER, AFTER A STOP at the Cannes Film Festival, where everyone was amazed and disappointed that Lattuada did not win the prize,

Steinberg was back in Paris. He met with Ernesto Rogers, who was there as a member of a committee of architects, Walter Gropius and Le Corbusier among them, to select a design for the new UNESCO building. Rogers had several projects in mind for Steinberg to execute in Milan, starting with decorations for a swimming pool, and they dined together on several occasions. Rogers, who was also Jewish, talked freely about how he believed their shared heritage influenced their celebrity. He confessed that he got more enjoyment from promoting his fame than from actually doing the work to earn it, which Steinberg called an "'I'll show them'" attitude. He confessed to Hedda that hearing Rogers admit it brought him great relief, "because I have some symptoms of this vice myself."

On his last night in Paris he had a vastly different experience when by chance he ran into an architect he had always wanted to meet, Walter Gropius. Steinberg was already a friend of Marcel Breuer, which gave them something in common and led to their having a five-hour dinner together. The thirty-eight-year-old Steinberg, who had never wanted to practice architecture, was enthralled by the seventy-year-old Gropius's discussion of the profession, whose challenges he still loved. Steinberg now began to think seriously that all the architectural drawings he had been making, of British railway stations, French arcades, and American buildings, might make a good subject cluster to include in a new book. The conversation with Gropius was one of the inspirations for some of the drawings he eventually included in *The Passport* in 1954.

The next day he got back to London in time to watch a BBC documentary in which three critics discussed his ICA exhibition, pro and con, for an hour. When Penrose told him that there had been other television shows with "pictures and talker[s]" and that reviews from as far away as Scotland and Ireland were universally good, he realized that he had accomplished what he had set out to do in Europe and was ready to go home. He was in such a hurry that he decided to get over his fear of planes and fly, but his reservations were canceled for several days in a row because an oil strike and a shortage of aviation fuel had curtailed the number of scheduled flights by American carriers.

There was another pressing reason he was so eager to return. As was his custom, he wrote loving letters to Hedda at least once every day and sometimes more often, but during this absence he had received very few letters from her in return. Early on she forwarded without comment a "personal letter, silly," from a "fan," a term he insisted was correct because he had never met the "girl" who wrote it. He remembered that she had once sent him some suggestions for cartoon gag lines, hoping it would lead to a "literary correspondence with [a] sensitive soul," but he had never replied. He tried to explain

to Hedda that he had had no personal dealings with the woman and that he had destroyed many such letters without showing them because he knew how greatly they disturbed her. He asked Hedda not to lose time over suspicions and unjustified accusations, but she was still smarting from the knowledge of how many women he had been with before his departure and was unable to do so, because she had never really felt brave enough to address the way those encounters wounded her. Time and again he begged her to overcome her suspicions, saying he missed her so much he would take "any fly by night plane to get sooner home." As she never replied, he did not know how he would find her when he got there.

Unfortunately, the airplane strike continued and he ended up taking the *Queen Elizabeth* back to New York, not arriving until June 2. The situation with Hedda was still unsettled when he had to leave again one week later for Boston. He did not want to go and was "scared stiff" of the work he had to do there (a department store mural that was never realized), but he was scared even stiffer by how he had left Hedda.

Saul Steinberg, *Untitled (Birthday Check to Hedda)*, n.d.

THE DRAFTSMAN-LAUREATE OF MODERNISM

*Your principal fear, I think, is caused by your great
talent—facility—which becomes a burden (like too
great beauty), particularly with a background that
causes masochism, like feeling guilty.*

t was more than "a point of honor" for Steinberg to fulfill the Boston com-
mission; he needed to do it for the money and was disappointed when it
was canceled. His mood improved after he persuaded Hedda that her anger
over the girl's letter had been unfounded. He stayed in New York just long
enough to pick up what supplies he needed before leaving for a *New Yorker*
assignment in Chicago, where he was to attend the two 1952 political conven-
tions and make drawings to accompany Richard Rovere's reportage. Hedda
went with him for the Republican convention, which came first, but she did not
stay on for the Democratic one. By the end of July he had exchanged Chicago's
heat and humidity for the steam bath that was New York in pre-air-conditioned
days. The rest of the summer passed in a lazy haze, too hot to do any real work,
so he went to the movies every night just to sit in air conditioning. "I must have
seen 200 films," he exaggerated to Aldo, remembering nothing about any of
them. He concluded that it was "a mistake to spend the summer at home" and
vowed never to do it again.

In early September, he and Hedda were off together, flying to Brazil for
a joint exhibition that opened at the most prestigious museum in the country,
the Museu de Arte de São Paulo (MASP), and then traveled to Rio de Janeiro.
The show had been in the works since 1950, thanks to the Civita brothers
and two other Italian friends who had been at the Politecnico with Steinberg
before settling in Brazil: Pietro Bardi, the founding director of MASP, and his
wife, the architect Lina Bo Bardi. The Bardis and the Civita brothers knew that
it would be an expensive exhibition and other sponsors would be needed to
help finance it, so they started with the enthusiastic American consul general,

William Krauss. Between the United States government and Brazilian bene-
factors, the money was raised and dates were set for a three-week exhibition,
which opened on September 18, 1952.

Steinberg and Sterne flew to Rio the day before the opening and then
spent the next ten days in São Paulo, where Bardi kept them busier than their
wildest imaginings. He was a brilliant publicist who filled every possible venue
with tantalizing information, and every day brought new press releases or pam-
phlets highlighting their work while dropping teasing tidbits about their per-
sonalities. Steinberg was described as having "invented a new world by simply
judging his own world" and by knowing "exactly how to reap the ridiculousness
in all things futile, all wrong headed ambitions and distorted vanities." Sterne
was touted as "an avant-garde painter . . . an utterly paradoxical artist, given
her intimate allegiance to the real object." By the time the show opened, the
public was lining up to see it and the press was clamoring for interviews.

An issue of the important arts magazine *Habitat* gave them the cover and
showcased their art with photos and articles. As the pressure for interviews
mounted, Steinberg rebelled, insisting that "his person" was of no interest
and all attention had to be paid to the work: "You could stand a matchstick in
front of the camera and it would be the same thing." Bardi saw this as another
opportunity for publicity and in quick rebuttal composed a new promotional
text using a passage from *Habitat* that declared "the man himself" was indeed
very interesting because of the way he resembled his own drawings: "His
bottle-end glasses hide his eyes, turning him into one of his own pupilless char-
acters, those empty-eyed figures that see nothing. He walks with his hands in
his trouser pockets and his blazer becomes a kind of wing. As he stands there
in the middle of the exhibition hall, shoulders hitched, surveying the public, he
becomes a bird. At least that is how we begin to muse . . . It was he who taught
us to transform people into animals, because it was he who turned the waiters
of San Marco Square in Venice into birds, and the pigeons into human beings."

Bardi had previously hosted exhibitions by other North American artists,
among them Richard Neutra and Calder, but Steinberg and Sterne were the
ones who brought the museum its largest audience to date. Everyone wanted
to meet them, and Bardi invited the cream of Brazilian society to receptions
at the museum and parties in his home, the famed House of Glass designed
by his wife. It was the first house built in what later became a fashionable
suburb but was then just a tropical forest on the outskirts of the city, a setting
that reinforced Steinberg's observation that the entire country was one huge
insect infestation. On their first night in Brazil, when they were on their way
from the airport to the Copacabana Palace Hotel, he and Hedda saw a traffic

accident that they thought was eerily prescient of their exhibition: a car was turned upside-down, reminding them of a beetle and bringing to mind images of the machines and machinelike insects in some of Hedda's paintings. When they went to stay in the House of Glass, they were witnesses to an "insect massacre" every night.

They were not impressed with the major Brazilian cities, which Steinberg dubbed "tropical Bucharest." The only beauty was "among the colonial things . . . the usual brass, mahogany and tiles as decorations, the open trams . . . thousands of equestrian monuments, the vultures that circle over the sidewalk in search of carrion." He made drawings of these, and they and other drawings he made while touring found their way into his sketchbooks; some, in one form or another, were included in *The Passport*.

By late October Steinberg and Sterne were back in New York, where Steinberg had to sandwich his own work in between commercial assignments. He needed thirty drawings to replace those that had been sold for the smaller version of the Parsons-Janis show that was to open at the Perls Gallery in Beverly Hills in December, and he had to amass a larger number for a more important exhibition at Galerie Maeght in Paris the following March. He had not done any lucrative work for such a long time that he had to spend the first three months of 1953 working on paid commissions for everything from a container corporation's advertisements to Hallmark cards. He was furious when Raymond W. Hall and other Hallmark executives interrupted his work to insist that he go to Kansas City for personal meetings to discuss their ongoing differences.

Raymond Hall wanted Steinberg's drawings badly enough to pay him a minimum commission of $10,000 each year, but he was a demanding employer who frequently questioned and often rejected Steinberg's offerings. One refusal that particularly rankled was when Hall responded to his Valentine's Day submissions through a committee memo: "The general feeling . . . is that this design does not express a Valentine's feeling and it would do much better if it had some Valentine motif, or an indication of a Valentine in it." The committee invited Steinberg to "try again." More trouble with Hallmark came when the Museum of Modern Art placed a large order for an original design for Christmas cards that Steinberg had done before he signed the contract granting exclusivity to Hallmark. Hall was furious with Monroe Wheeler's casual explanation that he had reordered the cards because "MoMA patrons wanted them." It took several telephone conversations and personal meetings for Steinberg to make Wheeler desist and to placate Hall. The incident was not resolved until Wheeler promised that MoMA would not reprint again, even

though he told Hall from the beginning that the museum's sales would never be "challenging competition" to Hallmark's.

Steinberg hated personal dealings such as these, but often there was no way to avoid them, since many employers insisted on dealing directly with the artist with the quirky vision. He tried to shunt them off onto his lawyer, Alexander Lindey, but if they persisted, he simply ignored them, thus earning a reputation for being cranky, prickly, and exceedingly difficult. Actually he was an inordinately polite man, sometimes upset for days over having to be rude when people who worked in advertising or publicity would not take his no for an answer and hounded him to change it.

STEINBERG WORKED STEADILY BY DAY, but every night he partied. More and more he was at the center of the most interesting and important social, intellectual, and artistic groups in New York. It was the beginning of the era of the iconic dinner table, when a hostess would mix and match guests from different worlds, wooing some from, say, Park Avenue society or national politics by hinting that important names in art or literature would be gracing her dining room. Quite often Steinberg's name was dangled as the magnet to attract others. It was also the beginning of the era when modern American art became a commodity with significant market value, and for every letter Steinberg received from a commercial firm wanting to pay for his work, he received at least two from people who wanted to buy and collect it.

Hedda recalled Saul's reaction at a small informal supper with Mark Rothko in her 71st Street kitchen, when Rothko bemoaned the way artists were being turned into "marketable mills, workers who produce something buyers want." She remembered Rothko telling how "people used to come into the studio and look at the work and you would have real engagement, a discussion before you made the transaction, the actual sale and purchase. Now, they just come in and buy. They hardly look at it. No discussion, no transaction." Steinberg sat silently while Rothko spoke, but after he left, he muttered something about how it was all very well for those who did not have dependents to complain about how buyers devalued their artistry and respected only the high prices; as for him, he had responsibilities and no time to kvetch about the attitudes of buyers or the prices they paid. Knowing full well the financial pressure he was under, Hedda wisely said nothing.

Besides supporting his parents and his sister's family, he steadily received requests from relatives, and just as steadily he sent checks by return mail to four or five in Israel. If one of them made a slightly barbed comment comparing Saul's wealthy and successful American life with their own poverty in Israel,

he ignored it. He was also trying to find discreet reasons to funnel money as regularly as he could to Aldo, and now to Ada as well. She had resumed fairly regular contact with Saul, and although she never asked directly for help, each letter contained an account of some new tribulation with a hint that she could use money; here again, he always sent a sizable check by return mail. And as his feelings of civic responsibility deepened, he felt an obligation to contribute money to everything from Adlai Stevenson's presidential campaign to the fund drives of suburban Jewish congregations. His friendships with Mary McCarthy and Dwight Macdonald grew, and both had a strong influence on his naturally left-leaning and liberal political sensibilities; in years to come he would quietly observe the positions taken by writers for the *Partisan Review*, *The Nation*, and the *Reporter* and often adopt them for himself. He gave freely to all the causes they embraced.

STEINBERG HAD ACCEPTED SO MUCH COMMERCIAL work that he found himself giving short shrift to one of his most important solo exhibitions, the one being mounted by Aimé Maeght for March 1953. In the few short years since its founding, the Paris Galerie Maeght had become one of the most prestigious in the international art world. Maeght wanted 110 drawings, but Steinberg had so many other deadlines that he did not finish his selection until early February. Because more than half were small, he decided to carry them by hand; the rest were shipped by Parsons and Janis, and he could only hope they would arrive in time for the opening, which Maeght had had to delay until April 17. Maeght planned to dedicate an edition of *Derrière le Miroir*, the exquisite oversized publication that featured lithographs of the artist's work, with an accompanying text by a distinguished writer. When he asked who should write the preface, Steinberg chose Le Corbusier, but time was short, and if Maeght actually asked Le Corbusier to write it, his reason for turning it down remains unknown. This *DLM* became one of the few without any text.

On March 1, with his new passport in hand, Steinberg boarded a plane to Paris, not sleeping during the fourteen-hour flight but "eating chicken, drinking highballs, and reading Orwell." He checked into the Hotel Crillon, planning to stay overnight to catch up on sleep, make appointments, and give himself a quiet day before telling Aimé Maeght that he had arrived. Then he planned to check into a smaller hotel on the Left Bank, where he could have an incognito week before surrendering for publicity engagements. He told Hedda he had not done anything but go to the movies, when in fact he was out all the time.

During his two months in Paris, his calendar was filled with every glittering name in the worlds of art and culture. He met many luminaries through

Maeght at his gallery or his home, among them two artists to whom Maeght was devoted, Georges Braque and Joan Miró. Braque remained a cordial but formal and distant contact, while Miró became a good friend. Mme. la Baronne Elie de Rothschild liked his show and invited him to dinner, which led to other invitations from members of the French nobility. The German publisher Rowohlt courted Steinberg by going to his hotel several times to discuss possible projects and to introduce him to some of his writers who were passing through Paris. Steinberg met several times with his European agent, Jennie (Mrs. William) Bradley, who tried to interest him in various documentaries that were never realized. On the personal side, Janet Flanner entertained him at lunches and dinners. He dined separately with Marcel Duhamel and Yves Tanguy and saw his friend Cartier-Bresson. He went to the home of Meyer Chagall, where he conversed with Roland Petit about the ballet and cemented his lifelong friendship with Jean Hélion over conversations about techniques of painting. In the short time he and Steinberg knew each other, Hélion became such a close friend that Steinberg initiated a correspondence in which he exchanged more personal information than he did with anyone else but Hedda Sterne and Aldo Buzzi. Among the other guests at Chagall's were Jean Dubuffet (who also became a cordial friend), the art historian Charles Estienne, and the wealthy English art collector Peter Watson, whose money was largely responsible for the creation of London's Institute of Contemporary Arts. There were also lunches, cocktails, or dinners with Robert Doisneau, Giacometti, and Giò Ponti. And Steinberg still managed to save several long afternoons to browse for rare books, which he had begun to collect.

On this trip he was especially interested in books about Turkey, because he had made several visits to study the Louvre's exhibition "Les Splendeurs de l'Art Turc." It was homework in a sense, because he had long wanted to visit Turkey and it inspired him to make a spur-of-the-moment decision to get away from his frenetic Parisian life and go there. He crammed the trip in before the one of several weeks when he had to be in Rome for work connected with an exhibition of Hedda's paintings. The journey began with a brief stop in Nice to visit his parents, where he stayed once again in a hotel to escape from Rosa's complaints. Then he flew to Istanbul via Zurich and Athens, as there were no direct connections at the time. The weather was bad and he was delayed in Athens, but he didn't mind because he liked the "beautiful and civilized city" and fantasized about returning for several months. It brought back memories of his first year at the Politecnico, when he studied Greek architecture and was so fascinated by the Temple of the Winds that he spent six months drawing it. But what impressed him most of all were the smells of Athens: "black

olives, garlic, cheeses, placinta, sweets . . . a real treat for the nose." Istanbul, by contrast, was "terrible." He had trouble finding a hotel room and slept the first night in a "nameless inn, filthiest bed." When he finally got a room, it was "modernistic and cubistic Turk." The food was inedible and the city was "full of shapeless people." Everything gave him nightmares and he could not wait to leave.

He flew to Rome, where he saw Aldo alone and was relieved that the reunion was filled with their old joshing camaraderie. He was happy when Aldo agreed to come to New York in the fall and stay for three months, but otherwise he worked mostly on the arrangements for the Hedda Sterne show at the Galleria dell'Obelisco. The hardest part of the work involved writing letters to persuade her that even though it was only a ten-day exhibit, it was well worth doing. She thought it was too much to do for too a short time, with too much of their money being spent on expenses for unlikely sales; he said the final decision was hers but he would be unhappy if she refused. To compensate for the show's brevity, he ordered the gallery to make "an especially beautiful catalogue" that he would pay for, and he gave specific instructions for the artist to be identified simply as "Hedda Sterne, painter," and not as "the wife of Steinberg." When she heard of how much money he had already spent and how hard he was working on her behalf, Hedda agreed to the show.

STEINBERG RETURNED TO PARIS, PLANNING TO BE "invisible" while the exhibition was running, but as usual his calendar was too full for him to hide out. This time he only saw people who had become good friends: Janet Flanner, Giacometti, Hélion, and Miró. His only business dinner was with Mrs. Bradley, but here again he turned her into another of his foreign representatives, all frustrated by the inability to get him to commit to any of the projects on offer. She wanted him to "settle a book or two, a documentary, drawings for a tapestry, [and to] decide on shows in Torino, Zurich, Stockholm, maybe in Germany, etc." He was too frazzled to make decisions and begged her indulgence as he postponed everything. He was actually relieved when he found out how many other requests he had avoided by running away to Istanbul, such as when his new German-language publisher, Daniel Keel of Zurich's Diogenes Verlag, made a spur-of-the-moment trip to Paris to meet his new author, only to find that Steinberg was not there.

By the middle of June and despite his resolve never to spend the summer in New York again, he was there for most of it, almost submerged by work and taking on many more projects than was reasonable because once again he needed to make up for all the time he had lost while in Europe. He had sold

some drawings at the Maeght show, but not as many as he hoped. As he had left instructions with Maeght's accountant to send all monies directly to his father in Nice, he had to earn more for his own support. Once again the commercial work interfered with preparations for an important upcoming show. This one, of forty-five drawings at the Virginia Museum of Fine Arts in Richmond, required much more personal involvement than usual: after selecting the pictures, he had to get them ready for shipping, fill out the insurance valuation forms, and then respond to the many requests from museum personnel for everything from publicity about himself to captions for the work. Clearly he needed an assistant, but he had no time to find one. At the same time he was dealing with legal issues concerning Aldo's forthcoming visit: his lawyer had to prepare an affidavit that Steinberg would be financially responsible if Aldo overstayed his visitor's visa, and this meant gathering various tax forms and earning statements from his accountant and attorney.

It was an unusually stressful time, and as usually happened when he was under stress, problems flared with his teeth. For several days before his appointment with the dentist, he girded for pain by drinking scotch more heavily than usual. He worried that he was drinking too much in general but did nothing to curtail it, as whiskey also kept him from worrying about time lost from work. It also helped him to cope with another major worry, this one that the editors of *The New Yorker* might be forgetting him.

Although he had seldom shown up at *The New Yorker*'s weekly meetings of the art department, he thought it professionally expedient to make periodic appointments with the staff to keep his work in the forefront of their minds. Lately there had been ominous signals: Jim Geraghty had started returning many drawings as unsuitable. Steinberg had always tried to make his work serve a dual purpose, often selecting from those he had on file whenever he thought they would fit into advertising as well as in magazines, and now that he was under so much pressure, he was trying to make much more of his work do double duty. He chose, for example, drawings and cartoons that had appeared in *The New Yorker* and *Harper's* to illustrate the small pamphlet *ABC for Collectors of American Contemporary Art*, and he sent others to E. H. Gombrich for his Bollingen book, *Art and Illusion*. Steinberg was plucking old work from his files for *The New Yorker*, and this was not working for Geraghty. It seemed especially important to drop in casually at his office and take him to lunch at the Algonquin, because Geraghty, who had always phoned Steinberg whenever he rejected a drawing, now began to send carefully worded letters like this one: "There must be an area where our demands coincide with your aspirations. This bunch of drawings is tantalizing, frustrating, infuriating, not to

mention wonderful, amazing, and (to use a patronizing word) promising. The Magazine Steinberg and the Gallery Steinberg can't be the same person and you shouldn't ask that they be."

Steinberg accepted that Geraghty would not automatically buy anything he happened to have on hand, and he put a great deal of effort into getting back into the good graces of everyone he worked with at the magazine. It was frustrating to take time away from meeting other deadlines just to be seen walking through the hallways, but Steinberg did it, his mood always lightening when he stopped on the compositors' floor and became deeply engrossed in technical conversations about layout and typography. He usually avoided the staff's large cocktail parties, but he needed to see and be seen, so he went to one hosted by the writer Maeve Brennan and another by Ross's ex-wife, Jane Grant. He was a frequent visitor at Geoffrey and Daphne Hellman's, first when they were still married and later after they separated. He lunched frequently at the Algonquin with the editors William Shawn and Hawley Truax.

He also began to frequent the gatherings at Benjamin Sonnenberg's nineteenth-century mansion on Gramercy Park and at Dorothy Norman's ultra-modern town house on the Upper East Side, where he could count on chatting with *New Yorker* staffers. After Cartier-Bresson introduced him to Dominique de Ménil at Betty Parsons's gallery, Steinberg spontaneously invited her to supper in the kitchen with him and Hedda; in return, she invited him to parties in her New York apartment and was soon an avid collector of his work. On one of his few excursions downtown he took Bill de Kooning to dinner at an Eighth Street restaurant, but he was much more comfortable in uptown venues and preferred to see people there. When Alberto Lattuada came to stay in the 71st Street house for several days in December, Steinberg took him to a party at Jane Grant's and introduced him to writers who he hoped might promote his films. He entertained Lattuada every day with lunches or dinners, but they never went below 52nd Street.

SAUL WAS NERVOUSLY AWAITING ALDO'S ARRIVAL in December 1953, mostly because he needed a foil between himself and Hedda. They had never really talked about most of the things they wrote in letters, particularly the fissures in the marriage caused by his relationships with other women. As there had been no discussion of the state of the marriage when he returned from Europe, there was no clarification about how his behavior was affecting it. Hedda continued to be the good wife who attended to all his household needs and desires, while he mostly came, went, and continued to do as he pleased. Hedda was shocked when Saul seduced the babysitter of Ad Reinhardt's

children: "The main thing about her was that she was foreign and exotic. They just had sex together." Of another conquest, "she was my girlfriend first and then he had to seduce her because he always tried to seduce my girlfriends. With this one, we were good friends and managed to remain so." And of still another, "she was one of those little duchesses he met in Europe and he brought her here to meet me. He always brought his girlfriends home. He needed my approval." Hedda had given up trying to discuss the things that truly hurt her: "It was always difficult to have an argument with Saul. He could touch a nerve and make you hurt, but he was never intent on hurting you. Usually he would diffuse an argument by telling you something about his work or showing you some of it, and of course you could not resist it. After a while he made it seem ridiculous to argue with him."

The one part of each day they looked forward to was what they called "the second dinner." No matter whether they held dinner parties at home or dined out together or separately, Hedda would cook a complete meal at midnight or later—a steak or chops, vegetables and salad—and they would pour wine and sit down together at the big kitchen table and eat and talk. The problem was, they never lacked for conversation, but it was always about other people or things they had done that day, their current work, or their plans for the following day. They never talked, as Hedda put it, "about the things we should have."

SHORTLY BEFORE ALDO ARRIVED, STEINBERG MADE a curious doodle at the back of his 1953 datebook. He was a constant doodler on all the pages of his daily calendars, using colored pencils or ballpoint pen to create elaborate geometric constellations of circles, squares, and triangles, of flags, banners, and exploding fireworks. Sometimes he drew faces and figures, but not often. In this instance he drew a heart that enclosed the face of a man with a disgruntled expression, whose features resembled his own. He had another habit of making odd jottings in his datebooks, of several words or phrases that might be the genesis of an idea for everything from an individual drawing to a series or a complete book. In this particular one, he filled the next several pages with comments about two subjects: his perceptions of architecture and the situation of the contemporary artist.

Architecture was very much on his mind, not only because of his friendships and collaborations with Alexander Girard, Le Corbusier, Breuer, Gropius, Charles and Ray Eames, and Dione and Richard Neutra. Steinberg followed the debates and controversies about Eero Saarinen and his floating, flamboyant commissions, and when he moved to New York with his writer wife, Aline, Steinberg was their frequent guest. He had friendly arguments with Bernard

Rudofsky about everything from the design of private homes to the planning of entire cities, and he had recently accepted a commission from Ernesto Rogers to make the drawings for a "children's labyrinth" that Rogers's firm was to construct in 1954 for the tenth annual Milan Triennial, the showcase of the best of Italian architecture and design. It was an important commission for Steinberg, because it would be on view before so many of his teachers and fellow students at the Politecnico. While working with Girard in Detroit, he had been dubbed "the draftsman-laureate of modernism," and it was a title he was especially anxious to live up to in front of his Milan colleagues.

He thought long and hard about the role of architecture in modern life and the artists who created it. Although what he wrote in this particular datebook seems to be a collection of random jottings without an orderly progression toward coherent thought, taken all together they do give an indication of what he was thinking and feeling.

Geraghty had identified only two categories into which to divide Steinberg's work, "the Magazine Steinberg and the Gallery Steinberg," but there were numerous others as well, the most obvious being the work-for-hire that consumed the major portion of his time (which Geraghty might have been including in the Gallery category). The notes Steinberg made in the datebook address these splits in his professional life and how—even if—they could be unified under the single heading of artistic identity. On the subject of architecture, his comments range from the awestruck to the sardonic, from "pure architecture is like playing the harpsichord" to annoyance with "the Mickey Mouse style" and the "amusement park quality of skyscrapers." The two specific architects whose personalities fascinated him as much as their work inspired him were Le Corbusier and Frank Lloyd Wright, with "their fantasy—articulate, aware." As for the artist, he probably had himself in mind when he wrote, "There is a tendency to dismiss talent." His final summation remains a mystery, because he

Steinberg and Buzzi at the 71st Street house.

carefully and thoroughly blacked out the last word of the sentence: "America is disarming—it finds the 'gimmicks' in the [word blacked out]."

HE WAS AT HOME ON 71ST STREET by November 1953, nervously willing himself to concentrate on work and trying to stay calm by playing billiards while he awaited Aldo's arrival. He sent letter after letter going into minute detail about every possible incident that might arise, from what clothes to bring to the best brands of sleeping pills for the fourteen-hour flight. Hedda was amused by Saul's nervousness but did "every crazy thing" he asked her to do to calm his nerves. She was not amused when she learned that he planned to take Aldo on a trip through the American Southeast just as soon as they rushed through all the things or places a first-time visitor to New York should experience.

She was distressed because Saul was so eager to see his friend that he gave little consideration to leaving her alone again. Two years had passed since they had moved into the house in joyful anticipation of working together side by side, and she got a terrible shock when she added up how much of that time he had actually been gone; she forced herself to stop counting when she reached one full year. She knew that Saul's calendar for 1954 was already full of new trips, and several more were planned for 1955.

When Aldo arrived and they went away, Hedda sent a letter apologizing for how "sad, mixed up, scared" she had been when they said goodbye. She felt "terribly guilty" about accusing him of using absence as an excuse to run away from the reality of his life. She asked him not to "interpret wrong," but she thought he should know: "Your principal fear, I think, is caused by your great talent—*facility* [her emphasis]—which becomes a burden (like too great beauty), particularly with a background that causes masochism, like feeling guilty." She tried to explain that she was like many other women who desire to "keep their man" and how such women push their character and honesty into the background and make themselves "ready for compromises." Such behavior crippled women, causing everything from "indigestion" to "spiritual troubles." Both were very real, Hedda cautioned, and occasionally one would lead to a manifestation of the other. A woman had to know that these were possibilities, and to survive in such a marriage, she had to "take care of what is in our power to maintain, which is a way of life and health, to a certain degree."

In her indirect way, Hedda was asking Saul to understand her plight and to change, but he never responded directly to this letter, and she never pressed her point. He continued to go away from the dream house while she stayed at home and waited for him.

BALKAN FATALISM

I've had and still have problems in which I get involved for no reason, caused rather by the lack of reasons and by Balkan fatalism. Every year or two I'm obliged to clean the stable and I suffer.

After three months in Aldo's company, Saul tried to get down to work, but he didn't find it easy. Aldo was there from November 1953 to the end of March 1954, and most of the time passed in a re-creation of their carefree student lives, only this time they had a lot more money with which to do it. They played billiards, but on Steinberg's private table, whenever they wanted and without having to wait their turn in a public bar. They did not have to be content with reading about boxing matches in the newspapers as they had done on long-ago lazy afternoons in Il Grillo; now they went to the arenas and sat in the best seats. If they wanted to see two movies on a single day, interspersed with a good meal in a chic restaurant, they did it. They saw Broadway plays and heard Toscanini conduct the New York Philharmonic. Just for fun, they were among the first flyers on New York Airways, "the first scheduled helicopter passenger service in the world." And when they traveled throughout the southern states, they flew to major cities, rented comfortable cars, and stayed in the best hotels. They were fascinated with what they saw in the Jim Crow South and read some of the novels of William Faulkner while they were there. Seeing segregation at first hand was a shocking reminder of Steinberg's life in Europe before the war and marked the beginning of his interest in civil rights and his later quiet activism on behalf of African-American causes.

Aldo's departure left him at loose ends. Steinberg had hardly worked at all during the visit, other than to choose drawings for his new book, *The Passport*, often amusing himself by dipping his fingertips in ink and using the prints as faces. When he bought a fingerprint kit to make the process slightly neater and

cleaner, it was the only work-connected event significant enough to record in his daily diary. He had selected the book's title and most of the content well before Aldo arrived, so he had a fairly firm idea of how he wanted it to look. He gave 241 drawings to the publisher, Harper & Brothers, and envisioned a book of 160 pages, which was more than they wanted or could use, but he was insistent, offering a halfhearted apology that there was "too much stuff in it but it's too late to change." Actually, he wanted to include more drawings, but he was unable to focus on selecting them, so he put the book aside to oversee the last-minute details of an exhibition at the Dallas Museum of Fine Arts. As he was so unsettled, he decided to go to the opening. He was not closely involved in the show, because it was the same exhibition that had originated at the Virginia Museum of Fine Arts and would go after Dallas to the Corcoran Gallery of Art in Washington, D.C. All he needed to do was to specify the order in which he wanted the works hung and then affix prices, in this case ranging from $250 to $500.

When he returned to New York, he could not avoid *The Passport* any longer, so he selected forty-nine additional drawings and sent them to his editor, Simon Michael "Mike" Bessie. Steinberg didn't like conflict of any kind, even genteel discussions about how to arrange the drawings or which could legitimately be cut, so he didn't stay around long enough to settle anything over one of the lavish lunches arranged by his Francophile, bon vivant editor. He was delighted to have a valid excuse to leave New York when *Life* magazine invited him to spend several weeks covering the Milwaukee Braves baseball team. However, before he could do this, he had to learn what "America's pastime" was all about, and he needed to educate himself fast.

STEINBERG HAD BEEN TRYING TO UNDERSTAND American culture and society from the first day he set foot on American soil. From the bus that took him to New York from Miami, to the cross-country trips by bus, train, and car, to the Alaskan cruise he took with Hedda and the journey to the Deep South with Aldo, he had been eager to see everything, to bring his memories and souvenirs home with him, and to turn them into trenchant observations in drawings that inspired a shock of recognition in everyone who saw them.

He expressed his interest in all things American through his personal library, which grew to include histories of the United States (particularly of the Civil War) and iconic fiction ranging from Melville, Poe, and Mark Twain to Theodore Dreiser, James T. Farrell, John P. Marquand, and John Dos Passos. After every trip his postcard collection burgeoned with photos of everything from county courthouses to Civil War monuments, motel cabins, fast-food

Steinberg at the Long Island Duck.

stands built in the shape of foods they sold (the Long Island Duck was a load ing example of the genre), wild animals in zoos, pinup girls, the Rocky Mountains, Niagara Falls, and even the Pennsylvania Turnpike.

"Whoever wants to know the heart and mind of America had better learn baseball," said the cultural critic Jacques Barzun, but sports, particularly organized sports, was probably the only aspect of American life that Steinberg had not yet investigated; with the exception of boxing (which he had learned to like in Italy), he knew nothing about any of them. When he told this to Dorothy Seiberling, the art editor of *Life*, she told the journalist Clay Felker that they had to take Steinberg to Yankee Stadium. As the game progressed, they tried to explain to their befuddled guest what was happening on the field, and when it was over, they asked what he thought of it. "It just confirmed my suspicions," he replied, leaving them to ponder "a remark that remains to this day undecoded."

The first thing he did on his own after accepting the Milwaukee assignment was to walk over to his favorite newsstand on Lexington Avenue and buy every sports magazine and baseball manual, and all the daily newspapers just so he could read the sports pages for the first time ever. He took them home, spread them out, and studied them. Every so often Hedda could hear him muttering to himself in Italian, then repeating words and phrases in English. When a game was broadcast on television he would sit without moving, staring intently at the screen and repeating words after the announcers: "A called

third strike . . . a line drive down the right field line . . ." All of this remained a foreign language to Hedda, while to him it became a familiar part of American English. When the game was over, he would consult his ever-growing stash of baseball magazines to look up biographies and statistics for the players whose names he had heard that day. He even taught himself how to score a game and often exclaimed out loud as he wrote the symbols for the player who got on first base with a bunt and the one who stole second.

When he joined the Braves in Philadelphia for the road trip, he had picked up enough of a vocabulary to be able to talk to the players in their own jargon, but he mostly kept silent, just as he had done when he was first in the navy and watched how other officers behaved so he could imitate their actions. The players were intrigued by the little man whose sketches captured the intensity of the game as well as its languor, and they were soon kidding around with him as they saw themselves take shape through his eyes. For Steinberg, baseball was all about "an incredible individual spirit done in a loosely collective manner." His pitcher stares down from the mound with the menacing intensity of a high-speed locomotive bearing down on a hapless batter, while his catcher is an immovable object, a formidable block confident of receiving the pitch. The batter poises on his toes like a gymnast ready to take off in an arabesque of movement. A drawing of the entire team mimics the annual group photograph for which every team in every league poses, and here Steinberg's players have indistinguishable faces as they cluster around the glowering figure of the manager, who hunkers down at their center. A baseball diamond floats like an oversized halo just above their heads, while in front of this tableau, a bat and ball lie crossed on the ground with two tiny trophies on either side, a loving cup and a figure on a pedestal.

The players took to the guy with the funny accent, thick black-framed glasses, and sliver of a mustache, who came to the dugout each day in bespoke or Brooks Brothers clothes and hand-sewn shoes. They gave him a baseball hat and jacket, boldly emblazoned with the Milwaukee Braves logo, and he wore them proudly for the rest of his life, especially when he watched a game alone at home. For Steinberg, baseball became "an allegorical play about America, a poetic, complex, and subtle play of courage, fear, good luck, mistakes, patience about fate and sober self-esteem (batting average)." He agreed with Barzun that it was "impossible to understand America without a thorough knowledge of baseball."

ONCE THE *LIFE* ASSIGNMENT WAS COMPLETED, it was June and well past time to get down to the business of earning money. For the past several years,

because Saul had been away so much, Hedda had decided on her own where they would vacation, usually renting a house from one of their many friends in Wellfleet, Cape Cod, with Saul joining her when he could. This summer he needed to work with Jerome Robbins on stage sets for a new ballet, so she decided to rent a house in Stonington, the Connecticut town where Robbins summered along with a collection of New Yorkers that included the poet James Merrill, who soon became Hedda and Saul's good friend as well. They both wanted to buy a country house and were still thinking primarily of Cape Cod, but because Saul had so many commissions to fulfill, Connecticut now seemed a more reasonable distance from New York than the Cape. They decided to see if they liked it by renting a house big enough for each to work in comfortably. Hedda set up her studio and painted while Saul spent most of his days at Robbins's house, informing himself about the ballet that became *The Concert*. He executed two backdrops, painted curtains that featured some of the same creatures and characters that populated his work for *The New Yorker*, in front of which the dancers played out the dance in costumes that reflected those characters. *The Concert* became one of Robbins's most successful creations and was responsible for many in the steady stream of requests for Steinberg to work in film and theater.

Working with Robbins provided a fun filled diversion when Steinberg compared it to his other commitments, which at this time could be divided into two large categories: moneymaking commercial projects and dealing with his ever-growing fan mail. It had been nine years since he sold his first cover to *The New Yorker*, and cognizant of Geraghty's concern for his slipping status at the magazine, he worked hard to get another. When it appeared, on March 20, it caused a sensation. For the next several months letters poured in, all similar to one written by a truck driver who delivered the magazine to subscribers in Salmon Falls, New York. "What the hell does this cover mean?" he demanded, referring to the black ink drawing of a tall mustached cat whose face resembles Steinberg's and who stands on two feet and holds a smaller cat

Steinberg in his Milwaukee Braves uniform.

in his arms while two others cluster at his feet. The staff writer who answered the letter gave its writer and most of the others who asked similar questions the same reply: "Our March 20 cover has no hidden meaning. It is simply Saul Steinberg's version of the standard, old-fashioned portrait of a father and children."

Steinberg read his fan mail carefully and kept all of it, both positive and negative, but he seldom responded unless it came from children, whose innocent yet penetrating questions and comments he could not resist. A nine-year-old from Brooklyn wrote to tell him how much he liked a picture of "baby shore birds" that he saw when his father took him to the Janis gallery. He wanted to buy it but was told it cost $200. The boy wrote that he counted forty-eight birds in total, which would make each bird worth about four dollars. "I have $20 saved up," he wrote, and asked Steinberg to make a drawing he could afford to buy, one with five birds. A week later the astonished little boy wrote a second letter, this time to thank Steinberg for "the lovely present" of birds that looked "just like sandpipers," made from fingerprints, ink, and crayon. In a postscript he wrote that he was sending a picture of birds he had drawn himself to thank the artist.

Unfortunately, the majority of letters Steinberg had to deal with were not as pleasant. Many kept his lawyer busy, for he was highly litigious and always on the lookout for possible infringement of his intellectual property rights. He wanted to sue the *New York Times* because he thought the newspaper violated his copyright when it printed a picture of a German production's stage set and costumes for Mozart's *Così fan tutte* that resembled some of his caricatures. To support their contention that they had not committed copyright infringement, the *Times*'s lawyers sent their correspondence with the German company, whose stage manager insisted that "they didn't copy directly—merely followed your style." Steinberg still wanted to sue and had to be persuaded once again by the ever-patient Alexander Lindey that litigation in this case would be both costly and futile.

Steinberg frequently created legal problems for himself by accepting every commission that came his way, regardless of whether one infringed upon another. A case in point concerned the Patterson Fabric Company, for which he had been designing for the past seven years. Other firms courted him throughout that time, and now, because the year was half over and he was still far short of the income he needed to support all those who depended on him, he accepted new assignments from other American companies and some foreign ones. Patterson Fabrics thought it deserved "slightly more consideration" than he was currently giving and sent an artfully couched letter hinting

at its disapproval of his designing for other houses. The company warned that although it was true he would sell more by creating many designs, he would soon saturate the market and "decorators will tire of you." It urged him to "consider this carefully." He ignored the advice because he needed the money and continued to accept nearly everything he was offered.

For a variety of reasons, most of what Steinberg agreed to do was never realized; for example, the mural the Beverly Hilton Hotel had commissioned was canceled because of budget problems. He was quite excited when Harold Arlen, Truman Capote, and Arnold Saint Subber invited him to design the sets for the Broadway production of *House of Flowers*, and because he could not work on Broadway without union membership, he immediately completed the extensive paperwork required to join the Scenic Artists Union. It was a shock to everyone when his application was rejected. Nor was he mollified by an invitation to join the National Society of Mural Painters, but he accepted anyway and sent the $10 annual dues.

Despite his abrupt resignation from *An American in Paris*, Hollywood was still interested in Saul Steinberg. Metro-Goldwyn-Mayer asked permission to use his name in a movie called *The Cobweb*, which was set in a "clinic for nervous disorders." The lead character was a patient who designed fabric patterns, and another character was to say of him, "I think [he's] more like Steinberg." Lindey sent the official refusal letter after the horrified Steinberg forbade MGM to use his name or anything else that might tie him to a mental hospital.

The volume of fan mail was equaled only by the requests for his work that poured in from commercial firms, most of which he accepted, with much of it coming due during his Stonington summer. Among the commissions, Remington Rand wanted cartoons for a promotional booklet for electric shavers; the Lawrence C. Cumbinner agency wanted ads for Smirnoff vodka; Jamian Advertising and Publicity wanted a two-page spread for ships designed to illustrate their Marco Polo line of fabrics. The Good Time Jazz record company of Los Angeles wanted designs for many of its record covers, and a St. Louis advertising agency wanted designs to illustrate a campaign slogan, "We teach copper new skills," for the Lewin-Mathes copper tubing company. This one in particular led to a long, lucrative, and exceptionally creative association.

As Steinberg was striving to earn money, the summer of 1954 saw the true beginning of the requests that flooded in until the end of his life for donations of his work as well as his cash. Everyone from the Citizens Art Committee for the New Canaan, Conecticut, public schools to the satirical French newspaper *Canard Enchaîné* wanted him to donate drawings. The Boston Museum of Fine Arts asked specifically to "borrow" the baseball drawings, but the request

carried the underlying hope that he would donate them. Roland Penrose began what became an annual plea for Steinberg to send a drawing to the ICA for its fund-raising. There were also requests from individuals who wanted him to draw something on a specific subject, such as the socialite Babe Paley, who asked for a Siamese cat she could give her husband, William S. Paley, the head of CBS, for Christmas. Hedda chafed because Saul spent so much time fulfilling these requests that he neglected his own work, but she never expressed her feelings to him: "He thought this country gave him a lot, and he could afford to give something back." After a thoughtful pause she added, "He was afraid people would think he was cheap if he didn't. He didn't want the stigma that he was a cheap Jew."

IT WAS HOT IN NEW YORK in August 1954, but Steinberg had to be there to finish all the work that was due before he left in September for Paris and Milan. Publication of *The Passport* was requiring his attention, and there were frequent meetings with his editor, Mike Bessie. Bessie had become one of Steinberg's fast friends, and the friendship boded well for their publishing collaborations, because Steinberg was a nervous perfectionist and Bessie was adept at soothing him.

At the same time, an extraordinary amount of correspondence had accumulated, starting with his father's American brothers and some of their offspring, whom he called "the Denver and Saint Paul Steinbergs." Both contingents had contributed money and energy to bringing Saul to America and were now just as eager to help Lica and her family leave Romania, which was why so much postwar correspondence was generated. And as the uncles' children grew up and Steinberg's fame increased, the letters came most often from the cousins, who saw his work in magazines and wrote to praise it. His cousin Judith Steinberg Bassow in Denver became the most frequent correspondent because of her interest in his work and the genealogy of the Steinberg family, but it was his cousin Phil Steinberg in Arizona with whom he felt a special affinity and to whom he became increasingly close several years later.

There was even more correspondence connected to his European trip in late August. He made a brief stopover in London, followed by several weeks crammed with activity in Paris, before he went to Milan to work on the mural he had agreed to design and execute for Ernesto Rogers. The list of people he had to see and the things he needed to do before he could begin the work was staggering. Bessie wanted the names of people who could provide blurbs to promote *The Passport*; Steinberg offered Dorothy Norman, Igor Stravinsky, Jane Grant, Alexey Brodovitch, and Walker Evans, all of whom agreed. For

the opening reception, he invited what would appear to an outsider to be a glittering list of celebrities but who were in actuality people with whom he had formed friendships that were both genuine and lasting. A contingent from *The New Yorker* included Shawn, Truax, Hellman, and Geraghty. Uta Hagen, Herbert Berghof, and Stella Adler represented his friends from the theater; Mary McCarthy, E. B. White, Ben Grauer, John Gunther, and Edmund Wilson represented literature; and from the worlds of art and design, Walker Evans, William Baziotes, Mark Rothko, Jose Luis Sert, Alexander Calder, Marcel Duchamp, and Alfred Barr. Everyone, it seemed, was invited, from Leo Lerman to Adlai Stevenson, and everyone accepted.

Steinberg's list of people to see in Paris was even longer and contained the names of many he had met the year before through Aimé Maeght. From the literary world the names Steinberg put on the invitation list included Janet Flanner, Albert Camus, Sylvia Beach, Adrienne Monnier, Henri Michaux, André Malraux, Paul Painlevé, and Jacques Prévert. Noticeably absent were Jean-Paul Sartre and Simone de Beauvoir, whom he had never forgiven for snubbing Hedda in the bar at the Pont Royal. Baron Rothschild led a sizable contingent from the social world, and that resulted in a number of invitations that he accepted. Some of his best friends from the art world did not attend the opening but wanted to see him privately—Hélion, Giacometti, Cartier-Bresson, Dubuffet, Doisneau, and Miró—so he made appointments to see them separately. After he squeezed everyone in, he was ill and run-down and had to stay for an extra day in Paris because he could not get out of bed.

THE FLIGHT TO MILAN WAS BUMPY, and by the time he checked into the Hotel Duomo, he was "very sick," not only with the upset stomach he was certain came from air sickness but also with a raging head cold and the flu. It was only August, but it was cold and rainy and felt like November. For the next several days he had to force himself to get out of bed and go to work in the rain while someone held a large umbrella over him. Rogers's firm, BBPR, had been commissioned to create a *labirinto dei ragazzi*, or children's labyrinth, for the tenth Milan Triennale. Steinberg's drawings were on all the walls, and no matter where the viewer entered, there was a Steinbergian panorama to guide him to the center and into the two other wings, the entire structure resembling a kind of three-leaf clover.

He had created the designs on long sheets of scrolled paper before he left New York, then mailed them to Milan to be enlarged to the proper size for the walls. They were then transferred a second time, to a kind of paper that could be placed directly onto the freshly applied plaster so he could do the actual

sgraffito, incising the designs through the paper directly onto the walls. He was prepared for the worst when he arrived, because everything from the weather to his health had been so dismal, but when he saw what the "three incredible boys" (two painters and a sculptor) had done, he was so pleased that he did something highly uncharacteristic: he insisted that the three men pose in front of the mural to have their photo taken, with him beaming at their center. He told Hedda that sgraffito was "a wonderful technique" that would solve all his problems for any future murals and he hoped there would soon be another. In the meantime, he planned to experiment on the walls at home, "in the basement perhaps."

It rained every day, and he could legitimately have stayed in bed until he was well, but he was captivated by the mural's progression and so he worked alongside his three assistants, improvising all the time. He flitted among them to make spur-of-the-moment additions, many of them easily recognizable Milanese landmarks. Some were whimsical, such as his rendering of the Castello Sforzesco, placed directly in front of where the castle could actually be seen if adults (and the children they held) raised their eyes to look over the wall. All the drawings inspired feelings of fun and laughter as viewers traipsed along the walls, and most of the reviews took note of the joy that people expressed. Steinberg's labyrinth was so different from the formality of all the other exhibits that the *New York Times* critic declared that it stole the exhibition. All the other designs and structures were "serious, professional, and well-meaning," but the only "humanity and humor" in the entire Triennale was found in Steinberg's drawings. It was high praise indeed, especially welcome because it came in his old hometown, but it was difficult to bask in it for long.

On August 29 the partners in BBPR gave a party in their studio to celebrate the opening, which was for Steinberg a reunion of ghosts. No liquor was served, so there was nothing to make him feel (in one of his favorite slang expressions of the time) "snappy." Most of the guests had been his professors and classmates at the Politecnico, and it was grating to be kissed on both cheeks by old teachers who hadn't given a hoot about him as a student. Even worse were the snide, damn-with-faint-praise articles in magazines he called stupid about how successfully American he had become to command *mille dolari al disegno* (a thousand dollars per drawing). The hardest thing to deal with was the culture shock when he realized that he was so deeply imbued with American values that he could not accept the postwar Italian way of conducting business in the worlds of art and culture, the *raccomandato* of "I do something for you, you do something for me." Whether it was truly far more blatant in Italy than in New York or Paris, or whether his entire Milanese experience was so disorienting

that he needed to find a scapegoat for the depression that enveloped him, it was no longer something he could take as par for the course. It left him deeply unhappy to think that the country he had so warmly embraced and that had embraced him in return now considered him a foreigner. The only high spot came when Alberto Lattuada and Aldo Buzzi arrived to make a movie and he was given a walk-on part as a passerby in a scene they shot in the Galleria. Even this pleasure of being with old friends was double-edged: "It was ok but they felt they had other obligations and at times it was clumsy."

WHEN HIS WORK WAS FINISHED, he told Hedda he wanted to go to Bergamo to have lunch with Aldo's mother and then go directly to Venice for several days to decompress after all the work and socializing. He said he planned to see no one and have several days of the privacy that he had been without since leaving New York, but he did not tell her his real reason for going to Venice: that he needed to sort through the welter of emotions that came from seeing Ada again. For the past several years, besides regularly sending her money, he had managed to see her on most of his trips, and when he was in New York he telephoned regularly for long, secretive, and rambling conversations. However, once he resumed their liaison, he was so embarrassed that he kept it secret even from Aldo.

There had been three previous postwar encounters between them before this one, and all had ended badly. She felt the first went poorly because of "insincerity" on both their parts, the second because he cynically made fun of her extreme neediness, and the third because he told her he had to flee from her excessive passion and if she had any pride left at all, she would disappear from his life forever. Ada's letters were a case study in self-contradiction. If she responded at first with histrionics, insisting that brain cancer would be preferable to the emotional torment and suffering he caused, which made her so ill she would soon die of whatever disease it caused, she would then swiftly become compliant and pacifying, with her next sentence, meant to be soothing, saying that all she wanted was to spend time with him, not necessarily in bed, just in his company; to be "maternal" rather than sexual. All she needed from him was "for the phone to ring," but when he did call, he had to listen to a series of elaborate dodges that she invented, claiming they were necessary to keep the affair hidden from her husband.

While he was working on the mural, even on the days that he was sick, he managed to slip away to meet her secretly. She still traveled a lot, always being careful never to specify the reasons, and when she was in Milan, she lived once again with her husband in an apartment on the Viale Misurata, not

far from where Steinberg was working. She arranged for them to meet half-way in between, in an apartment belonging to the girlfriend who had provided cover for them before the war. Ada was content with this arrangement, having accepted that Saul was married and so was she. She assumed that when he came to Milan they would resume their affair as if no years had intervened since he had been a student at the Politecnico, and when he left, each would return to their legal partner. This was easier for her than for him because she claimed never to have loved her husband, whereas despite his constant infidelity, he truly did love Hedda.

By the time he left for Bergamo and Venice, he was in an emotional turmoil because of everything that had happened during his time in Milan. Ada left him reeling; he had been affronted by the former colleagues who mocked his Americanness and by the two-faced behavior of his former professors, who now claimed they had known all along that he was a genius. Most troubling of all was his own shame about the duplicity of his relationship with the wife he professed to love above all others and the lover on whom he placed all the blame for luring him into bed each time he saw her. He could not help but contrast the two women.

When Hedda wrote letters, they were always on two levels. Hedda was a voracious reader, and she generally began with a philosophical interpretation of passages from books that she thought had relevance to their lives. Often she used them to launch into news of household happenings or of social occasions with their friends or events in the art world, because so many of their friends were artists. When Ada wrote, it was usually to tell him that he had left her in such a state of orgasmic ecstasy that she was having difficulty returning to married life with her dull husband. Her letters were blunt recapitulations of their time in bed, which almost always ended with how his departure left her ill and unable to work. She never asked directly but always implied that being unable to work meant that she sure could use some money. Ada was adept at blithely telling contradictory lies one after the other and getting Saul to accept them unquestioningly. First she told Saul that she was in such dire health from an undiagnosed illness that her husband, who "knows the cure for my ailment" (that is, Saul), actually took pity and guided her to the post office so she could mail a letter to him. In the next sentence she told Saul that mailing the letter immediately cured her, and as an aside told him to use her maiden name and a post office box number so her husband would not find out they were having an affair.

Saul hoped that several days alone in Venice would help him decide what to do about Ada, especially whether to end the affair permanently before it

became a public embarrassment. He decided not to tell her that he had to return to Milan for a number of public events scheduled to conclude all the necessary dealings with the mural and let her think he was going directly to France and England and then home to New York. However, Milan was a small town, and it was not difficult for Ada to find out that he had been there. It made her furious even as it made her more determined than ever to stay in his good graces. In a series of letters, she first told him that she was working as a teacher but did not specify where, only joking that the work made her eyes so weak that she had to buy new glasses, which made her feel not only "old" but also "ridiculous [to be] still in love." As soon as she told him she was a teacher, she changed her story in the next letter, saying that she had joined the theatrical company Senza Rete (Without a Net) and would be on tour in Padua, Florence, Naples, and Rome until the end of the year. After these illogical contradictions, she lapsed into fury, berating him for being his "usual pig" self, afraid to let anyone see him with her. She knew he had returned to Milan, not only because of the publicity surrounding the children's labyrinth but also because the writers for the theater company knew of their relationship and took delight in teasing her about how they had been with him and she had not. She demanded to know if he was afraid of the gossip that might have reached Hedda if they were seen together—or was it something more serious, that he did not want to see her anymore? "I can't help but tell you that you are"—and here she left a blank space before concluding that it was such "an ugly word" that she was unable to write it. Instead of ending the letter with her usual effusive phrases of love straight out of a romantic nineteenth-century Italian novel, she signed it with what was for her a cold snub, a simple "Ciao." A postscript offered another contradiction, as she instructed him to write to her in care of yet another new post office box so her husband would not discover they were back in touch.

THE FEW DAYS STEINBERG SPENT IN Venice before he went back to Milan were disappointing, as he did not resolve his emotional confusion. The weather was disagreeable and the food not to his liking, and once his work was finished in Milan and all the celebrations were over, he could not return to New York without making the obligatory visit to his parents in Nice. It was, as usual, "horrible." His father was slowing down, but his mother had deliberately lost weight and was in fighting trim to harass him more than ever. He planned to get through the visit by giving them money and behaving, "as usual, like Santa Claus." This did not assuage Rosa, who spent her time with him listing all her friends who had died since his last visit and all the family disasters in Israel.

His father couldn't get a word in edgewise. The only time Rosa was happy during Saul's visit was when she read and reread the first letter Lica's son, Stéphane, wrote to her, saying that he was well and his baby sister, Daniela, "eats carrots." Always before when Rosa talked about Lica and her family, her mood improved, and Saul had a brief respite from her dire accounts of gloom and doom. This time was different, as Rosa berated him for not telling her about things Lica had told him, which Lica had asked him not to reveal to their mother and then over time had inadvertently revealed herself.

Lica was understandably depressed by not being able to leave Romania, where her life was far from easy. Her husband had a series of undiagnosed illnesses and his job was in jeopardy; she herself had been ill and was worried about losing her job. Stéphane had had a serious case of scarlet fever, and now, with a second child, Lica was worried about basic issues of survival. She told one sad story after another of her own family's misfortunes as well as those of their various relatives and former neighbors. They all begged her to ask her rich American brother for help, and she did. She was still angry over one particular incident that had taken place two years earlier, when she asked him to send medicines via American Jewish agencies to "the daughter of the cardboard maker on Strada Palas." When they never arrived, she accused him of doing nothing: "If you could've helped her and you didn't do it, then you committed a crime against her." Lica told Saul she was still so bitter that it was difficult to return to thinking of him "with love and admiration."

Lica's charge was unjust, for he had sent both money and medicines to her and the others every time she asked. When Rosa learned of it, she changed tack and scolded Saul for trying to send money directly to Lica, since other efforts made through relief agencies had failed, and now her Communist bosses were threatening to fire her after they learned that she had rich relatives in America, which made her untrustworthy. As far as Rosa was concerned, it was all Saul's fault. Rosa was crafty enough to know that her letters upset him so much that he seldom answered them, so when she wanted money or goods, she wrote directly to Hedda, often giving the names and addresses of all their relatives and friends in Israel with instructions about how much financial help to send to each. Hedda told Saul she was disgusted and stopped replying. Saul told her that the house in Nice was flooded with six years' worth of letters from him and Lica that his parents insisted on reading and rereading aloud every time he visited. It was no wonder that he cut this visit as short as all the others, once again inventing urgent reasons that he had to go Paris, England, and then home.

The Passport, his "third, most overstuffed and diverse" collection of drawings, appeared in New York in October. He had indeed crammed all the draw-

Saul Steinberg, *Untitled*, 1954.

Saul Steinberg, *Untitled*, 1950.

Saul Steinberg, *Untitled*, 1954.

ings he wanted into the book, and every edition contained them all, including last-minute additions like the March 20 *New Yorker* cover. The book was another of his autobiographies, which he told through drawing rather than writing. There were false documents, diaries, and journals, and photographs real or invented, all doctored to make them as elusive as the documents. Several pages featured an artist drawing himself, with squiggles above his head or surrounding his torso. He used fingerprints to create human bodies and little birds with sticklike beaks and legs on graph paper. Cats tumbled freely about and crowds gathered to watch parades and festivals that featured flags, floats, and his iconic drum majorettes, whose legs ended in dangerous stiletto boots. There were couples in which he made either the man or the woman the dominant figure and cocktail parties where people talked past each other, always on the lookout for someone more interesting than the person they were with. He drew pages of riders on horseback, of cowboys and equestriennes. Musicians played before backgrounds of musical paper while dancing couples moved about on white space vacant of any other scenery. All the railway stations, bridges, and buildings that had fascinated him in England were there, as were French Métro stations and elegant Parisian buildings and monuments. Two shadowy men played billiards and shot pool; scenes of domestic life showed women dining with statues rather than real men; children in Victorian dress posed in front of houses straight out of Charles Addams's cartoons. Several iconic drawings appeared here as well—the sign painter whose final *k* drops off the word *Think*; an artist who sits before a blank sheet of paper with only an ink bottle beside him. Another drawing features the objects that cluttered Steinberg's real-life desk: an empty Medaglia d'Oro coffee can, a tin of Altoid mints, a bottle of India ink, a postage scale, and a packet of Philip Morris cigarettes. Two trees of life depict the lives of a man and woman who advance from infancy to adulthood and then decline into old age. Street scenes from Paris, Nice, Istanbul, Venice, and Los Angeles are interspersed among the individual drawings. Steinberg's keen eye takes note of some important postwar changes in American life: a couple stands proudly in front of a Levittown house that is dwarfed by its garage and the gigantic car beside it. He reveals the expansion of supermarkets and strip malls and the architectonics of the new skyscrapers, particularly the ugliness of brutalism. Streets are torn up and shadowy blobs represent the human figures who here and there dot them.

He was satisfied with the American edition, but he wanted to make sure that the British edition being published by Hamish Hamilton was up to his rigorous standards. The book was being printed in Edinburgh, but Steinberg insisted on seeing the proofs before publication and was willing to take the

time to go to a city he had not liked at all on an earlier visit. He traveled there by train in a sleeping compartment as antique as the publisher's representative who went with him. The man wore "a striped suit and mellon [sic] hat," and their compartment was made of "mahogany, brass, and ivory," with a small compartment in the wall for the chamberpot. There was much fodder here for drawing, and he made note of it for future use. When he inspected the proofs, he did not make a single change; in fact, he thought the book looked better than the American edition.

On his return to London he visited Victor Brauner and his wife, Jacqueline, who were living in straitened circumstances. It was depressing to see a mouse calmly staring at them from behind a broom in the corner. Brauner was old and unwell, and his wife had just returned from the hospital following her second major operation. Steinberg's sadness deepened when he returned to the hotel to find a letter from Hedda telling him that his uncle Harry had died and to break the news to his parents and send condolences to his uncle's widow. With illness, death, and suffering all around, he was more than ready to go home, but once again there were problems with the airlines.

He could get to Paris but could not get a direct flight from there to New York. He did have to see Mrs. Jennie Bradley, so there was a legitimate reason to fly home from there. While he waited, he went to the movies (*Pane, amore e . . ., Fantasia*), read popular books (Françoise Sagan's *Bonjour Tristesse*), and spent a lot of time walking to American Express to see if there was mail. Nothing he saw inspired him to draw, not even the "passersby loaded with children and suitcases" or the "tourists, sailors, dogs, prostitutes" who interfered with "the café workers making their rounds, and the street workers who drilled the asphalt directly in front of motorcycles, buses, ambulances." All of this would have been transferred to notebooks and turned into drawings had he been in a better mood, but he was tired and wanted to go home.

He had even lost interest in writing to Hedda, which led to a flurry of telegrams to see whether something had happened to him. He was uncharacteristically sullen when he told her it didn't matter if she didn't write because her letters mostly consisted of news clippings or quotations and there was seldom anything personal. He had been alone far more on this trip than on most others, and he didn't like the introspection that resulted. He realized that when he was the center of attention in social situations where he did all the talking, very little of what he said was "real." Everything became formulaic because it was simplified chatter and therefore "seldom true." He was full of self-pity and self-castigation for having let himself become a self-invented construct. His "Balkan fatalism" was overwhelming, and it was time to go home and sweep his stables clean.

SOME SORT OF BREAKDOWN

*I've been an inflated balloon for years now and being alone
it's deflating. This is what I wanted but it's hard.*

Steinberg returned to New York at the end of September 1954, anxious
about another round of the dental appointments that almost always
accompanied periods of extreme stress. There were two shows he
needed to prepare for in November, one in Santa Barbara and the
other in San Francisco, so he fluctuated between making careful lists of the
drawings he wanted in each and listlessly rearranging them with halfhearted
attention. The only point to which he gave full concentration was deciding on
prices. He raised them all, because his self-imposed burden of supporting fam-
ily, relatives, and friends was so high.

He began to suffer from insomnia and was unable to keep to his regular
habit of going to bed shortly after midnight and waking ready to put in a full
day's work between seven and eight a.m. He was unable to sleep for more than
one or two hours before he woke up with his heart pounding and his mind rac-
ing with thoughts of all the drawing he had to do to earn money and frustration
over the creative work that he did not have the luxury of time for. However,
such worries did not stop him from resuming the hyperactive socializing that
filled the holiday season in New York. His pocket diary noted parties, dinners,
theatergoing, concerts, and also, in brightly colored pencils or crayons, the first
names of women or merely initials followed by numbers. By Christmas he was
exhausted, his mind was empty, and he believed the only way he could save
himself was to go away and think through the morass his life had become.

With her usual willingness to put his needs before any she might have,
Hedda accepted his wish to go somewhere alone to refresh himself physically
while gleaning ideas for new drawings. His intention was to take a short trip

that could be directly connected to his work and therefore put toward a useful tax deduction, and a series for *The New Yorker* was the first thing that came to mind. He was still intrigued by the American South, and there were many places he had not seen on his earlier trip with Aldo. A quick flight from New York would get him there quickly, so he decided to spend a week exploring them.

On January 8, 1955, he flew via Washington and Nashville to Memphis, where he checked into the Peabody Hotel, dropped his suitcase, and spent most of the night prowling the city. His digestion had been in turmoil since he returned from Europe, and the sight of vulgar hotel bar patrons drinking beer directly from bottles was so offensive that he looked for a more refined place to dine. The local "candlelight restaurant" offered only huge slabs of steak, and to his surprise he enjoyed one without later distress. His late-night peregrinations took him through empty streets until he found the "dangerous looking Beale Street," where nothing was open except a late movie showing of *The Silver Chalice*. As he was not sleepy and there was nothing else to do, he sat through it.

The next day was Sunday and even more boring as nothing was open. After walking to the banks of the Mississippi, Steinberg took a bus via Jackson to Vicksburg. Everything was closed there as well, so he went to the movies again and saw *The Barefoot Contessa*. He spent the next day walking all over Vicksburg or hiring taxis to take him to the Civil War monuments and the stern-wheel boats that used to ply the river. He took another taxi back to Jackson and caught a bus to Faulkner's hometown, Oxford, but he made no notes about anything connected with the writer. Again the only thing to do was to go to the movies, and this time he walked out after five minutes of Frank Sinatra's singing. It was no better across the street, where he watched part of *White Christmas* with Bing Crosby and Danny Kaye.

Early the next morning he walked around Oxford, bought a new shirt, and took a cab to the airport for a flight to Atlanta via Birmingham, with Tampa, Florida, as his final destination of the day. His late-night walking in Tampa took him past "loans, bars, pawnbrokers," and somewhere in all this he must have encountered trouble, because he wrote the single word *robbers* in heavy black ink. The next afternoon, exhausted with walking and discouraged with Tampa, he went to St. Petersburg. There he was depressed by "old people, hearing aids, ambulance ads in movie house." There was nothing to do there either except a movie, this one starring Alec Guinness. Afterward he bought a necktie he didn't like and a silly hat with a compass on it. He had been gone only five days, but that was long enough, and he booked a flight back to New York.

Once he got there, he realized he was not rested, he had not rid himself of stress and anxiety, and his insomnia was worse than ever. When he tried to come up with an idea for drawings suitable for *The New Yorker*, his mind was a complete blank. When he was in transit, what had struck him most was the evidence of Jim Crow everywhere he went, of "colored" water fountains and restrooms, of African-Americans moving dutifully to the back of the bus, of segregated schools and restaurants. The magazine was not ready to publish pictures that would arouse political activism, and in truth, he had not yet identified segregation as anything other than an accepted way of life. He was certain that the entire trip had been a waste of time.

Several projects awaited him, and his spirits lifted slightly when he began to work on the first: Alfred Hitchcock had engaged him to create drawings for the title sequence in the film *The Trouble with Harry*, and after all the intense work of the previous year, it was "sheer fun." The second project was to prepare some of his architectural drawings and false documents for an exhibition scheduled for March by his good friend Jose Luis Sert at the Harvard Graduate School of Design, where Sert was the dean. This project did require the intense concentration and meticulous attention to detail that Steinberg gave to exhibitions, and he forced himself to do it. By the time he had finished, he was so exhausted and unfocused that he was not sleeping at all and often broke down in bursts of sobs and tears.

Hedda was sick with worry and tried to get him to talk to about it, either to her or to a therapist. He resisted both ideas, especially therapy, which he dismissed as a waste of time and money but which in reality frightened him with the possibility that it would lead to self-knowledge that he was terrified to confront. Also, he feared that telling his most private thoughts to anyone would reveal him as a weakling, and he could not bear to lose face before another human being.

Eventually, however, he did talk to Hedda. She was stunned when he said that he didn't think he loved her because he was not sure that he was constitutionally capable of loving anyone. He wondered if the intensity with which he had pursued her when he wanted to marry her had been honest love or merely a desire to acquire this incredible woman because of the qualities she possessed.

In her public life, Hedda was a beautiful woman and a respected artist warmly welcomed by her many friends within the artistic and intellectual life of New York; in their private life, she gave Saul the personal comfort that came from their mutual Romanian-Jewish heritage and that smoothed his entrée into this rarefied world. Being with Hedda provided all the trappings that enabled

him to enjoy what he believed represented success and happiness within the ideal American life, as well as the personal security that came from being loved so unconditionally. "Love is the only thing that makes life bearable," she told him.

Now, a decade into their marriage, all Saul felt was a tremendous desire to be free of everything in the life he had constructed with Hedda, starting with her and going on to the work he did for hire, all his financial obligations, and even America. He had an urgent, unfocused need to get back to Europe to see if he could find any trace of the self he had so eagerly discarded almost twenty years before, when the successful Italian cartoonist that he had been morphed into a stateless Jewish refugee totally dependent on the goodwill of others. He was not going to be the prisoner of a timetable on this trip; he would spend as much time as was necessary to roam from place to place throughout Europe until he could regain his equilibrium and find the stability and stasis that eluded him.

Hedda told him to go, saying that she could "easily" wait for him to return. Instead of soothing him, her serenity added to his general anxiety: he didn't want to lose her, but he wondered if he had the right to keep her tethered to a relationship that might come to a shattering conclusion. He was frustrated because for the first time in their relationship, she refused to solve his problems. He decided that the major problem was one of "honesty or truth," and that she had unwittingly helped to create it. They were so well suited to each other that it was difficult to sort out where she began or he left off within the marriage. He thought they were so "well mixed . . . that the truth becomes an animal with one foot size 5, one size 10½." He blamed this for his loss of individualism, which allowed him to fool himself into believing that the savoir faire he adopted for his professional dealings was an acceptable substitution for the truth and honesty that was absent from his most important personal one, his marriage. Also, because he liked being accepted among the "the *elegante welt*," as he called the social and intellectual circles Hedda had originally introduced him to, he accused himself of wasting the past decade putting on an elaborate front to keep himself at the top of it. In doing so, he had lost his identity to a collection of deeply unfocused fears, which he tried to bury by avoiding any occasion when his galloping insecurities might become exposed. Others often described his behavior in the social situations where he insisted on holding the floor as cold, rude, arrogant, and selfish, but it was merely his way of hiding his basic insecurity.

He told Hedda that two of his three most crushing fears were about her: that he wasn't sure he was capable of loving her, and that she only wanted to

stay married to him because of inertia. These were certainly valid fears, but the biggest fear of all was that he had made a terrible choice by sacrificing creativity for the need to make money, which he described quite simply as "I lost twenty years." He was forty-one years old and was so depressed that he insisted he had done nothing to be proud of since coming to America, that none of his drawings, books, exhibitions, or awards had given him any true pleasure: "My preoccupation has been success, probably. I need it, but very much the way I need whiskey." And so, he asked himself, if success was merely a palliative, where did personal satisfaction lie, and how would he find it?

Hedda agreed that he should go away to anywhere he wanted for as long as he needed. He decided to start with Paris, where he had pressing business, after which he would go wherever impulse took him. She intended to send him off with her usual stoicism, but when the time came for him to leave and he told her that "it may be for good," his words shocked them both. She could not stop crying and said that she could not forgive herself for sending him off with such a memory. He replied that he recognized how "horrible" her fears must be, for he could not get the image of what he had done to her out of his mind. He did not sleep on the long overnight flight, and spent his first twenty-four hours walking in the unseasonable cold or pacing in his room when he could no longer stand to be outdoors. "Now I understand insomnia," he wrote. "One blames the outside reasons but sleeplessness is inside." He tried to calm himself with his usual late-night recourse of going to the movies and saw *Diabolique*, which relaxed him but not enough to sleep.

In Paris there were things he had to do and people he had to see, starting with Mrs. Jennie Bradley, who had a slew of offers from galleries, museums, and publishers for which he had to make decisions. Aimé Maeght invited him to a private three-hour lunch at his home, where they ate multiple courses of "all sorts of sea monsters and mostly garlic." It made Steinberg literally sick, but he was actually grateful that this time his upset stomach was due to rich food rather than "bad conscience." Maeght had an ulterior reason for the lavish meal, to try to persuade Steinberg not to exhibit at the Berggruen Gallery, as he had promised, but to agree to a larger show the following year at Galerie Maeght. Steinberg didn't think he could be ready for a show anywhere and tried to stall for time. He had an appointment with Gallimard to oversee the imminent publishing of *Dessins*, a compendium of drawings from his three American books, and Robert Delpire wanted to discuss a proposal for his firm to publish another book, but it was not realized at the time. Steinberg was unable to concentrate on either project. As always, the one person in whom he could confide was Hedda, but she was not providing answers. He told her

that even though he was in Paris, staying in a good hotel and being wined and dined, it still felt like a concentration camp. After writing that letter, he went to the movies and saw Gina Lollobrigida, whose voluptuous pulchritude made him feel slightly better, but he still couldn't sleep.

He spent the weekend walking around, particularly at the Bird Market on the Quai de la Mégisserie, where he relaxed slightly by thinking of his beloved cat at home while petting the strays that lurked around the cages. By Monday morning he knew that he had to get away, because being in Paris meant business as usual and he needed to avoid people. Except for the appointments he had to keep, he did not go anywhere that he might be recognized, avoiding the Left Bank arrondissements where most of his friends lived and eating in obscure restaurants. And yet being alone did not have the soothing effect he sought: once he had the solitude to think about himself, he didn't like the self-portrait he created. He compared himself to an inflated balloon that was slowly deflating: "This is what I wanted, but it's hard." On the spur of the moment he decided that the only way to seek what he was now calling his "true identity" was to return to the places that divided his life from its first half—the one provided by his parents, which he had unquestioningly accepted from earliest childhood—and the life he had created since coming to America. He decided to go to Italy, expressly to return to Tortoreto and revisit his incarceration. "It's not a ham gesture," he insisted. "It's as good a place as any to spend a few days quiet, no smoke, no drink . . . I'm waiting for sanity to come back to me."

THREE DAYS LATER, ON MARCH 23, he was in Pescara, which he believed was the terminus of his original railroad journey from Milan to Tortoreto. He arrived there after a full day in a slow train from Rome, where he had flown from Paris in order to see Aldo and have dinner with him and Bianca: "It was bad. I was tired. We talked nonsense." The next morning he realized that the evening had been unsuccessful because he had wanted to confide in them and ask their advice but did not know how.

The mornings when he woke up alone in a hotel were terrible, because he was tempted to cable Hedda and ask her to come and rescue him; the nights were worse, because he had nightmares and could not sleep. Although Steinberg had no faith in psychoanalysis and did not believe that talking to an analyst would alleviate the various traumas that increasingly beset him, he had a deep and abiding interest in dream analysis and often kept detailed diaries of some of his most troubling dreams. On this trip, he no sooner fell asleep at night than he was jolted awake by dreams of someone pounding on his door. The setting was always his New York bedroom, because the knocks were always

accompanied by Hedda's screams. They would wake Moritz, who was also in the house and who ran up and down the four stories of the steep front and back staircases. This caused Saul to jump out of bed in alarm, fearing that his father would suffer a fatal heart attack if he could not catch and stop him. Saul attributed these nightmares not only to his "sense of guilt" but also to "something worse." As much as he felt he needed Hedda if he were ever to sleep again, he begged her not to come to Italy to rescue him but to stay where she was and "please worry about me."

To divert himself from his anxieties, he returned to a theme he had been expressing since he first met her, that everything would be fine if they could just buy a house away from New York, where he could hole up and work. This time he thought perhaps the Adriatic coast or Paris. But even as he wrote this he knew it was mere talk, because he was "confused as usual and postponing." He brought the letter to an abrupt end by admitting, "I think I had some sort of breakdown a few days ago and I'm recovering." Then he concentrated on getting himself dressed, packed, and ready for the pilgrimage to Tortoreto.

A slow train took him to Tortoreto, where he left his luggage in a dreary tavern so he could walk through the village. Nothing in the town looked familiar, but he was sure that was because he had seen it only when he was one in a long chain of prisoners being herded to the villa on arrival and departure. The town was small, but he thought he found the building where he had been incarcerated. It had been repaired and repainted and looked inhabited, so he did not enter through the large iron gates, not wanting "to get silly with strangers." He was filled with emotion as he walked back and forth in front of the house, and yet the only things that looked truly familiar were the few trees on the grounds. He was irritated to think that he had lost the memories of a place that once meant so much to him, so he decided to take a walk on the beach, because the prisoners were never permitted to go there.

For the next three hours he walked, enveloped in a dense white fog that the natives swore was highly unusual, but to him it was "one of the most pleasant things I did ever." Afterward, damp but happy, he went into a bar, had a beer, and wrote Hedda a lighthearted letter describing the villa as "a castle, a true romantic prison," and the town as "a summer resort for the poorer tourists." He described the local color, how fishermen fixed their nets, dirty children followed him and asked for handouts, and dogs barked at him. He was pleased with the adventure—until he got on the bus to leave the town behind.

As the bus belched its smoky way into the hills above Tortoreto, Steinberg chanced to glance out the window at the very moment the bus was passing the villa in which he had actually lived. "There are—I didn't know—two Tortore-

tos, and I had gone to the wrong one!" He made the driver stop the bus and jumped off in "the right one," Tortoreto Alto, where he walked around "recognizing with horror every house, shop, tree, stores, types of people, dogs." The villa where he had lived had been badly bombed and was abandoned in total disrepair. All the palm trees around it had been burned and were dead, and the town itself was filthy. He was lucky to find a taxi driver willing to take him to the next village, San Benedetto del Tronto, where he could wait for another slow train to take him as far away from the real Tortoreto as he could go.

That evening, from a hotel in Ancona, he described for Hedda all the emotions that beset him as he sat on the railway station bench. He was able at last to confess the real reason for all the traveling he had done during the past several years: that it enabled him to evade what his life had become. Constant traveling did not allow much time to think about his own needs or desires; frenetic movement was his way of coping with the things he needed to do to maintain his expensive way of life and to forget momentarily all the financial responsibilities he had willingly chosen to accept. He was able to hint that such behavior was probably cowardly or immature but stopped short of describing it as such, saying that he had forced himself to return to Tortoreto because he thought it would give him "proof of maturity or courage." He was not amused by his "curious mistake of unload[ing] my feelings on the wrong and pleasant Tortoreto." Instead, it made him so angry that even though he wanted to forget it had ever happened, he had to admit that the incident could stand as a metaphor to describe his life: "The truth is that I ran away as soon as I looked at the real one."

Hedda told him that she found it "strange, that a place can mean anything in itself, without recapturing the mood, situation." In two of her letters she made it clear that she had given his Tortoreto experience a great deal of thought before she addressed it directly. She called what happened to him "a sign," explaining her view that when people go through a period of "self-analysis, self-accusations," it is because they are unable to confront the real issues that trouble them: "They invent a guilt (edited, formulated in words) in order to camouflage the one that really bothers them, which is not quite clear possibly, or lacking glamour. There is some kind of narcissism, self-indulgence, to begin with, that causes our concern with our image, as it appears to ourselves, which also blurs the truth. We select the sins that we admit out loud and never would we subject ourselves to any penance. We have no standard that we would not adjust here and there, if it interfered too much. We have moral problems, when, and as long as we choose only!" Calling her thoughts "probably white beardish and confused," she searched for an analogy

that would lighten the appraisal she knew would upset him and found one in the popularity of jazz bands playing spirituals in nightclubs. She used the rest of the letter to tell him of the invitations that poured in despite his absence, reverting to the tried-and-true behavior that she always used when she needed to mollify him.

AND NOW HE HAD TO FACE another unpleasant truth: "I'm terrorized about going to Nice, but I have to." To prepare himself, he planned to play tourist as he passed through the small Italian towns of Macerata, Fabriano, and Recanati, but he could not enjoy the sights because of his wildly fluctuating moods. He decided he had had enough of solitude and on the way to Viareggio made appointments to see Nicola Chiaromonte, Carlo Levi, and Aldo when he got to Milan. Once in Viareggio, he checked into the only hotel open out of season, the dumpy third-class Astor, and spent most of his time reading in bed. He had bought a lot of novels along the way, casually and with no purpose in mind but to kill time. With the exception of Alberto Moravia's *Il Disprezzo* (A Ghost at Noon) and Ennio Flaiano's *Tempo di Uccidere* (The Short Cut), he left them unnamed but told Hedda how strange it was that they all seemed to be about his personal problems. He thought the resonances were most likely due to "my mind see[ing] things now."

For the next few days, while he stayed in bed to read, he also made pencil drawings of his hotel room and the view directly outside. Being alone in tranquillity provided the clarity to see himself as "unbalanced and too sensitive for the wrong reasons." It also made him realize how much he missed Hedda. He told her so but insisted that he was not trying to blackmail her into returning his affection. "I'm secure with you, protected probably. I don't know if this is the normal condition of marriage. I don't know anything any more." For the first time since he left New York, he ended the letter with "I love you."

SEEING TORTORETO MUST HAVE DONE SOME GOOD, even though he did not openly admit it. He stopped overnight in Milan, where he initiated a meeting with the publisher Mondadori to confirm future collaborations and possible publications. He accidentally ran into Gian Carlo Menotti and had lunch with him, Vladimir Nabokov, and Thomas Shippers. He wandered through the Galleria, where he was happy to see copies of his books lavishly displayed, and afterward meandered among the street stalls and bought books about architecture. He also indulged himself with a manual of instructions for playing the Milanese mandolin, which he decided to learn, and spent the rest of a peaceful afternoon at Tamburini, the art supply store that carried a particular brand of

pencil he could get only in Italy. He was in a mood of such exhilaration that he confessed to Hedda that he went to Ada's apartment to see her "for a moment." He explained apologetically that he went because Ada was sick and needed financial help, which he gave, and that he felt good about seeing her. He told his diary something different: that Ada confronted him about his "failure" as an artist and theirs as a couple. Her mere use of the word *failure* depressed him once again.

He left Milan thinking that at least one of the many issues troubling him, his relationship with Ada, had been resolved. She begged him to believe that her feelings were no longer those of a lover but were rather strictly maternal. They would always stay in touch, she said, implying that if she were now the mother, he as the child owed support to her as the parent. It led to a recapitulation of all the other problems still hounding him: "I feel fine but tonight I am going to feel the least free man in the world, full of worries, responsibilities, duties." He did not mention guilt, which he felt on so many different levels for so many different things, even for having escaped from Europe unscathed while everyone from his pre-American life had suffered in one way or another. Fleeing from Tortoreto for the second time and being back in many of his old haunts in Milan may have triggered something, for as if on cue, that night he had another nightmare. In this one he was running through a dark alley trying to reach a light so bright at the far end that it blinded his eyes. The image was so intense that he used his new pencils to draw it.

EVENTUALLY HE HAD TO GO TO NICE, but he never went directly there if he could help it, always stopping first somewhere pleasant to prepare himself. This time he chose Genoa, which he had never actually seen during the frantic years when he passed through in transit between Milan and Lisbon. The nightmare of the dark tunnel still troubled him, but he was able to maintain his good mood despite having to take long late-night walks if he wanted several hours of restless sleep. He took the train to Nice, and after three days with his parents, his emotions were so frazzled that he could barely control them long enough to write a short note to Hedda, apologizing for the long letter he had torn up because he was too embarrassed to send her all his "moaning, sobbing." Being with Rosa and Moritz turned him into "a mess" at his "lowest ebb." He was about to flee again, but first he had to try to tell Hedda why.

Rosa met him with her usual litany of slights, woes, and wrongs. After listening to her recitation of her troubles and everyone else's, he assumed his usual Santa Claus role, and without telling his parents, he bought a refrigerator to replace their leaking icebox. It was noiseless, shiny, and as big as those

found in American houses, overwhelming in a tiny French kitchen. The sight of it made Rosa "sick with fear as usual," while Moritz remained "without sufficient life to be scared." Rosa complained nonstop about how much electricity it would cost to run a refrigerator, even though Saul told her repeatedly that he would increase their monthly stipend to cover the minuscule rise. It made him physically ill to think of their parsimony, for he knew that the minute he left, they would unplug it and continue to use the leaking icebox. He called their behavior a "sickness" and blamed them for the origin of his own stubborn and selfish behavior and irrational superstitions and fears. Fleeing from Rosa and Moritz was really the only way to flee from the memory of what he had been when he lived in their home. He was afraid that if he stayed longer, he might resume what he called the old and despised Romanian habits and attitudes of his youth, of fear and distrust of anything new or anyone outside the household.

IT WAS EASTER AND NICE WAS FILLED with German tourists for whom he had scathing regard, so he decided to "run away" from them and from his parents. He went first to Tarascon, then to Nîmes and Avignon, but they were all filled with "German tourists shouting out loud all over, spending like hell the bastards, and their fat wives, horrible faces." He knew he could not stay there, but he needed an infusion of cash to leave and the banks were closed for the holiday. He threw a loud and noisy tantrum until the hotel manager cashed a check for just enough for a train ticket to Paris. On board the train, he found a seat and fell into a deep sleep, not waking until he was shaken by a conductor checking the compartments before the empty train was shunted to a siding. It had arrived in Paris several hours earlier, and Steinberg had slept right through.

His luggage was gone, and he was certain it had been "stolen by Algerians, etc." The police detained him in the Gare de Lyon for well over an hour as he filled out forms to establish his identity and claims for his luggage. He was not released until one of the custodians came running in from the lost-and-found with his old brown suitcase, everything in it intact. A porter escorted him to a taxi, which took him to the Hotel Pont Royal, where he was given his "old noisy room." He got right into bed and started to read, finishing Henry Miller's two *Tropics*, *Cancer* and *Capricorn*, Vasco Pratolini's *Metello*, and George Orwell's *Coming Up for Air*. He did not leave the room for several days, until he regained enough equilibrium to walk the streets of Paris as comfortably as he did in New York.

In a very real sense, he felt at home in Paris and it was good to be there. It

was also time to face the facts that he had been trying to avoid for almost four months. He decided to start with Hedda and their marriage. If the separation had taught him one thing, it was that he loved her "as much as I can love." But at the same time, being on his own and having to fend for himself had given him the freedom he craved. When she told him she was thinking of going to a Caribbean island for warmth and sun, and to think things through, he replied in a snit, demanding to know why she was not content to stay at home and wait for him. He told her he was still "half in doubt," but he invited her to come to Paris anyway, where they would rent an apartment big enough for both to work in and spend the summer on neutral ground while they (actually, he) sorted through their emotions and analyzed their thoughts about the state of their marriage.

In her customary way, Hedda gave careful and thoughtful analysis to her decision, and as always she could interpret the personal situation only by turning it into a universal. She cited literary examples such as D. H. Lawrence's *Sons and Lovers* and *Women in Love*, which she and Saul had both read, finding "affinities" between him and Lawrence's male characters, misogynists who are unable to love women freely and completely. Throughout Saul's absence, Hedda's primary concern had been to reassure him that she could cope if he did end their marriage: "I am living in a kind of atmosphere of emergency. I summoned all kinds of formulaic faculties that have served honorably before, and from this point of view I tell you it is not kind to pity me."

The New York "gossip vultures" had been out in force since he had left, but she had not allowed them to disturb her equilibrium. She saw only her few trusted friends, among them Richard Lindner, Vita Peterson, Leo Lerman, and a group of transplanted Romanians whom she described collectively as "the ghetto group." If she did accept invitations, it was only to parties where it was professionally important to see and be seen; otherwise, she stayed at home and painted fourteen or fifteen hours each day. If she worried about anything, it was that her eyes were giving out. That, and that alone, "terrified" her.

She told Saul that when she received his "half in doubt" invitation to come to Paris, she had already squarely faced her own doubts about whether the marriage could or should continue. She realized that the possibility of his leaving raised an abject fear of which she was deeply ashamed, and after she struggled to find her balance, his halfhearted invitation for her to join him aroused that fear anew. Again she juxtaposed literary and philosophical allusions with her personal emotions, settling on Aldous Huxley, whose novels of manners, behavior, and society (*Crome Yellow*, *Point Counterpoint*, *Brave New World*) she and Saul had read and discussed avidly. When he asked her to tell him her

honest feelings, she answered that they mattered little, "unless you are Huxley?" The important facts were that she loved him more "with each meal I cook for you, with each night I spend with you." As far as she was concerned, these were truths that needed no analysis: "To be with someone to whom you have already given love is partly being true to yourself. I do also love you because I *loved* you."

Referring to his fear that wanting her back was based on "inertia," she told him that she had just read a biography of the British prime minister H. H. (Henry Herbert) Asquith and had been struck by a similarity that might explain why Saul thought he needed her: "He [Asquith] seemed to get more and more fond of people he was used to." She had also been reading Jules Renan, where she found another correspondence that gave her pause: Renan was known as "the sweetest of cruel men." She told this to Saul, with only one comment: "Hmmm!!!"

Hedda did include one bit of "[self] analysis" by reminding him of the punch line in a joke he liked. A man asking for directions on a city street was told "first you pass the man standing on the corner." Saul was Hedda's "man on the corner," her "only determining point," her "patria." She believed that everything in her life that mattered began with him, and this conclusion brought her deeply hidden anger to the surface: "Your letters come and I react exactly as you want me to, and that's that! Hedda la complaisante sans caractère." She wanted him to grasp the seriousness of her situation, so she listed all the things he wanted her to be. She began with "Saul wants her independent, so independent she becomes." She tried to list other examples, but after realizing that her accusations were liable to create a chasm, she stopped after only one other: "Saul wants her [to] . . ." She could not go on. Even thinking about what he wanted made her "terribly tired." She stopped writing and went to bed.

She was struggling over what to do the next morning, when she began a new letter to try yet again to explain how she felt. She said it was not really a letter but a random collection of thoughts that she jotted down on the tiny sheets of notepaper she favored for literary quotes and philosophical maxims. She wanted him to acknowledge her as "a loving, *respecting* [her emphasis] wife" despite his insistence that he was incapable of love. She was determined to make him understand "the kind of friendship and intimacy that has to do with being a woman with a man but with no game or fight involved . . . like walking hand in hand in complete trust all the time, feeling the yearning for and the presence of 'something bigger than both of us.'" She sincerely believed that "all of this can be debunked but life does not offer anything better."

Knowing that he would probably scoff at such an open display of emo-

tion, she admitted that she probably should not mail the letter, but she sent it off anyway. Then she renewed her passport; made arrangements for Richard Lindner, who loved their cat, to take care of it; closed up the house and left the key with their devoted cleaning woman, Eleanor. And then she went to Paris.

A DEFLATING BALLOON

I was his long-suffering, uninterruptedly betrayed wife with a few honeymoons thrown in. The best one was when he sent for me to come to Paris.

As soon as Saul had the security of knowing that Hedda was coming to Paris, he was able to revert to his rigidly focused concentration on work, this time on hers as well as his own. Hedda's paintings were included in "Fifty Years of American Art from the Collections of the Museum of Modern Art, New York," a huge exhibition that filled the Musée National d'Art Moderne and brought in record crowds throughout the month of April 1955. Steinberg was determined to promote Sterne as the star of the show and to secure future solo exhibitions for her in Paris, preferably at Galerie Maeght. He was pleased to see how well placed her paintings were in the main room, where they were "certainly one of the best if not *the* best." As for the show itself, he dismissed it as "a little like [Alfred] Barr, prudent, pansyish fear of showoff, something like a bookkeeper's honesty." He was cognizant of the postwar shift of dominance in modern art from Paris to New York, and because he was always assessing how his own work was received in Europe and how its reception there might differ from that in the United States, he scoffed at Barr's selections, saying they were tinged with "the fear of *Oncle* (France)." He accused MoMA's illustrious director of unconsciously kowtowing to the French, which resulted in a selection of the mostly tried and true in American art, and ultimately the safe and boring.

Steinberg used Sterne's inclusion in the Paris show to try to persuade Louis Gabriel Clayeux, the gallery's artistic manager, to give her a solo exhibition at Galerie Maeght. Clayeux was not enthusiastic, but he hesitated to offend Steinberg, one of the gallery's most popular artists, so he used the polite excuse that he was away from Paris and would not return in time to see the

"Fifty Years" exhibition before it closed. He suggested that Sterne should try to be included in the Salon de Mai but did not offer to use his influence to help secure a place for her in the invitation-only show. Steinberg was not pleased when Clayeux said the only venue in Paris where anyone could enter a painting without an invitation was the Salon des Indépendants. There were approximately four thousand entries in 1955, but Steinberg planned to see the show and assess the quality of the submissions before deciding if it would be worth Hedda's while to enter in future years.

He was spending a great deal of time negotiating on her behalf, everything from persuading Alberto Giacometti to see the show and tell his friends to do the same to taking the art collector James Thrall Soby there in the hope that he would swing his significant patronage behind Sterne. Steinberg did all this on his own, without Hedda's knowledge. He did not tell her until after he did it, for she had little interest in promoting herself and never shared his drive for fame and success. All she wanted was to be with him and paint in the solitude of their home.

Besides Clayeux's refusal to give Hedda a show, there was another unpleasantness surrounding his affiliation with Galerie Maeght, and he did not know how to counteract it. "How horrible the mud splashes people around," he complained, as he tried to find out who started the rumor that the only reason Aimé Maeght had given him the 1953 solo exhibition was that he had paid for it. He thought this "bit of gossip" probably originated with Stanley William Hayter, whose techniques of etching and lithography Steinberg had observed in New York. He seldom joined the international coterie of poets, writers, and artists that congregated informally every night in Hayter's Rue Cassini atelier because he knew that Hayter was a great gossip, quite cheerful about adding color to existing rumors and making up new ones. Very few of Hayter's guests held his wicked tongue against him, but Steinberg saw it differently. "Hayter—Hate. When he laughs it's frightening. His eyes remain steely and mean, a bit crazy, too."

Steinberg always ignored gossip about his personal life, no matter how vicious it was, but when anything impinged on his profession, he dealt with it ruthlessly. Too many American painters hung out at Hayter's for him to ignore the gossip, even though they were only "small fry abstracts" whose names he could not bother to remember. "They do nothing because they feel that being here is enough," but they still managed to spread the rumor far and wide, all the way back to New York. He found it impossible to squelch, and it plagued him on and off for the next decade.

Meanwhile, he had real work to do and kept himself busy overseeing the

various stages of what became the 1956 *Dessins*, published by Gallimard. The book was a compilation of drawings from his three previously published books, and his task was to select those that would resonate best with a European audience. Making the selection created the first disagreement, for he originally wanted sixty and Gallimard only thirty. While choosing them and working on the layout, he was "horrified" by every single one, dismissing them as the work of the "clever little monster" he had been when young. At the same time, Robert Delpire wanted to publish a separate collection for a book whose working title, "Labirinte [sic]," was so appealing that Steinberg used the English version, *Labyrinth*, several years later for an entirely different kind of book. Delpire was the founder of the arts magazine *Neuf*, and later the promoter of photography as an art form and the publisher of important works about the genre. He was famous for always championing the unusual, if not the outré, and he planned to issue his selection of Steinberg's drawings in the unusual format of a *dépliant*, with the book's pages unfolding like an accordion.

"There may be trouble here," Steinberg worried, and indeed there was. He was never satisfied with the quality of the reproductions, no matter how many times they were redone, nor did he like the way they looked when the pages unfolded. He was "furious and confused" when both Delpire and Gallimard used the excuse of expensive publishing costs to cut his royalties, saying sarcastically, "Because, of course, I don't need money!" He was determined to finish both books despite the insult to his income and the technical problems involved in the visuals, if only to "honor" the drawing table he had bought and installed in his hotel room. After several months, when it became clear that no matter how much Mrs. Jennie Bradley intervened there would be no resolution in his favor, he made two decisions. Gallimard was the most prestigious publisher in France, so despite the cut in royalties he would not sever his ties there and would let the company publish *Dessins*; but despite his need for the money the Delpire book would bring, he made Delpire cancel it, because it would never meet his high standards.

The French publishing situation was insulting, especially after the previous two years, when he had enjoyed extraordinary attention and praise within the international art world. His reputation was in the ascendant, and his sales burgeoned after nonstop solo exhibitions in galleries and museums. He was the subject of articles and reviews in newspapers and magazines and on radio and television shows. Critics vied to dub him a cultural commentator, a visual historian of contemporary culture, and an authority on everything from the iconic to the ordinary. His work was seen in Paris, Amsterdam, Stockholm, Basel, and throughout Germany in cities like Dortmund, Hanover, Lübeck, and

Frankfurt. In the United States, there were solo shows in Chicago, Richmond, Washington, Dallas, and Santa Barbara. Steinberg's style was so well known that the adjective *Steinbergian* was coined, shorthand for a new, unusual, and slightly off-kilter way of looking at the world.

For Steinberg, it was wonderful indeed to be recognized for the sheer hard work he had put into creating, organizing, and occasionally helping to promote his drawings. On the one hand he took his reputation as his just reward, while on the other he blamed it for the turmoil and exhaustion that made him want to flee from everything he had worked so hard to create. The problem was that whenever he thought he could relax and enjoy the accolades and financial rewards, somebody needed something that only he could provide, and because of his overdeveloped sense of responsibility, he did what he could to help.

Just when he thought he was well under way to regaining the equilibrium he had gone to Europe to find, events conspired to throw him off track once again. Parsons and Janis were pleading with him to send more drawings for shows that would enable them to capitalize on the momentum of his European reception. Requests were coming from other galleries, such as the one from Elodie Courter, who organized traveling shows for the Museum of Modern Art and who was pestering Hedda to get Saul to participate. Courter wanted to include his work in an exhibition that would take recent American art to cities where it had not yet been shown and would not accept his refusal. Saul deputized Hedda to go in person before she left for Paris and repeat to Courter what he had already told her in letters and cables: "I don't want to be shown with just a few drawings . . . I hate group shows. I dislike humour in large doses and I refused constantly to participate in anthologies or cartoon festivals." "You don't have to feel responsible," he instructed Hedda. "Just tell her *NO*."

THE SUDDEN SPURT OF WORK WAS once again turning him into the "deflating balloon" he had been at the beginning of his European wanderings. He was having second thoughts about staying in "the misery that Paris has become" but had made too many appointments to leave. The main reason he could not leave was that the "Lica troubles" were starting up again. The Romanian government had relaxed restrictions slightly, allowing a larger quota of Jews to immigrate to Israel, and once again it seemed that the Roman family might be among them. Steinberg learned of this in a roundabout way when an official from the American embassy left a brusque message for him to appear at the Israeli consulate early the next morning. Fearful that his insomnia would cause him to miss the appointment, he took a strong dose of sleeping pills and went to bed early. He still slept so fitfully that he was groggy throughout his appointment.

It was a total frustration, a bureaucratic formality of filling out thirty new forms with the same facts he had been attesting to for years. After he verified his income and raised his hand to swear financial responsibility for the Roman family, the Israelis told him to go home and await further notice, while the Americans shrugged dismissively, implying that there was nothing more they could do. It was another stress-inducing runaround, but if this one held the possibility that his sister's family might actually emigrate, he wanted to be in Paris, where it was easier to leave at a moment's notice if the Israelis granted the visa that would let him shepherd them from Bucharest to Israel.

Hedda had dropped everything to come to Paris, and now it appeared that he might have to leave her alone yet again. He considered it one more depressing example of how external realities hindered him from having what he wanted, in this case the "Paris Honeymoon" he was counting on. What angered and frustrated him most was the way intimations and influences of Rosa and his Romanian upbringing surfaced during these times of stress—especially Rosa's maxims to keep his head on his shoulders and keep making money. Moritz added to Saul's confusion when he wrote that Rosa was having a serious nervous breakdown and making him ill with her negative thoughts and changes of mind. Saul's comparison of his own erratic behavior with his mother's was unavoidable.

The only time he felt "a wave of warmth and security" was when he was drawing for his own pleasure, and once again pleasure was eluding him. He complained that whenever he had to draw to make money, there was "displeasure that can last for many months, linger like an illness." Now he refused to see anything good in work that had originally pleased him, and to prove his point he made a list of all the projects that he claimed were responsible for making him impossible to live with. When he and Hedda had spent the summer in Vermont, he blamed the "cute mural for Bonwit Teller." Hollywood was "hell" because of the need to earn money by decorating a swimming pool. Stonington was "silly" because he resented having to work alongside Jerry Robbins in the same room, claiming he was "never able to work properly" unless in his own work space.

Brooding over the conflicting claims on his time and energy led him to seek the company of Alberto Giacometti. The artist lived and worked in an atelier that was one step removed from a hovel, and despite the money his sculpture was commanding, he had no desire to live elsewhere. The best part of his life was his work, and he communicated that joy to Steinberg, who after one of their evenings would spend the next day exclaiming, "I want to become a *clochard*" before fretting over the impossibility. "I don't want to be what I was but

how can I change? I have to make money." He decided that one way to lighten his load would be to enlist Hedda's help, which he had never done before for several reasons. Hedda was "never one of those artists' wives who make a profession of promoting their husbands." She already had her own esteemed professional life when Steinberg met her, and throughout their marriage, he respected her need to practice it. However, the main reason he never asked for her help was that he needed to be in total control of every aspect of his work. He found it impossible to delegate the authority to anyone else—not even Hedda, the person he trusted most—to make decisions on his behalf. These shifting attitudes collided when he told Hedda that as soon as she arrived, she would have to concentrate on helping him learn to live in such a way that he would not have to do any work but his own. Almost immediately he changed his mind, and for the first time he worried that he was not taking her needs into consideration, asking, "What about you? Do you want to live with [such a] monster?" He apologized for all the moaning and complaining he had done in the past several months, saying that he was embarrassed because he had done nothing for her while she was always so kind and reassuring toward him.

Even though he was still "a bit insane" in the midst of so much indecision, he resorted to the animal imagery he often used to describe their intimate relationship. "Rabbit" was his favorite term of affection for Hedda, and he called himself a "crocodile," both of which became iconic images in his drawings. Continuing with animal metaphors, he told her he was sure that in a few days his struggle to be either "worm or butterfly" would be over, and if she wanted him back, he would fall into her lap as her "old messy crocodile, loving and sedate."

HEDDA ARRIVED ON MAY 3, 1955, and moved into his room at the Hotel Pont Royal. Saul was sick of hotel living, and when their friend the painter Roberto Matta told him of an apartment at 26 Rue Jacob, he rented it sight unseen. In a spurt of happiness, they moved to what was then a shabby street on the Left Bank. They were several doors away from Natalie Clifford Barney's extraordinary house in the courtyard of no. 20 and the building of the same number in which Ellen and Richard Wright had an apartment. Hedda was fascinated by all the existentialists, members of the haut monde, and beatniks she saw coming and going at no. 20, but Saul told her they had friends enough already and she should concentrate on them, him, and her painting. However, for the next two months they led a highly social existence, their calendars filled with luncheon and dinner dates. They saw a great deal of Germana and Roberto Matta, and Saul went alone to visit Geer van Velde at his home in Cachan, out-

side Paris. Janet Flanner invited them to dine with her and the visiting James Thurber. On a single day they had drinks with Eugène Ionesco and his wife and dinner with the Giacomettis, and capped off the evening with a late-night viewing of *La Ronde*. Sonia Orwell demanded their presence at several dinners, and they went along cheerfully because they were amused by her imperious manner. Among the writers they saw were Georges Bataille and André Breton, who along with Matta introduced them to the Spanish filmmaker Luis Buñuel. Eugène Ionesco introduced them to the aged Tristan Tzara, who liked them so much that he invited them to lunch several days later. He also introduced them to Stéphane Lupasco, the Romanian-born logician and philosopher whose dense and elliptical writings fascinated them both, but especially Hedda, who puzzled over them for years afterward. They spent a great deal of time with the photographers Robert Doisneau and Cartier-Bresson, and Steinberg dined alone with Paul Rand and later with Le Corbusier.

Wedged into their social program were several visits to Hedda's mother and brother in Paris and an overnight visit to Nice to see Saul's parents, which was all they could tolerate. At the same time, several of Lica's "heartbreaking" letters reached Saul. Hardships and restrictions had made her "mean and ugly," and she did not know how much more she could stand. Between her anguished letters and his mother's hysterical ones, he was feeling suffocated by half-truths, and the two women chose this moment to introduce a new wrinkle. Under the Romanian Communist government, the only acceptable destination for any Jew who wanted to leave was Israel, and the only acceptable reason was to reunite with family already there. Since Lica's parents were in France, the government now wanted to know why the Romans had not applied to go to Israel, although of course they would not have been permitted to go there if they had. "On top of that, they are in Bucharest—a complete family with children of their own," the government decreed, and therefore they had no valid reason for emigrating. Most damaging of all in the government's view was Lica's rich brother, who lived at the epicenter of decadent Western civilization and who had already corrupted them by sending luxury goods and money on a regular basis (less than half of which ever reached them).

"I don't know what to do," Saul said, fearing that he was running out of options. He contacted "Rothschilds, Romanians, Israeli Consul," and then asked Maeght and other "art people" to use their influence with influential Jewish philanthropists and benefactors of Israel. He left nothing untried, in the hope that someone could open useful political doors. As he was working to secure the Roman family's passage to Israel, Lica dropped another bombshell, telling him for the first time that despite his years of efforts to get her

family to Israel, what she had really wanted all along was to come to France. She sent frantic appeals for him to get them a French visa, and this, he said, was "after I troubled the whole Palestine, consuls, etc." Embarrassed by all his earlier efforts to enlist the help of influential Jewish advocates for Israel and not knowing whom to ask for France, he turned to Hedda's brother for advice.

As if on cue, Rosa chose this moment to vent her frustration over Lica's troubles by chastising Saul for buying such an expensive refrigerator, laying all the blame on Moritz as the one who put him up to it. She saved a portion of her ranting for Hedda, blaming her mother for "hiding" her and Saul in Paris and selfishly refusing to let them go to Nice. Whatever Saul did, he knew it would always be "the wrong thing" for Rosa, and of course it was. When he stopped on the street to watch a funeral procession pass by, he "envied for a moment the principal."

HE CONTINUED TO WORK ON GALLIMARD'S *Dessins*, going frequently to the print shop and fussing over every single detail as both the printer and publisher tore out their hair over the constant changes his meticulous demands necessitated. Even though he did whittle the book down by twenty-two drawings plus "cutouts," no one was happy as he dragged the process on. Despite feeling that he was wasting his time, Steinberg still slogged away. "I'll never learn," he scolded himself each time he returned to the print shop. Eventually he and Gallimard agreed on a compromise: the publisher would agree to his final selection and allow him to paste the layout providing that he drew a new jacket and front and back covers. He agreed, and when the book was published, he was content that all his slogging had changed the "kind of anthology of old drawings" into a good book filled "with many new ones."

WHILE HE WAS AWAY IN EUROPE, his friends at *The New Yorker* had not forgotten him. Shawn and Geraghty had both rejected his idea for drawings of the southern trip, but they had a more ambitious project in mind for him. They were trying to secure a visa from the Soviet Union for him to go there and prepare a significant collection of drawings based on whatever he saw as he traveled wherever the government would permit. He was excited by the idea and eager to go. Originally he thought the visa would come swiftly and easily, so he completed all the detailed paperwork at the American embassy in Paris, patiently doing it on top of all the forms he had to fill out for his sister there and at the Israeli consulate. He had not counted on all the bureaucracies moving in their own good time, which was at a glacial pace, and by the middle of June there was still no word about his visa. Confronted with bureaucratic slowness,

worried about the need to bring in some cash, and not wanting to spend the summer in the heat of either Paris or New York, he sent Hedda home with instructions to rent a house on Cape Cod or anywhere else that had a sand beach but definitely "NO Stonington."

He spent his last days in Paris adding up the money he had earned from gallery sales and book dividends, a grand total of $868.34, which he spent at Hermès buying farewell presents for his friends.

HE LEFT PARIS ON A HIGH NOTE. At least one of his two books—Gallimard's—would turn out to be what he wanted, and despite canceling the other he still had cordial relations with Delpire, who was ready to publish another whenever Steinberg wanted. Most of his interaction had been with artists, and much of their talk had been about work. These conversations had given him some interesting new perspectives on his own work, and he thought about them on the flight home, but the one that resonated most had been with Geer van Velde. Steinberg was fascinated by the simplicity of van Velde's modest little house in Cachan, saying that he lived a life that reminded him of Voltaire's admonition to Candide to cultivate his own garden. As they talked after dinner, van Velde confessed that he was confused and troubled by the new direction his painting had taken, becoming stark, dark, and veering from abstraction toward representation. Van Velde thought it was changing spontaneously, without his being able to explain exactly how or why. Steinberg offered that it was moving from "pleasant semi-abstractions" to "things that are *not* pleasant looking." Van Velde responded that he was struggling through his painting with issues in his life of "moral problems" and "truth." Steinberg suggested that nonrepresentation was merely a way of "avoiding easy ways out (the old Jewish taboo of the human figure in art)." He offered the possibility that such struggles often led artists to "become inevitably Jews at heart and mind," and thought that this might be happening to the Dutch Protestant van Velde. Their initial discussion ended unresolved, but the subject of morality and truth in art became one they returned to frequently whenever they met from then on. That night, when Steinberg returned to his hotel room, he made a cryptic entry in his datebook: "Note: alone, people will become Jews. Abstract painting. Jewish."

He factored his thoughts about the exchange with van Velde into his recollections of the conversations he had had with other artists, writers, and filmmakers throughout his several months of peripatetic travel. Each social encounter usually included an exchange of information about current projects, often with details of new methods and techniques, which Steinberg digested

to make them relate to and sometimes apply to his work. As he thought them through, he usually explained them in letters to Hedda before recording his thoughts in his pocket notebooks or making drawings in his sketchbooks.

His thinking did not end there, for often traces of earlier conversations could be found years later in the random collections of pages that served in lieu of a formal diary or journal. In one such collection of notes, he titled a passage "What I learned from Artists." He asked de Kooning, "How do you achieve this or that effect?" De Kooning replied, "All you need is a strong desire to achieve this or that and you invent it." Barnett Newman gave him more practical advice: "Never laugh for photographers. Dress well, necktie. 'They' want to show that you are a regular fellow." Marcel Duchamp gave the best advice of all: "Answer or throw away immediately all mail as soon as it arrives." Unfortunately, this was advice Steinberg never followed. He did, however, follow the pattern of every other artist he respected, who, when asked to pass judgment on another artist's work, would always reply, "Great!"

NOW, ON THE WAY HOME AFTER several months totally immersed in thinking about himself and his career, and with the Russian journey he hoped to make uppermost in his mind, he began to think of the months in Europe as a natural break that divided his career cleanly and sharply into two parts: drawings he had done "before" his abrupt flight away from New York and the life he lived there, and what he would go on to do "after," when he intended to create both life and work anew.

When he thought about it, the divisions between his life in New York and his life in Europe were vast, with the major difference being work. When he was in New York, his main objective was to do enough commercial work to support himself and all his dependents during the several months when he would be in France or Italy doing only what he wanted to do. Also, his primary socializing was with a different sort of people in New York than those he saw in Europe. In New York, cocktail parties, dinner parties, gallery openings, and book launches were ubiquitous, and the guest lists were usually large enough to preclude anything but politely superficial chatter. In Paris, he was mostly with artists and writers, usually over dinner tables in their homes or in quiet restaurants where they were able to engage in serious conversation, more often than not about current work and ideas for future projects. On this last trip in particular he had been with so many other writers and artists that he could not help but think about his own way of life in relation to theirs. Even the artists who were financially comfortable, such as Giacometti and Miró, to give but two examples, lived far more quietly and simply than he did, and with a daily existence that centered completely on their work.

Steinberg was different from them in an important way. Although many of his friends on both continents were among the intelligentsia, his was a questing intelligence that was always on the lookout for whatever struck his offbeat vision and for new ways in which to use it. No matter how ordinary anything may have seemed to others—a street sign, a woman's clothing, even an overheard conversation—Steinberg always found a way to make it new. Everything was grist for his creative mill, from the silliest movie to the most serious book. By putting his own particular spin on what he drew, he could turn his subjects into an "aha!" moment for those who beheld his work. "I am a writer who draws," he said of himself, and he could legitimately have expanded this self-definition to include the social historian and cultural anthropologist.

From childhood, Steinberg was always a voracious reader, and he counted writers among his closest friends. If he read something he liked, he often wrote to the author, and inevitably friendships were created. His months alone had given him the opportunity to read widely and deeply, particularly in serious nonfiction. Like almost every other reader of Isaiah Berlin's famous essay "The Hedgehog and the Fox," he used Berlin's classifications to interpret himself. Steinberg saw Berlin's hedgehog as viewing the world through a lens that restricted itself to a singular fixed image, idea, or vision, while his fox drew on a large body of images and experiences in order to form an all-encompassing, all-inclusive worldview. In one of his brief notes Steinberg wrote, "In order to become a fox, I had to be a hedgehog for a long time. I can't make distinction between what is right and what my mind tells me is right."

When he had been a hedgehog, one single idea had dominated his thinking and behavior: the need to make money and the concurrent responsibility to support others. During his years in Milan, when he was a poor student, he had to sell his art in order to supplement the meager financial aid his parents could afford to send. When he was in Santo Domingo, in order to support himself he had to tailor his work to create a desire for it in American media. After the war, he needed to provide financial stability for himself and his wife, his parents, his sister, and his numerous other relatives. He also felt the need to help his friends, sending money to Aldo on the frequent occasions when he needed it and a monthly stipend directly to Ada's bank. By the time he ran away to Europe in 1955, he had been on a proverbial treadmill for almost two decades, during which he had been a hedgehog with a single fixed idea: to be successful as an artist in order to acquire money. And when fame came with it, he reveled in it, even though it meant he had to run harder, faster, and longer.

The time he spent in Europe encouraged him to think he could still fulfill his responsibilities while branching out to become Berlin's fox, one who knew many things and had many ideas. While in Paris he did buy a hedgehog's draft-

ing table for his hotel room, but he also bought a fox's white parasol, easel, and blue artist's coat, all for painting outdoors, which he had earlier given up because it took too much time away from paid projects. If he retained anything from his hedgehog years, he convinced himself that it was how to use his commercial work in ways that would continue to bring in the much-needed income while allowing his private creative vision to be like a fox's, multifaceted and ready to explore many different avenues of expression.

HE RETURNED TO NEW YORK AT the end of June but stayed only long enough to pack summer things before joining Hedda in Wellfleet, where she had rented a house through early September. He liked it there well enough to think that Massachusetts might be the place to buy a second home, but he was still eager to get back to New York and resume his frenetic socializing, as if there was nothing more important to do in life. Much of it was with friends from *The New Yorker*. Jim Geraghty took him to lunch at the Algonquin, where they plotted strategies for securing the Russian visa; he shared Charlie Addams's love of gambling and accepted all his invitations to play poker; and he even allowed Brendan Gill to take him to lunch at the Century Association as a prelude to proposing him for membership. He went to Geoffrey Hellman's large and boozy parties and lunched alone with St. Clair McKelway or Joe Mitchell, both of whom were writers he much admired.

He spent weekends with Mary McCarthy and her husband, James West, and he and Hedda made the trek to Utopia Parkway in Queens to see Joseph Cornell. But all the while he was out and about, he had not forgotten his European good intentions. He went often to Wittenborn, the shop of the New York dealer in rare art and architecture books, and added to his growing collection. He was still thinking about the self-knowledge he had gained during his time abroad and he continued to make self-referential notes that might translate into drawings. He was exploring his own "vices," both "good," which he defined as his love of drinking fine scotch whiskey, and "bad," which he equated with his tendency toward "avarice." To him, this meant the lust to make money and rake in as much as he could amass, greedily buying expensive clothing in greater quantities than he needed, and the need for sex with almost every woman he met. He was discreet about several French encounters, one of which remained an occasional liaison for years afterward; and when he returned to New York, the coded initials, times, and addresses continued to clutter his appointment books.

As he thought about himself, he was also collecting ideas for drawings that related to the larger world: women in mink coats were equated with

"schmaltz," while the president of Liberia lent himself to caricature because he "will not be seen without a top hat." In another encoded "note to myself" he described how an artist "becomes one (after 20) because he has the temperament of one." Several days later, he took mescaline for the first time and made notes while under its influence. He liked drugs because he thought they expanded his creative energies, but he never made them a daily habit like the whiskey and cigarettes he thought he could not live without. He used drugs socially, mostly marijuana, on and off for years afterward and was fortunate that he never had a bad reaction and all his experiences were pleasant.

The year 1955 was ending, and he was not too happy to look back on it. On the one hand he had made money, paid his bills, and survived a desperate personal crisis; on the other hand he had learned much about himself and was determined to put the knowledge to work as soon as the new year began. He still had not heard about his Russian visa, but his sponsors at *The New Yorker* assured him that it would come any day and that he should prepare to go at a moment's notice. It finally arrived in early December, two months before he was to depart. There was so much to do, and the first thing he did was to buy a larger-than-usual notebook and write on the first page in large block letters *"CARRY NOTEBOOK EVERYWHERE."*

A GRAND OLD-FASHIONED JOURNEY

*I've made a grand old-fashioned journey. Leningrad,
Moscow, Odessa, Tiflis, Tashkent, and Samarkand!*

There was much to do before February 14, 1956, the date of his departure. Besides the official documents and certificates from both governments, he needed a letter from Harold Ross verifying that he was a reporter for *The New Yorker* and traveling on official magazine business. The letter had to be notarized, and while he was in the notary's office, Steinberg remembered the document "dazzlers," the array of stamps and stickers lavished upon even the most ordinary letters by the Romanian and Italian governments, so he asked the clerk to affix his notary seal wherever he thought it might enhance Steinberg's legitimacy. There was a lot to buy as well, from drawing supplies to heavy winter clothes. He started with rubber stamps that read "all rights reserved. S St," which was the signature he thought he would use on this trip, and he also needed special pens with ink that would write in low temperatures, a stack of drawing tablets and notebooks, and a large supply of colored pencils. He went to Brooks Brothers to buy a heavy overcoat and gloves and to Bloomingdale's for a large green duffel bag to hold the overflow from the ancient brown suitcase that had been everywhere with him since he had sailed from Lisbon during the war. The duffel bag would turn out to be more trouble than it was worth, but he didn't know that until he was well under way. The last task was to call a bank in Philadelphia where he held several accounts and ask it to send traveler's checks and a fairly large amount of cash. Then he got a pedicure and was ready to go.

To enter Russia, he had to fly to Moscow from Stockholm or Helsinki, so he decided to stop first in Paris for two days of business. Winter weather delayed the flight from New York, and engine trouble forced an emergency

landing in Gander, Newfoundland. When the plane finally reached Paris, reporters swarmed to interview Leslie Caron, who was on the same plane as Steinberg, "the cruelest humorist in the world, celebrated for the most bitter and bitingly delirious exuberance of these traits." When they tried to take his photograph, he forbade them, "growling" that the caricature of his work was more than enough.

The lost time truncated Steinberg's layover in Paris, and severe jet lag led him to keep only the most important appointments and cancel the rest. When he boarded the plane for the flight to Stockholm, he found himself seated next to a "quiet Englishman" who eventually initiated a stilted conversation. After an hour, when they had moved on to "animated talk and fast friendship," Steinberg introduced himself and the man replied, "Graham Greene." By the time the plane landed, they had developed a "pleasant friendship." Steinberg had to stay overnight in Stockholm, but he had lost all concept of time and was still too jet-lagged to sleep. Despite the luxury of his hotel room, he was so cold that he went out the next morning and bought a fur hat, which he credited with saving his life once he got to Russia.

He was also thankful that he had prepared for the cold by wearing almost every article of warm clothing he had brought for the trip, because for the first

Steinberg in Russia.

of several times the green duffel bag was lost. When he reached Leningrad, so too was the old brown suitcase, which arrived one full day after he did. He was assigned a woman guide in Leningrad, Zina, who took him on a tour of the city by car and only reluctantly allowed him to get out and walk when he insisted on seeing the Finland Station, which he had wanted to do since reading Edmund Wilson's book of the same name. The brief walk taught him that his mustache was a good indicator of how long he could stay outside: when it froze, he knew he had to rush inside. After that he created consternation in Zina as he dashed abruptly from the car whenever it paused in traffic to run into bookstores and buy books about Russian architecture in the Cyrillic alphabet, which he marveled at but could not read. He was sure his movements were being monitored, particularly after Zina taught him how to use the bus and subway but would not allow him to take them without her. She took him to the Hermitage and to the ballet *Taras Bulba*, complete with "three horses galloping through the stage, smoke or fire, very impressive."

Steinberg expected to be subjected to the crushing restrictions and regulations his sister had suffered under the Romanian Communist government, but except for someone always directing his movements, there was none of it for coddled VIPs such as he. He knew it would be a challenge to get off the tourist path and experience the daily life of ordinary people, and as Zina remained firm while he was in Leningrad, he went nowhere on his own. They visited a monastery that had a splendid courtyard and ruined cemetery, walked on the Nevsky Prospekt, and toured the city museum. The closest he came to ordinary people was in the museum cloakroom, where he watched them as they sat eating their greasy bag lunches in the midst of the checked coats. Out on the snow-covered streets, where shapeless human forms moved listlessly, he was reminded everywhere of Dostoevsky's Raskolnikov. One night he went to a ballet at the Kirov Theatre, this time *Don Quixote*, with a real donkey and horse and a surrealistic "giant spider, trap apparition, knife dance." He noticed that all the men seated around him had cotton in their ears and wished he had some too, as the music was so loud.

On his last day there Zina finally let him walk alone, but he had to scramble into the car that slowly dogged his footsteps whenever his mustache froze. She had prepared a packed lunch, which they ate while their driver let the car idle in a park where Steinberg could watch people and draw. He was supposed to go from Leningrad to Kiev, but with the excuse of the still-missing duffel bag, he persuaded the Intourist officials to change his itinerary and let him go first to Moscow and stay there for three days. They agreed but escorted him off the plane and directly to the American embassy, where he wasted the morn-

ing filling out endless forms to try to trace the bag. At this point he didn't care if he ever saw it again, for he had indulged his passion for buying souvenirs and tchotchkes in Leningrad, so many that he had to pay hefty excess baggage charges there and would have to do so for the rest of his travels—and this was exacerbated by the difficulty of finding porters to carry everything.

While on the plane to Moscow he had sketched the Russian airmen who filled every seat, all of them freezing and then sweating as the temperature fluctuated wildly. A "young girl" guide met him and made the driver take him past the Kremlin and St. Basil's, with their "enormous scale piazzas" which were overwhelming to him in his exhausted state. She installed him in the main hotel for tourists, the Metropole, and he was finally ready for an early night's sleep, but the guide, whom he disliked and called "an automat delivering lessons," insisted on escorting him to his room, where she made him listen to yet another lecture before he could enjoy his first full night's sleep since leaving New York.

The next day she continued to pontificate on the glories of the state as she took him to the university on Gorky Street, a collection of nondescript buildings he had no interest in, before dropping him at the American embassy to spend the rest of the day. The building was decrepit and reminded him of the more dismal army camps he had seen during the war. He met the ambassador, Charles "Chip" Bohlen, and his wife, Avis, and most of the staff and the "lonesome American correspondents" who "only see each other and were glad to see somebody new."

No matter where he went, Steinberg could not escape the ballet, and his first night in Moscow found him at the Bolshoi for *The Nutcracker Suite*. This time the only histrionic on the stage was an enormous puppet. Everything in Moscow was "enormous," especially Red Square, the Kremlin Museum, and all the exhibits in it. He persuaded his guide to take him on the subway and got dizzy on the almost vertical escalator that took them down to it. Afterward he tried to persuade her to let him walk on the streets and take shortcuts whenever he saw something interesting. She agreed until he asked two curious waiters who came out of a restaurant to stare at the foreigner if they spoke English; seeing the guide, they said in loud English meant for her that they did not, then turned and ran back into the building. After that, the guide made sure there was no more straying from the beaten path.

Much of the rest of his three days in Moscow was taken up by his new American friends with lunches, dinners, and receptions. On the way to the airport he tried to talk to the taxi driver, who was a Jew from Tiraspol, the Russian city from which the Steinberg family had fled pogroms to become Romanian,

but he and the driver had no common language and the guide rigidly refused to translate.

He liked Kiev because it was warmer and much livelier than Moscow. He liked his interpreter, Victor Youkin, who gave him greater freedom than the Moscow guide and who let him walk the streets and go into any shop he wanted. He bought record albums and a cap that was lighter than the heavy fur hat, and he was pleased when a shopkeeper asked if he were "Chek [sic]?" Steinberg was alert for signs of Jewish identity and possible censorship or persecution, so he knew the clerk was Jewish when he replied "American" and the man responded "Goy?" He was also aware of a strong Russian Orthodox religious presence despite Communist strictures and went into ordinary churches to breathe incense and watch "beggars, solid peasants, praying." Every evening he had to endure something cultural, and in Kiev, it was Glinka's opera *Ruslan and Ludmilla*. Although a welcome change from the ballet, after "2½ acts of 4 (3½ hours so far)," he was happy to leave. Victor took him to a jazz club, where the featured entertainment was a man dancing alone. It was still better than the opera.

For the next two days they wandered wherever the urge took Steinberg, from agricultural exhibitions to the university to hear local poets and see contemporary paintings. They went to a nearby village, Lavra, famed for its museum of Ukrainian folk art and its fine collection of prerevolutionary painting. The town was also known for its local handicrafts market, and Steinberg bought many for himself and Hedda. Back in Kiev, he was touched by a huge monument to an ordinary gardener, which moved Victor enough to look the other way while Steinberg photographed the city streets. Despite the freedom, Steinberg was certain they were being followed and made the note "Private Detective? Impossible." He shrugged it off and went shopping, adding vodka and more Russian books on architecture and photography to the duffel bag, which had mysteriously shown up.

That night he took the overnight train to Odessa, sleeping fully dressed and sitting up. It seemed that the further he got from Moscow, the closer he was able to get to the people and the local culture. The man across from him was an artillery colonel who asked Steinberg if he was a Communist. He said no and the man turned away, even though Steinberg kept trying to engage him in conversation. He showed his camera, offered a ballpoint pen, pointed to a book on Russian art he was reading. The colonel's only response was "Dollar bills?" Steinberg wisely said that he had none to sell and the man replied "America nyet." That ended his conversation with "Colonel Big Hands," as he dubbed the man. Fat girls with garish makeup came through with tea trolleys

that also held vodka, and they were more eager to chat than the colonel. Several tried to explain the virtues of "the Marxist equation," and when they left, Steinberg felt "effusion, peace, friendship."

His hotel room in Odessa overlooked the frozen harbor and was furnished in "old fashioned, fancy" style with an enormous bathroom. In Odessa he had a "clever guide" who took him to the former home of a Polish count that was now a museum of Russian art. At the market he bought condiments (more weight for the duffel bag) and then asked the guide to take him to the countryside. He saw houses made of mud and also the local sanatorium, a building so grim that he drew it directly in his datebook. He did not like the food in Odessa and "ate little to sorrow of waitress." Once again he had to sit through *Don Quixote*, this time watching "heavy girls, bellies." Halfway through the shoddy stage set "blundered" but the well-trained audience sat silently as the stage crew tried to set it right, not knowing who might be watching if they booed or hissed.

The next day Steinberg went to the local airport, where bad weather rerouted his plane to Sukhumi, a small town in the midst of a bog of mud. There were no taxis, so he found someone to load his luggage onto a small crowded bus for the long ride into the town. When he checked into his hotel, there was great agitation in the lobby, which may have been connected to his unexpected arrival but was never explained, not even after his interpreter came, a "woman biologist who works with monkeys." He had already had more than enough of Sukhumi, so he made the guide take him straight back to the station, where he caught the overnight train to Tbilisi, the capital of Georgia. He almost missed it because he could not manage his luggage without a porter. He found a "poor old man" to carry his bags into a gloomy compartment, which he shared with a silent, sleeping army man.

His guide in Tbilisi was a young boy, a "beginner" who was only too happy to take Steinberg wherever he wanted to go. Finally he was able to see what he had come to see, an old town with "Turkish verandas on art nouveau or neoclassical houses, a narrow street bordered with trees, beautiful small piazzas." There was a funicular that took him to the top of a mountain, where he saw a "splendid" cathedral, a castle, and a bustling university. There were "more shops, restaurants, and sweets than anywhere," and he bought accordingly. He loved the food, which had smells and flavors that reminded him of Bucharest—lamb shashlik, olives, cheeses, and delicious local white wine—and he was entranced by the market's "rich variety, old smells." Unfortunately, the guide became a "bore, embarrassed, timid," but Steinberg knew what he wanted to see and made the reluctant fellow take him to the old capital of Mtskheta.

Some of the holiest places in the country were there, all of them with

architectural significance. He saw the Cathedral of Sveti-Tskhoveli, built between 1010 and 1029 on the spot where, legend had it, Christ's burial robe had been brought by a Jew who accidentally let it touch the ground. When a tree sprang up on the spot and could not be cut down with the sharpest ax, the place became one of the country's holiest sites. Inside the cathedral, Steinberg studied everything so intently that an old woman who had helped to restore the exquisite old murals and icons hovered over him, fearing that he was a vandal, until the guide told her that he was a trained architect. They went on to the Ivari Monastery, filled with religious paintings and iconography, and afterward to the sixth-century Jvari Cathedral, generally considered the proto-type for Georgian ecclesiastical architecture. Steinberg made a special effort to find and buy as many books as he could about the local architecture, for even though he had never practiced the profession for which he was trained, it held lifelong fascination.

That afternoon, despite being "embarrassed" or perhaps even frightened by the liberties Steinberg took in walking anywhere he wanted in Mtskheta, the "bore" of a guide gave up trying to stop him from taking photographs, espe-cially of people who wore the old-fashioned peasant dress and headgear. He ate shashlik at every lunch and dinner in Tbilisi, where his evening entertainment was the opera. This time it was "Turks, slave girls, nuns, monastery on fire, fights, murders, flags, scimitars, rugs, tent, castle, and the hairdo of the orches-tra conductor." It was so bad that he spent his time studying and sketching the opera house architecture onto his program, enjoying "style à la Caucasus."

The next morning he was at the airport for a 7 a.m. flight to Kharkov that made a stopover in Vladivostok. His seatmate was a naval officer who enter-tained him with his memories of wartime British and American airplanes, con-versing through the Armenian cabin attendant, who spoke English. Steinberg was glad for the diversion, because the flight took the entire day. In Kharkov, his guide was another "young amateur," who took him for a quick dinner and then on to the theater for a play distinguished only by "jumping, fighting." He was "picked up by girl in intermission" and left early. The next morning, in a different-colored ink, he recorded a cryptic conversation in his diary wherein someone asks when the plane leaves and someone else responds "At five."

The next day he flew from Kharkov to Moscow, where his first order of business was to go to the American embassy to see about extending his visa. The plane arrived too late in the day to start the process, so he called one of the correspondents he had met earlier and joined him for a single drink. He went to bed early to read *The Brothers Karamazov*, and was delighted to read in the introduction that Dostoevsky's father had been assassinated during a peasant

revolt. Early the next morning he began the visa extension process, saying that he needed to stay longer because he had not seen enough of the country's variety. He wanted to go to Asiatic Russia, particularly to Samarkand, a city that had long intrigued him because of its history as an ancient crossroads between East and West.

Since he was a schoolboy he had been interested in how one civilization superimposed itself on another, and especially in how so many invading cultures had melded Romania into the modern state in which he had grown up. He wanted to compare traces of the conquest of the Ottoman Empire with what he had experienced in Romania, and because what he had seen of modern Russia thus far was primarily Slavic, he wanted to see the oriental countries that clustered on the southern and eastern borders.

Steinberg was originally scheduled to spend his last week in Moscow and fly home from there on March 14, but instead of making preparations to leave, he was determined to see as much as he could of ordinary daily life while waiting to hear about his visa. To his surprise, it was issued the day after he submitted the application, so fast that he almost missed it. He was directed to remain in Moscow until March 16, after which he had until March 22 to go wherever he wanted in Uzbekistan, where Samarkand was located. He set out with a vengeance to capture the life and spirit of Moscow.

He was now allowed to move about the city without a full-time guide, so the first thing he did was to learn his way around the subway system, spending the better part of his first day joy-riding from station to station and making spontaneous stops to go out onto the streets and see what different neighborhoods looked like. He caught a bad cold in the process but pressed on, taking notes and making sketches. He bought more old books from a dealer one of his American contacts put him in touch with, and the old man told him where to go quietly and discreetly to see prerevolutionary paintings by Russian artists. He was most taken with the portraits but thought they and everything else were merely "good," curiously dated, and severely limited by lack of contact with outside influences.

He walked repeatedly through Red Square, even though he remained overwhelmed by "Russian scale," because that was where he could see the greatest variety of people. When he drew it, he conveyed a slice of Russian life with deft subtlety, leaving vast stretches of empty white space at the center of the page with a fly speck here and there, meant to be ordinary people who clung to the edges of the mammoth plaza. In the background he drew a hodgepodge of onion-domed church architecture competing with brutalist Communist buildings for domination of the skyline.

Steinberg was so engaged by the historical museums holding treasures that dated from the eighteenth-century reigns of the two empresses, Elizabeth and Catherine the Great, that he returned to them several times to study the "Napoleonic uniforms, poetic peasant art, wood relief ornaments on houses (lion & siren)," and particularly the gates of an old monastery. He got to see ordinary daily life when he walked alone on the foggy streets and took photographs and made sketches. On one of his subway forays, he found an unnamed "beautiful old street in dark popular neighborhood," but Gorky Street (which his guides told him he was supposed to praise) was "depressing, out of scale." The little side streets provided better material. He noticed the paucity of goods in food shop windows and described the meager displays as having "dignity." He used a different-colored pencil in his diary to note how Russians pronounced English words: "They have shit (for sheep); burned (for buried). I am Joe (Jew)."

On his earlier stay in Moscow, he had been such a charming raconteur that all the bored American correspondents clamored for his company. On his return, he learned quickly which invitations to avoid, particularly after a disastrous drunken dinner with "a mean vulgar couple" who engaged in "public screaming." News of his wartime service with the OSS had gotten around, and he thought that might be the reason for some of his invitations. He enjoyed the company of Jack Raymond of the *New York Times*, who taught him how to navigate various Russian bureaucratic intrigues and who introduced him to the young historian Priscilla Johnson, whom he liked and whose knowledge of Russian political history impressed him. Steinberg accepted invitations to parties at the British and Danish embassies because it would have been impolite to refuse, and he went to lunch with the French, Canadian, and Swedish ambassadors, who were eager to hear about what he had seen and what he had learned about Russia.

At a time when it was not prudent for Russian artists and intellectuals to fraternize with Americans, Ambassador Bohlen quietly arranged for Steinberg to meet some of the leading dissidents. On a frigid Monday afternoon when all the stores and museums were closed, Steinberg stood outside his hotel and waited for a car bearing the ambassador and his wife to take him to an apartment where a half-dozen people had gathered surreptitiously. There he saw "sensitive and brutal faces" with one belonging to the dissident writer Vladimir Maximov, the only name he confided to his diary. He was careful to describe the others with coded phrases: an architect who traveled to Egypt, the architect of a wooden arch built in 1942, another architect who spoke English, and a painter. His interpreter, "Natasha," was sympathetic to Americans, and she

translated rapidly and fluently. He was not surprised to learn of the difficulties these people endured to practice their professions, for he had been hearing much the same from his sister for many years. Exchanging stories gave Steinberg and the Russians much in common and the conversation continued until well after midnight. As he was leaving, they presented him with copies of the satirical magazine *Krokodil*, which he added to the overloaded duffel bag.

The next day Ambassador Bohlen arranged for Steinberg to meet the opposites of the dissidents, the government officials who oversaw culture and the arts. Among them were the minister of culture, the director of the Moscow Puppet Theater, and the manager of the Bolshoi Ballet. Bohlen also arranged an interview with the editor of the official Soviet journal for cultural relations, G. A. Zhukov of *Voks*, and it became one of the more bizarre interviews Steinberg ever gave. He was ushered into "an enormous Empire room, longest table, piano, easel," where he faced a "mute specialist, ashen, writing all the time, taking notes." Zhukov silently pushed a list of questions written in English across the table for Steinberg to read, after which his translator turned what he said into acceptable propagandistic answers, whether he actually gave them or not.

His evening entertainments were varied: Sol Hurok invited him to the Moiseyevich troupe of folk dancers, and unnamed diplomats took him to the theater and the opera. He left *La Traviata* after the second act: "Girl from Swedish embassy," he wrote in his diary.

On March 15, before his visa could be officially extended, Steinberg had the required conference with an Intourist representative. The man could not understand why he wanted to go to Samarkand and kept repeating, "There are no toilets there." Steinberg insisted that he knew what he was doing, and the next day he was at the airport for the 4:30 a.m flight to Tashkent via a long stopover in Aktyubinsk, where an interpreter who was "in a panic" for reasons he never explained was waiting. He made Steinberg sit in an airport shed at one of the longest tables he had ever seen, plunked down several little plates, and commanded that he eat his breakfast, which Steinberg dutifully did. Afterward the fussy little man loaded him onto a sledge pulled by a donkey and drove him into the town for a quick tour.

He arrived in Tashkent in the early evening and found the weather much warmer than anywhere else he had been. He had another "scared" interpreter, but the hotel was pleasant enough. He knew what the Intourist interviewer had meant about plumbing when he saw the "horrible toilet in the corridor." When he stood on the balcony outside his room and looked down at the street, he realized that the town had no plumbing or sanitation except for a steep

gutter that divided the sidewalk from the road and ran deep with sludge and effluvium.

He took an evening walk and found a mob in front of the town's only movie theater. A man was beating a woman who held a crippled baby; another man, whose legs had been amputated at the knee, walked on two sticks and begged. A Black Maria police wagon was leaving as he arrived, sent on its way by "screams, whistles, loud speaker, moaning." That night he had a nightmare that his head had been shot so repeatedly that it flew off his shoulders. Still, all of this was exactly what he had come for, and he sprang out of bed the next morning, eager to meet his guides and get under way.

There were two of them, an unnamed guide and "Mary, a girl from Omsk," who "together try hard." He told them what he wanted to see and they more or less tagged along, first to the bazaar, the old town, and the other parts of the town that were, in his words, the "slumming" sections. He hoped to see camels but there were none, so he shopped and bought two of his favorite things in the market, a cap in the local style and all the primitive old postcards that were for sale. For lunch he ate a meal reminiscent of his Romanian childhood: green onion, radishes, sour cream, and thick slices of black bread. He was leaving for Samarkand the next morning, but his most lasting memory of Tashkent was its smells and the "hotel toilet incredible."

In Samarkand it was much the same. His interpreter was a distinguished middle-aged gentleman who said he was a former professor of history and "teacher of English." Steinberg found his attempts to be erudite comic, but he enjoyed the man's company and never corrected him. He was amused when the guide insisted they had to make a courtesy call at the local university and his hosts, as a sign of respect, offered to let him use the ladies' toilet. The rest of his days passed in a blur as the guide took him to towns and villages where he saw cemeteries, parks, bazaars, cathedrals, churches, mosques, and ruins. In bazaars he bought more souvenir caps and watched men hammering teapots out of sheets of copper. Everywhere he went, he was frightened by people running up and shouting in his face "Harry Manchu." Steinberg had no idea what they wanted until his interpreter found the words to tell him they were asking "whether [Averell] Harriman was Jewish," a subject of general interest since the war, when Harriman had been the American ambassador.

Steinberg was intrigued by the local interest in all things Jewish. He stole the telephone directory, convinced that he had taken a great risk by stealing sacred state property. After he found the name Goldberg, the only Jewish one among the hundred or so citizens lucky enough to possess a phone, Steinberg told his guide that he was Jewish and wanted to see the Jewish quarter, where

he learned a new expression for the Yiddish word *goy* (gentile): to the Jews of Samarkand, they were all "Uzbek."

When it was time to leave, all flights were indefinitely grounded because of heavy fog, so his guide took him to the overnight train for Tashkent, where he could catch a plane to Moscow. As they said their goodbyes, Steinberg leaned forward with outstretched hand to give the man a generous tip. The guide, with what he thought was the polite English response, said, "Thank you my darling. I must go now." He tipped his hat and bowed, and Steinberg said and did the same.

On the train he sat with three other passengers, including a woman who was taking it all the way to Moscow, a journey of five whole days. Back in Tashkent, he was given the same miserable hotel room. The weather had turned, and once again there was snow and frigid cold. He was not as happy to be there the second time, seeing bestiality in everyone and finding everything primitive and ugly. Once again he was aware of a strong Jewish presence, of rug dealers from Bokhara, of peddlers hawking tinfoil pictures, of dervishes and women who covered their heads and faces. Drunks rolled around the streets while pedestrians laughed and policemen ignored the mess and confusion. He went back to the hotel, took a nap, bought a bottle of vodka, and headed for the airport, where several regional flights eventually took him to Aktyubinsk and then back to Moscow.

Whether because of a combination of disappointment and depression or simple exhaustion, he did not want to see anyone when he returned to Moscow. As he digested his experiences over tea and caviar in his hotel room, he realized what had characterized his five weeks in the country: "The smell of fear, a curious smell. You cannot even describe it." It reminded him of "the smell [and] the old fearful atmosphere of Romania," and it made him shudder. Later that evening he exchanged his last few rubles, then dined alone and slept fitfully until he left for the airport at 3 a.m. He had to take a roundabout route to Paris, flying via Vilnius and Prague and not arriving until late afternoon on March 22. He went directly to the Pont Royal, where he had an early dinner and slept well. The next day he boarded the overnight flight to New York, where he arrived in the midst of a blizzard.

His immediate task was to translate the Russian experience into sketches that would fulfill his commitment to *The New Yorker*. As he sat at his drawing table, he recalled the five weeks of "frozen snow, Bolshoi, caviar, by airplane over Siberia, camels and veiled women. Black Sea and the smell of fear, etc." It made him feel "like [an] authority, inscrutable, benevolent smile." As he worked, he remembered the experience as "a trip for my nose" that reminded

him of the Eastern European smells of his childhood: "beautiful ones of winter and also of elementary school, police station, disinfectant, the terrible odor of fear which at that time, with Stalin only recently gone, permeated Moscow and Leningrad and even the countryside."

He worked from notes, most of which were comments about the buildings he had seen, for if there was one single thing that made the greatest impression, it was the architecture. He made a handwritten list entitled "Comments about buildings in USSR," prominent among them his favorite structures, the "XVIII [century] wooden houses in Moscow," which were very rare, as most of them had burned down because of household cooking and heating fires during the reigns of the two empresses. He had other "questions about places" and answered them by consulting various globes and atlases; he studied books on subjects as diverse as "Pushkin drawings" and "19th & 20th Century Foundry catalogues of Russian typography," which he first learned about in the Lenin Library. These showed up in his Russian drawings, but mostly they came later, in the diplomas and the mock writing.

He devoted a separate page of notes to comments about "How [the Russian] artist functions," and, not content with the trunkload of books he had shipped home, he resolved to find a good secondhand bookshop on Russian architecture in New York and buy more. He consulted his daily diary to draw on memories of what he had seen, but he also filled two legal-size yellow pages with notes about everything from Russian politics to culture. Armed with all this information and, relatively speaking, in no time at all, he produced so many drawings that the editors decided to feature them in two separate segments under the heading "A Reporter at Large." The first, "Samarkand, USSR," appeared on May 12 and the second, "Winter in Moscow" on June 9.

Both portfolios were immediate hits with an American audience eager to learn whatever they could about the secretive Soviet society. A columnist at the *San Francisco News* thought Steinberg deserved a Pulitzer Prize for "the best reporting to come out of Russia this year." He echoed the general opinion of other readers and reviewers when he wrote that Steinberg's "pen and ink sketches in *The New Yorker* some months ago told more about life in Russia from Moscow to Samarkand than ten million words. Uncensored words even."

Unlike his previous European voyage, when Steinberg had gone in search of self-discovery and personal resolution but had come home with every aspect of his life still unsettled and uncertain, the Russian trip gave him the professional renewal that he worried he might have lost, or that he might never even have had. While *The New Yorker*'s readers were avidly embracing what he told them about Russia, he was thinking ahead to something new, to an interpreta-

tion of what it meant to be an American. He thought it was time to refresh his knowledge of the American landscape and to observe the daily life of the people who lived in the very different parts of it. Almost two decades before, he had willingly become a citizen of this polyglot society and accepted it as his true *patria*, and now, if he wanted to interpret it, he needed to find out what it meant to be an American in the late 1950s. If he wanted to observe the daily life of the average American, the best way to do this was to get Hedda, get in his car, and start driving.

COVERING 14,000 MILES

Back from Alaska . . . Covered 14,000 miles like a good
Babbit, saw the whole country including part of Mexico.

The first order of business was to get his financial affairs in order so he could take the cross-country trip he had promised himself. While he was away, much had happened that required his attention, starting with his annual first-of-the-year assessment of finances (postponed because of the Russian trip), which he had to complete before he could decide how much time he could afford to devote to travel and his own work. A check had come in from the Swiss magazine *Du* for drawings it had used in its January edition, so that was a start. His annual $10,000 stipend from Hallmark Cards was safely deposited, as were several other routine payments and retainers. Added to all these, his lawyer, Alexander Lindey, had settled two infringement claims, against *Time* and the Grey Advertising Agency, which together brought close to $3,000.

Steinberg made it clear to anyone for whom he worked, whether advertising agency, business firm, or publication, that he would not sell the ownership, only the rights to use his drawings, and only in the manner Lindey specified in his meticulous contracts. With the exceptions of Hallmark and the various fabric companies, which insisted on holding the copyrights, everyone accepted this stipulation. Every year, for example, *The New Yorker* sent him a contract made "in consideration of the sum of one dollar," in which the magazine agreed to receive credit as the original publisher of the drawings while Steinberg retained the rights to resell the work as he saw fit.

The two infringement cases Lindey settled were about contract violation. In the first, *Time* used several drawings originally commissioned to illustrate a single article for multiple and different uses besides the one originally con-

tracted for; in the second, Grey did the same, but in a far more egregious manner.

Grey had commissioned Steinberg to make several drawings for its client, the television division of Emerson Electronics. The Grey campaign, unveiled under the general title of "Wherever you look . . . there's Emerson," was aimed at women who were housebound and therefore most likely to be watching television at any hour of the day. Steinberg's first drawing was a striking departure from the realism of previous campaigns aimed at women, all of which routinely depicted a human model smilingly doing household chores while wearing a crisp dress, starched apron, and high heels. His drawing was of a deliberately noncontroversial caricature woman, middle-aged and sexless, having breakfast in bed while watching television. The set she watched was a popular Emerson model with a man's face on the screen, rolling his eyes discreetly upward and not looking directly at her. It was completely without innuendo and eminently successful in every print medium, but it was Grey's use of the second ad that inspired Steinberg's lawsuit.

In that one, Steinberg drew a naked woman seated in a bathtub, similar to his drawing of the Paris bathtub. Instead of reclining in full frontal nudity, however, the cartoon woman is seen from behind, as she scrubs her back with a long-handled brush and watches a television set placed at the foot of her tub. On the set is a photograph of a real man with a monocle and a slightly lascivious expression on his face, holding up a book he does not read because he is too busy glancing sideways at the woman. Like the "Woman in Bed," the "Lady in the Bathtub" was a huge success in whatever print medium Grey placed it, which Steinberg's contract permitted. However, the contract did not permit the agency to place it, without his knowledge or permission, on forty-five billboards across the country, where it drew complaints of obscenity from various civil and religious groups. Lindey settled the case for $1,500 and Grey's agreement not to use Steinberg's future work in any way other than what was specified in his contracts.

Steinberg's work for Grey was typical of the commercial work he did throughout the 1950s, particularly in the last half of the decade, when he was one of the artists at the forefront of the creative revolution in advertising that dominated the 1960s. His contribution to the genre's evolution was with innovative drawings that departed from the expected and took the viewer into the realm of the surprising and unexpected. Although a Steinberg ad might have seemed at first glance to be a drawing chosen mainly for its shock value, in reality it was the lead-in for a carefully orchestrated plot to make the viewer read the copy that went along with it. "Operation Steinberg," as the Swiss critic

Manuel Gasser dubbed his commercial work, was replete with "advanced non-sense." There was no smiling housewife pushing a vacuum cleaner or loading a washing machine; instead, his whimsical cartoon people stopped just short of being grotesque when he juxtaposed them with real objects (the lady scrubbing her back while watching an Emerson being just one example). Many of the ads Steinberg drew appeared in *The New Yorker*, and most of them for one time only, so that each week brought something new for viewers to chuckle over. When *House and Garden* advertised itself as a publication "for the House Proud," one week's ad showed a little man smelling a vase of flowers on a table and the next week's featured a woman climbing a ladder propped against a tree to pick an olive for her martini.

Steinberg's ads for Simplicity, the largest manufacturer of home sewing patterns, illustrate just how integral his nonsense drawings were to the sensible copy that came below them. A headline beneath his elaborately curlicued and swirled caricatures of women proclaimed "And she did it all by herself." The copy that followed explained what the product could do, but the product was not pictorially represented. In the ads he designed for Comptometer, the largest manufacturer of adding machines, he showed a man lying on a chaise longue in a garden, fanning himself on a hot summer day while an umbrella shades him and a pitcher of cold drinks rests on the table beside him. "It isn't the heat," the caption reads, as the copy explains how the man can afford to relax because his Comptometer is doing the work for him. If the picture is puzzling, the text explains it, so that, as Manuel Gasser noted, "in the final analysis, the picture is the riddle and the copy is the answer."

In one ad for Noilly Prat vermouth's highly successful "Don't Stir Without Noilly Prat," Steinberg has an elegant thin hand stirring circles and squiggles that rise above a photo of the bottle in a crescendo of imaginary writing. Only the vermouth bottle beneath the slogan is literal; everything else is conceptual. For Schweppes, he created a comedic double take when he drew a man and a woman in a living room whose furnishings resemble one of his interiors in *The New World*. They hold glasses as they stand, each with one leg hitched onto a low bar rail—but there is no bar between them, just the rail.

Perhaps the most wildly imaginative print ads were those Steinberg created for Lewin-Mathes, the St. Louis firm that manufactured copper pipes and tubing under the general heading "We Teach Copper New Skills." In one, a man's head very much like Steinberg's is turned into an angel who sports a halo made of copper tubing; in another, circular rows of copper pipe look like the repetitive writing exercises grade school children were taught when they learned the Palmer Penmanship method.

The agencies that commissioned Steinberg's ads generally sold them first to *The New Yorker*, where sophisticated readers lapped them up as if they were part of the magazine's visual content rather than a commercial adjunct. The art editors were well aware of the enthusiastic response to Steinberg's commercial work, and Jim Geraghty's impassioned letter of several years earlier in which he had expressed frustration that the magazine and Steinberg could not reach an agreement where the magazine's "demands coincide with your aspirations" still rang true. With the exception of the two Russian spreads, most of Steinberg's artistic contributions to the magazine were still "spots" or "spot-pluses," the filler drawings editors pulled from the files to round off a page or fill a column. Ever since Steinberg had completed a last-minute assignment to make the portrait drawing that accompanied a profile of Le Corbusier, William Shawn and the art editors had fallen into the habit of sending assignments that had strict deadlines, because they knew they could count on him to meet them; but when it came to printing the kind of work he wanted to do, such as his spreads of daily life in the segregated South, it seemed as if he and his *patria* had not yet found the common pathway that would allow his aspirations and their demands to go forward in harmony.

All Steinberg's ads were print, with only one exception, a television commercial for Jell-O. In the days of black-and-white transmission, his line drawing of a woman has her shuffling along on a treadmill while a frazzled female voice-over intones, "Busy, busy, busy." The woman runs faster and faster as images bombard her: of a demanding child, a ticking clock, a man whose needs she is obviously not meeting. A black scrawl swirls across her and becomes deeper and darker until the screen fades to black while a sonorous male voice tells the viewer that there's no need to be embarrassed or ashamed about not making dessert on a busy day now that Jell-O has a new line of instant puddings. The scene cuts from Steinberg's obliterated cartoon woman to the midsection of a real woman, who pours milk into a bowl of powdered pudding and whips it with an egg beater so easily that even "the children can make it themselves."

Steinberg's contributions to advertising were not only easily recognizable but also ubiquitous. His work was so well known that Hallmark featured him as one of its famous artists in ads touting contributors to their "Hall of Fame" collection, a campaign that featured photographs of artists such as Norman Rockwell and Winston Churchill. Described as a "comic draughtsman of outstanding genius," Steinberg stands out in a sea of dark suits, looking stiff and uncomfortable in a beige deerstalker hat and matching tweed jacket, in a pose reminiscent of something between an English country gentleman and Sherlock Holmes.

Unquestionably he had arrived commercially, and the boxes and boxes of business correspondence he saved throughout his life attest to his commercial popularity. Requests literally poured in daily, with offers of complete freedom for him to create whatever he wanted, if only he would agree to create it. Clearly he ignored Marcel Duchamps's advice either to answer or to burn letters as soon as he received them, for often the initial requests led to a series of increasingly impassioned others in which the writers begged Steinberg please to respond, if not by mail, then by telephone or telegram. In most instances he was given the option of naming his fee, choosing his delivery date, and setting any other condition he wished to impose. His talents and abilities placed him in a fortunate situation: because he could deliver the goods, so to speak, he had the luxury of being selective, taking only those commissions that were intellectually appealing or so financially rewarding that he could not afford to refuse them.

At the same time as the demand for his commercial work rose, so too did the demand for his creative drawings. Only *The New Yorker* remained picky and selective, while galleries throughout the United States were eager to exhibit his work. He planned to visit several of them on his upcoming auto trip. International collectors were lining up to buy, and European offers for exhibitions and projects were also coming in a steady stream. All in all, much of the financial pressure that had contributed to his flight from New York the year before was fast becoming a thing of his past. He was on the verge of becoming a very wealthy man who had the luxury of doing exactly what he wanted to do.

MOST OF STEINBERG'S FRIENDS DID NOT understand his desire to leave New York so soon again, especially for a rambling drive across the United States, which, as far as they were concerned, had no real purpose. He and Hedda were ready to go by the end of May but hung around until June because they wanted to see Aldo Buzzi as he passed through New York on his way to Mexico to work on a film with Alberto Lattuada. Steinberg promised Buzzi to try to time his driving for a visit to the Mexican location before the film wrapped. By the nineteenth, he and Hedda were finally ready to go, and he made the last entry in his datebook until their return on August 16: "Left by car."

For Hedda, driving across the country made real most of the dream she had envisioned of what their marriage should be; although they were not working together in a room, they were at least alone together in a car. For her, the trip was "the beauty of an eventless life . . . quiet working and real understanding." At the time of her marriage, Hedda had believed that happiness came from being with Saul in "some room, any room . . . forgetting about the other

for half an hour and then coming back and seeing you and remembering reality: that you are right there and are going to be there and were there before—and it's just too wonderful." She thought they were like-minded, that Saul hated "lies and over-statements and sentimentality (not sentiment)" as much as she did. Hedda was sure that an "understanding between [two] people is possible, and real friendship and complete relationship and mutual confidence." Now, a decade later, she wanted to persuade Saul that such a relationship could exist between a man and a woman, even if they happened to be married, and even if the man held what she gently accused him of having: "a rather bad attitude about women."

In the car, with just the two of them driving for long days, it was much the same as being alone in a room together. They talked constantly, each saying whatever came to mind without fear of offending the other. They had no set itinerary, and everything about the trip was spontaneous and subject to change at a moment's notice. As they drove along one of the main highways, a mere twist of the steering wheel might take them onto a dirt road just because it looked interesting. A sign pointing to a place with an unusual name they never heard before was one that simply had to be investigated.

On their way through the northern mountain states on route to the West Coast, they saw a sign for a Native American reservation, so they made an impromptu detour and went to see it. The tribe was not one that catered to the tourist trade but consisted of poor people who were not used to seeing other Americans, let alone those with foreign accents whose big car had a backseat filled with enough equipment for two artists to set up easels whenever the urge struck. To get there, they had driven down a rutted, rock-strewn road that was little more than a path, so far out in the middle of nowhere that the tribal elders insisted they had to spend the night for their own safety. When they left the next morning, it was with the certainty that they had experienced something profoundly spiritual and moving. As they drove on, Hedda tried to put the experience into philosophical perspective by entertaining Saul with tales from the writings of Lin Yutang, Confucius, and several New Age lecturers whose talks she had heard and books she had read. They both vowed to investigate Native American myths as soon as they returned to New York

They had the same sort of reaction when they drove through British Columbia to reach the boat that would take them to Alaska. Ever since they left New York, Saul had been filling the car with the "junque" that always caught his fancy. In the Pacific Northwest, masks and totems joined the other purchases, with everything from the cheapest roadside souvenirs to examples of arts and crafts from galleries and museum shops. In Alaska he photographed

all the local objects he saw, from kitsch to high culture, and much of what he saw later found its way into his drawings, the ones in which seemingly random objects—a blue-and-white Chinese vase, a can of pistachio nuts, a paper bag mask, a tin of tea, or a telephone—originated in a personal biographical moment that resonated in a multiplicity of meanings for those who saw it.

Driving down the California coast led to inevitable conversations about the place of pure art in a philistine culture. There were long conversations wherein Saul and Hedda swapped stories about their relationships with their artist friends. Saul spoke of Joseph Cornell, who preferred to talk about esoteric eighteenth-century French writers rather than make observations about daily life on the magically named Utopia Parkway, the street where he lived in the borough of Queens. Saul said that like Cornell, he relished conversations about literature, but he was more interested in "direct experience, and spontaneous inventions of the moment." Hedda was closer to Mark Rothko than Saul was, and they had had many intense conversations when Saul was away and Rothko dropped in unannounced to stay for casual suppers in her kitchen. Rothko's insistence that he painted himself with blanked-out eyes because he was not "visual" puzzled her as she filtered his perceptions into her own thoughts about portraiture, particularly when she painted Annalee and Barnett Newman. Hedda made Annalee larger than life to fill a long narrow canvas that showed a strong, beautiful woman in command of the world before her; she painted Barney (whom Annalee supported until his work began to sell) smaller and seemingly crouched at the bottom of the canvas, the space above him largely white and open. Hedda had enjoyed the challenge of conveying the individual personalities and circumstances in each portrait, and the mutuality of the relationship when they were viewed together.

When Hedda painted the Newmans in 1952, she was torn between wanting to do more portraits and doing none at all. This conflict led to discussions in 1956 as she and Saul talked at length about what they wanted to achieve in their art, and if they were at cross-purposes on any subject at all, it was what they expected from their work: she insisted that she had no ego and no ambition for public recognition, while these things governed everything he did. Her recent painting had evolved to the point where she believed there was no "vanity" to be seen in it, no personal, social, or political agenda, and nothing that could call attention to the glamorous woman and brilliant artist who created it. With her large-scale machines and spray-painted cityscapes, she had removed everything pertaining to her biography from the viewer's consideration. Her semi-abstractions were raw and brutal, far different from, say, the color fields of Helen Frankenthaler or the big blowsy blobs that Joan Mitchell slapped

onto huge canvases in thick layers and wedges. Hedda Sterne believed that something "interesting" had happened to her personally that was responsible for the departure of vanity from her paintings; "very little ambition" remained in her, and she was no longer interested in scrambling for success. Saul could not understand her indifference to showing or selling her work, but as no agreement seemed possible they did not dwell on the subject.

On the other hand, Hedda spoke often about Saul's work, usually claiming that she could write the definitive book on it. She thought his type of humor, which she called "mostly comic," was different from others because of how he "deflavourized" emotions, ideas, and situations. She equated his "humour" (she always used British spellings) to "poetry" because of his ability to bring "a tender smile upon things one never looks twice at." Steinberg brought "magic" instead of taking it away by making viewers see the world as he did. "The humour is *in the line* [her emphasis], and most of all, the love that transfixes your affirmative attitude, accepting good and bad of life never as one assuming the right to judge." Hedda found "one and the same attitude toward life" in all his drawings, what she called the "deeply intelligent and understanding" ability to make his point "in the simplest and best way and impose [his] point of view without violence but with force and grace." For lack of a better phrase, she called it his "sense of humour," which she insisted was evident in his drawings but "not in what I know of you as a person." This too was a subject they did not dwell upon.

They did not stay long in Southern California and made no attempt to see the many friends who lived there. It was as if they did not want outside influences to spoil the purity of their intensely personal experiences. They dashed across the southwestern desert states into northern Mexico but were too late to connect with Aldo and the film crew, so they meandered back through the southern states and eventually headed for the mid-Atlantic coastline, New Jersey, and New York.

BACK ON 71ST STREET, THERE WAS an inevitable feeling of letdown after two months of getting up every morning with a sense of urgency to get started on whatever the adventures of the day would bring. They were tired from the constant movement and New York was still hot, so they decided to spend the next few weeks in Wellfleet. Hedda liked Cape Cod well enough for vacations but was not enthusiastic about buying property there. Neither was Saul, but somehow he managed to persuade himself that it was the thing to do. He found a house on the outskirts of Wellfleet and impulsively decided to buy it, making a significant nonrefundable deposit and then hiring a team of house inspec-

tors from Hyannis to make a report. Because he had locked himself into an iron-bound contract to buy the property, it was a shock when the report came back showing that the property was "a disaster—everything was in poor shape, no direct access to the house except through someone else's property, termites, etc. etc." Lindey engaged a local law firm to handle the matter, even though Steinberg claimed he didn't want to know anything about the deal except that Lindey had gotten him out of it. The Massachusetts lawyer told Lindey that they were "charming clients really in need of the protection you requested we give them," and "it was a relief to know that they had decided after all not to buy trouble and expense." However, it still took both lawyers to get Steinberg out of the mess.

Meanwhile, Louisa and Sandy Calder invited them again for Christmas, and they went, sending a huge ham before them as their gift. Steinberg, who had never really liked Connecticut, now decided that Roxbury would be a fine place to buy a house and asked Calder to help him find one. Calder said they never knew of houses until they were already sold and told him to engage a realtor and take several days to look at properties. Steinberg declined, and the idea of living in Roxbury fell by the wayside.

Tino Nivola heard of Steinberg's quest for a country home and told him of a house in Springs, near his, that was for rent. Again acting impulsively, Steinberg rented it. It turned out to be a good decision, and everything about the place made him happy. He liked the two-hour drive across Long Island to get there, which was then mostly along an easy highway bordered by potato fields and the occasional farmhouse. He liked the physical activity of country living: "I enjoy chopping wood for the fireplace, and once I've made this effort and the wood has been burned I go back to New York." There was a whole colony of artists and writers in what was loosely called "the Hamptons," among them Jackson Pollock and Lee Krasner, Bill and Elaine de Kooning, and May and Harold Rosenberg. The Nivola house was the gathering place for every visiting or transplanted European, and the warmth and vitality of the Nivolas' hospitality was always available to Saul and Hedda. Even though Saul had told Hedda the last time they had been weekend guests of the Nivolas that he could never live in the Hamptons because there were too many artists there, he changed his mind and was relieved to think that he had finally found the perfect location for a second home. He planned to look seriously for one to buy, but this happy prospect was still not enough to keep his galloping insecurities at bay, and he did nothing about it just then.

By the end of the year he was in a "bad mood because I'm dissatisfied with my work and also my behavior or whatever it is. During the night I think of

what I've said or done during the day and it doesn't seem true to me." Shortly after the 1957 New Year, everything he did was "a great waste of time, with people who are indifferent or worse, but they're around."

It was time to go traveling again, and this time he planned a complete vacation, no work at all, and he asked Hedda to choose where they should go. She suggested Spain because neither of them had been there, and by April they were on their way.

SIX PEOPLE TO SUPPORT

*Latest news: sister out of Romania, finally . . . A nightmare,
six people to support.*

The trip to Spain was just short of disastrous. The cities were clogged with tourists, the food was appalling, and Saul complained that it took two days to digest a meal. The only beauty was at the seaside, where dilapidated grand hotels in Anglo-Arab style fronted deserted beaches. The scenery was not enough, however, to make up for the hassles involved with the two accidents Steinberg had while driving his brand-new "never-seen-before Citroën DS19," a car that drew crowds and made him and Hedda objects of curiosity wherever they went.

They bought the car in Paris in early April 1957 and drove fairly uneventfully to Nice, where they spent several days paying brief duty calls on Rosa and Moritz before escaping to nearby villages to recover from Moritz's silence in the face of Rosa's nonstop complaining. When they could no longer endure Nice, they drove through northern Italy to Milan for a brief visit with Aldo. Then they headed directly toward Spain and were between Parma and Genoa when the first accident, a collision with a Fiat, happened. The other car was only slightly damaged, but the Citroën lost the left headlight, fender, and front bumper, and they had to wait several days for replacements to arrive. Once they reached Spain, they were engulfed by hordes of curious Spaniards, who surrounded the car just to touch it or climb on it and who made driving through narrow village roads and city streets difficult. In early June they arrived in Madrid, where the second accident occurred. "A gentleman of Madrid" who was trying to park scratched and dented the entire left side of the Citroën, causing an extraordinary amount of damage.

On their way home, they drove the car slowly and carefully to Paris, where

Steinberg sold it and was happy to be rid of it. They were back in New York and settled in by the end of June. To recover from Spain, they planned to spend the rest of the summer in the quiet and empty city.

IN HIS LATER LIFE, STEINBERG DESCRIBED the way each year unfolded as either "important" or "obscure." He placed 1957 in the latter category, claiming it had been an "obscure" year whose events he had trouble trying to remember. "What happened?" he asked himself twenty years later, unable to recall anything of lasting importance, but whether he wanted to admit it or not, things of lasting importance actually did happen.

For the most part it was a quiet summer with a number of interesting proposals awaiting his consideration. James Ivory asked about the possibility of a film project. There was a request from the Juilliard School for him to design the decor for a production of the Rossini opera *Count Ory*, and *Life* wanted him to go to Belmont Park to make a series about horse racing along the lines of the highly successful baseball drawings.

Otherwise Saul and Hedda saw friends with whom they were comfortable and relaxed, among them two Greenwich Village couples whose homes had become informal salons: the artist Ingeborg Ten Haeff and her architect husband, Paul Lester Weiner, and photographer Evelyn Hofer and her then husband, Humphrey Sutton. The Nivola household in Amagansett was, as always, the center of hospitality for Italian expatriates who lived and worked in New York, and Saul and Hedda quickly became mainstays at many gatherings. A friendship with Ugo and Elizabeth Stille blossomed so rapidly that they became frequent visitors to the Stilles' Upper West Side apartment. After an evening of spirited dinner-table conversation that covered everything from international politics to literature and music, both Hedda and Saul found it "difficult to wind down and go to sleep," and the conversation would often continue into the wee hours once they were back home on 71st Street. Personal interactions often added an extra tension to the Stilles' table, as guests with strongly held views sometimes carried their arguments over into flirtations, casual flings, or serious affairs.

The two couples, the Stilles and the Sterne-Steinbergs, developed an intense friendship that found them on the phone to each other every day whether or not they were going to see each other that night. Throughout Saul and Hedda's marriage, their custom had been to form separate friendships with couples or individuals. Richard Lindner, for example, went to the Metropolitan Opera with Hedda and to the movies with Saul. When Katherine Kuh and Janet Flanner were in New York, they had casual suppers with Hedda in

her kitchen if Saul was away, and if she was unavailable, he took them to dinner in one of his favorite neighborhood restaurants. If either Saul or Hedda simply didn't want to go somewhere, the other went alone, such as to the cocktail parties given by the wealthy art collector Edgar Kaufmann (Saul) or the art director of *Mademoiselle*, Leo Lerman (Hedda).

But the friendship with the Stilles was different, because it was the first time that Hedda and Saul were so closely involved in a two-couple friendship. They were both so entranced by the Stilles that it was almost as if they were competing over who could become closest to them. The friendship began because of a natural affinity between the two men: Ugo Stille began life as Mikhail Kamenetzki, a Jew born in Moscow whose family fled persecution to live in Italy. Stille was educated at the University of Rome during the same years that Steinberg was at the Politecnico in Milan, and afterward they worked in journalism in their different cities. They had many friends and experiences in common, but what united them most was the disorientation they had experienced when racial laws forced them to give up the strong Italian identity each had forged. Each man had to learn how to re-create himself in a third language, culture, and society, but they did so in very different ways. Steinberg never gave up his love of the Italian language and spoke it whenever he had the opportunity, while Stille spoke it only professionally and refused to speak it at home to his wife and children.

A significant change happened as the friendship deepened, when it became triangular rather than square. Ugo often traveled for his job as a reporter for the Italian newspaper *Corriere della Sera*, leaving Elizabeth in charge of entertaining the foreign friends who passed through New York whether he was there or not. As trusted friends, Saul and Hedda were often invited, and as friends do, they helped with the rituals of entertaining—serving drinks, preparing food, and staying afterward to help clean up and offer postmortems on the other guests. As the relationship among the three intensified, it was enlarged naturally to include Elizabeth's children—first her infant son, Alexander, and later his younger sister, Lucy.

Always before Saul had been irritated by the presence of very young children. His attitude gradually changed when he became fascinated with watching how charming Claire, Ruth and Tino Nivola's daughter, became as she developed from a toddler into a bright and alert little girl. He was so smitten with her that he nicknamed her Chiaretta and showered her with special drawings and toys. One of his gifts was a very personal book he called an *ABCedarian*, which he told Aldo was his way to "avoid or postpone more urgent things . . . work without responsibility." He was "enjoying it a lot" as

he illustrated every letter of the alphabet with a special meaning that was in many cases known only to him. He reserved the letter *E* for Elizabeth Stille, with whom he had become so deeply infatuated that he was certain he was in love for the first time. Steinberg drew Elizabeth's *E* as a swan that filled the midsection of the page. At the bottom, for reasons known only to him and her, he wrote the names Chiaromonte, Pollock, and Le Corbusier.

Elizabeth Stille had been born Elizabeth Bogert and had grown up in Chicago, where her father was a professor of law. She attended Cornell and joined a sorority, concentrating more on fraternity parties than on studying until her mother, who was otherwise a traditional housewife, "yanked her out of Cornell and made her go to a new school in Chicago, a reconstituted Bauhaus under Moholy-Nagy, unproven and unconventional." This New Bauhaus, as it was originally called, became the Institute of Design, and it not only brought the world of European intellectuals into the life of the young midwestern sorority girl, it also changed her life entirely. She studied painting with Bob Wolfe, a married instructor who fell so deeply in love with her that he left his wife to marry her. They moved to New York, eager to live the life of starving artists, but the marriage did not last after Elizabeth met Ugo Stille, whom she married in 1948 and to whom she remained married until her death in 1993.

When Saul and Hedda became enmeshed in what Hedda called, many years later, "the Elizabethan triangle," their marriage had already weathered too many of Saul's infatuations, affairs, and flings to count. Their friends tried not to notice at parties and receptions when Hedda stood at one end of the room suffused with shame and deliberately ignoring Saul, who was deeply engrossed in persuasive seduction at the other end of it. These were the years when Hedda woke up every day with "the terror that grips the shoulders . . . the promise of a new day of torture, disaster, humiliation." But she was a stoic who accepted that she could not change her husband's philandering ways, and she consoled herself that no matter how often he strayed, she was his rock and his anchor and he would always come back to her. This was true until he met Elizabeth Stille, and by late summer 1957 he had told Hedda that he was in love with Elizabeth and they would have to find some way to resolve how they lived so that it would include his being with Elizabeth and her children.

His proposal was that he and Elizabeth should be permitted to be together as a couple, but that this would happen while they remained within their separate marriages. Hedda had come to love the infant Sasha (as Alexander was called), so Saul saw no reason that their triangle could not be enlarged from three to four (and, after Lucy's birth, five). He was convinced that a *ménage à cinq* was not only a possibility but one that could become a happy reality.

Hedda was stunned, but there was no time to digest his alarming proposal, let alone respond to it. In late August they received word that the Romanian government had finally processed the documents that would permit Lica and her family to leave, and he had to drop everything to go to meet them.

THE NEWS THAT THE ROMAN FAMILY was permitted to leave came as a total surprise to everyone, even the principals. Steinberg had given up hope after he asked Alexander Lindey to add his contacts to the host of influential people he had been importuning over the years and to do what he could to get them out. Lindey did so, and reported back in February 1957 that no one in the government could help because no exit visas were being granted by any of the Iron Curtain countries, and the Roman family could only leave if they "managed to slip out . . . without authorization." Steinberg resigned himself to sending more packages than usual and hoping they would get through.

On August 20, Moritz and Rosa wrote that Rica, Lica's husband, had been called into an official office and told he had been approved for departure on an unnamed date and to an unnamed destination. As this had happened so many times before, Saul did nothing. A telegram from his parents jolted him into action on August 26: "They leave on September 1st through Vienna Genoa. They want to come to France. We beg you to facilitate." He was ready to fly to Europe, but the question was, to which city? He asked advice from everyone he could think of, starting in diplomatic circles with the American, French, and Italian embassies and consulates. They all told him to go to Genoa, because Vienna was merely the transfer point for Romanian refugees, who would be shuttled onto other trains as soon as the train arrived because the Austrian government did not permit them to stay in the country, no matter how briefly. No one knew for sure, but it was assumed that the Roman family had to go to Israel and had been directed to sail there from Genoa. Steinberg decided to fly to Genoa but was too nervous to wait for them, and as he had friends working on their behalf in Milan, he decided to go there to see what they had accomplished. Ernesto Rogers, "through an exchange of favors" with the French consul, secured a temporary French visa so Lica could have a brief reunion with her parents and introduce them to the grandchildren, especially Daniela, whom they had never seen.

By September 8, with a temporary visa valid only until the sixteenth, the Roman family was still in Bucharest while Steinberg fidgeted in Milan. The eighth was also Saturday and all the official offices were closed until Monday, but he still spent the weekend making "hundreds" of phone calls and sending cables to anyone he could think of who might prove helpful. In Nice, his

parents were "frantic," and while he was bombarding officials and friends with telegrams and phone calls, they were doing the same to him. He decided he had to do something, so he flew to Vienna after he sent wires to the station master at the main *bahnhof*, the International Refugee Committee, and the American consul, telling them all that he was on his way the next morning. Late that night his parents sent a telegram saying that everyone had arrived in Vienna and would be sent directly to Nice the next day. Shortly after, a telegram came from the Vienna station master saying that Ilie Roman and his wife and two children had arrived at 7:40 a.m. and would leave shortly by train for Genoa. More confusion ensued until phone calls to Vienna assured Steinberg that they would indeed board the train for Genoa. He left immediately and booked rooms there for them and himself in a quiet and genteel hotel where they could decompress for a day before going on to Nice.

IT WAS A DIFFICULT REUNION WHEN Saul saw Lica for the first time in so many years, as if they were strangers being suddenly forced into a false intimacy. Theirs was a childhood relationship forged twenty-five years before, and since then he had all but forgotten how close they had been. Still, he felt "a duty, a responsibility," to take care of her and her family. Lica was haggard and thin, and to his surprise showed "a great desire to be alone." Rica seemed "all right," but at forty-nine, he was "not a strong or tough man," and he suffered from high blood pressure. Saul didn't know what to make of his nephew and niece, whom he called "the boy" and "the girl." Stéphane was eleven, "tall for his age, intelligent eyes" and Daniela (called Dana) was "still too small and too Romanian." He was surprised when they both occasionally overcame their silence, fear, and exhaustion and behaved like normal children, at which times he called them "savages, but not bad." It took a few days, but he got along well with everyone and they "got to be friends again."

Steinberg still had trouble believing that their documents were in legal order, so before he tried to take them across the border to France, he asked to see them to make sure everything was as it should be. He was distressed to find only a "Romanian and Russian piece of paper" that gave them a visa to Israel, with no mention of the temporary stay in France. He hid his concern, left them in the hotel with instructions to rest, eat, and watch television, and rushed to a Jewish agency that handled the steady stream of refugees that passed through Genoa. The agency personnel told him that the Roman family needed "a so-called passport" which the agency could not release, so they should simply board the train to Nice, which they did. One meeting after another with various bureaucrats in Nice failed to resolve the stalemate over

how long they could stay in France. "It looks like Israel is the only solution," he told Hedda glumly.

In Nice, "too many things" were going on, particularly Rosa's euphoric hysteria over seeing her daughter after so many years. Saul wanted to get away from the family drama as much as from the problems the Roman family had unwittingly caused. He was convinced they would be allowed to stay in France, even if only for a few months, and to get them away from Rosa, he found several apartments for them, but they were stunned by the possibility of making choices, which they had never had to do in Romania. As they were unable to decide, Saul chose one and helped them move. He told them where and how to enroll the children in school but ended up doing most of the work himself. He transferred a sizable amount of money to the account he had set up in the American Express Bank in Nice for his parents and added Ilie Roman's name as someone authorized to withdraw funds from it. As soon as he got to New York he planned to arrange for an increase in the stipend so it would cover four additional dependents, which made him worry about finding enough income to replenish the account every month. When he thought he had done all he could to get the family settled, he made tentative reservations to fly to New York on September 17, but one problem after another kept arising and so he had to stay on until the twenty-fourth.

He was in New York on September 25, 1957, when Moritz wrote to send greetings for Rosh Hashanah, the Jewish New Year. It was a great relief to learn that Rica had withdrawn money from the account without incident, the Roman family was settled in the apartment, and the children were enrolled in a French school that they liked. Moritz told Saul that Rosa was "on cloud nine" when they came to her apartment every evening to watch television, and he blessed his son for everything he had done for them. But despite her happiness at seeing her daughter, Rosa was still Rosa, and she had complaints: the children were "very cute but also too energetic and spoiled." Lica was too thin, and Rosa was upset that she did not look like the "princesses in [*Paris*] *Match*." Only Stéphane passed Rosa's muster, but the six-year-old Dana was a "scoundrel" who made too much noise and caused too much confusion. Lica's interpretation of the family dynamic was more soothing, as she told Saul and Hedda that "the different generations are beginning to get along." That was before everything shifted, when, on top of their unhappiness over having to become French, they became too expensive to support.

Once Saul added up all the costs involved in supporting six dependents in France, he told Rica to begin the process that would allow them (Rosa and Moritz included) to enter the United States as permanent residents. Rica was a

lawyer trained to navigate bureaucratic byways, so he knew that he had first to secure an "extension of stay in France" before the long process of immigrating to the United States could happen. Also, less than a month after their arrival in France, the Roman family became unhappy with living there. On their own they made significant changes. The original apartment was too dark and noisy, so Rica found another because Lica had caught a cold and was too sick to get out of bed. Rosa's attempt to be helpful was more obstructive than usual; in trying to cure Lica, she made herself sick with various aches and pains and had to take to *her* bed, which meant that the still-sick Lica had to get up to minister to her mother. The move to the new apartment meant the children had to attend a new school, which Stéphane accepted but which upset Dana, gave her headaches, and made her "antagonistic." Lica and Rica found French too confusing after many years of speaking only Romanian, so they decided to learn English instead, in preparation for either the United States or Israel, which they still considered a viable possibility, much to Saul's consternation.

They did, however, follow his directive to go to the American consulate for the medical examinations that would set in motion the long, involved paperwork process that might allow them to immigrate, and to the prefect of Nice, who needed to grant an extension of their stay in France until the American application was resolved. They dutifully began the process of swearing affidavits and gathering documents that would explain that they had never been members of the Communist Party, that Rica had been held in a Romanian detainee camp for continuing to practice law after Jews had been forbidden to do so, and that he had otherwise been a model citizen who would uphold the laws of the United States if he were permitted to live there.

All of this spurred Steinberg into action, starting with a visit to the Hallmark headquarters in Kansas City to negotiate new and more lucrative contracts. He resented having to put on "a good act as an artist according to the notions of the idiots" in a city he so disliked that he used one of his favorite expressions to disparage it, saying it smelled like Gogol's nose. At the same time, more letters asking for help came from relatives in Israel, and Ada chose this moment to hint that she too could use a little money.

AT HOME, THINGS WERE CALM BECAUSE Hedda refused to address Saul's obsession with Elizabeth Stille and also because he was unable to talk about it or decide what he wanted to do. It was actually a relief to be able to postpone thinking about it or coming to a decision after the United States government invited him to accept a prestigious commission to design a 100-meter mural for the 1958 World's Fair in Brussels.

"I'm in trouble," he told Aldo after he accepted it, as he lapsed into Spanish to say he would have to use his *cabeza* and think. His assigned subject was *"people* in the U.S." In 1957, long before the term came to be accepted popular use, he described the most important problem the creation of the mural would raise: "How do you draw the blacks?"

A BITING SATIRE OF AMERICAN LIFE

If my life, or yours or others were translated into architecture,
who knows what incredible constructions, lack of logic, waste
of materials, miraculous equilibrium, wrong locations.

The official invitation to create a mural for the American Pavilion at the 1958 Brussels World's Fair came from the State Department, but Steinberg's good friend Bernard Rudofsky had a great deal to do with his selection. Rudofsky was the chief designer for all of the United States' cultural exhibits, and his charge was to tell "the American Story" within the general framework of the fair's theme, "A New Humanism." Rudofsky was looking for "exhibition design with a sting," one that "pricks our complacency . . . [and] puts doubts into our heads." He wanted the exhibits to be controversial, and he was confident that Steinberg was just the man to help him fulfill his desire. Rudofsky got more than he bargained for when reactions to the exhibits ranged from bewilderment and confusion to anger and accusations of sabotage from American visitors who could not recognize themselves or their way of life. President Eisenhower was so disturbed by the controversy that he sent an envoy to investigate.

The American Pavilion was a domed building with an adjacent annex, both designed by Edward Durrell Stone. Leo Lionni, a friend of Rudofsky and Steinberg, had an exhibition in the annex entitled "America's Unfinished Business" that featured the controversial desegregation of schools in Little Rock, Arkansas. It was too controversial for the government and also for visitors and was shut down within days of the fair's opening. Although Steinberg had intended to portray "blacks" in his mural and worried about how to do it, he ended up by not including any, thus avoiding being drawn into the political controversy. His charge was to cover five freestanding walls that contained eight panels of various widths but all a uniform ten feet high, with the entire

length totaling about 260 feet. He undertook the commission with the highest seriousness and concentration, poring over the sketchbooks he had made on his numerous cross-country trips to find the eight to ten themes that he thought best represented America. Before he began to arrange old drawings or make new ones, he studied techniques to find which one would work best, and he made a series of notes about his overall intentions.

As he promised himself to do after the 1954 *labirinto* mural in Milan, he had worked on perfecting the technique of sgraffito in the 71st Street basement, and he felt confident about adding it to the other techniques he planned to use in Brussels. He finished fifteen pen-and-ink drawings, which were then photographed and enlarged to the sizes they would fill on the walls before brown-paper cutouts were made of most of them. His overall plan was to create composites that would show the vast variety of American life and landscape to curious Europeans. Some of the titles he settled on were "The Road," "Main Street—Small Town," "Downtown—Big City," "Farmers," "Drugstore," "Cocktail Party, and the all-American pastime, "Baseball." Because Europeans were fascinated by California and Texas, he included scenes from those two states and threw in Florida as well.

He did the initial drawings in New York and shipped them and some small brown-paper cutouts and boxes of other supplies to Brussels, where he arrived on a Sunday in mid-March to begin three weeks of work. He chose to stay in the Hotel Canterbury, unlike the Rudofskys, who had an apartment and insisted that he come to dinner on his first night. He would have preferred to go directly to bed but instead went to listen to "Bernard full of politics intrigues, etc." He told Hedda, "The whole thing smells of nest of vipers, we'll see."

Everything started well on Monday morning. He liked the white photographic paper that had been chosen for the background cover of the walls because it was "beautiful, like enamel," and when he pinned several of the brown-paper figures on it to get an idea of how it would look, he thought both scale and visibility might make it "quite a beauty." The pavilion was open to the elements and there was noise, dust, and confusion throughout, but his section had been screened off so that he had a modicum of privacy in which to work. He blessed Hedda a million times a day for forcing him to take woolen underwear and socks and heavy work shoes, because the space was unheated and he was freezing. He used an office chair on wheels to scoot around from screen to screen, and as he did so, he saw that the size of the walls was "very misleading" and he would have to invent at least one hundred new figures to fill it up. When he began to glue the brown-paper figures onto the white background, he found that the glue did not hold, so he "lowered standards" and used staples until

he found a fixative spray that he hoped would work. Unfortunately, "things already glued unglue. Fixative spray bungled. Great incompetence around. Lots of disasters."

The exhibition was to open on April 17, and to be ready for it, he worked for ten or more hours every day, seven days a week. He made it a point to return to the hotel at 6 p.m. for a two-hour nap; then he went to a solitary dinner and directly back to bed, managing to sleep through the night with the help of sleeping pills. Brussels was as cold and dark as Moscow, and he was so tired that his entire social life for three weeks consisted of two dinners at the Rudofsky apartment. When panic over the isolation and the unfinished project was setting in, he broke down and hired a German art student to help him during the "slaving 12 hrs day pasting and fixing." He credited her for saving the work "from worst disaster" and told Hedda not to worry because he found her

very unattractive. However, neither his helper nor anyone else could do anything about the only fixative they could find to hold the collage together, which turned everything yellow. "A pity, but all in all it may look good," Steinberg concluded. The next day brought more "miseries and disasters," when someone attached a vibrating motor for another exhibition to the rear of one of his panels: "Things are peeling off, mural hardly finished. It's so huge I could work for two more years." At this point he didn't care and was determined to finish it as best he could and leave for Paris the day before the fair officially opened. Between the problems with the mural and Rudofsky's ongoing political contretemps, he felt like someone who was being slowly poisoned, and he just wanted to get out of there.

In fact, his mural was the

Saul Steinberg at work on his *Americans* mural, Brussels World's Fair, 1958.

greatest success of the entire pavilion. When an American journalist commented that Steinberg showed everything about America but people at work, he replied that it was a deliberate choice not to, because tasks of work were "the same everywhere." As an American, he wanted "to show how we really are. There are few people who can afford to grin a little bit at themselves. We can." It was the age of Sputnik, and neither Steinberg nor the critics and journalists could resist comparisons between the Soviet Union and the United States. The French journalist Pierre Schneider called the mural "a biting satire of American life" and found "no such good humored relaxed self-irony at the Russian Pavilion. The atmosphere there is of relentless propaganda and self-glorification."

THERE WAS ONE BRIGHT SPOT DURING Steinberg's stay in Brussels. He arranged to buy a Jaguar, and it was ready in time for him to drive it to Paris and then on to Nice. He was thrilled with the car but not with the color, which he called "ugly dark blue." Still, he had always wanted a Jaguar, so he accepted what he could get. He drove slowly to Paris because the car was new and had to be broken in; by the time he arrived at the Hotel Pont Royal, he had had a long and tiring day and was happy to sleep the better part of his first twenty-four hours in Paris. He was depressed when he woke up but blamed it on "a hangover of the three weeks excitement in Brussels," conveniently ignoring the unsettled triangular situation he had left at home with Hedda and Elizabeth Stille. He invited Hedda to come to Paris and travel with him, first to Nice, then to Spoleto, where "they are frantic about the [Robbins] ballet" and wanted him to redesign parts of the backdrop and create a new front curtain. He wanted her along because he planned to look again for a house to buy in Italy, and if he found one, he intended to stay there for several months. He urged Hedda not to doubt either his love or his need for her, both of which were true, but the problem was, as she knew, that he felt the same emotions for Elizabeth Stille.

Hedda replied with an uncharacteristically frank letter. "Decisions, decisions," she began, as she addressed his instruction that she should not make hers on the basis of his "desire or need." She asked if he would allow her to make the definitive decision about him and Elizabeth if he were not so riddled with doubt. For the first time, she told him how she thought he treated her as "an object of dislike and irritation in New York," where she had her "functions" and served his needs because he was away from home so much that he seldom saw her. To enforce her point, she told him how she was acting as his secretary, busily responding to the many social invitations that were pouring in

from various European nobles and international art dealers, all for him alone and not for them as a married couple, and how difficult he had made the task because he had not left her the address of his Brussels hotel, only its name, and she could not consult him in a timely fashion. In conclusion, she told him that he had to decide what he wanted and needed, and whatever it was, he would have her blessing.

HE WAS IN PARIS LONG ENOUGH to see the three good friends with whom he could talk about his work and theirs, the painters Hélion, Matta, and the aged Victor Brauner. He refused an invitation to dinner from Darius Milhaud and avoided returning Oriana Fallaci's telephone calls because he did not want to be interviewed again after having sat through so many interviews in Brussels. Most of his time was taken by negotiations with Robert Delpire, who was more or less in charge of a book of the Brussels murals that would also be published by Hamish Hamilton in England, Rohwolt in Germany, and Mike Bessie at Harper. Delpire had various mockups and proofs ready to show Steinberg, but, ominously, he also had "suggestions to reconsider certain aspects." Delpire particularly wanted Steinberg to "describe the contents" or at least "to give a written hint as to what they represent." Steinberg was furious and demanded to see the French translation of the few remarks he had already provided: "It seems to me they are obvious. The sort of people who need explanation deserve a mystery." He did not approve of Delpire's suggested changes, nor did he approve of the color plates of the first four panels. He pronounced them "terrible" and brooded about it until he reached Nice, where he sent a telegram telling Delpire to "interrupt production book."

The project dragged on for one full year before Steinberg decided that he did not want the book to be published "anywhere, in any form" because it did not meet his meticulous standards for any reproduction of his work, and it seemed unlikely that publication would ever happen. Delpire had already spent more than $8,000 on it, so Steinberg proposed that all four publishers split that cost and he would agree to let them all publish his next book, to which he had already given a working title, "Steinberg's America." Alexander Lindey thought that this would be "a happy solution to an unpleasant situation."

An unhappy resolution occurred while Steinberg was in Paris, though, when William Shawn declined to feature portions of the murals in *The New Yorker*, saying that he could not see how to make them suitable for the magazine. Shawn tried to soften the blow by inviting Steinberg to call him as soon as he returned from Brussels to discuss future possibilities, but it was still a disappointment on two levels: financially, because Steinberg needed the money,

and professionally, because it had been a long time since his last spread in the magazine.

AFTER SEVERAL DAYS IN NICE, he was glad that Hedda had decided not to meet him. "I'd be horrible to you if you were here now," he wrote from Genoa, to which he had driven all night long to escape from his family, especially from Rosa's "distinguished conversation and other horrors." He was dismayed by Lica, who had had "some sort of breakdown: poor sister, a tragedy. Sensitive, simple, ignorant, terrorized by mother, affected by pity, staying with the stupid husband, living still in Rumania [sic] (or in Nice, which is worse). She stays indoors for weeks, paints in confusion (trying to discover Cubism). It breaks my heart. She really needs help. I behaved like the usual grandfather, brought gifts to the children."

To clear his head, he spent the day in Genoa making advertising drawings for a New York bank. Then he drove on to Rome, thinking that if he stayed long enough he could avoid having to go to Spoleto, because the Robbins ballet would have opened without his redoing the rear curtain and designing the new one for the front of the stage. However, he was almost irrationally worried about money, despite the fact that lucrative requests were coming to him on almost a daily basis. A huge shipping company in Genoa, thinking that he was in New York, offered to pay for a flight to Genoa just to see if he wanted to accept a commission to make a drawing approximately fourteen feet long and four feet high for a new building; They invited him to name any price he wanted, which they would gladly pay. Stanley Marcus, of Neiman-Marcus, wanted to see him as soon as he returned to New York to discuss further projects for the store, and the newly reissued *Horizon* magazine was willing to pay him top dollar for whatever he wanted to contribute. Nevertheless, he still drove north to Spoleto to collect his $500.

He started driving in late afternoon, and by the time he arrived, it was late and he was tired, so he parked the Jaguar on the street and checked into a hotel without unpacking it. The next morning he discovered that thieves had broken in and taken everything inside, including a green hat that he was fond of, a sweater, and a small drawing portfolio, which fortunately contained nothing he cared about. On top of everything else he had to do for the festival, he had to negotiate with the Paris agency that had insured the car. He chose not to report the theft to the Spoleto police, fearing headlines about the "affamato artista e la sua pottente giaguar."

Despite the "horror of the brutality of the robbery," he enjoyed Spoleto, a "splendid town ruined by snobs. He liked it, but the robbery and all his aim-

less driving through Italy convinced him to give up the idea of trying to buy a house in which to live semi-permanently. Living in Italy would have been too great a change and might have made him "forget all the good or wrong things of America." He told Hedda, "We have no idea how much we are protected in America." Also, he was aware for the first time that no one in Italy, not even his closest friends, still thought of him as Italian. Although he remained close to the old friends—Aldo, Zavattini, Rogers, and others from his days at the Politecnico—and to the new friends he had made since the war—Federico Fellini and Giulietta Masina, Monica Vitti and Michelangelo Antonioni, Ennio Flaiano, Primo Levi, and so many others—he was still, to them, "the immigrant," or even in some circumstances, when Americans were disliked, "the goy, the abuser." This marked the first time that he considered himself fully American, and it made him realize that he could not make a permanent home in any other country.

His feeling of being an outsider continued in Rome, where he saw Nicola Chiaromonte and Ennio Flaiano. He did not see Aldo, who was working on a film in Yugoslavia, but he did take Bianca to dinner before he headed north for one final day in Milan. The realization that he was no longer considered to be an Italian was so disorienting that he had to go to the Politecnico and walk around familiar places for a while before he could become fully functional within the rest of the city's geography. It was as if he could relax only by sticking to favorite haunts, such as the bookstore in the Galleria, and only buying books that were in Italian. It was a shock to read Carlo Emilio Gadda's novel *That Awful Mess on the Via Merulana* and find that he could not fully understand the Milanese and southern Italian dialects in which it was written.

STEINBERG CONTINUED ON TO NICE, where he girded himself for one final visit with his family. He did not relish his "undesired role as head of the family," and to fortify himself he made an unplanned excursion to Picasso's Villa Californie, high on a hillside overlooking Cannes. Both Aimé Maeght and Daniel Kahnweiler had been urging Steinberg to do so for some time, as they agreed with the many other critics and scholars who saw similarities in the two artists' vision and who also called them the best draftsmen currently working. In his influential 1915 essay, "The Rise of Cubism," Kahnweiler was the first to interpret Picasso's approach to art as a language and to suggest the link between the cubism he practiced at the time and what Kahnweiler called "scripts," or sign systems. In the 1950s, when Maeght began to show Steinberg's work, Kahnweiler believed this was true of Steinberg as well, and he thought a meeting between them would be interesting and perhaps beneficial. Earlier in 1958,

when Kahnweiler was in New York, he had invited Steinberg to a cocktail party and once again entreated him to find a way to meet Picasso.

The afternoon at La Californie passed pleasantly enough, but the artists were a bit wary of each other until Picasso proposed that they play the surrealist game *cadavre exquis* (exquisite corpse). A sheet of paper was folded into small squares, and first one man, then the other, would draw a line or fill a square. When the squares were all covered, the paper was unfolded, and most likely a nonsensical drawing resulted. Picasso gave the paper to Steinberg as a souvenir of the afternoon, which turned out to be their one and only meeting. Years later, Steinberg remembered Picasso as "an old Jewish man in the Florida sun—all torso and shorts. The voice of a cigar smoker . . . the falsetto of a cello."

WHILE IN NICE, STEINBERG PLANNED TO spend most of his time in his hotel room working on one final curtain for Spoleto. As always, no matter how irritated he was at having to do a commercial project, once he began to do the work he became engrossed in it, and feelings of satisfaction, even happiness, suffused him by the time he finished. The work was steadying, and it prepared him for the uncertainty and chaos he found when he visited his family. There were many legal obstacles obstructing the Roman family's attempt to move to the United States. The French government would not let them go to Paris, where it would have been easier and faster to make the arrangements, but would provide visas only for several months at a time and then only for the Alpes-Maritime province in which Nice was located. The United States government still considered them to be in transit between France and Israel, which meant they could not be put on any country's quota list, and none of Steinberg's influential contacts could persuade either government to bend so many conflicting and contradictory rules and requirements.

Meanwhile, Rosa decided that the Romans could not leave Nice because she was too old to consider another move, even to an apartment that would take her closer to them. Moritz was still sad that Rosa had refused to go to Israel, where he could have been happy, surrounded by all their relatives and friends from Bucharest. Now that there was a possibility that Lica and her family might have to go to Israel, he hoped silently that Rosa would agree to follow them. Saul was so appalled by the family's indecision on every front and so alarmed to think of what his life would be like if they were in New York that he insisted they stop trying to immigrate to America and think instead about where they could all best live together, whether in Israel or in France. He promised to give them whatever financial assistance they needed to make

everyone content, if not happy. He was willing to pay any price to keep them an ocean away.

The Romans were seriously considering Israel, because Rica had a better chance of working in the legal profession there than he had in France, where he faced barriers in becoming certified to practice law on top of his difficulties in learning the language. But whenever they tried to talk about Israel, Rosa became hysterical and claimed to be felled by everything from heart palpitations to migraine headaches. She could not stand being with the children, whom she called "noisy savages," but she still went to Lica's apartment every day to berate her for her many faults, from her inability to control her children to her continuing loss of weight and the depression that kept her in bed or unable to leave the apartment. Saul understood that the Romans were having a difficult time making the transition from life in an Iron Curtain country to the tremendous freedoms of life in France, but Rosa chose to blame everything wrong in their lives on Saul, saying that he was obviously writing unpleasant letters to Lica because he never wrote to her. Nor did Hedda, at whom Rosa aimed one barbed dig after another.

While she scolded them for not writing to her, she was whining and writing to them to ask for things like a new television (it had to be the same brand as the last one), a new coat (a fur, but not too heavy), a trip to a spa where she could take the waters (someplace refined, with a good clientele), and money for her ongoing dental problems (her dentures were ill-fitting and needed constant adjustment). Meanwhile, Moritz took her pills, because she would not give him an allowance to buy the ones he needed to keep his erratic heartbeat under control; nor could he do anything pleasant, because she refused to give him an allowance. When they first arrived in France, Moritz won a small amount of money on the lottery, all of which he spent on Rosa, staying at home while she booked rooms in expensive hotels near the various "cures" she claimed she needed. Whenever Saul's checks arrived and he asked for spending money, she insisted that he still had plenty of lottery francs and could entertain himself with those. Moritz wrote secretly to Saul, asking him to send money separately from the household allowance and to wrap it in a different-colored paper so that he could surreptitiously remove it when he opened the letters before Rosa's prying eyes.

Saul told them all to think seriously about moving to Paris, where Rica had a better chance of finding work, where Lica could return to her painting, where the children would receive a better education, and where he would be better able to buy a house large enough for them all to live in, his parents separately from the Romans but still together. For the rest of the year, the family

drama consisted of anguished letters about whether they should move or not, whether they should all go or just the Roman family. He left them to sort it out and prepared to return to New York.

As he left Nice, he realized that he had made several important decisions, starting with the one that he would not allow his family to join him in New York. France or Israel, he didn't care; it just could not be New York. An equally important decision was the one not to live in Italy. Having made these two, he felt such elation that he swore he was no longer depressed. He drove back to Paris, arranged to ship the Jaguar by boat, and flew to New York on May 21, confident that he could face whatever was waiting for him.

CLASSIC SYMPTOMS

I'm a bit troubled and confused—all of a sudden I discover that the last fifteen years have gone by too fast. Classic symptoms.

Steinberg had been at home for less than a month when the Jaguar arrived and gave him the excuse that he needed to go away again. He said it needed further breaking in, so he planned to drive across Pennsylvania to West Virginia, southern Ohio, and Kentucky. Even though *The New Yorker* had not been interested in the drawings from his earlier trips to the South and Southwest, he hoped to interest the editors in the new ones. He sensed a new political urgency in American life and wanted to contribute something that would awaken readers, albeit quietly, to the social inequities and injustices. He wanted to see for himself "the ancestors of the Americans, the heroes of our best fiction," and these included "cowboys, crooks, and country derelicts." He went to company towns where coal miners lived and worked in dire poverty, to small towns where residents were both isolated from and deeply suspicious of the outside world and where rampant distrust of it made local prejudices harsh and threatening. He saw and drew a way of life so different from that in New York that it might have been a foreign country, one dominated by old-time religion and violence, where landscapes were despoiled by mining and commerce and daily life was as primitive as that in African villages. "Here's where they ought to make a film," he said of one urban landscape, but once again *The New Yorker* was not ready for it.

Hedda stayed behind in New York, where she was busy preparing for new exhibitions and taking care of last-minute details connected with several that were just ending. "I hear you are rich," Saul teased, after she sold several large paintings through Betty Parsons and received commissions for several more following the annual exhibition at the Whitney Museum. She had four new

shows to prepare for throughout 1958 and had already received two more invitations to show in 1959. It was a period of surprising public recognition for an artist who was still entirely content to paint quietly at home and who would have been happy to do the work without showing or selling it.

An important reason for Hedda's growing introspection was that it kept her from thinking about Elizabeth Stille. Their friendship had become so close that when the women came down with severe flu at the same time, they talked on the telephone several times daily to compare their cases. Saul was away, as he almost always was, but when he phoned Hedda, one of his first inquiries was usually about Elizabeth. Hedda's antennae were alerted that Saul's infatuation with Elizabeth was still strong when she noted how charmed he was by her tale of how Elizabeth was too sick to get out of bed to stop Alexander, then a toddler, from flushing a twenty-dollar bill down the toilet. Such excessive delight in a child's doings were quite unlike him.

Saul's restlessness was such that he could not bear to be at home any longer than absolutely necessary, because by staying he would have to face "doubts and complications." He needed an excuse for his inability to concentrate, so he blamed the outsize Brussels murals for making it difficult to return to drawing on "the usual scale." And as he dawdled, a number of commissions languished. He told Aldo that in the past, the moment he plunked his "ass on the chair" he could always focus on the project at hand, but it was not working this time. Still refusing to face the complications in his life, he insisted that all his anxieties were caused by his work, and if he did not have so many financial responsibilities he would give it up entirely. Deep down, however, he knew that he was kidding himself and would not change a thing because he liked success, the books, the temptations, and was afraid of missing out on something good.

TO PULL HIMSELF OUT OF MALAISE, he decided to get serious about a new book, envisioning a biographical exploration of "life . . . seen here like a voyage from birth A to the end, B." When he was in Europe and pondering how he had changed from a transplanted Italian to a bona fide American, he thought about calling the book *The Labyrinth*, but after the driving trip, the content took a temporary detour to become something different and he gave it the working title "Steinberg's America." The basic premise was autobiography, but at the start he could not clarify the unifying idea that would let him emphasize either his inner life (that is, "Labyrinth") or his life as an observer of the external world ("America"). He still owed the four publishers a book to make up for the aborted murals project, so every now and again, when nothing else commanded his attention, he gave thought to what a new one should be.

He was tending toward "Steinberg's America" because he had just provided the cover drawing for Delpire's publication of Robert Frank's revolutionary photographs of everyday American life, so sensational in their ordinariness that every American publisher Frank contacted refused the book. Frank, a Swiss-born Jew, loaded his then wife, the artist Mary Frank, and their children into a shabby used car and drove randomly back and forth across the country, taking photos of the "easily found, not easily selected and interpreted." Delpire recognized that the book, which he published as *The Americans*, was groundbreaking, but as Frank was unknown, he thought a Steinberg drawing would help to sell it. Both Robert and Mary Frank were good friends of Steinberg and Sterne, but as much as Robert admired Saul, he did not want a drawing on the cover of his book of photographs. Delpire, aware of Steinberg's enormous popularity in France, insisted that his drawing would be a selling tool, and the book was published that way. When the matter was settled, Steinberg was sure he had found his next book.

EVEN THOUGH HEDDA WAS CONTENT TO spend the summer of 1958 in the city because of all the work she had to do, Saul was itching to let the Jaguar take him somewhere else. In July, saying that he needed more drawings for the "America" book, he imitated Frank's car trip, but unlike Frank, he drove with purpose in mind. He filled a sketchbook with drawings from cities like Aberdeen, Maryland; South Hill, Virginia; Greensboro, North Carolina; Greenville, South Carolina; Chattanooga, Tennessee; Athens, Georgia; Middlesboro, Kentucky; Williamson, West Virginia; and Uniontown, Pennsylvania.

The trip did little to relieve the anxieties that beset him when he started out, and he returned from it "a bit troubled and confused," saying only that "the last fifteen years have gone by too fast." By the autumn he was looking for someplace else to go when an invitation conveniently arrived from Denmark, one similar to so many that he had always declined in the past but that this time he decided to accept. Piet Hein, the Danish poet and mathematician, who was a fan of Steinberg's work and with whom he had exchanged several letters, invited him to meet the filmmaker Carl Theodore Dreyer, to discuss the possibility of Dreyer's filming several of Faulkner's novels. Steinberg was intrigued by the proposition because he admired Faulkner's fiction and had gone to Mississippi several times, thinking that seeing the state would help him understand why its people thought as they did. He brought home numerous souvenirs of Oxford, and on one of his trips stole a phone directory because he was fascinated by the "many Faulkners and Falkners" who were listed in it.

He decided to make Denmark the first part of a business trip that would

continue with a visit to Rowohlt's headquarters in Hamburg, then on to Paris to talk to Delpire, and at the end the obligatory visit to his family in Nice. He arrived in Copenhagen on December 3, 1958, and was immediately certain that going there had been a big mistake. He was the celebrity of the moment, a hapless being who felt as if he had been dropped smack in the center of a bowl of monkeys who were all yammering and picking at him to explain his work. He bore it stoically, saying that it was fortunate he could not read Danish and therefore could not understand what they wrote about him.

His hosts pulled out all the stops in order to give him one solid week of activity, festivity, and adulation. A welcome dinner was scheduled only hours after his plane landed; a meal of many courses (each with appropriate wines) that ended with a dessert served on a tray with exploding firecrackers, preceded by a violinist playing a spirited march. Afterward there was coffee and brandy, but it was still not over: another course followed, of smoked fish, caviar, and aquavit. After all the food and liquor, he thought he was hallucinating when he finally got to his room, looked out the window, and saw a monument to the Viking explorers that featured sailors blowing horns while carrying wounded boy trumpeters, a bear fighting a bull, and a musk ox fighting a giant fish (or perhaps it was a dragon; he was never certain). He was so tired that he was unable to sleep, but he had to get up early for several days in a row for endless rounds of speeches, lunches, and dinners with various local "bigwigs." They took him to Elsinore Castle, to all the museums, on a tour of the countryside, and then on a walking tour of Copenhagen. He liked the city and told Hedda they ought to come as private tourists, but only in the summertime.

Carl Dreyer took him to see the work of an "interesting insane Dane-painter," and Steinberg thought the topic of "another normality—that of the neurotic or insane"—worth pursuing if the book's content became more "Labyrinth" than "America." He had time to think on the day-long journey to Hamburg by train and ferry, much to the amusement of his German contacts, who had expected him to fly there in an hour. He spent his single day in Hamburg soothing his editors with promises that a book would soon be ready. After another mammoth meal, he had his first good night's sleep since leaving New York. He was well rested when he flew to Paris, where he needed all the energy he could muster for his first order of business: to find Lica and Rica, who had made a sudden decision to move there permanently.

Armed with a huge supply of mechanical toys from Germany, he found them living in "Raskolnikoff quarters" in the run-down working-class seventeenth arrondissement on the northwest outskirts of the city. The children were happy in school and ecstatic with the new toys, but Lica looked "pathetic"

and Rica was exhausted from the only job he could find, going door-to-door trying to sell typewriters. Rica Roman was a cultured, sensitive man, who bore quietly the shame of his family's total dependence on his wife's little brother, as when he wrote to express it: "Dear Sauly, we live in the 'City of Lights,' but the life is tough and you need a lot of art and power to stay out of the darkness."

ONCE STEINBERG WAS BACK IN NEW YORK, there was no escape from what he described to Aldo as "the usual. I see too many people and talk too much, but for real or invented reasons I don't have the courage to change." An onslaught of commercial requests was awaiting him, all of which required decisions, which, in his usual manner, he ignored. A more pleasant barrage was the fan mail that greeted his third *New Yorker* cover when it graced the January 17, 1959, issue. The magazine was not yet ready for the literal reality of the life Steinberg saw in his journeys around America, but the editors were delighted with his allegory of "Prosperity," or "The Pursuit of Happiness."

Steinberg drew a multileveled pedestal upon which a collection of men and symbols shared the spaces that normally held statues. Uncle Sam shared the base of the pedestal with Uncle Tom, while the two most influential characters in American culture were at the top: Santa Claus and Sigmund Freud. The cover caused a sensation, and fan mail flooded in. Stanley Marcus bought the original drawing as soon as he saw it but continued to pester Steinberg for an explanation of the dichotomy represented by the pairs of men, while Steinberg evaded his questions. A housewife in Berkeley, California, said that if the Nobel Prize were given for magazine covers, Steinberg would surely get it. A professor at the Harvard Graduate School of Business asked for oversized copies to display in the school's entrance, because Steinberg's "wonderful anachronisms . . . deserve more attention from thinking men." An owner of the Farmers' Hardware Company in upstate New York represented dozens of so-called ordinary readers who asked Steinberg to tell him what it meant, as did a student at Brooklyn's Abraham Lincoln High School, whose POD (Problems of Democracy) class got into such a spirited debate about what the cover meant that they decided to ask Steinberg if he "would be so kind" as to tell them. In Philadelphia, a grandmother had the cover framed, not only because it amused her but also "as a sort of time capsule" for her grandchildren: "One day when and if they become thinking adults, they may say 'this is a time that tries men's souls,' but then, having studied your cover, they may take heart and realize that the sophistry, demagoguery, social, political, and economic ills which beset their times are nothing new, but were rampant and recognized in 1958."

———

THE *NEW YORKER* COVER MARKED THE beginning of Steinberg's new relationship with the magazine, one that lasted for the rest of his life. Within his American *patria*, *The New Yorker* became his professional homeland as his status rose to an iconic level. It helped that his work was now selling for impressive prices in galleries and private collectors were buying it for themselves or to give to museums. It made him less dependent on commercial propositions and placed him in the fortunate position of being able to concentrate on honing his vision for drawings that would appear in what he believed was the most intelligent mass media publication in the country. He did continue to work for a few other publications, but it was *The New Yorker* for which he mostly tailored his vision.

Because the magazine, from this moment on, almost always published everything he sent the editors and exactly as he wanted it to be seen, an apocryphal story grew up: that if the editors rejected his drawings and sent them back through the mail or by messenger, he would simply put them in a new envelope and resend them exactly as they were, first to Jim Geraghty and after he retired to Lee Lorenz, both of whom would get his message and quietly accept them. Even though Hedda Sterne insisted the story was true, others had firsthand knowledge that it was not. Roger Angell and his wife, Carole, who worked in the art department, became Steinberg's good friends and saw in person how he was always ready to change a questionable submission and how he was constantly revising his work, even after he handed in drawings that were deemed print-ready by others. Lee Lorenz said that the apocryphal story "was just not in his character. He was not a prima donna like some of the artists. He did not mind suggestions but they were rarely offered. By the time he sent in his work, it was ready to go." Frank Modell, one of the editors who often worked with Steinberg, recalled how he was "very particular about his drawings. When he turned them in they were ready to print. We would think it through, maybe make suggestions to change the size, perhaps adapt something. Maybe we might have thought once in a while that it was still a little rough so we'd send it back, but he was always very anxious to do the best he could, so he'd cooperate." Modell noted that Steinberg "usually didn't deal with other editors, though. He went right to Geraghty." Everyone else thought Steinberg went directly to the editor in chief, William Shawn, who usually met him for lunch at the Algonquin so that Steinberg was not often in the magazine's offices.

Steinberg seldom went to the weekly art department meetings, where everyone from the editorial and production departments to the artists gathered

to go over the content of the current and coming issues. When he did visit, it was most often to the production floor, where the magazine was actually made up. He was intrigued by the various processes by which raw drawings became images on the printed page and was curious to learn as much about them as he could. Steinberg, who was compulsively neat in his own working space, loved what Lee Lorenz called the "noise and confusion, the old-fashioned character and the idiosyncratic cast" who worked in the makeup department: "There was paper all over the floor; the place was in a constant uproar as we tried to meet our deadlines." Mostly, however, he conducted his business with the magazine over the telephone, and if he went to the offices, his real destination was Shawn's office, as he became the central figure for the remainder of Steinberg's long association with the magazine.

Shawn was quick to recognize that Steinberg and *The New Yorker* were, as Roger Angell recalled, "a perfect fit, entirely right for each other. Saul brought class, pleasure, honor, to the magazine. He was an elegant dandy, perfectly dressed, beautiful manners, exquisite behavior . . . Shawn really appreciated Saul and was very aware of Saul's originality." Each, in his polite and private way, became a good friend to the other.

STEINBERG'S MOOD WAS GREATLY LIFTED BY the enthusiasm that surrounded the "Prosperity" cover after it appeared, and it was further buoyed by his own sudden prosperity. There were several unsettling situations connected with his finances, one that brought money and one that did not. The latter concerned a promotional booklet commissioned by the Foote, Cone & Belding advertising agency for Lincoln automobiles. Steinberg pocketed a sizable fee for the drawings he made for the booklet but was incensed when the agency used one of them on the mailing envelope as well. He complained that the purchase order made no mention of a "direct mail piece," which he believed the envelope to be, and that by sending it out as a mass mailing, the agency implied that Steinberg was personally endorsing the car. "It is repugnant to me to have my name linked with a deception," he wrote, as he instructed Alexander Lindey to begin litigation. Lindey cautioned that no matter what "ethical considerations" Steinberg felt had been violated, there was not enough "reasonable probability" for a legal claim to succeed. He reminded Steinberg that a court case would seriously impair his lucrative advertising commissions, because "advertising agencies don't like to deal with troublemakers." Steinberg was disgruntled, but he accepted his lawyer's advice and did nothing.

In another instance he did not follow Lindey's advice. This one was more delicate, because it involved Hallmark, his cash cow for more than a decade.

Besides the usual stipend for cards, Steinberg agreed to design calendars for an additional annual fee of $20,000. For the calendars—unlike the cards, for which he had to surrender the copyright—he expected Hallmark to honor the same arrangement he had with *The New Yorker*, paying to use the drawings but designating that all other rights and ownership of the originals were his. Hallmark disagreed, saying that it had bought both the drawings and the rights. Steinberg argued that they had not compensated him for the drawings' true value, which he set separately from the original fee-for-use at a minimum of $5,000 each. However, his strongest objection was not the extra money but the possibility that Hallmark "could authorize anyone—say a beer concern, a shoe manufacturer," to use the drawings without his consent and without paying him for the additional use. "This is unfair and I cannot agree to it," he insisted. After several rounds of increasingly tense negotiation, Hallmark withdrew its claim of ownership and the matter was settled in Steinberg's favor.

SUDDENLY FLUSH WITH MONEY, HE THOUGHT it was time to be serious about buying property away from New York. Hedda liked Cape Cod and would have been content to spend the summers in Wellfleet; Saul thought it pleasant enough but was not sure it was the ideal place. It was a haven for many of their friends in architecture and design, including the Breuers and György Kepes, and the summer home of a large community of writers, everyone from Edmund Wilson to Alfred Kazin and Ann Birstein, Mary McCarthy, and the Philip Hamburgers. Steinberg found himself increasingly drawn to the company of writers and became interested in exploring the genre himself. He went so far as to promise Kepes that he would write an article for *Daedalus* magazine, and Kepes began hounding him to finish it. Steinberg was stymied by his search for words to express the visual images he wanted to convey: "I find it impossible to write sentences containing ideas without their being mysteries that I'm the only one to understand." It was much easier to draw what he meant and leave the multiplicity of interpretations his drawings inspired up to his viewers. As for writing, he decided to "give it up," and at the same time he decided to give up on Cape Cod as well.

In early spring, Ruth and Tino Nivola invited Saul and Hedda to spend a weekend at their house in the Springs section of the township of East Hampton at the eastern end of Long Island. The Nivolas had been in Springs since 1948, when they had bought a run-down farmhouse with a barn and chicken coop on twenty-eight acres. In the decade since, they had created a comfortable home in the midst of landscaped gardens and what Tino called "open air rooms" that he designed to function as extensions of the house. Bernard

Rudofsky contributed ideas for the exterior design, particularly the layout of the walkways and the placement of some of Tino's sculptures on walls that were built for him to paint on and others that were stuccoed with abstract murals of his own design. Inside the house, Ruth Nivola designed jewelry that was as at home framed and hung on walls as it was being worn, while Le Corbusier decided that two large walls in the house needed a mural, so he painted one.

The Nivola household had become a gathering place for most of the poets, painters, writers, and artists who gravitated to the potato fields of eastern Long Island after Jackson Pollock and Lee Krasner led the way. They lived nearby, as did many other artist friends of the Nivolas and the Steinberg-Sternes, among them Denise and David Hare, Bill and Elaine de Kooning, Robert Motherwell and Helen Frankenthaler, Mark Rothko, Franz Kline, Charlotte and James Brooks, and Carmen and Hans Namath. Architects who often came for week-end lunches included Bernard and Berte Rudofsky, Frederick Kiesler, and Paul Lester Weiner and his artist wife, Ingeborg Ten Haeff. So too did the photographer Evelyn Hofer and Humphrey Sutton; the philanthropist Doro-thy Norman, who collected interesting people for her own gatherings; and May Tabak and her husband, Harold Rosenberg, who became one of Steinberg's closest friends and to whom he turned increasingly for stimulating conversa-tion and intellectual companionship.

On this particular weekend at the Nivolas', Steinberg mentioned casually how easy it was to relax in the setting and wondered if he should think about buying property there. Ruth and Tino spoke almost in unison: "The house across the road might be for sale." It was a run-down farmhouse at 433 Old Stone Highway and belonged to the keeper of the Montauk lighthouse, who was seldom there. Over the weekend there were many jokes about what it would be like for the Steinberg-Sternes to live across the road from the Nivo-las, but on Sunday afternoon, when it was time to drive back to the city, Saul told Tino he was serious and asked him to get in touch with the owner to see if he wanted to sell. He did, and several days later Steinberg was contacted by the lawyer representing the owner, with an offer to help resolve the sale. Steinberg paid $12,500 cash, and the property became his on May 22, 1959.

"We're neighbors now and have become closer friends," he told Aldo when he thanked him for the Italian edition of Giuseppe Lampedusa's *The Leopard*, which he passed along to Tino. Unlike the Nivola homestead, which was a con-stantly evolving artistic creation, Steinberg at first did nothing to his home, a simple house with two bedrooms upstairs, two rooms and a kitchen downstairs, and a front porch. The house was "not beautiful," but he thought it "smelled good inside" and would be "ideal when in the winter I'll need a prison." He

enjoyed everything about being there, particularly the two-and-a-half-hour drive across the island followed by "the best pleasure, the first mouthful or noseful of cold clean air, a visit to the ocean—at night, with the waves illuminated by the headlights of the car." A weekend was usually enough to satisfy him and make him eager to return to the city, where he could once again become an anonymous cosmopolite. And besides, he was used to city noises and streetlights, not the darkness of the country, where he slept badly because of the night noises.

BECOMING A HOMEOWNER WAS NOT ENOUGH to keep him settled, and to pass a restless summer he went often to the Bronx Zoo. "Too bad it's full of children, and worse, parents," he told Aldo. Still uncertain about which theme to pursue for the next book, he made repeated visits to draw monkeys, peacocks, vultures, and flamingos, and also to draw "Women—Portoricans [sic]—fighting in the Bronx."

In August 1959 he was beset by such anxiety that he left again, this time to roam for two months through the western states by plane, car, and bus. He flew from New York to Salt Lake City, where he called briefly on friends but did not stay because their children had mumps. His next stop was Denver and a visit to his Steinberg cousins, the children of his father's brother Milton. They took him to a Shriners parade, where he chuckled at the men in funny fezzes driving tiny cars, but most of all he liked the cowboys who sang songs for the Salvation Army. He rented a car and drove to Elko and Las Vegas, where he stayed in the Hotel Tropicana and was "disgusted" by everything he saw: "Even the cigarette machines are crooked . . . take money and give you nothing." He drove to Los Angeles, this time "shook" by "the frightening desert." He drove aimlessly for three days along back roads in the "most horrible landscape," which made Monument Valley "seem like a bourgeois garden." In Los Angeles, there was not much to see and no one he wanted to talk to, so he took a bus to Phoenix, where it was much the same. In a hurry, he flew to Tucson, where he was bored once again, and in an effort to stall, he continued on to El Paso by train. Suddenly ready to go home, he flew to San Antonio and then back to New York.

His rambles may have seemed without purpose, but he knew what he was doing, and why: "Traveling has been for me a gift for avoiding solutions . . . I was traveling to forget! And I knew it but it was such a pleasure."

In New York, he found he could not settle down to work. All he could manage was to "continue to see people, to talk and drink." He needed to unburden himself but was unable to do so, not even to Aldo, his most trusted confidant. He could only confess that he had "lost hope of having what you call charac-

ter but maybe something *sui generis* can be saved." The major cause of his anxiety was the unsettled relationship with Elizabeth Stille. Speculation and gossip about what it was—a full-blown affair or a flirtation, true love or mere infatuation—whatever he and she felt for each other, it was threatening to explode and shatter the marriages of the two couples and destroy their friendship with one another.

If the memories of the last living spouses who participated, Hedda Sterne and Ruth Nivola, were true to the events as they happened, during the second half of 1959 the behavior of Saul and Elizabeth became too obvious for others to ignore. Hedda confirmed that she encouraged Saul to make the trip to the western states to give him and Elizabeth time to think about the consequences for the four adults and the two Stille children if their affair became public, and of the dual divorces that would certainly follow. But when Saul returned, neither he nor Elizabeth had come to any conclusion except to resume the relationship. It created a tremendous personal crisis in Elizabeth's life and led both her and Saul to consult analysts. Hedda, as was her wont, ignored the resumption of the affair and went on with her painting. Ugo Stille seems not to have known about it until later, when it caused a severe marital crisis. However, as none of the principals took precautions to hide it, gossip among others was rampant.

Ruth Nivola, who cared deeply for the two couples, felt that she could not stand by and watch two marriages fail, nor could she bear to have any of the parties suffer the gossip of outsiders. She confronted Saul and Elizabeth separately but directly, and they admitted their passion for each other and their inability to decide what to do. Both told Ruth that they loved their spouses and did not want to hurt them. Saul's solution to their problem was for him and Hedda to live with Elizabeth and her children, a relationship that could be lived openly in the Springs house and more discreetly when they were in the city in their individual residences. He was confident that Hedda would agree to this arrangement, because she had learned to cope with and accept all his other infatuations, affairs, and one-night stands. He gave no indication that he was aware of the suffering it caused her.

Ruth was horrified when she heard his plan and told Elizabeth and Saul that she would give them two choices: they could end the affair and she would say nothing; if they did not, she would tell their respective spouses before some unkind gossip did. If they forced her to do the latter, they must take the consequences. Apparently they did not end the affair, for Ruth did tell Hedda, who never forgave her for meddling.

The year 1959 ended in a haze of uncertainty, of little work, little thought

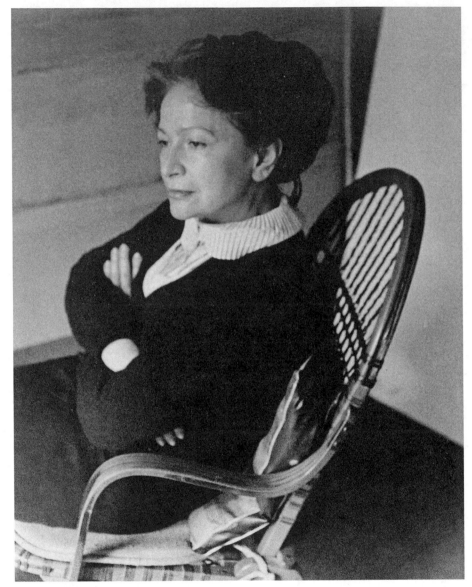

Hedda, after the separation from Saul.

about the new book, and more aimless drifting. Elizabeth Stille disappeared from Saul Steinberg's life quietly, without fuss or fanfare, and she and Ugo Stille remained married to each other for the rest of theirs. Although he saw Ugo from time to time, Steinberg had no meetings with Elizabeth until a chance encounter happened in 1984, when he was on his way to a dental appointment and she was walking down the same street: "She calls out to me. Unrecogniz-

able. Fat face of businessman. Cruel. Talks about my fancy 75th Street [apart-ment]." He often wrote about the other women with whom he was involved in the many biographical jottings he made later in life, but this was the only time he mentioned Elizabeth Stille.

A NUMBER OF NEW INITIALS, dates, times, and addresses filled Steinberg's appointment diaries, but otherwise he read constantly because he could not concentrate on anything else. He was happy to discover that he liked Colette, but mostly he reread *Ulysses* and *Finnegans Wake*, which he was happy now "to understand—in part. A great loss of time not to have understood it years ago." He went alone to concerts of avant-garde and abstract music and was upset by "the impossibility of understanding" it. It made him feel like "an ape reading the newspaper."

Just after the start of the new year, 1960, he wrote to Aldo that "for some time I've been drawing up a balance sheet of lost years, mistakes, wrong paths, connivances, etc. etc., an endless list." He did not write again until August, when he told his friend, "I haven't written you in all this time because I've been too busy with the changes and new things in my life."

It had been a busy eight months: during the hiatus in their letters, Saul Steinberg left Hedda Sterne because she "kicked him out." He moved to a new apartment, found a new companion, and settled in for what Hedda called "the thirty-five years' war."

THE THIRTY-FIVE YEARS' WAR

If Saul wants pasta tonight, he gets pasta; if he wants separation, he gets it.

He didn't actually move out of the 71st Street house until the day after his June 15 birthday, which he celebrated on the sixteenth to honor Joyce's "Bloomsday." Hedda baked two cakes: one for his birthday and one for his new life, to wish him well and assure him that she hoped sincerely he would finally find the peace that had eluded him throughout the years they had lived together. She had asked him to leave because she could no longer endure "the terror that grips the shoulders," nor did she want to live in the daily fear of saying something to provoke his cutting remarks or silent treatment.

From January to April 1960, while he still lived in the house with Hedda, he would have withdrawn entirely from the normal routines of the marriage if she had not demanded that he behave otherwise. She insisted that as long as they lived in the same house, they must be more than civil to each other, they must be kind. Her fear was that if they did not behave cordially, they would part with such acrimony that they could never be friends again, and she actually wrote a letter to convince him that she meant what she said.

Saul's initial response to her ultimatum was to insist that she shared half the responsibility for the separation by not believing that no matter where he strayed, his ultimate loyalty was to her. She refused to accept it, saying, "I am afraid that all you have is a fear of my possible ill will toward you and the superstition that it might mythically affect you!" Her conclusion was poignant: "Just let me know and I'll vanish from your life as if I had never been. With all my love (strange, isn't it?)."

———

AFTER HEDDA MADE HER POSITION CLEAR, Saul lived in a state of confusion that veered between embarrassment and shame. He was bewildered that things had degenerated to such a sorry pass that he could not think clearly about what to do next. Hedda had taken care of him for seventeen years, and he had forgotten how to manage the ordinary acts of daily life, starting with how to look for a new place to live. His response to her demand for civility and kindness was to be excessively polite when they encountered each other, and that was usually in the kitchen, for he spent most of his time sheepishly trying to avoid her by hiding in his studio and concentrating on the new book.

The theme had finally become focused on the idea of the passage of life as a labyrinth, and that became the book's title. In its most basic conception, *The Labyrinth* was a continuation of Steinberg's autobiography, a collection of drawings intended to show how one gets from point A (birth) to point B (death). Steinberg illustrated his life's journey as it had been thus far, portraying his travels to foreign countries, his observations about American culture and society, and his interior musings on what both the life of the mind and the artist's representation of the body (his own and others', particularly women) meant. He asked himself questions such as "what is marriage," made notes about equality of sexes, and dismissed existentialism as "balls."

These notes and a number of others provide allusions and insights into the drawings that fill the book, and the dust-jacket copy (which he suggested) confirms that the content is a "continuation" of Steinberg's biography, wherein "he is discovering and inventing a great variety of events." The dust jacket bears one of Steinberg's most famous drawings, a man's head with a rabbit inside; some of his women resemble the battle-ax Rosa had become, bullying their tiny husbands from within the massive furs and towering hats his mother favored; his couples are both poignant in the absence of emotional connection and unsettling in their barely controlled hostility toward each other.

Steinberg wasted nothing, and when he put the book together, he gathered drawings from his disparate travels and adventures, some of which had appeared in other publications and others that he used for the first time. There are horses and jockeys from his stint in the paddocks at Aqueduct Raceway, baseball players from his time with the Braves, and main streets, motels, highways, and deserts from his travels crisscrossing the continent. Some drawings may have dated from his time in China, and others were from his travels in Samarkand. The Russian trip is there, as are vast European plazas and monuments, Greek street scenes, and French skylines. The crocodile is there in many guises, sometimes swallowing the artist at his easel, other times jousting at mathematical circles, squares, and geometric equations, and sometimes

dressed up in medieval armor, sprouting wings, and riding a horse into battle. Mythical maps measure how to get from art through law and on to "prosperitas, caritas, and mediocritas."

There are many playful drawings in which single words tell stories that depict plot, character, and setting, thus allowing Steinberg to fulfill his self-described role of "the writer who draws." Letters, for example like those forming the word *tantrum* are diving crazily in the full throes of what they describe, while those in the word *sick* drape themselves along a hospital bed in languid weakness. Steinberg's nod toward existentialism has his "thinker" poised on a bench, pondering a question mark which he holds before him. His male characters in particular are enveloped in mazes, labyrinths, and cages of their own making, either creating puzzles to explain themselves to themselves or in a panic as they try to find a way out of them.

For every drawing that inspires a grin of surprise and delight, there are others that evoke wry recognition of the difficulties of balancing life and work while maintaining personal and professional relationships. Whether astride Don Quixote's horse or not, each of Steinberg's cartoon characters is, in his or her own way, jousting at windmills, and so too was he.

Saul Steinberg, *Knight and Pineapple,* 1970.

—————

IN EARLY APRIL 1960, JUST AS Saul accepted Hedda's ultimatum that he had to start looking seriously for someplace to live, a series of unfortunate events struck his family in France. Rica Roman lost so much weight that he was hospitalized for three weeks with a combination of ailments that suggested exhaustion, depression, and a mild heart attack. When he was diagnosed with infiltrating pulmonary tuberculosis, he was sent to a sanatorium at Evreaux, where he stayed for three months, until the disease was brought under control. Even before the illness, when he was still at home, Lica was too depressed to cope with running the household; now that he was gone, she was initially paralyzed with fear and grief. Her version of coping was to tell Saul that she had moved herself and the children into an artist's studio in the eighteenth arrondissement, on the Rue Caulaincourt, and that she had found a part-time office job nearby. She did not convince Saul, who heard another version from Rosa, which convinced him that his parents were unraveling and Lica was "disintegrating."

Rosa complained nonstop about the obstreperous children, insisting that Lica "doesn't really work. She fights with the children all the time (who are almost their parents' enemies)." Not so, Lica wrote to Saul, criticizing him for not writing to Rosa, thus making her totally responsible for having to "cheer Mom up." She berated him for not helping, even though all Rosa's letters could be described as "one futile moan" for his attention.

Rosa had been diagnosed several months previously as a diabetic with congestive heart failure, and in her inimitable style, she milked the situation for all it was worth. She took to her bed and refused to get up until the day Moritz was too ill to get the mail and there was no one to bring it to her. Rosa got out of bed and went to the mailbox, where she found a brief note and a check from Saul for $500. As he had written earlier to say that he was sending $400, she knew immediately that Moritz had asked him for spending money, and she was furious. "Mom doesn't let go of money as soon as she grabs it," poor Moritz wrote to his son. "Please explain to her that one hundred dollars should be mine because I also need a buck."

Rosa wrote a separate letter to scold her "Dear Saul" and instructed him to ignore Moritz's letters: "He has become childish. I have too many fights with him, only I know how many. I won't go into details." Not content with her letter, she threw a tantrum and "forced" Moritz to enclose a note saying that he had no need of spending money. When she was otherwise occupied, Moritz wrote a second time: "What a scandal she created in order to write you just as she dictated. She didn't want to give me money because she already feeds me.

Supposedly I don't need anything else. It's shameful for me to sink this low and be afraid of her."

Steinberg needed time to prepare himself to confront these family crises, so he decided to sail to France. He had to share a cabin, but he entertained himself by teasing his fellow passenger Salvador Dalí: "I gave it to him last night, blasting him here and there without letting him quite know it." Baiting Dalí was his only enjoyment; otherwise, he worried about his sister and pondered his future. Even though he and Hedda were for all intents and purposes already separated, he still needed to confide in her and wrote to her every day. He told her, "I think of you often and I hope that you know how extremely important this part of your life is. Good luck to you, dear."

In Paris, Steinberg's first order of business was to get Lica and her family out of the dismal apartment and into a house in a good suburb, where they would not be subject to the shocks and buffets of city life. The shift from Bucharest to Paris had been too abrupt, and he felt they needed more time to adjust to the freedom of Western culture. Before he sailed, he contacted the painter Janice Biala, who had lived in Paris long enough to be an excellent source of information about the city and the surrounding suburbs. He asked her to find a good real estate agent who would make appointments for him to see suitable properties, thus letting him avoid "loss of time and fatigue."

Finding a house was not easy: it had to be large enough to hold his parents in separate quarters on the ground floor, as they could no longer mount steps; it had to have privacy, with a good-sized yard and room for a garden; and it had to have good schools nearby for the children. His days in Paris dragged on because his agent found nothing suitable. The weather was inclement and he caught the flu, which left him bedridden for several days in his hotel. He was unable to resume the frenetic activity that usually characterized his time in the city, so he spent long afternoons sitting with Rica, who was back from the hospital. Steinberg found him "much improved as a person," and the two recovering invalids found genuine companionship as they sat in the sunlight and discussed all the books Rica had read in the hospital. "He's all right, or maybe I'm now all right," Steinberg concluded.

He was still generally irritable and blamed his mood on no longer being willing to tolerate phonies, particularly the people with whom he socialized in Paris. The only positive note was his deepening friendship with Jean Hélion, which became a sincere exchange of ideas about art and painting. Of two other good friends, Giacometti was "weak" and Ionesco was "suffering." Steinberg accepted Aimé Maeght's invitation to see one of Samuel Beckett's plays, but when he was introduced to the author after the performance, he thought

Beckett was "a coward and sick" and no friendship developed between them. Steinberg's disposition suffered further when Maeght hosted another of his extravagant fish dinners and sent him back to his hotel with dyspepsia and a silk scarf for Hedda that featured a print by Giacometti.

There was continuing trouble and confusion over real estate, as he was "almost taken in by crooks and saved by an honest lawyer." He was convinced that everyone connected with any sort of financial transaction in France was dishonest but admitted that things were probably the same everywhere and he had always been insulated from them by Hedda's protection. He was still optimistic that he could settle the Roman family soon so that he could go to Nice to see his parents. "I am not depressed yet and I hope I'll never be, but this trip is tough," he told Hedda.

A house purchase was pending but nothing was resolved when he left Paris, and to his surprise, things in Nice were "better than usual." Rosa was in good spirits because she had lost a great amount of weight and was able to move about more easily, and her mood made Moritz's life easier as well. It also helped when Saul told them that he had found an excellent house in the Parisian suburb of Cachan and was negotiating to buy it. As always, he needed to apprise Hedda of how he felt when he was with his parents, and he wrote at length. He described his entire time in France as a trial and a test that he passed by being indifferent and remote to his family's concerns. He discovered that instead of responding or reacting to a family crisis in the usual way, buying the house permitted him to determine the crisis's outcome. Taking charge and making decisions let him understand for the first time "how it feels to be adult."

He flew on to Rome to spend three days with "poor Aldo, fat, sad, very sad." Aldo's letters had been depressed, as he was going through many of the same emotional crises as Steinberg; he too was worried by the passage of time, the inability to work creatively, and his dissatisfaction with present circumstances and relationships. The only difference between the two friends was that Saul had the wherewithal to make changes while Aldo did not. There was no time for Saul to go to Milan to see Ada, but he sent her a sizable check and left another for Aldo. It felt good to be able to help his friends without worrying about when the next cash infusion might come and from where. It felt even better when, after "unbelievable complications," the big house with the large garden in Cachan finally became his. He stayed in Paris long enough to sign all the papers and pass the keys to his sister and her husband, and to make arrangements for the remodeling that was necessary before Rosa and Moritz could move there. He left instructions with Rica to tell them to begin paying

the rent in Nice on a monthly basis so Rosa and Moritz would be free to move as soon as the house was ready. He thought he had solved all the problems and flew back to New York.

Naturally Rosa found fault with everything and did not hesitate to tell him. The house was surrounded by a large and verdant garden, but Rosa wanted to know, "Is this suitable for our age? How much does this type of garden cost? . . . It must be very pleasant in the summer but it must also be very gloomy in the winter." As for Cachan, "Is it a village or a little town? . . . We'll move there and won't find any Jews. We'll be the only Jews among Christians. Of course it would have been better in Paris because at least there we have some acquaintances . . . You acted too hastily," she scolded. "A house cannot be bought so fast. I don't want to upset you but I have to express my opinion."

HE HAD TO MOVE BACK INTO Hedda's house in May because he had not had time to look for an apartment before he went to France. He found a real estate agent to help him, and when he was not looking at the places she found, he went to furniture stores to order basic necessities such as a bed, a sofa, and a dining table and chairs. Although the Upper East Side had been his home since he had returned from the war, he thought he needed to make a complete break from the life he had led as Hedda's husband, but he did not tell anyone the reason that he decided to concentrate on Greenwich Village, where he had lived briefly before he was drafted. They would learn his reason later, but for now he just told everyone he was moving into Washington Square Village. It was a new development typical of 1960s architecture, massive, brutal, and without charm, but it did have light, space, a long terrace, and two bedrooms, so that one could function as a studio. It would not be available until mid-July, so he had to live in Hedda's house until then.

In his newfound freedom, his appointment book was filled again with the cryptic notations that usually indicated he was having another affair. Cass Canfield had become his editor at Harper and *The Labyrinth* was now scheduled to appear just before Christmas, so he needed to copy names and addresses into a new book in order to leave the old one for Hedda. He went alone to the house in Springs for a long weekend, during which he had dinner with May and Harold Rosenberg, who invited the activist and social critic Paul Goodman to meet him, and back in the city, he made sure he had an invitation to dine out every night. He spent a lot of time in the Village with Joan Mitchell, who was staying in her studio at St. Mark's Place; Mary Frank invited him, as did the Nivolas, who kept an apartment on 8th Street. He had told no one that he was leaving Hedda, and none of his hosts suspected that anything was amiss

because they were used to seeing him without her. He did not tell anyone that he was moving back downtown because of a woman who lived there.

ON JULY 2, STEINBERG WAS INVITED to a party at Larry Rivers's home, where he fell into conversation with a stunningly beautiful German girl who until recently had been the lover of Rivers's son, Joe. Steinberg flirted, as was his wont, and she flirted back shyly, for he was forty-six, rich, and famous, and she was twenty-five, awkward, and insecure. He went home to 71st Street and a few days later received a letter from "Barbara" (Barbara Daly Baekeland), who had also been a guest at the party and with whom he had had an earlier relationship. Barbara enclosed a card and a drawing "by the beautiful young German girl" who was "so adorable" and "so dying" to talk to him. "Would you like to be reintroduced?" she asked. Barbara was upset that all the "1/2 men" she had hitherto introduced to the young girl ignored her, as did "everyone in fact."

"Call me," Barbara directed. Saul Steinberg did as she asked, and "the thirty-five years' war" between him and Sigrid Spaeth commenced.

CHAPTER 25

CHANGES AND NEW THINGS

I haven't written to you in all this time because I've been
too busy with the changes and new things in my life.

Steinberg did phone Barbara Baekeland to say that he would not mind meeting the German girl again. On July 9, 1960, he wrote in his daily diary that he saw "Gigi" in the afternoon but left her after a few hours to spend the euphemistic "all evening" with "Ala." Steinberg made no other entries until July 21, when he wrote the lyrics of a popular song, "Catch 'em young treat them rough tell 'em nothing" and then added "Gigi" at the bottom of the page. He continued to see her concurrently with "Ala" until July 30, when he wrote something that caused him to tear out all the pages until August 2. After that, "Ala" disappears from the diary, and on August 5 he wrote "Gigi non-stop," with her name from then on surrounded by exclamation points and decorated with fireworks, rockets, and shooting stars.

If Saul Steinberg's descriptions of his affairs are studied, from the mundane one-night stands to the more serious and long-lasting encounters, the most intensely sexual relationship he ever had was with Sigrid "Gigi" Spaeth. Those who were present at the start of the long liaison used adjectives like "bowled over," "thunderstruck," and "blindsided" to describe how besotted he was. He was in the midst of several personal crises throughout the month of August, but he put them all aside and concentrated on seeing Gigi almost every day. They went to the movies, to concerts at Carnegie Hall, and to the Jazz Festival on Randall's Island. He even gave in to her plea to take her drinking at the Cedar Tavern, where she wanted everyone to see that she was with Saul Steinberg and where he was embarrassed to be seen hanging out with a woman half his age in a bar he never patronized. He did it anyway, because she wanted it. When she told him she was planning to hitchhike to Provincetown for a

Saul Steinberg and Sigrid Spaeth, shortly after their first meeting, dancing at Benjamin Sonnenberg's Gramercy Park mansion.

vacation, he gave her money for the train and a good hotel. When she became ill and had to cut her stay short, he brought her to Washington Square Village and put her to sleep while he went to the pharmacy for medications. And when she was well enough to go to the apartment she was temporarily sharing on 57th Street, he made the trek uptown to take care of her and bring clean clothing and more medicine.

It was a far different relationship from the one he had had with Hedda, wherein she took care of all the details of their daily life. With Gigi, he was also the caretaker, responsible for the happiness and well-being of a girl who had become his ward as well as his lover. In the short time he had known her she became the center of his existence: when he listed his "engagements for the week," he noted that she left for Provincetown on Sunday and he must write to her on Monday; on Tuesday he had to design a record jacket for RCA and

lunch with Russell Lynes of *Harper's Magazine*; on Wednesday he had to fol-
low her instructions to shop for new shirts, handkerchiefs, and a hat because
she didn't like the ones he wore. Also he also had to have a photo she liked
enlarged to give her as a gift when she returned. On Thursday, when she was
back and recovering from her illness in his apartment, he had to find a book on
Mozart because she wanted it, then take her to a movie, and afterward "buy
Gigi something." On Friday he had to follow her command "Don't drink too
much." On Saturday he drove her to the house in Springs, and on Sunday he
had to do something that shocked everyone who knew him: to shave his mus-
tache, because she didn't like it. He said he would take her anywhere in the
world she wanted to go for her birthday, and off the top of her head she said
Niagara Falls. They went, "but I never got to see the Falls," she told her diary.
And in the week following, he phoned everyone of any importance whom he
knew in the world of art and design to see if they would give her work as an
artist or graphic designer.

"GIGI" WAS THE NICKNAME SIGRID SPAETH insisted on being called, and if
people to whom she was introduced slipped and called her Sigrid, she would
correct them in a voice that was a raucous and irritating nasal whine, so at
odds with her stunning physical beauty. Friends described her as "classically
Nordic, Teutonic, with lovely rich thick brown hair, large dark brown eyes,
and a beautiful complexion—so healthy." She was slightly taller than Saul,
between five-eight and five-ten, with a heavier bone structure, which gave her
the appearance of being much larger and stronger than his thin, fine-boned
self. Her body was as curved and sculpted as a fine marble statue, and Stein-
berg showed her off proudly, unembarrassed because her physical appearance
represented his idea of Eros. "She was everything he wanted from a woman in
bed," Hedda recalled many years later. "He knew he was robbing the cradle
but he didn't care."

Sigrid "Gigi" Spaeth was born in Baumhelder, Germany, on August 9, 1936,
which made her twenty-two years younger than Saul Steinberg. Her father was
a midlevel bureaucrat for the German railway and her mother was a housewife.
She was born long after two older siblings: a brother, whom she despised, and a
sister, who married an American GI and moved with him after the war, first to
Columbus, Ohio, and then to the Cleveland suburb of Lakewood. When Gigi
was still a child her father was transferred to Trier, where the parents and the
two elder children lived during the war while she remained with her grandpar-
ents in Baumhelder. Her mother was often confined to hospitals for clinical
depression, and Gigi did not rejoin the family until she was fifteen, to live with
them until she was nineteen.

Gigi was fond of shocking people at elegant New York dinner parties by saying that her father had joined the Nazi Party in order to keep his job, which was the same reason he had dutifully signed the papers and then averted his eyes when the transports carrying Jews to the camps went through the Trier rail yards. She liked to joke that her parents' only participation in Nazi activities had perhaps been to throw a stone or two through the window of a Jewish business on Kristallnacht. Because Mrs. Spaeth was so often hospitalized, Gigi's maternal figure was Uschi, as her sister Ursula was nicknamed. Uschi was particularly important during the "terrible years of the war and just after," and the two sisters remained devoted to each other throughout their lives, especially because Uschi protected Gigi from the harshness of their mother's constant criticism.

Gigi's parents were elderly and settled when their independent and exuberant third child was born, and her relationship with them was difficult and strained. Her teen years were full of rebellion against a mother who dismissed her as "evil or bad" during the brief periods when she was not hospitalized. Her father stood for "authority and establishment," and because her mother was so often absent from the family home, he became the one who (as she recalled in one of the many diaries she kept) was always "ordering me, forbidding, disapproving of all I want and like. Telling me how to speak, dress, behave, etc." In the four years she lived in her parents' home, she could usually be found on the town's main street, "hanging out after classes and cruising on Saturdays." At one point she hitchhiked to Cologne to find a boy she had a crush on and together they hitchhiked to Holland. "It didn't work out," she told her parents when she returned.

She was one month short of her twenty-fourth birthday when she met Saul Steinberg and had been on her own since she was nineteen, when she had run away to Paris to work as an au pair. Her parents made Uschi tell them where she was and sent money to persuade her to come home; instead she used it to hitchhike to Avignon, and then throughout Spain. She returned only when the money was gone, and ran away again in the spring to Paris and another au pair job. She was now twenty and spent her free time "looking for love" at the pick-up plaza in front of the statue of the Vert-Galant. When she didn't find it, she hitchhiked to Lapland, and when she ran out of money again, she slunk back to her parents. They sent her to a school in the Saar District to study photography, for which she had a genuine talent, and after the course ended she went back to Paris, hoping to land a job. She didn't find one, so she went to Brussels in 1958 to photograph the World's Fair, but she did not encounter Steinberg there and had no recollection of his murals. On September 11 and on the spur of the moment, she went to Frankfurt and bought a ticket to New

York. She was later vague about how she had paid for all these doings, and she was always vague about money except to say that she "took" some from her "Tante Else," who also lived in Trier.

The flight to New York lasted seventeen hours, and when it landed at Idlewild Airport, she vomited with fear and relief. She knew of several other young Europeans in the city, who took her in and introduced her to Greenwich Village. She never explained how she survived until January 1959, when she met Joe Rivers and began a brief affair, which lasted until the end of March. On June 20 she had an abortion, and on the thirtieth she began to hitchhike across the country to California. She was hitchhiking back to New York when she was forced into a van by several men and raped in El Paso, Texas, an event she wrote about from time to time in a matter-of-fact, dismissive manner, with no further detail. By August 1959 she was back in New York and drifting, noting in a series of diary writings that she was alone on Christmas in the Cedar Tavern and on New Year's Eve 1960 in Times Square.

She was vague about what she did until she met Steinberg on July 9, 1960, except to say that she was crashing in a friend's apartment. She never forgot their first exchange, how in her "stupid and innocent enthusiasm" she raved about having admired him for a great many years. "So have I," he replied. At the time she thought it was his cute way of trying to impress her. And then, just as suddenly as he had caromed into her life and let her take over his during August, everything cooled while he dealt with various catastrophes in September.

HEDDA CALLED TO ASK HIS ADVICE about a house she wanted to buy on Hog Creek Road in Springs, not far from the one they had shared, and she asked him to meet her early the next morning on the property. He left late that night and on the drive hit another car and "smashed the Jaguar." No one was hurt, but there was significant damage to his car. While he was dealing with police reports and insurance documents and lining up inspectors for Hedda's house, he received word from Lica that his father had died suddenly in the early morning hours of July 30.

Steinberg had been hemorrhaging money since he had moved and met Gigi, most of it on the Roman family's house in Cachan. The house had to be gutted to a shell before installing bathrooms and outfitting a kitchen, and every room needed furnishings. There was also a continuing stream of local fees and tax charges connected with the purchase, which Steinberg had not been told of when he bought it, and they seemed certain to continue for the indefinite future. There had also been significant expenses connected with moving

Moritz and Rosa to Cachan and then having to pay for an apartment (which he was already doing for the Roman family) until the house was ready. He was also sending money for an excursion to a French spa where Rosa insisted she had to go if she were to recover from the ailments that plagued her. Steinberg wrote checks for everything, including the $100 he had been sneaking to his father every three months.

There was no indication that Moritz was seriously ill before he and Rosa left for the spa. Rosa was, as usual, commanding all the attention, insisting that she suffered such pain that she would already have committed suicide if she was not afraid of being called "a neurasthenic mother" who brought shame to her children. Moritz told this to Saul as he described his daily routine of shopping, cooking, and cleaning, and then "poor woman and poor me, who must sit with her all day." Still putting his wife first, in his very last letter, on July 28, Moritz wrote that "Mom doesn't feel very well. Maybe the air will cure her."

When Rosa didn't nudge him awake at night to listen to a litany of her ailments, he usually slept soundly until morning, but around 3 a.m. on Saturday, July 30, he woke up, asked for water, and then stopped breathing. Rosa screamed for help and a doctor soon came, pronounced him dead, and took charge of removing the body from the hotel. A telegram was dispatched to Lica and Rica, and they arrived on Sunday afternoon. Despite the Jewish tradition of burial within twenty-four hours, French law forbade Sunday funerals, so interment was delayed until Monday. "You can't imagine my pain," Rosa wrote, genuinely shocked by an event over which she had no control, the unexpected death of her husband of forty-nine years.

An energized Rica took charge of the family's logistics. His health had improved dramatically, and the doctors assured him that by the end of the year he could work. Steinberg used his contacts with Dominique and Jean de Ménil, who gave Rica an introduction to Jean Riboud, the director of the French branch of the Schlumberger oil company, Dominique's family's corporation. With the promise of a job on top of seeing his family securely settled in a good home, Rica told Saul that he had given Rosa two alternatives, "either to remain in Nice and come [to Cachan] in mid September or move in right away on September 1st." Rosa chose the latter, and they installed her in a comfortable pension where she would not be bothered by the children's noise or subjected to the dirt and confusion of work on the house. However, they had to tell her that it cost 300 fewer francs than the actual rent, because she needed "the impression that she's getting a bargain."

Once the move to Cachan was completed, Rosa never stopped complaining. In her version, the house was filthy and Lica either ignored or berated her

when she was not arguing rudely (Lica had secured a job as a graphic designer for the Jewish publication *L'Arche* and was wildly happy with her general good fortune). The children behaved like savages and kept the television on too loudly for Rosa's taste (they were both well-mannered and highly intelligent; Stéphane had been admitted to the prestigious Lycée Henri IV in Paris, Dana was excelling in the local grammar school, and neither had time for television). Rosa begged Saul to take her away. Now that Moritz was gone, her memory of their ten years in Nice was far from reality: "We loved each other and lived beautifully in Nice . . . He was very satisfied with his beautiful life."

Lica told Saul to ignore their mother's complaints because the entire family was bending over backward to make her happy, even buying her a seat in the local Jewish temple so she could observe Rosh Hashanah. Eugène Ionesco's wife, Rodica, had become Lica's good friend, and she visited Rosa frequently to bring her treats and speak Romanian. Hedda's mother and brother came too, and invited her to gatherings of other Romanian immigrants, but nothing assuaged Rosa. For Lica, content in her job and happy to live in the new house, it was "like being on a permanent vacation. Only poor Mom is trapped in her miserable universe."

STEINBERG DID NOT GO TO FRANCE when his father died. He stayed in New York and afterward sent frequent checks but did not write letters. When he had lived with Hedda, it was she who wrote the chatty, news-filled family letters that he was too irritated to write. Now it was easier not to write at all than to reply to Rosa's tales of misery and woe. He did not tell his family that he and Hedda had separated, and neither did she. She made a quick trip to Paris to tell her mother and brother but asked them to keep her visit secret from Rosa and the Romans. She also stopped writing to them, in effect removing herself from the lives of Saul's family and leaving it up to him to decide when or what to tell them. At the end of November, when Gigi was busy moving into Saul's apartment, Rosa was still wishing him and Hedda "lots of health" and "a long and contented life together." In almost every letter to Saul, she wondered why Hedda no longer wrote the chatty letters that had been her only connection to her son's life and work.

Hedda had gone through a humiliating period after Saul moved out. Although she initially insisted that they had to part as friends, it was he who, uncharacteristically, did the hard work of ensuring that their postmarital relationship evolved into "his idea of friendship, what it was he thought friendship was." They had shared all their friends, and most were at a loss about how to keep both of them in their lives. The friends were puzzled about the separa-

tion, but it was not a subject they could raise with Saul, who sent the clear and unspoken message that everyone was to welcome Gigi and no one was to ask questions about Hedda. Some friends felt that they had to choose one or the other, and they usually chose Saul, because he was the more social of the two and the one they saw most often. As Hedda described it, everyone "found it a little difficult because all Saul ever did was to go live in another apartment. We were always in contact. We never formally separated. We always stayed married. Only his body left the house and the marriage."

Friends were sheepish about how to greet Hedda when they encountered her on the few occasions that she appeared in public, at large parties such as museum or gallery openings or in the Hamptons during the summer season. Over the years many drifted back into her life by simply showing up on 71st Street to sit and talk in her kitchen and stay for one of her excellent meals. There was a fairly large group who insisted throughout their lives that they stayed friendly with both Sterne and Steinberg, but years later, when many were long dead, Hedda Sterne edited the list to a small group: Betty Parsons, the art critic Dore Ashton, and Tino and Ruth Nivola.

Hedda admitted in retrospect that she probably added to the initial confusion over how others were to behave by withdrawing into hermetic seclusion. She continued to live as she had always done, painting for twelve hours every day: "I did that with or without a man, but in spite of that, I didn't think of what I was doing as a career. I always had a man to take care of me and that freed me to do what I wanted, which was to paint without having to go around to the galleries and enter into that art museum–gallery world." After the separation, she did have "one unfinished love affair that lasted about a year and a half, but after that I decided it wasn't worth it: too much loss of energy and time [from painting]. To the horror of all my friends, I became celibate."

GIGI MOVED INTO WASHINGTON SQUARE VILLAGE in November, when Steinberg was busy nonstop with launching *The Labyrinth*. She could not have been happier as she thanked him for changing her life: "I was a zombie when you met me and made me into a person." She set to work at once to assume all the duties of organizing his daily life that Hedda had previously performed. However, there were several major differences between Gigi and Hedda: Hedda was Saul's wife and always would be, and Hedda had her own money and her own career, while Gigi had neither, and also no legal standing. When Gigi moved into Saul's apartment, they had not discussed the status of their relationship beyond the fact that they would live together. She put any worries she might have had aside, simply assuming that if they stayed together,

he would eventually divorce Hedda, marry her, and let her have children. As for work and money, she was totally dependent on his beneficence for both.

He did try to get work for her, and his friends did fulfill their promises to help her find it. Every now and again a commission to design a book jacket came in, but over the period of the years they spanned, the projects were few and far between, and many could be considered quid pro quo, such as the jacket Gigi designed for Steinberg's friend John Hollander, which featured one of Steinberg's drawings. Steinberg did make his phone calls and sent his letters to Gigi's prospective employers, but then he more or less closeted himself in the bedroom he used as his studio to work on final preparations for launching *The Labyrinth*. That left her on her own for long stretches of time, and in her loneliness she sent him a postcard that poignantly illustrated her situation. It showed Ellis Island, and on the back she wrote, "To you my darling from this Ellis Island of my mind. Missing you a lot in the other room."

THE REVIEWS FOR *THE LABYRINTH* WERE universally good, but Steinberg did not think the important one, Grace Glueck's in the *New York Times*, was a selling review. It was short and more about him than about the book. Glueck described him in a way he found offensive, as a "relentless recorder of urban types, graphic punster who can put a single line to double or quadruple purpose, and Picasso of the art form known as the doodle." As if at a loss for what more to say, she filled the rest of the space with his biography—his Romanian birth, Italian education, and American navy service—and ended with the facile comment that one of his line drawings might not be "the *shortest* distance" between two points, but it was certainly the wittiest. Glueck's review appeared too close to Christmas, when busy buyers of gift books could easily miss it. Some months later, the *Times* of London almost made up for her review by dealing more with Steinberg's art than with the artist, praising the book for "even greater inventiveness than its predecessors." The reviewer called attention to E. H. Gombrich's analysis of Steinberg's art in his influential *Art and Illusion* before touching on Steinberg's talent for making straight lines perform multiple functions within a single drawing and his ability to use words and images to create the idea of sound. There was a degree of damning with faint praise: the reviewer wrote that because the drawings were so "deliciously comic," they probably kept Steinberg from being recognized as "far more imaginative than the surrealists . . . and one of the most versatile and accomplished of living draughtsmen."

Steinberg was furious about both reviews, thinking that they "failed to grasp the essential quality" of the book. He demanded that Cass Canfield

phone the review editors of both publications and lambast them for their reviewers' obtuseness. He was enraged when he made the call, and it left Canfield "feeling sick." To make sure that Steinberg had calmed down when he tried to address his complaints, Canfield wrote instead of telephoning. He said that he regretted that the book was published so close to Christmas, which in retrospect was too late to spark demand for an unusual coffee-table gift book that had been reviewed only in New York and not in the regional or local papers. He tried to offer a gentle apology for the bad news that as early as January booksellers were already returning copies to the publisher because it could "hardly [be] considered a new fresh item for 1961." As for Steinberg's insistence that Canfield complain to the book review editors, he tried to explain the futility of such an action and hoped that Steinberg would let the matter rest. The book sold around six thousand copies and shortly after went out of print, leaving the publisher with a large overstock of almost fifteen thousand copies, which were still unsold five years later.

Despite Steinberg's opinions, every review was positive and encomiums poured in from individuals as well. It was not sufficient to mollify him, not even when Edmund Wilson and Lewis Mumford lavished praise, or when Canfield told him how useful Aldous Huxley's admiration would be in promoting the book after Huxley wrote to say it was "a treasury of spidery fancies." Canfield planned to use the phrase prominently in advertising. He was still trying to placate Steinberg three years later. "Let's face it," he wrote, "we were all disappointed . . . but there is no point in looking backwards."

Steinberg, however, could not put the bad sales and mixed reception behind him. The misinterpretations of *The Labyrinth* still rankled five years after it was published, when Steinberg did something highly uncharacteristic. He seldom replied to his critics and hardly ever explained what his intentions were in a particular drawing, as was evidenced in the vast volume of fan mail to *The New Yorker* that he never answered. He was in Paris in 1966 when a letter reached him that he thought was so wrong he had to correct the writer, a "Mr. Kunz." Steinberg objected to Kunz's description of the various mazes in the book as full of "rich humour or ironic self-mockery." Steinberg said that the only place this could possibly be true was in "the prejudice caused by the context (humor book, etc.)." His line, he corrected, was "a fantasy [that] causes pleasure that is often confusing to the scholar." He was particularly offended by Kunz's comparison to the satire of "R.G." (unnamed, but this may have been Steinberg's friend Red Grooms) and insisted that his drawings were "not a satire on anything but only an indispensable way of showing a poetic invention." "Notice the drawing," Steinberg commanded Mr. Kunz: "The maze is made of

all possible lines: crooked, ugly, elegant, calligraphic, orderly & parallel, etc. Some are traced with a ruling pen, others with a compass. Meaning that a labyrinth contains order (prejudice, bureaucracy) and disorder or poetry of any sort, good & bad—both indispensable."

The Labyrinth was such an important book for Steinberg that he continued to refer to it for years after its initial publication. In 1972 he was captivated by a student at Vassar College, Meera E. Agarwal, who wrote about his depictions of art and the artist for her senior thesis. When she was trying to determine the origin of his interest in the theme, he rushed to his bookshelf and opened *The Labyrinth* to the last two pages, which he called "very important . . . key drawings" that represented "the life of the artist." The young interviewer wrote about how serious and absorbed Steinberg was while he studied his book and how when he finished, he snapped it shut and "walked around with feigned nonchalance." He told her that the true artist goes on through "Asperity" or "Difficulty" in order to get to the stars, but sometimes he lands in "Stercus—which means shit." Agarwal remembered that "he laughs at the cult of art and yet he calls his art his religion, a way of life."

PRAISE FROM HIS PEERS WAS NOT enough for Steinberg, who had counted on large sales because he needed the money. However, even more than money, he wanted the acclaim that would have come with a bestseller, as he was eager to impress his young companion. To keep his income on a steady keel, he had a lot of work to do in New York and many preparations to make for a trip to Europe in the spring. It was difficult to do it while in the throes of a passionate involvement with a beautiful woman who spent most of her days literally hanging around waiting to be noticed, eager to satisfy his every whim. It was both nerve-racking and distracting to have her underfoot all the time, and within a month or two of Gigi's moving into Saul's apartment, it was clear that something had to change or he would never get any work done. He told her she needed to go to Europe on her own, first to Trier to see her family and make as much peace with them as was possible. Then she should go to Paris, certainly to meet Lica, but not Rosa until Lica could figure out how best to introduce her. While in Paris she was to stay in a good hotel and use it as her base of operations for a complete makeover. She was to visit the finest couture houses and stores, to shop for clothes, jewelry, and accessories, to learn to use good makeup and get her hair styled. In New York she dressed like a hippie, and he didn't like it. He could not show her off at the Park Avenue dinner parties where he was now a frequent guest until she became another elegant example of the beautifully dressed and groomed women he met at such gatherings.

He should have known there would be trouble ahead when she wrote from Trier to tell him that she had spent all her shopping and traveling money, but not in Paris. She never explained what the money went for, as it was not until she reached Cologne that she bought a bottle of perfume and a "suit that looks more like a suitcase," which she was sure he would not like. And she was most proud of the real "triumph" of her entire trip: "finally having my old coat relined."

I LIVED WITH HER FOR SO LONG

Hedda and I have become friends, now perhaps more than before.

It now seems to me something remote, like elementary schoolmates. And I lived with her for so long I'm amazed.

The physical separation between Saul and Hedda was smooth: he simply found an apartment and moved out. The aftermath was more complicated. First there were the legalities: although they had separate bank accounts for income and savings, they shared a checking account and paid joint taxes in the names of Saul and Hedda Steinberg. Saul explained that the easiest way to deal with taxes for the year just past and the one to come would be to let his accountants, Neuberger & Berman, file their return as a married couple now living in separate residences. The house had always been in Hedda's name, so that would not present a problem, but they owned two cars registered in both names, and their vehicle, medical, and household insurances were also in both names. Now that they had separate addresses, everything had to be modified. There was even a cat they both adored, and they joked that Hedda retained custody while Saul had visiting privileges.

The actual question of divorce was never directly addressed. Everything was couched in terms of how best to deal with immediate legal requirements, while the main issue of when or how to bring a formal end to the marriage was left to drift without discussion. In later years, Hedda believed that they stayed married for almost sixty years because Saul "got all he wanted without formality." She offered several explanations for why they never divorced, the first being Saul's overdeveloped sense of responsibility. She thought this was a strange attitude for him to have since she had always supported herself, thanks mostly to her first husband and for a time to the robust sales of her paintings. She thought he was probably experiencing a combination of guilt and embar-

rassment over the way he had unceremoniously "dumped" her to "rob the cradle." But Hedda believed the most important reason they never divorced was that she was "Saul's Elaine [de Kooning, the legal wife], who protected Bill from ever having to marry any of his women." As for Steinberg himself, whenever the question of marriage to Gigi was raised, either by her or by others, if he did not say, "I already have a wife," he usually said, "The only purpose of marriage is to have children, and we don't want any."

The legal issues dragged on because one or the other spouse always seemed to be traveling and unavailable to sign the papers. During the first year of their separation, Hedda Sterne had six exhibitions that took her away from New York, and she had to prepare for two more that came early the following year. She had also just fulfilled an important commission to paint her impression of tractor parts for the John Deere Company, photographs of which became a featured article in *Fortune* magazine and brought even more requests for sales, commissions, and shows. Her absence was responsible for most of the delays and missed deadlines for the numerous forms that had to be signed and notarized, and all the negotiations threw Saul and Hedda into closer contact than either had envisioned when they separated. Much of it was through letters, which provided enough of a buffer for both to make admissions that might not have been possible in face-to-face encounters.

For an artist who shunned the limelight, Hedda Sterne was very much in it. Knowing of her preference for solitude, Steinberg monitored all her public activity and took care to ensure that no one took advantage and nothing untoward happened. When she went to Rome in March for a show at the Obelisco Gallery and caught the flu on top of what most artists describe as the usual problems connected with preparations for an opening, Steinberg wrote letters, made phone calls, and enlisted his Italian friends to give her whatever help she needed. "Please take good care and have courage. I am your friend and I care for you," he wrote, signing his letter "Love, Saul." And yet, even as he wished her his "best love," he still pressed her to tell whether she had the original sale documents for her car, which he needed for the insurance company.

Hedda's trip to Rome overlapped with Gigi's to Trier and Paris, and Steinberg was left on his own in New York. He spent a lot of time in Springs, which was different from all the previous times he had been alone. Now, with both women in his life unavailable, he had to become self-reliant. It led to his discovery "that having pleasure for a reason is no good (it brings counterpleasure, like a hangover) and that the only way to have pleasure or a good time is for no reason at all." One of the ways he gave himself pleasure for no reason at

all was to play tricks on friends. On impulse, he bought a carload of pink plastic flamingos at the local hardware store and at night sneaked around to his friends' houses and planted them on the front lawns. When the rumor spread that Steinberg had played the joke, everyone wanted one: "It's now a mark of distinction to have a flamingo planted by me!"

HE WORKED IN SPRINGS BUT HAD very little time to do much thinking about new work when he returned to New York, where his social calendar was full. He had become close to Inge Morath since Cartier-Bresson had introduced them several years before in Paris, and now that she was with Arthur Miller, Steinberg befriended him as well. Morath often asked Steinberg to let her photograph him in his studio while he worked, but he always stalled, insisting that he was bashful and uninteresting. She responded that there had to be something he was not shy about, which made him think about ways to show his work while hiding in plain sight. Eventually he let her capture him while wearing the brown-paper-bag masks he had been making for the past year to amuse himself and his friends.

Much of his conviviality was with creative friends like Morath, who also wanted his cooperation on various projects, such as when Herbert Berghof and Uta Hagen tried to persuade him over dinner to design posters for the Broadway play *Do You Know the Milky Way?* He accepted the dinner invitation because he was so fond of Hagen, but he still asked to be paid for his work and had a contract drawn up that stated his usual conditions. He went to parties at the homes of Thomas Hess, Philip Hamburger, and Walker Evans, lunched with the visiting Le Corbusier, and was the only luncheon guest Marcel Duchamp invited when he entertained Salvador Dalí (to whom Steinberg was more polite than he had been on the transatlantic crossing). Steinberg played gracious host to Monica Vitti and Michelangelo Antonioni when they came to New York, happy to repay the generous hospitality they showed him whenever he was in Rome. He went downtown to meet with Julian Beck and Judith Malina but found their version of theater too off-putting to contribute art to it. There were casual suppers with old friends as well, and the names of Bernard and Berte Rudofsky appear often in his engagement books, as do those of Charlie Addams and Isamu Noguchi and Priscilla Morgan, who were now a couple.

Morgan was the American associate director of the Festival of Two Worlds in Spoleto, Italy, for which she asked Steinberg to loan his de Kooning drawing "Self-Portrait with Imaginary Brother." He and de Kooning were good friends who exchanged their work, and Steinberg was exceptionally proud of

this important drawing. He was happy to loan it but was upset when he learned that another good friend, Sid Perelman, did not like the drawing Steinberg had done for the cover of his forthcoming book, *The Rising Gorge*. The rejection came via the publisher's art director, who thanked Steinberg for his "wish to present something abstract" and claimed that "Sid will not be happy with this treatment." The art director thought it best to pursue "a different approach."

WHENEVER A COMMISSION FELL THROUGH, it always made Steinberg aware of how much money he was spending, and in this case he made an informal list of what he had earned since the start of the year: There was close to $1,000 from an Italian newspaper, several fabric companies, and *Glamour* magazine; another $210 came from investments in the stock market, and $25.50 from two weeks of jury duty, which amounted to a grand total of $1,306.36. He planned to use the money to cover what he was calling "a spur of the moment" visit to Paris in early June to see his mother, who was "in very bad shape," and perhaps to meet Hedda, if she was still there. She was staying at the Hotel Aiglon on Boulevard Raspail, so he reserved a room next door at "the usual Pont Royal," where they had formerly stayed together. He was especially eager to see her because she had become almost irrational about money and he needed to reassure her that she need not worry.

He was finding it increasingly difficult to micromanage Hedda's affairs via letters. Before she left, she arranged for the top floor of her house to be made into an apartment, and since then she had convinced herself that she could not afford to live in the rest of the place and would have to rent that as well. Steinberg sent a check for $1,000 to sooth her fears, but she mistakenly deposited it in the joint account they were supposed to close. With more patience than he had ever shown before, he instructed her in how to use the new account that he had carefully set up in the name of Hedda Sterne, rather than the Hedda Steinberg she had used before. His most pressing task was to persuade her not to lease the apartment to an artist friend who could pay only a minuscule rent. "It's not fair; it's too cheap," he told her, but once again she ignored his advice. Most of all, he wanted to persuade her that she "should live well and live there . . . You have no reason to live in hotel rooms."

THE REASON HE WAS SO ANXIOUS about Rosa was that Hedda had finally visited and told his mother that she and Saul had separated. She made no mention of Gigi and left it to Saul to tell his mother whatever else he wanted her to know. Although Rosa was resigned to his uncommunicative ways, it had never stopped her in the past from demanding answers to her questions, and yet she

was surprisingly timid about the end of his marriage: "I don't know what the cause might have been and I won't even ask. Besides, I know you won't tell me." Now that he was no longer living with Hedda, Rosa put aside all her earlier criticisms to declare that Hedda had always been "an angel . . . very kind and nice with us."

Steinberg's main reason for going to Paris was not as spur-of-the-moment as he led Hedda to believe, nor was it his concern for Rosa's health. He wanted to surprise Gigi and take her on a whirlwind, first-class vacation to the Riviera. He did not tell Hedda or Rosa that Gigi was in Paris, but he did arrange for Lica to come into the city to meet her. Whatever Lica's initial reaction was to Gigi, she kept it to herself and was kind and cordial—indeed, almost motherly. This became her genuine attitude as years passed and Gigi became a good friend first to Lica and then to her daughter, Daniela, as she reached adulthood.

Saul and Gigi drove south to the Côte d'Azur and checked into the posh Hotel Ruhl in Nice, which she found "all very glamorous," particularly as their room was one of the most luxurious at the front of the hotel, with a balcony that fronted on the Promenade des Anglais and overlooked the beach beyond. Afterward he took her to Rome, Venice, and Milan, where he introduced her to as many friends as he could. Here again, everyone accepted her and there were no untoward incidents. "Happy times," she recorded in her diary.

THEY SPENT THE REST OF THE summer of 1961 fairly tranquilly, mostly in Springs. Gigi busied herself planting a garden and Saul learned the "instinct or new pleasure of taking care of the house." He also learned to swim at nearby Louse Point, a quiet inlet just down the road from his home that became the inspiration for some of the landscapes he realized several years later in watercolors, drawings, and the faux canvases he later painted on Masonite board. He told Aldo that it was a "marvel" to speak of such simple country pleasures, "because they've always seemed to me things for other people."

But when autumn came and they were back in Washington Square Village, Steinberg found it difficult to settle down to work. In Springs, he and Gigi had the house, the garden, and the seven acres of property in which to keep busy independently. Their social life had been mostly with old friends who accepted them as a couple despite the discrepancy in their ages, so they faced none of the awkwardness they encountered in New York, such as when the shocked Connie Breuer invited Steinberg to bring his young friend "Sigfrid" to dinner.

When they were alone together in the country, Saul and Gigi rode bikes to the beach at Louse Point for a late-afternoon swim, then went home to drink

chilled white wine, grill some fish and vegetables, perhaps to read and listen to music, and then early to bed. Their passion was strong and steady, and their quiet life in the country sustained it. In the city, the apartment was spacious by New York standards, but it was too confining when one partner was engrossed in trying to work while the other had very little to do.

Gigi was not a shopper, she had no friends her own age, and very few of Saul's friends became hers. She was not one to visit galleries and museums, but she did like to read. Because of Saul's voracious appetite for books, she wanted to educate herself to be a worthy conversationalist, but she found it difficult to concentrate on the English language, which she still did not know well, and often she didn't finish what she started. It was good that he loved the movies and they went often, which gave them something to talk about. He liked to go to concerts, but she claimed not to understand music; he only went to the theater when one of his friends was involved in a production, and she never went alone to any kind of performance. Consequently, there was not all that much to talk about when they were together, and there were not many opportunities for Steinberg to have the apartment to himself to work.

Gigi did like to decorate, so the apartment soon reflected many of her little domestic touches. As soon as they became a couple, Saul put her on his payroll as a studio assistant and gave her a separate and generous checking account. Because she spent relatively little on things for herself, she had enough every month to buy whatever caught her fancy for the apartment. Steinberg was not always pleased with her purchases, but in the beginning he managed not to let her know it.

What she really wanted was for him to help her find a gallery to show her work and to use his contacts to bring in design projects that would let her demonstrate her excellence in the hand lettering that was her forte. Steinberg's friends recognized her frustration over not being able to create, let alone advance a career, and some of them did try to help. When Sasha Schneider praised her drawings, she gave him one, and in return he bought another for $50; the editor Aaron Ascher gave her three book jackets to design after Steinberg asked him to look at her portfolio. These occasional sales and commissions were not enough to give her the financial independence she craved or to keep her from feeling like "the appendage in this relationship" and becoming depressed. She wrote about her feelings on the back of an envelope that she left next to Steinberg's place at the large table that filled most of their living area, the only place they seemed able to communicate, and then only through brief notes: "I sit here all evening waiting for you to talk to me—until it started to drive me crazy—I wanted you so badly to talk to me—all day—give me a

chance to talk—but I am to [sic] scared + stiff with panic and very ashamed and unhappy. I can understand if you had enough and don't want to be bothered anymore just let me know—I would be very sorry—but then it is mostly my own fault—and maybe what I deserve."

The only time Steinberg had ever been able to communicate with Hedda was through letters when they were apart, and now he was repeating the pattern with Gigi. When he wanted to be alone to work, he withdrew into bleak silences that shut her out completely. She searched for explanations for his behavior even though she could not accept them, accusing him of being "so wrapped up in his 'art' and the business of it, the administration, etc. that there is no room for life or pleasure." And because she was "not devoted to art," the more time they were together and his silences increased, she felt "more and more bored and distant."

AS ALWAYS, TRAVEL PRESENTED A WAY for Steinberg to avoid problems, and he planned to take advantage of it by accepting a commission to execute a mural in a private home in the center of Milan, the Palazzina Mayer on the Via Bigli. While he was making preparations for the November 1961 trip, news came from Lica that their mother had died, on October 3. Rosa had been hospitalized since August 22 with a combination of ailments that included severe anemia, diabetes, and microbial flora in the lungs, most likely caused by cancer. In September she suffered a minor stroke, which left her bedridden and unable to speak, and shortly after, when she became unable to move or swallow, she needed gastric intubation. Her doctors said that the usual ravages of old age had been intensified by severe "delusional mental stress," as she continued to worry about money and mourn her dead husband whenever she was semiconscious. Rosa was mostly unconscious in her last days, but when Lica tried to show her a letter from Saul, she brightened long enough to call out a garbled version of his childhood nickname, Sauly.

Knowing that Saul had work in Italy and Rosa had to be buried before he could get to Paris, Lica asked him not to change his travel plans. She told him not to be unduly upset that he had not been there when their mother died, because he had been "her miracle maker with boundless powers" and done so much for her throughout her lifetime. To make him feel better, Lica related the story of how she whispered to Rosa that the distinguished neurologist who was examining her was a "famous professor." Rosa nodded and said, "Saul told him to care for me," convinced that the doctor had come at her famous son's bidding. Lica begged him to be comforted that he was his mother's "myth until the end."

It was a difficult time for both Saul and Lica as they dealt with their mother's death and at the same time the death of their dear Aunt Pesa in Israel. Of the elder generation, only their aunt Sali Marcovici, Rosa's last surviving sister, was left, and Saul, who had been sending her and her family money for years, increased his generosity toward them. Saul and Lica were drawn together in their sorrow and found a common bond in their mutual love of art. Through their work, they recaptured the closeness that had seemed forever lost when language and distance separated them for so many years. As adults without parents, they turned to each other for solace and became close and loving friends from that time onward.

Lica asked him to write to her in French, as she had all but forgotten Romanian, especially the vocabulary to describe aspects of her work. When he sent birthday greetings in April 1962, she told him she was undergoing a period of "great changes and renewal" in her art and implored him to try to do the same: "If you feel like your work has become routine or it bores you, try to change your technique. It's amazing what you can discover through lithography and engraving. I'm truly my father's daughter with the press . . . I stay in the studio for days on end." She had created a studio within the house and urged him to bring Gigi for a holiday so they all could work together.

AFTER HE FINISHED THE VIA BIGLI MURAL, he returned to New York to find a welcome check from *The New Yorker* for $500 and the bad news that he needed a new roof on the house in Springs, which would cost $650. Good news soon followed when *Sports Illustrated* asked him to go to the Rose Bowl to create a portfolio of drawings. He started to make lists in preparation, starting with things to buy for Gigi ("bed, stockings, underwear"). He followed the notation to "work" with an arrow pointing to "make money." There were also two notations to "write Gigi letter" (even though they were living together in the apartment) and "be nice to Gigi."

While Saul was away, Gigi's letters told him that she was feeling "low" and had resorted to a combination of brandy and sleeping pills to keep from being "depressed." He was worried when she told him that she could not eat and was losing weight, but he was terrified when she described her great pleasure at driving her "new friend, the Jaguar," especially after she told him that she left it parked on the street because she never got around to putting it in the garage. He knew about her mother's crippling depressions and was torn between consoling her and scolding her for carelessness with his beloved car. He thought to solve both problems by buying her a car of her own, a four-door Chevrolet sedan, and by sending her to the first of the long series of psychoanalysts she

would consult in years to come. And yet no matter how much he cared for her, he still had difficulty curbing his temper when she described falling into one of her self-absorbed depressions; he was only slightly relieved when she wrote in her imperfect English that it was actually "amazing" that she managed to be as well as she was: "No crying or spook. Feel cheerful etc. You have no idea how good you have done to me. I finally feel like a mensch."

Gigi kept a sort of diary too, and while she was writing letters of gratitude for everything he gave her, she was also confiding to herself that she had "met a younger man." She was not one to stay at home while Steinberg was away, and she frequented a succession of bars, where she liked to drink and pick up men. In later years Max's Kansas City became a favorite, but at the beginning of her life with Steinberg, any nearby watering hole would do. She kept the incident of the "younger man" to herself when Steinberg returned and was thrilled to learn that they were going to Hollywood, where they would stay at the Beverly Hilton and spend New Year's Eve with some of his fancy friends at a party given by Billy Wilder. She swam in the hotel pool, drove down Sunset Boulevard to the Pacific Ocean, and helped Steinberg drive the rented car across the desert to Las Vegas, where they both gambled.

Unfortunately, the trip was not all sunlight and roses: the *Sports Illustrated* accountants spent most of the following year refusing to pay the $106.47 for the rented car, which they had not approved in advance, and demanding that Steinberg return the $23 they had overpaid for unauthorized expenses.

IN NEW YORK, STEINBERG FOUND HIMSELF turning down more requests than he could possibly fill even if he had wanted to try. Lincoln Center wanted posters and programs for Claudio Arrau's concerts, a British woman living in France wanted him to contribute to an "Artists and Writers Cook Book," editors from Putnam, Knopf, and Harper all wanted books, and Cass Canfield was urging him to think seriously about a new collection that would remove the sour taste left by the non-selling *Labyrinth*. In Italy, Rizzoli wanted to publish a book that would lead off with the cartoons Steinberg had done for *Bertoldo*, *Settebello*, and other Italian publications before culminating with some of his current work, and the publisher Feltrinelli wrote to congratulate him on winning the 1962 Palma d'Oro per la letteratura illustrata. There were other foreign requests as well, particularly from Germany, where Rowohlt Verlag was pressing for a second book.

Despite the upheavals in his life, he still managed to produce two *New Yorker* covers in 1960 and three in 1961, and he was full of ideas for more to come. He had designed several book jackets and contributed cover drawings

to periodicals such as *Art in America* and *Opera News*, and he was featured in a special all-Steinberg issue of the *Journal of the American Institute of Planners*, edited by his friend the artist Jesse Reichek. Steinberg had always been a popular subject for journalists and art historians, and depending on his mood, he answered their questions with thrusts and parries that sometimes veered close to the truth but never quite told it. Seldom did a questioner cause him to shut down completely, but the art historian and curator Katherine Kuh managed to do it.

Kuh had been a booster and friend to both Steinberg and Sterne from her days as curator at the Art Institute of Chicago. Now she was living and working in New York and had become close to Sterne, frequently dropping in for the informal suppers and long conversations about art that were one of Sterne's greatest pleasures in her post-Steinberg life. Kuh was collecting interviews with prominent American artists for the Smithsonian's Archives of American Art, and she was eager to include Steinberg. He sat with her for an afternoon, patiently responding to her questions, after which he went home and wrote a letter explaining his reasons for not completing the interview. He told Kuh that "the man involved in his own history becomes himself a work of art. And a work of art doesn't permit changes and it doesn't paint or write." To complete the interview would be his equivalent of the "planting of artistic ruins for present and future archeologists," and it could only result in "predictable originality . . . and other catch-the-fleeting-moment arts." By cooperating fully, he would be creating "a complicity in which I would play my part according to popular expectations." He offered this explanation for "the sake of courtesy" to her and also for himself, so that he would not be "poisoned by unfinished business."

ALL THE WHILE THAT HE WAS fulfilling his many commissions and professional obligations, he was also busy introducing Gigi to his New York acquaintances, most of whom had grown used to seeing them together. He was grateful for invitations from women, among them the painters Elaine de Kooning, Buffie Johnson, Sibyl Moholy-Nagy, and Helen Frankenthaler. Steinberg took Gigi to large gatherings but left her at home when he attended small dinners where conversation was likely to be about ideas, literature, and art. He saw many friends alone, such as Bill Steig, with whom he was now exchanging recommendations for reading or having an occasional lunch after meetings at *The New Yorker*'s art department. He joined Ad Reinhardt, who communicated with friends via "bellicose postcards that were an affectionate reminder of his constantly hostile presence," for a gallery opening on the day the world

was supposed to end according to "740 Hindu priests in New Delhi." Aldo Buzzi was passing through New York en route to Los Angeles to work on one of Lattuada's films, and although he had not yet met Gigi, Steinberg saw him alone at the Plaza Hotel. He did not take her to the dinner party hosted by the British publisher Lord Weidenfeld for one of his important collectors, Mrs. Henry J. (Ruth) Heinz, and he went alone to a dinner given by Otto Preminger, who tried from time to time to engage him in projects that were most often unrealized.

He was out almost every night, and most of the time without Gigi. She became deeply unhappy with living her life "on a stand-by basis" and forced a confrontation in which she accused him of taking no pleasure in her company and causing her to look for what she euphemistically called "other things." She accused him of not liking her and disapproving of anything she might say "that was not originated by you or your interests." When they argued about it, he accused her of a "lack of devotion," while she retorted that there was too much loneliness involved in trying to live with him and she needed to search for something else. He thought it was a good idea, and suggested two ways she might go about filling her days with worthwhile interests: she could find her own apartment, one in which she could express her individuality and creativity on her own time and in her own milieu; and she could take some courses to broaden her experiences and educate herself to fit better into his world. He told her she could start by attending a school that would rid her of her heavy German accent, and he arranged to pay for her lessons in spoken English.

She attended several sessions but decided she could do better on her own. She wanted a real education, so she enrolled in comparative literature at Columbia University's School of General Studies and began a rigorous program that, had she completed it, would have given her a master's degree. To prepare for the fall term, she found her own apartment at 109 Waverly Place and moved there in April 1962.

Sigrid Spaeth and Saul Steinberg stayed mostly together for the rest of her life, but they never lived under the same roof again except for vacations in Springs or when they traveled. This was their first of many partings and probably the gentlest of all, but it still was not easy.

BOREDOM TELLS ME SOMETHING

I get slightly bored with my work, I don't find the excitement, real excitement, now this boredom tells me something, it's a message.

Once Gigi had moved into her own apartment, Steinberg believed that they were developing a genuine friendship such as he had never known with a woman before. He found that he liked living alone and especially liked being able to fit her into his life on his own terms and in his own time: when he wanted to be with her, she was available, and when he wanted to be alone, she went her own way. Sex remained a major bond between them, but she was introducing another level of communication into their relationship because of how eagerly she looked forward to studying at Columbia in the fall. She was preparing for courses in comparative literature by reading many of the books Steinberg recommended, among them *Madame Bovary*, which he cheerfully reread in order to discuss it with her. They also increased their moviegoing, especially to European films such as the latest Buñuel and Bergman pictures, so that between her reading and their mutual love of cinema, they were able to communicate intellectually in a far more relaxed manner than when they had been living together.

Shortly after Gigi moved to Waverly Place, her mother came from Trier on the first stop of an extended visit to her other daughter, Uschi, in Ohio. Things were so good between Gigi and Saul that when she asked to borrow the Jaguar to drive her mother to Columbus, he agreed. When she returned, he also agreed to pay for her to spend the summer traveling alone throughout Europe. Once again she went first-class, staying in grand hotels in London and Paris, taking the Train Bleu to the Riviera, and then renting a Citroën DS-19 for a leisurely drive from Menton to St. Tropez. Eventually she wound her way to Trier, where she kept her father company while her mother remained

in Columbus. Steinberg was happy to see Gigi go, because the more she was happily occupied, the less likely she was to become depressed and create problems.

In June 1962 he went to Appleton, Wisconsin, to receive his first honorary degree, from Lawrence College. When it was first offered, he questioned the selection committee's wisdom in choosing him and intended to decline until the college president assured him that he deserved the honor and would not regret accepting it. In all his travels across America, Wisconsin was one of the few states Steinberg had not been to, and he was curious to see the Dairy State and meet the people who lived there. Much fuss was made of him in Appleton, and when a reporter for the local newspaper interviewed him, he shied away from personal revelations with the excuse that he could not answer "conventional" questions because he himself was "so unconventional." When the reporter asked if he was pleased with the honor, he responded evasively that he was "curious about the process." He insisted that he had no idea why he had been chosen, but the degree citation provided the answer, saying that Steinberg never wasted time asking "what is reality?"; he simply presented the reality of "the crooked mirror where we find ourselves distorted into truth."

STEINBERG TOLD ALDO BUZZI THAT RECEIVING the degree initially made him feel stupid, but in reality he was flattered by what he believed was an invitation from the intellectual community to join its company. Always a voracious reader, he found himself more at home in the company of writers, where the exchange of ideas and opinions was intensely verbal, swift, and sharp, than in the company of painters, where words were not as important as physical activity, which often led to aggressive or outlandish behavior as a substitute for conversation. Writers sat around the dinner table and exchanged verbal barbs that could be deeply wounding to the psyche, but painters were more likely to get falling-down drunk at the Cedar Tavern or at Max's Kansas City and start throwing punches at each other. To Steinberg, the abstract expressionists who ruled the art world in New York were "artists of gesture," and "the stronger the gesture . . . the greater the fame." He placed Jackson Pollock at the top of this list, saying that he painted "in cahoots with the law of gravity . . . He used it as a companion." With the exception of the old friends who were painters (among them Mary Frank, Bill de Kooning, Sandy Calder, and Ad Reinhardt), Steinberg made few new ones among the up-and-coming generation in New York, because, with the exception of some "girls, all are timorous and conventional people, especially the so-called painters." Among his old friends, Louisa Calder disapproved of his separation from Hedda, so he and Gigi were not invited to

Connecticut as often as before, but he enjoyed the outings to Princeton, New Jersey, where Esteban Vicente lived and worked. Their closeness deepened when Gigi and Harriet Vicente developed their own close friendship.

A decade later, in the 1970s, when an interviewer asked how Steinberg had experienced the art scene of the fifties, he described the painters who were his friends then as "the survivors," saying that he remained friendly with them "but we are separated now, divided by a variety of reasons, among them changes in the social class." He used "social class" as a euphemism for money: in his mind, those artists who made a lot of it became different from those who did not. He insisted that it was not like this for European artists, for whom money was not the principal determinant of class and status, and although he did not overtly use himself as an example, he implied that he had succeeded in both worlds. Steinberg, who was born into the working class and now moved easily within the upper classes, not only because of his talent but also because of his ever-increasing wealth, thought of himself as "some sort of link between the Europeans and the Americans." When asked to describe this link, he said it was primarily because he shared with French painters the general quality of being literary. There were three with whom he was extremely close, all of them as immersed in philosophy as they were in literature: Geer van Velde, Jean Hélion, and Joan Miró. Van Velde lived in Cachan, as did Lica and her family, so there was ample opportunity for conversations about his personal philosophy of art, which were stimulating for Steinberg and from which he felt he learned much. He met Hélion every time they were on the same continent, and they engaged in a lively correspondence about their work and the influences upon it. Steinberg had a more formal relationship with Miró, almost the homage of a younger artist toward an older and revered one, but there too the visits and correspondence were consistent and energizing for both.

Thinking about himself as a link between the two worlds of painting made Steinberg want to define the cultural differences between the United States and Europe, especially Paris. He was serious when he argued that the first great "large scale American painter" was Tom Sawyer, when he painted the fence. To him, Tom's fence was emblematic of the culture, for he believed that the premier school of American painting was not "the Academy," but rather "the do-it-yourself House Painter school." This was because American painters emerged from "peasant, proletarian, immigrant primitive sources"—so different from Paris, where painters traditionally came from "intellectual sources, polished by the academy, by fancy conversation, by friendships with other artists, poets and writers." Steinberg was starting to think that he was no longer the lone link between these two worlds, because a whole new "third or fourth

wave" was rising to dominate the American art world. It consisted of "strange artists coming from Nebraska etc. from universities, not artists but teachers and art historians." He did not see this as a positive development, because they were "not true intellectuals" but were more interested in establishing fiefdoms and bureaucracies. He worried that they were the ones acquiring the important positions in museums, galleries, and the media, which gave them enormous influence and the power to dictate what artists needed to produce if they wanted to succeed. Steinberg believed this for the rest of his life, and in his last decade, whenever he passed a museum where the facade was festooned with a gigantic banner bearing an artist's name, he insisted that "these are artists who confuse success fame fortune power with happiness (or what I call: to be content) just like their businessmen colleagues in Wall Street or Hollywood." "What dishonor, in America!" he thundered, questioning the kind of power attained by those who flourished through art: "Power? For what. Impress head waiters."

VERBAL ABILITY BECAME A MAJOR COMPONENT of Steinberg's friendships, and next to that with Aldo Buzzi, his deepest one was with the writer and critic Harold Rosenberg. Harold and his wife, a sometime novelist who wrote as May Natalie Tabak, owned a house near Steinberg's in Springs, where the two men met frequently for the one-on-one conversations they both relished. "He is perhaps the only friend I have here," Steinberg told Aldo. "I can talk to him in the best way, that is, I have the possibility of thinking, I mean inventing, while I'm talking." Harold called Saul "a writer of pictures, an architect of speech and sounds, a draughtsman of philosophical reflections" and said he was, in short, "aesthetically delectable." Saul was often the only guest for dinners at the Rosenbergs' because Harold instructed May not to invite the "Irish rabbis" (that is, their mutual friends and neighbors), who tended to "interfere with the rhythm of [Saul's] style." When Saul held forth, Harold listened "with total respect, admiration, and enjoyment—but not for long because he liked to do most of the talking. They enjoyed watching themselves perform."

Saul Steinberg's friendship with the art historian Leo Steinberg also always contained an aspect of performance. Most of their conversations were colored by the tone of their first meeting, at the Sidney Janis gallery sometime around 1960, when a friend who intended to be clever said, "Mr. Steinberg, I'd like you to meet Mr. Steinberg." Leo Steinberg remembered feeling "suddenly trapped in the banality of a shared name," but Saul Steinberg relieved the awkwardness: "Well," he said, "it's a very rare name in Indochina." Although the Steinbergs shared a love of James Joyce, Leo found it next to impossible to

discuss this work or any other with Saul because "the word *my* would always be there . . . It would be *his* Joyce, or what use *he* made of Joyce, never a discussion of Joyce's work, or an exchange of ideas about it." Leo found it particularly grating when Saul compared his drawing to the writing of Joyce and Nabokov and turned all their conversations about literature into conversations about his work.

Often Saul's choice of literary topics veered into what Leo called "the strangely unguarded confession that led to revelations about his art that he might not have intended." Leo told Saul that this was "exhibitionism, the need to expose coupled with the need to deny the exposure." Saul bridled and asked for examples, and Leo offered the drawing of Saul standing next to the cardboard cutout of his portrait as a young boy, or his use of masks, which told so much about the person beneath even as they hid the face. When Saul did not reply, Leo offered the use of rubber stamps as another example, and Saul did reply to this, saying that he used stamps because they kept him from having "to show his hand." When they talked of the "fake books," the wooden replicas that Saul took such delight in carving, which were nothing more than blocks of wood with titles and the authors' names, Leo told Saul, "You want us to know that these are the books you read, but that's all you want us to know." Saul replied that telling even that much was "enough."

After a conversation with Leo Steinberg, Saul Steinberg often felt the need "to round things out" by talking to "the other Saul," and he would telephone Saul Bellow. They had known each other casually since the early 1950s, but the friendship did not intensify until a decade later. Steinberg believed that Bellow had become "something of a relative to him—a kind of cousin." But Bellow had a more guarded opinion of their rapport: he saw the friendship as one of "all good will and cordiality" but insisted that they were never close enough to exchange ideas in the same way that Steinberg did with Rosenberg. Steinberg disagreed, saying that he could begin a conversation with Bellow about any mundane thing at all, and from that would come an exchange of "discoveries, small epiphanies, unexpected connections, paradox, pun, nonsense, [everything] will advance the talk in a zigzag upside down or inside out manner that makes me stop and ask what are we talking about? Let's remember what we started with. What was it?"

Steinberg reveled in spontaneity that revealed something unexpected, and as the conversations continued over the years, they sometimes inspired him to draw something and send it as a memento, while Bellow got into the habit of sending some of his work in progress and asking for comments and criticisms. Among Steinberg's archives, various drafts of Bellow's typescripts show cor-

rections or questions in Steinberg's hand, many of which Bellow then incorporated into his subsequent writing. Bellow may have dismissed himself as a "sort of kinsman from the urban wilds of Chicago," but their friendship was mutually enriching. He used Bucharest as the setting for *The Dean's December*, and the personality traits he assigned to his main character might well be those he attributed to Steinberg several decades later, in the twilight of both their lives, when questions of artistic vision and identity were among those they tossed back and forth in the long telephone conversations Steinberg initiated when their friendship had attained its highest level of truth and intimacy.

Steinberg's friendship with Vladimir Nabokov developed slowly, even though they had known each other since 1947, when Alexander Schneider gave a dinner for Véra and Vladimir Nabokov and invited Steinberg and Sterne to meet them. Shortly after the great success of *Lolita* in 1955, the Nabokovs left the United States to live in Montreux, Switzerland, which Steinberg visited whenever he had the opportunity. On the Nabokovs' rare visits to the United

Saul Steinberg, *The Nose Problem*, 1963.

States, they made a point to see him, and Steinberg was prominent on the guest list when the Bollingen Press honored Nabokov for his translation of Pushkin's *Eugene Onegin*. As the two couples (Saul was with Gigi) walked together afterward toward home and hotel, Nabokov asked his wife to show Steinberg what she carried in her tiny beaded evening bag. Véra Nabokov opened it to reveal a dainty Browning handgun, meant to be reminiscent of the one in Pushkin's famous duel. Steinberg was astonished by the casual way she carried the gun and thought the gesture "ripe with symbolism."

Although they saw each other seldom and the correspondence they exchanged tended to be formal, their friendship was grounded in literature. Steinberg was fascinated by all of Nabokov's writing, but the text that resonated most strongly was the extraordinary "biography" of Nikolai Gogol that was more about the biographer Nabokov's quirks, qualms, and prickly foibles than the writer's life. Gogol was a writer Steinberg reread whenever he needed an example or an analogy, particularly his two favorites, the novel *The Overcoat* and the short story "The Nose." The story was especially resonant for Steinberg, whose sense of smell was so intense that he used verbal descriptions of how something or someone smelled almost as often as he used visual imagery to convey how it looked.

In his own art, there are numerous references to smell and even more examples of noses, with quite a few exploring or explaining Gogol's influence. Steinberg called a drawing he made for *Location*, the literary magazine cofounded by Harold Rosenberg and Thomas Hess, his "version of the nose problem" and the "equivalent in drawing of Gogol's treatment of the same problem in literature." In real life, olfactory sensations served Steinberg as an aide-mémoire, something akin to Proust's madeleine. Of Betty Parsons, for example, he said, "She left a very good taste, like something good you smelled or tasted or saw that increased in importance in memory." Even his sister Lica acknowledged his fascination with noses when she described her first impression of the move to Cachan in a phrase he would appreciate, as being "surrounded by [Armenian] noses, one bigger than the other." Images of noses fill his sketchbooks, and in one, a man sits on a chair with a small table between him and another chair on which sits a gigantic nose. He called it "I talk to my Nose about Childhood."

Like much of Steinberg's art and Gogol's prose, Nabokov's so-called biography was a slightly off-kilter look at life. He begins not in the traditional manner, with Gogol's birth, but with his death, when doctors applied half a dozen slimy black leeches to his long nose in an attempt to cure the disorders of his stomach. Poor Gogol spent his dying moments desperately trying to pull

off the "slimy, creeping, furtive things," which is how Nabokov segued into crediting Gogol's actual "long sensitive nose" for the "nasal leitmotiv" that pervades his fiction. Nabokov concluded that "it is hard to find any other author who has described with such gusto smells, sneezes, and snores," and he found the same gusto in Steinberg, who was his favorite contemporary artist. What Nabokov liked best about Steinberg was how he "could raise unexpected questions about the consequence of a style or even a single line, or could open up a metaphysical riddle with as much wit as an Escher or a Magritte and with far more economy."

STEINBERG WAS LEFT TO FEND FOR himself during the last months of the 1962 summer, while Gigi was still on her European vacation. He chose to stay in Springs, where he found himself truly alone because the Nivola family was in Tino's native Sardinia and there were no sounds of children or the informal running back and forth across the road from house to house that usually punctuated his days. He swam or fished at Louse Point and pedaled slowly up and down the country roads on his bike, but mostly he sat on the front porch and read. In his semi-isolation, a novel that resonated deeply was Richard Hughes's *The Fox in the Attic*, about a fairly clueless upper-class Englishman who visits his German cousins in their Bavarian castle between the two world wars and observes Hitler's rise to power. Steinberg was struck by Hughes's ability to convey the "sadness or despair that we're familiar with," which he was feeling too, but "rarely and for a short time."

Even though it was the dog days of summer and he was virtually hiding out in the country, the offers of commercial work still came in the usual flood of letters and telephone calls. He ignored them, because he was taking a one- to six-month respite from projects that came with stipulations and deadlines, and from his own creative work as well. He knew he was in a mood where nothing he did would please him: "Work derives from work and that has to be avoided . . . What used to be excitement once, it's no more so." He estimated that he had enough money to take time off from everything connected with art, commercial or personal, and still be able to meet his self-imposed responsibilities. Lica and Rica were both working, but they depended on his large contributions. He continued to send regular payments to his Aunt Sali and her children in Israel, and he always responded to the occasional requests for help that came from his other cousins. His largest expense was Gigi, for he had become her sole support, and it took a lot of money "to get her out of granny dresses and keep her in couture and jewelry in the style of Marilyn Monroe," but he was determined to do it. He also had to find a discreet way to funnel

money to Aldo, who had been desperate after *The New Yorker* rejected a hastily written memoir of their trip to the American South. Aldo needed money to pay the expenses of an "Anne" as well as to contribute support to Bianca Lattuada and her two daughters, and his financial distress threw him into a depression that left him nearly incapacitated. Steinberg's problem was to find the way to offer money and persuade him to accept it without wounding his pride. Also, Ada chose the moment of his deepest concern for Aldo to dump a new load of financial troubles onto her "Olino Caro," whom she knew would always come to her rescue. In frustration, he begged Aldo to see her and learn the truth of the matter.

WORK AND TRAVEL CAME TOGETHER IN an intriguing manner while Steinberg was alone in Springs, despite his intention not to accept any commercial proposals for the next several months. Dino De Laurentiis had wanted to work with Steinberg for years, and to entice him into finally agreeing, he phoned repeatedly to dangle an invitation for him to collaborate on a new screenplay that he wanted to film, written by Mario Monicelli, one of the most distinguished proponents of *commedia all'italiana*. Steinberg had long admired De Laurentiis's talent for producing a string of award-winning successes, among them Fellini's *Nights of Cabiria* and *La Strada*, each of which won him an Oscar, and the possibility of working with Monicelli was irresistible.

As Steinberg was mulling over the proposal, an offer to design a mural arrived. Murals were not as intriguing as film, but this one promised a great influx of cash and he felt he had to consider it. It was never realized, but it gave him the excuse he needed to travel to Rome, as it was to be built there. He had had enough of tranquillity and was bored by his bucolic solitude, and he wanted company and needed pampering; he planned to spend the last two weeks of September at luxurious Italian resorts, where he all but begged Aldo to join him. Then, just as he was writing to various Italian friends to set up appointments, a totally unexpected invitation arrived. The Israeli shipping firm Zim asked him to create a mural for one of its passenger ships and proposed to pay his expenses for a visit to Haifa at his earliest convenience.

STEINBERG HAD A GOOD TIME IN ITALY, despite the fact that De Laurentiis was mysteriously unavailable and the Monicelli project withered and died without his ever knowing why. He declined the Rome mural project in short order and then concentrated on having a happy vacation for the two weeks he was there. Aldo and Bianca were his guests at several posh resorts on the coast above Rome, and he went alone to La Spezia, Naples, and Iscia, where

he enjoyed "beach fronting." One of his most pleasurable meetings was his lunch in Rome with Nicola Chiaromonte, one of his oldest and most respected friends, to discuss various ways in which his work might appear in *Tempo presente*, the publication Chiaromonte coedited with Ignazio Silone.

On October 1, Steinberg flew to Tel Aviv, ostensibly "to work" and primarily "to doubt," but to his astonishment, everything about Israel struck him as a delightful surprise. Before he was invited to visit, he had not thought about the country as anything other than the place where a slew of relatives had settled among many others from his old neighborhood in Bucharest (which may have been why Israel was never high on his list of places to see). However, once he landed in Tel Aviv, the sheer beauty of the landscape was almost overwhelming. As he traveled to Haifa, Jaffa, and Jerusalem and after he visited a kibbutz, he was assaulted by a series of unexpected sensations. Israel was composed of "the poetic, romantic . . . of the ancient, medieval, Turkish, Arabic, Romanian places." In short, it brought back memories of his native Romania with its similar layers of settlement and the same "odors and perfumes." What he liked even better than observing the landscape was how easily he was able to glide into conversations with ordinary citizens as they went about their daily life. He could not wait to write to Hedda to tell her how calm and happy it made him, to be "surrounded by Jewish faces," with whom he felt very much at home, and how the sight of so many "Jewish noses" almost made him cry out with joy. Everywhere he went, he was accepted as a *lanzmann*, and he told Aldo that it made him almost delirious to find he could talk to people so easily and "immediately, in the most subtle way."

Steinberg and Sigrid Spaeth: "He's aFreud she's too Jung for him!"

Until he went to Israel, Steinberg's Jewishness had been cultural rather than religious. He did not attend services regularly, but if he heard of a particular rabbi

whose ideas interested him, he would go to the temple just to hear the ser-mons. If a certain synagogue was noted for its music, he would go to hear it as if he were attending a concert. Most of all, if there was a political underpinning to the service, he could be counted on to attend, and whenever a Jewish group, cause, or organization asked for a contribution, he sent whatever it wanted, be it money or art. It was interesting, however, that despite the distance he maintained between himself and any practice of the Jewish religion, he always fasted on Yom Kippur.

STEINBERG DECIDED NOT TO MAKE THE mural for the Zim ocean liner, and it was just as well, for shortly after, the company decided that airline travel had made passenger service unprofitable and ended it. It made him determined to resist all further "work on command," no matter how tempting the project might seem. As the year ended, when he drew only what he wanted, he found himself unable to concentrate long enough to produce anything worth keep-ing. It was difficult to sit at his work table for the long periods of time that had in the past made him feel that he was working happily and well. His disposition was not helped by a new spate of troubles with his teeth, which kept him seated in the dentist's chair several times each week for a series of appointments that lasted almost two months.

Everything, it seemed, was giving him trouble. He was fed up with the Jag-uar, which was in the repair shop more than it was on the road, so he sold it and bought a Buick. He was beset by unexplained "terrors," and the only way he knew to rid himself of them was to draw them "in a comic way, in the manner of savages." Everything he drew became "part of a diary," and he filed the very few drawings he kept under the word *Confessions*. For a time he thought this would become the title of the book he was forcing himself to work toward, but he so disliked what he saw that he stopped drawing and tried to write instead. "This is a sad but very human story," he began, quite ordinarily, before trying to imitate some of the wordplay associated with Joyce's *Finnegans Wake*: "Blue of spirit . . . a middle-aged introvert has been contemplating the problems of a union with a red-blooded, cigarette addicted, lush young moll. He's aFreud she's too Jung for him!"

He was writing about his relationship with Gigi, who was happy in her studies at Columbia, where she had met many people her own age and befriended quite a few, including a student from Ethiopia who insisted he was a prince of royal blood and with whom she was having an off-again, on-again affair. Steinberg still had a retinue of women with whom he slept routinely, but unlike Gigi, several were married, and all the others had independent lives and

professions so they were not dependent on him, as she was. When his other women were otherwise occupied, Steinberg was often alone, and his way of overcoming loneliness was to immerse himself in literature. He reread all of Chekhov's work that was translated into English and countless "random biographies of obscure people." He did enjoy Enid Starkie's life of Rimbaud, who was one of his favorite writers, but it took several years before his imagination allowed him to construct "Rimbaud's Lost Diary," a document that looked so authentic that he actually fooled some friends into thinking it *was*.

In January, to get away from the cold and to cure himself of depression, he took Gigi to Key West for the month, but he was not happy when they had to return so she could start the new semester. The cold weather in New York made him feel "sadder still." He withdrew in boredom from the constant round of socializing but then could not stand the solitude, so he invented excuses to phone people whom he knew he could trust to accept him unquestioningly. Harriet and Esteban Vicente were two he counted on for frequent invitations to their home in Princeton, and he often made the trek to Penn Station "if only to have an hour's train ride in the evening."

Gigi told him she wanted to go to Europe again as soon as the spring term ended, and she had an ambitious itinerary: she planned to start in Paris with shopping and sightseeing, then continue on to Trier, Berlin, Hamburg, Frankfurt, Munich, Salzburg, Vienna, Sarajevo, Dubrovnik, Istanbul, and Samsun, with one or more stops in St. Tropez to rest up for successive stages of her journey. She wanted to be away for two and a half months or maybe longer. He told her to do whatever would make her happy and said he would meet all her expenses.

Even before she left, he knew he needed to fill his life with some sort of work, no matter what it was, and as he could do none that he thought worth keeping, he began to experiment to see how well he could copy other artists: he made "cubist collages" in the style of Braque and Gris and painted a "very elegant collection of Mondrians," all of which he framed and hung in the house in Springs. He was proud that no one recognized them as fakes. Then he busied himself in physical work without thought by painting the interior of the Springs house, with all the walls white and the floors gray.

When he did think, it was only to arrive at the same sad conclusion: "I don't like being alone anymore." In the past, when he was unhappy with his life, he had always found a way to flee from it. Travel was the great eraser, and for the next several years he seized on it with a passion.

THE TERRIBLE CURSE OF THE CONSCIOUSNESS OF FAME

*Impossible to recount things . . . As always, I was more interested
in myself (that is, trying to understand what sort of man I am)
than in seeing outside things . . . Also coming home and finding
myself no longer the same.*

'm not working," Saul told Aldo as June became July 1963 and all he could
do was make collages in Braque's 1912 style. He was mired in an "unhappy
period—but not even unhappy, intense rather, but not bad." He defined
his malaise as stemming from a desire for "absolute happiness (who knows
what it is)" and the resulting "confusion, which comes from not following the
highest ideals." He moped around until August, when Gigi's return from her
triumphant tour of Europe made things brighter. To celebrate her homecom-
ing, he did something he detested: he drove to Idlewild Airport to surprise her
by meeting the plane. And he did something else he disliked almost as much:
he planned and organized a surprise party for her August 9 birthday, inviting
everyone he knew to join them at Ashawagh Hall in East Hampton.

The party was an extravagance, for he was preoccupied by money and the
fear that he did not have enough of it. He had wanted to go to Europe with
Gigi and make the trip a truly grand tour that she would never forget, but
he sent her alone when his income tax bill was much higher than expected.
Shortly after, he learned that his 1961 return was being audited because the
IRS wanted a dollar value for each of the eleven paintings he had contributed
to the Library of Congress. He assessed the lot at a modest total of $2,000 and
it was quickly settled, but he was still shaken by the experience. Although he
had been in the United States for two decades, his initial reaction to any con-
tact with authority aroused the same fear he had felt as a Jewish boy in Roma-
nia, always on the alert for arbitrary government persecution.

By the autumn his money worries had lessened, and he was in a slightly
better mood after two covers on *The New Yorker* drew a large volume of fan

mail. His satisfaction was enhanced when the critic Herbert Mitgang asked to buy a drawing of the Galleria Umberto I in Naples, where he had been stationed as a correspondent for *Stars & Stripes* during the war. Steinberg was further delighted when Mitgang described a visit to Michelangelo Antonioni's Rome apartment, where he saw one of Steinberg's drawings hung prominently among others by Klee, Kandinsky, and Morandi. Mitgang told Steinberg that when he saw where Antonioni placed it, he understood what he aimed for in all his films; when he told this to Antonioni, he replied with one word: "Exactly."

Steinberg's usual retainers brought a new influx of cash, starting with the annual $20,000 from Hallmark, and a new spate of litigation brought more before the year ended. *Life* and *Time* had infringed his copyright by using full-page ads drawn by M. Lado that depicted a wife drinking coffee while staring at a statue of her husband at the other end of the table. It was so close to one of Steinberg's that had been in *The New Yorker* ten years earlier that Alexander Lindey agreed he had been "substantially injured" and brought suit and won.

Steinberg's talents permitted him to straddle numerous areas within the art and design worlds, and this polymorphism often led diverse professional organizations to invite him to share his expertise. He was flattered but he usually refused the invitations, such as those to be the featured guest and principle speaker at conferences of the California Council of the American Institute of Architects and the California Eyes West group. Both were significant honors, which he declined because he did not consider himself qualified to dispense information to those whose work lay entirely within specific areas which he occasionally visited but did not fully inhabit: "I don't quite belong in the art, cartoon or magazine world, so the art world doesn't quite know how to place me." He believed such honors contributed to "monumentalizing" the artist and carried the "terrible curse of the consciousness of fame." To accept would have meant the difference between being an "Artist, with a capital A"—that is, one who made a living by assuming an aura of expertise—and being an "artist with a small a"—that is, one who went about his own work and left it to others to judge and evaluate it.

At the same time as these genuine honors came, there was also a fairly dubious one that marked a major change in his public image: he was no longer just an "artist," who could count on being reviewed or written about every time he sold a painting, published a book, or held an exhibition; he was now a public figure, recognized as a bon vivant and man-about-town. The editors of the *Celebrity Register*, published by Cleveland Amory and Earl Blackwell, asked him to submit "another glossy portrait" because the one they had published in

the first issue was "unsatisfactory." Steinberg was flattered by the request, but as he had not given them the first photo, he ignored the request for the second.

THE BARRAGE OF FAN MAIL STILL poured in for several months after *The New Yorker* featured Steinberg's dual versions of the letter *E* on the May 25 cover. It was another of the captivating drawings that signaled a shift in his subject matter, one that fell into the category of the quasi-philosophical drawings that left readers pondering and puzzling over his contributions to the magazine during the past year or so. His "strange, silent world" had been identified a decade earlier by Alexey Brodovitch as "peopled with chinless, blank-faced men, beady-eyed women with monstrous headdresses, precocious animals, and weird architectural fantasies," but viewers mostly attributed it to a "comic technique" that raised many laughs but few questions. In the 1960s, when his letters, numbers, and punctuation marks either took on insistent anthropomorphic qualities or reflected the existential situations in which animals, little men, and disparate women find themselves, the influx of fan mail from the magazine's readers burgeoned.

After the appearance of the October 6, 1962, cover, featuring the numbers 5 and 2, readers demanded interpretations and answers to questions that became intense, urgent, and sometimes even angry. Basically, they were all asking, "What does it mean?" The scene is one of Steinberg's traditional café tables, with a trim and tailored number 5 sitting confidently in a chair on the left, a thought balloon above its head brimming over with complicated mathematical equations and symbols. A highly ornamented 2 sits on the chair opposite, and if a number can be made to look dejected and depressed, this 2 certainly does, with its edges all frilled and furbelowed but with nary a balloon above it to show that it is capable of even the most ordinary thought.

Steinberg talked about this cover when he sat for a far-ranging interview several years later with Jean Stein, calling it "a dialogue between a No. 5 and a No. 2 . . . who are both drinking and trying to figure out their relationship." He described the 5 as "more solid looking, made out of straight, simple lines," whereas the 2 "has frills and is sort of pinkish; it denotes a woman." As the 2 looks at the 5, she tries to figure out their "potential combinings," while at the same time the 5 is figuring out "the same geometrical, mathematical, or arithmetical possibilities." Steinberg insisted that the drawing worked because of the numbers he had chosen; if he had chosen a 6 talking to a 9, it would have been "unprintable."

The love of numbers came from his childhood interest in typography, when he had played with the big wooden type that his father used to decorate

mortuary wreaths. Throughout his life he remained "obsessed with the question mark, and numbers—one, two, three, four—*big* numbers." The memory persisted of how, as a small boy, he held the oversized type his father used and how it comforted him. Steinberg was often asked about the many different ways in which he represented numbers, particularly the number 5, which he used so often. He depicted it lying in bed, wrapped erotically around a question mark, or wrapping itself like an oversized tuba around a little man who trudges disconsolately with the burden, or serving as the cupboard which a cat in search of food opens to find only apples and pears, which he cannot eat. Steinberg was uncharacteristically gleeful when he talked about the number 5, particularly the 5 as a cupboard. That one was "so simple—I even give hints. This is how children see the meaning of a number—as an abstraction: two apples and three pears make five—but five what?" By answering the question this way, Steinberg delighted in posing another, far more existential one. His questioner asked why the number 5 was always so predatory and unsettling. "Oh, that's easy," he replied as he leaned in conspiratorially to whisper, "You can never trust a 5."

His seven pages of question marks in *The New Yorker* on July 29, 1961, were meant to depict this particular punctuation mark as "a problem, a weakness, or a curiosity," and ultimately an erotic dialogue. When he drew a tri-

Saul Steinberg, *Untitled*, 1961.

angle in bed with a fat question mark, Steinberg saw "a line making love to a mass . . . a liveliness being made love to by reason." It represented "a very noble idea" for him, the idea "that love itself, including sex, is a continuation of a dialogue."

This series continued the trend toward the drawings that Joel Smith called "the serious core of this wordless comedy," and the letter *E* on the May 25, 1963, cover was its next logical extension. Much of the fan mail about this cover's meaning came from high school students, who spent their lunch hours in school cafeterias arguing about it. They wanted Steinberg to give them a solid explanation of what he meant, even as they offered their own interpretations and expected him to agree that they were right. One group thought it was simply an exercise in typography, while another was certain that it was a pun on the old song about keeping soldiers down on the farm after they've seen "Paree." Most of the mail, however, came from people whose initial was *E* and who wanted to buy the original, or those who sent their copy of the magazine for him to autograph. He enjoyed the many interpretations, because they represented viewers whose responses ranged across a spectrum from shock to admiration to uneasiness. Whatever the response, his viewers were all made slightly uncomfortable by what they saw, and this was exactly what Steinberg wanted, for he believed that the artist had the responsibility to "make people jittery by sort of giving them situations that are out of context." When he told this to the critic Grace Glueck, she offered her own interpretation: "In other words, you don't want to make them reason, but you want to shake them up a little bit." Steinberg agreed, admitting that even as he wanted his readers to figure out what each drawing meant for themselves, "The most difficult thing in the world is to reason."

EVERYTHING SEEMED TO BE GOING WELL as autumn lengthened. Gigi's return had lifted his mood, as did another successful *New Yorker* cover on October 12, which provoked almost the same volume of fan mail as the earlier one in May. This one featured two of his spiky females with pointy features and garish red slashes for mouths and lips: one's mouth spouts Steinberg's version of a street map of Paris's St. Germain-des-Prés, while the other's spews a map of Sardinia. The women drink cocktails and boast of their travels, talking across each other without an inkling of true communication. Most of the mail for this one praised Steinberg's comic vision, while his larger message of the women's inability to communicate was not addressed. The cover's overall effect was directly opposed to what he wanted: it made his readers laugh instead of making them jittery and unsettled. He took it personally, as another warning

that he had grown stale and was not communicating with his audience. Whenever he felt this way, he knew he needed a change of scene, and that always meant taking a trip.

His restless mood made him seek out Elaine de Kooning, whose company he could normally tolerate only in small doses. She had begun to make frequent trips to Texas whenever she wanted to "get a gig for a workshop or a slide lecture or a commission," and Steinberg shared her fascination with the state where everything seemed to be bursting with "frontier energy" and "everything is possible." "Call Elaine about museum in Texas," he wrote at the top of a very long list surrounded by doodles—always a dangerous sign that he was bored and didn't want to do any of the irritatingly mundane items on it. After the one-sided reader response to his October *New Yorker* cover, he wanted to go to a place where he could look at the world with "a fresh eye, to put myself in a condition to have a fresh eye," and there was no chance of finding a fresh eye in New York, what with all the details to which his long list attested.

Gigi was peremptory and demanding, and he had to buy "ice-scates and easle [sic], paint and colored pencils for you-know-who." Friends asked him to write recommendations for grants and fellowships, an onerous task because he disliked writing official letters in English for fear he would misuse the language. Despite having a lawyer who took care of such things, he personally hounded Mrs. Jennie Bradley about long-overdue foreign royalties. He had begun to see more of the group of Upper West Side intellectuals that included Diana and Lionel Trilling, Mary McCarthy, and Dwight Macdonald, all of whom routinely enlisted him in social causes and political events that meant lending his name, donating art, or giving money, and usually all three at once. His Buick was not running smoothly, and many phone calls and service appointments were not solving its problems. He had to call his accountant, deal with the Stedeliijk Museum in Amsterdam, pacify Galerie Maeght in Paris, and "think about [an unspecified] Research Institute" that wanted to use his name on its letterhead. And there was also his dear friend Inge Morath, who could sweet-talk him into just about anything but whose proposed book he had been stalling for months.

He was making desultory plans to follow Elaine de Kooning to Texas, and to use her contacts as the starting point for a jaunt to meet dealers and collectors throughout the Southwest, until November 22, when President John F. Kennedy was assassinated. Steinberg joined the world in mourning, and going to Texas became unthinkable. The nation's trauma left him more desperate than ever to get away in order to gain the distance he thought he needed in order to figure out how to represent it.

Kennedy's assassination was a stunning personal blow to Steinberg, for

this was anarchy, something he thought was behind him forever when he left Europe to embrace American democracy. His politics were always liberal and left-leaning, a reaction against the punitive social inequity of his youth, and he had voted for the young Kennedy because he seemed to be cut in the mold of one of his great heroes, Franklin D. Roosevelt. Steinberg believed in a government that offered the greatest good to the largest number of citizens, and to him, Roosevelt's New Deal was a monumental achievement. He never forgot how it offered meaningful work to artists and writers during the Great Depression, some of which he studied in search of ideas. With the Kennedy administration, Steinberg found another cause to believe in just as fervently, a shared antipathy to segregation.

Ever since his first trip to the South, he had been a supporter of the NAACP and CORE, and he also held separate memberships in some of the local chapters and organizations they sponsored throughout the region. He donated drawings as well as money whenever he was asked, and in some cases he volunteered to sign petitions for causes and affidavits for individuals. If he were to travel around the South after Kennedy's death, what, he asked himself, could he possibly draw that would contribute to an understanding of, if not an explanation for, what his adopted *patria* had become? He had not loved his homeland for the past decade as unequivocally as he had when he had first arrived on its shores, but nevertheless, it was still the country he respected and admired above all others. He thought about the situation of the artist in a violently changed society for a week or so after Kennedy's funeral and then decided that if he were ever to understand what had just happened in America, he needed to distance himself from it. He decided to go to Europe to see what he would find there and where it might lead him. He had the time and the money and would just let things happen.

HE WAS EAGER TO SEE HIS SISTER and observe firsthand what her daily life was like now that she and her family were so contentedly settled. He wanted to visit his mother's grave and see the headstone that had been laid according to Jewish custom since his last visit. His primary need on this trip was an intense desire to renew himself through contact with other creative persons, especially non-Americans such as Eugène Ionesco and Jean Hélion, with whom he had developed sustained correspondence about their personal philosophies and their impact on their work. Steinberg wanted to avoid anything that smacked of actual work while he was in Paris, so he went out of his way to avoid having to see his publishers and gallerists. He thought, and rightly so, that they were more interested in the commercial prospects for work he had already done

than in any new ideas he might have. He wanted to talk about this with Hedda Sterne, who was in Venice on a Fulbright scholarship.

To live in Venice was expensive, even with the stipend from the Fulbright, so Hedda rented her New York house for the year she was to be away. She was counting on sales from her exhibition at Betty Parsons's gallery in December, and because she was not able to attend to the details in person, she asked Saul to do it for her. As she was particularly worried about the photographic reproductions in the catalogue, he worked hard with Betty before he left to make it what Hedda wanted. Unfortunately, despite excellent publicity and a beautiful catalogue, not a single painting sold. Hedda hesitated to tell Saul, because she was determined not to take any money from him, but he knew and quietly deposited $1,000 into her bank account, telling her not to worry.

He accomplished everything he wanted to do in Paris in less than a week, so he flew to Milan and went directly on to Venice. Hedda had rented the house where the poet and painter Filippo De Pisis had lived during and just after the war. He had amassed a huge personal library that featured such works as Casanova's memoirs and other "mild pornography" that Hedda was sure Saul would like. She joked that she would steal one of the volumes of Casanova's *Intrighi di Francia* for him, and when he saw Di Pisis's collection of erotica, he asked Hedda to look for erotic paintings of nude women, particularly the legend of Susanna and the elders. Like Hedda, he was intrigued by illustrated periodicals of the 1880s, and together they spent hours in De Pisis's library turning pages and searching for his annotations, sometimes touching, sometimes very strange (he died insane).

Saul was worried about Hedda while he was with her, not because of her financial needs, which he intended to take care of, but because of her health. She had arrived in Venice wearing a black eye patch because her sight was impaired, and for the entire year she was there she had to be careful not to damage her vision further. As soon as she moved into the house, she came down with a lung infection, which she called pleurisy, bronchitis, cold, or flu, depending on the symptoms of the moment; whatever it was, it did not go away for the entire winter. Her health was run-down and her mood dispirited, mostly because everyone praised her work but did not buy it. In a gossipy letter to Saul about the Biennale, she told him that the museum director James Johnson Sweeney raved "enthusiastically" about all her "periods," which led her to ask acerbically "why he don't buy ten?"

However, it did them good to see each other, for it was apparent to both that once they had stopped being lovers they had become each other's closest friend and most valued sounding board. Now that they no longer lived together

as man and wife, they could talk about anything—and they did, from their views about the way art had become a commodity to their personal philosophy of how an artist should conduct him- or herself in an increasingly philistine world. At the Biennale, Hedda found "such poverty of spirit, imagination, or even simple talent" in so much of the art world, "and what savagery, brutality, in the fight for a prize, recognition!" She told Saul about "Castelli's revenge," as "the triumph of pop [art]" was being touted that year in Venice. She thought there were too many "fat middle aged 'enfants terribles'" parading themselves before the press, with Robert Rauschenberg leading the lot with his "phony enfant terrible statements."

Mostly, however, they talked about themselves. Hedda feared that she would sound pompous when she told how the luxury of a fellowship year was letting her clarify her views about art in general and giving her insights into what she valued about her own work. She was reading some of the volumes of art history in De Pisis's library, and it made her feel "vaguely nauseated" when she came across critics who would say (as she paraphrased) "the painter speaks a truth he does not know," implying that the work of art had no validity until the critic pronounced upon it. She went to an exhibition and was horrified to find that there were two names printed in the same size type and given equal prominence in all the advertising: the artist's and that of the critic who wrote the introduction to the catalogue. Hedda said she made up her mind then and there that she would have no more of "this 'career' business" in her life. When she painted, she would transfer only the purity of her thoughts to her canvases, and the world would be free to evaluate the paintings on those terms. She told Saul she hoped this did not sound "pompous" and said how grateful she was to have these conversations.

As such talks had always done throughout the twenty-some years of their relationship, the discussion turned specifically to Saul's version of his current unhappiness, of his inability to concentrate on work, his constant need to travel in search of new places, his inability to tolerate most of the people he knew, and his frustration over the lack of communication with others. Hedda was no longer afraid to risk offending him, so she told him that from here on, no matter what transpired between them, she felt the obligation to tell him the truth as she saw it. In this instance, she hoped it would lessen his despair when she told him that his current state of mind was nothing special or unusual; it was the same malaise that infected any creative artist worthy of the name, and rather than fighting it, he should accept it for what it was, a tribute to his genius.

———

HE LEFT VENICE IN A FAR BETTER MOOD than when he had arrived. Being with Hedda was restorative and gave him the energy to push onward in search of "the fresh eye," which still eluded him. The entire trip became something far greater than he had originally envisioned after he attended a reception for the diplomat Carlo di Bugnano, who was then the Italian ambassador to Indonesia and who invited him to visit. Steinberg had not thought about where he would go after staying in Rome for a week or so, but while in Venice he mentioned offhandedly to Hedda that he sometimes thought about returning to the places in North Africa where he had been stationed during the war and that retracing his postings might help him to put the past fifteen years into perspective. She told him to think about it, because he could always cross North Africa and fly back to New York from Algiers. At the time he shrugged it off as a whim, but after he met Bugnano, he decided to expand the trip to include many places in Africa he wanted to return to or to see for the first time. It made him think of India, where he had flown across the Hump; China was off-limits to Americans, but there was British Hong Kong, and if he went to Hong Kong, he might as well go to Japan. The next thing he knew, he had a round-the-world itinerary.

On the spur of the moment he decided to leave Milan and go to Florence on his way to Rome, to spend several days as an art tourist. He did not plan his African itinerary until he got to Rome, so he decided to get there via Athens, because he wanted to see the ruins again and smell the magical flavors he always associated with Greece. He flew from there to Cairo, where his main sightseeing was of the Pyramids. They inspired him to visit his old friend from the Politecnico, Sandro Angelini, in Ethopia. Steinberg flew from Asmara to Gondar, where he saw the royal compound of Fasil Ghebbi. He stayed briefly in the capital, Addis Ababa, and then went to Lalibela, where he toured the rock-hewn twelfth- and thirteenth-century churches built by Ethiopian Orthodox Christians. It was always a pleasure to see Angelini, but as a trained architect himself, Steinberg thought the churches in Lalibela were "stupidly made," poor imitations of Coptic Christian churches. His only praise was for the setting, "a terrific plateau with purity and magic, a concept of heaven."

He flew from Lalibela to Nairobi, Kenya, where he saw for the first time "gazelles and giraffes and hippos and crocs and so on," and with the "fresh eye" he was thrilled to find had been rejuvenated: "By cutting my bridges, by being in a condition that is new to me, I suddenly have the eye that sees, the nose that smells. All my senses are active. I'm not taking for granted anything the way one does when living day after day in the same routine."

His next stop was India—first Bombay, where he was most impressed by the architecture of a railway station that the natives insisted had been built by

Rudyard Kipling, and then Calcutta, where his flight, "Great Eastern 229!" touched down at midnight on New Year's Eve 1964. He spent the next day at the New Market, happily engaged in one of his favorite pastimes, buying "junque." Early the next day he boarded a Swissair flight to Bangkok, where he visited temples during the day and went to the movies at night. Thailand did not impress him, so the next day he flew to Hong Kong. On January 6 he flew to Tokyo, where he checked into the Imperial Hotel. He played tourist the next day, visiting the Ginza with "Mary," whose name appeared in his date-book during the eleven days he toured the country. He stayed at inns as well as posh hotels, visited geisha houses, took trains into the countryside, played pachinko, visited temples, and saw sand gardens that reminded him of some of his own drawings of labyrinths and mazes. From Tokyo he circled to Osaka, Nagasaki, Beppu, Kobe, Kyoto, and Saigo before returning to the capital city on the nineteenth. On the twentieth he went to American Express and found a letter from Gigi. He had done enough traveling to regain his fresh eye, and now it was time to go home and put it to use.

HE WAS BACK IN NEW YORK early in February 1964, but it took several weeks to get used to being there. "I'm still confused," he told Aldo on February 19, because returning to New York was akin to being back in Romania. He had seen so much that it was difficult to find the words to describe such things as the wild animals in Kenya and the hot baths in Japan. It would all come out eventually in his drawings, but for now, "as always, I was more interested in myself (that is, trying to understand what sort of man I am) than in seeing outside things." He thought his confusion at returning to so-called familiar circumstances might have been as disorienting as that of explorers who returned to civilization after long stays in primitive lands. Steinberg wondered if they felt as he did after "coming home and finding myself no longer the same."

A short time later he was still questioning his role and place in New York, in the United States, and, by extension, in the art world. He made another list, on which he noted that he had given money to an organization that wanted to do away with all organized charities, because he detested all the "monks and missionaries of bureaucracy." But most of all he had his own mission: "Artists of the World Unite. You have nothing to lose but your balls."

AUTOBIOGRAPHY DOESN'T STOP

The fact that stuff gets printed even if not perfect is a blessing.
It clears the path and lets us go forward toward things never
thought of before and still based on stuff from the past. So one's
autobiography doesn't stop.

When Steinberg returned to New York in early 1964, the requests were piled up and much work was waiting if he wanted to take it on, but he was mostly concerned with reentry into what passed for ordinary daily life. His main creative activity was fiddling around "rediscovering Cubism" and making collages, but "not the usual ones of course." When he actually finished making drawings, they were mostly "jokes about art history and the conventions of drawing, still lifes representing not objects but elements of drawing and painting combined with 'speech balloons' placed on the tables of still lifes."

On the personal side, he was worried about Hedda, whose eye problems had been exacerbated by a winter of debilitating flu that left her with chronic fatigue, low blood pressure, and stubborn infections that lodged in her eyes. One was so badly inflamed that she had to cover it with a black eye patch, and she had to coddle the other by limiting how much she read or painted. She tried to joke that the patch made her look as sophisticated as the male model in the ads for Hathaway shirts, but she told Saul more seriously that nearly all her "allowance," the monthly stipend he put into her account, went to pay for prescriptions and doctors. Hedda was so worried about money that she was trying to extend her Fulbright until the autumn of 1964 so that the renter could stay on in her house. It led Saul, who never discussed money concerns with her, to confess that he was in a temporary bind and feared running short himself.

When not worrying about Hedda, there was the nagging question of his relationship with Gigi and how it should progress. She was still taking occasional courses at Columbia, where she had befriended a group of fellow stu-

dents with whom she spent much of her time. It gave her warm satisfaction to know that she was welcome among interesting people of her own age and also the jolt of self-confidence she did not have in the early days of the relationship with Saul. While he was away, she had several brief affairs with men she met at Columbia, but she ended them when he returned, managing to keep the lovers as good friends. Throughout the affairs, Gigi made no secret of her relationship with Saul and how dependent she was on his largesse; when she ended them, she told her lovers that his disapproval was the reason. She always behaved with discretion, and even though Saul knew that she regarded their relationship as he did—*open*, to use the word that came into increasing prominence in the sixties—he was still not pleased about it. This time, however, he managed to keep quiet, because he realized he bore some responsibility by going off around the world and leaving her alone.

Gigi was an outspoken woman who never hesitated to vent her true feelings, even though she knew her eruptions would lead to ferocious arguments, black silences from Saul, and total separation as each waited stubbornly for the other to give in and apologize. Usually it was she, because she was dependent on his financial generosity, and that was why, when he announced suddenly that he was going around the world alone, she was miffed but said nothing. Now that he was back, she was restless. The term was ending and she wanted to go somewhere. Europe was out of the question this year, as he had to make money, so he promised her an auto trip through the western states, but not until late summer. Until then, he needed to catch up with everything that had happened while he was away and line up possibilities for future work.

Steinberg had not published a new book since *The Labyrinth* in 1960. Like his previous two, it had not sold well, and now all four were out of print. There had been two other recent books, but they were mostly reprints, compilations of drawings taken from the earlier ones: *The Catalogue* appeared in the United States and *Steinberg's Paperback* in Germany. Alexander Lindey was still handling all his book contracts, but he was overwhelmed by the barrage of requests that came to his office on a weekly and sometimes daily basis, mostly to reproduce Steinberg's drawings in other publications. Lindey thought Steinberg's financial interests would be best served if he continued to vet all contracts, but he insisted that the time had come for Steinberg to have an American literary agent who would deal specifically with publications, as Mrs. Jennie Bradley did in Europe.

Steinberg was seeing a lot of Arthur Miller now that he was married to Inge Morath, and with their urging, he agreed to be represented by Phyllis Jackson at the agency of her name (where Miller was represented by Kay Brown).

Jackson soon found that Steinberg was the kind of client who "needed a lot of hand-holding, a little too much for her," which was how the young Wendy Weil, just starting out at the agency, was assigned to deal with what she called "Steinberg's scut work," the continuing flood of requests to reprint Steinberg's drawings in other books and periodicals. Weil handled them all with such dispatch and efficiency that a cordial working relationship resulted, and when she left for the Julian Bach Agency around 1971, Steinberg followed her, first there and then to her own agency when she founded it some years later.

Before Steinberg went around the world, Cass Canfield reminded him that he still owed a book to Harper & Row and urged him to come home with one. He thought about it while he traveled, and when he returned, the idea of questions of identity was uppermost in his mind. As he retraced his steps through places he had been during the war, he thought about who he had been in those days and was disappointed to realize that the man he had been previously was not the same man who had just returned as a tourist. He sensed that a new book would have to be far more autobiographical than the previous ones, and for that reason he was determined to call it "Confessions." The book bore that title until the eve of publication, when he reluctantly changed it to *The New World*, fearing that he was in a profession where such a title as "Confessions" would leave him "vulnerable to the stupidity of critics and scribblers." By the time the book was published a little over a year later, he found that he had indeed entered into a personal New World, so the title took on multiple meanings that became his own private joke, his veiled jest to the world.

FOUR MONTHS HAD PASSED SINCE STEINBERG returned from Japan, and he told Aldo that he had resolved none of the issues that troubled him when he went away and was more confused than ever by "amorous delights and suffering." Ostensibly he and Gigi were a couple, a status he wanted to maintain even though his behavior continued to be the same as it was when he lived with Hedda. Her observation from the early days of their marriage still rang true: "Saul thought he had the obligation to seduce every woman he met, no matter whose wife or girl friend she was." He still slept with a succession of women with whom he had previous ongoing sexual encounters, even as they led separate lives and forged their serious and lasting relationships elsewhere. And he did not hesitate to have casual sex with any new woman who struck his fancy.

Unlike Hedda, who suffered his infidelities in stoic silence, Gigi railed and ranted and then went off to have her own independent sex life. He was surprised by how much he resented it when she behaved exactly as he did. It created a troubling time in his life, and as he always did whenever disturbing

events invaded his dreams, he kept a dream journal. In one, he and Gigi were in a forest where dogs barked to signal the approach of a hunter. The hunter morphed from a man into a long-haired reddish monkey about four feet tall and Gigi became a frightened cat who jumped into Saul's arms. He had difficulty holding on to the Gigi-cat and felt it grow tense and ready to jump. Saul dreamed, "If she jumps now, lost forever." He tightened his grip on the dream cat and woke up in bed to Gigi's screams because he was squeezing her arm so tightly it hurt. In another dream he was in Venice, taking a water taxi around the lagoon, trying to catch up with an elusive Gigi, whose boat was always one stop ahead of his. He transposed his next dream into a drawing for the newsletter of the American Council of Learned Societies that featured a man with a bull's-eye for his head and a woman with a square for hers. It was another in joke, but this one was not so funny: Saul told Aldo "at a crossroads with her and must decide—a mess."

They were at the first crossroads in their long, fractious relationship, and as Steinberg was in command, he chose the road forward. Again, quite unlike Hedda, Gigi chose not to follow but to go her own way. He chose to accept honors and invitations while she chose to become more of a hippie than ever. While he accepted accolades and entry into the highest echelons of society, she used drugs, got drunk, and picked up men. One of his honors came when Paul Rand invited him to become a fellow of Morse, one of the two new residential colleges at Yale designed by Eero Saarinen and featuring sculptures by Constantino Nivola. He was flattered when James Laughlin asked him for a blurb—not a drawing—for a book of Stevie Smith's poems, as he thought it far more impressive to comment on a writer's work than to illustrate it. Steinberg was invited to join the National Committee of Citizens for Lyndon Johnson and Hubert Humphrey as part of an august group that included Aaron Copland, Charles Eames, Martha Graham, Walter Gropius, and Calder and de Kooning. Jean Stein and William vanden Heuvel, to whom she was then married, invited him for cocktails in honor of John Kenneth Galbraith and Arthur Schlesinger, Jr., who were speaking in support of Robert Kennedy's senatorial campaign. He was also a sought-after dinner guest in the highest social circles: Mme. Helena Rubenstein invited him to dinner; Bert Stern invited him to meet the model Dorian Leigh; Amanda and Carter Burden invited him to a black-tie dinner for Geraldine Chaplin; and Mr. and Mrs. Benjamin Sonnenberg invited him to meet Hedda Hopper, an invitation he accepted with disgust, as he abhorred her politics.

He did all these things alone, as Gigi either sulked, brooded, and smoked marijuana at home or went bar-hopping with friends like the young Mimi

Gross, who lived across the street from Steinberg on LaGuardia Place. Gigi had also become dependent on Evelyn Hofer and Humphrey Sutton, who treated her like an adult daughter, which gave her another kind of security. It was, however, a dangerous dependence, as Evelyn and Humphrey liked to play off one person against another; while swearing that they kept everything Gigi told them in confidence, they often repeated it to Saul. Ruth Nivola watched the drama play out from her house across the road and now and again brooked Saul's wrath by trying to intercede. He dismissed her concerns as "the Nivola family spectacle, which is a cross between Balzac and Joyce."

Ruth Nivola was one of a number of mothers who worried about the attention Saul Steinberg paid to their teenage daughters. Steinberg had been captivated by Claire since she was a child, and now that she was a lovely and intelligent young woman, he found that he could engage in lively conversations with her about books and paintings. He called her "Chiaretta" and was generous about giving her everything from spontaneous drawings of things that happened in daily life to special valentines or the carved wooden boxes he liked to make. He even had calling cards printed for her that announced "Chiaretta!" Ruth was an attentive mother who kept a stringent eye on the friendship, which remained correct for the rest of Steinberg's life. Dore Ashton was another mother who became upset after she brought her fifteen-year-old daughter to a working lunch at Steinberg's house to discuss an article she was writing. As they were leaving, he invited the girl, to whom he had said very little, to return the next day for a private lunch. Ashton was direct and to the point: "She is fifteen and cannot drive and therefore cannot get here on her own, and I certainly am not going to deliver her!" When Steinberg invited a third girl, who was just sixteen, to a lunch for just the two of them, her mother wrote a much harsher letter to Steinberg, saying that she had no idea what he was up to but would not allow him, "even in complete innocence . . . to put her in a situation of questionable taste." She ended in sarcasm, telling him not to "put such temptation before her sociable little heart until she is considerably older." These three invitations appear to be the only ones of this kind that he made; he never referred to why he made them in any of his occasional diary writings, and he left no explanation for such curious and uncharacteristic behavior.

He did, however, frighten Anna, the nineteen-year-old daughter of his friend the Italian journalist Riccardo Aragno, when he invited her to spend a weekend in Springs. Anna Aragno was a ballet student who shared with Steinberg an "Italian affinity based on intellectual interests" and enjoyed it when he took her to the theater or the ballet. She felt no qualms about spending the

weekend alone with him, because she assumed that his feelings were paternal because of his friendship with her father. In the middle of the night, she woke up, "petrified with fear," to find him in her bed. He embraced her, but she "froze and wouldn't budge," until he eventually "just sort of gave up and went to his own bed." The next day he drew her portrait, capturing her downcast face and hands crossed tightly over her thighs. It was the last time they were together other than on social occasions.

SAUL AND GIGI LEFT FOR THE western states on August 4, 1964, driving long and hard the first day as far as Wheeling, West Virginia. As soon as they got onto the Pennsylvania Turnpike, a tire blew out and they had to buy a new one, which put a damper on the entire trip. Steinberg thought Wheeling was a rough town, distinguished only by a good army and navy store, where he bought a "smokey [Bear] hat." He was not happy about making a detour to Columbus to stay with Gigi's sister, Uschi, and her husband, Bill Beard, but it made Gigi happy so he did it. Between August 6 and her birthday on the ninth they drove from Columbus to Chicago, Des Moines, Council Bluffs, Omaha, and Ogallala, Nebraska. They spent her actual birthday on the road between Ogallala and Cheyenne, and she was ecstatically happy with everything about the day, from the scenery to Saul's devoted attention. The rest of the trip took them through the desert of Utah to Navajo Indian reservations that made them feel as if they were in concentration camps. They drove across the desert with the windows open to the hot winds, speeding at 90 miles an hour or faster, both describing it as an experience unlike any other. They crossed Arizona through Caliente, Tuba City, Flagstaff, Window Rock, Phoenix, and Gallup, New Mexico before traversing Texas, from El Paso and Uvalde to San Antonio and Houston. Throughout the trip, the goal was to see how far they could go in a single day, so they could tire themselves out and not have to talk to each other as they crashed late at night in a roadside motel. They went to Natchez, Selma, and Montgomery, Savannah and Charleston, and over the Chesapeake Bay Bridge to Washington. They did not stop in New York but went directly to Springs, where on August 26 they collapsed in exhaustion, each of them loaded with questions they dared not broach while on the road.

Once back, Saul tried to avoid the major issue Gigi wanted him to decide by concentrating on the illustrations Aldo wanted for a short book he was writing, which was intended for a primarily Italian audience: a loosely woven description of his travels through America coupled with his philosophical musings on such topics as "the limitations of liberty." The text fit Steinberg's current concerns, and some of his quasi-philosophical drawings seemed appropriate

as illustrations, but he dawdled unnecessarily over which to choose. Pretending to concentrate on Aldo's book was a good excuse to evade Gigi's question, a simple one which was not yet an ultimatum: When was he going to divorce Hedda and marry her, and then, would he let her have children? He didn't answer, and for the time being she stopped asking.

Several decades later, when she stopped calling herself Gigi and had become the mature Sigrid, she reflected back on her first ten years with Saul Steinberg and saw for the first time how lonely she had been throughout most of them. One of her strongest memories was of sitting alone in her bedroom most evenings and then going to sleep simply because she had nothing better to do, while he sat in his own room contentedly reading far into the night. When they walked up the road to Louse Point on lovely summer evenings, he refused to hold her hand, never putting his arm around her or giving what she lacked and needed, "the more primitive togetherness of people cuddling." By the time she called herself Sigrid, she was a perceptive judge of character who described Saul as being satisfied with a "spiritual togetherness" that was not enough for her: "My life is not based on my intellect, rather on the senses." She made another discovery as their relationship stumbled on: that actual sex, either as a single act or in quantity, was not of major import to her; rather, what mattered most was "the nearness, the pleasure of touching in passing that's reassuring and satisfying, the sense of a body being there rather than a political figure."

They were both exhausted after the trip, and exhaustion was not the proper state in which to make life-changing decisions, especially after a month of driving dangerously fast to go as far as possible, as if eluding pursuers. Gigi went back to the city, because Saul told her what he had earlier told Aldo: "Tired now and, as always when I come back from these experiences, never sure that I'll be able to resume my work." She knew they were at a terrifying impasse and it was probably best to let things ride for now.

I HAVE TO MOVE

I have to move. I left everything to the last minute . . . I don't find myself an apartment because I don't have a clear idea of what I am or want to be. Husband? Painter? Old, young, uptown, downtown, man about town, hermit? Also: rich or poor?

Steinberg knew for almost a year that New York University had taken over Washington Square Village. In December 1963 he was notified that present tenants would be allowed to renew their leases but that as apartments became vacant, they would be rented to the university's faculty and staff. He did nothing about renewing his lease, and the following August he received a letter saying that as it was expiring and he had not replied to several previous letters, management assumed that he planned to vacate. He got as far as reading the real estate ads, but there as in everything else, he was crippled by malaise; at the last possible moment, at the end of September 1964, he renewed the lease. "I thought summer would last forever," he told Aldo as he more or less drifted until Christmas, when he and Gigi went to Roxbury, Connecticut, to spend the holidays with Inge Morath and Arthur Miller.

The relaxed informality of the Morath-Miller household provided a welcome buffer for Saul and Gigi, who were not quite on the outs but close to it. Good drink, excellent food, and pleasant company did much to relieve the tension between them. Inge was another of the older women to whom Gigi looked up as something between a substitute mother and an older sister, and it helped that Inge liked Gigi and enjoyed conversing with her in their native German.

Whatever relaxation they found in the Connecticut countryside evaporated as soon as they returned to New York and began to snipe at each other before they were even out of the car. On the spur of the moment, Saul decided that they had to get out of the cold and announced that they would go to Santo Domingo, where he had not been since he lived there as a refugee. They went first to Jamaica for a week, which passed without incident, mostly on the beach,

and then to Santo Domino for a brief day and a half, which gave him little time for sentimental journeys to old haunts. They flew home via Puerto Rico and were both in a much better frame of mind.

Before they left, Steinberg had mailed to Maeght in Paris a collection of drawings plus the thirty-three photos that he and Inge Morath had decided upon for a publication that Maeght titled *Le Masque*. Morath had known of Steinberg through Cartier-Bresson, but Gjon Mili had actually introduced them by asking Steinberg to let Morath take his photo when she arrived in New York in 1956. For their first session in 1956, Morath was thinking of a formal portrait-of-the-artist-in-his-native-setting and Steinberg agreed to sit for it, so she was surprised by the man who opened the door of the 71st Street house he shared with Hedda, wearing a brown-paper-bag mask on which he had drawn a self-portrait. He was delighted when she laughed at his prank and took her into the big kitchen to meet Sterne. Morath noticed that the room opened onto a large backyard, and she asked Steinberg to stand against the fence or next to the statuary in various poses and to wear some of his other masks. The formal photo session never happened as a "wonderful game" began, with Steinberg changing his clothes and donning different masks and Sterne joining in as well. Steinberg was delighted with Morath's perception that "different sartorial details and various positions or gestures influenced the impact of the mask." The session, which was supposed to last for an hour, took the rest of the afternoon and part of the evening, as they moved into the house and up to Steinberg's study, where he sat behind his desk or posed against interior walls, as did Sterne. It became a game all three liked so much that they enlisted their friends to help them play it throughout the next several years. By the time the book was in preparation, many of their friends in the city (Evelyn Hofer, Jean Stein, and Hedda's dear friend, the artist Vita Peterson, among them) had donned masks; in later years, when they held photo sessions at the Springs house, Arthur Miller and Sigrid Spaeth were featured prominently.

Preparing the Maeght book was fun for Steinberg, but it was also hard work because of the exhibition connected with it. He had to choose drawings and ship them to France, and to choose titles, set prices, and determine the order in which he wanted them hung. For the book he had to determine the content and the order of the pages, and in many instances arguments ensued when his wishes conflicted with those of the publisher, Jacques Dupin. It was quickly apparent that not everything Steinberg wanted could be included in the book, so he postponed decisions about the final choice for later but remained insistent and even more specific about the masks. He drew them on brown grocery-bag paper and wanted them mounted "on canvas perhaps," where they

would be shown alongside Inge Morath's photographs and hung in a grouping that represented "a temporary sculpture recorded by photography . . . psychological and social definitions of Western Europe and America."

Steinberg worked on the book's *mise-en-page* and maquette sporadically throughout 1964, still hoping for an exhibition in November 1965. It soon became clear that there was so much work to do for both that nothing could happen before early 1966. With the book, progress was hampered by Steinberg's perfectionism, which made it a constantly changing entity. At a time when air mail was expensive and took five to seven days, time passed and the book was stalled until Steinberg was satisfied with each individual change in the visual content, with the written texts taking as much, if not more, time to settle.

Without hesitating, Steinberg chose Harold Rosenberg to write the preface, but there was another request he was hesitant to make himself: he wanted Maeght to ask Jean-Paul Sartre to write the introduction. Steinberg believed that his drawings were "quite similar" to Sartre's thinking, but if Sartre chose not to write it, Steinberg suggested Nabokov, "who knows how to see." He explained his reluctance to ask them himself because the fear of being refused would bring back old memories of other "celebrities who wrote crap about my drawings." Sartre and Nabokov both refused, and Jacques Dupin suggested Samuel Beckett, who declined as well. Steinberg then suggested André Breton, whom Dupin refused to ask, saying that his reputation was passé and would not enhance Steinberg's. Instead, he suggested Michel Butor, describing him as one of the most talented and respected postwar "new" novelists in France whose philosophizing was on a par with Sartre's and whose fiction placed him with Baudelaire, Balzac, and Victor Hugo. It was enough to convince Steinberg, and Butor wrote the preface, entitled simply "Le Masque."

Then there was the adjunct publication that accompanied each of Maeght's major exhibitions, an issue of *Derrière le Miroir*, which required another selection of drawings plus a special lithograph to be inserted in the publication, which could be removed and framed. As for the dates of the exhibition, Steinberg insisted on mid-April or later, while Maeght insisted that it had to be early March. Steinberg reluctantly agreed but in his usual careful yet suspicious manner had Alexander Lindey prepare a veritable blizzard of contracts, agreements, and other documents. To soften the blow of what appeared to be a barrage of distrust, Steinberg apologized for Lindey's "lawyer-ese," even though he was responsible for it.

All the work he had to do for the Paris show galvanized Steinberg into dealing with other projects, such as finding a way to stall Sidney Janis, who

insisted that he was Steinberg's primary dealer and demanded that any show in Paris had to be preceded by or concurrent with one in New York. Steinberg was reluctant to offend Janis because his gallery brought in higher prices and better sales than the others; Janis was not pleased with the compromise Steinberg offered but eventually accepted it, to hold a joint exhibition at his and Betty Parsons's galleries in December 1966.

Work was melded into a frenzy of activity and travel that began in February 1965, when Steinberg went to Paris for the first time to work on *Le Masque*. Much of it was social, as always, but he was clearly attending to furthering his public image and his income. In Paris he met Jean Folon, who wanted to make a film using his drawings. A week later he was in Rome, seeing Aldo Buzzi and dining with Mary McCarthy at Nicola Chiaromonte's but also seeing Italo Calvino, whose writing he admired and who later wrote the introduction for Steinberg's fifth *Derrière le Miroir*. When he returned to Paris, he called on Marguerite Duras to discuss a project that was never realized. On an impulse, he flew to London to meet with his British publishers in the hope of persuading them to buy his two forthcoming books. His friend and fan Michael Davie, the editor of the *Observer*, was eager to "milk the [paper's] exchequer" for a lucrative commission and made him the guest of honor at party that included "two Astors" and his good friends the Australian artist Sidney Nolan, and his wife, Cynthia, whom Steinberg had known and liked since his first postwar trip to London.

Back in New York, March passed in a whirl of personal and professional activity. He was Gigi's witness at the March 2 ceremony at which she became an American citizen, and immediately after, he made frantic preparations for a trip to Cocoa Beach, Florida, where he was an official NASA artist at the launch of a Gemini rocket. His diary was filled with mundane things to do ("buy toothpaste, razor blades"), which filled him with resentment toward Gigi, who did none of the housewifely things Hedda had always done. When Gigi asked him one night to open a tight jar lid, he snapped, "Be your own gauleiter." Off he went to Florida, hobbled by indigestion after writing another note to remind himself to try whole-grain brown rice on his return.

HE RETURNED TO NEW YORK IN a calmer frame of mind and with his digestion improved enough to accept dinner invitations from Christo and Jeanne-Claude, who was famous for the unrecognizable concoctions she served at dinner parties. Steinberg was fond of the couple but fastidious about food and could not bear the glop she doled out. It irritated him that they always crowded ten people around the table, who all talked at once, shouting over each other in loud

and spirited conversation, and at one especially lively gathering he sat glumly silent. Jeanne-Claude asked him why. "They are all talking and I am not," he said. "And I am not a listener, I am a talker." With Christo, he had "a real refugee affinity," admiring him "as an artist who invented himself . . . not only himself but his art, and even more amazing, he invented his public." Steinberg liked even more that they had both studied architecture but never practiced it.

Perceptive friends recognized Steinberg's desire to hold forth and took care to create social situations in which he could. Priscilla Morgan usually had eight at her round table, and if Isamu Noguchi was there, he and Steinberg alternated in dictating the tone and tenor of the conversation. Jean Stein made sure that a congenial group surrounded Steinberg, managing gracefully to seat him among guests who let him do all the talking. She remembered his monologues as "more than enjoyable. You wanted to hear what he had to say." Saul Bellow had a slightly different impression: "Conversation seemed to make him awkward . . . you felt, when you met him for drinks or dinner, that he had prepared himself, had gotten up a subject from his very special angle. You were careful not to disturb him by introducing terms of your own and spoiling his planned effects."

Jeanne-Claude and Steinberg at one of Priscilla Morgan's famous dinner parties.

———

FOR THE NEXT SEVERAL MONTHS, STEINBERG'S calendar was full of invitations proffered by a list of glittering hosts from the worlds of high society and the arts, from Jacqueline Kennedy Onassis and Arthur Schlesinger to Günther Grass and Muriel Spark. In short, he was out every night, impeccably dressed in bespoke clothing, always bearing the perfect hostess gift and always on his own, without Gigi. By July thunderclouds were threatening the relationship, and she proposed one of her favorite ways to get rid of them: to ignore them through a haze of recreational drugs. This time it was LSD.

On July 7 they drove to the Foundation Castalia in Millbrook, New York, made notorious by Timothy Leary, to take LSD under his supervision. Gigi was a steady user of drugs, mostly whatever was being sold on or near the Columbia campus, while Saul generally made do with the occasional marijuana cigarette. She was so insistent that LSD would give him a far better experience than the mescaline he had taken six years previously that he gave in and decided to try it. Steinberg initially described the experience as one in which the drug was administered so that doctors could observe him while he was in the process of creating: "They wanted to see what I would do—brushes and pens supplied and so on, put on records. Listening to western music, even Mozart, became a nightmare." He described something different to Aldo, saying that LSD had given him "a day of such happiness that the memory of this possibility existing in me makes everything else unimportant, reduces miseries to their proper scale." He said he was convinced that the drug would become "something very important that can change the meaning of life." Interestingly, although he took other drugs from time to time, there is no record that he ever used LSD again. The euphoria dissipated when the drug wore off, and when he went home, his disposition returned to what passed for normal: the gloom of depression. It coincided with his sister's first trip to the United States.

Lica came alone in July 1965 to the overwhelming heat and noise of a New York summer, so they spent most of the time in Springs. She was content to laze away the days sitting outside in the sun with a stack of old newspapers and magazines, or to ride bikes to Louse Point for a late-afternoon swim, then go home for a quiet dinner, usually of grilled fish and vegetables from Gigi's garden, followed by an evening of listening to music and eventually reading herself to sleep. When Saul described Lica's visit to Aldo, he said that it had been pleasant to have the time and tranquillity to renew and deepen their friendship in ways they had never done before, but what intrigued him most was when he studied her as a scholar and saw "certain differences and suspicions caused by a simple fact: that we now belong to different social classes."

SAUL'S LEASE WAS UP FOR RENEWAL again when Lica returned to Paris, so he went to see an apartment at the elegant Beresford on Central Park West, though he immediately ruled it out because the Upper West Side was a foreign territory. Gigi had never liked Greenwich Village and often expressed the desire to return to the Upper West Side, where she had lived when she first arrived in New York, and on September 23, 1965, she moved there. After she became Saul's companion and while he lived in Washington Square Village, she gave up on the idea until they were driving home after Christmas with the Millers in 1964, when he said something that shocked her so much she began quietly to prepare herself to leave both him and her own apartment in the Village. Gigi asked Saul if he planned to marry her and let her have children. He told her, for the first of the many times he said it over the years, that he did not love her, and besides, Hedda was still his wife and even the thought of children was beyond the realm of possibility.

When she recovered from the shock, Gigi's first objective toward achieving independence was to get a job, which she did, in a design studio where she was mostly assigned to do hand lettering on preliminary sketches and to draft layouts. The pay was certainly not enough to support her, so she remained financially dependent on Saul's largesse and stuck in the Village. When she complained once too often about how far Waverly Place was from her work and her classes at Columbia, he told her to find an apartment wherever she wanted to live and he would buy it for her. She jumped at the chance to have a permanent home, mortgage-free and legally in her name, and chose one in a fine prewar building at 375 Riverside Drive, on the corner of 110th Street. It was on the second floor, where she could see the Hudson River only when the leaves were off the trees, and then only if she stood just so at the proper side of the large bay window in the light-filled corner room where she set up her drafting table, unpacked her books, and considered herself divinely happy. She lived there for the rest of her life.

Gigi kept busy on her own until the holidays were approaching, when she realized that it had been several months since she had seen Saul and made a note asking herself, "No Xmas?" She had been as social as he, renewing her friendship with Richard Fedem, a young instructor at Columbia who had married and divorced since their first encounter, and she became close to some of the neighbors in her building, particularly Jay Fellows, a young professor at Cooper Union, and his wife, Courtney. She also had several lovers, telling them all straightforwardly that she was the sometime mistress of Saul Steinberg and dependent on his support, and if he called she would have to leave to go to

him. Most of her lovers still wanted something serious, among them "Bill," who told her a relationship could only be what she made it, and "Peter," who urged her to let him take their affair to a new level. As Christmas approached and she did not hear from Saul, Gigi was upset about being alone. She considered accepting Harriet Vicente's invitation to join her and Esteban in Princeton, but in the end she stayed on at Riverside Drive and waited for the phone to ring. When she sent her regrets to Harriet, she signed her name as Sigrid, and Harriet replied that she was glad to know her true name. It was the one decision Gigi was capable of carrying out alone, without Saul Steinberg's support or approval: from now on she wanted to be known as Sigrid Spaeth.

Meanwhile, Saul continued to make his social rounds and the rest of the time to stay alone in Washington Square Village. He renewed the lease for another year, until September 1966, because of lethargy over the thought of moving all the possessions he had acquired, from the "junque" he brought back from his travels to the large collection of art he was informally amassing. Bill de Kooning gave him a drawing and Sandy Calder exchanged a mobile for one of his drawings. When Sidney Janis owed him $400, Steinberg asked for a Magritte instead. Lacking energy to work, he mostly read, finishing *War and Peace* and rereading Tolstoy's short stories. He marveled at Tolstoy's ability to write in what he was sure must have been a state of "ecstasy." Steinberg told Aldo that upon reflection, he could remember drawing in a state of "well-being" for two or three unspecified years, a satisfactory enough state until he realized that "well being doesn't count—what's needed is ecstasy." Thinking about it left him sadly convinced that he had never known creative ecstasy, which deepened his depression as the year ended.

He berated himself for being a semirecluse who worked sporadically and produced little of lasting importance Even going to Springs gave him no pleasure: "I seldom go to the country, alone I don't like it. Even the landscape is sad, trees with red leaves, like the painted old women of America." He had always liked to drive fast to East Hampton on the empty roads of wintertime, but this was no longer a thrill. Being alone in the house did not provide the same contentment as sitting alone in one room when he knew that someone else was in the next and available if he wanted her.

Quite simply, Saul Steinberg did not know what he wanted. He was fifty-one years old and at several crucial junctures in his life and work. Gigi, now known as Sigrid, was happy to be settled in an apartment of her own but nervously awaiting his summons to play out the next chapter of their relationship—to be dictated by him and complied with by her. He had brought in enough money to be so financially secure that he no longer had to work four to six months of

every year to meet his responsibilities. There was enough money to work only when he wanted to, and only on what he wanted to do. He could buy anything that caught his fancy and still be generous to family and friends, especially Ada, whose sole support he had now become.

From the mid-sixties on, his commercial work—if it can be called commercial—was mostly for nonprofit organizations which he supported by donating drawings, or for individual friends who asked him to provide book jackets or illustrations. In both cases, he sometimes designed posters, but here again he did the work in his own time and on his own initiative, and everyone had to take what he gave them. Even George Plimpton, who flattered him by asking him to "look around for something that might do for a *Paris Review* poster," had given up waiting for it by the time Steinberg finally got around to doing it. He did, however, manage to contribute a drawing in time for a benefit concert by a chamber music group with which Alexander Schneider was involved, perhaps as his way of responding to a harsh letter Schneider wrote that rankled deeply. Schneider was critical of the "new" Steinberg, who was so busy accepting invitations from the wealthy and privileged that he had no time to spend with the old friends who cared about the "man" Steinberg rather than about how the "artist" Steinberg could be used to enhance the dining and drawing rooms of the rich and famous.

Steinberg was never one to brood over snide comments, but he paid attention when Hedda sent one of her little unsigned squib notes saying much the same thing. He had gotten into the habit of telephoning her frequently, sometimes daily, and as it had been during their marriage, the conversation was always about him.

"Why do I feel the need to talk to you every single day?" Saul asked in one of their rambling telephone conversations. "Oh, that's easy," Hedda replied. "It's because we are the two people in the world who love you most."

Hedda always carried a tiny notebook in which she wrote snippets from her current reading or aphorisms and quotations from other writers and philosophers whose works she admired. Now her squibs were personal and sharply critical of how embarrassed she was to see him succumb to "snob appeal." Coming from Hedda, who never criticized him, this was truly terrible, and he did not know what to do about it.

Others criticized him as well. Dore Ashton was "shocked" by his response when she asked him to introduce her to Eugène Ionesco while he was in New York. When Ashton told him she wanted to interview Ionesco for an article she planned to write, Steinberg "gave way to [his] essential voyeurism" by suggesting that there were reasons other than professional in her request. He insisted

that he had to be present to observe the chemistry between them. Ashton told Steinberg that this was just another in the succession of times when he had not treated her with the respect a professional woman deserved; he had hurt her feelings deeply, and now it was time for her to tell him what she thought of him: "I feel I should give way to my own analysis of you as you have never hesitated to do with me. Saul, you do not love women. What you love is *your* reaction to them. They are merely another stimulant to your ravenous imagination. As for me in relation to you, I have indulged your attitude and cherish you for what you are. But I well know that deep sentiment is alien to you, that somewhere you are lamed, and that secretly you are afraid of and despise love. You give yourself to no one but take . . . Why are you like that?" She ended with asking him to let her be the "faithful old friend (how you detest 'old' friends!) that I am."

SUCH CRITICISMS MADE STEINBERG EVEN MORE reclusive and introspective, but rather than focusing on them, he tried to concentrate on the upcoming Paris exhibition. He started by making lists of tentative titles that the installers could use to identify the drawings, only some of which he ended up using. As he doodled with pen and paper, he indulged in reflections that became a guarded appraisal of where he found himself at this stage of life; he titled them "Notes on Writing." He began with a general, nonspecific observation that "writing in order to define oneself" was like mapping out territory he already knew in order to explore what lay outside it from different angles. Such reflection had a purpose: "To be one's own witness."

It made him think of "Wife and property or Real Estate, Love and Money." He gave himself advice: "Keep my money in the belt. Keep my wife in the belt. Whenever in doubt I refer it to money." After several further musings about money, he changed direction and wrote a phrase he did not explain: "Wife not pregnant this year." It led to musings about dogs, "miserable creature . . . lacks the duplicity of the man he imitates." In a musing about laughter, he put it "in the family of hiccups—fart, belch—therefore *not respectable.*" "The trouble is," he concluded, "that I give too many clues. Less clues, more chances for inventing—for *creating*—for taking over." Ultimately, his question to himself was whether to pay attention to those who cared deeply for him and whose concern was genuine. And if he did, what could he—or would he—do about it?

THE DESIRE FOR FAME

I was doing so well—playing the gentleman, drawing only as I pleased, and now once again I've got the desire for Fame and to compete with the other jackasses. A mystery, this wish to go against myself and court danger.

n terms of the evolution of Steinberg's oeuvre, 1966 was a watershed year. His subject matter took several interesting new turns as he used themes and ideas that had been successful in the past to create new work of a more philosophical nature, work that he said was "camouflaged as a cartoon" but did not really belong in that category. He wasn't worried that it would not suit *The New Yorker*, because he and the editors had reached an agreement several years previously: "They only want me to be sure that I myself know what it means. They want to be more in the position of a reader who is puzzled and intrigued than of an editor who wants to judge it." The editors knew that whenever he submitted a drawing, it was with the intention of making readers sense that there was "something else beyond the [initial] perception," and that he wanted them to share "the voyage between perception and understanding."

As a way of keeping ideas fresh for the drawing table and of jogging his memory later, he did a lot of doodling, calling it "a form of brooding of the hand [that] contains no reasoning." Among some of the many doodles he made during this frenzy of creativity were lists of titles for groupings, which he separated into general categories such as "the Hyphen," "the Accent," and "The Dominant Species." Occasionally he wrote commentaries that were meant to be explanations of a personal credo or instructions for what to aim for in future work, such as "say something interesting about Religion becoming autobiography." After this he wrote "Tillich?" but did not clarify whether he was referring to the theologian Paul Tillich or to himself. Religion and autobiography were two subjects uppermost in his mind, two parts of a puzzle that engrossed him as he thought about an important new project.

The philosopher Ruth Nanda Anshen had been asking Steinberg to provide drawings for a volume by Paul Tillich for the better part of a year, even before Tilllich's sudden death from a heart attack in October 1965. Steinberg vacillated, because he was busy fulfilling other commitments but also because accepting the project would require him to think about himself as much as about Tillich's personal credo. He had met Tillich in East Hampton shortly after he bought the Springs house, and in the years since had enjoyed discussions over the good dinners served by Tillich's wife, Hannah. Steinberg almost never held the floor when he was with Tillich, for he preferred the role of "first-class observer" as he studied how Tillich's unwavering spirituality and religious beliefs governed his every action. These were alien topics among most of his other friends, particularly the artists, and were hardly ever subjects for dinner-party conversation. Still, being with Tillich made Steinberg, who had always pondered questions about his cultural identity as a Jew, think about his heritage and how he expressed it (or not).

Ruth Nanda Anshen was an editor as well as a philosopher, and before Tillich's sudden death she had commissioned his volume for the series she founded and directed. The overall title, *Credo Perspectives*, reflected her special interest, the relationship between self-knowledge and the meaning of existence. Anshen's contributors to the *Credo* series came from many different walks of life; among them the art historian Sir Herbert Read; Pope John XXIII; Harvard president James Bryant Conant; and Supreme Court justice William O. Douglas. All were asked to write intellectual and spiritual autobiographies that would explain the creed by which they lived, how it related to their creative activity, and what aspects of their personal life had contributed to its formulation. Tillich was well suited for the series, and he gave her one of its most popular selections with *My Search for Absolutes.* The text was ready for publication before he died and lacked only illustrations.

Tillich died without suggesting an artist, but Anshen had two reasons for asking Steinberg. The first was that she discerned the philosophical musings in his earlier drawings and believed he was perfect for a biographical essay that focused on religious beliefs. Her second and more important reason was that she wanted to entice Steinberg into contributing a volume of his own to the series. He was perfectly willing to give Anshen a generous supply of drawings for Tillich's book, but he was not sure he wanted to—or even could—contribute a volume of his own. It took him the better part of a year to accept the Tillich commission, because the very idea of a book of his own induced an almost irrational fear of what he would have to face and might unwittingly reveal if he tried to write about himself. Even if he only submitted drawings without text,

he worried that they alone would give away far too much personal information. With great reluctance, he allowed Anshen to announce on the jacket of Tillich's book that his own was forthcoming, but he found repeated excuses to postpone it, and eventually the series came to its natural end without his contribution.

Steinberg was struck by how much Tillich's essay resonated personally, and his earliest illustrations were as much about himself as about Tillich. The essay reminded him of his own quest for autonomy, particularly in the years when he left Romania for Italy and then Italy for the United States. He worried that he was revealing too much with "this game of autobiography," but he could not keep from playing it and wondered if his interest in himself came from having read too many "biographies written by biographers—mediocre works really—where life is justified constantly by obvious causes, more like alibis."

In the past, Steinberg's wry and whimsical drawings had often disguised the seriousness of his inquiry (sometimes to his dismay, as when readers saw only the surface humor in his *New Yorker* cartoons and drawings), but the technique of whimsy was a perfect foil for Tillich's profundity. Anshen described Steinberg's playfulness as his innate understanding of life's ambiguities and of how, "in what might be called a negative myth, [he] *draws* attention to the phenomenon of contemporary existence."

Steinberg used many of his iconic figures light-handedly and lightheartedly, and yet each drawing compels the viewer to stop and ponder, to think not only about what there is to see on the page but also to consider the deeper meaning that lurks beneath the laughter. The viewer's first response may be to smile, but almost always it is followed by emotions that might begin with perplexity but ultimately lead to the recognition of something personal. Steinberg plays with the question of existence in everything from the hand that holds the pen and draws the artist who wields it to the mazes, question marks, and the words *yes* and *no* in various ramifications. Evoking Descartes, he posits existence by poising a man on the edge of a large cube in the middle of an imaginary landscape, with a faithful dog sitting attentively behind him. The man's head (both a caricature of Steinberg's own and his usual version of Everyman) has a thought bubble above it that reads "Dubito Ergo Sum"—"I doubt, therefore I am." It is Steinberg's response to Descartes's certainty that if one thinks, one exists, "Cogito Ergo Sum," and it offers a perfect parallel to Tillich's assertion that the tragic history of the twentieth century forced him and his colleagues out of the academy and "far closer to the reality" of the external world than their forebears ever were.

As Tillich plumbed his own life for the experiences that led him to create a system of absolutes, Steinberg provided him with expressive examples of

deeply personal meaning for both the writer and the artist. Steinberg depicts the existential anxiety of every stage of life from infancy to old age by showing men, women, and children climbing staircases or ladders or standing on a seesaw that has one side firmly grounded on land and the other teetering on the edge of a precipice. Everything in life is a balance, and some of his figures are more successful in achieving it than others: Steinberg's iconic figure of the artist holds a palette in one hand and a brush in the other as he draws the staircase on which he mounts steadily upward—until he reaches the top and finds that he has drawn himself inside a closed box. Boxes figure in the drawings, as do other geometric shapes that reflect the society in which his people live; buildings loom massively, overwhelming the phalanx of rubber-stamp figures that march in tandem beneath them—all except for a single figure who sports a thought bubble that depicts another self marching in the same direction as the others. Is Steinberg asking whether this is the beginning of mass man's search for individuality? Tillich certainly asked the question.

Everything Steinberg drew for Tillich's book was a veiled "confession" about his own life as well, which may have been why not all of his drawings were what Hannah Tillich had envisioned. She sent a letter saying that although she found them "strong and penetrating," she needed to muster "courage (without wild onrushes of stubbornness)" to tell Steinberg that she had qualms about how he interpreted some of her late husband's beliefs. She thought of "Paulus," as she called him, as a bridge between outmoded systems of belief and the new one he promulgated, and she urged Steinberg to portray this literally: "Draw me one bridge (across the enigmatic question-marker monsters and cat-ghosts)." He gave Hannah Tillich the ladders and staircases that he thought reflected the text, but he drew no bridges. Mrs. Tillich was also insistent that the book jacket should feature a line drawing of her husband's head, and she did not want Steinberg to draw it. Nor did he want to: Ruth Nanda Anshen had specifically asked him when he accepted the commission, and he had most emphatically refused. When Anshen sent Steinberg a copy of the finished book, she apologized for a jacket that was not in keeping with his drawings, insisting that the only thing that mattered was the "superb" content: "You and Paulus in the diversity of your unity."

STEINBERG WAS WORKING ON HIS NEW book during the time he worked on Tillich's, and when he finally settled on *The New World*, he called it "a great title which says nothing." That may have been true, but the content was something else altogether. He meant this book to have a strong, serious, and unified theme, to be a collection of metaphysical drawings that represented problems

and situations in life, "like a novel with a beginning, a development, an ending, and an epilogue." After the modest success of his previous books—or, in his mind, the lack thereof—he wanted this one to achieve the sales and reviews usually associated with blockbuster bestsellers, despite the fact that 133 drawings had already appeared in *The New Yorker*, so that his biggest audience might not be willing to rush out to buy a book they had, in effect, already read. Still, he worked harder on this book than he had on any of the others, for he was used to adulation and was determined not to settle for anything less. Also, there were three exhibitions on the horizon, at Maeght, Parsons, and Janis, and he wanted the book to create an audience and a market for the drawings on display.

In preparation for the book's launch, Steinberg gave a series of interviews to his friend Jean Stein in the summer of 1965, where he explained his work with far more honesty and openness than he had ever done before. There were other writers and critics who pursued him during this period, when he was in the public eye to a degree unprecedented in his past, but he chose Stein to convey his creative truths and *Life* magazine to be the venue for their widest possible dissemination. For those who might be newcomers to his work, and for those who were already familiar with it as well, he went through *The New World* with Stein, drawing by drawing, intent to explain how he himself interpreted his work. It was uncharacteristic for him to speak so freely about it, especially because he was working on the Tillich book at the same time and was often filled with panic and terror at the thought of having to contribute his own autobiographical volume to Anshen's *Credo* series. What makes the conversations with Stein extraordinary is that Steinberg spent so much of his life using casual evasion or outright deception to lead astray critics, art historians, and especially would-be biographers. Now he made the conscious decision that he was willing to lift his curtain of privacy in the quest for, at the very least, recognition, and at the most, fame.

One of the most personally revealing drawings in *The New World* is "the biography of a man, a famous man," who walks briskly along a path, followed by a hyphen that precedes the numbers of his birth year, 1905. Steinberg called this drawing "the monumentalization of people, this freezing of life," and with an almost sly relish told Stein that "anybody who is clever destroys fame or tries to mislead his admirers and biographers by being unpleasant or unreliable." Any "good man" who did this and got away with it was "a skunk," and Steinberg gleefully counted himself among them.

The title page featured the drawing that he called the "motto" for the entire book, one of his chubby little middle-aged men with pointed nose and chin, this

Steinberg with Papoose, the cat he loved as his best companion.

one in profile, with hands in his pockets and a thought bubble that reads "Cogito ergo Cartesius est." In Steinberg's translation, it meant "I reason—so it must be true that Descartes exists." His little man was a "symbol drawing" that could be used to explain every drawing in the book: A "symbol drawing [means] that what I drew is drawing. The meaning in terms of my work—my drawings—is that drawing is drawing. It's not a reality."

He explained further by using as an example his most important symbol drawing from the beginning of his career, and one which remained the most important until the end: the line, the straight flat line that "never makes any pretense of being anything else but a line." The line was the central component of almost every drawing in *The New World*; anything that appeared on or near the line, from shadows or flowers to trees or buildings, had no importance to or influence on the line itself, which was "a form of art criticism, a satire on drawing." The first full-page drawing in the book exemplified the importance of the line, where a man is poised at one end of a seesaw that is balanced by his drawing of spirals and doodles on the other end. Steinberg called this quest for balance a recurring motif in his art, that of "the relationship between a man and his work." The seesaw tilts slightly toward what the man has created, because "the work is his platform and the work is heavier than he." Steinberg meant for this man to be seen as an artist, and the work was "probably the only form of altruism the artist has. It's through his work where his arrogance and self-centerism stops."

Numbers appear throughout the book, and Steinberg uses them to combine "an illusion of reality with an abstraction." The number 4 was especially interesting because it offered the opportunity to include one of his real-life passions, cats. He had them when he lived with Hedda and he became enamored of one of Sigrid's, which he named Papoose, a black-and-white, intensely curious cat who figured prominently in many of his drawings. Four was a number he particularly liked because it could "arouse the curiosity of a cat," and indeed he drew a generic cat peering into a 4. He dismissed the number 8 as too visibly closed, and therefore "a cat has no business to look inside"; cats should peer into something that is "a little bit open, a mystery." Three was too "obvious" to elicit much interest; and the number 1 was a "nothing." A 5 is "maybe more intriguing," but only a 4 is "perfectly designed."

Another of his iconic totems, the crocodile, makes an appearance as "a monster—a dragon—who is the real essence of beauty." The crocodile had fascinated Steinberg since his trip through Africa, and he tried to describe it to Grace Glueck, saying that he was frustrated by wanting to get "some sort of

Saul Steinberg, *Untitled*, 1960.

idea of what a crocodile looks like, and I didn't." A surprised Glueck replied, "But you *know* what a crocodile looks like." Steinberg said, "I know, and I don't know . . . The main thing is to find out what sort of technique the crocodile is employing to show itself."

By the time of Stein's interview, the crocodile had become a recurring symbol, and in this book he depicts it as an "ambiguous line" in which the creature's backbone becomes "the horizon line on which a gooey, disgusting, so-called beautiful landscape appears with all the elements of beauty: moonshine, moon, clouds, palm trees reflected in the calm water, a swan—the true elements of beauty." That may be, but Steinberg meant the drawing to convey a sarcastic message: "Beauty is crocodilian."

He returned to a theme from the Tillich book when he pictured people coming up from somewhere underground to find themselves adrift in a landscape. He called this "a sort of sadistic play on perspective," because the people cannot locate themselves in space and therefore have to learn how to become located in time. "Time," said Steinberg, "is much quicker and plays

Saul Steinberg, *Untitled,* 1961.

tricks with us. Space is more reasonable; it has to be accounted for; it has to be logical."

He returned to the subject of the individual adrift in the middle of life when he placed two drawings facing each other on adjacent pages. In the first, a man walks on a horizon line toward a tree, a house, a windmill, and other objects denoting civilization, while behind him the line that was the horizon curls into a spiral. This was "his past; there is nothing; it's completely canceled." The man is walking toward his future, but the past is following dangerously closely in order to "eat him up." In the facing drawing, the man cannot look to the future to keep himself alive because he is inside the spiral of the past and it threatens to engulf him. "This is a sort of frightening drawing," Steinberg concluded. It represented "the expressionist who lives by his own essence . . . unconnected with the political and moral life of people or of the artist."

He returned to the sadness of people who are unable to communicate when he represented several conversations "in a stenographic way." On a sofa and several chairs he seats a "fuzzy" spiral, a "boring labyrinth . . . with a hysterical line," a "giggling, jittery bit of calligraphy," and several comic-book symbols for speed, noise, and confusion. When Steinberg lost his usual precision and drifted into a convoluted explanation of the many meanings a spiral could have, Stein asked if this was because he saw himself in any of the stenographic figures. "No," he said emphatically, "no place."

Various kinds of drawings representing uncommunicative conversations follow, from thought bubbles with his unreadable false writing to the paper-bag cutouts of figures spouting maps of their travels. They all lead up to one of his most popular drawings of all time: a boss who sits behind a big desk, smiling sadistically at a timid worker while over the boss's head a huge *NO* looms, entirely filled with unreadable false writing. When it appeared in *The New Yorker*, so many people wanted to buy the original that it generated the most fan mail Steinberg had received in all his years with the magazine.

Stein wanted Steinberg to talk about the many drawings that featured question marks, but he cut her short: "Let's not talk about question marks; it's boring. They are obvious by now, I've made so many." He wanted to talk instead about three other drawings that he thought were vitally important for an understanding of the book's general thesis. The first was of another of his fear-inducing spirals, this one a "misleading" series of concentric circles in front of a man who holds a pen in his hand and is visible behind it. In a nod toward his architectural background and the riddle of spatial relations, Steinberg called this drawing "a form of perversion." Because the man behind the spiral is visible, "actually this space does not exist . . . This is a spiral line that contains an even mass of space instead of opaque and transparent space the

way I indicate here." What he had done in drawing such a picture, he insisted, was beyond perversion: "It's a form of cruelty."

The second drawing depicted "a completely droll situation," an art lover standing in full emotional thrall in front of painting in a museum. Steinberg ridiculed viewers who gaze rapturously for long periods of time at art: "It's something intellectual that must be perceived in a fraction of an instant; the true lover of art going through a museum goes on roller skates and is extremely tired after five minutes."

The last one he wanted to discuss was the top one of two drawings on the same page, this one representing "the hero fighting a giant baby." On what appears to be an altar or the plinth of a gigantic monument, there stands one of his "mechanical" drawings, a doodled Don Quixote complete with shield and spear who points his horse toward a gigantic upside-down baby that is balanced on top of the plinth by its wiry strands of hair. In one hand the giant baby dangles a kitty-cornered midget version of itself. Steinberg said there was a "key" to this drawing: "the dragon the hero picks out for himself to fight, and anybody who fights a giant baby is really a dragon; it's not a hero."

For the cover, he found a sheet of the marbled paper used on the inside covers of old books and created what could easily pass for a journal, ledger, or diary, a blank slate on which readers could affix their own personal meaning. Steinberg left the marbled paper plain and unornamented except for "real gummed labels." The one in the center of the page that bore his name and the book's title could have graced any ordinary file folder. On the upper and lower edges he placed triangular blue protectors used to mount photos in albums, and he ran a red leatherized protective strip down the length of the spine. When his publisher questioned why he used such things to make a simple cover for a complex book, Steinberg said, "I liked them and they stuck and that simplified the whole thing." Stein was also puzzled by the simplicity of the jacket, especially because it gave no indication of the often startling content within. She asked why he chose not to use a drawing that would immediately identify him as the book's author, as he had done on his previous books, especially *The Labyrinth*, the cover of which showed a drawing that became one of his most famous, the man with a rabbit inside his head. In *The New World*, this drawing appeared on the back jacket flap, which Steinberg defended by saying that he had "no business to put a drawing on the jacket of a book of drawings." He thought it best to leave the rabbit man where he was, where he would be the reader's last (and lasting) impression as he closed the book.

———

Saul Steinberg, *Autogeography*, 1966.

Saul Steinberg, *Galleria di Milano*, 1951.

[TOP] Saul Steinberg, *Techniques at a Party*, 1953.

[BOTTOM] Saul Steinberg, *Untitled*, 1979.

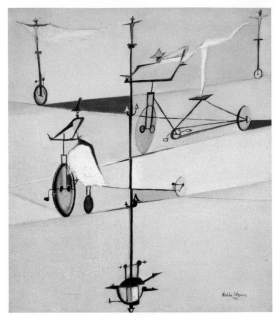

EXAMPLES OF HEDDA STERNE'S ART DURING
THE YEARS SHE LIVED WITH STEINBERG

[TOP] Hedda Sterne, *Untitled [Circus]*, 1945.

[MIDDLE] Hedda Sterne, *New York, NY*, 1955.

[BOTTOM] Hedda Sterne, *Antro II*, 1949.

[LEFT] Saul Steinberg, cover drawing for dustjacket of *The Labyrinth*, 1960.

[BELOW] Saul Steinberg, *Untitled*, 1969–70.

Saul Steinberg, *Bleecker Street*, 1970.

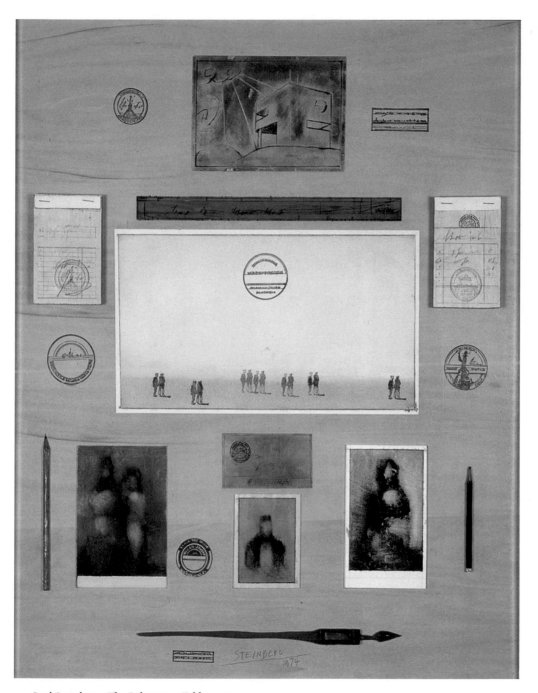

Saul Steinberg, *The Politecnico Table*, 1974.

[LEFT] Cover of *The New Yorker*,
March 20, 1954.

[BELOW] Cover of *The New Yorker*,
January 17, 1959.

[LEFT] Cover of *The New Yorker*,
May 25, 1963.

[BELOW] Cover of *The New Yorker*,
October 12, 1963.

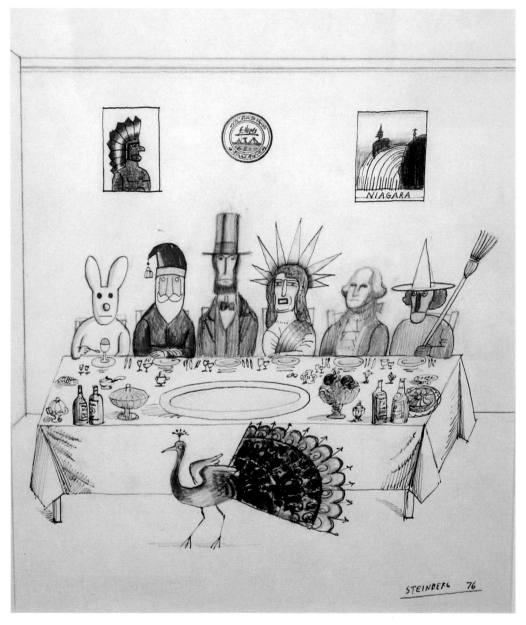

Saul Steinberg, *Peacock Thanksgiving*, 1976.

Saul Steinberg, *View of the World from 9th Avenue*, 1976.

Saul Steinberg, *Corrugated Catcher*, 1954.

[TOP] Saul Steinberg, *Dal Vero (Sigrid and Papoose), September 10, 1979*, 1979.

[BOTTOM] Saul Steinberg, *Long Island Duck, on Highway*, 1979.

Saul Steinberg, *Library*, 1986–87.

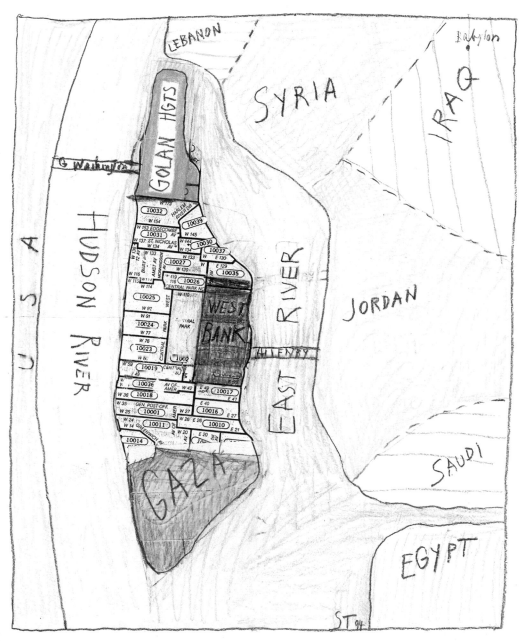

Saul Steinberg, *Zip Code Map*, 1994.

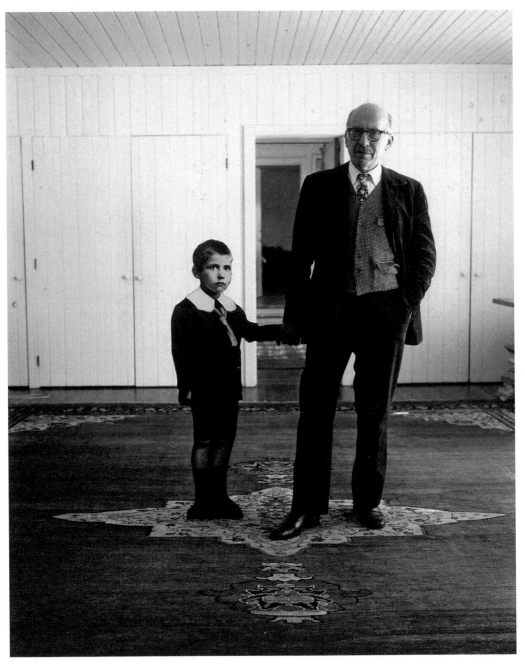

Saul Steinberg holding the hand of his eight-year-old self, 1978.

STEINBERG WAS PROBABLY WISE TO CHANGE the title of the book from "Confessions" to *The New World*, for when the drawings are taken as a whole they create a very different impression from when they are viewed individually. Like the man with the rabbit in his head, the reader cannot help but wonder what was going on inside the head of the artist who produced them. The wit combined with seriousness that Steinberg portrayed so elegantly in the Tillich book is certainly present, but the overall message is darker, the tone harsher, and the subject matter progresses in almost unrelieved starkness. When taken all together, the words Steinberg used to explain the drawings become—to use his word for the "Gog" drawing—an "interesting" way of interpreting the book. He labels some of them "satire" and says they are "sadistic," "frightening," and "unconnected," with components that are "hysterical," "giggling," and "jittery." In the conversations with Stein, he uses the words *destroy, destroying*, and *destruction* repeatedly to describe what is happening within various drawings. He is pleased that a number are deliberately "misleading," and "cruelty" is a recurring and satisfying theme. In short, the drawings in *The New World* convey a far different message from that of the illustrations in Tillich's *Search for Absolutes*.

STEINBERG'S EXHIBITION AT GALERIE MAEGHT WAS to open in March, and he went to Paris a month beforehand to oversee the work connected with it. Sigrid assumed that she would go with him and was stunned when he told her he planned to go alone. She flew into a rage when he refused to discuss his reasons, but when he stayed silent and would not engage in argument, she grew still herself. She was hurt, but she was also afraid of provoking him to an irreparable breach.

He went alone to Paris, where he burst into a flurry of activity, going every day to the printer in Levallois to oversee the production of *Derrière le Miroir*, the original lithograph for the exhibition posters, and the series of lithographs and prints that would be sold along with the drawings. *Le Masque* had become a much larger book than the one he had originally envisioned, but he was pleased with how it looked. He also liked the preliminary plans for the accompanying *DLM* and was content with the studio space in the gallery that Maeght set aside for him, where he could work on his mural and the panels on which Inge Morath's photographs would hang. Everything conspired to give him pleasure, and he was surprised to discover that even though he was exhausted, the work made him happy. All around him were "tables, light, cabinets for drawing, all my familiar objects."

He had been living in a hotel but was tired of it, and Morath insisted that

he move into her apartment when she and Arthur Miller returned to Connecticut. He was happy to be there after a full workday, when he was too tired even to go to the movies. He stayed in and read books about the Greek islands, because he had relented and wanted Sigrid to come to Paris and go there with him on vacation after the show was safely launched. "I'm happy," he wrote to her, enclosing a check for apartment expenses and an airline ticket, "NYParisNY." If she wanted to do him a favor before she came, she could buy a pair of his favorite English shoes at a Madison Avenue store, but she was not to bring "too much stuff" for herself, because he wanted to buy her whatever she needed in Paris.

Sigrid was wary of his sudden change of heart and did not join him in Morath's apartment. She booked a room at the Hotel d'Angleterre and said she would "show up at the opening for a moment." She assured him he would have "nothing to worry about. I don't expect you to stand there holding hands with me but I have to do what I consider right." In her last letter before her flight, she told him she was "very hysterical and full of anxieties," especially after the people she occasionally worked with at the design firm gave her tranquilizers as a going-away gift, and only half in jest. It was not the most soothing message he could receive on the eve of a reunion that was bound to be tense.

The exhibition opened to great success, with large crowds, good reviews, and excellent sales, especially to new collectors. All his friends were there, among them Hélion, Geer van Velde, Matta, Ionesco, and Sandy and Louisa Calder. Lica came with her family, and Sigrid spent much of the evening standing quietly with them instead of near Saul. She was ill at ease, and he made it worse by simmering angrily over her lack of poise and self-confidence. Some years later, when she was trying to relive the events of their relationship in a journal meant to help her understand it, she wrote about the strain of this opening and others that followed: "I never fitted, never was quite at ease with his friends. I don't have enough manners, class. And I don't have the clothes. I only embarrass him and myself."

Sigrid stayed on in Paris after the opening, but things remained strained when they took their holiday in Athens, Salonika, and Crete. Afterward, Saul went on alone to Rome and Milan before returning to Paris and Morath's apartment, while Sigrid flew there directly and moved back into her hotel. Saul let himself be caught up in the whirl of Paris socializing and did all that he had been too tired to do before the opening, dining out every night with old friends and new, especially with Maeght and the flock of collectors who had purchased drawings from the show and wanted to be seen with the Paris art season's current sensation. Sigrid was mostly on her own until May, when she

went to Trier to see her father for what turned out to be his last birthday (he died in September).

Things continued to deteriorate badly between them. In a cryptic entry in her journal jottings, Sigrid wrote the single sentence "This is when he hit me." She neither explained the comment nor referred to it ever again. Saul never did either. Whatever happened remains known only to the two of them.

WHEN HE RETURNED TO THE UNITED STATES, Steinberg holed up in the country, spending the summer and early fall hard at work on the Parsons and Janis exhibitions, which loomed in November "like an exam in a French Lycée." He knew from the start that the joint show was "going to generate a lot of interest and excitement" because it came on the heels of the French one and was his first American exhibition in thirteen years. The year 1966 had indeed been a memorable one, overwhelmingly full of new experiences generated by the two successes, the exhibition in France and the publication of *The New World* in the United States. Both gave him a huge boost of self-esteem; as he said tongue-in-cheek to Aimé Maeght, "Seeing the book always makes me realize how great I am."

He used this combination of arrogance and self-confidence to deal with the onrush of reporters and photographers who clamored to interview a suddenly newsworthy artist who had just received two exceptional honors: he was about to become the first ever artist in residence at the Smithsonian Institution and a Chevalier de l'Ordre des Arts et Lettres of the French government. The medal was conferred in September at a ceremony in the French embassy in Washington, where Steinberg's "embarrassment" was eased by the French cultural counselor Edouard Morot-Sir's "very nice speech" about him. The Smithsonian appointment was widely viewed as "another medal of honor," which Steinberg was to earn by spending two to three months in Washington, beginning in January 1967. He had to begin to think about the details involved in making the move as he juggled all the work for the joint exhibition and a host of other projects. Steinberg told Aldo that he was "in that state of trance of soldiers or actors who must do something without any longer knowing why."

On top of the work connected with the gallery shows, he was overseeing the curators who were installing some of his other work in several museums. Maeght moved most of the Paris drawings and murals to St.-Paul-de-Vence, where his Fondation Maeght hosted another show after the one in Paris closed, and the Museum of Modern Art in Brussels planned to show the mural panels from the 1958 World's Fair. The Cincinnati Art Museum exhibited several of the murals Steinberg had made for the restaurant in that city and wanted to

know if he would consider making several others. He sent a telegram saying, "My fee today would be seventy-five thousand dollars," and there the matter rested.

Money was pouring in from the sale of his drawings and the reprints that he had authorized as illustrations for books and articles. One of the many buyers was the Hamburg, Germany, newspaper *Die Welt*, which used them to illustrate John Steinbeck's article "America Today." Steinberg was pleased to be associated with such a distinguished writer and gave permission readily.

With all these requests came a new series of legal concerns. Steinberg objected that he would have no control over the drawings sold in the Parsons-Janis exhibitions, as the owners would normally have the right to do whatever they pleased with them. He wanted the same agreement with the galleries that he had always insisted on with publications, that he sold the drawing for one-time use but all rights of reproduction remained with him. This was fine for periodicals but was not usually the case with gallery sales. Alexander Lindey told him that copyright was "a complex subject that resists simplification" and his only option would be to rely on "statutory copyright" if he insisted on retaining all other rights. He advised Steinberg to draw the standard symbol for copyright (the letter *c* in a circle) somewhere on each drawing, and to photograph every one, making sure that the symbol showed clearly. He also advised him to make a rubber stamp reading "© 1966 by Saul Steinberg. The sale of this drawing covers only the physical drawing itself. The artist reserves all other rights in it, including copyright." And he warned Steinberg to make sure that the catalogue was copyrighted in his name and not in the names of the galleries.

In retrospect, Steinberg was wise to retain control of his drawings, for the works in the Parsons-Janis shows sold even better and for much higher prices than those at Maeght. He bragged about it to Aimé Maeght: "I sold eighty pictures at respectable prices—even more and at higher prices than Paris. Naturally, this gives me great pleasure." He told Aldo it gave him "paternal satisfaction" to watch his drawings being "sold at high prices." Even the articles and reviews gave him pleasure, particularly two he singled out for their "high quality," *Vogue* and the *New York Times*.

By the time of the American exhibitions, the publicity bandwagon was clipping along at an astonishing speed. Journalists were first alerted to the possibility of a good story when *Time* and *L'Express* wrote about the Maeght exhibition. *Time* described crowds who rubbernecked, chuckled, and occasionally snorted, saying that the scene was "ready-made for a Saul Steinberg cartoon." The article also noted that Steinberg was "breaking a 13-year self-imposed

ban on exhibitions," and journalists lined up to find out why. When Pierre Schneider took Steinberg on a walking tour of the Louvre and published their conversation as "an unsettling trip through art history," the flood of requests took off like one of Steinberg's cartoon rockets. Many interviewers came from Europe, and before the year ended Steinberg had been filmed for programs dedicated to his life and work on German and Italian television networks, and others were in the works. In the United States, in the heyday of magazine popularity, some of the leading cultural critics ensured that he was everywhere: Jean Stein's long article appeared in *Life*, he was photographed by Irving Penn for *Vogue*, Hilton Kramer wrote about him in the *New York Times*, and Harold Rosenberg published one of their conversations in *Art News*. He was actually disappointed when the *Times* story did not feature him or his work on the cover, as he had been led to believe. Rosenberg commiserated, but only slightly: "Congratulations on your non-appearance on the cover of *Times*. By this time you must be sick of this whole business of appearances and realities."

Steinberg was not actually sick of the publicity merry-go-round, but it was a mixed blessing. He was no longer just an artist whose work was easily recognized on sight (primarily by readers of *The New Yorker*); he had become famous and he was a celebrity. On the popular television program *College Bowl*, contestants were asked to identify "the line philosopher-artist-cartoonist." Without even seeing a drawing, they all answered, "Saul Steinberg."

Everyone, it seemed, wanted a piece of him. Groups and organizations that recognized the cachet of using his name invited him to lend it; others simply wanted to welcome him among them. The Romanian Socialist Republic requested his company after the opening of the eighteenth session of the United Nations General Assembly; he was horrified by the invitation and ignored it. SACO (the Sino-American Cooperative Association), the organization of those with whom he had served during the war, invited him to the annual reunion; he never joined, never paid dues, and ignored this one too. Those he did not ignore tended to be political, but he was cautious about how he showed his support. A committee known as Angry Arts, whose members included David Dellinger, Paul Goodman, Grace Paley, and Robert Nichols, invited him to join a protest against the Vietnam War by appearing in support of those who planned to burn their draft cards in Central Park. He supported the protest but did not attend, and when this same group wrote to Picasso to ask him to withdraw *Guernica* from the Museum of Modern Art, Steinberg offered vocal support for that as well, but he did not sign his name to the letter. He had never hidden his support for civil rights and was pleased when a drawing he donated to support the Southern Christian Leadership Conference in

honor of Martin Luther King, Jr., was put on view in the Museum of Modern Art; when the Congress of Racial Equality asked him to join other artists in donating one of his works to raise funds, he sent a drawing of a knight on a horse aiming his spear at a tiny alligator. His support for Jewish organizations was always unwavering, and when Brandeis University's Women's Committee asked him to contribute to its annual auction, he sent ten signed catalogues of the Maeght show, which they estimated would bring in a minimum of $500, a substantial sum at the time.

There were too many invitations, and because he still did not have a gallery assistant to help with the work or a full-time secretary to help with correspondence, he tended to ignore anything he did not want to do. A committee that included Philip Pavia and Lester Johnson felt the need for a new place where artists could gather and invited him to join the Second Street Workshop Club (formerly the 8th Street Club). He did not respond. When he ignored a letter from the Guggenheim Museum inviting him to lecture on his affinity with Paul Klee—a facile association that was beginning to irritate him more and more, and one that he did not want to promote—he not only ignored the initial letter, he also ignored the several that followed.

Everything went well in 1966, and 1967 augured to be much the same. "I go on working (like the winners of lotteries)," he told Aldo, "recognizing that it's the only valid pleasure." To Aimé Maeght he described what he would be doing next: "I'm going to live in Washington for three months, in grand style in an elegant house, with a Chinese cook, etc. etc. Come see me!" He was not as welcoming to Sigrid, telling her to stay in New York and keep herself busy, as he would not have time for her. This time she did not confront him but confided her anger and dismay to a collection of diary jottings.

Her insecurity pervaded what she wrote about how he had dictated every aspect of the relationship and she had gone along with whatever he wanted just so it would continue. Now she found "the constant fear of insults . . . unbearable." It was "amazing" to see how unkind he could be, but she warned that if he continued to be so cold and undemonstrative, he would have no problem getting rid of her: "I may be slow and sticky, but even I slowly accumulate enough resistance to resign myself . . . As long as I am with you, I am dependent and my misery is at least partly your responsibility." She blamed him for "getting me down, putting me down, and making me miserable." Their relationship had disintegrated into "a constant watch on either side, for the offense from the other, or . . . " Unable to finish her thought, she left it there.

She was alone on New Year's Eve and saw very little of him before his departure on January 25. By February, even though there had not been any-

thing like a separation, she was begging him to take her back, telling him she was "down" and not sure she should be writing at all: "Don't mind my vocabulary. I'll never be a pleasant or elegant letter writer—or probably person—for that matter." When he did not respond, she tried a different tack. As he was in Washington, she asked, "How does the whole Viet Nam story look from there? Here it becomes more and more unbelievable. Maybe everybody including me should do something." He did not respond to that either. He was conscious that he was not American by birth and careful not to make any overt gesture that might bring criticism. He had been reading Henry James and found a quote that he particularly liked: "It is a complex fate to be an American." It came to mind often during his three months in Washington.

SUCH A DIDACTIC COUNTRY

*The Washington experience is over now and I see it's left me with
a bad taste. It's my fault. I went there to meet the chic, political
world, a world I already knew to be a fake but which awed me.
Now, having overcome the monster, it's not that I feel better. But
I worked well, or at least a lot.*

A h, America—such a didactic country!" Steinberg said this every year
when he was summoned like clockwork for jury duty in East Hampton
as well as in New York. It was a blessing to be excused in 1967 when
Charles Blitzer, the director of education and training at the Smithson-
ian, wrote a letter attesting that he was on "official duty" at the institution.

The Smithsonian took care of all Steinberg's arrangements for the move.
His stipend for the three months was a handsome $25,000, with an extra $3,000
for the "unavoidable expenses of relocation." In an article about local celebri-
ties, the *Washington Post* featured his glasses (but not his full face) and said
that he would live in the grand Georgetown mansion of Mrs. Harold Coolidge.
As soon as word got out that he was coming, requests of every kind flooded
the Smithsonian's publicity office, all from local organizations and individual
taxpayers who thought they were entitled to get something for their money
from Steinberg.

These were in addition to the requests from the local media and those in
even greater number from international correspondents, who were delighted
to have something other than politics as usual to write home about. A recal-
citrant artist like Steinberg was grist for their mill, and the chase was on. The
reporters' letters literally begged him for interviews, and he declined them
all. A headline in the *Washington Star* described their frustration: "Smithso-
nian's Steinberg: An Artist Not-in-Residence." Technically, he had no duties
at the institution; he was simply to be there and do his own work, with the
hope (but not the promise) that he would consent to give some sort of public
program during his tenure, of his own choosing and in his own time. He was

quite within his rights to ignore all the requests except for one that he could not legitimately refuse, from Mary Krug, the managing editor of the museum's house organ, the *Smithsonian Torch*.

With the *Washington Post*, Steinberg was "an easy interview . . . quotes just spilled out of him," but it took several months of Krug's reminding him firmly and persistently that he was "a subject of interest to Smithsonian personnel" before he would talk to her. Steinberg was capable of exuding tremendous charisma whenever he wanted to charm someone, but if he did try to impress Krug, she did not fall under his sway. She barely hid the tension between them in an article bound to raise the hackles of everyone who read it, including Steinberg. Krug called him "the Steinberg enigma" and quoted what the *New York Times* said about his place in the art world: that there were "mixed feelings about him among his colleagues, even among his friends. Some . . . consider him a major artist; but a few will not concede that he is an artist at all."

They met in the Coolidge residence, a detached four-story mansion, "one of the elite of the elite in that high rent district [Georgetown]," where all Steinberg's needs were catered to by four Chinese house servants, a couple and their two daughters—who were asked by the neighbors to go through his trash and give them anything with his writing or drawing on it. Steinberg called the house something akin to a "Norwegian Palace," as it belonged to the widow of a zoologist who had specialized in "large anthropoid apes." The library had an excellent collection of zoology books, classics, and many nineteenth-century travel writings, and the voracious Steinberg read his way through most of them. As for the Chinese servants, the husband "cooks pretty badly," so Steinberg survived on boiled eggs and toast when at home, which was seldom, because he dined out every night and most days for lunch. The high living took a toll on his digestion, and he had to consult a doctor, who put him on a strict 2,000-calorie-a-day diet that he did not follow until he returned to New York.

He met so many people that he had to keep a notebook of their names and jot brief descriptions to help remember who they were. Senator Edward Kennedy was "Teddy K—no gossip." Other political luminaries included Averell Harriman, William Fulbright, and Eugene McCarthy. He liked "Mrs. Longworth: 83 yrs dtr of Roosevelt." From the press, he met "Kay Graham, pub *Wash Post*," "Herb Block [Herblock]," and "Scottie Lanahan, Scott Fitz daughter." Gore Vidal rated only his last name without a capsule description, but Joe Alsop did better, earning a parenthesis: "(good food, snob)." Steinberg drew an arrow from the names of "Polly & Joe Kraft" to the word "HORRIBLE!" He renewed his friendship with the heiress Kay Halle, whom he knew from his navy days in Washington, and he also met a number of eligible and attractive

women, whose names were on the list with no other identification, except for one who had a "bed w[ith] bells."

He did not meet President Lyndon Johnson, but Vice President Hubert Humphrey took him to a recital at Constitution Hall, where he met "the famous daughters," Lynda Bird and Lucy Baines. Every embassy in Washington had him on the guest list, and he made false documents or diplomas for many of them, including the Venezuelan ambassador, who thanked him effusively for "the most admired diploma from the great philosopher, architect, and social critic, Saul Steinberg." He did not meet any of the Supreme Court justices, but he went to the Court to sit in the gallery and sketch. He made a list of the justices' names, collected their photos and signatures, and used some of both with only slight changes for his imaginary writings and documents.

The one document that truly spurred his imagination was the Smithsonian stationery, which featured an engraving of the 1855 building known as the Castle, a huge red sandstone pile built in the late Romanesque–early Gothic style of the twelfth century, tailor-made for Steinberg's imagination. By the time he left Washington, he had made countless drawings that incorporated the logo, but he left only thirty-six for the museum's collection. He included the logo on drawings of teapots, dinner plates, and a drafting table; in another drawing, a dog stands on the edge of a cliff and dreams of it in a thought bubble above his head; in another, it graces a moonshine jug, top-heavy on a spindly table; and in still another, the logo adorns a bottle of India ink.

All these drawings were play, as was the thirty-foot-long scroll whose inspiration Steinberg thought might have come from his daily contact with the Chinese house servants. He called it "a diary in drawings" on which he recorded the events of each day, working faithfully until he realized it had "enslaved" him. He abandoned it when he thought he had ruined it by "trying to make it too beautiful.

All the reporters who denounced the "artist not-in-residence" might have been kinder had they known how hard he worked every single day. His output was steady, especially when juxtaposed with the constant socializing, which started in the afternoon and ended every evening with him in formal dress. And just because he was in Washington, it did not mean that he had left behind all the work that originated in New York. He had to put the finishing touches on the drawings for the Tillich book and deal with the details for the Brussels exhibition and the subsequent shows when it traveled to Holland and Germany. There was the usual flood of requests from publishers, corporations, and cultural institutions, which he had to ignore or reject, and the preliminary negotiations for agreements pertaining to an exhibition in Venezuela the fol-

lowing year, and several others in the year after that. He was also working on a vast new project, four curtains for Stravinsky's *L'Histoire du Soldat* commissioned by the Seattle Opera Company. Steinberg was captivated by the task, because it was for a traveling company that performed in "remote fishing, lumber, and farm communities," and he had fond memories of seeing some of them firsthand when he was in the northwestern states. He was quite pleased with the project and boasted of it in his interview with Mary Krug, telling her that "nothing is ever created in Washington except in a political sense" and that painting the opera curtains was the first boon of his residency: "In the short time I've been in Washington something has been created here."

WHEN STEINBERG WENT TO WASHINGTON, he and Sigrid had not been together for months. She was still attending classes at Columbia, working sporadically for a design firm, and occasionally doing the lettering for a book jacket. She continued to have relationships with other men which she initiated, then ended, and then usually resumed, almost lethargically and almost always in tandem with the ups and downs of her emotional state. Saul arranged for money to be deposited in her bank account at regular intervals, and he also paid the many bills sent directly to him by Saks Fifth Avenue and Bloomingdale's, incurred by "Mrs. Saul Steinberg," as her name on the charge accounts read.

He planned not to return to New York until his residency ended, but he had to make an abrupt trip when his accountants advised him to protest another IRS audit. The bureau claimed that he owed an additional $5,956.02 for the years 1964 and 1965, which meant that he and Hedda had to appear at a hearing on a weekday. He did not want Sigrid to know he was in the city, but he feared that someone would see him and tell her, so he broke his silence and sent a polite letter telling her he was well and well looked after and that he might have to return to New York for a short time. She replied swiftly, but not until after she tried to phone and could not reach him because he had given her the wrong number. It was a disjointed letter in which she first asked if she could come to Washington for a weekend and then crossed out her next sentence: "Maybe I should take the hint and leave you alone." She ended with the hope that she would hear from him again and with the poignant observation, "There isn't anything else I can do." A pattern of behavior was forming between them: whenever she was depressed or her mood swings made her act out in unseemly behavior, he always responded with alacrity to try to get her back onto an even keel. In this instance he phoned and told her that a ticket was waiting and she should fly down for the weekend. She was ecstatic.

The only part of the weekend when they had "a good time together" was when they were "hiding under the blanket." She found his affection "reassuring" and looked forward to his visit to New York the following weekend. Unfortunately, when he was there she asked him to clarify their status, and a violent argument ensued. Sigrid began by saying that since he was in almost daily contact with his accountants and his lawyer, and since he would be in Hedda's company because of the audit hearing, she thought now was the time for him to ask Hedda for a divorce so he could marry her. She was thirty-one years old, she was tired of being his "sidekick," and she wanted to have children. To calm her down, he told her that divorce would not be a simple matter, not only because of the laws in New York State but also because of the complexity of his and Hedda's financial ties. He told Sigrid that he would have to consult the head of Neubauer and Berman, the firm that handled his investments, to see if divorce would be possible. It provoked her to rage: "Why do you behave like a hysterical old woman and go hiding behind Neubauer? Why do you have to tell me what he thinks and sort of add that's what you feel, too? Why can't you be straight ever like a man!"

He returned to Washington after the audit hearing, and except for the occasional letter or phone call, there was no real contact between them until he was back in New York at the end of April, and even that was usually only when she needed to discuss money.

WHILE STEINBERG WAS IN WASHINGTON, he had a ringside seat for the controversy over Vietnam. He had been against the war from the start and quietly, gradually, met other people who shared his view. There were certain homes where they gathered to talk about what they might do, and there was such a feeling of hiding out in the face of danger that it brought back memories of "the way we met in air-raid shelters during the war."

The first major battle of the war began that November at Ia Drang and lasted for three days, from the fourteenth to the sixteenth; the U.S. Seventh Calvary was ambushed on the seventeenth, and a national protest was scheduled for November 27. On that day 35,000 protesters gathered at the Washington Monument and surrounded the White House. By the time of Steinberg's arrival in Washington several months later, the war had given him back the "outrage" he thought he had put aside when he took off his navy uniform and returned to civilian life.

Anyone who asked Steinberg to contribute to a protest against the war knew he could be counted on, as long as he could do it quietly and behind the scenes. He was still grateful to America for taking him in, and he bal-

anced his gratitude carefully against his disagreements with political policy. He agreed with his old friend Ad Reinhardt, whom he had met when they worked together as cartoonists for the leftist paper *PM* during World War II, that they could not use the same excuse the Germans had used against Hitler and the Nazis—that they did not know what was going on—and that it would be criminal to stand by and do nothing. Steinberg quietly stepped up his activity in early 1967, and his work on behalf of antiwar protests continued for as long as the conflict lasted. Among the first to enlist Steinberg was the group Artists and Writers Protest, when Dore Ashton and Max Kozloff, both members, asked him to contribute to a "Collage of Indignation," which was exhibited the same week he left to take up his residency at the Smithsonian. From then on, Steinberg gave money and signed petitions, but mostly he donated art or designed posters that were auctioned to raise funds.

There were significant changes to his work at the beginning of the war and subtle touches as it dragged on. Instead of drawing the seals and stamps on the false documents by hand, as he had been doing, he began to have them made to order. In addition to the official-looking seals, signs, and stamps, he had figures made—of men on horseback, soldiers on foot, and other figures and animals in various poses and activities. All told, an informal count of his collection numbers around four hundred, but he insisted that he needed only a core group of fifty "to render space, nature, technology" in what he called "a computerized form of art." He told this to Grace Glueck when she had interviewed him in 1966, well before computers were in general use; he also told her that he liked to use rubber stamps because they helped him to "avoid the narcissistic pleasure of hand work." He said he kept his vision fresh by "making these simple elements and then arranging them."

He used other "simple elements" as well, many of them as collage objects. Graph paper became hulking skyscrapers, airmail envelopes became ominous warnings of possible bad tidings, and postcards were given new meaning when he drew people, animals, or landscapes on top of the original picture. This posed a problem for *The New Yorker*, because the magazine did not use color until the 1990s. However, it was the rubber stamp—the "cliché," as Steinberg called it—that gave the real "political meaning" to his work. For him, "the cliché is the expression of the culture of a period," and in his "territory, which is satire," he served up both "mediocrity and clichés" whenever he criticized the things he did not like. Uppermost among them was the Vietnam War.

Steinberg's contributions to *The New Yorker* increased steadily throughout the decade of the 1960s and continued to grow at the same steady pace throughout the 1970s. The sixties were truly the decade when his name and the

magazine's became synonymous, when his drawings were used to lure advertisers and subscribers alike. Under William Shawn's editing, the magazine had come to exemplify a "greater social and political and moral awareness" and was a haven for writers who explored and exposed the clashes in culture and society. Steinberg's work paralleled the shift, especially after the magazine began to feature essays that dealt specifically with Vietnam by writers such as Richard Rovere, Neil Sheehan, Richard Goodwin, and Jonathan Schell. Steinberg replaced his abstract and cerebral ponderings with what he saw on the city's streets, heard on the nightly news, and read in the underground newspapers that proliferated in Greenwich Village, where he walked the streets every day and observed the passing scene. Bleecker Street became a bizarre psychedelic playground populated by wailing police cars, cops brandishing phallic billy clubs, wigged-out druggies, and costumed counterculturists. Anthropomorphic animals roam Steinberg's streets, some of them bearing a vague similarity to Mickey Mouse on their threatening visages. His women sport overblown helmeted hairdos, sprayed to the nth degree, their mouths spewing aggression and their bodies dissolving into long legs and killer stiletto shoes or boots.

Were they funny? Were they comic? Many readers thought so, even though so many more objected to the magazine's increasingly overt political content. Steinberg wanted to make them aware of the criticism as well as the humor, and many times it was tough going to get the point across. Humor was a way of somehow telling the truth, but he knew that humor could also be "subversive" when he used it to camouflage the political meaning of a drawing and make it a shade or two more palatable than it would have been without its slight disguise. He believed that most of his audience would not be able to grasp a "political response" to his work, because "the response to art comes a generation or two later." As for what he was trying to convey, he saw the drawings as having "two levels—entertainment and morality." He held the idealistic view that "any artist has a basic morality and responsibility. Morality doesn't mean 'do's' and 'don'ts.' One learns morality during a lifetime."

LIVING IN THE PAST

*I work and see few people, of my mafia, a sign of advanced age.
I live twenty years or more in the past.*

Steinberg was in New York for one month before the urge to travel struck again, but he had no one to travel with, because Sigrid was in Paris. She told him to invite Aldo to spend the summer, but instead he began to collect want ads and hired a real estate agent to show him apartments, this time concentrating on the Upper East Side, in the same neighborhood where Hedda lived. He was still in real estate limbo at the end of the year when he invited Sigrid to go to Mexico, where nothing was the same as he remembered it from his 1948 trip with Hedda and the Cartier-Bressons. "Things change," he concluded, and he began to think about making some of his own changes at home. He decided to put an addition on the Springs house that would give him a large ground-floor workroom with a bedroom behind it, and he also decided to find studio space in the city that would include living quarters so that he could leave Washington Square Village. Once again time passed, he dawdled, and he did nothing concrete except renew his lease.

In April 1968 it was almost as if the perfect studio space dropped into his lap without any effort on his part. When he heard that the eleventh (and top) floor was available in the building at 33 Union Square, near 16th Street and Broadway, he acted quickly and secured the lease on 4,500 square feet of raw space. It was in an office building, but the view was so beautiful and filled with light from windows that looked out on the Consolidated Edison Building's famous clock tower that he wanted to live there. He secured permission to use part of it for his residence and planned to move in the following spring, which would allow time for a leisurely departure from his apartment. His intention was to build walls for a bedroom and kitchen in the part of the loft that already

held a staircase leading to a small tower room overlooking Union Square. It reminded him of "a pavilion, a kiosk with windows halfway between Turkish and Venetian," and he planned to use it to sit and think and to gather ideas from watching the street life down below. "Isn't it sumptuous?" he asked all visitors who toured his raw space before he took them to lunch at one of his favorite neighborhood places, Max's Kansas City. His building took on extra glamour when he learned that Andy Warhol's Factory was three floors below his studio, although it was disappointing never to see Warhol or any of his regulars in the elevator because they did not keep the business hours that he did.

Before he could move in, there was much to be done to make the space livable. He got as far as making a list of tradespeople whom he asked for plans and estimates, but mostly he left the space in the condition he found it in while he spent the summer dealing with adjunct events that arose from the numerous exhibitions held that year in Europe, South America, and the United States

Friends on Steinberg's porch: left to right: the Nivola family (Claire, Ruth, Tino, Pietro), Evelyn Hofer (seated on porch), Saul Steinberg, Dore Ashton holding her daughter.

and preparing for the two important ones the following year at the Parsons and Janis galleries. In Springs he was content to work and see old friends like the Rosenbergs and Hedda, who had her own house nearby, on Hog Hill Road. He had renewed his friendship with Muriel Oxenberg Murphy, a wealthy woman whom he met when she worked at MoMA and who invited him to her salons in the city, and during the summer he accepted numerous invitations for dinners at her house in Wainscott. Occasionally he visited Betty Parsons in Southold, where she had a house on the beach, and he and the Nivola family were casually back and forth across Old Stone Highway.

It was a low-key life, and as summer lengthened into fall, the country was so pleasant that he stayed on longer than usual. Sigrid was with him occasionally, happy to be there to harvest her garden and take care of "the little house," a small cabin similar to the early cabin motels that used to dot Long Island highways. Steinberg had bought it for her as a birthday present and had it moved onto the property just below his house. It was a simple wooden shell of four walls and a roof, without utilities or facilities, but she loved it and planned to use it as her studio. "We're going through a nice period," he told Aldo, "maybe because we're both learning to be less *testardi* [stubborn]."

WHEN WINTER FINALLY ARRIVED, IT WAS a brutal "Romanian winter" that seemed unlikely ever to end and brought illness and depression with it. Steinberg, who liked to think of himself as "healthy as a crocodile," caught a grippe that would not go away, and with it came uncharacteristic migraine. On top of the headache, there were ongoing problems with his teeth and another onslaught of dental appointments. When he finally conquered everything that he lumped into the single word *ailment*, all he had left was "the fear," his name for free-floating anxiety. While he lingered on in the country, being alone there gave him so much time to brood intensely that the physical symptoms caused by worrying made him give up his customary daily bottle of white wine and several scotch whiskeys. However, he intensified his smoking to several packs a day. "I function poorly these days," he told Aldo, "because I have doubts and uncertainties that leave me paralyzed."

His sleep was interrupted, so he spent long nighttime hours rereading Joseph Conrad (an old favorite) and books that Hedda recommended: a biography of Richard Wagner ("written for those who know music") and the memoirs of the revolutionaries Aleksandr Herzen and Pyotr Kropotkin. The only way he could alleviate his stress was to work, and he kept himself busy preparing for the two New York exhibitions and making what was for him a veritable deluge of drawings for *The New Yorker*. He thought it ironic that by presenting

the magazine with so many offerings he was "sabotaging the show and art with a capital A, maybe so as to free myself from that commercial world."

STEINBERG MADE OCCASIONAL TRIPS INTO THE city as fall turned to winter, going mostly back and forth between the studio and the apartment. With each trip the stress mounted as he saw the work piling up in both places and knew he could not handle it. He was not good with his hands, so there was no one to take care of mounting and framing the drawings for the exhibitions. His correspondence was a mess, as letters remained unopened and dunning letters warned of bills seriously overdue. An occasional series of part-time secretaries came and went with swift regularity, overwhelmed by the mess of so many papers. He had better luck with a studio assistant when he found the Dutch artist Anton van Dalen, who stayed with him for thirty years. Steinberg was walking down 57th Street on his way to his galleries when he passed van Dalen and asked if he knew anyone who was looking for work. "Why not me?" van Dalen asked, and the partnership began.

Steinberg was greatly admired in Holland, and van Dalen had been one of his fans while growing up there. They met for the first time in September 1965, on van Dalen's second day in New York, when he found Steinberg's number in the phone book and called to ask for a meeting. Steinberg said he was busy and asked van Dalen to phone again in two weeks. When he did, Steinberg invited

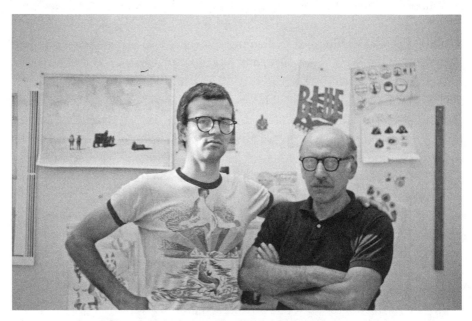

Anton van Dalen and Steinberg in the Union Square studio.

him to the apartment, where they talked about art for more than two hours. When they met again on 57th Street and Steinberg told van Dalen how much he needed help now that he had a studio, van Dalen offered to begin work the next day.

To van Dalen, Steinberg was a man "who lived largely in his own head [and] was really not good with his hands. He was of the society where to work with your hands meant you were of the laboring classes, and he thought himself above that. He would watch me carefully, fascinated by simple things like mounting his artwork on boards, or gluing strips of wood together."

The gratefully relieved Steinberg called van Dalen "Saint Anthony," and once he was on board, their way of working fell into a pattern. Van Dalen went to the studio every Wednesday and did whatever needed to be done that day. Sometimes Steinberg would ask him to go to the downtown galleries or the uptown museums to see and report on shows he did not want to attend himself. When he became intrigued by an idea, such as the shape and color of New York taxicabs, he sent van Dalen out on the streets to "just snap pictures," after which he used what he wanted. Steinberg asked van Dalen to walk the entire length of Canal Street and take photos of buildings and people. When Steinberg saw a tree growing in the most unlikely space outside a Chinese dry cleaner's on 75th Street, he made van Dalen photograph it at every season of the year. "He seemed always to be trying out things," van Dalen remembered. "I had to pay very close attention to everything he did in order to figure out what it was that I was supposed to do." Steinberg was fascinated by some of van Dalen's tools, particularly a chisel that allowed him to cut wood in forms that resembled books. He raved about it to Red Grooms and Mimi Gross, two friends whom he saw a lot during his early days on Union Square and who shared his fascination with tools as toys. When Gross bought a glue gun, Steinberg insisted that Grooms had to demonstrate it, and together they built an arch out of Styrofoam blocks. And when Steinberg discovered the Staedler eraser, he bought one for Gross, who told him truthfully that it was one of the greatest presents he had ever given her. It pleased him more than any of the compliments she paid when he gave her presents of his own creation.

Very quickly van Dalen observed that despite such working friendships, Steinberg was an extremely private man who expected him to be the same. If anyone talked in the studio, "it was usually Steinberg, in a monologue; my job was to listen and not interrupt. The only time I could ask questions was if they were perfectly phrased for what I needed to find out, and if they were minimal, brief, short." Steinberg's favorite topics of conversation were the books he read

and the movies he saw. He also liked to talk about his sister, Lica, and much of what he said was to marvel over the joy she expressed now that she was exposed to the Paris art world and exploring new directions in her own work. Sometimes he would leave van Dalen alone while he kept a luncheon engagement or dropped in at another artist's studio, often that of Mimi Gross, who worked nearby. He would stand quietly and patiently observing whatever she was doing, and if she was impatient with something difficult, Steinberg usually made the same response: "The true artist never takes any shortcuts. You deal with the work no matter how hard it is until you get it right." In his own studio, he exhibited the same sort of patience with van Dalen, who learned early on to hide any frustration he might have felt.

One very important part of Steinberg's day was his telephone conversation—and sometimes multiple conversations—with Hedda Sterne. Usually they talked about the books each read, with Hedda being the one most likely to recommend the writings of a little-known philosopher or the memoirs of revolutionaries. She kept up with the literature of their native Romania, and despite Saul's supposed disinterest, she passed it along to him and he read it, so that even though he never spoke of contemporary Romanian culture, he was well informed about it. Van Dalen learned to keep busy in another part of the studio while Saul and Hedda talked, as their conversations could last a very long time.

Mostly, despite Steinberg's love of music and van Dalen's wish to hear it, they worked in companionable silence. Steinberg had an "old-time record player" but seldom used it, he kept his violin in the studio but seldom played it, and he never talked about music. A major part of van Dalen's job became keeping order in Steinberg's life. He made the phone calls to set up appointments with workmen and tradesmen, he settled the overdue bills, and he spoke to the near-hysterical petitioners who wanted something from Steinberg, everything from accepting an advertising project to selling a particular drawing that the person wanted to buy. Even though Steinberg appreciated what van Dalen did, he was still uneasy about having someone in his workspace: "It was very hard for him to have people around him. He wanted his own space, his solitude." Van Dalen noted how this attitude dominated Steinberg's "arrangements" with women, not only Sigrid and Hedda but the constant procession of others as well: "He saw them in his own time, on his own terms. They were never a daily part of his life."

AFTER "SAINT ANTHONY" TOOK OVER, Steinberg thought his life was in good order at last. The dunning letters from Sam Flax, the Union Stamp Works

and Printing Company, Kulicke Frames, and Mourlot Graphics stopped, as Anton wrote the checks with regularity and Steinberg duly signed them. He was well taken care of in the city, but there were still problems at the house in the country. It needed a new water pump and well, and the expense of a new roof was looming. He spent so much time there that although he no longer had sufficient work space, the studio addition had to wait because so much needed to be done to the existing structure. Money became a concern again, although not nearly to the degree it had been when Steinberg's parents were alive, but he still kept a separate daily calendar to list his income and earnings.

He had been a prudent investor from his first stock purchases in the 1940s, and his blue chips brought steady returns over the years. He had three covers on *The New Yorker* in 1969, and there were other individual drawings and portfolios in the magazine as well. He invested a good part of everything he earned at the magazine in its "participation trust," and was pleased to see its value increase steadily in each quarterly statement. There was also a steady income from reprints of his drawings in books and magazines, royalties from his fabric designs, and sales of his work by Parsons, Janis, and his foreign galleries. All told, his taxable income totaled $64,000 and he paid $18,000 in taxes. He had more than enough to take care of his self-imposed responsibilities: monetary gifts to Hedda, his regular support of Sigrid and Ada, and generous gifts to Lica and her children. After all this, there was still more than enough to pay all of Aldo's expenses and invite him to spend the summer in Springs once Steinberg decided he could not go to Paris and Milan.

Sigrid was noticeably absent that summer, as another troubled period between them had begun. In a datebook/diary she wrote, "July 24: S. hits me." Several weeks later she went alone to Wyoming, but not before writing pathetic letters begging him to let her make one final visit to "the little house." He retreated into silence and did not reply, so she went away until late summer. When classes began at Columbia, she enrolled for several at the last minute, having nothing better to do. In November she met a new lover, Reesom, an African foreign student whom she told friends was an "Ethiopian prince." He was twenty-five, ten years younger than she, and besides being beautiful, she found him to be kind and gentle. She knew the relationship did not have a future, but within weeks she was deeply in love and so happy for the first time in years that she invited him to move into her apartment. In early December she sent Saul a letter explaining how surprised she was by "such an extreme and extravagant change" in her life, "to have found someone to be with and like, who likes me." She told Saul it was a relief not to be "drifting around bars, lonely and desperate, or sick alone at home, or begging [him] to be nice." She

thought he would ignore Reesom, as he had all of her previous lovers, because his enormous successes of the past several years had made him even more remote than usual, so that, poignantly, "It didn't seem to matter what I did or what became of me."

Saul did not respond to her letter until he phoned at Christmas in a frightening fury. All she recorded of their conversation was "no food money." On New Year's Day 1970, she wrote another letter to say she was sorry that all he felt for her was "hate and disgust." She told him that she could not undo her affair, but he might be able to consider it "less horrible" if it led to some improvement in their relationship. She told him she would go back to him if he wanted her, because once again she had discovered that her "(so dubious) loyalty" was to him. Even so, she was both hesitant and afraid to resume their relationship: "You have been putting me down and calling me names for such a long time. I can't stand to hear you insult me, and hate me, and it makes me want to hate back and I don't want to do that ever."

Saul let his anger fester until January 7, when Sigrid received a "mad call from S. to throw R. out." When she didn't do it, he demanded to see her, and on January 13 he issued an ultimatum: if Reesom did not leave, they were through—but only emotionally and not financially, for he would honor his commitment to support her until she could take care of herself. Reesom did move out, not because of Saul's threat but because he was spending the next semester in Europe and had to leave anyway. Sigrid and Saul met again, a "sad meeting" on the eighteenth when he told her that he was going to Africa in ten days and he expected her to be waiting—alone—when he returned. Sigrid did not obey, and a week after Saul went to Africa, she followed Reesom to London. Together they went to Spain for a month, then back to London, where she stayed until mid-March, even though Saul returned to New York in February. When she recorded this period in her datebook, she gave no details of her life with Reesom, only a vague itinerary of their travels; what she wrote instead was about Saul: "Not with S. almost 4 months (later), painful."

STEINBERG HAD WANTED TO RETURN TO Africa ever since his visit to the central part of the continent in 1963. This time he decided to make Kenya his headquarters but to take a roundabout way of getting there. First he made his usual circuit of Paris and Milan, and then he revisited Jerusalem and Tel Aviv. From there to he flew to Nairobi, then to Murchison Falls in Uganda before making his second visit via Addis Ababa to Sandro Angelini in Lalibela, Ethiopia. He was not looking forward to the rest of the trip, knowing in advance that

it would be "a disaster" to make his first visits to cities in the newly independent nations: Lagos, Nigeria; Accra, Ghana; and Dakar, Senegal. Ghana was "the armpit of the world"; Dakar was beautiful but full of rude and arrogant people taking advantage of their "recent independence to give you trouble at customs, in hotels, etc." He had a basic hatred of the Arab world that dated from his Romanian childhood, and it intensified when he revisited the places in Morocco where he had been stationed during the war—Marrakesh, Casablanca, Fez, and Rabat. On this trip he was especially irritated by "too many people who follow you around, offering things, begging, they touch you. I was never left alone."

In later years Steinberg always joked that he went to Kenya to meet a "crocodile man [who] thought he was going to have a nice crock talk with me." He was speaking of Alistair Graham, a distinguished biologist who studied crocodiles for the Kenya Game Department at Lake Rudolph. Graham urged Steinberg to go to Lake Rudolph to see them for himself, but Steinberg was set on going to Murchison Falls and did not make the trip, promising Graham that they would go together when he came again the following year.

Before he went to Africa and while he was corresponding with Graham, Steinberg went to Brooks Brothers to get himself fully outfitted in the clothing he assumed all white men wore on safari. On his first day in Nairobi, he was a vision in khaki as he sauntered down the street in a bush jacket of many pockets, shorts, knee socks, sturdy boots, and a pith helmet. He even had a swagger stick, which he left in his hotel room after the first time he ventured out, when he saw that no one else was dressed as he was except for—"of all people," as he later expressed it—Saul Bellow. Neither man knew the other was in Africa, so the meeting came as a complete surprise to both. When Steinberg told Bellow that he was on his way to Entebbe, Uganda, as the jumping-off point for a visit to Murchison Falls, they decided to join forces and go together. From this point on, their accounts differ greatly.

In an article Bellow wrote after Steinberg's death, he described a booze- and drug-fueled trip in which everyone was high on hashish, including the "madly happy" Steinberg. Bellow claimed that hashish made him "deeply depressed," so he stopped using it, but he implied that Steinberg continued to take it and to drink heavily throughout the trip, not resuming his "regular, orderly, non-narcotic life" until it was over. This seems highly unlikely, for whatever Steinberg's behavior might have been in private, in public he was impeccably circumspect, the very model of discretion and correct social behavior. Also, at a time when Idi Amin was not yet in full power but was already dictating public conduct and cruelly punishing anyone who did not adhere to

his puritanical standards, it is highly unlikely that Saul Steinberg would have risked calling attention to himself by the egregiously bad behavior that Bellow described.

What he did while at Murchison Falls was far from drunken carousing. He spent long days accompanying an English biologist who was following the same lines of research on crocodiles that Graham was undertaking in Kenya. Steinberg observed how the biologist killed and dissected crocodiles to find out what they ate, watched while he cooked and ate some of their flesh, and politely declined to share the feast, as the thought of eating such meat "disgusted" him. Steinberg was fascinated by the crocodile's behavior—the way it could lie in the mud like a dead log and then suddenly flash into action to devour unwitting prey. Most of all he was mesmerized by the "toothpick bird" who sat inside the crocodile's open mouth, unconcernedly pecking its food off the gigantic teeth: "Nobody in the world is as safe as that bird in the crocodile's mouth. They have an understanding, a pact between them, a deep relationship between two systems."

He saw the crocodile not as a reptile but as "a study in camouflage disguised as a crossword puzzle, all dark green, light gray, and sepia, alternating in a vertical and horizontal system of words, a magic animal with riddles and puzzles on its sides." The only thing more powerful than itself and the only creature the crocodile feared was the fat and placid hippo, "who can hit him with its head and cut him in half." Steinberg "hated" the crocodile, because it was "obviously part of the primitive system of nature where certain privileges were given unevenly to different species . . . the son of a bitch is vicious, has terrific teeth, is a great swimmer, and on top of it he's armored. So he's got everything, and this is why I think he is of the nature of the dragon." He also thought the mythical dragon "had too many advantages," and that was why he used the two interchangeably in his art. Both symbolized "the monster, the political life of administrations, of power, and just like the crocodile, power has too many advantages. It spits fire, swims well, and has terrific teeth and is armored. It's corrupt and wicked; it's impossible to have power with equity and modesty and nonchalance." For him, the crocodile symbolized any "administration in evil form, political power in general, specifically economic, artistic and cultural. Anything you want—it's a crock."

ALTHOUGH STEINBERG INSISTED THAT "traveling is not for picking up an idea" but rather to be used as an "intermission or a time out," he still returned to New York full of ideas and eager to try them. The sheer size of the Union Square studio gave him the sudden desire to experiment with "big things,"

and he took up oil painting with gusto, working on some of the landscapes and rubber-stamp collages that would eventually become part of his next book, *The Inspector*. He had accepted an extremely lucrative commission from the art publisher Harry Abrams for a series of lithographs and had conceived "a series of riddles" for *The New Yorker*. The Abrams deadline loomed, but he was captivated by playing with a reproduction of Millet's *Angelus* that he had torn out of a French newspaper in Paris; when he got home, he could not stop superimposing his rubber stamps of the praying couple onto the various photocopies he had made. Steinberg had van Dalen work diligently to pack and send the works for his two solo exhibitions in 1970, one at the Kiko Galleries in Houston, the other at the Felix Landau Gallery in Los Angeles. He was more lackadaisical with organizations such as the Carnegie Institute Museum in Pittsburgh, to which he had promised four paintings for an international exhibition, and which started to make repeated demands in June, when he was almost six months late in delivering them for a show that autumn. At the same time, the Spectra Media Corporation of Hollywood wrote and phoned repeatedly to beg him to "enter into investigative discussions" about a television special or series. He eventually sent the paintings to Pittsburgh, but he ignored the group from Hollywood. Van Dalen also had to take care of Steinberg's donations to various institutions and organizations, everything from a watercolor for the Palm Springs Desert Museum to a poster designed specifically for the East Hampton Guild Hall's fundraising.

Requests from the world of politics intruded as well. Lica had become politically active in France and wanted him to sign a petition prepared by a group of Maeght's artists who were against the Vietnam War and wanted artists throughout the world to boycott all cultural programs sponsored by the American government. Steinberg was against the war but thought the petition went too far by inadvertently penalizing those who made their living through the arts and refused to sign it. He did, however, contribute to the manifesto entitled "The Demands of Art Workers' Coalition to the Galleries," and when the Fellowship of Reconciliation invited him to Nyack to meet Danilo Dolci, he accepted with alacrity.

DESPITE ALL THE ACTIVITY THAT SURROUNDED HIM, Steinberg insisted that he lived "closed up . . . into my shell like a turtle." Most of his feeling of isolation came from yet another estrangement from Sigrid. He was enraged not to find her in New York when he came back from Africa, and when she returned, he would not take her phone calls or answer her letters. Despite his silence, she sent postcards to express how much she wanted to reconcile, such

as one that featured two cuddling lion cubs from the Zurich zoo. She begged him to take her back, but he maintained his usual stony silence. He did agree to let her stay in the Springs house in May, but only because he was not there himself. She left a letter on the kitchen table for him to find when he returned, telling him that she was "less lonely here alone than with you."

It had been ten years since they began their relationship, and Sigrid analyzed it from her perspective: "We were never a couple . . . What you need (and got finally) is not a woman but a sidekick . . . What really was there between us in the last (how many) years? Some dirty pictures and lots of pulling and pushing and tension. You made me into a lonely old maid. Yes, Mr. Steinberg, you don't know how to be close, only in the mind. But I am human not an idea and the caress of a bum at the right moment when I needed it was more assuring than all your words."

Sarcastically, she berated him for not wanting a flesh-and-blood woman but only an audience of one, avid to scoop up his every golden remark and precious idea. He might have thought that he was wasting his words on her, but probably not, she concluded, because "you don't really waste much, sooner or later you exploit everything and make it pay." Sigrid was sure that he would find a way to turn whatever unhappiness he was currently feeling into something that would bring further fame and fortune, and that he would use any brilliant or cute remark that seemed wasted on her on more appreciative audiences.

Steinberg ignored her letter, and when he broke his silence, it was to tell her that they were never going to be together again. She was devastated and so distraught that Mimi Gross feared she might be suicidal. Gross and Grooms were so concerned that they invited Sigrid to spend the summer with them in Provincetown. Being there seemed to lift her spirits, especially after she found a run-down shack and put her personal touches to the place. She even tried to work again by setting up a space where she contentedly painted watercolors with the intention of preparing a portfolio to take to galleries when she returned to New York. She also planned to get in touch with some of the publishers who had previously hired her to design book jackets to see if they would have work, and she was going to ask the design studio where she had worked part-time or freelance for something more permanent. "She was just getting used to being on her own," Gross remembered, "and then he called and she ran back to him, leaving everything."

The reunion lasted less than a month, and this time they both thought the separation would be forever. "It has been coming for a long time," Sigrid wrote in what was to be her last letter to Saul for quite a while. She had returned full

of hope, only to find that nothing had changed, and the ups and downs were incapacitating: "I just don't think I can make it, and the more I get discouraged, the less I can cope." She insisted that since Reesom had left, she had been faithful to Saul and not used drugs, staying straight and not cheating because she wanted to win him back. Saul was not swayed by her pleas, and once again his response was an impenetrable wall of silence.

He claimed that once she was gone, he deliberately restricted his social life to spend most of his time alone, but as always, his appointment calendar contradicts the assertion. It listed (among many others) novelist Anthony West, songwriter Adolph Green, publisher Roger Strauss, literary agent Candida Donadio, and gallery owner Xavier Fourcade. He was correct, though, when he said that he saw a lot of the old friends he called "my Mafia," among them Betty Parsons, the Vicentes, and the Nivolas, because he was happy only when living twenty years in the past.

When he was in New York, he was reluctant to leave; when he went to Springs, he always stayed far longer than he intended. He compared himself to the turtle in his shell, because he was doing what he always did when he could not arrive at a decision, tucking in his head to "pretend the problem does not exist. Or," he added, "rather several problems."

For years he dithered about whether to live permanently in the city or in the country, in the United States or Italy or France, but now he was in the sad state of "inevitable confusion . . . three houses, not to mention the three girl friends, etc." He wondered if he should give up both the apartment and the studio when the leases expired. If so, he would have to buy a bigger house in the Hamptons or else put a huge addition on the house in Springs to hold all the treasures he had accumulated over the years. As for the women, even when things were fine between him and Sigrid, he indulged in ongoing long-term liaisons with several married women in New York, two off-again, on-again married lovers in Paris, Ada and another occasional lover in Milan, and still another in Turin, all of whom he saw regularly for copulation without constraints on either side. Sigrid used to mock him for "looking absolutely silly performing for those cold fish, the tall blond American college girl type," whom he pursued openly in every social situation, to the embarrassment of his friends and the amusement of those who saw "the ridiculous aspect" of his pursuit of younger and younger women.

In all situations he excused himself by saying that he could not make decisions on his own and was "waiting for a *deus ex machina*." One quiet Sunday afternoon when he was alone in the city apartment—the first time he had been there in seven months—he dreamed for a brief moment of walking away from

everything and moving into one room to live like a student. Swiftly he dismissed the idea as "a fantasy" and concluded that the only decision he could make was to make no decision at all. "Meanwhile," he decided, "confusion is an excellent climate for working," and working was his only "area of calm, a refuge."

FURNITURE AS BIOGRAPHY

*I got to work as though out of remorse and work has
become a vice.*

Here I've spent five days in a beautiful prison," Steinberg wrote to Aldo
Buzzi in February 1971 from Zurich, Switzerland. He had checked
himself into the Privatklinik Bircher-Benner on the advice of Vladi-
mir Nabokov, to see if he could stop smoking, cold turkey, through a
regime of controlled starvation. There were also medical tests, examinations,
and massages, but unfortunately the hunger treatment did not work, and he
continued to smoke his several packs a day for another year or so.

He liked Zurich, a "clean and orderly city." The clinic stay was actually a
side trip tacked on to an exhibition of his work at Maeght's Swiss gallery after
it closed in Paris. It was one of his two solo exhibitions that year, the other
at the Richard Gray Gallery in Chicago, and he was in three group shows at
the Art Institute of Chicago, Washington's Corcoran Gallery of Art, and the
Bibliothèque Nationale in Paris. He had submerged himself in his own work
with such a passion that his interests spilled over into activities within the art
world and he became a more public artist. He was a judge for the American
Institute of Graphic Arts show, chaired that year by Milton Glaser, and because
of his friendship with Donald Barthelme (they met through *The New Yorker*),
he donated the drawing "Two Women" to a show called "She" at New York's
Cordier & Ekstrom Gallery.

He was also turning out work at warp speed for *The New Yorker*, which
featured five of his drawings on covers during 1971. Three of the five were
quasi-philosophical and word-dependent, with the one for July 31, "I do, I
have, I am," among his most lastingly popular. It generated enormous mail,
including a letter that Steinberg particularly liked from a fan who told him

he must have befriended "a couple million scientologists" because the drawing represented the three conditions of existence according to Scientology's founder, L. Ron Hubbard: "Be, do, and have." Another cover was more quietly profound, a landscape peopled with vaguely figurative words either marching in a parade or floating ethereally alone and depicting states of being based on the verb *to be*.

As Steinberg drew these covers, he was already thinking of the kind of drawings his next book should include, and unlike the previous ones, for which the title was a last-minute decision, this one had a title that he had already settled on: *The Inspector*. He chose it carefully, to convey the idea that his was the all-seeing eye pointing out the enormous changes happening within culture and society, manners and mores. Steinberg always liked to meditate on the twin topics of art and reality, and he did so here with drawings that illustrated the onrush of tectonic shifts and changes in the art world of the seventies and of how the artist was affected by them. He dealt gently and humorously with the theme by featuring an artist-dog who stands on his hind legs holding a brush and palette to ponder the canvas on which he has just painted the adage "Beware the Artist." Storm clouds explode over the artist-dog's head as he critiques his work, perhaps an indication of the ferment and fracas that Steinberg glimpsed or heard about every day when he went to his Union Square studio.

The cover he titled "Bleecker Street" signaled another change in his subject matter, as it marked the time when Steinberg "left his study for the streets" and much of his work became "all about New York: its images, streets, and city scenes."

Besides his sightings of what went on in Warhol's Factory, which was in full swing a few floors below his studio, he could see and hear the noise, confusion, and chaos of the passing parade in Greenwich Village from his front-row seat on the balcony of his fifteenth-floor apartment. His version of what happened on Bleecker Street incorporated sentiments from his growing involvement with antiwar activity, his ongoing iconic imagery, and his serious explorations of materials and techniques that he had experimented with only briefly in the past. To render the drawing, he added graphite, colored pencil, and watercolor to his usual crisp black line, all of which were smudged, smeared, and softened in various degrees. They gave a blurred and unfocused quality to various parts of the drawing, which as a whole he intended to be unsettling but also to be instructive and educational. In this drawing, the process of making it was as important as the idea it conveyed, and he wanted viewers who studied it to see how he, as the artist, made the decisions that led to the completed work. To make sure viewers could see the process, he gave strict instructions to the

magazine's art department not to erase the many signs of strikeouts, erasures, and other changes and corrections he had made as he worked.

Some of Steinberg's ideas about how to portray people in street scenes came from the underground comics that he had been collecting for several years, everything from R. Crumb's eccentric vision to the characters in Japanese manga. From them he took grim, scary, and pop-eyed faces, shiny black-helmeted authority figures, and creatures either bristling with fear or armored and threatening

The last of the five *New Yorker* covers was far more serene, a collection of six small paintings he called "Six Sunsets," positioned to resemble two rows of postcards, mini-canvases depicting Steinberg's fascination with the way the light changed throughout the day at Louse Point. As he worked on this series for the next several years, he turned to executing both large canvases in oil and watercolor on paper, and a major component of the paintings became clouds. He was delighted with them and proudly included many that featured clouds in the Maeght exhibition of 1973, as well as in the exhibitions at Parsons and Janis. Hedda Sterne trained her critical artist's eye on the paintings and found them seriously flawed, lacking in originality as well as technique, and they sparked one of her most stringent and caustic criticisms of his work. She told him she could not understand his fixation on such a mundane subject, saying that he, who had always known his strengths unerringly, had "evidently lost all sight of the uniqueness of your gifts. Thousands and thousands of idiots can outcloud you!" She admonished him to "have fun. Play! . . . Don't underestimate your god-given ability to enchant and delight . . . beware of the wrong kind of pride and self-challenge!"

Without making direct references to Sigrid, Hedda was not only criticizing Saul's subject matter, she was also criticizing the way he was conducting his personal life. He had not recovered from the shock of Sigrid's affair with the Ethiopian, Reesom, but he succumbed to her tearful pleas that he should to try to forget it. Hoping that travel would work its usual magic toward reconciliation, he put her "on probation" and took her on a holiday to the Virgin Islands, Mexico, and Arizona. It was not the healing experience either wanted, for everywhere they encountered wealthy retired Americans who seemed to be turning idyllic scenery into "concentration camps for old folks." They returned home despondent, and by Easter, when Sigrid claimed that Saul called her "a pig," they had separated yet again.

STEINBERG RETREATED INTO A WHIRL OF work out of "remorse" over the distress in his life, and work quickly became an absorbing "vice" he could not

get enough of. While he was churning out new drawings, an intriguing offer came from the Geneva publisher Albert Skira to contribute a book of writings as well as illustrations to the series called *Les Sentiers de la Création* (Pathways of Creation). Skira, who was renowned for his beautiful art books, invited an elite group of international artists, writers, and other intellectuals to write about the genesis of their personal creativity. Among those who had already written or accepted to write were Steinberg's friends Joan Miró and Eugène Ionesco and an artist he admired and to whom he was pleased to be compared, Pablo Picasso. He relished being in the distinguished company of Michel Butor and Roland Barthes, whom he knew through their essays for the two volumes about his work in the *Derrière le Miroir* series; he had been acquainted with Elsa Triolet and Louis Aragon since his encounters with the Sartre-Beauvoir existentialists at the Pont Royal bar in the 1950s; and he had been aware of the international theoretical influence of Jean Starobinski and Claude Lévi-Strauss ever since Hedda Sterne had encouraged him to read their books, along with the poetry of René Char and Octavio Paz. Steinberg was inordinately proud to be included in such company, and as "the writer who draws," he set to work with alacrity in Springs and scheduled a meeting with Skira in Geneva on his next trip to Switzerland, in November. Steinberg did not come away with any insights into what Skira wanted after they met, because all the publisher talked about was Picasso. Still, he remained enthusiastic about the challenge, telling Maeght that "a writer's work is a lot more difficult and tedious than mine is, but what a pleasure to learn a new craft." The euphoria dissipated abruptly when Skira gave the book the title *La Table des Matières* (Table of Contents) and announced its imminent publication before Steinberg had written a word or made a single drawing.

WHEN HE MET WITH SKIRA, STEINBERG had just made his third flight to Europe in a single year, still something of a novelty in the early 1970s. He had flown to Zurich for the October 22, 1971, opening of his exhibition at the Maeght gallery there and joked to Aimé Maeght that going back and forth so much was bound to raise suspicion that he was smuggling heroin. He had made the two previous flights because he was worried about how his new work might make the forthcoming shows "risky," and he wanted to do what he could to mitigate the danger.

In June, depressed and in a bad mood after his travels with Sigrid, he had gone to Paris, mostly just to get away but also to make sure everything was proceeding according to plan. Once again he irritated everyone working at the gallery as he obsessed over what each picture should be called, where it should

be hung, and how much it should cost. The last decision was the most crucial, as he had spent money lavishly during the past year and was so desperate for an infusion of cash that he had to ask Sidney Janis for an advance of $10,000 against future sales.

Steinberg spent the evenings systematically working his way through dinners with his sister and her family, his long list of friends, and the two women with whom he had been in sporadic long-term liaisons since the late 1950s. When he finished his business in Paris, he made his usual circuit of friends in Milan, including Ada and especially Aldo.

He had a difficult time in October trying to fit in everything that he wanted to do. There was his opening in Zurich, and as soon as his show was safely launched, he went again to the Buchinger Klinik but this time to the one in Bodensee, the Überlingen facility in the isolation of Lake Constance that Nabokov had recommended for overcoming his cigarette cravings. This time the starvation treatment worked, and two months later he told Aldo the "sensational news . . . no more accordion in the chest, no more human ashtray." It made him feel so strange not to crave cigarettes that he used one of James Joyce's favorite words to describe what happened to him: "metemphyschosis" [sic], a veritable transmigration of the soul.

The isolation on the shores of the frozen lake in the depths of winter brought on the need to reach out to friends he could confide in, and as always happened when he was away from home, his feelings toward Sigrid softened. He sent her a postcard that he signed, "Saul with warm blue scarf [her Christmas gift to him] who sends love." Even though he had been away from home for the better part of 1971, and even though he claimed he was desperate to get back to his studio to settle down to work, the Zurich show sold so well that he was once again flush, with enough money for the travel bug to infect him. He wrote from the clinic to ask Sigrid to go with him to Africa and she was thrilled to accept. He didn't have time to think about his impetuous action until he was back in New York in November, when he told Aldo he was "confused—but very busy."

ON JANUARY 19, 1972, MR. AND MRS. SAUL STEINBERG (as it said on the tickets issued by Thorn Tree Safaris, Ltd., in Nairobi) left for a grand tour of every tourist destination on the African continent. They used Zurich as the point of departure because of the easy connection to Cairo. And because Sigrid felt the need to cleanse her system from drugs and drink before undertaking such a momentous journey, they both checked into the Überlingen clinic for several days. They flew to Cairo and Luxor, Nairobi, and Kampala, making

stops at Paraa, Murcheson, Entebbe, Ngorongoro, Arusha, Lake Manyara, and Amboseli-Kilimanjaro. The trip meant different things to each of them, but for Sigrid it was the beginning of a lifelong fascination with Africa, particularly Mali, to which she returned as often as she could, sometimes with Saul, mostly alone, and often several times in a single year.

Africa thrilled Sigrid, and for years afterward she tried to explain how it touched the depths of her soul. One of her best paintings was a representation of the African continent, all done in luminous shades of browns and greens. Occasionally she kept journals and diaries in which she tried repeatedly to describe how much it meant to her to evolve from a nubile woman into the wise old one who had gained the respect and friendship of the local people, particularly in Mali. Africa became the only place where she was truly at peace, a sensation she felt from the very first trip, and some of her happiest memories were of driving in companionable silence in an open jeep across landscapes where the wind gently fanned their faces. She wanted to believe that the mere fact of being there was enough to resolve many of their problems and bring them closer.

For Saul, the trip was fine, but when anyone asked, he dismissed the African experience as just another "of these absurd trips in a world ruined by the damned race of tourists." Once they were back in Europe, he returned to business as usual and became his brusque and peremptory self. He and Sigrid had been guests of the Maeghts at the Fondation in St.-Paul-de-Vence (to which the Zurich show had moved) and then stopped in Paris, where Saul tended to business and Sigrid spent time quietly painting in Cachan with Lica and her family. He was itching to go home to Springs, where he could be alone to sort out the swirling feelings aroused by his personal problems. They all came down to one: Sigrid, who was now thirty-six to his fifty-eight, and who in middle age had become a far different woman from the young girl who had entranced him.

HE COULDN'T TELL HEDDA WHAT HE was going through because he was too proud to admit that his personal life was not as placid as he pretended, nor that he had no idea of how to smooth it out. Also he couldn't talk to Hedda because of something that had happened some time before between the two women. Sigrid had tried to make Hedda assume the role of mother/big sister, which she made many other women play, but Hedda refused and told Sigrid what she already told Saul when their liaison began: that she did not want him to ask for advice or confide personal details to her. When Sigrid tried later to do so, Hedda told her that they could never be close friends or confidantes;

Sigrid could always expect cordiality and politeness, but that was all. When she related this to Saul, he knew it was Hedda's way of telling him not to expect her to help him sort out his problems with his younger lover.

The only other person Saul had ever trusted as implicitly as Hedda was Aldo, so he continued to confide in him, but a shade more openly than before. They had always written in Italian, and although Saul considered it his first language, he had been away from Italy long enough that he had become removed enough from the language for it to provide a buffer from the harsh reality that came when he expressed embarrassing or emotional thoughts in English. He was as honest as he could permit himself to be when he told Aldo that once he was back in New York, he was going through "a special period, I mean a sad one—changes—not feeling like myself."

At the time, the word *depression* had not come into general casual use, nor was it in Steinberg's vocabulary, so he passed off his feelings as an inexplicable malaise or melancholy. When he had to address his general lack of enthusiasm for life and work, he told different stories to different people. To Hedda, he said merely that overwork had made him tired and perhaps he had also picked up a bug in Africa that he could not shake. To Aldo, he said he was working steadily but had wasted too much time on the book that became *The Inspector* and "like the previous collections will be mixed and confused." He only found "freedom and diversion" when he could "invent new work," but he had little time for it because of all his responsibilities and commitments. To Aimé Maeght, he said everything was just fine and he was working cheerfully for his own amusement, but the rest of his letter contradicted the comment.

Of all the work connected with the 1973 Paris show, he was surprised by how pleased he was with the lithographs, especially the drawing he called "Le mois du coeur" in homage to February and Valentine's Day. It had always been a very special holiday for Sigrid, and he was puzzled about what led him to produce such a drawing during a time of unsettled, possibly tumultuous feelings about their relationship. Other projects were not even that clear-cut: he promised to sign off on the *Derrière le Miroir* proof ("bon à tirer") during the summer, but when autumn came, he had to apologize for being late. He blamed everything on his "struggle against tobacco," with the excuse that he was so "vigorously not smoking" that it had become his full-time occupation. In truth he was convinced that the absence of tobacco in his body had altered his "chemical composition" and changed him into "somebody else—less fun or actually boring." He was grateful to have something external to blame for his increasingly melancholy state of mind.

———

IN JUNE 1972 HE COULD NOT DECIDE where his oil paintings fit within his canon or whether they even contributed to it. Just looking at them made him go through his files to contrast them with drawings done long before. By comparison, the old work looked so "beautiful and simple" that he questioned why he was driven to waste so much time on "paintings that look printed." Obviously Hedda's letter chastising his cloud fixation had struck a chord. She was the only person who could criticize his work and get away with it, so anything that displeased her rankled him.

As a respite from painting, and because he now had a second studio assistant, Gordon Pulis, to help him in Springs, he found another diversion when he decided to work in wood. He joked that he turned to wood because he had two carpenters in his employ and had to invent work to keep them busy, but that was only partially true. He was unable to identify his other reason, saying that he thought it "a bit sinister" that he had become nostalgic for "things from architecture school and in general from the drawing table." He watched in awe as Pulis and van Dalen cut the wood to his exact specifications for rulers, triangles, T-squares, pencils, and pens, leaving him to draw the markings delineating inches and centimeters. Sometimes he found a remnant that lent itself to an illustration directly from his imagination, without any help from the carpenters, such as the slice of pinewood bisected by a natural crack that he turned into the drawing known as "the Montauk Highway Map." He began to make other objects as well, everything from wooden dog tags like the ones he had worn in the navy to a series of wooden cameras that he gave as gifts to photographer friends, among them Henri Cartier-Bresson and Helen Levitt. Eventually his vision expanded, and so too did the works in wood when he began to make large-scale tables, both flat tabletops and three-dimensional stand-alone structures.

Steinberg believed that working in wood brought him closer to "the rather animal world of painters." As he watched the carpenters, and as he took over to contribute his vision to the raw shapes he asked them to cut, it gave him the only "pleasure" he could find within his work: "The mind is at rest, it's the happiness of a horse . . . it makes me work and even dream that I'm working."

"I think there were many too many [tables], but he just loved the idea of them," van Dalen recalled after Steinberg hired a carpenter, Sig Lomaky, to do the actual construction. He himself may have been unable or unwilling to learn carpentry, but even before the wood was touched, he always knew what it should become. "He was all about ideas," van Dalen said, and Pulis agreed: "He could make it look like I did it, when really it was all his own doing."

One of the earliest tables, entitled "Politecnico," was a precisely arranged

collection of objects that hinted at Steinberg's past experiences as a student in Milan. Pencils, an old-fashioned straight pen, and a ruler frame the other objects on the table; at the bottom, varnish smoothes and blurs three photographs just as memory might do, while above them, a languid landscape is populated by rubber stamps of human figures, with one of Steinberg's fake seals hovering in the sky above as if to bestow authenticity on the scene below. On each side of the landscape he arranged two small plywood wedges carved and striated to represent receipt tablets. At the top of the tableau, a piece of thin wood colored and scored to resemble an etching plate provides architectural detail, as it depicts a mythical building in the brutal style so popular in Mussolini's Italy when Steinberg studied there.

He began to make the tables, both the flat tabletop assemblages and the three-dimensional stand-alone pieces, in the early 1970s and continued until the last three years of his life. If all his work was an autobiography of sorts, the tables are among the most teasing, as they conceal even as they reveal. Steinberg called one of the most intriguing (and possibly concealing) "Furniture as Biography." It was one of the three-dimensional pieces which he chose not to sell and kept in the basement at Springs for years, although he allowed it to be shown late in his life, in 1987, under a different title ("Grand Hotel"); once again he refused to sell it, and finally he partially disassembled it. On this table was a collection of furniture of the size usually associated with dollhouses—chairs, tables, beds, dressers, armoires, and chests of drawers. Many were three-dimensional replicas of furniture that was loosely reminiscent of the hotel rooms he stayed in during his travels, a lot of which he drew in his sketchbooks. Whether he referred to them or drew from memory is not known, because he worked on the furniture alone, with no help from Pulis. When the table was finished, Pulis posits, Steinberg thought it too crudely assembled to let it be seen; Hedda Sterne thought it was because it might have brought back too many memories that he decided were best left in the past.

One of the most revealing wooden constructions is the one he called "Library," a high, spindly, and large-as-life bookcase-cum-secretary on which two shelves resembling a wooden crate hold a collection of some of his favorite books, all ornamented with his lettering and cover drawings. His taste in literature was eclectic and occasionally surprising. While he raved about Richard Hughes's novel *The Fox in the Attic* and recommended it to all his friends, he chose instead to commemorate another of Hughes's novels, *In Hazard*, which he liked less. He loved anything Italian or about Italy; Norman Douglas is there with *Old Calabria*, and he honored his friends Aldo Buzzi and Ennio Flaiano along with Kipling and Jack London in the Italian translations in which he read

them. Tolstoy, Flaubert, Gogol, and Nabokov are on his shelves, as are Jules Verne and Dostoevsky in the Romanian translations he read as a schoolboy. Curiously absent is his all-time favorite novel, James Joyce's *Ulysses*. However, Steinberg enjoyed a Joycean in-joke when he included a book whose author's name suited his subject: W. M. Oakwood's *Carpentry and Cabinet Making*. As he played with wood, he marveled over everything about it, telling Aldo that he was so captivated that "in fact, I'm preparing a show for Maeght in October [1973] all tables." Working with wood was akin to a miracle: "Who would have said old Saul would be revived and obsessed by work!"

UP TO MY NOSE IN TROUBLE

All's well here. Up to my nose in trouble. How have I managed to fall into the usual traps (at which I've been barking for years)?

T he show, yes, it went well and I made the usual trillion," Steinberg said when the tables were first shown at the Parsons-Janis exhibition in February 1973. He liked the way they were displayed and was elated when audiences found them enthralling. When the reviews came, Steinberg dismissed them as "vulgar compliments," but he still thought they were good enough to send to Aldo. The kind of reception he wanted came from other artists, prominent among them Philip Guston, with whom he was sharing an increasingly close friendship through letters that dealt with what they were striving to attain in their work and hoping to convey to audiences. Guston said he was "utterly captivated and excited" by the tables and understood that they were "all about art and your adventures in art—your autobio." Steinberg could not have asked for more.

Shortly after, *The Inspector* was published, to decent critical response but not the raves Steinberg wanted or needed to help generate sales. He blamed the lukewarm reception on his new publisher, the Viking Press, which positioned it as a gift or coffee-table book and priced it at ten dollars, a hefty sum at the time. When taken as a whole, all the responses to the book were much the same as those to the rest of Steinberg's professional undertakings—successful—and success in work was sweet after such a long period of being down in the doldrums. It made him full of energy and ready to tackle "the boring problems" that he had put aside for the past several years.

Suddenly he decided that it was "important to get out of the Village, more than anything else," and he made his first major decision by not renewing his lease. He had never really liked living in Greenwich Village, and now that his

sixtieth birthday was approaching, he was uncomfortable being surrounded by the young and the hip and wanted to return to the staid Upper East Side. He found what he wanted almost immediately, a duplex apartment at 103 East 75th Street, "close to the old neighborhood" on 71st Street where he had lived with Hedda, "expensive," but he could easily afford it.

As with all co-op apartments in New York, he had to pass board inspection, and that required letters of reference. Marcel Breuer, John de Cuevas, and Betty Parsons all attested that (as Parsons wrote) he was "a talented, charming, reliable man, who fulfills his obligations in every way." The letter that probably carried the most weight, however, was from his accountant, Martin H. Bodian, who stated that Steinberg's earned income for the past several years had been "in excess of $75,000" and that his net equity in real estate, marketable securities, and bank accounts was "in excess of $250,000"—a veiled way of saying that he was a millionaire several times over. His application was approved, and he was given a certificate attesting that he owned 180 shares in the building's corporation. It resembled all too closely one of his false documents, which may be why he stashed it in the folder where he kept all his other "honorary" memorabilia, including his "Kentucky Colonel" certificate and a letter telling him to pay his long-delinquent dues to the Royal Society for the Encouragement of the Arts or he would be removed from the membership rolls (he didn't pay). It also included copies of his letter of resignation from the Century Association, whose members were distinguished authors, artists, and amateurs of letters and the fine arts. His dues were in arrears there as well, so he paid up and sent a letter announcing his "friendly resignation."

New York is really a collection of small villages, and the natives are not prone to go outside them. Steinberg became a walker in his part of town, often encountering old friends and casually joining them for something informal. Leo Steinberg invited him for a meal, and when Saul ran into Niccolò Tucci they would walk along together and then often dine. His new and stylish address garnered invitations to glamorous benefit dinners such as one for the Cooper-Hewitt Museum hosted by Mr. and Mrs. Henry J. Heinz II, ("Jack and Drue," who were collectors of Steinberg's work). He was on the guest list that included George Plimpton, Diana Vreeland, Brooke Astor, and Arthur Schlesinger. "Everyone . . . looked fabulous," wrote "Suzy" in the *New York Daily News*, "especially Saul Steinberg who arrived in a deerstalker."

Other collectors of Steinberg's work wanted him to grace their tables, and Sigrid was usually included in the invitations. More often than not, Saul did not tell her she was invited, and most of the times when he did, she refused because she was uncomfortable in such settings. Apocryphal stories, always

of their bad behavior, abounded about them both. Sigrid was reputed to have deliberately vomited on a society hostess's dinner table because she was bored by the company; at another dinner, when Saul was allegedly disgusted with the superficial conversation, he rose from the table and threw down his napkin, saying, "This can only get worse" as he stomped out. The most oft-repeated story of their bad behavior concerns a Giacometti painting that hung over the toilet in the powder room of a Park Avenue apartment. Sigrid emerged from the room and in her raucous voice announced what she had seen to all the guests in the very large drawing room; Saul said it was an insult to a great artist, grabbed her arm, said, "We're leaving," and off they went. An entire mythology grew up about the bad behavior of Saul Steinberg and Sigrid Spaeth, much of it probably stemming from hearsay about their fractious personal relationship. But very little of what they were alleged to have done in public was actually true, and almost none of it could be verified.

ONCE THE APARTMENT WAS HIS, STEINBERG made changes to it over the next several years. He hired the architect Ala Damaz to alter the layout, calling her back several times until he had the spaces exactly as he wanted them. He wanted the public areas to be on the entry floor, where he had a separate kitchen and a combination living and dining area that could hold a table as big as the one he already had in Springs and as big as Hedda's, which he remembered sitting at with great affection. There was also a maid's room and bath behind the kitchen area, which he used for art storage, as his housekeeper came in daily and he never had houseguests. His private quarters were on the floor above, where he had his bedroom, bath, and a large studio. There was also a small room which became the sanctuary where he kept his meditation cushion and did his yoga sitting, which he had recently taken up and which he practiced faithfully for the rest of his life.

The apartment was in such a state of disrepair when he bought it that he was unrealistic to think it could be completely remodeled in the short time before his lease ended and he had to move. He ended up living through the "horror" of renovating the kitchen and bath and having all the rooms painted and refurbished, but he left the details of clearing out his Village apartment to "Saint Anthony" and counted on him to "perform a miracle," which he did. Anton did the packing, sorting, and tossing of rubbish and discards; he arranged for the movers, oversaw their work, and made sure that everything arrived safely and was installed where Steinberg wanted it, all without fuss or bother on Steinberg's part.

Once Steinberg was committed to buying the city apartment, it was as if a

barrier had given way and he found it fairly easy to make another decision he had been worrying about and postponing for the past several years: to add a studio onto the country house. At first he wanted only one large room leading off the kitchen, but he soon realized that he would need far more storage space than even an extremely large workroom would provide, so he asked the architect to dig down and make a full cellar under it. To secure the necessary building permits, he had to go before the various town boards, and in his case many more times than was usual. As he did with catalogues, books, and exhibitions, he kept making changes to the architect's plans, and every change was major enough to require repeated appearances, thus delaying the start of construction. Finally everything was settled and approved, and one brisk November day found him out of bed uncharacteristically early as he got up to watch every move the carpenters made when they began to build the wooden framework over the big concrete hole that had been dug for the cellar.

THE TWO HOUSING DECISIONS WERE MOMENTOUS, and as soon as Steinberg made them, his euphoria was overwhelmed by "doubts." After thirteen years downtown, he was finding it difficult to settle uptown, for 75th Street was in a far more elegant and formal neighborhood than Washington Square, and even walking the streets or shopping in stores was different enough to make him feel as if he had moved to an entirely new city. Starting with the uniformed doorman and the hushed hallways in his building, everything about the apartment took some getting used to, and it didn't help that he remained uneasy about whether building the country studio was the right thing to do. Once the exterior was finished and the carpenters were putting the final touches on the interior, Steinberg was embarrassed by the size of it. He thought the addition dwarfed the original house and reviled it as "architecture for the poor but built with lots of money."

That was in February 1974, when everything was bleak and cold and the studio was so empty that the slightest sound created a booming echo. By June, when grass was growing around the exterior and chipmunks were already living under the new porch, and after he had moved in many of his treasured objects, set up his work tables, and put things on the walls, he changed his mind and thought it was "turning out nicely." Still, it had been a tremendous change to go from being a renter to an owner in the city and to having more than twice as much room in the country house. He could not make himself move beyond feeling that his new life was "temporary . . . improvised" and blamed himself for the irrational "fear of the definite" that he could not keep from consuming him. As he did with so many other thoughts or feelings

he was ashamed of, he blamed all his insecurities and uncertainties on his upbringing as a Jew in Romania, "fucking patria who murdered millions, who never accepted me."

ROMANIA WAS ON HIS MIND WHEN his niece, Dana Roman, now a young woman, came to visit in the summer of 1973. Dana was quick, self-confident, and often peremptory, and having her in the Springs house made him aware that it had been some time since he had lived with anyone on a daily basis, even Sigrid. He wondered if his disposition would have been different if he had lived within a family's confines rather than having been so much alone. Temporarily, however, he was part of a couple, because things with Sigrid were "in harmony for the moment." She loved to be in the country and oversee the household, freeing him to concentrate on work, where he had much to do.

First on his agenda was finishing the tables for the Maeght exhibition by early summer so they could be shipped in time for the October show. He used the tables as the excuse to drop the Skira book, which had become "a nightmare." He was unsure of his ability to write the text, but was too embarrassed to admit it, so he used the excuse that he was too busy with other work, and to divert himself of anxiety, he concentrated on the tables. Maeght had asked the philosopher Hubert Damisch to write the catalogue essay. At first glance Damisch, who was a philosopher specializing in theories of aesthetics and the history of art, seemed to be among the best-qualified French intellectuals to write about Steinberg's "biographical" tables. However, when Steinberg read Damisch's essay, he thought it "depressing, disaster," too heavy on theory and too little about what Steinberg called the biographical impulse from which the tables sprang. But the catalogue was in production, and there was nothing he could do about it.

French audiences were not as captivated by the tables as the Americans had been, nor were the critics. Edith Schloss, the reviewer for an important arbiter of European taste, the *International Herald-Tribune*, thought they had none of Steinberg's sharp and precise irony or inventive wit. She dismissed his latest work as a rehash of the old, and said that, having come full circle, it was "biting its own tail." She heaped the most scorn on the table Steinberg was proudest of, the "Politecnico," and in summation said all the tables were "prevented by their own irony from expressing more than an abstract argument."

Steinberg was not prepared for critics who thought the tables were self-indulgent and sentimental, who could not understand the themes and ideas they were meant to convey, and who seemed resentful because the new work departed from the old and did not merely continue what had come

before. Despite the muted critical reception, sales were good, but that was not enough to assuage his miffed feelings.

A major purchaser was a Belgian art dealer and collector with ties to the New York art world, Serge de Bloe, who had become a trusted friend. Steinberg had occasionally used de Bloe as a conduit for sending money to Aldo and Ada, and now that became something he did fairly regularly. Although the Internal Revenue Service audited Steinberg's tax returns with alarming regularity, he was never caught when he used de Bloe as his intermediary. Until now he had never volunteered money to Ada but only given when she asked for it, and she had routinely asked for money or goods several times each year (the latest request was for a television set). Now he worried whether he was "doing a good or bad thing" and asked Aldo for his "sage advice." Whatever the advice, from here on, Steinberg included something for Ada whenever he diverted funds to Aldo.

FOR A MAN WHO COMPLAINED THAT he was beset with depression and indecision, Steinberg managed to hide it from public view while being much in the public eye. At his opening reception in Paris, he had the opportunity to see many old friends whom he was often too busy to see individually. Mary McCarthy came, and he was so happy to see her that he danced her around the floor. The next day she sent a confidential letter that led to Steinberg's behind-the-scenes but highly active involvement in the antiwar movement. McCarthy was trying to raise money for Chilean dissidents, particularly Carlos Altamirano, the man most wanted by the Chilean junta. An underground network had been established in Argentina to raise between $10,000 and $12,000, and she asked Steinberg to contribute whatever he could. He sent almost the entire amount, and McCarthy sent grateful updates about the progress his money was making for the remainder of 1973.

He was generous with his work as well as with cash: during the 1972 presidential election he donated a painting to the McGovern-Shriver campaign, and he made a special lithograph for Spanish Refugee Aid, Inc., to raise funds for aging refugees of the Spanish Civil War. He was a generous contributor to local politicians and if he believed strongly in a candidate's platform, as he did with Judith Hope, who was running for reelection to the town government of East Hampton, he created an original poster. He gave permission for the National Peace Action Coalition to use four pages of drawings, cartoons, and caricatures from *The New Yorker* free of charge for an antiwar anthology. There were organizations who wanted to use his name as well as his work and his money, among them the National Emergency Civil Liberties Committee, which asked

him to sign a petition along with other artists who were concerned about freedom of expression and the protection of the Bill of Rights. Shortly after, the group asked him to create an original work for the twenty-fifth anniversary cover of its *Bill of Rights Journal*, an honor he willingly accepted. But when the National Lawyers Guild asked him to contribute money for the Attica Brothers Legal Defense Fund, he replied with a firm "NO." That decision was based on his personal belief rather than political correctness, for he did accept a place on the honorary committee organizing a "salute to Charlie Chaplin." It was not a politically correct thing to do in the early 1970s, but it affirmed his commitment to left-leaning and liberal politics and causes.

His work had always been of interest to the scholarly community, mostly among editors who wanted to use it to illustrate books and articles, but now it had become the subject of theses and dissertations. Artists and art students who respected his work wanted to meet him. Among them were the graphic artist Tibor Kalman, who simply liked Steinberg's work, and the cartoonist Garry Trudeau, then a graduate student at the Yale School of Art and Architecture, who offered to show Steinberg some examples of his syndicated Doonesbury cartoons. Steinberg's work even penetrated the Romanian Iron Curtain: the country's leading cartoonist, Matty Aslan (who published his work as Matty) so admired him that he risked censure and punishment by entrusting an American newspaper correspondent to deliver a gift of ethnic embroidery similar to that done by Rosa Steinberg. It was a deeply touching homage.

Concurrent with these requests were many from people Steinberg hardly knew as well as from friends he did not think he could turn down. He had met Susan Sontag only in passing and did not know her well enough to be asked to contribute to the appeal for funds made by the *Partisan Review* editor William Phillips after she was diagnosed with breast cancer, but he still sent a $200 check. He provided the jacket drawing for John Hollander's *Vision and Resonance: Two Senses of Poetic Form*, not only because of his friendship with Hollander but also because the publisher commissioned Sigrid Spaeth to design the cover. Atheneum Publishers offered a $100 pittance for an original drawing for the cover of Howard Moss's book of poetry *A Swim Off the Rocks*, and Steinberg accepted because he liked Moss, who was the poetry editor of *The New Yorker*. When Nora Ephron, then an associate editor at *Esquire*, asked him to contribute two pages of flag drawings for a planned bicentennial issue, he paused long enough before he accepted to send a copy of her letter to Lee Lorenz, asking if *The New Yorker* would be interested (it was). He had his loyalties and was careful to nurture them.

———

AS THE ONSLAUGHT OF REQUESTS GREW in seemingly exponential fashion, and as he was trying to fulfill most of them from the new studio in the Springs house, he complained to Aldo about what it was like to live in an art colony: "And the telephone rings and letters arrive asking for donations in money, drawings, lithographs, for the benefit of museums, nations, Indians, etc. etc." It was a barrage he could barely handle, and Aldo chose this moment to introduce another factor, which left him totally flummoxed.

Because Steinberg was having so much trouble formulating a text for the Skira book, he had hit on the idea of doing it in collaboration with Aldo. His plan was to have taped conversations with Aldo about his most important influences, after which Aldo would select the most revealing remarks and prepare a transcript. Some of the examples that came immediately to Steinberg's mind were Romania and everything connected to his life there, and painters such as Van Gogh and Courbet, whose lives he studied avidly in order to understand their work. Most recently he and Nabokov had disagreed strongly about Courbet, and he was eager to talk about the artist with Aldo. Steinberg agreed that with the give-and-take of this sort of collaboration, "maybe it could be done."

But Aldo did the flummoxing when he introduced something else he thought should go into the book: extracts from every one of Steinberg's letters, all of which he had kept from the first year of their friendship, when Steinberg had gone home to Bucharest for summer vacation, and then from the year that he left Italy for good. Steinberg was stunned to learn they were extant, and when Aldo sent copies, he was unable to read beyond the first five pages. He was so emotionally paralyzed that a month passed before he could even skim the rest to craft a reply. He said it took "courage" to reread what he had written throughout the past thirty years, and he had needed the one-month hiatus before he could face himself when younger. The time off gave him the distance to declare them "indeed good and moving because it really shows the development in a clinical fashion," but they did create a new worry: that he might become "artificial" when he wrote to anyone in the future. He put the worry aside to insist that Aldo come for the summer, to see the new addition and to work on the proposed book. Aldo agreed, and he and Bianca came in August 1974, as Steinberg's guests and with all their expenses paid.

STEINBERG WAS HONORED TO BE ELECTED to the American Academy of Arts and Letters in 1968, and since his induction he had participated fully in the academy's events and activities. He took the responsibilities of membership seriously and gave great care to nominating likely candidates, putting up many of his friends, writing fulsome letters of recommendation, and actively

networking with other members to secure their admission. Awards and accolades from other institutions were offered to him almost every year throughout the 1970s, and he accepted most while carefully refusing others. By 1976 he was confident enough to decline the gold medal of the National Arts Club in New York, because it had become "impossible to witness and listen to speeches praising me," especially "if my presence is necessary." But in 1974 he was pleased to be present when the American Academy of Arts and Letters honored him with the Gold Medal for Graphic Art. Philip Johnson was the presenter, and his statement raised many of the same questions that Steinberg had recently asked himself, particularly when working with Aldo for the Skira book.

Johnson prefaced his remarks by asking not who but "*what* is Saul Steinberg?" Johnson noted that Steinberg's gold medal was being given for his ability as a graphic artist, but wasn't he also a satirist, and wasn't he also a painter? To corroborate the latter, he noted that Steinberg's work had been shown at MoMA as long as thirty years before, but—again a qualification—wasn't he also a humorist, and wasn't he also an architect? When it came time to determine Steinberg's place in contemporary art and culture, Johnson metaphorically threw up his hands over the impossibility of the task: "With the twentieth-century insistence on careful categories, our academic enthusiasm for dichotomy and definitions betrays us: we cannot pigeonhole Saul Steinberg."

Now that Steinberg was fast becoming the darling of the intellectual world, these were the same questions—the same irritating questions—that he would be asked repeatedly as others strove to define him. Even worse, to his way of thinking, was that others would pose these questions and then wait expectantly for him to define himself.

EVERYTHING WAS GOING WELL FOR STEINBERG in mid-1974. Sigrid was on one of her many solo trips to Africa, this time to Mali and Upper Volta (Burkina Faso), and before she left, they had bid each other farewell in a desultory but basically fond fashion. They were in one of the periods when he was involved in a succession of casual flings and her attitude toward them was one of casual indifference. He was alarmed when one of the women threatened to want more than a brief affair and complained that he would never learn, as he landed up to his nose in trouble and became mired in one of the same old traps he had been baying at for years. At the age of sixty, he thought of himself as an old man, but even as he questioned his need for continual conquest, he had to admit that he could not help it that he still loved women, loved the foreplay of seduction, and loved most of the initial sexual encounters. Always in need of

something to blame for his general melancholy, he focused briefly on his appetite for many women but soon discounted it to blame something else. "What does this sadness mean?" he asked rhetorically. He decided that it had to be "the nose speaking. It must be old age."

The sadness was mixed with a vague, unfocused fear of death and the actual deaths of friends and family. Nicola Chiaromonte had died in 1972, and Steinberg was reminded of the death when he deepened his ties to Mary McCarthy over their mutual opposition to the Vietnam War. He kept in touch with Chiaromonte's widow, Miriam, whom he always visited in Rome and who sent him articles and homages to her late husband for many years. Ennio Flaiano, the Italian novelist whom Steinberg much admired, had died, and he regretted that he had not managed to know him better. His brother-in-law, Rica Roman, died that winter, a death not unexpected because of his years of ill health, but still the suddenness of it came as a shock. In accord with Jewish custom, Rica was buried the next day, and in a gesture that comforted all the family, in a grave abutting Moritz Steinberg's. It was not possible for Saul to be there, but he planned to visit Lica as soon as he could arrange to get away, and he intended to persuade her to come for a long visit to Springs at the earliest possible moment.

When nothing succeeded in helping him shake the doldrums, he scheduled another visit to the Buchinger Klinik in Überlingen in the hope that a stay in the sanatorium would alleviate his sadness. He had been suffused for years by malaise, melancholy, depression—whatever name he called it during the periods when he was enduring it—so these periods were nothing new, but this one was more alarming than usual. As it deepened, it reminded him of the kind of sadness that had often come over him in Romania when he was very young. "One is never saved," he concluded, even as he hoped that several weeks of fasting in a spartan setting would raise his spirits. He put so much faith in the clinic because he had not smoked for the previous two years and was confident that another stay could cure anything, even depression. When it was over, he told himself and others that it had worked, but his letters to Aldo and the occasional jotting whenever he tried to keep a journal proved otherwise.

LICA DID GO TO SPRINGS IN MAY 1975, to stay for a month. Steinberg gave her the happy news that the Association of American Artists had just agreed to purchase her edition of drawings that she called *La Famille* for the impressive sum of $1,400, but it was not enough to raise her spirits, which had been down since her husband's death. She was more subdued than usual and wanted only to sit on the porch in the warm sun and browse her way through the huge pile

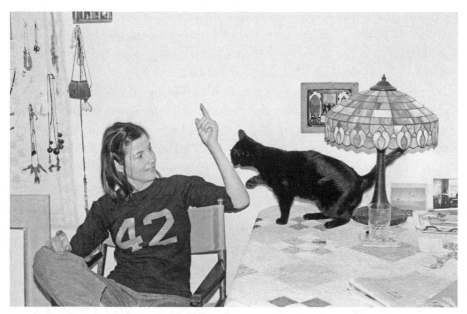

Sigrid Spaeth and Papoose.

of back issues of the *New York Times* that Steinberg had accumulated. Sigrid came on the weekends, along with her new cat, Papoose, whom Steinberg was convinced was far more intelligent than any human and whose antics he never tired of watching. He adored the cat, and throughout Papoose's long life, if there was anyone or anything that could make him smile, it was he. But during Lica's visit, even that respite was brief.

Steinberg blamed his sister's lassitude on more than grief over her husband's death. No matter how much he tried to reassure her, she was unable to accept that he would always provide the income she needed; nor could he persuade her of the value of her own art. He wondered if her low spirits were caused by "envy "or "stupidity," but they were "real, nonetheless." The only time they had fun together was when they recalled incidents from their childhood and laughed about their "comical parents." When Lica returned to Paris in June, she went directly to her doctors, because it was clear that her problem was more than simple lassitude and something was physically wrong. Stéphane wrote twice, first to tell Steinberg that his mother had had an exploratory operation in early June and then again to say there were no tumors and nothing out of the ordinary had been found. When it appeared that Lica would soon be released from the hospital, Steinberg wrote to her on July 10 to say he was convinced the French doctors had not arrived at a diagnosis because she was suffering from Rocky Mountain spotted fever, as he was calling tick bites. He

told her that Papoose brought ticks into the house, and he and Sigrid had to examine themselves and the cat constantly to be sure they were not infected. He filled the letter with chatty news, even enclosing a photo of the artist Syd Soloman, whose work he admired. He told Lica that he loved working in the studio now that he had so much light streaming through the new windows, and then, desperate to think of something she would care about, he told her that someone from the Smithsonian had visited and admired one of her portraits hanging in the studio. Steinberg said he hoped to persuade the museum to buy it. His biggest news of all was that in June he would give up the Union Square studio, and there would be a horrendous amount of work involved in deciding what to keep in the city and what to move to Springs. He closed by telling her that Sigrid and Hedda both sent warm good wishes, and he sent all his love to her and to Dana and Stéphane.

Lica never read this letter. Four days after he wrote it, she died, on July 14.

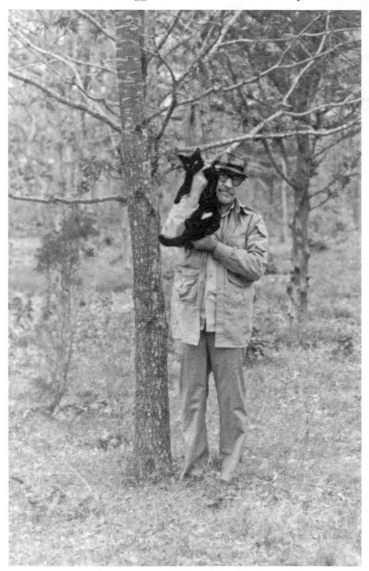

Saul Steinberg and Papoose.

SADNESS LIKE AN ILLNESS

I've found and taken a good look at my childhood photographs and I look at myself as a passerby. I find no familiarity with that little boy.

Lica's death at the relatively young age of sixty-three came after a "difficult and frightening" lung operation that led to pulmonary complications, probably stemming from the dermoid cyst she had had since birth. Steinberg flew at once to Paris and was with her children and a small group of close friends when she was buried next to her husband and parents on July 18, 1975. He stayed in the Cachan house for several days before returning directly to Springs. Aldo wanted him to go to Milan, but he was too sad to see anyone then or even later, when he rescinded his invitation for Aldo to spend September and October with him. He begged Aldo to understand that he could not have visitors because his "sadness was like an illness, and very tiring."

Conflicting emotions were only natural after the loss of the one person who had been dear to him far longer than anyone else. He told Aldo he had not been aware of how much he loved Lica until she was gone, when he realized that he would mourn her for the rest of his life. At her graveside, he wept for the first time since he was a boy in Romania, and when he tried to analyze why he sobbed so unrestrainedly, the very fact that he could cry was almost as shocking as the death that inspired his tears. When he was back in Springs, he was roiled by the same emotions as those he experienced during Lica's last visit, when he was "depressed, scared in the morning, sad in the afternoon." All the while she had been with him, he was forced by her state of mind—and Sigrid's too—to play a role that was foreign to him, the strong male presence who provided calm reassurance for others. He was so accustomed to having women take care of him on every level from the physical to the emotional that he found it difficult to have to be the giver of strength and stability.

Sigrid had begun sustained psychotherapy after it appeared that she had inherited her mother's clinical depression and become almost catatonic. She had tried one or two analysts in the past, usually for a few consultations which lasted several weeks at the longest. Her newest analyst became the first on the fairly long list of those she would consult and dismiss throughout the rest of her life, switching from one to another on what seemed little more than impulse or whim. When she became disillusioned with her current treatment or heard of a new therapeutic technique, she went eagerly to the next new thing, convinced that this would be the one to cure her forever. Sigrid perked up after finding an analyst who (according to Steinberg) featured an "anti-tears cure" that used a great many mood-altering prescription drugs to be effective. Knowing Sigrid's proclivity for recreational drugs and basically unsure that any treatment would be successful, he was still willing to pay for whatever she thought might cure her. As her health was otherwise robust, he feared that she—and he as well, because he was so loyal—faced a long life of battling demons that were far more serious than anything he had thus far personally endured.

He did everything he could for Sigrid in the early years of her severe depression. If she felt the urge to visit Africa, he paid her way and sent her off for as long as she wanted to stay; if she thought she was well enough to work, he was discreet about asking friends in publishing to send commissions her way. A number of interesting projects resulted, among them the lettering for the cover of Philip Roth's *The Ghost Writer*. He stayed quietly aloof when she took her drawings to the Whitney Museum and asked to have them included in an exhibition or when she took them to downtown art galleries that specialized in emerging artists, knowing that her work was not good enough for either. Everywhere she submitted her portfolio, she was asked to return at some future time, when her "ideas were more developed." Unfortunately, her moods fluctuated so unpredictably that she was never able to sustain equilibrium and capitalize on the periods when she was productive.

One year after Lica's death, in 1976, Steinberg was in Cachan for the unveiling of the headstone on her grave. He realized that the date was July 9, the sixteenth anniversary of the day he met Sigrid, and he wrote a letter addressed to "Dear Papoose," using the name of the cat they both adored, which had become their private symbol of tenderness. His letter was filled with more sentiment than he had expressed in all their years together and was exactly what she had long wanted to hear him say: "Of course I still love you and think of you as my dearest friend." She was stunned when he told her that his gift for her birthday on August 9 would be the little cabin she used as a studio and all the land around it in the meadow, starting from a poplar tree she particularly

liked and extending to the vegetable garden she tended so lovingly. Even more astonishingly, he told her that "the rest of the land will be yours after my end, of course. You know more and like it more and deserve it and enjoy it [more] than anybody." In retrospect, looking at their later lives as their "thirty-five years' war" played itself out with dramatic intensity, both his gift and his sentiments became tinged with the irony for which he was famous.

THE SUMMER WAS GRUELING AS HE moved out of the Union Square studio, which was far more complicated than going from one apartment to another. Before Anton could do the actual packing, Steinberg had to decide what to keep and discard, what to send to the country and what to keep in the city. As he sorted through everything from the lace bib his mother had made when he was born, to wartime souvenirs from China, to photos of himself, his family, friends, and lovers, he was haunted by the way Lica's death had made him fearful of "the brutal image of the end of life."

As he sifted and sorted his papers, he was coming across so many things from his past life (or lives, as he thought of his years of living in different places) that he dubbed himself his own "voyeur." He realized that he had saved every scrap of information that pertained to his life and much else that pertained to his times, from movie ticket stubs and hotel bills to take-out menus from neighborhood restaurants, calling cards from countesses and dukes, business cards from his local dry cleaner, news clippings of current events, and obituaries of everyone from his friends to strangers whose deaths were bizarre or garish. Such intense immersion in memories exhausted him physically even as it made his mind race, energized by the curiosity to remember more.

He asked Aldo to send him a copy of their class photograph from the Politecnico, and he searched his own files for images of the places connected to his Romanian boyhood, even though he refused to return there because the country could not be magically transformed into the 1924 version he held in his mind. He asked anyone traveling to Bucharest to take photos of his house on Strada Palas and to bring him souvenirs, particularly old street maps or postcards showing street scenes. And yet he insisted that no aspect of his life in Romania had influenced his work. His poet friend W. D. Snodgrass, who went to Bucharest and took some of the photos Steinberg requested, raised an interesting question about the origins of his drawing. Fascinated by peasant clothing, especially the black embroidery on white coats, Snodgrass wondered if the quality of Steinberg's line might have been heavily influenced by it. Steinberg emphatically dismissed the possibility. Even so, Bucharest became ever more prominent in his memory, and a quarter century later he was avid to collect

images of how it had been in the 1920s. Each time he spoke of his collection of things Romanian, he called it "an emotional orgy, exhausting," but he was happy every time he went through "this secret life."

BY OCTOBER 1975, THE MOVE FROM Union Square was over, and Steinberg was in the country and reluctant to return to the city and his life there. He stayed in Springs until the end of November, and while he was there, letters of condolence came in steadily from friends all over the world, every one of them deeply touching in their concern for him. There were also many from friends in New York, which was why he stayed away: it would have been too difficult to accept condolences in person without becoming emotional.

Ada's letter was especially poignant, as she had known Lica since they were young girls; now she tried to cheer him up with a diversion, telling how she had become an old but still pretty woman and coyly inviting him to come and see for himself. Ada had also written a touching letter when Ennio Flaiano died, which struck him with her ability to convey exactly the sentiment he needed to hear. He realized that she had always done this, and also that she had become almost (but not quite) as necessary to him as Hedda. Ada had been the companion during his formative years, and those were now the source of most of the memories that engulfed him. With Lica gone, he drew closer to Ada, because she was one of the few people who had known Lica since her first visit to Milan when Saul was a poor student; they had corresponded over the years off and on and had a genuine friendship based on their love for "Sauly" (Lica's affectionate nickname) and "Saulino" (Ada's *"mio olino caro"*).

HE STAYED ON IN SPRINGS THROUGH the early winter, content to spend his days sorting through his boxes of papers when not actively creating new work. He was mostly alone now that the friends he saw regularly in the Hamptons had gone back to the city, so he got into the habit of fixing simple solitary suppers at the end of his workday. The meals reflected his Romanian heritage and the foods of his Italian years: peasant breads and cheeses, scallions to dip in good olive oil, zesty olives to nibble before the main course of grilled vegetables or pasta with simple sauces. The only part of his diet he worried about was his tendency to drink too much, mostly the expensive French white wines that he ordered by the case.

After dinner he tried to relax for sleep by reading voraciously, always on the lookout for something that would not intrigue him enough to stay awake. He followed Aldo's suggestion to indulge in harmless thrillers like Dashiell Hammett's, saying that he knew Hammett's widow, "who keeps writing won-

ders about him." Referring to Lillian Hellman allowed him to avoid commenting on the fiction itself. His taste in literature was more cosmopolitan, and if he wanted a thriller, he preferred a writer like Manuel Puig, whom he called "Joyce's illegitimate son."

He often recommended writers to friends, particularly to Claire Nivola, with whom he had carried on an intellectual correspondence since her Harvard student days. His recommendations often came in the form of something whimsical or charming, such as the multicourse "Literary Menu" he drew for her "degustation." The "antipasto" featured selections that ranged from Victorian explorers (Burton, Gordon, Kitchener, etc.) to Kropotkin's autobiography, while the "soup" course offered a biography of Charles XII of Sweden, "boring [but] worth reading." The "entrée" was serious nonfiction: Van Gogh's letters to his brother, Delacroix's journals, Herzen's autobiography (all "6 or 8 volumes"), books about Lawrence of Arabia, a biography of Dostoevsky, and Enid Starkie's *Rimbaud* and Richard Ellman's *James Joyce*. For "dessert," he recommended Norman Douglas—not the *Old Calabria* he loved but rather *Looking Back*—and Nabokov's *Gogol*, which he thought "one of the best things written." They were both fond of Tolstoy, and after each read Henri Troyat's biography, Steinberg said they must find another that was "more contemporary and more historical," because Troyat's was too full of "anecdote and quotation." His most recent suggestion was for them both to read Roland Barthes, whose writings they occasionally talked about during the next several years.

Because the Skira book was still unwritten and long overdue, Steinberg told Aldo to read the biography of Courbet he had discussed with Nabokov on his last visit to Montreux. Steinberg found the disconnections between the artist's dysfunctional life and his art endlessly fascinating, and he said that when he and Nabokov talked about Courbet, they agreed that biographies of artists were often unsatisfactory because biographers understand "only other writers (as shown in diaries, letters, etc.)." This assertion led him to Roger Shattuck's *The Banquet Years*, in which he heavily annotated the passage about how Flaubert would not allow illustrations in his novels. Flaubert believed they limited the reader's imagination and offered the example of how a drawing of a woman would render the text "closed, complete, and every sentence becomes useless, whereas the written woman makes one dream of a thousand women." Steinberg's problem was the opposite of Flaubert's: he made drawings whose interpretations were legion, whereas if he wrote about what he drew, he would be the one rendering his work "closed, complete, and useless." He had to think about this.

Several months later, the Skira book (for he refused to call it by the

despised title given by the publisher, *Table of Contents*) was still going nowhere and he needed an excuse to explain why, not only to others but also to himself. Even though he read constantly and liked almost everything he read, he told anyone who asked that he had "completely lost faith, enthusiasm and respect for books." It was only a matter of time until he gave up entirely on the project. Meanwhile, he insisted (and it was true) that the only thing that gave him genuine unalloyed pleasure was what he dubbed "the exercise" that he set for himself every day, of turning out drawings with alacrity for *The New Yorker*. After not having a single cover in 1973 and 1974, he had four in 1975, and Parsons and Janis were planning a large exhibition for 1976 that featured many of his "old cartoons."

Now that he had his studio in the country set up as he wanted it and as it would remain for the rest of his life, he found that he did his best work there. He papered the end wall with page after page of drawings from his sketchbooks, which he mixed, matched, and shifted into "Manhattanite dystopias and memory-caricatures of Fascist-era Milan." Glass sliding doors kept him in touch with the changing light, landscape, and wildlife he had come to love. Papoose was endlessly entertaining as he bravely swatted flies, stood up to the occasional fox, and actually chased the deer who ambled up to eat the flowers just off the porch. Tranquillity came through painting watercolors and crafting collages; a new pleasure came through arranging the ordinary objects that gave him pleasure in his daily life into whimsical still lifes, such as the blue-and-white Chinese vase or the mushroom and pistachio cans on his large kitchen table. He took renewed pleasure in sketching his friends in what he called *dal vero*, as he captured Sigrid in the act of reading a newspaper or Harold Rosenberg holding forth as he emoted from his favorite chair.

Steinberg went into the city for New Year's and left it in a slightly better mood after several weeks of being warmly welcomed by his many friends, who were genuinely glad to see him. Sigrid was in Africa again, Cameroon this time, and because she and Steinberg were on the outs, she left Papoose with a cat sitter to spite him. The cat misbehaved, the sitter resigned, and Steinberg took Papoose to where both were the happiest, Springs, where he had the tranquillity to work and Papoose could chase everything from birds to foxes.

He was productive during the winter despite his depression, although he was worried enough about it to try to alleviate it on his own. His first action was to stop drinking except for an occasional glass of wine when he dined out or when he had a visitor, when he sipped just enough to keep company. His relationship with Tino Nivola was in one of its quietly companionable periods, and he accepted more invitations to dine with him and Ruth than he had for

a long time. No one could understand why Saul Steinberg had a tendency to tease, taunt, and even belittle his old friend, but he departed from his usual impeccably polite behavior to do it to Tino, even in front of others, and no one ever questioned or upbraided him. While Ruth seethed—mostly to herself, because her husband forbade her to engage in rebuttal—Tino usually smiled and shrugged off the barbs as just "Saul's way" and not worth fussing about because his mood was bound to change momentarily. The Nivolas knew how stunned Saul had been by Lica's death and how unnerved he was by Sigrid's depression; they worried that he brooded when alone, so they invited him to dine casually and often. There was the excuse that they needed him to help eat the squid Tino bought directly from the fisherman who caught it, then grilled lightly and served with salad from their garden and boiled local potatoes. Tino invited Saul to help him hunt for mushrooms and rejoice in the cache of porcini they found behind the house, which were then cooked to perfection by Ruth.

The meals served by the Nivolas in their welcoming kitchen were also triggers for pleasant memories of past culinary pleasures. Steinberg told Aldo they reminded him of some of the first pasta dishes he ever ate, the rigatoni "in boarding houses in Milan, made with mysterious sauces of leftovers and stuff from the day before." One of the things he liked best about Colette's fiction was her description of village markets, particularly the cheese stalls; one of the things he liked least about Tolstoy was in the novel *Family Happiness*, because he was "outraged" that Tolstoy wrote a lengthy description of the conversation at a dinner party "with no mention of food. Gogol would have."

The exchanges about food began toward the end of 1976, during a time when Aldo was especially worried about Steinberg's depression. For five months he had not received a single one of the chatty letters Steinberg usually wrote several times each week. When Aldo probed for his reasons, Steinberg attributed his inability to write to "laziness or worse." Aldo was so worried that he lectured him about taking better care of himself and sent actual menus for him to cook, eat, and report back on. "I'm following your advice to count my blessings," Steinberg wrote, describing his previous night's dinner, a cutlet prepared in the Italian style and an eggplant appetizer that was pure "Romanian food." To thank Aldo for his concern, he sent a copy of *The Joy of Cooking* and, as an "hors d'oeuvre," two drawings for *L'uovo alla kok* (The Perfect Egg), the book Aldo was writing, for which Steinberg volunteered to provide illustrations. He was engaged by a text that, even though "disguised as a cookbook," fell somewhere between philosophy and the novel, and he thought it deserved translation into English, which he was unable to make happen.

Still, it was difficult for Steinberg to be cheerful, and his correspondence remained sporadic. "I'm a little depressed," he confessed, as he told of waking up every day "at 3:30 full of terrors, regrets—the usual suffering." Even though he was in the country with the "delightful" Papoose, who walked beside him like a companionable dog when he went into the woods, and even though Sigrid was now well enough to make the occasional weekend visit without its ending in her tears and his silence, he could not force himself to be happy or even to be content with his lot. He was embarrassed to think he was becoming like his father and all his other Romanian Jewish male ancestors, something he had long vowed never to do.

BUT HE WAS VERY GOOD ABOUT creating excuses to justify himself, to himself as well as to others, and all too quickly he found quite a few "excellent reasons" to explain why he was entitled to this depression. He blamed it on the overwhelming workload as he prepared for the Parsons and Janis dual "cartoon" exhibition and for the 1977 retrospective Maeght was determined to have. He was also drawn into the commotion connected with the ending of the two-year-long retrospective that began in Cologne in 1974 and was just now ending in Vienna. Despite his best efforts to stay aloof, the show garnered so much publicity as it traveled that he was roped into granting print interviews to European publications and being filmed for German television. Aimé Maeght shrewdly appraised the steadily mounting enthusiasm as the show traveled, and despite Steinberg's insistence that he would not cooperate on a retrospective, Maeght insisted that his next exhibition had to be one and had to be ready by November 1976. That was too soon for Steinberg, who cabled "next year with pleasure," all the while plotting how to postpone any exhibition for as long as possible.

Maeght surprised him by moving with such alacrity that members of his exhibition staff were in New York within the week of Steinberg's cable. Maeght instructed them to go to Springs and make Steinberg work with them every day during the month of October to prepare the catalogue and the content for the show, which he insisted on calling "The Retrospective." Steinberg picked up the phrase and grudgingly began to call it "the retro show," even though it was a difficult concept to accept. He told Aldo he wanted a "less posthumous" title and asked for suggestions.

To Steinberg, a retrospective held the specter of another kind of death: of a career that had reached its zenith and was all but over. Since his sister's death, he had certainly been in almost constant biographical reflection, especially about "the brutal image of the end of life." Now he would have to reflect

on personal brutal images as he sorted out which works belonged to each of the "lives" that represented Milan, Santo Domingo, New York, and the places where he had been stationed during the war. It meant dividing the work into geographical as well as chronological periods and setting up categories within each. It meant finding terms and titles to define various works and periods and perhaps disputing the terms and definitions critics and scholars applied to it.

He had to make the initial selection of works to be shown, and in some cases he and those who worked with him had to track down works that he had given away or his galleries had sold. He had to become the scholar of his own life, and as Maeght's staff took over to scrutinize what he selected, they naturally disputed the facts and events of it. There were the ongoing questions of how other artists influenced him and corrections for all the biographical obfuscations and falsehoods he had given out to interviewers over the years. There were the apocryphal stories to deal with, such as how Steinberg often wore one of his paper-bag masks to cocktail or dinner parties just to draw attention to himself while pretending to be doing just the opposite. And there were the by now boring arguments about how to categorize his work, whether he was a cartoonist, a magazine illustrator, or a museum-worthy artist. All this had been reported or debated in so many articles and interviews that he was sick and tired of it. He did not want to do the external work that a retrospective required, and he was not sure that he was strong enough to face everything internal that he would have to dredge up and relive. It was almost too staggering to contemplate.

THE YEARS 1974–76 HAD TRULY BEEN watershed years in Saul Steinberg's life. He thought of them as a time of life-changing events, the two most meaningful being the death of his sister, Lica Steinberg Roman, and the coming into his life of the beloved cat Papoose. Such a linkage may have struck others as falling somewhere between the shocking and the superficial, but he spoke of it with such seriousness that no one dared to question it, at least directly to him. There were other changes as well, but perhaps with hindsight they were not so much changes as solidifications of his interactions with others. Sigrid's role as the principal creator of Sturm und Drang intensified, while Hedda's role as the level-headed sounding board who told him the worst about himself but loved him the best held steady. Ada remained her lusty, cheerful self in the face of constant adversity (always needing money, seeing doctors for one ailment after another, having to move house often); she reminded him of how lovable he had once been as her youthful *olino caro* and of how much she still loved the sad older man he had become. But instead of cheering him up, all

this attention and affection made him feel old, especially when he discovered that it was getting harder to lure nubile young women into his bed for the brief flings he still needed and wanted. He still had his steady bed partners in every one of his cities—New York, Paris, Milan—but even that was depressing. It convinced him that there was diminution on two important fronts, his creative powers and his sexual prowess. All he had to look forward to was gradual death, his own and others'.

His close friend Sandy Calder died suddenly in November, the day after they had dined together at one of their favorite hangouts, Joe's Italian restaurant on Macdougal Street. When Steinberg was notified, he went immediately to give what comfort he could to Louisa and the two daughters, Sandra and Mary. He spent the entire day with them, all the while trying not to let them see the "many emotional reactions" that engulfed him. The primary one was how difficult he found it to accept his friend's death without the finality of a religious ceremony. As Steinberg had aged, his Jewish identity had become stronger and his thinking of himself as a religious Jew had deepened. He always honored Passover quietly and alone, preferring not to participate in a seder. He went to temple on Rosh Hashanah and fasted at Yom Kippur. Although he did not formally sit shiva for his friends, engaging in the funeral obsequies had come to be the most important part of his acceptance of the death of a dear one, so he was dismayed to learn that there was to be no religious ceremony for Calder, only a memorial service at the Whitney Museum of American Art several weeks after his death.

As one of Calder's dearest friends of longest duration, Steinberg was invited to speak. He recalled the happy weekends and holidays at the house in Roxbury, when there was music and laughter and everyone danced, especially Sandy, who would dance with a chair or his Labrador retriever if there was no other partner. Steinberg told of an evening when the noise level was so high he had to bend down to hear what Calder, sitting in a chair, was saying. To hear him, Steinberg "comfortably and naturally" sat on Calder's lap, and he thought afterward that it had been sixty years since he had sat on a man's knee.

After he spoke, he was relieved to find that he had delivered his oration without "getting tongue-tied, fainting, laughing hysterically, etc." He was happy that he had finally overcome his shyness at having to stand before a microphone in front of a large crowd and a phalanx of reporters. He called it a combination of "duty and age" but it served him well once he decided that it was akin to religious expression and all he had to do to get through it was to bear down and speak. When it was over, however, he had to retreat to the country to deal with the pain of this newest terrible loss.

———

IT WAS NOT THE HAPPIEST OF HOLIDAY SEASONS, and to get over it, he made a hasty trip to Paris at the start of 1977, to tell Maeght that he could not face a retrospective but would help the staff mount an ordinary exhibition. Maeght more or less accepted his decision but still called the show "The Retrospective," which it was. Maeght also insisted that Steinberg had to meet Italo Calvino, whom he had asked to write a critical essay for the catalogue because he wanted Steinberg to be elevated to the pantheon of European intellectual thought and he wanted Calvino to do it. Steinberg had forgotten that they had been introduced ten years previously, but Maeght, who was determined to bring these two iconic figures together, reminded him. Steinberg was irritated and puzzled by Calvino's desultory conversation until he suddenly blurted out that he wanted very much to write a preface and was volunteering to do so. It made Steinberg wonder if his initial response to such a respected writer might be due to his increasing intolerance for meeting new people. He thought Calvino's preface was "not bad," mostly because it was filled with quotations about Galileo, Michelangelo, and other luminaries but, most important of all, because he was "not praised directly."

The show was to open on May 11, 1977, and he planned to be there for the opening before taking his niece, Dana, to visit a cousin in Israel whom he did not know and "who rather scares me." Still, he liked being in Israel, where he was comfortable surrounded by people whom he thought he resembled and whose lives reminded him of his Romanian youth. He never passed up a chance to go there.

DESPITE STEINBERG'S APPREHENSION, IF NOT REVULSION, over the idea of a retrospective, he could not avoid the one proposed for New York in 1978, which seemed a natural outgrowth of the 1977 show in Paris. Harold Rosenberg and Tom Armstrong, the director of the Whitney Museum of American Art, were the instigators of the American show, which gave Steinberg such "big worries" that he delayed for several months before eventually allowing them to persuade him that he had to do it, although he was perturbed that the "damned flatterers and confounded old men" would get their way. Astonishingly, they were all younger than he, and he was not at all happy about being "venerable."

It took the always succinct and direct Alexander Lindey to put the occasion into the proper perspective: "A retrospective usually comes toward the twilight of an artist's career. In your case it has occurred at a time when you are at the height of your creative powers. What a happy circumstance!" Steinberg wasn't so sure about that, but it was always difficult to refuse Harold Rosenberg, who

recognized his old friend's deepening depression and saw the retrospective as a tremendous opportunity for personal and professional renewal. Steinberg remained convinced that it was just the opposite, downhill all the way. In that glum mood, he began one of the hardest-working, most grueling years of his life.

THE MAN WHO DID THAT POSTER

There is no frontier in America. If you want, the nearest thing would be Weehauken. The frontier goes from New York to New Jersey.

From the moment it graced the cover of *The New Yorker* on March 29, 1976, until Saul Steinberg's death more than two decades later, he was known to most people (as he lamented later in life) as "the man who did that poster." Nobody knows whether the genesis of the "View of the World from 9th Avenue" came from one of the free-wheeling, far-ranging dialogues of free association that happened every time Saul Steinberg and Harold Rosenberg got together, but it is a possibility, because one of Steinberg's favorite anecdotes was about how a real-life incident had led him to create the pineapple as one of his most iconic symbols.

A decade before he made the "9th Avenue" drawing, Steinberg told Claire Nivola that "one of the very rare times when a real incident gave [him] the idea" of the symbolic meaning he wanted to convey came whenever he drew a pineapple. It happened in the mid-1950s, during the years of his closest intellectual friendship with Dorothy Norman. Steinberg was visiting her in East Hampton, where, as in her New York town house, she presided over an informal salon of some of the most interesting people in the creative professions. Norman was writing a book titled *The Heroic Encounter* to accompany a collection of objects and photographs she planned to exhibit at the Willard Gallery in New York. As she described her intentions to Steinberg, he thought the project seemed "hopeless" because the material was so vast, disparate, and personal. The only point on which they agreed was that the history of art was the story of humanity's ongoing struggle in one "heroic encounter" after another, all of which were portrayed through myth and symbol.

Some months later, on a hot summer afternoon when Steinberg dropped in

at the Rosenberg house in Springs, he found Harold sitting at the kitchen table wielding a large kitchen knife and "bothering" a pineapple. "Voila! The Heroic Encounter," Steinberg said theatrically, as Dorothy Norman's title popped into his mind. Harold hacked away at a pineapple that stubbornly refused to be cut, and his expression seemed to Steinberg "crocodilian . . . a sinister smile." Steinberg didn't remember who won, but the memory of Rosenberg's battle always made him think that the top or "feathered" half of the pineapple was "the hero," whereas the prickly bulb below it was "the dragon" that the hero was compelled to slay.

Steinberg had been playing with representations of the North American continent for well over a decade before the "9th Avenue" poster took its final form. In 1966 he did a series of drawings for a three-part profile of Los Angeles in *The New Yorker*, some of which featured the West Coast as if the artist were poised high above the Pacific Ocean looking down on the city. In 1973 he switched coasts for "The West Side," a drawing that placed Manhattan Island at the center of a universe that included a collection of amorphous lumps denoting the five boroughs (Bronx, Manhattan, Queens, Brooklyn, and Staten Island), with a vague sixth lump known as Upstate. Beyond the city, a sun peeked over the Atlantic Ocean at the top of the drawing, while the largest lump of all, an upside-down bean-shaped "USA," filled the bottom. After he made this one, Steinberg started to draw visions of a city that might have been New York and might have had a river beyond it, but without any of his iconic images: no Chrysler or Empire State Building, no Statue of Liberty, and no other recognizable landmarks. There was only a power station, which may or may not have been the one on East 14th Street, but the buildings along the horizon looked as if they would be more at home on Red Square in Moscow than along the Hudson River.

There were other versions of cityscapes, and in one of them Steinberg added words, marking off 9th and 10th Avenues, the Hudson River, and a vague "America," but it was still very much like his earliest drawings, with nothing except the street names to make the viewer aware of a specific place. In another version, "Jersey" showed up beyond the Hudson River, and the landscape included Texas, Nevada, and Canada. All these were drawn on 8½-by-11-inch paper, but he expanded the next version to 20 by 15 inches, then to 26 by 19½ inches, and finally to the largest, 28 by 19 inches. The streetscape eventually included the ordinary squat redbrick apartment buildings and warehouses that dot the midtown West Side of New York, to which he added some generic-shaped cars and many scritch-scratches of rubber-stamp people who scurry along the sidewalks.

When viewers first saw the magazine cover, the usual response was almost always a smile of recognition swiftly followed with a nod of superiority over the parochialism of supposedly sophisticated New Yorkers, who allegedly believe the world ends once they cross the Hudson River. Nobody, it seemed, stopped to consider that Steinberg was showing how the New Yorkers' parochialism was no different from every other American's, the only difference being that New Yorkers seldom ventured outside the small neighborhood villages into which the great city is divided. Steinberg's ordinary "crummy" New Yorkers are rendered as impersonal rubber stamps who live in the "crummy" parts of town seldom seen by tourists, and who are too busy just making it through another day to have time to think about the larger world beyond the appointed rounds of where they live and work.

After the magazine's legendary reader, "the little old lady in Dubuque," enjoyed her moment of condescension with the cover, she and the rest of Steinberg's viewers wanted to know why none of his typical landmarks were included to identify the grandeur for which the city is famous. He had a ready answer: this was a drawing of how "the crummy people"—that is, the working classes—see the world that lies beyond their immediate neighborhood. He never intended to make people feel superior or even comfortable when they looked at this drawing, for his thoughts about America, particularly New York and its environs, had darkened considerably during the past decade. Like most of the rest of the country, he had been "glued to the television" and was in "paralysis" over the Watergate affair. During the worst of the Vietnam War, he thought it was probably for the best that the average American was confronted by its brutality in every newspaper headline or television broadcast. In a paraphrase of Gertrude Stein's famous remark about Oakland, California, "There's no *there* there," Steinberg enlarged the phrase to include the entire continent: "Today you get from here, where you board the plane, to there, where you get off. There's nothing in between, not like it used to be."

And just as the country was facing one crisis after another, so too was he. There were too many "boring parties and primitive conversations, nagging, bragging, the usual kindergarten." He fled from the city at every opportunity because he thought it had been ruined by an influx of poor people, while paradoxically, East Hampton, where he went for solace and tranquillity, was "ruined by invasion of the rich." The country was roiled by gasoline shortages, falling house prices, and rising unemployment, and he could see all this clearly in eastern Long Island, where there were no cars in the supermarket parking lot, many stores had to close, and "everyone has left, due to poverty."

By the time the "View of the World from 9th Avenue" appeared, it was

not meant to be the cheerful, optimistic poster people took it for, and the public misreading of Steinberg's intention only deepened his chronically gloomy outlook. When the demand for copies of the cover became more than the magazine could handle, a contract to reproduce a poster was quickly drawn up, and by 1980 25,000 copies had already been sold. As years passed, it became a kind of public shorthand for New York in the American imagination: in 1992, at Ruth Bader Ginsburg's confirmation hearings for the Supreme Court, the president of the New York State Bar Association used Steinberg's iconic poster as an example of how Justice Ginsburg's vision would be far vaster than "how the world revolved around 7th [sic] Avenue." Chambers of commerce all over the world literally stole the idea as they adapted the poster to promote their cities and organizations, while individuals as well as publications created other kinds of rip-offs.

Steinberg amassed a file of imitations a good five or six inches thick, as people from all over the world sent him various versions, and it made him fume repeatedly about everything from plagiarism to copyright infringement. Time and again Alexander Lindey had to restrain him from suing over everything from T-shirts to coffee mugs that bore an adaptation of the poster. Steinberg complained that he hated to walk down Fifth Avenue between 42nd and 59th Streets, for the windows of every souvenir shop he passed had some rip-off relating to the cover that made him wince. There were heated exchanges between the angry and outraged Steinberg and the obviously irritated Alexander Lindey, whose patience wore exceedingly thin as he told his client repeatedly that he had no grounds to sue. Steinberg insisted that he did, and just when the situation threatened to explode, he usually backed off and sent Lindey another of his many euphemistic apologies for his "Mittel Europa attitudes."

The fuss over the cover showed no sign of abating, and Steinberg festered for the next seven years, until 1984, when he finally had legitimate grounds to sue for copyright infringement. He sprang to the ready when Columbia Pictures Industries, Inc., appropriated specific images of some of the buildings from his poster for one they created to promote the movie *Moscow on the Hudson*. It took four years for Steinberg to win his case, and by that time Alexander Lindey had retired. After Steinberg paid his new lawyers at Rembar & Curtis, his share of the settlement was an impressive $225,859.49.

Despite the fact that the decade from the time the drawing appeared on the *New Yorker* cover until the lawsuit was settled was so full of personal trauma and an overload of professional work, Steinberg was possessed with an energy fueled by anger, and he stayed focused on righting alleged wrongs con-

nected to the poster. Other people were making a great deal of money using his creation, and it was natural for him to want retribution. He remained fixated on justice until he got it, for as with so many other aspects of his character, looking back and focusing on the past was what he did best.

MEANWHILE, HIS IMMEDIATE PROBLEM WAS THE Whitney retrospective, and there were many facets with which only he could deal. Once he made the commitment to the "nightmare" (as he called the exhibition), Steinberg took the entire process very seriously: "I accepted, I have to do it and will get to work so as to do it well." A major undertaking was the chronology, and only he could prepare it. He had been out of touch with his Denver and New York cousins for a very long time, especially the Danson family, who had done so much to bring him to the United States. To ensure that his memories were factually correct, he contacted Henrietta Danson to ask for any help she could give, particularly with family photographs. She was a great help, as she had saved everything pertaining to his coming to America, starting with correspondence dating from the time he was desperate to leave Italy, and she sent it all to him. She called the letters "a treasure trove" as she again read about all the false starts and confusions connected with securing his visa. She noted how his writing showed the development of his ability to express himself in English in the chatty letters he wrote about the trials of life in Santo Domingo. She also had his wartime letters, full of blacked-out material, and even the "secret note" he had tried to send to his parents, which obviously never made it through censorship. From the vantage point of what his life had become since the war ended, she told him, "It all reads like a novel . . . It seems hard to believe any of it."

STEINBERG URGED ALDO BUZZI — or perhaps begged is more accurate — to come to Springs in September 1977 and help him prepare for the retrospective. He was so eager for Aldo to come that he tried to entice him with the news of his first flying lesson, during which the pilot was so pleased with Steinberg's progress that he let him take over the controls. He promised to take Aldo on a flight, but that news did not thrill him. He came to Springs but managed not to get into an airplane at all, let alone one piloted by Steinberg, who soon tired of lessons and gave them up.

To help both himself and Aldo, Steinberg made an outline of the work he had to do for the retrospective. The first task was to select the pictures: at first the museum wanted approximately 150, but by the time everyone had considered all the phases of his career, they agreed that they needed almost 250

to encompass its full range. Steinberg knew that was too many but resigned himself to making the selection. Harold Rosenberg was engaged to write the text and edit the catalogue, and with his usual exuberance, he was full of ideas for what was becoming a very large and expensive book. Steinberg called it "the *Art Book* I've feared and avoided, and which makes my hand tremble." When he agreed to the retrospective, he had hoped for "a show and a simple catalogue," but it was fast becoming the very thing he had tried for years to avoid: "a heavy, expensive vulgar book, which is the stuff on which museums feed." Part of his animus came from the fact that although he would get a small royalty on every copy sold, the book was a catalogue and the property of the museum, which would glean the real profit.

To get through the preparations for both the book and the exhibition, he was determined to do two things: to "defend" himself and to make the best of the situation. He and Aldo conducted mock interviews based on the questions that interviewers were bound to ask. It paid off, and he thanked Aldo when they quoted him "with *precision.*" He prepared for the ordeal of the opening and its hoopla by working on his physical stamina, riding his bike most days around the country roads leading to Louse Point and watching his diet by elim- inating whiskey, bread, and desserts. He slimmed down to the same weight he had carried in 1955, a fact that he knew because he checked the scale against his driver's license from that year, one of the documents he had unearthed while trolling through his past life.

To prepare the chronology of his life and work, "a guy from the museum, slow and patient," was assigned to help him. The compilation was frustrat- ingly slow, and as he needed someone whose memories overlapped his own, he naturally turned to Aldo. There were also the bibliography and the list of titles, both for works that already had names and for those that did not, which had to be assigned titles. Also, although the museum staff was in charge of contacting collectors who owned paintings the curators wanted to exhibit, they occasion- ally had to enlist Steinberg to help with a few of the recalcitrant, the reluc- tant, and in several rare instances the uncooperative. It was exactly the kind of human interaction he detested, but he did it. Everything had to be finished by November to be ready for the April 1978 opening. When time seemed against him in mid-August, Steinberg decided that if it turned out well, it would be by a miracle.

He hovered over the museum's staff as they did the work of assembling the paintings and drawings from which he made the final selection, but he needed help to assemble the non-art material. Sheila Schwartz, an art historian and editor who had been working with Leo Steinberg, agreed to help him one

day each week whenever he was in the city. One of her earliest duties was to buy a typewriter on which to record his remarks for the chronology and, as he asked her to do, to correct him if he made mistakes in English. When she did, Steinberg would listen intently, then say, "No, that doesn't sound like me," and as Schwartz remembered, "back we'd go to his original wording."

Working with Schwartz required Steinberg to go through his voluminous files of letters and papers. His file cabinets contained "fat, messy, amorphous folders," and he explained how he wanted her to put them into an order that would permit him to lay hands on exactly what he needed. Schwartz began by breaking down the contents of the first several files and creating many new folders with precise identifications. Steinberg took one look at it and said, "No, I can't work this way," and put everything back into the original messy files. She thought he was bothered by what was "(to him) excessive categorization and definitiveness; his intellect and imagination wanted things in a constant state of flux."

Everyone who read the chronology agreed that it complemented Rosenberg's text and vice versa; as the book dealer John L. Hochmann, put it, "Most chronologies read like tombstones, but this one reads like a narrative." Work on the retrospective continued as 1977 ended, with Steinberg giving interviews nonstop and being photographed for the many feature articles generated by the Whitney's publicity department. He still had to complete the poster, give final approval for the printed invitations, and, most important of all, prepare the guest list, a task he compared to the logistics for the Battle of Austerlitz.

IT WAS TOO COLD AND THERE was too much snow that December to go to the country, so Steinberg stayed in New York and went to dinner parties every night in a constant round of "new people and pretty women." He was able to hold court and pontificate with pleasure because Sigrid was "traveling," and since he was not involved with other women at the time, "words and ideas [came] more freely." As had happened in the past when he had allowed himself to be wined and dined exclusively by the cream of New York society and the celebrities whose boldfaced names dotted the tabloid gossip columns, he earned the enmity of old friends. One among the several was Sasha Schneider, who asked Steinberg to create a poster for a concert he planned to give to celebrate his seventieth birthday in October 1978. Steinberg knew that he had too many other commitments, and when the deadline arrived, he had not been able even to begin it. When Schneider phoned to ask about his progress, Steinberg became nasty and defensive and Schneider withdrew the request, saying that it was more important to keep the friendship that had begun almost

four decades earlier than to fight over a poster. But he accused Steinberg of having time to hobnob only with the rich and famous and claimed that, as one of Steinberg's oldest friends, he had "the right" to remind him that his own seventieth birthday was fast approaching, and when it arrived, he might need the old friends who truly cared for him. Steinberg did not reply, but he hurriedly made the poster.

This was the social climate in which Steinberg prepared his guest list for the opening night dinner on April 13, 1978, for friends of the museum, lenders, and his personal guests. Not only did he have to hobnob with the international glitterati at the dinner, but he also had to see them at other times, and he anticipated having a few frantic weeks after the opening. After all the help Aldo had given him, Steinberg asked him not to come because he would be too nervous to enjoy his company or give his old friend the attention he thought he deserved. However, he put Hedda at the top of his list of invitees. Despite her protests that she should not attend the dinner but should leave the evening free to be Sigrid's, he insisted that she had to be there.

He and Sigrid were in a period of cooled passion and a pattern of cordiality when she was in New York, which was not often because she spent so much time in Mali. She was especially dreading the opening, and to get away from it she had gone to Mali, where she had a long-established network of native friends and was having an affair with one of a series of African lovers. Steinberg insisted that she had to be present for the opening dinner and she came back reluctantly, which was enough to make them both tense.

On the night of the opening, photographers lined the sidewalks as everyone from Jacqueline Kennedy Onassis to Andy Warhol to Woody Allen mounted the steps into the museum. What a "classic way to show muscle," Steinberg gloated. The *New York Times* critic Enid Nemy could not resist a tongue-in-cheek appraisal of the crowd by quoting Leo Lerman's partner, Gray Foy, who gushed about how much he adored Hedda Sterne before he got in a zinger about how she and Steinberg had "separated (but did not divorce) almost two decades ago, but artists never did care about time." And, as Hedda had feared there would be, there was an incident at the dinner involving her and Sigrid.

Steinberg was seated at the head table with Mrs. Onassis on his right and the museum director, Tom Armstrong, on her right, the rest of the table being filled with various luminaries and dignitaries. Sigrid and Hedda were each placed prominently at other, separate tables. As the dinner was winding down and guests were getting up to mingle and chat, Dore Ashton sat down next to Steinberg to offer praise for the exhibition. She was a genuine friend to Stein-

berg and to the two women, so she made a remark in total innocence about how wonderful it was that his "ex-wife" (Hedda) could be on such good terms with his "new one" (Sigrid). Steinberg erupted; he slammed his hand down on the table and set the cutlery bouncing as he said, "Hedda is my *WIFE*! She is, was, and always will be!" Unfortunately, Sigrid was standing directly behind him and heard everything. So too did several others, who hurried to tell Hedda what had just happened. Hedda left quietly and quickly; Sigrid stayed on, awkward and insecure, and she never forgave him. Her embarrassment was magnified when *People* magazine interviewed Steinberg and chose to highlight his relationship with the two women in its coverage of the exhibition. In a diary entry from 1985, Sigrid wrote a list of reasons that she hated him; most of all she hated him for his "last exhibition, 1978," and "your interview . . . and what it did for me."

AS FOR THE EXHIBITION ITSELF, there was mostly critical praise, with a few of the usual questions and quibbles about Steinberg's place in the world of art. *Publishers Weekly* led off with a review of the catalogue, and after calling it "a dazzling gallery [of his] mad, sardonic, and hilarious" work, it referred to him as a "cartoonist" and offered a "resounding 'yes!'" to the skeptics who asked, "But is Steinberg *an artist?*" The architecture critic Paul Goldberger sidestepped the question, calling the retrospective "one of the best pieces of architectural criticism in years," while reporter Kim Levin paraphrased Anaïs Nin by calling Steinberg "A Spy in the House of Art." Clearly the critics did not know what to do with such a vast collection of disparate creativity. The *International Herald-Tribune* paid more attention to the "media blitz" surrounding Steinberg than to the show itself, as it seemed more content to list feature articles—in the *New York Times Magazine* and *Newsweek*—and the cover features in *Horizon* and *Time*, among others, than to appraise the art directly. The writers said that Steinberg's "canonization" had come "after many years when museums shied away from his work," and they wondered why there was this sudden barrage of attention and whether it could be attributed to his "true weight as an artist." They concluded that "long-range assessment must remain an open question."

Anatole Broyard wrote an article that began by saying he was eager to read the show's catalogue/book because he felt he was missing something when others praised drawings that he often did not understand. He may have been reacting to the glitter of the opening when he objected to the "chic and automatic assent that surrounds Steinberg's work," and concluded that many of the drawings looked like cartoons and "perhaps they ought to be looked at

as if they were." Like many readers of the book, Broyard found Rosenberg's text "almost as baffling as the drawings" and "the sort of esthetic blather that Rosenberg usually satirizes." Broyard quoted Steinberg as having said that his drawings "appeal to the complicity of my reader," and his dismissive response was that "too many artists are appealing to my complicity right now."

Broyard's article unsettled Steinberg, but it did not carry the critical weight of the review by the *Times*'s John Russell, which was a devastating blow with a punch that continued to wound for many years afterward. In his very first sentence, Russell said that by Steinberg's own admission, he had known "nothing but admiration, affection, and cash on the nail." To Russell, Steinberg was the quintessential example of the art world's "insider's insider": he was shown in the best galleries throughout the world, no one ever gave him a bad review, museums begged and pleaded to mount shows, and he managed to create the best of all possible worlds, for he "didn't even have to part with his work; he just sold the reproduction rights." On the one hand, Russell thought the Whitney retrospective was a possible mistake that could well send Steinberg scrambling back "onto the treadmill of commercial art." On the other hand, he thought Steinberg had figured out how to beat the system in order to live as he liked and at the same time keep his integrity intact: "He's still doing it and good luck to him."

Russell did end his review on several positive notes, but as readers seldom read reviews in their entirety, very few remembered some of the compliments, such as his comparison of Steinberg's portrayal of New York to the way several distinguished writers portrayed their cities: Italo Svevo's Trieste, Constantine Cafavy's Alexandria, and also Vladimir Nabokov's America, when he wrote about the country in *Lolita*. Russell praised Steinberg's talent for parody and epigram and urged his readers to see the show "many times over." He said that they would learn something and be amused, and they would even profit from Harold Rosenberg's text.

Never mind that the show and the catalogue were both sell-outs; never mind that the international press notices were abundantly positive; and never mind that John Russell compared Steinberg to distinguished writers (as Steinberg himself liked to do). The opening portion of his review was, as Leo Steinberg told Saul, "intentionally malicious" and "so wildly unrealistic that only its own stultified malice comes through." Saul Steinberg was unable to put it behind him. What rankled most was the insinuation that he was only in the business of art to make money, and it festered like a recurring boil for years.

————

AFTER ALMOST TWO YEARS OF NONSTOP activity connected to showcasing his work, it was only natural that Steinberg felt a bit of a letdown once the exhibition was safely launched. But there were other reasons for sadness as well. Richard Lindner, one of his oldest friends in New York, died peacefully in his sleep on January 13, 1978. They had been neighbors during the years Steinberg lived with Hedda, and the friendship grew close again when Steinberg moved to 75th Street. The funeral was a dismal affair, and he was among the few friends who took Lindner to "a sad cemetery in the suburbs." He went home knowing that every time he thought of his friend he would feel "a wave of affection and tenderness."

Steinberg was too busy to brood in the early months after Lindner's death, but once the retrospective was ending, the sensation of "loss and emotion" hit so strongly that it surprised him. It became overwhelming when Harold Rosenberg died suddenly on July 11, of a stroke after complications from pneumonia. Ironically, John Russell wrote Rosenberg's obituary for the *New York Times*, noting that his last book had been about Steinberg. Hilton Kramer posited in a separate article that when Thomas Hess died two days after Rosenberg on July 13, "An Era in Art Comes to an End." Indeed, for Steinberg it had, beginning with Ad Reinhardt's death in 1967 and encompassing Vladimir Nabokov's a decade later; he mourned Nabokov vividly for several years afterward.

It took him until the following April, in 1979, after May Rosenberg had arranged two memorial services, for him to process the loss of Harold. Steinberg spoke at both services, in New York and later in Chicago, where Harold had been on the faculty of the university's Committee on Social Thought. He worked diligently on the speech he delivered at both memorial services, editing repeated versions until he was satisfied, but the one paragraph he kept in every version was the one he chose for his ending: "In my mind, the conversation with Harold will continue the rest of my life with the same polite tenderness that marked our friendship." When he set up the meditation room in the 75th Street apartment where he practiced "sitting" as part of his yoga regimen, he hung a photo of Harold, in a coat and swinging a cane, directly in his line of vision. The photo was there until he died.

STEINBERG RETREATED TO SPRINGS, where he rented a house for the summer of 1978 while contractors installed French doors and more large windows in the studio. He did not want to be alone, especially in a rented house, and he begged his nearest and dearest to visit, starting with Aldo, whom he invited to stay for a month or longer. Lica's son, Stéphane, and his wife, Danielle, were living and working in Africa. Steinberg offered to pay for everything if

they would only come visit, but they were unable to do so. He also invited Daniela Roman, but at a different time from her brother because he thought they reverted to their childhood relationship when they were together for too long. He liked it at first, but as he was not used to being around children and did not appreciate how they re-created their earlier rapport, it quickly wore on him. He wanted Aldo's company most of all, and he sent a sizable check to make up for income Aldo would lose from not working and to pay for his travel expenses. He sent more than enough and told Aldo to give at least $1,000 of it to Ada, who was the only close friend he did not invite to Springs. Although she had made several trips to the United States in recent years, Steinberg always managed to be in Europe when she passed through New York, and he preferred to keep her safely sequestered in Italy.

While he was waiting for Aldo's arrival, the only activity that brought him pleasure was working on drawings for *The New Yorker*. Lee Lorenz and William Shawn were greatly relieved to see so much productivity, for they had feared that the retrospective might have created the equivalent of a writer's block that would greatly hamper his output. Instead he created a series of portfolios, two- to four-page spreads of everything from his own dreams to interpretations of classic Japanese art and American public architecture, to whimsical maps of his own creation. While he was involved in all this, he followed his usual custom of making notes to himself in his pocket diaries or some of the datebooks he kept sporadically. In 1978, one of the questions he pondered was the "influence of subway on Dubuffet. He thought of making drawings of Rimbaud and Verlaine that would show "how the true influence is hidden." He quoted Harold Rosenberg on Céline: "An evil man cannot be a good writer." Perhaps considering subjects for future *New Yorker* spreads, he wrote "Summer—baseball, winter—football." And perhaps when he wrote "Ideal vs. Survival" he was writing about himself and what he was going to do with the rest of his life, now that he had known so much professional closure and personal loss. Like Steinberg's Don Quixote, who jousted at pineapples from his rickety horse or thrust his spear at the world from a quasi-safe perch within the open mouth of a crocodile, the two concepts would figure repeatedly in Steinberg's ever-elusive quest for, if not happiness, then certainly satisfaction.

WHAT THE MEMORY ACCUMULATES

Nothing is lost of what the memory accumulates, an immense computer that continues to register and classify data that are used only in a minimal proportion for conventional and mono-tone life. Life in this sense is like a huge ocean liner in which only one cabin is used.

While he was caught up in the media excitement generated by the Whitney retrospective, Steinberg received a letter, via *The New Yorker*, from a man in Arizona named Phil Steinberg, who said he was the son of Moritz Steinberg's brother Beryl and therefore Saul's first cousin. Phil Steinberg had read the glowing profile in *Time* and decided to get in touch with his famous cousin. His letter came totally out of the blue, for Saul had never been in contact with the Arizona contingent of his family. He and his uncle Martin in Denver, and later Martin's son, Charles, wrote from time to time about providing support for the relatives in Israel, but his only fairly regular correspondence was with Charles's daughter, Judith Steinberg Bassow. It was a pleasant exchange, with Judy sending news of her doctor husband's work and her quest to balance her work as a lawyer against the needs of her two daughters, whom Saul occasionally entertained in New York when they were attending eastern universities. He usually wrote short notes to accompany frequent gifts of art to the Bassows, and when they came to New York, he enjoyed their company. He formed a close friendship with Judy when they exchanged information and cooperated on a Steinberg family geneology.

The letter from Phil came as a shock, not only because of the eloquent simplicity of Phil's life story but also because he enclosed a photograph of himself, and when Saul looked at it, it was as if he were looking at himself. Phil was his age, had been in the Marines, and had seen heavy fighting during the battles for Guam and Iwo Jima. When he came home, he married Rita, an Irish girl originally from New York, and like his father and uncles before him, worked as

a typesetter until he taught himself to build and repair radios, televisions, and other electronics. He opened a small shop and did as much work as he needed to do to support his modest lifestyle; when he retired, he bought a house trailer where he and Rita lived, sharing a passionate love for motorcycles and roaming together throughout the Southwest on his enormous Honda. Phil's letter was an honest and straightforward account of a life satisfied with the simplest of pleasures, and he told his newfound cousin that he was sorry to say that he had great difficulty understanding Saul's work. Phil hoped Saul would come to Tucson, because he would never go back to New York. Saul was captivated by "the mysterious cousin," and even though he had just returned from a trip through the western states, he had such "a powerful desire to meet a cousin whom I'm not ashamed of" that he went west again, to Arizona, in November.

PHIL'S LETTER CAME AT AN INTERESTING time in Steinberg's professional life, when the idea of family and its effect on the individual was uppermost in his mind. "These days," he told Aldo, "I'm drawing my aunts and uncles from photographs, and I recognize (scrutinize them as real people for the first time) parts of myself: an ear, an eye. Archeology!" He had conceived the idea of creating mythical family groups that were loosely based on portraits of his own relatives and on some of the paintings and photographs he had observed in foreign cultures, particularly Russia, where family photographs were still taken in the old-fashioned tradition, "where dignity was the most important thing." Over the years he had amassed a large collection of such photos, starting with his own family and then with those he picked up in flea markets and his beloved "junque" shops. When he started to tinker with them, he began by making totally new drawings, which he intended to turn into easily recognizable parodies, until one day he discovered that by applying a thin overlay of black enamel paint to the photographs themselves, he could turn them into perfect imitations of old-time photography, "as varnished as the painting of Ingres that were their models." Eventually both his new drawings and the transformed photographs became two thematic portfolios for *The New Yorker* called "Uncles" and "Cousins."

The fixation on family marked the start of Steinberg's increasingly introspective vision, as he plumbed his own life to convert it into the pictorial autobiography that became one of the dominating motifs, if not *the* dominating motif, of his last two decades. "Nothing is lost of what the memory accumulates," he wrote in one of the many notes he made on this subject. The question he pondered repeatedly was how to reveal these memories so they transcended the personal and became universal, which in his worldview always

became drawings suitable for *The New Yorker*. How it rankled when he tried to explain what he wanted the portraits to convey to Bernard Rudofsky, who cut him short by asking, "Are you working or only selling?" "He thinks he's funny," said Steinberg, who thought this was a truly "nasty" comment.

Steinberg had always been a serious reader whose main interest in the ideas of others was to see how he might relate them to his own personal experience. From Gogol's nose to Joyce's peripatetic Leopold Bloom to the many philosophers whose aphorisms Hedda Sterne sent his way, Steinberg always found something he could use. When he read Proust (whom he thought boring and never finished), the one idea that resonated for him was how certain scents or objects could serve as lifelong triggers of memories. It was, therefore, a "wild" experience when the curators for the retrospective uncovered some of the drawings he had made thirty years earlier and not seen since, thus assaulting him with memories long forgotten. He felt that looking at these old drawings was akin to playing a game he named "First and Second Class Reality," where the artist looking at his art engages in "a sort of voyeurism that probably interferes with life, a truly unnatural act." He had always made the occasional jotting in the past, but after the retrospective he started to make more frequent and far more detailed notes about his thoughts and experiences, especially as he tried to recapture the emotion he had felt at the time he created the work. The two portfolios for *The New Yorker* became, like so many other photographs he agonized over, a serious search for the truth of himself and the essence of his being.

One of his most famous first- and second-class realities is a photograph taken by Evelyn Hofer, of the adult Saul Steinberg standing in the middle of the immense Persian rug that filled his studio floor, which appeared from time to time in his drawings, holding the hand of a life-size cardboard cutout of himself as a boy of six or eight. Both the cardboard boy and the real adult look steadily at the camera, as if in all seriousness they are inviting the viewer to join them in playing a game to find the reality.

STEINBERG WENT TO TUCSON AT THE end of October to visit Rita and Phil Steinberg. During the fourteen years they had lived in a trailer park out in the country, they had watched as the city encroached until it surrounded them with suburban clutter. Steinberg had a difficult time fathoming this new relative, especially when he saw the elderly childless couple, Phil and Rita, set out on their motorcycle surrounded by a phalanx of other old people on theirs. He was grateful that their trailer was so small that he did not have to risk offending their hospitality by staying in a hotel, and he managed to invent reasons to

keep himself occupied during the day so that he only spent evenings in their company. Anything more would have been too emotionally exhausting, for simply being with his cousin gave Steinberg an image of the person he would have been "without education, without success." He left Tucson with deeply divided emotions, aware that he could not understand living the life of a man like Phil and that he would never grasp how anyone could be satisfied with it. He made a comparison unflattering to himself: that Phil was indeed "an authentic person," whereas he was not.

BACK IN NEW YORK, HE WENT immediately to the country, where he was happiest and could do his best work. He was in another of the recurring daydreams about living there permanently when the phone rang, abruptly summoning him back to the city because his apartment had been burgled. A thief had entered through a courtyard window and made off with gold cuff links that had been a gift from Hedda during their marriage. This distressed him deeply. Also stolen were the various medallions Steinberg had been awarded during his career, which turned out to be real gold and not imitations, as he had thought. Losing the medallions did not upset him nearly as much as losing the cuff links, but what upset him most of all was the loss of his "tranquillity." His first impulse was to move to a different apartment, claiming that he had never liked the one he was in because it was too dark. In the end he stayed there, after installing a security system and renting a warehouse where he could store his work, the many souvenirs of his travels, and his beloved "junque," all of which was crowding him out.

STEINBERG WAS AT LOOSE ENDS AS the seventies ended, alone in the country because of tension with Sigrid, whom he told to stay in the city. As he was without female company and because he could not read all the time, he was determined to find something other than his work to occupy his hands as well as his mind. For reasons he could not understand, let alone explain, he settled on wanting to play the violin again, something he had not done since his student days at the Lycée Basarab. Steinberg told Sasha Schneider, who immediately made him the gift of a good instrument, and he began to practice seriously, easily recalling some of what he played a half century before in the school orchestra. He liked "playing it loudly, out in the country; with no neighbors nearby, it is a pleasure." To make sure he was playing properly, he began each session with simple warm-up exercises he remembered from his youth, and later, when he progressed to playing actual music, he tape-recorded himself and then listened to the playback, mostly "with admiration." Sometimes

he taped himself accompanying recordings, but when he played the tape back, he discovered that fingering was "still difficult . . . but with time, perhaps . . ."

He had long had an important musical friendship with Sasha Schneider, but another was developing with Leo Treitler, the musicologist husband of his friend Mary Frank, whom he had known since she was Robert Frank's young wife living in a 9th Street studio with rear windows that were directly opposite Bill de Kooning's. Seeing her again brought back memories of how, depending on which of his two friends he was visiting, he could wave out the window to the other one. Mary Frank soon became an increasingly important friend. She was one of the few people whom he trusted enough to introduce to Lica on her last visit, and after Lica's death, Frank realized how much he loved his sister when she tried to comfort him by saying that she thought she could understand his grief well enough to share it because of her daughter's untimely death. He made no reply, but she intuited that a new level of unspoken closeness had grown between them.

Mary Frank played the recorder and "a very bad piano" and thought it would cheer both her and Steinberg to play duets. He refused at first, but she cajoled him into agreeing, even though they both thought that music for recorder and violin was not the best. After two or three such sessions Steinberg stopped, because "he could not stand that he played so badly in comparison to professionals. It was shaming for him; others could be amateurs but for him it was unbearable. It made him sad and angry." He settled for hearing music played well at the Frank-Treitler home whenever they hosted one of the musical evenings at which Leo's son, Max, a distinguished cellist, played.

Steinberg became especially unhappy with his own ability after Isaac Stern invited him to a recital and reception in his apartment. He was disgruntled all evening, calling Stern's playing of Sibelius just "so-so" and Stern himself "flabby and surrounded by over-stuffed furniture that resembles him." He went home intending to capture the evening in drawings that were initially "unkind," but his inherent dignity made him abandon it as "too easy and not right." Nevertheless, he continued to play the violin when he was alone and with more proficiency than he gave himself credit for, playing everything from "Johann Christian Bach (the Milanese Bach)" to Vivaldi, Mozart, and Haydn. He took lessons from a woman who taught at the Mannes College of Music, a Russian he called Sushanskaya whom he described as a martinet originally from Leningrad, who made him play "wicked, difficult exercises by the noted sadist Schradieck." She insisted that he join two of her other pupils, talented schoolchildren who played piano and cello, for trios. This caused Steinberg more trepidation than if Isaac Stern had invited him to play, but once he joined the

children, he delighted in the feeling of having "made progress," even though it made him feel his "lack of talent acutely."

AFTER HIS VIOLIN PLAYING BECAME SOMETHING he did routinely, he needed to create other diversions to fill his time. He took to visiting the many wooden churches on the east end of Long Island, where he drew them *dal vero*. He thought the structures were interesting because they were "architecturally sound," whereas he disliked the many stone churches in the area because the proportions were all "built to the wrong scale." Besides these renderings of buildings, he kept his hands busy with still lifes and portraits. The objects on his desk or dining table, the wooden sculptures he put together from bits and pieces left over from Gordon Pulis's work on the tables, the iconic blue-and-white Chinese vase, were all turning up frequently. He caught Sigrid in many different poses but mostly in the quiet serenity that being in the country instilled in her. And of course there was his beloved Papoose, either captured on one of his stalking adventures or disguised as a caricature cat within other drawings that eventually appeared in *The New Yorker*.

To all this playful exploration Steinberg added photographic experimentation, first by capturing a person or an image on a Polaroid camera, then by making a drawing from the photograph. In the drawings he strove for the same "Courbet-style colors" that Polaroid photos usually became after they had been exposed to the light for a while. He played with postcards in much the same way, creating an original drawing and coloring them "Courbet-style" as closely as possible or drawing over the original and using it in collages. He liked to use airmail envelopes in collages and would send envelopes to friends and ask them to mail them back to him because he wanted the postmark.

His favorite entertainments continued to be reading and going to the movies, and he did both avidly and voraciously. He was aware of the feminist movement and tried to educate himself by reading books written by women, but when it came to the proper role for women to play in men's lives, he was still very much the traditional European gentleman and expected them to be submissive. After he met the journalist Shana Alexander and liked her, he read her books and articles with grudging respect, but he did not put her on his list of women who were "good writers." Two who made it were Elizabeth Hardwick, for *Sleepless Nights* because he thought her plot mirrored his own depressive behavior, and Renata Adler, for *Speedboat*, which he liked because it was "a quasi novel in fragments."

In his almost frenetic search for pursuits to pass the time, he agreed to take a winter vacation in February 1980 with "la Sigrid," as he had begun to call her

when he wrote or spoke of her to mutual friends. She wanted to go to Mali, but when Saul refused to go that far, she settled for Guadeloupe, first because it was French and then because he insisted he would only go somewhere "not yet cursed with poverty or political strife." He loved to travel and was always ready to go at a moment's notice, but his preference was for cities where he had a network of friends with whom he could eat a pleasant meal and have a meaningful conversation, or find shops where he could buy such things as a brand of ink or a kind of eraser he could not get in New York, or where he could have clothes made to order by tradespeople who were delighted to fit fine fabrics to his exacting specifications. In recent years this had meant making the circle of Milan (and sometimes Rome), Paris, and London and nowhere else. Going to a resort gave him a "horror of hotels and restaurants and tourists." Sitting on a beach was "inertia, indolence, and sloth—the anticipation of death." But Sigrid liked that kind of vacation, so Saul allowed her to drag him along on "whimsical trips, almost always good despite my grumbling."

Despite his hesitation, he did have a good time on Guadeloupe. They left New York in a snowstorm and he had a bad case of flu, but the warm weather soon cured it, and he spent a lot of time floating in the deep blue water or sitting on the beach reading *Babette's Feast* and *Out of Africa*. What he remembered best about these readings was his single meeting with Baroness Blixen in New York toward the end of her life, when "her stockings hung in folds."

Still, even after all this pleasant activity, Steinberg retreated into one of his increasingly frequent "periods of paranoia," when he compared himself to a tortoise or an armadillo to insist that, despite all his activities and the quantity of work he published and the even larger quantity that he left in his carefully saved but unpublished files, he could not write, work, or read. He was bitter that his drawings were not being bought by people who took simple delight in them but rather "by people with money, as an investment." He groused about this adjunct of fame, that it forced too much responsibility on him to have to decide every time he put pen to paper whether he wanted "riches or the ruin of widows and orphans." Where, he asked himself, was the wisdom that came with age? If it was true that wisdom was indeed a benefit of age, he was hard-pressed to find it. While he was visiting Phil in Tucson, he went to an afternoon "blue movie" and was insulted when the youngster at the cash register sold him a senior citizen's ticket without his asking for it. It made him feel old, and he hated the feeling. There were new problems with his teeth, and at times he measured out his life not in Prufrock's coffee spoons but in weekly or even daily dental appointments. It helped him to be able to turn to writers whom he identified with old age, such as Giuseppe Pontiggia, whose "greedy,

avaricious characters" in the short stories reminded him of "Checkhov [sic] as influenced by Gogol, in that the essential is masked by secondary issues."

Was that what he was doing, he asked himself—masking the essential with the secondary? And if so, what was essential and how could he identify it? On every level, this was the question that permeated Steinberg's life at the start of the new decade.

THE DEFECTS OF THE TRIBE

*I realize that for many years I've encountered only celebrities
and admirers . . . I haven't gotten to know anybody . . . with the
exception of celebrities or waiters, porters, drivers, and other
indifferent people.*

The only person Steinberg thought might be capable of understanding
the curious emotions that were now besetting him was Aldo Buzzi. He
had always confided the daily facts and events of his life to Aldo, but
now he unleashed his deepest feelings. "It's clear that the desire for
stamps and seals is not only a visit to the past, but to the country I have avoided
since I left it," he wrote of his newest passion, stamp collecting. Steinberg
believed that one of the best ways to determine the things that matter most in
adult life was to revisit the important memories of childhood, in his case what
it was like to be ten years old in the Romania of 1924. He believed this was one
of the most "essential" periods of his life, and the memories of it produced a
confusing surge of emotions that he was at a loss to interpret. One of the first
was his adult "mania" for postage stamps that were issued in 1924. As a poor
Romanian boy, he had had no access to real collectibles, so his acquisitions
were limited to the stamps that came through his family's mailbox or to those
his kind neighbors gave him. Once he had collected all that were issued, his
interest waned and he drifted to other pursuits, but now, when he happened
upon some of the stamps he remembered from boyhood, he was overcome
by a feeling so "powerful, confused," that he could not decide whether it was
happiness or pain.

As was his habit with every new interest, he pursued this one with relent-
less intensity. He read all the material in the Amagansett Library, went to auc-
tions, made friends of dealers and collectors, bought catalogues, and even tried
unsuccessfully to buy a very expensive album that contained an important col-
lection of stamps issued between the mid-nineteenth century and 1924. This

long-dormant "passion" was "re-emerging with such alarming force" that he thought it was a sign of one of two things: "an interesting and lively senility" or the deep need to "return" to the Romania of his childhood.

Aldo had always been his sounding board, but now they became even closer, because Saul was going through a serious change in his relationship with Hedda. He was somewhat reluctant to involve her in the search for his past as he stood on the cusp of old age and was slightly embarrassed by his deepening introspection. He hesitated to confide in her, because even though they were both scrupulous about never discussing his relationship with Sigrid, he feared she would interpret this serious change in his habits as something caused by Sigrid's increasingly erratic behavior.

Hedda's conduct toward him never changed: she continued her custom of copying interesting sayings and pithy aphorisms onto the pages of her little tablets and mailing them along with articles and photos she thought would either amuse him or trigger the urge to draw. As he became obsessed with aging, he stopped trying to hide his pathological interest in death and dying from her, so she sent everything from respectful obituaries of their friends to bizarre accounts of how perfect strangers had died, the latter in the hope that he would find something comic to cheer him up. They spoke on the phone almost every day, sometimes more than once, and she continued to be ruthless in telling him exactly what she thought, always restricting her criticisms to his art and almost never mentioning his life. He respected her judgments and usually heeded her advice, but most of all he counted on her for the constant warm bath of unconditional love and approval he knew she would wash over him, no matter how silly he was or how stupidly he behaved. Sigrid, on the other hand, screamed at him for looking ridiculous as he squired the steady succession of "thin blonde WASP women who get younger every year," whom he either seduced or tried to, but Hedda always welcomed them to her house: "He brought his girl friends home to show off to me what good lookers he could get. Usually, after he finished with them, they still came to see me and became my good friends."

Saul had no qualms about letting Hedda see him with other women, but he was reluctant to talk about anything even vaguely connected to their shared Romanian origins. He often felt inferior or inadequate when he compared her privileged upbringing to his modest one, and even though Hedda would never have been judgmental, he felt more comfortable confiding the emotions aroused by his country's anti-Semitic attitudes to Aldo. He was not embarrassed to tell Aldo about anything connected with Romania, especially how "hungrily" he read stamp catalogues, or to talk about the sheer joy he felt when he looked

at stamps on old envelopes and saw them with entirely new eyes. When he bought a "Venetian-Austrian [envelope] with stamp in relief," it marked the start of his purchasing a collection, slowly, using astuteness more than money. It was a game he enjoyed, because the stamp dealers he dealt with in New York exhibited the same behavior that he remembered from 1924: they may have loved stamps, but they were still vulgar and cruel. It was fun to toy with them now that he was an adult with money and discernment. "They are pimps," he concluded, and the game they played was "archeological pornography." Still, collecting stamps let him meet new people and go to new and different places, and with these experiences came the startling insight that for years he had not formed any new and meaningful relationships. The only new people he met were celebrities or his fans, all of whom made him feel inauthentic, phony, and lacking in any admirable quality. The vast majority with whom he interacted were waiters, porters, or chauffeurs, all of whom were polite because they were paid to be. He did not tell the people he met in the stamp world that he was the famous artist but pretended instead that he was a simple retiree who was beginning a new hobby. Whether or not they knew of his reputation, he hid behind the false persona, because he feared that if he told the truth, he risked revealing too many emotions that should remain private. "In general they treat me as a fool," he told Aldo. "Maybe they are right."

As his interest in postmarks and envelopes intensified, he thought of his large personal collection of old postcards. He brought them out of their boxes and filled the horizontal surfaces of his house with them. As he looked at them with the new eyes he had earlier brought to stamped envelopes, he found different subsets among them, such disparate things as reflections in water or nude women reflected in mirrors. Many of these were on the cards he had bought in Russia, which led to musings on the Russian national character and the study of Cyrillic handwriting, which in turn led him to study all the cards and ponder the sender's obvious and perhaps hidden meanings. It drew him back to his own boyhood and young adulthood and reflections about what he might have intentionally concealed and inadvertently revealed.

Perusing the postcards led him to the collection of family photos that he had filed in a folder titled "Romania." He embellished almost every one, usually by superimposing various versions of his older self upon the younger: in a studio photo in which he wears a sailor suit and stands stiffly posed between his parents, he disfigures himself with a beard, mustache, glasses, and a large and pointed nose; in another of himself wearing the same sailor suit and pushing a hoop, he drew the large table in the Springs kitchen with the iconic blue-and-white Chinese vase on it that he used repeatedly in other drawings.

———

STEINBERG WAS SPENDING SO MUCH TIME in the country that he instructed his housekeeper, the "Majorcan Pearl, Josefine," to redirect all his New York mail, visitors, and phone calls to Springs. Sigrid went back to Africa in early January 1981, leaving him "as usual, full of qualms, doubts, fears," and it was easier to deal with them in the country. His relationship with Sigrid had reached such a low point that he allowed her to come to the house only when he was absent, but he had relented at Christmas and for two days they had been able to "love one another" as they had not been able to do throughout the previous year. In keeping with his new openness to Aldo, he described their difficulties as "symptoms similar to those of Pirandello's pedestrian wife," a cryptic allusion to the mental problems presented in a "scary" biography of the author that Steinberg read mainly for its depiction of the troubled marriage. "Me, too," he told Aldo as he described his own depressed state, "the usual moments of melancholy, or worse."

Sigrid's depression, like Antonietta Pirandello's, took several forms. Sometimes it made her so angry that she acted out in public with outrageous behavior; at other times she threw things and threatened bodily harm to herself and injury to others; and at still others (mostly when she and Saul were alone in Springs) she was catatonically silent and still. He was terrified about what she might do to herself, particularly after the night he accepted an impromptu invitation to an early dinner at his friend Ellen Adler's apartment. As they exchanged greetings, Adler mentioned casually that she had just seen Sigrid (whom she had not invited) wandering aimlessly outside her building. The two women had known each other since Sigrid had been involved with Joe Rivers, and over the years they had forged what Adler called a "very complicated friendship." Thus she was not overly concerned when she met Sigrid, disoriented and muttering that she never should have had the abortion as she would at least have a teenage child to comfort her in the loneliness of her middle age. Adler mentioned seeing her to Saul offhandedly because she knew that Sigrid's "suicidal depressed moods" could lighten in an instant. He, however, bolted for the door as soon as she said it, calling over his shoulder as he ran to the elevator, "This is the tragedy—she can't fit in anywhere." He did not return for dinner that evening.

ALTHOUGH SAUL BEGGED SIGRID NOT TO go to Mali, she left as scheduled in January but returned in haste two weeks later, frightened by the tense political situation. While she was away and for the next several months, Steinberg's solitary nightly consumption of scotch and wine interfered with his ability to

work, and he realized that he had to stop drinking. He found that with mineral water he could still become "drunk out of habit, but in a happy manner, minus the torpor and nastiness."

There was so much going on in Steinberg's professional life and so much work he had to deal with that he needed to keep his wits about him. He had just finished making complicated arrangements to close up the house while he went to Los Angeles. Going to California was one way to get away from having to deal with the phone calls and letters that interrupted his concentration every day, as everyone seemed to want or need something. Among them were his dear friends Jean Hélion, who, old and ill, begged Steinberg to help promote his retrospective exhibition, and Ray Eames, who asked him to make a mural for the building she and Charles were designing for the Federal Reserve Bank in San Francisco. He offered to attend Hélion's opening but declined to help publicize it, and he also declined the Eameses' invitation. No matter how highly he regarded his friends, he still declined to work on commission unless the spirit moved him, and in these instances it did not.

He planned to stay in Los Angeles for the month of February, making his headquarters the printmaking atelier Gemini G.E.L., where he wanted to learn what he called *incisioni*, the Italian term for all intaglio prints. While he was there he planned to check into "a kind of Überlingen," the Pritikin clinic in Santa Monica, where he expected diet and exercise to rid him of the paunch that came from too much rich food and good wine. Steinberg was as fastidious about his body as he was about the clothing that covered it, and his fussing over his appearance stopped just short of hypochondria. His checkbook stubs list the names of one doctor after another and his calendars record appointments with specialists ranging from dentists to dermatologists, primary-care physicians to podiatrists. The only specialists whose names never appeared were mental health professionals, for he did not believe in analysis for himself, even though he always paid without question the increasingly expensive bills in Sigrid's ongoing quest for the analytic experience that would heal her.

In Los Angeles he took what he wanted from the Pritikin experience, which meant that he did a few exercises but otherwise did not follow the program. He did, however, throw himself enthusiastically into work at Gemini, where he managed to make "Two Women," the first print of the half dozen or so that he made during the next several years whenever he returned to work there. He enjoyed the processes but preferred to do them alone rather than in collaboration with others, as he told a reporter a decade later: "I do wish I had been more stoic and more craftsmanlike in order to be able to work together with the printers, with the fellows who lift lithographic stones, not to mention

the acid people and the other difficult and dramatic professions. And signing and numbering, all the Zen fuss about packaging. These things are beautiful and I'm very sorry I haven't been able to reach that state. The truth is, I probably get intimidated by the contrast between my modest contribution and the giant effort done around me. I feel uneasy; I feel guilty about it, and in no time I escape." The problem, as he explained why he could not enjoy the experience, was that his mind was "working all the time," busy performing "a form of autobiography—very complex, not a two-dimensional or one-idea affair."

ONCE HE RETURNED TO SPRINGS IN April 1981, "various woes" were among the major and minor problems that kept him from doing the work he wanted to do. He ended negotiations for two large exhibitions with museums he identified only as "Middle West, Japan, etc." He found the courage to cancel the show Sidney Janis had scheduled for the fall, and exactly one year later, in April 1982, he left Janis "due to his avarice, which came to him as part of advanced age, minus the wisdom." Steinberg had an overdeveloped sense of responsibility, and making changes or cancellations was not easy for him. In the process he offended "some respectable people" in the museum world, but he nevertheless believed that he had spared them from the even "worse things that would have happened further down the road."

Just as he thought things had calmed down and he could get back to work on his own, a series of "small disasters" struck. Sigrid fell off a horse and cracked several ribs, and shortly afterward he fell off his bicycle and injured a knee. The Nivola house was struck by lightning during a summer storm and "everything—telephone, tv, electricity—was destroyed." The house itself was not damaged, but the immense fir tree outside Claire's bedroom window was decimated, with wood chips flung far and wide from where it had stood. Across the road at Steinberg's house, only the television and the septic system were hit. "Saved by a miracle," he rejoiced, as all the damage was covered by insurance. He planned to make an ex-voto in gratitude.

Suddenly he was able to work again, and getting down to it lightened his mood. He made one still life after another of ordinary household objects; he delighted in making woodcuts and a host of small wooden objects, which included a bed, an easel, chairs, tables, and vases with flowers. He also made more of the large tables and was engrossed in a series of drawings that he called variations on the Japanese printmaker Hiroshige's bridge in a rainstorm. They, like so much else that was connected to the quest for the "essentials" of his past, appeared in one or more of the portfolios he contributed to *The New Yorker* between 1978 and 1985. He even made architectural drawings

in the manner he had been taught in his Politecnico courses, using as models some of the post offices and federal buildings in his postcard collection. He spent the rest of the summer making what he called "sample cases and boxes for necessaries, compasses, jewelry, etc.," then wondered if he was doing it because he wanted to re-create his father's professional experiences in making cardboard boxes. He stopped trying to analyze why the process of creating all these objects made him so extremely happy; he just kept making as many as he wanted, even though his shop assistants told him timidly that they worried he might be flooding his own market. He also spent whole days making drawings based on the extemporaneous sketches he had been instructed to draw as part of his training at the Politecnico, where an instructor would point abruptly at something and tell the students to draw it quickly. "Who would have thought it?" he asked himself as he admitted that trying to relive his architectural training had become yet another "obsession."

The autobiographical imperative was strong in the summer of 1981. When he was not trying to re-create his past through memories of the Politecnico years, he was teaching himself to speak fluent German. He studied texts on grammar and built his vocabulary by reading the dictionary, but his real motive for wanting to speak fluent German was to be able to recall his Yiddish without having to resort to hiring a teacher. The need to re-create the "intimate language" of his parents became another "essential," not so much for the words "but more than anything else, sounds, cries." When he said the Yiddish words, the memories of family life returned, bringing "pleasure and surprise." Once again he used the phrase "archeological discoveries" to explain the reward that plumbing the depths of his early life gave him.

While he was deep into relearning Yiddish, Lica's daughter, Dana, came to visit. Having her there, a young woman who reminded him so much of her mother, took him back to Romania and the days of "regression, childish rages, commotion, feelings I had forgotten, healed forever. Instead, no, nothing ever vanishes. I contain all the defects of the tribe." It appeared that no matter how much pleasure he felt when he began the various explorations into his past, the conclusions he reached would not be entirely positive. He invariably found that the "defects" were in him and not in the exercise or activity, that there was something in his character or personality that made him unable to be genuinely happy and left him melancholy, if not actually depressed.

STEINBERG GOT SMALL COMFORT FROM KNOWING that some of the most interesting people in the worlds of arts and letters and international society found his company so highly desirable that he was regaled with invitations for

every day and night of his life. He chose instead to concentrate on the negative, brooding that these people were mere acquaintances and that he had no real friends with whom he could converse comfortably about the things that mattered to him. Since Harold Rosenberg's death, he watched his world become increasingly constricted as illness and death took one friend after another. Aimé Maeght died of cancer in September 1981; Betty Parsons had a debilitating stroke in November and died in the summer of 1982; his longtime and long-suffering lawyer, Alexander Lindey, died that same year. Steinberg's collection of obituaries that he or Hedda cut out of newspapers and magazines grew steadily, and most were of people he had known and usually known well. There were also too many sad tales about the infirmities and indignities of old age from friends such Jean Hélion, who confessed with some embarrassment that he could no longer paint because he was going blind and who timidly asked Steinberg to help him find a buyer for the beloved country estate he could no longer afford. Among the few old friends who remained active and healthy, some unpleasant changes were happening as well. Leo Steinberg sent a caustic, backhanded invitation for Saul to come to dinner with him and his then companion, Phoebe Lloyd, saying that it would have to be just the three of them as Saul had behaved too badly the last time they had been together in a larger group, when he had let everyone know he was miffed because they were all having such a good time conversing that they did not allow him to be the center of attention.

Even Hedda addressed his dismaying personal behavior by couching her observations obliquely through comments about his art. After one of their daily telephone conversations, during which he was more self-centered, bitter, and depressed than usual, she sent one of her undated, unsigned missives telling him that every time she talked to him it upset her so much that she had to pull out some of his past drawings and study them intently before she could get over her distress at what he had become. She asked him why he was wasting his time and energy on so many pointless diversions and what led him to have such "total disregard for [his] gift." She wondered if it was because he operated within the public art world, where there was only "abeyant hostility," which left him unable to separate how he acted there from how he behaved in his personal relationships. It seemed to her that instead of avoiding these unnerving encounters, he sought them out. This was still no reason for him to behave as he did toward her and others—"to reprimand & put down, to sting, to 'give low marks,'" all the while insisting that he needed so much "to be loved." Most puzzling of all was how completely he lacked any sense of humor or proportion: "You, of all people!" Clearly, when even Hedda, who loved him

unconditionally, could not tolerate his negative behavior, it was time to make significant changes.

HE MADE CHANGES BY REACHING OUT, mainly to writers with whom he forged some of the most meaningful friendships of the last decades of his life. One of the closest, probably because he saw him more than the others, was William Gaddis, whom he met through Muriel Oxenberg Murphy. When Steinberg moved to 75th Street, Murphy welcomed him with a "block-busting warming party" and made him a regular dinner guest at her New York salons and her house in Wainscott. Gaddis soon became one of Steinberg's closest friends, although he was touchy and thus the friendship began cautiously. Gaddis was in a particularly morose period, dejected because his books were not widely read or reviewed and quietly resentful that he owed his comfortable lifestyle to Murphy's largesse. Steinberg was pleased to befriend someone whose personality seemed similar to his own, for Gaddis could be dour and was often laconic. In Steinberg's semidepressed state of mind, he found it comfortable to be with another man who did not speak until or unless he had something intelligent and interesting to say. He was, however, wary of what he assumed was Gaddis's ferocious intelligence, because he had a great deal of difficulty whenever he tried to read one of the novels, none of which he had yet succeeded in finishing. When Gaddis sent him work in progress to ask for comments or critiques, Steinberg fell into the mental equivalent of a cold sweat and usually tried to find something inoffensive and innocuous to say that did not betray the galloping insecurities he felt every time. It was when they began to talk about politics and philosophy that the friendship flourished, and it flourished quickly when they discovered similar tastes in literature as well.

Each man was aware of the discrepancies in their professional circumstances, and it sometimes caused an unspoken tension between them: the accessibility of Steinberg's art, the positive public reception it received, and the huge income it generated were almost something to be embarrassed about whenever he compared it to the way the inaccessibility of Gaddis's dazzling fiction brought him few readers and generated little income. But Steinberg was a generous friend, and one of the ways he dealt with the unease Gaddis instilled in him was to do everything he could to further his friend's career. He was largely responsible for the novelist's membership in the American Academy of Arts and Letters, acting as Gaddis's sponsor and soliciting seconding letters from Saul Bellow and petitioning other members to support his candidacy. Steinberg was one of the background figures who recommended candidates for the MacArthur Foundation's "genius" grants, and he worked tirelessly to

ensure that Gaddis got one. He never revealed his role in securing the grant but allowed Gaddis to take full credit for the generous anointment proclaiming him a genius worthy of half a million dollars.

Steinberg and Saul Bellow had been good but casual friends for several decades until Bellow married his fourth wife, the Romanian scholar Alexandra Ionescu Tulcea, and wanted to introduce his "Romanian friend" to his "Romanian wife." Bellow told Steinberg that he was planning to visit her family in Bucharest, and Steinberg jumped eagerly to help him plan the itinerary, which included detailed instructions for the inspection of his boyhood home and haunts. Bellow's Romanian trip eventually resulted in his novel *The Dean's December*, which Steinberg read in manuscript. By 1982, Bellow was routinely sending manuscript copies of other writings and asking for Steinberg's comments and corrections. Whether it was a philosophical/political essay or a work of fiction, Steinberg responded, engaging far more freely in a critical dialogue than he ever did with Gaddis. Each time Steinberg went to Chicago, he made sure that his activities would leave time for a long dinner with good conversation. Steinberg thought Bellow was one of the rare people who took friendship seriously, "even if his style is naturally witty and tongue-in-cheek." They had a rich correspondence and talked often on the phone, but as Bellow was a political conservative while Steinberg was moving slowly from the far left toward the center, they never discussed politics per se; it was as if they realized their friendship would not withstand it.

Gaddis and Bellow were Steinberg's contemporaries, and the thought that he and they were old and growing older did not escape him. He deliberately sought to make friends younger than himself by starting with some of the writers he admired at *The New Yorker*. For several years he enjoyed the company of the fiction editor and satirist Veronica Geng, who had the reputation of being opinionated but whom he liked because she conjured up word games and images for his amusement. He liked to go to the movies with Geng, because her vision of what she saw on the screen could be offbeat but was always good for long conversations that could go on for hours. However, Steinberg could be dismissive, even cruel, when it came to tolerating the differing opinions of others. He was astounded when Geng voiced a positive opinion about an innocuous movie that he felt had no redeeming value, and he ended the friendship without a backward glance. And yet when she was dying of a brain tumor and Philip Roth was soliciting $5,000 from each of a group of friends to help her, Steinberg gave it at once.

"He could do this, just cut people out of his life," said Ian ("Sandy") Frazier, another of his younger *New Yorker* friends. When Frazier asked Steinberg

one day if he still saw Geng, he said as matter-of-factly, as if he were refusing a second cup of coffee, "No, I divorced her"—*divorced* being the word he often used to describe the way he severed a friendship.

Steinberg contacted Sandy Frazier shortly after *The New Yorker* published his comic essay "Dating Your Mom." He told Frazier he was a "fan" who thought the younger man "could do no wrong" with anything he wrote. The praise meant so much to Frazier that he showed Steinberg's letter ("like a diploma!") to all his friends. It would have meant even more if he had known at the time how competitive Steinberg was with younger men and how unusual it was for him to reach out to one, particularly one who was tall, good-looking, and talented. He had actively avoided befriending such men for most of his life, but whether old age had made him mellow or whether he found it irresistible that Frazier's slightly off-kilter way of perceiving the world so matched his own, he instigated a friendship that flourished.

He did the same with Donald Barthelme around the same time, when he started to go fairly often to the fabled apartment on 11th Street where Barthelme had lived for years, both alone and through several marriages. Steinberg had known Don for at least a decade, but it was not until Barthelme married his second wife, Marion, that he became a frequent dinner guest, perching on the edge of the sofa, holding forth and regaling the other guests with his stories. Art was a common bond between Steinberg and Barthelme, and although they talked often of collaborating on a project, they never did. Marion and Don moved to Don's hometown, Houston, in 1980, and he died there of throat cancer in 1989. Long before that, Marion recalled, "Saul fell out of both our lives." Although they both enjoyed and valued Steinberg's friendship, there was not enough time to devote to the kind of intense friendship he required.

It was different with Frazier, who was younger and single and who thought being with Steinberg was "totally magical." Frazier thought it almost uncanny how "he could make something happen in the real world to confirm his vision." He told the story of how Steinberg wanted to get rid of a dead pine tree on the property at Springs and said that he remembered enough about demolition from his navy years to set the explosives himself. Indeed, the explosives went off and the tree rose high into the air—only to come down to rest upright in the same spot it had earlier occupied. And after a restaurant meal when the two men wanted to share a dessert, Steinberg asked the waiter for "one dessert and a blank plate." When they were delivered, he cut the dessert so artistically that "it was as if he had made a drawing out of the situation." Frazier was learning Russian, and he told Steinberg that some of the Cyrillic letters looked "really weird." No, Steinberg demurred, they looked like "sneezes." He reached for

his pen and drew them, and to Frazier's amazement, "You could see that they did look like sneezes." He and Steinberg discovered so many parallels in their intellectual curiosity, particularly in their perception of the otherness of the external world, that they eventually collaborated on the book *Canal Street*.

Steinberg took Frazier to meet Hedda, who liked him at once and whose devoted friend he became. He had heard there was another ongoing, if not permanent, relationship in Steinberg's life, but he was not introduced to Sigrid until later. It was the architect Karen van Lengen whom he thought of as "Steinberg's girlfriend," because Steinberg made no secret that they had begun an affair, and he often took her to Frazier's loft or she joined them for dinners. At the time she was working in the offices of I. M. Pei, and in the style of the times she wore her blond hair long, straight, and with bangs, which led Steinberg to make jokes about his "Blonde Chinese." It was evident to Frazier that Steinberg "never took her seriously or gave her the recognition she deserved," and when they became friends, both van Lengen and Frazier agreed not to take offense when Steinberg became "very airy about people," particularly women. In a time of increasing political correctness, whenever anyone objected to his dismissive comments about women, he would say, "Yes, yes, it's not important" and wave away the criticism. Hedda told them it was ingrained in him to treat women as all the men did in Romania, "like garbage." They all regretted that he thought less of women than they would have preferred but agreed that overall "he was still a really good judge of people" and could recognize excellence when it mattered. After van Lengen won an important international competition and began receiving both brickbats and accolades fast and furiously, Steinberg celebrated her success with the drawing of a statue in which a man was falling off his pedestal. He interpreted the drawing, she recalled, "as telling me what I already knew, that the building would never get built. But then he said, 'Don't ever forget that you won this.'"

LIKE FRAZIER, VAN LENGEN KNEW OF Sigrid long before she met her: "He kept her in a place where he could have total freedom, but still, he could not separate from her." She mostly observed the relationship from afar but believed that Steinberg's behavior was a combination of the intense physical relationship he had with Sigrid when they were together (which he did not hide from her) and, even more, that it was due to "the loyalty issue—he could never abandon her." She knew that Steinberg had long-term, ongoing sexual relationships with other women and that he had one-night stands with others as often as he could arrange them. She also knew that he invited other women to join him and Frazier for dinner, but Sigrid was never one of them. Frazier

thought it "kind of strange" that, on the rare occasion when he was invited to Springs, there were signs everywhere of Sigrid's presence, even though she was never there.

Sigrid was a shadowy background figure in Steinberg's friendships with Frazier and van Lengen, both of which deepened over the years and lasted until the end of his life. They seldom saw Sigrid and then it was only in passing, and when she made her first attempt at suicide, in 1981, they were totally unaware of it. So too were the few people to whom Sigrid was, in her strangely distant way, close. Evelyn Hofer, Dore Ashton, the Nivola family—no one was aware that she had tried to end her life, let alone of the method that she used. Only once did Steinberg speak of it, when he told Mimi Gross many years later that he was "embarrassed" by what Sigrid had done. By the time he made this casual remark there were vague references by others to "the time before," but by then there had been several other times before, and no one was sure which one was being talked about.

"Poor Sigrid," Aldo said as he tried to comfort his friend Saul, who had taken to phoning rather than confiding his worries to letters. Every time the telephone awakened him at some ungodly hour, Aldo knew that Sigrid had done something upsetting. The only comfort he could offer was to tell Saul that it was too bad that he and Sigrid could not live in friendship, for there did not seem to be any other way they could be together. From time to time the few other persons who were privy to Saul's private life wondered if his obsessive concentration on hobbies or his ongoing need to experiment with new techniques for conveying his art might be strategies to distance himself from his troubled companion. If they were, they were seldom successful.

THE PASSION OF HIS LIFE

Saul truly loved her. He said she was totally sincere in everything she did. She was the passion of his life but it was difficult to live with her.

Perhaps Sigrid was not fated to find peace or happiness in this world, Aldo concluded after Saul told him how worried he was about her ill-mannered, erratic behavior and her heavy use of prescription drugs. She could not be accurately described as manic-depressive, for her usual condition was depression and the manic periods almost always stemmed from rage and humiliation when Saul effectively isolated her by cutting her out of his daily life or when she learned that he had taken up with yet another woman. These phases of flamboyant behavior occasionally led "Mrs. Saul Steinberg" (a name she used when she wanted to provoke him) to rack up enormous charges on credit cards whose bills went directly to him. More often, these episodes occurred when they were together in public, where Sigrid took perverse delight in embarrassing him and shocking others.

Ruth and Tino Nivola invited her and Saul for dinner on a weekend when Dore Ashton and her husband, the Russian painter Adja Yunkers, were their houseguests. As they all sat around the Nivolas' big table chatting after the meal, someone referred in passing to the Nazis. Despite everyone's repeated wish that she not talk about it, Sigrid insisted on praising the wartime behavior of ordinary Germans like her parents, who were "not all that bad because they may have thrown a few stones on Kristallnacht, but that's all." Ruth gave Saul a hard look that meant he should do something to stop her, but Dore was aghast to see that the look on Saul's face showed he was enjoying it. The outraged Adja left the table and stomped up the stairs to spend the rest of the evening in his bedroom. Both women recalled that Tino was very upset, but what upset everyone most was that Saul didn't say a word.

This was the era when stories (many apocryphal) about Sigrid's erratic behavior, many of them concerning her German origin, proliferated. She allegedly enjoyed telling everyone that V-E Day was the worst day of the war for her family because her father was a member of the Nazi Party and from that day on their "comfortable" circumstances became "horrible." Most of all, she was accused of taking perverse delight in teasing Saul about how he could "be with a Nazi's daughter when he himself was such a Zionist." There was truth, however, in the story that she would occasionally belittle his contributions to Jewish charities and other organizations, usually in front of a table full of stunned dinner guests who did not understand how he could sit there in composed silence. The general impression was that "he was very sweet to her in public, quite tolerant, but it must have been different in private."

Some of their friends who were able to observe how Saul and Sigrid interacted in private as well as in public agreed that "deep down, he loved how outrageous she could be." Hedda Sterne said it was more than that: he himself was too timid to épater le bourgeois, and he took vicarious delight in how recklessly she could do it. One clue as to why he neither responded to nor engaged in her reckless behavior might lie in an undated page among the voluminous diary writings Sigrid began to keep sometime in the 1970s and in which she sought solace on and off for the rest of her life. She had no qualms about letting Saul read what she wrote, no matter how cutting and wounding the accusations she leveled at him were. However, there were other times when what she wrote was so personally painful that she hid the diaries in her room at the Springs house, where she thought he could not find them. For whatever his reason, he often snooped until he found them and read them. She would write about his snooping expeditions in one of her next entries, and according to her, the arguments they had when he defended himself against her accusations were frightening and ferocious. He told Aldo that she had the same temperament as Papoose, her cat: "Not bad, but fierce." On one page, where it is not clear whether she gave him the diary pages or he read them without her permission, Saul wrote several numbers. He did not explain what they refer to, but the assumption is that he was trying to itemize the medical expenses he would have to meet, for next to the numbers she wrote: "The question is—who of us is sick. Why not check with Dr. Rosen before you tell *me* that I am insane."

To others, the overall impression Sigrid presented was one of "terrible loneliness." She had picked up another of Saul's habits, which in her case interfered with forging real friendships: she could not engage in conversation and wanted to do all the talking, and as she did not have his wit and intelligence, her efforts to hold the floor drove people away instead of bringing them closer.

"She had very few friends because she drove people nuts," said Mimi Gross, who was better able than most to put up with her wildly fluctuating behavior.

Sigrid loved Springs and wanted to spend a lot of time there, but her ongoing battles with Saul often resulted in long periods when he "banished" her (to use her expression). Sometimes she was able to persuade him to relent and allow her to use the house when he was not at home, but as he was living there more and more of the time, these occasions were so infrequent that she was provoked into taking the train to East Hampton and staying in a rooming house in town. She confided to her diary about how she had to skulk about and hide as she darted in and out of stores for fear that she would accidentally run into him on the street and he would create an angry scene. At other times they reached a stasis when he would allow her to be in the house while he was there, just not anywhere near him. They ate their meals at separate times; he rode his bike alone during the day and spent his evenings in the studio listening to music and reading, while she sat alone at the large kitchen table until she was tired enough to go to her bedroom on the second floor in the old part of the house. Many of their friends knew they were "two people living together in the same house who don't talk to each other." More than one wondered, "How could they have managed *that*!?!"

Sigrid loved the house but loved the grounds even more. She was the one who planted and tended large flower and vegetable gardens, and she always did the housework, heavy cleaning, and shopping herself. Even though she enjoyed every one of these activities, she complained bitterly about Saul's lack of consideration for all the work she did, grousing that he did body-building exercises while she did the hard work of spring cleanup and getting the property ready for summer. Sigrid and Dana had become friends, and when Dana came to spend the summer, Sigrid tried to think of "girl friend" things they could do; even so, she was bitter that Saul spent the days sunbathing, riding his bike, exercising, and body-building while she had to cook for Dana and clean up after her. Sigrid was angry when she told the diary, "I'd rather be like Hedda. She may be married to you but she got more freedom than I, and less duties." She noted that Hedda had houses in East Hampton and New York and no responsibilities except for herself and her work, but she did not acknowledge that Hedda was not indebted to Saul but fully independent, thanks to her first husband's generosity and the sales of her paintings.

It had been twenty-five years since Sigrid had left her parents' home and more than twenty since she had become Saul Steinberg's lover. She was now a middle-aged woman of forty-six who had no marriage, no house, no real income of her own, and therefore no independence. The year encompass-

ing 1981–82 had been one of her better ones, as she made $6,000 designing book jackets; otherwise, she was totally dependent on him for her support. It made her feel "trapped, living month to month on handouts, as your sidekick." She was outspoken with the few friends she had who were separate from his (mostly the other tenants in her apartment building on Riverside Drive) and told them how she resented the fact that he did so little to help her professionally; one of them later said, "She felt she was worthy of more attention, respect, and jobs. She was angry and disappointed, very serious about her art and feeling diminished that he didn't help her." The problem was that her talents were very modest, and Steinberg, who never took advantage of his friends in high places, was embarrassed to ask for favors. To do so might mean that they would both have to face the possibility that her work would not be good enough, and it would be more devastating to her fragile psyche to experience failures instigated by his intercession than if he stayed completely out of her professional life.

Because he paid the rent on the apartment, she claimed she had nothing to call her own, not even the little cabin just behind the house that he gave her to use as a studio. During one of the periods when she was banished from the house, she sent him a postcard begging to be allowed to use the cabin whenever she wanted. He did not reply. She was enraged by his silence on top of his ostracism and insisted that their relationship had to under go a major change: "I don't want to subjugate myself my will [sic] to your will. This has always been your game unless I holler and scream. I don't want to anymore. You drove me to those hysterics but please no more."

When she wrote this, Sigrid was trying to assess the relationship objectively, starting with her real feelings about his work. She did not think she was jealous of his talent, because she recognized and admired his genius and was envious that hers was not comparable. She did not resent the time he spent sequestered in his studio creating new work, because that was what geniuses did; rather, the cause of so much of her "anguish" was the obsessive attention he paid to his hobbies. If he devoted only a fraction of the time to their relationship that he spent practicing the violin or collecting stamps, she was sure everything would be better: "You see me in my hole, struggling and getting deeper into the mess, and all you can do is nothing."

What he did do was contact his accountant and ask him to send her a check for $3,000 for "all the extra work" she had recently done, and to increase her monthly stipend from $800 to $1,000. He also agreed to let his lawyers make significant changes to his will that would lessen taxes, but he insisted that Sigrid remain the beneficiary of one-third of his entire estate. He did not tell her

about this significant change, but to her, the gesture of increasing her monthly stipend was a metaphorical slap in the face, another sop for the sidekick. She ended these pages with one affirmation uppermost in her mind, that she could not spend the next decade living as she had during the ten years just past—"not even the next ten days. I'd rather have nothing."

She set a goal for herself: one thousand days in which to make great changes. To get started, she counted her money. She estimated that she had enough on hand to support herself for one hundred days without needing to bring in any new work, but she hoped to find as many commissions as she could and save what she earned for another trip to Africa. Both her parents had died some years before, and each of her trips brought back touching childhood memories. She recalled how she and her father had often pored over maps of the continent and daydreamed together of visiting, and now she wondered if her fascination with Mali might have begun because her mother's nickname, "Malli," first sparked her interest in that country. Now that she had been there five times, she had such feelings of displacement in New York that she wondered how she could go on living there.

A full year after she made the declaration of "1000 days to change," she had not done any work or made any money of her own and was even more depressed than usual. Saul was worried about how the depth of her depression might have an impact on his own, which he now thought of as an "illness" that he named "the dread." He thought he hid it well, but his friends noticed that "when she got horribly depressed, he got very sad." At those times he tried to protect himself by keeping her at a distance, but this time he had another reason for wanting her out of the way: he had begun a serious affair with Karen van Lengen and wanted to concentrate on it. So he gave Sigrid enough money for her to spend two months in Mali, January through March of 1982.

She made a long nomadic journey by road, rail, bush taxi, and truck throughout West Africa, from Algeria to Cameroon, before crossing the Sahara and ending in Mali. It was dangerous and difficult, but she was always happy going wherever adventure called, even though she came down with so many "bugs" that she teetered on the brink of permanently ruining her health. She did not care what afflictions ravaged her body, because being in Africa always repaired her spirit and her soul. She had made this trek so often that she was well known in the towns and villages along the way, and now that she was a middle-aged woman, she was granted authority and treated with respect, neither of which was the case in New York. It was only when she returned to what she sarcastically called "Western 'civilization'" that life became "difficult and bizarre."

All her unresolved problems beset her as soon as she was back, the most important and pressing being the desperate need to change her life and not having the financial wherewithal to do it. Her dependence on Saul, both financial and emotional, meant that whenever he called on a whim, she usually dropped everything and ran to him. This time, however, she was so confused and ashamed of herself that she took the only refuge she knew, in drugs, which she did not name but which she had been using fairly steadily since her student years at Columbia. Saul joined her occasionally, but mostly drug taking was something she did alone, whenever she reached the point in their relationship where she thought that "nobody can live like this." Her way of trying to cope was to "get stoned," even though she knew beforehand that it would not solve anything. Still, she relied on drugs because they

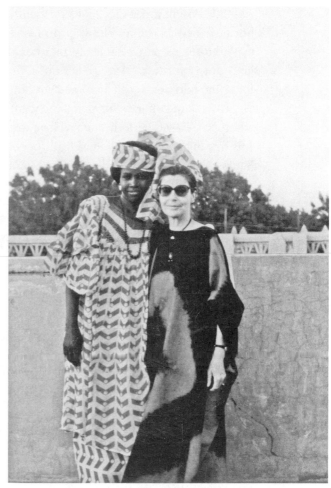

Sigrid Spaeth with a friend in Mali.

made life temporarily "tolerable." These were periods when all she did was "juggle pills and dope . . . because I can't do anything else."

Her "valium summer" began when Saul ignored her pleas to take her with him and went alone to Europe in late spring 1983. While he was away, she was "mostly stoned." When he returned at the end of June, she telephoned to welcome him back and was stunned when he cut her short to say that he had been far happier without her and their relationship was finished. "It's over," he said, and she dosed herself with codeine and went to bed and slept for the rest of the day and all night. The next day was Sunday, and she took the train to Springs to confront him. She remembered it as a lovely day, probably made lovelier in her memory because she fortified herself by getting stoned on the train. Saul

was "nice" to her and they had a pleasant dinner together, after which he sent her to her bedroom and he went to his. The next morning she was up early, expecting to prepare a breakfast they could eat together, but he told her to get her things and leave. He gave her the address of a motel and the money to pay for it and told her to call a taxi and get out.

Instead of going to the motel, she went to Ingeborg Weiner's house nearby, where she stayed "mostly stoned" for the next three days. Between July 4 and July 19, Sigrid went back and forth between New York and Springs despite Saul's telling her repeatedly to stay away from him. She took a room in East Hampton, from which she phoned at all hours and begged to be allowed to visit; then she sneaked to the house when he did not answer the phone and was likely to be away, or after she happened to see him on the street in town. Mostly she stayed in her motel room, calling and crying when he hung up on her, then finding solace in drugs. He told her that their separation was permanent, and to prove that he meant it this time, he bought the Riverside Drive apartment and gave it to her, then made arrangements with his lawyers and accountants to see that "for the time being" she would be properly supported. He was sure that with the gifts he had given her (most of it expensive jewelry) and "a good amount of [his] good drawings well-chosen by her," she would have "lots of capital." His conscience was appeased, and he was confident that, having settled Sigrid financially, he could "avoid the errors of the past and steer clear of the shortcuts." He hoped that she would accept the separation peacefully and amicably, "without drama." He admitted that it was likely to be "difficult" for her, but she was "often logical and intelligent," and that was "the good part of her" that he had always admired. All she wrote about what he had just done was to tell the diary that he bought the apartment in her name and had her old car, an Audi, fixed.

SAUL WAS ALMOST AS HAPPY WITH his new freedom as he had been in 1960 when he left Hedda to be with Sigrid. Now that he had succeeded in slotting Sigrid into the niche in his life where he wanted her, he compared this new outlook to the satisfaction he felt after he ended the relationship with Karen van Lengen. He had been prompted to end that one because of his "indecision" about accepting Karen's "habit of physical and spoken intimacy." Karen was "used to being close," while he preferred to keep his "distance from others."

He preferred distance on his own terms, which he kept changing: not even two weeks passed after he had told Sigrid it was over before he relented and told her she could come to the house while he was there if she first did his

shopping and then prepared his lunch. He told her she would have to leave for a while later that afternoon because Inge Morath and Arthur Miller were coming to take him out to dinner and he didn't want them to see that she was there. After they were gone, he permitted her to come back and watch television, but she would have to leave and go to the rooming house where she had taken a room before he returned for the night. She told the diary, "I feel like an outcast and cry for three hours, take valium & codeine." She disobeyed his instructions, took a heavy dose of drugs, and stayed in the house that night. The next morning they walked together on the beach and he allowed her to join him for lunch at Warner LeRoy's house, after which they went home and "had a nice nap together." Later he made a movie of her dancing nude with Papoose. The day after that she was too stoned for him to make another movie and she stayed in bed, alone. After he put her on the train back to New York, Saul told Aldo that they had spent a "nice weekend" together and the separation was indeed "amicable."

On her next visit, he relented enough to let her join him for a dinner at Michael's, a favorite restaurant where he often dined with Muriel Murphy and William Gaddis. He usually kept Sigrid away from them because he did not think she was intelligent enough to engage in their conversations. This night, sensing that she was "on probation" (a galling term he had used many times after past reconciliations), Sigrid was on her best behavior, drug-free and sober throughout the dinner. The conversation led to one of her moments of self-analysis, during a time when she was fraught with anxiety over her place in Saul's life and worrying about whether, or even how, after being in Africa, she could continue to live in "Western 'civilization.'" Sigrid wondered why Muriel insisted on talking about "black people's hair" and asking if she had ever touched it, but, knowing that the truth of her relationships would enrage Saul, she answered carefully that she "might have" touched it. She did not tell them that she had lived with one African man, Reesom, and had "been with others." As they drove home, she recognized that she no longer wanted to lie or hide things she was not ashamed of, and she wondered how she could let herself be friendly with people from whom she had to hide the truth. Ever fearful of Saul's reaction, however, she kept her thoughts to herself.

She described August 10–28, 1983, as "all well with minor ups and downs. Difficult times together, afraid again." On September 6 she noted that it had been one month since they had resumed the relationship and "it's all going bad again." Her only comfort was "valium and grass," and more and more she retreated into them: "All I have to do is lie down and try not to be unhappy." Shortly after she wrote this, she made a halfhearted attempt at suicide with

a massive cocktail of a mélange of drugs, and just before it took full effect, she wrote in the diary: "Coming down again. I feel sick. I hope I am not dying—despite the interesting side effects it would have—on Saul." He never knew of this attempt, because she made it in her apartment and he was alone in Springs. Whether she was serious about suicide or not, she simply woke up when the drugs wore off and went about her business.

Now that Saul had her safely situated at a distance, his primary emotion was relief. He was satisfied that he had been generous to her and therefore had every right to keep her at a safe remove. He was confident that if things remained amicable between them, there was no reason they could not be together on his terms. He traveled a lot during the fall of 1983, so there was no opportunity for disagreements to surface. When he returned, the holiday season had begun and her depression increased dramatically, as it did every year, starting at Halloween and not ending until after New Year's. Her dislike of the festive season affected him too, and his "dread" made him morose and sullen. This year, in an attempt to stave off his annual melancholy, he refused to see her.

She was calm but still in dark despair when she sat down in early December to compose the letter that was meant to be her last will and testament. "If I should die," she began, she wanted "my friend Saul Steinberg" and her sister Uschi "to take care of everything." She would not mind "being burned," but she hoped her ashes would be buried in the woods behind the house in Springs, where there was still a gravestone left from the colonial era, when that part of the property had been a cemetery. She was very specific about what she wanted: a plain wooden box that would be lowered into the grave by hands and ropes "(please no hydraulic devices and no artificial grass to hide the dirt)." She wanted wildflowers and, for music, the "lacrimosa" from Mozart's *Requiem* and the last movement of his Clarinet Concerto K.622. If, however, she died in Africa, she wanted to be buried there. She wanted her old Leica camera to be buried with her, or else given to "someone young and talented who'd appreciate it." After dispensing with her personal effects ("most . . . belong to Saul, who gave them to me") and her bequest to her sister, she divided the money she had in bank accounts in Germany, France, and New York between her brother's four children and her sister and made small gifts to people who had been kind to her. She gave power of attorney to the CPA whom Steinberg had engaged to set her up in the apartment and dispense her monthly stipends. "If I die," she concluded, she wanted it to be "without regret, as I would have liked to live." Then, to make sure that her readers would know she was quoting Dostoevsky, she wrote by hand on the typed letter: "'One moment of happi-

ness,' etc., from *White Nights*." She filed the letter away very carefully, in her apartment and not in Springs, so that Saul could not find it until she was ready for him to read it. She wasn't quite ready to die just yet, but she was preparing herself to be preemptive, just in case the time might soon be right.

Her life was "empty, boring," and "harder" than she had thought it would be. "Oh well, too bad. And I had so many dreams and hopes."

"STEINBERGIAN"

A drawing from life reveals too much of me. In other drawings—those done from the imagination—I do only what I want and show myself and my world in the way I choose.

Steinberg began 1984 by avoiding "the racket, the hysteria" of Christmas in New York and "hibernating in the heat of home" in Springs. He had more important news than the weather to tell Aldo Buzzi: "Bulletin: I stopped drinking." For an entire month he had not drunk wine or whiskey and so, just to prove to himself that he was not an alcoholic, he planned to enjoy an occasional finger of scotch or glass of wine. The act of abstaining from liquor made him "glad," but even better was the feeling of "something like dignity" that bolstered his belief that he had done the right thing to separate from Sigrid. He no longer felt "oppressed" by "the threat of [her] tears and scoldings," and best of all, he no longer fell victim to the "remorse" those episodes always produced. In fact, by exerting controls and sticking to them, he felt so good that he began to work again with real pleasure in the evenings after dinner, something he had not done "for many years (30?)."

He was also practicing another kind of control, a physical one that started when he had escaped for three days during the fractious month of August 1983 to hide from Sigrid's erratic behavior. He had checked himself into a Zen temple in the Hudson Valley, where he practiced sitting in silence in the lotus position for four to five hours during each of the three days. Even though maintaining the lotus position that long played "havoc" on his seventy-year-old legs and feet, sitting was "a savage delight" that gave him a sense of accomplishment for being able to endure it "without weeping or running away." Steinberg practiced sitting for the rest of his life, even going so far as to convert the small room that adjoined his studio in the apartment into a dedicated meditation chamber. To acquire knowledge through practice, he went to other

Zen retreats, particularly the Zendo in Sagaponack, where the writer Peter Matthiessen was the roshi. Steinberg became such a convert to sitting and so convinced of its many benefits that he tried to enlist Hedda and Sigrid to join him. Hedda declined, saying that she was content with the forms of private meditation and the few yoga positions she had long practiced; Sigrid sometimes accompanied him to the Zendo, although she went mainly for his companionship and never practiced with anything like his diligence and dedication.

Zen had other beneficial effects on his daily habits. Steinberg's sleep patterns had always been fairly consistent: if the work was going well and things were calm with Sigrid, five hours were restorative, but when he was unhappy or depressed, he would sleep for eight or nine hours at a stretch and when he woke up would lie abed with eyes tightly shut until he could no longer avoid facing the day. Insomnia tortured him in the last years of his life, but it was still mostly occasional when he began sitting in the mid-eighties. The physical conditioning Zen required gave him new mental energy, as did a mental exercise that he learned in one of his classes, to think of himself as being enclosed in a cylinder that prevented any outside ideas from entering his mind. Usually pretending to be encapsulated would put him to sleep within minutes.

Another physical exercise he used to tire himself out and help him sleep was riding his bicycle on country roads. He bought a first-class racing bike and rode it every day into Amagansett, where he stopped to buy the newspaper, then pedaled happily home along a road that paralleled the ocean while allowing his mind to free-associate. Going into town entailed a strenuous uphill climb, but the return was fast and fun as he whizzed along downhill all the way. Even in bike riding Steinberg expressed his sartorial elegance, enjoying outfitting himself as much as he enjoyed the actual experience

Steinberg in full biking regalia.

of riding. He decked himself out in a helmet, goggles, leather riding gloves, black spandex tights, and a professional red-and-black jersey like those worn by champion Italian riders. "I am an amazing sight," he crowed, boasting that he cut "quite a spectacle." He found such euphoria in riding the bicycle that he wrote a paean to it, "The Bicycle as a Metaphor of America."

STEINBERG'S RITUALISTIC DAILY ACTIVITIES HELPED TO free his mind to roam through the thoughts and ideas they generated during the 1980s. Practicing Zen offered ways of thinking about how to withdraw from the constant influx of demands on his person and his time, as he learned how to be "inside with oneself in silence, an escape from the constant chatter of introspection and conversation." It was in this period that Zen became one of the many "elective austerities" he practiced in his personal life so that he could concentrate all his energies on creative activity.

Steinberg "sitting."

He still traveled as much as before, usually finding a way to relate his journeys to work and often adding something pleasurable along the way. After he went to Chicago in early 1983 for the opening of his works on paper and wood at the Richard Gray Gallery, he went to Las Vegas to indulge one of his long-standing passions, gambling at the casinos. He was an uncanny gambler who could have been a pro, but this time he had to settle for ultimately losing his winnings, so that "only the pleasure of having won remains."

As he spent more and more time in the country, he took pleasure in cooking simple meals for himself. He, who had always needed the stimulation of company and had gone out almost every night to find it, was now

content to spend his evenings listening to music, reading, and drawing. His creative output during this period was just short of astonishing, as the decade from 1978 to 1988 saw his largest and most sustained contribution to *The New Yorker* and several publications and major exhibitions. He made many drawings that could not be slotted into portfolios or other categories, which he called "ex votos," saying that they were inspired by biographical reminiscences from either his recent or the far distant past. He compared their genesis to "film exposed sixty years ago and only now developed and printed."

He had no fixed schedule for working but could sometimes start early in the morning and continue off and on until the night, so that friends who lived nearby and wanted to see him knew better than to drop in. They learned to phone first and to stay away when he used his standard expression, that he "could not make plans at the moment." However, when he did want visitors, he suddenly became "a person of impulse" and would insist that they come at once for everything from late-morning coffee to afternoon tea or an early evening drink. But he never invited guests to dinner, for if he ate with others at that meal, he preferred not to entertain but to be entertained by them. On the rare occasion that he initiated an evening meal, he took his guests to restaurants, unless it was during one of his good periods with Sigrid, when she was there to cook.

Steinberg balanced turning inward toward a simpler way of life by deliberately turning outward for the intellectual sustenance he needed, finding it through actively nurtured friendships with writers. He began a correspondence with Sandy Frazier, who had moved to Big Fork, Montana, which was as satisfying as the letters he exchanged with Aldo Buzzi. He and William Gaddis had a standing date to meet at one of several different East Hampton restaurants every week, and whenever Muriel Murphy had a dinner party, there was always the possibility of a new friendship with someone interesting, such as Joseph Heller, whom he met at her table He had always kept a respectable distance from most of the artists of his generation, and few were still alive. He was one of the few trusted friends permitted to visit Bill de Kooning, but it always made him sad to see his old friend's steady decline into senility. Every witty letter from Philip Guston reminded him of how much he missed Ad Reinhardt's caustic postcards. Guston always invited Steinberg to visit his farm in upstate New York, but he never went. He did go to Vermont to see Jim Dine, whose "windowless studio, noisy electrical lighting and unimaginable chaos" were so overwhelming that he had to escape into Nancy Dine's beautifully kept house. Dine was one of the few artists Steinberg liked to talk to, because they always conversed "with pleasure about professional matters, like schoolmates."

He liked being in the company of Helen Frankenthaler and Robert Mother-well when they were together during their marriage and separately after they divorced, but it was usually they who initiated the contact, and it was almost always in an East Hampton gathering where conversation was difficult. Most of the old friends from the worlds of commercial art and graphic design had either died or moved away, and as Steinberg had not made close friends among the younger generation, he was able to regard this area of art and culture as he perched outside—or perhaps above—the fray. From there, he instigated several important shifts in how he would present his work in the future.

A few years earlier, as the decade began, Steinberg was grudgingly coop-erating with galleries and museums that wanted to capitalize on the success of the Whitney retrospective by mounting the same sort of show. Once he became engulfed in the frenzies related to picking and choosing work to exhibit, he realized that he did not want to waste valuable time becoming the chief archival authority of his past, because he had so many ideas for future work. He objected to the canonization of his oeuvre as something fixed and final and would not engage in any activity that even hinted at the closure of his career. Saul Steinberg decreed that there would be no more retrospectives and he would concentrate on what he wanted to do rather than on what he had already done.

He began to put this decree into effect after he allowed himself to suc-cumb to Arne Glimcher's abilities and charms, and especially to his promise of higher prices and better sales through the Pace Gallery. Glimcher reminded Steinberg "perhaps a bit too garishly" of the late Aimé Maeght, but he was also "an excellent person, concise, rapid, even intelligent," and Steinberg knew he could count on Glimscher for "a capable job." His first show at Pace in 1982 did indeed command higher prices and sold so well that it pulled him out of the financial hole he claimed to have been in since 1978.

The exhibition featured new drawings and some of his wooden construc-tions, and it was an energizing experience to see them so well received. The positive feeling was bolstered when two books appeared in 1983 to confirm that the work he had been doing over the past several years was well received by a public who had not seen it in book form since *The Inspector* a decade ear-lier. Both books contained texts provided by distinguished scholars, the critic Roland Barthes for the French *All Except You* and the poet John Hollander for the American *Dal Vero*.

Steinberg and Barthes had known and respected each other's work since they had begun a cordial but formal friendship in the late 1950s in Paris. Barthes was well equipped to analyze Steinberg's drawings because Steinberg

had been explaining them since 1967, when Barthes had asked about the children's labyrinth at the Milan Triennale and the mural in the courtyard of 5 Via Bigli. Steinberg said they were best understood by first considering the line of "rope" (*echelle*) or "string" (*ficelle*), for he intended the line to be the internal guide that showed the viewer how to navigate the maze. He asked Barthes to note how the rope became something different as it passed across the changing horizon, veering in some places from being water on the ground to a ladder reaching toward a ceiling or an arrow pointing at the sky. He insisted that the artist's ultimate task was to ensure that the viewer needed to make only a minimum effort to grasp and absorb the entirety of the labyrinth, and to realize that everything seen individually is but one of the many elements within the total illusion.

Barthes wrote his essay in French, but from the beginning the book bore the English title *All Except You*. Throughout, he tried to arrive at an overview of the many meanings each individual drawing inspired and to ask what a viewer's lasting impression might be, but however much he wanted to "chase after the being of [Steinberg's] art," it remained elusive. The drawings remained "a mirage . . . whose deceptiveness is always put off until later." Barthes called this the true definition of reading, a conclusion that must have delighted Steinberg, the self-described "writer who draws."

The idea for the American book originated with Brendan Gill, Steinberg's friend at *The New Yorker*, on behalf of the Whitney Museum. Each year a writer and an artist were invited to collaborate on a book that was privately printed as a gift for the select list of donors known as the Library Fellows. Gill asked Steinberg to make the drawings and he in turn asked John Hollander to provide the text. Steinberg told Hollander that he had "a collection of drawings that were unique" for him because they were from "Dal Vero, á la verité," a genre he had consciously avoided publishing as much as possible. He wanted this group of around twenty or twenty-five drawings to be published, but he worried that they were too personal and therefore not what the book's audience would be expecting from the usual Steinberg, which they could recognize even before they saw his signature. He also worried that because they were all informal sketches from life, they might not be of the same quality as those he had been presenting to the public throughout his career.

Steinberg was a true perfectionist, famous among his friends for discarding and sometimes destroying almost as much of his work as he actually kept. His studio assistants remember how he studied each finished work with scrupulous intensity before agreeing to let it leave his studio, peering closely as he turned it this way and that, looking at it upside down and sideways; his friends

remember how diligent he was about destroying his discards so that it would not be worth the trouble for an unscrupulous scavenger to try to fish something out of his trash can.

Steinberg thought he was taking a huge risk by exposing deeply personal matter. He had always taken pains not to let the public see the people, places, and things he cared about most, and drawing from life made him fear that he was revealing "certain parts" of himself, "areas of vulgarity where I don't tell the truth, making use of what I already know, commonplaces." He was frustrated when "things don't end up the way they should—the results don't live up to the promise." It was the opposite of drawing from the imagination, when, in the guise of the protagonist, he always knew when the work was final and finished, ready to leave his studio and be sent out into the world. But this was the work that made him happy and satisfied, and this was what he wanted to publish. His worry was eased by the thought that he would be working with John Hollander.

Steinberg had known Hollander since the late 1960s, when they were often invited to the same events in New York, and as they both owned houses in Amagansett, seeing each other there as well. It was in Springs that Hollander got the title for one of his books of poetry, *Blue Wine*, when he visited Steinberg and watched him fill wine bottles with an unidentifiable blue substance. He had written about Steinberg in magazines such as *Commentary* and *The Listener* and he had written the introductions to the catalogue for Steinberg's Smithsonian exhibition and the new edition of *The Passport*. The two men had many discussions of Steinberg's art throughout the collaboration on *Dal Vero*, but some years after it was published, they talked more fully about it in a conversation that Hollander remembered long after.

Steinberg told Hollander that throughout his long career, he had always felt "uneasy" about being treated as an artist, for he thought of himself primarily as "a cartoonist who drew for immediate publication." He spoke of the difference between doing graphic art as an ancillary to painting or sculpture and doing graphic art as the necessary consequence for painting, and said he fell between the cracks and crevices that separated the two. Steinberg offered the example of Goya, who also prepared what he called "graphic art for publication." Hollander demurred, saying that he found more resonances between Steinberg and Blake, for "Steinberg was an intellectual cartoonist, a satirist of representation, and Blake was a satirist of conceptual representation." Steinberg said he didn't care who Hollander compared him to or where the art world placed him; what he disliked was seeing his work hanging on walls, for he was far more comfortable seeing it on paper. He objected to the institu-

tionalizing of painting and everything connected with the commercial process of getting it out for consumption by viewers; if he did veer into "painting" with these drawings from life, he still wanted their initial appearance to be on paper.

STEINBERG SUBMITTED APPROXIMATELY TWENTY DRAWINGS TO Hollander, almost all of them featuring Sigrid in some sort of repose, reading, sewing, just sitting quietly and often staring off into the distance. He made one double portrait, of Sigrid and Aldo, but mostly, when not drawing her, he captured the objects on the kitchen table, the view outside the studio's sliding glass doors, Papoose prowling or sleeping sometimes on Sigrid's lap. The only other person besides Aldo whose portrait Steinberg submitted was Harold Rosenberg's, but shortly after, quietly and without an explanation, he withdrew it. Eventually they settled on sixteen drawings to accompany sixteen "prose meditations."

Hollander created a dreamy, shimmering text that matched the tranquillity of the drawings. A reader could move easily between the two, pausing to savor first one and then the other, concluding, as Barthes had done earlier, that they could be approached "endlessly" even as they remained "a mirage." Steinberg, still unsure that he had made the right decision to let the drawings out into the world, told Hollander that they should probably "brace ourselves for more surprises." But there were no surprises when the book appeared, and it did "come out well," praised by the collectors for whom it was intended. Steinberg was proud of this book and pleased that his worries had been for naught.

STEINBERG BROKE HIS OATH NOT TO be involved in any more retrospectives when the University of Bridgeport in nearby Connecticut invited him to become the Dorne Professor in the arts, an honor he accepted proudly. He broke the oath because the exhibition featured (among other artists he liked and respected) Alice Neel, Josef Albers, Mary Frank, Robert Motherwell, Red Grooms, and Louise Nevelson. He learned of an honor of another kind when Rodica Ionesco, the playwright's wife, wrote to congratulate him on being listed in the authoritative French dictionary *Larousse*. He was described as an "American drawer [*dessinateur*] of Romanian origin," noted for his humor, satire, and exceptional originality. His name had long been used informally as the adjective *Steinbergian*, and now the *Larousse* gave legitimate dignity to this usage. In New York, he graciously accepted the Mayor's Award for contributions to the arts and culture of the city, and an equally impressive invitation came when Saul Bellow invited him to participate in a "Great Books"

conference led by Professor Allan Bloom at the University of Chicago. He took Bellow's request for critiques of his speech very seriously and made many handwritten suggestions for changes on the typescript, which Bellow incorporated into the final text.

He was also broadening his circle of younger friends. One of his neighbors in the Hamptons, the lawyer Lee Eastman, introduced him to his daughter, Linda, and her husband, Paul McCartney of the Beatles. Steinberg gave them all gifts of drawings after he designed the cover for McCartney's album *Cold Cuts*, and when Paul and Linda were eager to have him design another cover, he sent a second drawing as a gift. Linda McCartney said they would be delighted to have it but insisted on paying for it. Michael Kennedy, Robert's son, invited him to a reception for the Nicaraguan politician Daniel Ortega after he addressed the United Nations General Assembly; Steinberg declined, saying that he would see Kennedy and his wife, Eleanore, at another time.

IT SEEMED TO STEINBERG THAT HE had made all the right decisions about putting his personal and professional lives in good order. After he and Sigrid resolved the details of their latest separation, they went to Martinique in March 1984 and had a pleasant holiday. They were both using the Springs house, albeit often in separate bedrooms and at separate times, and when they were together they were able to enjoy casual suppers in "low-rent restaurants" that stayed open during the winter. Steinberg had agreed to have new work ready by 1986 for exhibitions at Maeght Lelong (as the Paris gallery was now known) and Pace in 1987, and his literary agent, Wendy Weil, was hinting strongly that he should be thinking about a new book. Everything seemed under control until several things happened to disrupt his peace of mind.

Ada resurfaced for the usual reason—she needed money. She was living with her husband now, and he was badly crippled with rheumatoid arthritis. She teased Saul with the comment that she had just suffered an *infarcto*, a heart episode, but neither she nor Aldo (when Saul pleaded with him to find out) explained any further. All this was a prelude to Ada's telling him that there was an opening in a desirable retirement home in Erba, just above Bellagio, and they had been invited to take it. She was reluctant for two reasons: they did not have the money for the entrance fee or the monthly maintenance, and, more important, she was not yet ready to admit she was old enough to live in a home for the elderly. Saul was surprised at how deeply this news upset him.

He had not seen Ada, nor had he corresponded with her, for so long that the thought of resuming the friendship (for that's what it was now), even

though at long distance, was quite unsettling. But being his usual generous self, he knew he had to do something, so he phoned her, and the conversation was "magic—return to forty years ago." It awakened his need for frequent telephone contact, which became "strong and essential," as did his need to see that she was well provided for: he gave her the money for the entrance fee to the Casa Pina and made arrangements to deposit a generous monthly stipend of $1,000 into her bank account, plus more whenever she needed it. She had only to ask (and often she did) when she wanted a holiday or vacation or one of her appliances died and she needed a new one. Ada's only other income was the modest support she received from the Italian government, and so Saul willingly became her primary provider for the rest of her life.

He worried about Ada long-distance, but Sigrid was right there, with medical problems that were truly frightening and needed immediate attention. She was always in pain from what she called quite simply "a bad back," and she realized something was seriously wrong only on the day that she tried to jaywalk across a busy Manhattan intersection, when she was in so much pain that she could not walk fast enough to cross the street before the light changed, nor could she lift her leg to mount the curb once she got there. She consulted a neurologist, who sent her to Lenox Hill Hospital for tests, which revealed a large tumor on her lower spine. Immediate surgery to remove it was performed on April 16, 1984. Fortunately, the tumor was benign, but there were other problems, all caused by the deprivations of her wartime childhood diet. There was significant curvature (lordosis) to her lower spine, and she needed a laminectomy to correct it. All told, it was a long and difficult operation which kept her in the hospital and on morphine for a week, but she healed quickly afterward and had an "extremely benign post operative course."

Steinberg took her to Springs and saw to it that she was cared for and coddled. She was still there when it came time to plant the garden in late May, and she was strong enough to put in all the flowers she loved and take delight in doing it. Steinberg thought it "quite lovely—indeed a touching and childish garden, a compensation for her unsteady mind."

But he was kind to her, and she was grateful. There were no tantrums and no depression on her part. He certainly tried to be happy and positive while she was there, but it wasn't easy and nothing seemed to work. In a "gastronomical update," he told Aldo that he was determined to lose weight and get over the insomnia that was becoming fairly constant, and his intention was, "above all, to avoid melancholy." To that end, he stopped drinking liquor again and ate only brown rice and steamed vegetables, a regime he was encouraged to stick to after the eighty-year-old Isamu Noguchi came to spend the day. Steinberg

was impressed when they took a long walk and Noguchi strode steadily at a faster pace than his, talking and listening with equal intensity. He thought it would be a good idea to keep Noguchi firmly in mind as a role model, but like so many other good intentions, this one was pushed aside when other crises presented themselves.

WINDING UP LIKE MY PARENTS

*I see with terror that despite the progress, journeys, books, etc.,
I'm winding up like my parents, confused and fearful. What a
shame . . . I remind myself that I'm seventy-one and that I've sur-
vived wars and disasters and that hypochrondria, too, will pass.*

Despite all the work he had done on the Springs house, it was old and
in need of a constant succession of repairs and renewals, and this
time they were all major. Starting with a new roof, the entire exterior
needed replacing. The cedar shingles on the walls were smothered
by an ancient tangle of ivy that had caused most them to rot and fall off. Roof
and walls had to be stripped to bare boards, reinsulated, and then re-covered.
As long as the workmen were there, Steinberg decided they might as well
tend to the second-floor bedrooms; new windows and heating apparatus were
installed, and the interior was painted. With all that under way, the first floor
looked extremely shabby, so he had the walls covered with wood paneling,
new windows put in, and interior painting done there as well. But before any
of this could happen, the house's entire electrical system had to be upgraded.
The "mess" began in the winter of 1984 and was not finished until late sum-
mer 1985, all of it happening during a "rotten moment due to complications
with Sigrid, the house, work." Steinberg coped by practicing Zen to cultivate
"the happiness of a stoic." His outlook was reinforced by his new friend Joseph
Heller, whose cheerfully ironic pessimism was just the kind Steinberg appreci-
ated.

Just as the house renovations were getting started, his cousin Phil suf-
fered a stroke and died. Although they had not spent much time together, their
friendship had deepened through Phil's rambling, stream-of-consciousness let-
ters, which touched on everything from local politics to the satisfactions of
work, the love of a good woman, and the importance of family ties. Phil was
the only member of the extended Steinberg family with whom Saul felt real

affinity, so his death was a serious loss, especially because it was so unexpected. What Saul found most unsettling about Phil's death, however, was that he and his cousin were exactly the same age, seventy. This intimation of mortality hit far too close to home.

With Sigrid, the ups and downs continued despite their supposed once-and-for-all final separation and despite the kindness Saul dispensed during her convalescence. When she wrote another of her ongoing series of accusatory letters, he made an uncharacteristic attempt to mend the breach with a letter of his own. "We have to be careful," he wrote, adding that he loved and missed her. But they were incapable of breaking their old patterns and could not be together for long without a major blowup. Silence once again dominated their interactions in the house, and they were back to communicating via written messages. Steinberg kept a huge supply of paper plates on hand, the ordinary white cardboard ones with fluted edges. He was fond of drawing on the dessert-sized ones, sometimes making masks with cut-outs for noses, other times making household lists or jotting down thoughts that might become drawings. Sometimes he would dash off a drawing pertaining to whoever was seated at his table, and many ended up as valued souvenirs of the people who received them. Sigrid had her own use for the paper plates, as informal bulletin boards on which to post her latest ultimatum, which she always left at his place so it would be the first thing he saw when he sat down to a meal.

And yet when they traveled together they were the most loving of couples. While the house was uninhabitable they took several trips, first to Martinique and Barbados and then to Sanibel Island, Florida, where they had been the year before. They rented the same apartment, on the fourth floor of a condominium that was a short walk from the ocean. Although it was luxuriously furnished and spacious, it forced them into closer proximity than they had in Springs, but they managed nonetheless to live in the peaceful harmony that eluded them everywhere else.

When the vacation was over they returned to their separate apartments, and Steinberg abruptly decided that he had to sell his and move. He knew he was behaving irrationally and he knew why: it was how he had reacted since Milan, when he had moved from one student hovel to another, thinking that the cure for his unhappiness would be a new place to live. He told Aldo that making changes to the Springs house whenever he felt the old restlessness brewing was not enough, and said that he was free to conclude—correctly— that he had "changed landlords" instead of changing his bad habits. For a week he attacked the search for a new apartment with the intensity of one of his Don Quixote figures girding to vanquish a pineapple, but after getting no further

than reading the want ads, he gave up, and moving became something he only hinted at now and then. Instead of changing landlords, he changed locations through travel.

ONCE STEINBERG WAS BACK IN TOUCH with Ada, her attitude toward him veered quickly from what he wanted, a warm friendship based on a shared past, to her desire for a renewal of the intense sexual passion they had enjoyed before the war. He was a little frightened by her love letters and blatant overtures on the telephone, but at the same time he wanted—indeed, needed—to see her. He flew to Milan "first class TWA" and checked into one of the best hotels in the city, where Aldo and Bianca met him for dinner that night. The next day he went to Erba and spent the afternoon with Ada before going to Turin to see Consolata Solaroli, a graphic designer he had known and liked for many years, despite her penchant for using green ink, which gave him shudders. On a whim, the day afterward he flew to Zagreb and then to Zurich before returning to Milan to spend his final afternoon with Ada and his last evening with Aldo. He and Ada had come to an understanding that there would always be a very special intimacy between them but that it would be a shared memory and no longer sexual. The next day he flew to Paris for three days of pure holiday, and then back to New York.

WHEN HE ARRIVED, HE WAS STILL under "the beneficent illusion of travel, the illusion of liberty," but the freedom was short-lived: "The mail was waiting, the telephone, and other chores are already closing in." As the new year, 1985, arrived, he settled into his well-heated apartment and seldom went out, and when he did, it was usually for long walks along the avenues and streets of the Upper East Side. Steinberg tried but could not keep himself from falling into a profound "melancholy," his euphemism for periodic bouts of serious depression. This one found him constantly replaying scenes from his past life and immersing himself in reading as a way of coping with angry thoughts about his past humiliations. Books he had once loved were now merely "clever," and if they did help him to sleep, it was only for a few hours, after which he would wake up agitated and fixating on things from the past he had all but forgotten or other "oddities" he was at a loss to explain. "We are the victims of childhood for too long," he said, as he was suffused with inexplicable nighttime anxiety and terror. Despite all the sophistication he had acquired and all the admiration and affection that had been lavished on him since he had left Bucharest, he feared there was no way to avoid "winding up like my parents, confused and fearful. What a shame."

All winter long, as he stayed in the warmth of his apartment, he immersed himself in reading everyone from Tolstoy to Primo Levi; from L. P. Hartley's *The Go-Between* to Joan Didion's *Slouching Toward Bethlehem*. He boasted of reading every writer from Gadda (in the Milanese dialect) to Gaddis to William Gass, but nothing helped. When summer came, he spent it quietly in the country, sitting in the sun and watching as the last of the work was done by a young and cheerful construction crew, enjoying the days, which he thought spawned the "excellent, pleasurable, sometimes ecstatic insomnia" that gripped him all night long. He coped with his wakefulness by sitting (the term he always used for meditation) for long hours several times each night.

Sigrid caused much of his anxiety, as her behavior veered toward the dangerous, not only to herself but to others as well. She was almost always high, but that did not stop her from driving with reckless abandon. He made the mistake of asking her to pick up his car after routine servicing at a West Side garage and deliver it to his apartment. On the way she went through a red light on Riverside Drive and 89th Street and hit another car head-on. Neither she nor the other driver was hurt, and Steinberg's large Chevrolet sedan had "only a dent." Sigrid found it amusing that the other car, a tiny sports model, was (in her words) "smothered." She was blasé about it when she described the accident over the phone, blithely reporting how relieved she was not to get a summons and how, still in a stupor, she had gone to her apartment, got Papoose the cat, and taken off for the country—not the apartment where he was waiting. It was not fair, she told him when she phoned from Springs, that after escaping so many serious consequences, she got a speeding ticket on the Montauk Highway.

Through Evelyn Hofer, a staunch believer in Jungian psychology, Sigrid had begun analysis with Dr. Armin Wanner, who would become the last and longest-lasting of her many therapists. Occasionally she thought she was well enough to see Wanner once a week, but most of the time she had twice-weekly sessions. As time went on, she was often in such distress that she saw him every day, not only for sessions in his office but also for long walks, visits to museums, and other meetings that were more social than clinical. Wanner had her keep a dream journal, writing what she remembered about her dreams of the night before. Instead she was much more engrossed in keeping a detailed diary of her life with Saul Steinberg, and around 1985–86 the dream journals became sporadic as she filled tablets and notebooks with angry outbursts that described each ultimatum he issued and each outrageous retort or response they inspired from her. One of her diary entries describes the general pattern of most of them: "Basically while we did talk, we found no solution, made no decisions

except that he won't go with me anywhere here, chez people, for dinner, etc, so I am stuck." Angrily she added, "Better start looking for new friends, maybe among the other losers in my neighborhood, among the local bums."

Saul told her the one constant she could depend on from him was what she called "the money question." In 1987 he gave her $31,200 for that year's living expenses and expected her to supplement it with interest from her savings account and money market fund. If he also hoped it would inspire her to seek work, he did not say. Instead of calming her financial concerns, his stipend filled her with rage and resentment. She took one of his best drawings, a gift given at a happier time, to Sotheby's, where it fetched $86,985 at auction. She told him what she had done in a letter, boasting that she had had to do it because he had left her with nothing, not even Papoose, who now lived mostly with him. "Go fuck yourself," she wrote. "I have nothing left but money and I will take it and run."

Her behavior was fast becoming a public embarrassment, as she did not stop with the Sotheby's auction; she took another of his gift drawings to Arne Glimcher, who quickly sold it for what it was worth, just under $10,000. She thought it should have brought more and wrote Glimcher an angry letter saying that he had taken advantage of her straitened circumstances and had left her no choice but to accept it. She told everyone who knew Steinberg that Glimcher had gypped her, knowing full well how mortified Steinberg would be when the story eventually got back to Glimcher through the art-world rumor pipeline. Then she went through an "I'll show him [Saul]" phase when she took her portfolio to every gallery in the city, from the high-end uptown establishments to the downtown storefronts and alternative spaces. She did not help her presentation by wearing her most bizarre outfits, and her hair was often dirty and unkempt. Most gallerists would not even look at her work, using the standard excuse that they were not taking any new artists just then. She knew museums had their own publications staff, but she went anyway to beg for a job doing the most menial hand-lettering or book design. They all knew who she was, and she enjoyed watching some of them squirm in embarrassment as they turned her away. Many of Steinberg's friends were so concerned about her disheveled appearance and unstable behavior that they wrote cautious letters hinting that something was very wrong with her. Unfortunately, no one, starting with him, knew what to do.

WHILE ALL THIS WAS GOING ON, Steinberg was besieged by death on all fronts, starting with the news that his mother's sister and the aunt he loved most, Sali Marcovici, had died in Israel at the age of ninety-one. He had sent

regular support to her since he first earned money after the war, and he continued to send the same stipend for the rest of his life to her daughter, a cousin he remembered as "thin and whining," whom he had not seen since 1930. From the American Academy of Arts and Letters he received a stack of notices of the deaths of members during the previous year, and he spent far too much time shuffling them as if they were a deck of playing cards and obsessing over how old the people had been when they died. Some were people he thought had died long before, so that seeing their names revived them eerily in his mind. "Too late," he concluded, mimicking one of his most famous word drawings, in which *Sooner* and *Faster* aim for the stratosphere while *Too Late* sinks into a murky pond. Rodica Ionesco sent news of Mircea Eliade's death, and Steinberg mourned the news of his passing and Primo Levi's, a new friend whom he had not had enough time to get to know. Two days before he died, Bernard Rudofsky, one of the first friends Steinberg had made in America, asked him to come to the hospital; Rudofsky told Steinberg that despite Steinberg's lifelong "indifference," he loved and admired him. Steinberg was shocked because he had no idea Rudofsky felt that way about him. Another death that inflicted strong emotion was that of Jean Stafford, a friend and neighbor in Springs who always delighted him when he saw her running down Fireplace Road toward his house, ready to use her "very unexpected and complicated mind to such devastating advantage." Other neighbors who were old friends died, among them Jimmy Ernst, at whose home Steinberg often ate his Thanksgiving dinner in the company of "all the other doddering old painters, all hard of hearing," and about whom he groused, albeit fondly.

As his collection of newspaper obituaries grew thicker, small comfort came when Brendan Gill advised him not to die on a Friday or a weekend, because it was "poor timing for obits in the *Times*." Another small comfort came from an article in the *New York Times* about how new therapies were helping men overcome impotence. He underlined the sentence "people realize that you should, if you want it, have a satisfactory sexual relationship into your 90's."

ALL STEINBERG'S MOORINGS WERE COMING UNDONE, and he felt adrift and unable to tether himself to anything solid. For years he had proudly used the stationery of *The New Yorker* for his correspondence, often embellishing the letterhead with the same kind of fanciful drawings he had used earlier to decorate the Smithsonian stationery. Now, for some vague reason he could not define, the magazine that was so vital to his existence had become a less important presence in his life. Searching for the reason why it happened, he compared his changing feelings about the magazine with the death of his Aunt

Sali, equating the loss of his professional *patria* with the loss of people he loved. But then he dismissed this as "exaggerating, perhaps to avoid frightening myself." He thought his drawings were "no longer right for the magazine," and even more alarming was the knowledge that "the idea of making them has no attraction for me." He thought it might have begun when the magazine was sold to Advance Publications, as he shared the view of the majority of the staff artists and writers that the moment the Newhouse family bought it, *The New Yorker* became "a more vulgar thing, adapted to making a profit." Still, no one expected the shattering announcement that the venerable (and venerated) William Shawn, aged seventy-nine, would be fired with the utmost public humiliation after S. I. "Si" Newhouse offered his job to Robert Gottlieb, who accepted it.

Gottlieb had been a brilliant book editor at Knopf, but he had no experience in magazine publishing, the point on which the magazine's staff members focused their anger. The staff hastily called a protest meeting at which Roger Angell led them in composing a letter telling Gottlieb that he should not take the job, even though he had earlier made it clear that he would only serve as a "conservator" until a new and permanent editor was appointed. The letter was rightly deemed "an act of self-delusion performed by 153 people who had long spent their working lives in a protected singular world," and when the writers asked longtime contributors to sign, John Updike was among those who acknowledged the hard reality of the changes installed by the new regime and refused. Among those who were upset at the passing of the old ways and who did sign were J. D. Salinger and Saul Steinberg. Like so many others, Steinberg was "sad, hurt, infuriated." He asked rhetorically what would become of the magazine now that the new editor possessed "a *punk* sensibility, convinced that brutality is chic." And then he sent Roger Angell a drawing on the magazine's stationery, embellishing the letterhead by turning it into a factory, which is what he thought it had become.

STEINBERG WOULD BE THE FIRST TO say that any form of psychoanalysis was unlikely to lead anyone to startling new insights into his or her character, but in old age he never stopped analyzing himself, especially about why he was so prone to the increasingly frequent and increasingly long periods of "melancholy." He admitted that whenever he was unhappy, he had doubts about everything and believed that nothing he did or said was good or right. Still, "unhappiness *does not* affect my reasoning my ideas my imagination," he insisted. No matter how mean a gesture he made in life, nothing impaired his work. It was how he rationalized his increasingly rude behavior, which resulted

in a terrible error of judgment sometime in the spring of 1985 that caused anguish and regret for the rest of his life.

No one is sure how it began or what exactly caused it, but sometime in 1985, Steinberg had a serious falling-out with Tino Nivola. It might have had something to do with an inexpensive Polaroid camera, which he insisted he had loaned to Tino, who failed to return it, while Tino claimed he had never borrowed it. No one who knew of this altercation can swear to any part of it with any certainty, but the story of the camera became the tentative explanation others offered after the two men fell into silence, stony on Saul's part, sad on Tino's. The change in Tino's demeanor began in 1982, after he underwent radiation treatment for cancer and went into a remission that left him lethargic and subdued, no longer the cheerful, energetic friend who was always just across the road and ready to stop whatever he was doing whenever Saul wanted to see him. Tino had an "amazing reverence for Saul's genius," and he "utterly, utterly, respected and admired" him. That sentiment never changed, his wife and daughter attested, so that after the discord (whatever it was), there was no sudden break between them; it was more like Tino's "slowly detaching himself from Saul's orbit." The silence continued for three years and was still in effect when Constantino Nivola suffered a fatal heart attack on May 5, 1988.

Claire Nivola phoned Saul to break the news of her father's death. She remembered how he emitted a sound she had never heard before, a "pained cry" that was somewhere between a moan and a cry of anguish. "I'll have to call you back," he said, and hung up the phone. Fifteen minutes later he had gained enough self-control to call and ask for the details of his friend's death. He listened carefully and told Claire to tell her mother that he would be just across the road if she needed him, but he could not be with her in person.

The Nivola family knew how deeply Tino's death affected Saul, but several years had to pass before he was able to talk to Ruth about his feelings, and then he could do so only over the phone. He told her that it had felt like losing a brother when Ugo Stille died, but "Tino was more than a brother." And then he made an admission that left Ruth at a loss for words, as he had never before revealed himself this way: "Since Tino's death I have tried so hard to break through the asbestos that coats me. Inside, deep inside, I am soft, but I have this exterior coating of asbestos." Ruth thought it was the most intimate and moving conversation she had ever had with Saul and recorded it in her diary.

Steinberg's relationship with the Nivolas, who, after Hedda, Aldo, and Sigrid, were the people to whom he was closest, was always a curiously distant

one. Even though there was a time when they all commuted into the city after every weekend, the Nivolas knew better than to ask him for a ride unless they had no other choice, because "it made him feel trapped into having to leave according to someone else's schedule and it made him uncomfortable." They knew that "he did not have natural kindly impulses," but they excused him because "he knew it, and it gave him tremendous guilt and remorse." They knew that he preferred to be generous with money and would always offer assistance, but only if he could do so from a distance, without personal involvement, for "doing that always made him feel incredibly good." Now that the Nivola children were grown and had gone to pursue their own careers and start their own families, there was only Ruth across the road, and Saul called her "the sole person I know with whom I can commiserate." He continued to accept her many kindnesses, but always on his own terms.

All their friends knew how close Saul had been to Tino, and many sent letters of condolence to him as well as to the family. Among the closest to both men was Henri Cartier-Bresson, who wanted Steinberg to know that he understood his sadness and shared it. Even so, these demonstrations of affectionate concern provided small comfort. Shortly before Saul made the remark that so stunned Ruth, he wrote a message on a sheet of blue-lined memo paper, folded it, and put it inside a file folder that he addressed to himself and sealed shut with folder labels. He affixed a twenty-five-cent stamp with the image of Jack London to it but never put it in the U.S. mail; instead he filed it carefully away among his other correspondence and never looked at it again.

The message was both sad and chilling:

"Dear Saul
Love from
But who loves you?"

"NOW FOR SOME SENSATIONAL NEWS," Steinberg told Aldo when his lawsuit against Columbia Pictures was settled in his favor in 1987. The decision gave him "true primitive pleasure" and was "the glorious dream of every humble individual persecuted by invisible forces." He could not help but crow: "Vindicated in full. A triumph." The lawsuit had dragged on for three long years, until the defendants made the mistake of arguing that their poster was based not on Steinberg's drawing but merely on the same buildings he had used; however, as the buildings were from his imagination and not real, the case collapsed in judgment. After three years of endless meetings with his lawyers, which sometimes left him frightened, confused, and always resentful, he actu-

ally enjoyed giving his "endless and quite interesting" deposition. He received $225,858.49 in settlement of the case he called "ST vs. the Scoundrels," and he promptly made photocopies of the checks and inserted them in his appointment diaries. He was so gleeful that he made photocopies of Judge Louis L. Stanton's thirty-five-page decision to pass out among his friends, and he was quite pleased when Gaddis told him he was thinking of using the legal documents as a collage in his next novel.

The case generated a new friendship with Judge Pierre N. Laval, who sent him portions of the opinions in several similar cases and a postcard showing how the city of Edinburgh had copied the poster, hoping that since the case had been settled in Steinberg's favor, it would amuse rather than upset him. Steinberg actually enjoyed it so much that he decided to collect the imitations of what he now always called "that famous *New Yorker* cover." When friends sent versions from Rome, Florence, Venice, Berlin, and Jerusalem, he told Aldo, "Lo and behold, a pretext to travel to Europe. Or maybe not."

There was another legal matter that needed attention, one that Hedda joking referred to as "when Saul and I divorced our money." Although they remained married, they signed a legal document that "settled the rights and interests" of their money and property and gave them the right to dispose of individual assets however they wanted. At the time, Steinberg's net worth was $4,669,000 and Sterne's was $3,500,000. Shortly after, he made another legal decision, appointing Sigrid Spaeth to be his agent in a living will, as he "trusted [her] to do the right thing because she knows better than anyone else what I would do."

STEINBERG WAS LEADING SUCH A QUIET LIFE that his cousin Henrietta Danson chided him for not keeping in touch with his family now that he had "dropped out of the limelight." In the past she had been able to keep up with his doings by reading the newspapers, but now, if she did not hear from him directly, she knew nothing. His professional life was busy because of various awards, honors, and exhibitions of his work, all of which generated interviews, articles, and books, but when they were judged against the activity of earlier years, they added up to less.

The Royal College of Art in London made him an honorary doctor at the 1988 convocation, a quiet and low-key ceremony compared to the one at Yale the following June, when he was awarded another honorary doctorate. He was about to decline it when Arne Glimcher insisted that he had to go, and not only that, he had to go in style: Glimcher chartered a small plane to fly Steinberg from Springs to New Haven, a twelve-minute flight, as opposed to the more

than two hours it would take by ferry and highway. A limousine met the plane and took him to the Yale campus to meet his hosts, John Hollander and his wife, the sculptor Natalie Charkow. Steinberg broke his ban on being seen in public with Sigrid by inviting her, and since he was allowed as many guests as he wanted, he invited quite a few to the ceremony.

Steinberg was delighted to be in the company of the other honorees, who included Isaiah Berlin, the archbishop of Canterbury, and Stephen Hawking. He went through the ceremony in a daze, accepting "demonstrations of affection from substantial people," and was relieved when it ended and he could board the plane for the short flight back to Springs. The experience was so emotionally exhausting that he fell sound asleep on the flight, and when he woke up, he reminded himself that "the pleasures of vanity are poisonous."

Granted, he was in a deep "melancholy" two years later when he recorded his official version of the event in a diary he had begun to keep, but what he described in 1991 was far from his earlier memory or from those of the people who were with him on that day in June 1989. Everyone else remembered a slight man of impeccable manners, dress, and demeanor who was quietly pleased to wear an academic robe and have a great fuss made over him. But when he summarized the event for the diary, he wrote: "How monstrous. Nervous hosts . . . Tension of academics." As for the event itself, "Secretly I thought it was a demeaning honor. Best part the small plane ride pilot and fat girl copilot." His enthusiasm for participating in the fellowship activities of Yale's Morse College was over: "Bedraggled New Haven, dangerous town."

THERE WERE FOUR MAJOR EXHIBITIONS OF Steinberg's work as the 1980s came to a close, the first at Galerie Maeght Lelong in 1986, followed in 1988 by one at the Galerie Adrien Maeght. Both shows received good sales and positive reviews and were accorded the same enthusiasm that had characterized all of Steinberg's European appearances. In the catalogue for the first, he gave a long, thoughtful interview to Jean Frémon, and the second featured an essay by Eugène Ionesco, his fellow Romanian and good friend. Ionesco was a respected denizen of the literary avant-garde, and his praise was welcome to an artist who sometimes feared that his work was considered mired in a now passé tradition.

When Steinberg showed his work in Nuremberg at the fourth Internationale Triennale der Zeichnung in 1988, he joked that it was "a kind of personal payback for 1939," as a way to gird against too-high personal expectations. However, essays by Italo Calvino and the museum's director, Curt Heigl, enhanced the catalogue and the show received rave reviews in the German press, further

adding to his always positive reception by the German public. It helped some, but not entirely, to mitigate the shock he had received the year before, when he showed his newest work at the Pace Gallery and John Russell wrote a snide, tongue-in-cheek assessment similar to the one of a decade earlier written after the Whitney retrospective. Russell's second damn-with-faint-praise dismissal was unexpected after so many years of nothing but fulsome critical praise, and it was therefore shocking not only to Steinberg but to all his friends. To head off their many attempts to console him, he phoned one after the other to say, "Wow! I've survived," and to tell them that the review didn't matter. Again and again he repeated, "I'm all right," as they railed against Russell. This was unusual behavior for him, as in the past he had always read reviews carefully and usually had something nasty to say about critics who did not praise his work wholeheartedly.

THE INTERVIEWERS WHO CAME TO TALK to Steinberg now were more interested in assessing the place he would hold in perpetuity than in the immediacy of whatever work he was exhibiting at the time. He was often curt and dismissive with art historians or cultural critics, because he thought they were shortsightedly assessing his canon as final and finished while he was busy all the time with new work. Despite the Russell review, he did not think his best work was behind him; nor did he think he was merely producing more of the same old tried-and-true. He sincerely believed that he was creating something new each time he put pen to paper.

Steinberg was only interested in talking to interviewers who would let him hold forth about the themes, events, and ideas that engaged him as the decade of the 1980s wound down. He had not given many interviews for the past several years because the press had pretty much left him alone until the recent spate of exhibitions brought him back into their ken. Now that there were new requests to talk to him, he was beset by the same sort of shudders he had felt after the Whitney retrospective, and just as he had refused then to collect, collate, and preserve his past, he insisted on doing the same now.

His resentment against becoming "an acquisition" for collectors intensified, but once his work was sold, there was little he could do to control what became of it. He railed against pressures from all those in the art world "who understand nothing but profits and sniff them out. Still upset over "the famous poster," he was further outraged when *The New Yorker* "published an ugly book" that included seventy of his covers, "poorly printed, shrunk down, mixed in with vulgar stuff." In this instance, the magazine owned the rights and did not even notify Steinberg, "so I'd better defend myself," he concluded. What

he meant was that he needed to take an active role in overseeing anything about his work that was being put into print.

He moved immediately to take a commanding role when two of his most astute buyers, Jeffrey Loria and his then wife, Sivia, decided to produce a book of their collection in connection with its exhibition at the University of Pennsylvania and Yale. The Lorias both had backgrounds in the art world and were perceptive about what would be important and lasting, so they purchased accordingly. In Steinberg's case, they were interested in the chronological development of the artist's oeuvre and especially how a drawing came into being, so they bought early versions of work in progress as well as the finished drawings. Their collection (to name only some) ranged from Steinberg's 1940s Manhattan taxis to some of his various Main Streets to several series of studies: "View of the World from 9th Avenue," "The American Corrida," and "Lexington and Wilshire."

With his semi-antagonistic attitude toward collectors, Steinberg resented having his work presented in book form by someone other than himself and wanted as much control over the project as he could claim. The Lorias were delighted to have his participation, as it gave a special imprimatur to the book, even though they were aware from the beginning of how stubborn he could be about its appearance. Jeffrey Loria asked the distinguished book designer Nathan Garland to be in charge of the project and told him when he signed on that Steinberg would be "a definite problem." Loria told Garland to "be firm," and Garland did try, "but in the end, Steinberg got almost all of what he wanted." Garland thought that many of Steinberg's ideas about book design were the insights of a "genius, but in many others, he was just wrong. I deferred to him always but it was really wrong to let him get away with it."

In the end, Steinberg groused about the book but was also pleased with it. He told John Updike that his introduction made him "happy to be taken seriously by a man whom I admire," but he arrived at this opinion only after a fairly extensive exchange of correspondence concerning the rewriting of "sensitive spots" where he thought Updike was "over-nationalizing [his] art as the product of a Romanian looking at the U.S." Updike explained that "the title and drift" of the book had led him to this emphasis, but he was happy to revise and eliminate as much "discomfort" as Steinberg wanted. Steinberg was more swiftly satisfied with Jean Leymarie's "appreciation," which had not required as much rewriting. Whereas Updike praised Steinberg for his vitality in conveying "national symbols," calling him a "visual philosopher who continues wonderingly to trace our tribal markings," Leymarie acknowledged Steinberg's affinity with Joyce and Nabokov, saying that he shared their "cult of style, and

predilection for parody, as well as an ambition for the universal and a quest for the autobiographical."

This was exactly the "context" Steinberg wanted for his work, and he could not have said it better himself. But by the time this generous praise came, his "melancholy" had become crippling depression and he was unable to appreciate it.

THE LATEST NEWS

What I do these days is to review the past, revive the past.

Sometime in mid-June 1989, the cat Papoose disappeared, and Steinberg and his friends and neighbors spent the next two weeks combing the area as they tried unsuccessfully to find him. Saul was alone in Springs, so he phoned Sigrid in New York and she came at once, distraught and weeping. Papoose was fifteen and, though not in obvious bad health, had been noticeably slowing down for some time. Saul thought he had become "Sigrid's cat" as he aged, following her everywhere and walking slowly like the old men Saul remembered trudging along on Mexican roads. He didn't realize the intensity of his own attachment until the cat was gone, when he enumerated Papoose's human qualities, "courage, grace, and dignity, a true man." Many months later, when he could not stop mourning, he told Hedda that of all the people he loved who had died, he missed Papoose the most. And then he corrected himself to say that he still missed Lica just as intensely, even though she had been dead for sixteen years.

For the entire month of July, Saul and Sigrid and the others searched the surrounding roads and woods, and in late August, Gordon Pulis found Papoose's body. Saul and Sigrid buried him with the full dignity they believed he deserved. Hidden in the trees behind the house was the remnant of a Revolutionary War cemetery, with one tombstone still standing over the solitary grave of a young girl. It seemed a fitting spot, and Sigrid told Saul that when she died, if she could not buried in Africa, she wanted to lie next to the cat, but to make sure she was facing east, toward the continent she loved so much. He told her she would have to make her own arrangements, as he was much older and would be the first to go.

Steinberg with Papoose.

With the death of Papoose, the most important of the few remaining bonds that held them together was severed, but they still could not separate entirely. Several months later, Sigrid was back in New York, begging to be allowed to come to the house and medicating herself far more heavily than before, while Saul was stubbornly solitary in Springs and starting an antidepressant regimen that lasted the rest of his life. He began with Prozac, then changed to Zoloft, and after that he took Librium. The depression that began after the cat died was different from previous ones, in that every peripheral thing irritated and upset him.

When Tina Brown became the editor of *The New Yorker* in October 1992, Steinberg was still so incensed over Shawn's dismissal that he refused all her overtures to persuade him to submit new drawings. He called S. I. Newhouse "a perfect shit" and threw out his stash of the magazine's stationery because the content had become "stupid" and he no longer wanted to be associated with it. "Who would have thought it?" he asked—"a real divorce, which should have happened years ago." It was wrenching to cut himself off, and it left him unmoored and adrift, asking rhetorically where his real *patria* was and whether he still had one. His refuge was no longer the magazine, nor was it the Pace Gallery; Sigrid and Papoose had been his anchors for years but "less now," he concluded sadly.

HE WOULD NOT LET SIGRID COME to Springs and he could not stand to be alone in the house during the winter because bad weather made everything "disappear." He hastened to the city and decided that all he had left to hold on to was "75th and Park and my apartment." He made a series of drawings of his neighborhood, one of which eventually became a *New Yorker* cover, a simple collection of white street grids with yellow squares for the buildings, a red *X* carefully marking the location of his. By the 1990s, Lexington Avenue, where he had enjoyed walking, daydreaming, and window-shopping since his earliest days in New York, had become dark, frightening, and infested with aggressive beggars. Homeless people slept in cardboard boxes on the sidewalk directly opposite his building, some of them covered incongruously in colorful silk or velvet rags they had pulled out of dumpsters. "How frightening! Baghdad!" he declared as he drew chaotic cityscapes to capture the impression. There was a citywide strike of all the workers in apartment buildings and tenants had to take over the maintenance; Steinberg was assigned a day of "desk duty" to answer the phones and monitor the traffic in and out of the building. Mostly he read the papers and hoped he would not have to interact with his neighbors, particularly the "slightly unbalanced" woman who lived above him, who

was "the daughter of Somoza, the old butcher of Nicaragua." His once vibrant neighborhood reminded him of Russia and was "as dead as Wall Street."

There was a momentary lull in Steinberg's self-pity when Saul Bellow came to town and invited him to meet Janice, his newest wife. It was the second pleasing event in a row, for the previous night he had dined with President Vaclav Hável of Czechoslovakia, who flattered him with such a fulsome declaration of "devotion" to his books that the "depressed state of [Steinberg's] soul" was momentarily raised. Otherwise, he was beset by "the dark winter, some rotten accurate news [about the Persian Gulf War], other stuff like my teeth, which make my life ridiculous and destroy my appetite." Extractions and implants made eating a chore, but even worse, they reduced his stamina so that he could not work for the same length of time or with the speed and precision of his younger days. He experienced "drowsiness, ill temper, doubts about everything." He still could not get over how much he missed Papoose and how the cat continued to be "an important character" in his life. Sigrid was hurting too, but Saul was worried about something other than how she was dealing with the cat's death.

After Sigrid told him that every time she went to Mali she was sexually involved with a tribal leader she called an "African prince," Saul scheduled AIDS tests for them both. There was a momentary scare when his physician requested an additional blood sample, but in the end both he and Sigrid were declared "negative for antibody to HIV-1." Although he continued to collect articles explaining how men could enjoy sex well into their nineties and pamphlets that showed the positions they should use after hip replacement surgery or back injury (some of which he attached to the AIDS test results), by the time of the tests in February 1991, his sexual relationship with Sigrid was virtually over and he looked for partners elsewhere. Whether it was the specific idea of her being with an African or whether it was his general uneasiness because she was twenty-two years younger than he and at fifty-five still yearning for a committed relationship, he simply could not deal with the fact of her sexuality.

Meanwhile, at seventy-seven he was sexually active whenever the opportunity presented itself, and he intended to be so for the rest of his life, even though he complained bitterly about the bed partners with whom he had had ongoing dalliances for anywhere from twenty to forty years. He grumbled that they still expected him to woo them first with dinner and then to perform vigorously after he had ruined his stomach with the bad wines and dreadful food most of his neighborhood restaurants served, which he described as one step up from indigestible "chicken nuggets and French fries." He wondered how he could possibly be expected to "make it, full of white wine and restaurant food."

Always before, no matter how estranged he and Sigrid had been, one or both could count on good sex to bring them back together (albeit temporarily, and they both knew it), but by 1991 those days were well and truly gone.

STEINBERG WAS FOND OF GIVING ALDO "the latest news" in the style of a flashy headline. His big announcement in April 1991 was that he was finally over the "melancholy" that had all but crippled him for the last nine or ten months. He was so full of energy that he was enthusiastically practicing the simplification of Zen to declutter his two homes. He threw away huge numbers of drawings and objects in both places, and because it made him feel so good, he began to keep a diary of everything he thought or did, "every day, long or short." For two months, from April 25 to July 5, he described what he wrote as "talk in shorthand," a collection of brief notations he probably intended to use to jog his memory at some future date. Clearly he intended the diary to be a document he could refer to, for he noted ideas for visual drawings, lists of words that might lend themselves to word drawings, and musings gleaned from his readings that might translate into single-subject portfolios. He was also playing with one of his new toys, a color Xerox machine, and he arranged pictures into a dummy that he thought might become a book, although he still needed time to think about whether he was ready to take on another one.

When he finally got under way with *The Discovery of America*, Steinberg insisted that it had never been his idea, and he convinced himself during one of his "melancholies" that it originated with others who were only out for money. He blamed the book on pressure from his agent, Wendy Weil, and his dealer, Arne Glimcher, claiming that they were unnecessarily worried that by refusing to submit new work to *The New Yorker* he was removing himself from the public eye and thus beginning a slow slide toward public indifference that would harm his reputation and their income. They were entreating and he was resisting when "complications" arose in the form of an offer from the publisher Alfred A. Knopf for the then astronomical sum of $100,000 as an advance against royalties. It left Steinberg astonished, his agent delighted, and his dealer "aroused [with] jealousy" as he prepared to schedule an exhibition to publicize what Steinberg called his "personal nightmare, a *Christmas Gift* book."

The Knopf contract made no mention of such a concept, but it did insist that the book had to be published by November 1992 to attract the holiday book-buying public. It was also specific about what the content should be: a showcase of Steinberg's unique vision of America, in which he was free to portray any aspect of the country and its culture. The publisher hoped that he

would create all new drawings but did not insist on it, and if he chose to use some he had on hand, he was to use only those that had not been published elsewhere. The only exception was those that had appeared in *The New Yorker*, for there was a large audience always eager to see them again in a more permanent form.

Steinberg's previous books had never sold well and his advances had been small, so this whopping offer came at the perfect time to help him over the "galloping pessimism," the gloom that always beset him when he thought about the intense work preparing a collection entailed. This particular task was more difficult than previous ones, because it came just as he was vigorously cleaning out his studio in the country and his office in the city, throwing away enormous amounts of work, convinced that there was very little worth saving. None of his drawings gave him pleasure anymore, not even "the famous ones" he had once admired.

As always happened when he became involved in a new project, once he got started on the new book, Steinberg became as fascinated with processes as with ideas. The color Xerox delighted him as he played with different sizes, parts, perspectives, and shadings of the same drawing. Aldo was alarmed by the uncertainty attached to the outcome of such games, but Steinberg assured him that the book would only be "50% in color or even less. Don't worry."

He was in constant contact with Aldo about the book's content, but Aldo was worried about something that coincided with his letters: Steinberg's embrace of the long-distance telephone to call him and Ada several times each week, sometimes on a daily basis. Steinberg boasted that his monthly bill was never less than $400, and when Aldo admonished him, Steinberg dismissed all his reservations by saying that the temptation to talk about possible selections instead of writing was too strong to resist. He did not tell Aldo the most important reason he phoned: that he could not bear the silence of being alone so much and his need to hear another human voice had become as strong as his need to write. He insisted passionately that their correspondence was the oldest, most lasting, and most important part of his life, and despite laziness and fear of senility, he implored Aldo to keep it going.

Steinberg's loneliness eventually bred disinterest in the book, but he forced himself to do some work every day, even though much of it gave him little or no pleasure. Another ailment joined his growing list, as his eyes were beginning to develop cataracts and the resulting strain left him bleary-eyed and fatigued at the end of a long day of drawing. Often he collapsed in his favorite chair while the television droned on as he snored with his mouth open; when he woke up, he reminded himself of his father in old age.

THE DISCOVERY OF AMERICA WAS THUS a book created in loneliness, anger, depression, and outrage. The emotions that beset Saul Steinberg were so intense that they frightened him, and in the hope of controlling them, he used his diary as an account of his emotional ups and downs. "What mistake the book!" he wrote in one of his earliest entries, as he blamed it for all his unhappiness. He recorded how his insomnia was so pronounced every night that for every eight hours he spent in bed, he had to get up several times to sit in the lotus position for two to three hours at a stretch. Nothing gave him pleasure, not even using the hitherto enjoyable practice of Zen to concentrate his full and loving attention on preparing his simple evening meals.

He thought the original working title of the book might be "My Biography," then "Biography," or "A Biography," depending on whether he was in an open and expansive mood or one in which he was overcome by some of what he called the "secret paranoias" that had arisen to the forefront of his consciousness. Ever since December 1989, when he had sat for hours in front of the television and watched, grimly mesmerized, as the punitive regime of the Romanian dictator Nicolae Ceauşescu came to an end, whole days had passed when he was gripped by thoughts of the psychic damage done to him by the country of his birth. Scant relief came when his friend and fellow Romanian E. M. Cioran told him that all his fears, regrets, and miseries were definitely caused by being born Romanian. It helped to find a countryman who had also re-created himself as a Western man, who thought "in the same surprising way" as Steinberg, and who had a "similar" biography.

He told Aldo about his similarities with Cioran in a letter he wrote on Yom Kippur, the day on which he always fasted, even though he never attended religious services. It was his way of "showing respect for my tribe, but it's for me alone." He had never come to terms with the grim childhood memories of "national horrors [and] Jewish superstitions" and in old age found himself unable to stop reliving them. As he could not dissolve the almost physical pain they made him suffer, one of the ways he compensated was by being an overly generous cultural Jew.

Steinberg received a confidential letter from the American Jewish Congress describing a dangerous similarity between the attitudes that led to the persecution and slaughter of European Jewry and the worrisome rise of such beliefs in America. He was among a select number of prominent Jewish artists and intellectuals who were invited to a private dinner with Senator Carl Levin of Michigan, who, along with several of his colleagues, wanted to develop strategies to counteract what they saw as a dangerous trend. Steinberg was asked for

his support and gave it generously. Quietly and usually anonymously, he supported Jewish candidates for office, among them Elizabeth Holtzman, who was running for Congress. Without being asked, he donated another selection of drawings to the Israel Museum in Jerusalem, bringing his total to fourteen and complementing a large number of others given in his name by Sasha Schneider.

THE DISCOVERY OF AMERICA WAS THE MOST autobiographical of all Steinberg's books, and by his own admission an "uneven book." In a sense, he had three identities competing for primacy during the several years he made the drawings and wrestled with the selections, and he was aware of it. There was the Romanian boy who was ashamed of his birth country, the young man who became a stateless Jew when the Italy he had embraced rejected him, and the cultural American who loved his adopted country even as he cast a cold eye on every single one of its faults and foibles and revealed them for everyone to see. By the time he collected all the drawings and photocopies he wanted to use, he put them into one large folder with the new title he had decided on: "America's Book." A little later he changed it to its final, more autobiographical title, one that reflected his personal discovery of his homeland.

When the book appeared, the first thing most reviewers noticed was how Steinberg's vision of America had become "tougher, grittier, darker." He still portrayed America with a sense of humor, but more often than not, it was through drawings that "make you suck in your breath sharply rather than let it out with a laugh." The reviews were generally positive, and one of the most perceptive was by Red Grooms in the *New York Times Book Review*. It was a review written by an insider, someone who knew that the artist's life story was only slightly hidden within the pictures. Grooms had been a friend and observer of Steinberg's life since the long-ago summer in Provincetown when he and his then wife, Mimi Gross, took Sigrid in to help her deal with the first breakup. Grooms recognized that Steinberg's first book in fourteen years required the viewer to look at the work as an expression of his life, "a kind of autobiography that leaves the reader intrigued and searching . . . a kind of running commentary by the artist on his art and us."

Grooms worked his way through the litany of Steinbergian icons, warning that even though the drawings were all designed to produce a smile at first glance, the viewer should be prepared to confront the "anger" that lay within them. Like Picasso in his later career, Grooms thought, Steinberg created "many monsters." He wrote of the rage that lay behind the initial wit in Steinberg's drawings of women; he appraised the depiction of American architecture as a "great comedy" that exposed all its pretentious imitations of

past styles and motifs; he observed quietly how, in contrast to the buildings, Steinberg's portraits of people dissolved into "indistinct things, jots in a whole landscape." He called Steinberg "the smartest person around in art," who with this book had become "a great visual artist almost in spite of his analytical intelligence." For Grooms, Steinberg was "in a sense like a superb writer; he can sit down in front of a clean sheet of paper and go absolutely anywhere he chooses to—and take us along with him."

This was how Steinberg wanted his work to be judged, and he certainly would have appreciated it if he had been in a better frame of mind. Another critic who appraised these drawings when they appeared in the Pace exhibition that was concurrent with the book's publication unknowingly interpreted Steinberg's vision in art in a way that could have explained his attitude toward life: "However playful, clever, and funny the pieces of Steinberg's puzzle are, he has a morbid, existential, peculiarly tragic vision of America."

IF THE GENERAL RECEPTION OF THE book cheered Steinberg out of his melancholy, it did not last long. Sales were (with the most positive spin) tepid at best: 7,360 copies were sold, and the book was soon remaindered. Although the art critic Arthur Danto's introduction was praised by all who read it, Steinberg was close-lipped and noncommittal when asked what he thought of it, so if he had objections, he kept them to himself. He was famed for writing letters of complaint to his editors and publishers about every aspect of a book's production and final appearance, starting with Cass Canfield; continuing through Christopher Sinclair Stevenson at his British publisher, Hamish Hamilton; the soothing and patient Elizabeth Sifton, who was famed for her ability to calm emotional writers; and Peter Andersen, who kept him calm at Knopf. In the aftermath of the publication of *The Discovery of America*, Steinberg was dissatisfied with everyone and everything, and he wanted to make a change—any change. Since he could not change his landlord (as he did in his student days in Milan), he changed his agent. Wendy Weil had represented him since 1967–68, but in 1992 he allowed Sandy Frazier and Arne Glimcher to persuade him to leave her for Andrew Wylie.

Weil was clearly hurt by Steinberg's decision, which he delivered as a fiat in a short phone conversation. She summed it up almost two decades later as Steinberg's "way of going always to the ones who were eager to bring in the money. He had a way of going to more and more competitive representation."

STEINBERG SAID HE STOPPED TRYING TO write a diary because doing it made him get used to being happy and he didn't like the feeling. He preferred

to complain about "real sorrows and some imaginary ones," listing a few but not specifying which was which. He was becoming even more "cantankerous (*bisbetico*, the dictionary says)." The voices he overheard grated, and he hated "gabbing people, the type who use *you know* or *sort of*." He could not stand the smell of perfume, so he went out of his way to avoid elevators and would not take buses. Not until the dreaded Christmas holidays were upon him and he was alone in Springs did he admit the real reason behind his "kvetching" (a Yiddish word he much admired but seldom, if ever, used in writing or in public): "Every now and then I'm afraid of finding myself alone, without any real family, my friendships distant or neglected or purely social."

A friendship that developed slowly but became important in his final years was with Prudence Crowther, whom he first met in 1984 when she contacted him about the collection of S. J. Perelman's letters that she was preparing for the Viking Press. She wanted to know if it was true that Perelman had been so touched by Steinberg's gift of a large collage that in exchange he had given Steinberg his copy of the first edition of the book that was "his bible, *Ulysses*," knowing that it was Steinberg's favorite novel as well. Steinberg told her the story was true and invited her to dinner. It was pleasant to find someone who had been close to his beloved old friend Sid and who could join him in recalling his wit and his skewed and quirky insights into the world he wrote about. Steinberg remembered how reading Perelman's stories in *The New Yorker* when he was a newly arrived immigrant provided "an invaluable shortcut to the clichés of American culture." When Prudence began to send Saul clippings from newspapers and magazines, he learned that she shared his and Sid's predilection for news of the offbeat, the weird, and the silly, and it cheered him to read the comments she made on the small notes or Post-its that she sent with them.

Saul discovered that he was comfortable in Prudence's company, and he enjoyed her friendship so much that once he had made the ritual (and almost desultory) pass and been gently rebuffed, he was content to let her become a boon companion and caregiver, but he no longer felt the need to seduce her. They saw each other sporadically until the mid-1990s, sometimes only several times in a single year. When he began to see her more frequently, he told Aldo that he was surprised by the realization that she was the "only" female friend with whom he had not had a sexual involvement, which was a demonstration of his "evolution." It followed naturally that he would want to introduce her to Hedda.

Prudence believed that what Saul especially liked about her was how completely separate she was from the small circle of people he considered his close friends, but the most important quality she represented for him was that he

saw in her someone in whom he could confide other than Hedda. He could tell Hedda anything and he did, but there were times when her unremitting honesty was not what he wanted to hear. Prudence was nonjudgmental and seemed to be able to cope with whatever came her way, but he was careful about what he confided to her. Increasingly he needed a buffer of protection and comfort, and that is what she provided. He wanted to share his new friend with Hedda, but also he wanted (perhaps unconsciously) for Prudence to learn about him through someone else's perspective, without his having to tell her directly about his personal life.

At their first or second meeting, Saul told Prudence that Sigrid was his "well—[pause]—fiancée." She remembered it as his "attempt to find a gracious way to acknowledge the attachment . . . without getting into a complicated story he saw no need to narrate." When she and Hedda became friends, she often learned more about Sigrid from Hedda than she did from Saul, for "he trusted Hedda to explain the sentimental arrangement of his life in a way that was fair to all of them, and if it wasn't, well, he accepted that possibility, too. Hedda was entitled to her judgments."

Saul attempted to work out what he felt for Prudence in a conversation with Hedda when he sat in her kitchen on a summer Sunday afternoon. He began by trying to explain the general "remorse" that gripped him, telling Hedda that it was a "constant thing in my relationship with P" and it stemmed from "the old remorse-revenge thing" that colored so many decisions he made within his other personal relationships. He wrote in the diary that being with Prudence offered a chance to make "a change, a real change in my life that implies many other changes: honesty, sobriety, and prudence," using the lowercase letter to indicate the trait and not the person. After that, he wrote two words he did not explain further: "Work. love?"

The conversation with Hedda that began about Prudence moved naturally to Sigrid, and although they seldom talked about her except for generalities about her health or activities, Saul launched into details of their recent disagreements. This led Hedda to chastise him for a litany of accusations about who was the guilty party in their ongoing "war." As soon as she began, he realized that opening up to her was "a mistake: facts become gossip. Everybody, victim & judge show the worst of themselves. Hedda contaminated becomes petty." He felt "stupid, ugly, etc." and left as soon as he could get away.

STEINBERG WAS ALWAYS PROUD OF HIS membership in the American Institute of Arts and Letters ("only 200 members," he told Aldo), but he was inordinately proud when he was inducted into the smaller, elite American Academy,

boasting that he was now one of "the crème de la crème, numbering only 45." Being elected to the seat held by the late Isaac Bashevis Singer filled him with "surprising, unexpected, and innocent enough pleasure," but he still managed to put a morbid twist onto the "affection" the members showed by his election, claiming that nowadays "fear" was the only emotion he routinely inspired.

Another mixed pleasure came when his first cover in five years appeared on *The New Yorker* on January 13, 1992, "to universal surprise and astonishment." It showed a woman standing on a pedestal holding a violin aloft in one hand and a bow in the other, her wrists shackled with handcuffs from which broken chains dangled. It was one of the drawings he had made some time before and was followed by three more covers that year, all gleaned from the files, all fairly calm and traditional, in the Steinberg style that readers had come to expect. When Tina Brown replaced Robert Gottlieb as editor and appointed Françoise Mouly as art director, the covers took on the edginess and buzz that characterized Brown's tenure at the magazine. She selected one drawing for a cover in 1993, of a woman's face as a high-heeled shoe, that would qualify neatly to slot Steinberg into an affinity with Picasso's late "monsters." When he succumbed to Brown's peace entreaties, three more covers followed in 1994. After that, whenever he felt he had something for the magazine, he either submitted new material or pulled old drawings from his files, but by then everything had become (again in Grooms's description) "tougher, grittier, and darker" on its own, without Brown's prompting.

Tina Brown was so intent on having Steinberg's art appear within the pages of the magazine that she put Mouly in "personal charge" of him, warning that he could be "heavy furniture." Brown, whose reputation was for brash and cocky self-assurance, took care to write Steinberg a personal letter explaining how she made editorial decisions and what she intended for the magazine to become under her leadership. She told him that she was well aware of the universally negative chatter about her, but what would sadden her most about "such absurd one-dimensional publicity" was if Steinberg were to let it convince him that all her choices were "suspect and exploitative." She hoped to persuade him that when she expressed enthusiasm for his work, she was being sincere: "I want to put something on the cover because I love it, not because I am obsessed with sensation." She hoped that over time he would believe that whenever she expressed approbation for his work, it was not an "irretrievable black mark" but rather sheer appreciation.

Steinberg never changed his initial negative attitude toward Brown, that her emphasis was on "buzz" rather than thoughtful commentary, perhaps because he had been so close to Shawn and so respectful of the way he had

run the magazine. Steinberg had a good relationship with Mouly, and as his love-hate relationship with the magazine continued, she became an acceptable stand-in for his earlier rapport with Carmine Peppe, Jim Geraghty, Shawn, and even Ross. When he had drawings he wanted to submit, he would invite Mouly to his apartment for long afternoon sessions of drinking espresso and slowly examining them one by one, all the while watching her face to gauge her response. As their formal and polite friendship developed, he counted Mouly as the one constant entity in his professional contact with a magazine that he thought had degenerated into a frenzied glorification of celebrities and glitz. Steinberg still had a few old friends on the staff with whom he socialized, among them Roger Angell and Brendan Gill, and also Joseph Mitchell, whom he never saw because he never set foot on the magazine's premises and Mitchell never left his office.

After Brown persuaded Steinberg to submit new work to *The New Yorker*, he wrote to Shawn to tell him he had done so. Shawn did not reply to his letter, so Steinberg reached out again when *The Discovery of America* was published by sending him a signed copy. Shawn did reply then, saying, "Whenever and wherever your work appears, all of us have reason to be grateful . . . I cherish your work whenever and wherever I find it." His letter was mistakenly dated December 8, 1992, the day he died of a heart attack, but he had written it earlier, because Steinberg received it on December 5. Steinberg thought of it as a "merciful" letter of farewell that forgave him for the "hurt" Shawn must have harbored, even though the four covers were file drawings and Steinberg had not submitted anything new since Shawn had been fired.

WITH SHAWN'S DEATH, THE OLD DAYS were well and truly gone, another indication that the world Steinberg knew was so changed that he was hard-pressed to find a place in it. In an attempt to raise his spirits, he set mental exercises to force himself to recall when he had been truly happy, and he concluded that the last time was June 15, 1960, when he had moved to Washington Square Village. He had to stop playing this mental game, because thinking about his first years with Sigrid made him sad to remember how long it had been since he had felt that "everything was possible."

Much of his unhappiness was caused by anxiety over Sigrid's escalating erratic behavior. He always used the term *remorse* to describe his responses to it, and frequently he assessed the range of emotions that gripped him when she was in one of her frightening downward spirals by making lists of them. Some months earlier, after she had read Kate Millett's *The Loony-Bin Trip*, she recorded her thoughts in one of the diaries she left behind in Springs so

he would be sure to find and read it. Sigrid wrote of how Millett described "the awful helplessness of the ill person, not only in relation to what the world may do to her but what her own mind may do to her." Then she wrote: "—if I let it." Saul blamed himself for always giving in to Sigrid and letting her get her way through a kind of emotional blackmail, to which he always responded with "the same mistake." In this case, it was giving in to her insistence that she should be allowed to come to Springs while he was there. During a long night of sitting in the lotus position, he listed what had become a ritualistic litany of his assessment of her mental instability and how he always dealt with it: "Postpone, delay, cover up, ignore, deny."

She arrived by bus on Monday afternoon, June 10, and by evening he had consumed more white wine than he had drunk in a very long time. He was so alarmed by her condition that he invented excuses to be away from the house each day she was there, even something so uncharacteristic as "walking for two hours in foolish shops" on the streets of East Hampton to kill time after his car had been serviced. When he was in the house, things were so tense between them that when it was time for her to leave, on June 16, he took her to the Hampton Jitney even though he knew he would be driving into the city the next day for more of his ongoing dental surgery. While he was there, she went back to Springs to stay alone, and on June 27 managed somehow to get herself to the Southampton Hospital emergency room, where she asked to see a psychiatrist who could help her cope with "acute depression." She did not tell the physicians there that she was under the care of Dr. Armin Wanner in New York and left the hospital, apparently with a new prescription, to return to the house in Springs.

By July 5, Saul was back in the country and planning to spend the rest of the summer recuperating from several tooth extractions, which were followed by the first stages of implants. Sigrid was still there too, keeping to her quarters on the second floor, occasionally walking down to her "little house" studio, but mostly just sitting quietly outside in the sun. On July 13, when she felt so tormented that she thought she could not go on living, she went to her bedroom, swallowed a bottle of sedatives, smoked what she thought would be her last cigarette, and fell asleep. When she woke up, she was once again in Southampton Hospital, this time having her stomach pumped.

AFFIRMATION OF THINGS AS THEY ARE

*Something else, too, came to me from my illness. I might formu-
late it as an affirmation of things as they are: an unconditional
"yes" to that which is, without subjective protests—acceptance
of the conditions of existence as I see them and understand them,
acceptance of my own nature, as I happen to be.*

Steinberg found Sigrid in the upstairs hallway on the night of July 13,
1992. The sedatives she had taken put her into a restless sleep and
she awakened in the haze of a nightmare, confused by loud sounds of
banging, clanging, and smashing, all coming from the kitchen below
her bedroom. Dreaming that she was a child in wartime Trier, she stumbled
into the hallway to call for her father to end the noise and come to comfort her.
When she tried to turn on the light, her fingernail caught in the switch and she
called out in pain for her papa. The pain became so severe that it shocked her
into momentary consciousness and she realized where she was and cried out
for Saul. The next thing she remembered was "waking with his name in my
mouth."

At first he thought she was merely high on drugs and booze, but then he
took her back to her bedroom and saw the suicide note propped on the bed-
side table. In it, she asked him to forgive her "for doing this awful thing to you
(and to myself). I can't go on." Sigrid's note explained that she had taken the
overdose in the house because it was the only place she felt safe and she did
not want to die in New York City. She implored him not to blame himself, for
everything was all her fault, and without him she would have "perished long
ago. Though you don't believe me, I loved you more than you know. Now I just
want to sleep. It's too late." Her last sentences conveyed both astonishment
and relief: "I finally did it. I can't believe it."

An ambulance took her to Southampton Hospital, where her stomach was
pumped and she was kept under constant watch. Steinberg called her New
York physicians, the psychopharmacologist Dr. Arnold Rosen and the Jungian

psychotherapist Dr. Armin Wanner. There was some discussion about transferring her to a New York facility, but when the Southampton doctors determined that she was unlikely to make another attempt, everyone agreed she should stay there. "It's rather nice and beats the Hamptons parties," she wrote to Steinberg on July 17, even though a psychiatric ward was "a strange place to be on Quatorze Juillet." She told him she could go on and on describing the "fascinating patients," but she wouldn't because he would probably think she was "insane."

Several days later she was discharged into Steinberg's care and allowed to return to Springs until she was well enough to travel to the city. He did not want to send her off to be alone in her apartment and invited her to stay in the house, mainly so he could keep alert for further signs of trouble. She declined his offer because she was practically frantic about the need to see Dr. Wanner, whom she wanted to appoint as her proxy for health care. Once back in the city, she and the doctor signed a living will wherein he agreed to honor her wishes to have a "DNR: do not resuscitate." She settled into her apartment and resumed her therapy sessions with intensity, at first three to five times weekly, then gradually weaning herself to once, sometimes twice. Wanner told Sigrid that she must not discuss her treatment with anyone, particularly Saul. This worried Evelyn Hofer enough to tell him of her concern.

Hofer had been Wanner's patient, and she had recommended him to Sigrid shortly before she ended her own treatment. She told Steinberg that she feared Wanner was isolating Sigrid from the people who loved and wanted to help her, since he had also ordered her not to see Hofer and the several friends who lived in her apartment building and who routinely checked to see if she was all right. Wanner insisted that his request was merely part of the normal confidentiality between doctor and patient, but Hofer called it unnecessary isolation and "secrecy." She said that as Sigrid would no longer see or speak to her, it was up to Steinberg to do something. As Sigrid obeyed Wanner completely, all Steinberg could do was to support her treatment by paying her bills.

Now more than ever he was engulfed in all sorts of variations on his usual "remorse," particularly his knee-jerk responses of "delay, cover up, ignore, deny," which he had been invoking for the better part of the past year. To them he added unfocused anxiety and a great deal of fear and worry over what Sigrid might do next. In April, several months before the July suicide attempt, she had sent him a copy of a letter she had written to Arne Glimcher six years earlier when she gave him one of Steinberg's drawings to sell, one of the most meaningful gifts he had ever given her, which she sold to spite him. In the letter, she told Glimcher not to fear that she would make a public scene about her

dissatisfaction with the price he obtained, because there was nothing she could do about it. Then she changed the subject and drifted off into talking about Africa, warning him that Africans have a saying, "Elephants and women never forget." Telling him that in Africa time and money do not have the same fixed meaning as in Western societies and that unresolved issues do not go away, she launched into what had been festering within her for years, her perception that Glimcher had such disregard for her that he ignored her completely and was unaware that she even existed. She was only writing to remind him that she did exist, and that he would never hear from her again. The letter was typed to this point, but she ended with a handwritten scrawl: "I had lots of fun writing this letter—I seem to enjoy writing crank letters."

She also enjoyed writing unsettling messages on the white fluted paper plates, such as the one she left lying on the kitchen table shortly after she sent Saul the copy of her letter to Glimcher. On it she wrote three words: "Reproche [sic], Remove, Revenge." A great deal of the last sentiment colored her behavior in the months leading up to the suicide attempt. She felt that she had been deeply hurt, snubbed, and humiliated by many of Saul's friends, and she wanted them, but especially him, to feel some of this same pain. He was shocked and in despair when she took a Giacometti drawing he had given her to Christie's and sold it for $70,000. It had been a gift to him from the artist, his dear friend, and he had given it to Sigrid because he was reluctant to express deep emotion openly and wanted to show that he loved her without having to put it into words, and he wanted her to have something he truly loved. Her share of the sale was $64,100, but such a large check did not stop her from inflicting more pain. She sent him color photocopies of two more of his drawings she had just sold, along with a note saying that as her demands were increasing, she should probably sign her name to this letter as James Joyce's spendthrift wife, Nora Barnacle, who, no matter how much she had, always wanted something more.

Sigrid blamed Saul for not using his influence to help her in the art world, and she was always frustrated by her inability to earn money, so she added up her total income for the year and left it where he could find it: "From Steinberg: $30,000, bank interest $873.68. That's all." Then she listed her medical expenses, a grand total of $30,279.17. She had Blue Cross insurance, which paid for $22,718.33, leaving her to find the remaining $7,520.84. Without comment or criticism, he paid, as he always did. Then she made another list, of all the things she had bought during her "depression and recent hypo/manic episode," a spending spree of $14,300 charged to credit cards issued in the name of "Mrs. Steinberg" and billed directly to him. She had charged new linoleum

in her apartment and payment to the carpenter who put it down, a wheel-chair that she needed after her back surgery, mirrors, other decorative objects, and—ominously—a coffin. Saul paid those bills too, without comment, and that made her even angrier, because he responded to everything with perfect equanimity and she could not provoke a rise.

In truth, he was so frightened that his own health was affected. He told Aldo that her suicide attempt had raised such powerful emotions within him that he "reflected the entire drama like a mirror." He thought he was having a stroke and rushed to Dr. Morton Fisch, his trusted internist of more than twenty-years, for tests. Dr. Fisch told him that people don't die of "powerful emotions." Often they died of blocked arteries, but Steinberg's were clear, his pulse was strong, and he was in excellent health everywhere but his teeth. He accepted that "nobody dies of heartbreack [sic]. They have a sick heart waiting for a strong emotion."

Still, he could not stop worrying, because Sigrid continued her ominous brooding. She became obsessive about collecting obituaries of people who committed suicide and articles that gave all the gory details of how they had done it, or of people whose lives ended at fifty-eight, the same age she was. On a photo of the novelist Sigrid Undset, she wrote that Undset was fifty-eight when she died, and next to it she added, "I am the same age as Lincoln when he died."

She continued to see Dr. Wanner, who was most likely responsible for her sudden intensive study of Jung's writings, which she also left lying about where Saul could find them. She photocopied many pages from Jung's letters, includ-ing one in which he counseled an anonymous patient whose life was made mis-erable by depression. Jung's advice for the letter writer was to seek one or two persons whom she could count on, to raise animals and plants and find joy in caring for them, to surround herself with beauty, and to eat and drink well. In summation, Jung advised "no half-measures or half-heartedness" in confront-ing depression head-on. The letter was important to Sigrid, for she followed every bit of Jung's advice, and by December she was euphoric.

Saul was in the city and she was alone in Springs on the six-month anniver-sary of the suicide attempt. She wrote a letter to tell him "how extraordinary" it was in the depths and darkness of winter to feel "wonderfully happy" with "blissful moments, just being alive." She wondered if her well-being was due to the heavy medication prescribed by Dr. Rosen, and she asked him whether her depression was "a biochemical deficiency . . . like diabetes" that could be controlled by treatment. Dr. Rosen told her that she should face reality and prepare herself to revert at some point "to being like before." She was not

ready to accept this verdict, because the medications were working so well and seemed to have no side effects. She did not feel "medicated" or anything other than "normal," and the inference in her letter was that she would accept her "problem" and then hope for the best. She just wanted Saul to know how "glad and grateful" she was to be alive, and to thank him for saving her.

Sigrid wrote about her feelings in one of the notebook jottings she made from time to time, this one perhaps for Wanner, perhaps for her own understanding of her fluctuating moods. "Everything is going so well it is almost frightening," she wrote, adding somewhat defensively that feeling good was her long-overdue reward for having "fought for it through superhuman efforts to do it all." Nevertheless, she was frightened that she "might not have the faith to enjoy it all."

As Dr. Rosen had predicted, the euphoria gave way to unfocused anxiety. As the winter ended, so too did her well-being. She sent another worrisome signal when she clipped a newspaper letter to the editor written by a Harvard professor who was commenting on the brightness of some of Mark Rothko's last paintings; Sigrid underlined the passage "beware . . . of depressed people who [appear to] recover suddenly . . . and who assume a calm and settled purposefulness. Not a few have decided to die." Next to it she attached an article about Cézanne in Aix, again underlining a passage: "For me, what is there left to do . . . only to sing small."

STEINBERG REMAINED "CONSTANTLY WORRIED" ABOUT SIGRID, which impelled him to try to fathom what she was thinking in an effort to help her stave off another depression. Even though she kept insisting that she was so much better, he could not accept it, because when she was with him she was "removed from life," remote, uncommunicative, and lost in thought. He saw the books she left lying around, deliberately placed where he could find them, especially Jung's autobiography, *Memories, Dreams, Reflections*. He decided to read them all, even though he disdained psychotherapy for himself and now, because of his concern about Wanner's therapeutic methods, for her as well. As Steinberg read Jung's life story, the pages that resonated most were those where he wrote of himself in old age as he was recovering from a serious accident.

In one of their earlier conversations, Evelyn Hofer had tried to explain Jung's theory of individuation, but she did not express herself clearly and Steinberg wasn't interested enough to ask her to explain further. He did not understand what she was trying to tell him until he read the several pages of Jung's autobiography where he described how he had slipped on the ice and fallen,

been hospitalized with a broken leg, and then been beset by a life-threatening illness. When he recovered, he began his most "fruitful period of work" and wondered what had happened to provoke such a torrent of writing. He concluded that he was somehow responsible for the accident, and in its aftermath he had had to recognize himself for what he was—"my own nature, as I happen to be." Jung had to accept that he was fallible, could make mistakes, and when certain things were beyond his control, he could not control the outcome. What he learned was that an individual could control one thing only: to "forge an ego that does not break down when incomprehensive things happen, an ego that endures, that endures the truth, and that is capable of coping with the world and with fate." Reading Jung's text provided Steinberg with relief and absolution: he wanted to believe that he had done everything in his power to ensure Sigrid's mental health and stability; he needed to believe that he was not responsible for her behavior, and that her inner conflicts were far beyond his control.

Jung never became one of the philosophers Steinberg quoted, nor did he discuss Jung's writings with Hedda Sterne, who shared his disdain for most psychoanalytic theory, or with Aldo Buzzi, the faithful sounding board who always responded to everything Steinberg told him with insight and understanding. These several pages of Jung's were the only ones that resonated deeply enough for Steinberg to photocopy and highlight, and to place in a folder where he could easily find and reread them. Through Jung, Steinberg learned that "one does not meddle inquisitively with the workings of fate," but it was not something he accepted easily, if at all.

STEINBERG WAS STILL COMPLAINING ABOUT HOW *The New Yorker* had changed and railing against what he thought it had become: flashy, trendy, and dedicated solely to making money. And yet he could not let it go: "I can't. It's my magazine. I played a major role in creating it." He was glad Shawn was not alive to see what it had become. He clipped articles that criticized Tina Brown's stewardship and highlighted the parts with which he agreed, as he did with the writer Jack Miles's "endpaper" in the *Los Angeles Times*. Miles wrote that the magazine had stopped being a "calm" publication that reflected and shaped "a broadly American and democratic culture" and had become "increasingly anxious . . . buying and selling the buzz." Steinberg put this piece into his "America's Book" file, along with a host of other articles that responded to the *New York Times* columnist Bob Herbert's frequent use of the phrase "the dumbing down of America." Just as bad as its dumbing down was the magazine's new "shoddy" design, and on the rare occasion when it contained

an article Steinberg thought lived up to its past standards, he called it "fine wine in an ugly filthy glass."

His irritation with *The New Yorker* and his general malaise were symptoms of his usual wintertime blues, always compounded by the barren and dismal countryside. He felt isolated when bad weather confined him to the house, but because of what he now referred to as "the incident of last year," he did not like to be there at all. He was uneasy in the country, so he passed most of each day working lackadaisically in the studio for the mere experience of doing something rather than doing it for satisfaction, let alone pleasure. Instead of creating new work, he drew portraits of friends and people he knew, either from life or from photographs. He drew his old friend Joseph Mitchell because "he's one of those people who already looks like he was drawn by me," and he drew quite a few of a casual friend to whom he had recently become close, the poet Charles Simic. He felt an affinity with Simic, a Serb who came to America as a teenager and, like Steinberg, "remembers everything about the earlier days."

Steinberg was musing on the concept of fame as he made the portraits or the book-shaped blocks of wood that became a deliberately unreadable library when he drew only the authors' names without any of their titles. The wooden books constituted a game similar to one he liked to play when he made portraits, drawing some as caricatures and making others in the style or manner of different schools of drawing. Playing with portraits and blocks of wood were two diversions from the nagging fear that most of the other work he was doing was disappointing and of doubtful value.

IN THE CITY THERE WAS A GREAT DEAL of the kind of entertaining he detested even though he went anyway, of visiting Europeans who were given large parties where recognizable American faces and names assembled to greet them. There were intimate expensive lunches and dinners at which he was the honored guest of those who wanted to use his art in some way and who thought wooing him with rich food and fine wine was the trick to persuade him to give them what they wanted. It was too much for Steinberg's almost eighty-year-old digestion when Stefano, the "young and well-nourished son" of Umberto Eco, took him to such a lunch to persuade him to prepare a book of drawings about Italy. At first Steinberg equivocated, but as soon as he found out that Eco and his colleague, the poet Luigi Ballerini, wanted to "resuscitate" some of his *Bertoldo* and *Settebello* drawings, he ended the discussion and strictly forbade them to reprint anything connected to those years. Some weeks later he was invited to an elegant supper party for Umberto Eco "at the home of his publisher, many famous people." It was a "horrible" evening,

where so much "fame" struck Steinberg as "nothing but the maintenance and administration of a publicity campaign no different from commerce." He liked Eco's wife, but as for Eco, "that big beast of a husband knows everything about the art of celebrity."

Eco's American editor was Drenka Willen, a Serbian like Simic, whose work she also edited. Steinberg had known Willen since he met her at Dorothy Norman's in East Hampton in the early 1980s, and he liked to talk to her, because she edited distinguished European authors (Italo Calvino and Günther Grass, among many others) and routinely sent him copies of their books. She introduced him to Simic, and when Simic asked him for drawings to illustrate one of his books, Willen tried to pay the usual fees. Steinberg would not hear of it: they were all friends, and this was an act of friendship. He got into the habit of enjoying casual suppers at Willen's Greenwich Village home, and when the Simics were in town, he invited her and them to his favorite neighborhood Turkish restaurant.

Other supper parties that he did enjoy were given by Shirley Hazzard and Francis Steegmuller. They invited small groups of cultured and intelligent people to gather in their perfectly appointed dining room, to eat exquisite meals appropriate for elderly digestions, and to talk about literature, particularly

Steinberg, Priscilla Morgan, Peter Duchin, and Joan Mondale at the opening of the Isamu Noguchi Museum.

Steegmuller's new translation of the Flaubert–George Sand correspondence. Reading the book was one of the few experiences Steinberg enjoyed in that long and grim winter of 1993. He especially liked the way Steegmuller retained French phrases and expressions without translating them, thus ensuring that the book would remain "a cult item" that did not pander to "dumbing down" in English. One year later he had to write a condolence letter to Shirley Hazzard, telling her of his "loyal love for the man whose work gives me courage and normality" and of his admiration for Steegmuller's "lack of interest in that debilitating passion, the maintenance and propagation of fame."

As the dreadful winter dragged on and spring seemed unlikely to come, Steinberg decided to try "an experiment." He wanted to do something he had never done—to give a dinner party—and he asked his housekeeper, Josefine, to prepare her specialty, paella. He took such interest in the evening that he even shopped for "a couple of salads" and a "nice" cake. He planned to invite trusted friends, William Gaddis and Muriel Murphy, and "a civilized young woman named Prudence [Crowther]." Gathering them at his table, he knew that he could count on an evening of good conversation without the background noise that made dining in restaurants unpleasant for elderly gentlemen such as Gaddis, who had trouble hearing. The evening was indeed a great success, but Steinberg never repeated the "experiment."

He read a great deal that winter, most of it English fiction, reveling in the discovery of Henry Green, whose elliptical one-word-title novels were full of "hidden surprises." It made him go back to and finally finish Gaddis's *JR*, because he thought Gaddis was of "the same family" as Green. Someone sent him a copy of Joseph Brodsky's *Watermarks*, but he declined to read it because the critics lavished so much praise on it, and critical praise always made him "suspicious." Evelyn Waugh was "a discovery" that surprised him. Another author who made him reach out in search of friendship was Alice Munro, whose stories he first read in *The New Yorker*. For the next several years, Steinberg sent Munro drawings, wood carvings, and other small tokens of his work to accompany his letters of praise; she replied to all of them with reserved pleasure and an air of slight surprise at being so singled out by an artist with such literary discernment.

Brian Boyd's biography of Steinberg's friend Vladimir Nabokov gave him hours of pleasure, even though each tome of the two volumes was so heavy he could not hold it to read in bed. He dipped into the biography off and on for well over a year, a bit miffed that he was mentioned only once, when Nabokov wrote to a friend that he had just had a "marvelous visit with the marvelous Steinberg." He wondered how Boyd could have overlooked Nabokov's state-

ment in the introduction to his novel *Bend Sinister* that Steinberg was the artist and "rivermaid's father" who drew "the urchins in the yard" in chapter 7, or how he could have missed Nabokov's in-joke when he added that "the other rivermaid's father" was James Joyce. However, his main reason for rereading the biography was that he found so many correspondences in their lives: Nabokov had suffered from troubles with his teeth and had also consulted a long list of physicians who treated his various ailments, and he too had had ongoing "struggles with editors, publishers, lawyers, biographers, relatives." Steinberg was amazed at Nabokov's productivity and saw himself in comparison as "extremely lazy, my biggest flaw." It was probably the most inaccurate self-appraisal he ever made.

AS SPRING 1993 APPROACHED, THE URGE to travel returned. Dr. Fisch told Steinberg that hypochondria was what kept physicians in business, but Steinberg was still convinced that he had all sorts of genuine maladies and made a reservation to go to the Überlingen spa in April for his usual cleansing and purifying rituals. This time, however, he wanted to be somewhere warm and sunny, so he went to the branch clinic in Marbella, Spain, instead of the main facility in Switzerland.

He flew to Paris first, staying in the high-rise PLM–St. Jacques Hotel, where he could see much of the city from his room on the fifteenth floor. He did not tell anyone he was there and walked familiar streets "blessed with invisibility . . . avoiding the damn sycophants." He went to Cachan to visit his niece, Dana, who was living with her husband and children in the house he had bought for his sister many years before. The next day he and Dana rambled around Paris like two sightseers, and when they got to the Place des Vosges, Steinberg felt the urge to visit Victor Hugo's house. At the ticket window he asked for a ticket for an *ancien combatant* (senior citizen), and the attendant demanded to know his age. When Steinberg told him *quatre-vingt* (eighty), the man was so surprised that he told the two of them to go in for free. It was a nice boost, since Steinberg was leaving the next day for the clinic and in anticipation had begun to feel as old and crotchety as someone twice his real age.

The stay at the Marbella clinic was not the pleasant experience he had hoped for but one he summed up as "the rich live badly and pay through the nose." The beach was "miserable black slime," so he spent most of his time in his room, making notes about the fasts he endured, the people he met, and his ruminations on all sorts of things that struck his fancy. Throughout the notes there were tinges of the depression he had gone to the clinic to avoid. Harking back to 1924, the watershed year when he was ten and began to realize the

awful reality of daily life for a Jew in Bucharest, he searched for a good memory to dispel the black mood that such reveries induced. He remembered that his first responses to art were emotional, and whenever he looked at colors, read a book, or went to the movies, he equated everything with "sadness." As an afterthought, he added that "maybe all emotions" were connected to sadness. He made several charts, one of the births and deaths of "great people" and their ages when they died and another that he called "biography" for some of them: Corot was "tall," Delacroix was "the illegitimate son of Tallyrand," Ingres was "a Chinese in Athens," and the British historian Peter Green was an "Aristotle who looked like the young Disraeli." For each he gave height, weight, and "head and foot size." He also made lists, such as the one for "simple and strong words (composite)," which featured (in his orthography) "icebox, jukebox, shithouse, badass, kneehigh, lardass, junkyard."

IT WAS A RELIEF TO GO HOME and find that Sigrid's condition had not worsened. He knew that he would have to face further drastic situations, but for the time being he could avoid them. He rejoiced in his own good health and "the companionship with one's selves that is essential, the ancient friendship with one's memory, senses, and instincts." His birthday was always a movable celebration, and that year he chose June 28 instead of June 14 or 15. Hedda sent a note asking him please to advise her on what day she should extend congratulations, and what about Joyce's "Bloomsday," June 16—had he given it up, or did he still celebrate that date as well?

The summer in the country was "paradise" until late August, when Hedda, aged eighty-four, fell in her house and broke her hip. As her husband, Saul was the first person the hospital notified, and he rushed to the city to take charge of everything. Hedda was both grateful and amused when he arrived at the hospital "so worried and caring that all the nurses thought he was the ideal husband. It was the first and last time he behaved like that." He was proud of himself as he organized her hospital stay with daily visits and a retinue of private nurses, whose chief responsibility was to keep the rubbernecking friends at bay—from him as well as from Hedda. When it was over, he complained that all this unusual activity left him bored and exhausted. He told Hedda that it was lucky that they had money "and the other important thing, friendship and love." Once he was certain that she would be properly cared for at home with round-the-clock nursing, physical therapy, and her books and other diversions, he went back to Springs. They resumed their daily telephone conversations, but this time "with added intensity," because Hedda, "who used to be the mama, now becomes the daughter, too."

———

STEINBERG MADE CERTAIN TO LEAVE TIME to be with Sigrid, and in February 1994 they went back to St. Bart's, where they had always been happy together. He noted how well she seemed when she had tasks to perform that kept her from brooding about herself, and as she always coped well with administrative details, he put her in charge of making travel arrangements and supervising their activities once they arrived. As her usefulness made her feel confident and secure, he relaxed and enjoyed the vacation. Afterward, he relived it in his mind. "My happy memory of St Barth remains and grows," he told Aldo.

In March and April there were two shows in New York, "Major Works" at the Adam Baumgold Gallery and "Saul Steinberg on Art" at Pace. Bernice Rose curated the Pace show, and Steinberg praised her for "understand[ing] drawing (a rarity because most curators devote themselves solely to painting and sculpture)." He had three covers on *The New Yorker* in 1994 and some drawings inside, and he selected a number of black-and-white drawings for his friends Barbara Epstein and Robert Silver to use in the *New York Review of Books*. For a time he thought he could re-create the relationship that he had had with *The New Yorker* with the *Review*, but although it was always cordial, it never matched the one he remembered with such fondness. He could not live without at least some connection with the magazine, so he grudgingly "made peace, more or less," and began to submit drawings with some regularity.

Always intrigued by imaginary maps, he had a new idea when he saw a zip code map of Manhattan and converted it to a map in which parts of the city corresponded to parts of Israel: Riverdale became the Golan Heights, the East Side was the West Bank, and all the territory below Houston Street was Gaza. The Bronx, Brooklyn, and Queens became Lebanon, Syria, Iraq, Jordan, and Saudi Arabia, while the northern tip of Staten Island became Egypt. "Of course Tina wants it for the noise," he wrote to Saul Bellow, "as the zip zones become symbols of the balkanization of everywhere." He sent a photocopy to Bellow with the instruction "SECRET EYES ONLY," asking for his judgment as "friend, artist, and rabbi." He was well aware of how many groups the map would offend, everyone from Jews to Arabs, African-Americans, Israelis, and residents of the boroughs, "and of course the selfrighteous [sic] and stupid." Hoping to mitigate at least part of the anticipated protest, he removed the two things he thought the most controversial: the Metropolitan Museum as Jerusalem and Zabar's as Tel Aviv. He told Bellow that making the map inspired him to create another one, of how Europe would probably appear in the year 3000, and he would send it as well. Bellow advised caution, which made Stein-

berg even more uncertain about publishing than he had been, and after protracted wavering by Brown, he withdrew both pieces. He had already been paid $10,000 for each one, and he sent both uncashed checks back to Françoise Mouly, asking her to "return to me all photocopies of the magazine—it may fall into the wrong hands."

STEINBERG HAD ANOTHER BOOK IN PROGRESS, one he was not at all sure about, but Aldo Buzzi wanted it to happen and so he agreed to consider it seriously. It had been germinating for the past two decades, mainly when he rented vacation houses in East Hampton for Aldo and Bianca. Aldo thought Steinberg's reveries about his life and work would make an interesting book, and so the two men spent long afternoons in 1974 and 1977 tape-recording his memories. They spoke originally in Italian and for many years dithered over a typescript and an English translation. Steinberg was reluctant because he thought the conversations too biographical and more revealing of himself than he wanted. Now that both men had achieved the venerable age of eighty, Aldo insisted that it was time to work seriously. To persuade Saul to do it, he said that it would be published first in Italy, where the likelihood that an American publisher would see it was slight, and the possibility that one would buy the rights and pay for a translation even slighter. Thus guaranteed a modicum of anonymity, Saul agreed to give it a try.

Steinberg called their collaboration "The Book of Saul," and as his memories resurfaced, he found many of them so upsetting that he cautioned Aldo that they might disturb him as well. His permanent memory of childhood was of being frightened because he was Jewish and then of being corrected and scolded by everyone in a place where "even dogs gazed at us reproachfully." When he escaped to Milan, his initially happy student days in the Via della Sila gave way to "a terror mixed with curiosity about the future." Most of all as he wrote his impressions of himself as a younger man, he thought about his family and mourned many aspects of their lives, particularly that of his father, in whom he discovered qualities he had not been mature enough to see at the time. Saul remembered how Moritz would concentrate his compete attention on an object or event and realized that this was indeed a rare quality, "a man in the act of thinking something through, stockpiling it, the beginning of art."

Steinberg and Buzzi talked about and sometimes reworked some of the material that became the book *Reflections and Shadows* whenever they were together, and Steinberg volunteered information for it whenever they were not, mostly in letters but sometimes in telephone conversations. For any number of reasons, but mostly because of Steinberg's unwillingness to present

himself so openly, the book that was begun in the 1970s was left hanging in 1994 after he "thought it over once more." When he read what was to be the final text of conversations that had happened twenty years before, his initial response was "with pleasure, with surprise," but when he cast his editorial eye on them, he did not think they withstood the test of time. He had no desire to reread any of it, and he doubted that others would want to read it even a first time. He decided that it was too much "a document of that era" and revealed a "primitive side" that made him uncomfortable. Reluctantly, Aldo withdrew it.

Reflections and Shadows was not published until 2001, after Steinberg's death and then only in Italy. In 2002 it appeared in an English translation, a charming little collection of vignettes in writing and drawing. When Aldo Buzzi edited it, he explained that his beloved friend had withheld it because he was "a man full of doubts" who might have felt that "as a writer he was not up to his own level as an artist, an artist who used to say that he was a writer who drew instead of writing."

STEINBERG WAS MORE AMAZED THAN CELEBRATORY when he wrote across a clean sheet of paper, "June 28, 1994: Today I'm 80!" Working on *Reflections and Shadows,* coupled with his increasing concern about Sigrid, made him aware that time was passing and he had not done all that he should to prepare his estate for his eventual demise. She was in one of her hyper periods, on medications she liked because they kept her from being depressed. She chastised Saul for being fearful rather than grateful and for making a deal with her to "keep quiet or go talk to the cat or my chickens."

Steinberg had always been careful to provide for himself so that he could provide for others. He bought life insurance the first year he came to America and increased it periodically after that. He set up a financial portfolio at the same time and followed what was sage conservative advice from his tax accountant and investment adviser. He kept a sharp eye on his galleries and publishers and had a keen knowledge of what his own art was worth, and he had his significant holdings appraised by professionals. He also had his collection of the works of other artists appraised; most of them skyrocketed in value, like his $400 Magritte that became worth millions. When everything was added up, he had full knowledge of his impressive total worth. And as litigious as he was, he never boasted but always let his close friends know how pleased he was the few times that his lawyers allowed him to take legal action against the misuse of his intellectual property, for he won his case every time, and these settlements also added to his estate. He was always careful about updating his will, and after he and Hedda completed their "financial divorce" (as she called it), he was legally

free to disperse funds and grant bequests to whomever he wanted. He had always planned to leave the major part of his estate to Sigrid and to make her his executor, because she was so much younger and likely to survive him. But now, with her deepening depression and her wildly fluctuating behavior during her manic periods, he thought he should consider other ways to protect his estate and still ensure her well-being.

He was also thinking about what to do with his massive archives. He had engaged professional photographers off and on throughout his career to take photographs of his works and then had the eight-by-ten-inch photos encased separately in plastic sheets before filing them chronologically. On his own initiative, he thought of contacting the Smithsonian Institution to ask if it would like to house his papers, but he had not yet done so when John Hollander wrote to ask if he would consider leaving them to Yale. Hollander explained that the Beinecke Rare Book and Manuscript Library would be the repository and everything would be readily accessible to scholars and other interested readers and viewers. Steinberg had enjoyed his affiliation with Morse College and was proud of his honorary degree from Yale, but he did not make a decision until 1995, when he gave everything to Yale, "mostly because not having children or a loyal family, I wouldn't want the intimate details, etc." He explained his decision by telling the story of something he had witnessed many years before as he was walking down Bleecker Street. He saw "a flock of letters, postcards, papers," that had blown out of a trash can and were floating all over the sidewalk and the street. Like other pedestrians, he picked some up and read them, becoming engrossed when he saw that they were in Italian, poignant letters written by the families of Italian immigrants. He watched as other passersby picked them up "and then—goodbye, back to the sidewalk!" It was a deeply disturbing episode, and it left a lasting impression on him.

Steinberg, who could not bear to reveal "the Saul of 1960" for a small book published in a foreign country and language and who had difficulty giving a basically honest answer to the rare interviewer who asked the occasional probing question, was nevertheless determined that when it came to revealing himself for posterity, he would be the one to decide what to do with his archives: he saved everything, and he left it all to Yale.

STEINBERG STOPPED READING THE *New York Times* because he found himself turning immediately to the obituaries, surprising himself by studying them with "curiosity . . . searching, strangely enough, for my own." June was his birth month and always a reminder of age and infirmity, and the month when he went "like a sleepwalker" to a memorial for Ugo Stille that "stirred up

all kinds of powerful emotions." Next to Tino Nivola, Stille was the only friend with whom he thought he had had perfect communication. Thinking of friends who were gone, he went through his files until he found a snapshot of himself, Tino Nivola, and Bill de Kooning, posed in front of Rodin's *Burghers of Calais* and taken in 1968 at the Hirshhorn Museum and Sculpture Garden in Washington. Now Tino was dead, and Bill had been in decline with Alzheimer's for the past fifteen years. Steinberg felt sorrow that such a vital man was kept in the world only because of the constant ministrations of attendants, a "definition of immortality," but at what a cost to the soul.

Other things that he thought of as fixed and long-lasting were shifting and changing. It was a "tragedy" when Muriel Murphy and William Gaddis separated, and a loss of epic proportion when Sandy Frazier moved his family back to Montana for the second time. Before Frazier left, he visited to say goodbye and assure Steinberg that he would be back. Steinberg's only acknowledgment was to spread his hands in a gesture of despair.

He was constantly worried about Sigrid, and he took her to St. Bart's again

Nivola, de Kooning, and Steinberg in the Hirshhorn Sculpture Garden.

in February 1995 for what he hoped would be a repeat of the previous year's happy vacation. After several days she suffered a breakdown so severe that she had to be sedated for the flight back to New York, where she was hospitalized in the care of Drs. Rosen and Wanner. Steinberg coped by invoking Jung's interpretation of his own accident, pleased that he did not consider it a tragedy and could accept it as a "duty" and find "consolation . . . in doing normal things," such as phoning the doctors from the plane to alert them that she was on the way to the hospital and instructing the taxi driver how to get there. Still, every time he was alone in the evening, trying to console himself and obliterate the memory by staring blindly at the television screen, he could not keep fury at bay. He exploded every time he thought about Sigrid, enraged over the solitude her condition caused for each of them and, for him, the adjunct sadness of old age.

By the end of the year he had an "absence of terror," thanks to the newly prescribed Librium and the freedom from appointments with doctors and dentists, who had all taken off for holiday vacations in warmer climes. He was unusually quiet and solitary over the holidays, mostly because he lost his appetite and with it significant weight, which he could hardly afford to lose. Dr. Fisch had put him on a health program, and once a week a personal trainer came to his apartment to put him through a regimen of yoga and weight training designed to build his strength and increase his appetite. When the new year, 1996, began, so too did his appointments with doctors, by now a routine round-robin that had him on the elevator from floor to floor, as many were in the same building. He started his appointments of 1996 with the dentist, after which he would go directly to Dr. Fisch. "This time," he told Aldo, "I'm going there with fear."

WHAT'S THE POINT?

The tragic depression, the constant and inexplicable terror,
have passed for the moment. Perhaps they will return.

Du800ring an examination in October 1995, Dr. Fisch told Saul Stein-
berg that he probably had thyroid cancer. It was an enormous shock,
as two years before Dr. Fisch had noted that his neck glands were
enlarged but "definitely not malignant." Steinberg's first indication
that things had changed came during his stay at the Marbella clinic, where
routine blood tests unexpectedly revealed the presence of tumorous activity.
When he returned to New York, Dr. Fisch saw a significant physical change
and ordered a CT scan of his chest and abdomen. A second CT scan con-
firmed the likelihood of "medullary carcinoma of the thyroid gland," and Dr.
Fisch referred Steinberg to Dr. Jatin P. Shah, the chief of head and neck ser-
vices at Memorial Sloan-Kettering Hospital. Throughout early December, Dr.
Shah scheduled tests that showed "extensive lymphadenopathy," and when
Dr. Fisch confirmed that the glands had been enlarged for five years or lon-
ger, Dr. Shah concluded that the recent changes suggested Steinberg might
have lymphoma. He scheduled a neck node biopsy for December 19, and
Steinberg initially agreed to it. But several days beforehand, he claimed he
had the flu and postponed it. Dr. Shah noted on his medical records, "I have
a feeling that his psychological make up did not permit him to go ahead with
the biopsy."

Steinberg delayed until mid-February 1996, when the biopsy was finally
performed and did confirm thyroid cancer, with the official diagnosis of "med-
ullary carcinoma of the thyroid gland with bilateral cervical and mediastinal
lymph node metastasis." His physicians agreed that he did not need immediate
"active surgical intervention" but kept him under observation until he could

get used to the diagnosis and decide what to do. Two weeks later, when a subsequent examination found no change in the original finding, Dr. Shah told Steinberg he had two treatment options: he could have surgery to remove the mass, or he could continue to live with it while keeping it under close observation. The medical report noted that the patient was still unable to make a decision and needed more time to think about his options. Dr. Shah concluded that taking more time was acceptable, because Steinberg was in "remarkably good

Saul Steinberg in his early depression.

health for an 81-year old man . . . a cartoonist still actively working" whose only prior surgery had been a childhood tonsillectomy.

Throughout December, as Steinberg's doctors compiled his medical history, a portrait formed of a man in as much mental distress as physical. He was a "robust" eighty-one-year-old who had blood in his urine and took Librium for severe anxiety. He had not smoked a cigarette since 1972, but his recreational drug of choice was "grass, last used in June," and he drank "more than seven" alcoholic beverages every week. He ticked "yes" to "feeling sad/depressed, anxious, hopeless, guilty, and suicidal," and he also answered "yes" to "Have you ever planned or attempted suicide?" A subsequent, more in-depth examination concluded that he had "a severe depressive disorder for which he has been treated with Prozac and Zoloft." Steinberg told the examiner that he stopped taking the drugs because he was unable to tolerate them, but the doctor concluded that he had not taken them long enough to gauge their effectiveness. The doctor next prescribed Lithium, which Steinberg took for a while but stopped when he decided that it too did little to relieve his depression.

Six months later, in August 1996, Dr. Fisch retired and Steinberg transferred his care to Dr. Jeffrey Tepler, an internist recommended by William Gaddis. Tepler's diagnosis was far blunter than Fisch's: "He has had suicidal ideation . . . He has had many other vegetative symptoms and has become quite nonproductive." Dr. Tepler believed that thyroid cancer had been present for at least nine years, although no symptoms had manifested until recently. Because the tumor was indolent, Steinberg did not need surgery to remove it, but he did need hospitalization for "severe depression which has worsened over the past several months." Dr. Tepler sent him to Silver Hill in New Canaan, Connecticut, a hospital specializing in psychiatric disorders and substance abuse. From August 20 to August 31, Steinberg was treated for depression, anxiety, and panic, with the drugs Effexor (25 mg) and Serzone (100 mg).

When his stay at Silver Hill ended, a limousine took him back to New York, where his absence had passed unnoticed, as if he had only been away as usual in Springs. Although most of his close friends were aware of how he had gradually withdrawn into a more private and quiet life during the past year, few recognized the depth of his depression and the degree of his impairment. They all ascribed the changes in his behavior to his worry about Sigrid and did not probe further. Muriel Murphy put it best when she said that he had such an "austerely private self" that she, like others, was reluctant even to ask how he was, and especially to ask "the very important question: how is Sigrid and even more important, where is she?"

———

SIGRID WAS LEADING A LIFE THAT was both intimately connected to Steinberg's and separate and detached. She made another journey to Mali in January 1996, despite Steinberg's contention that there was too much political unrest there. He was doubly worried, not only about her safety but also about providing for her in case his thyroid cancer caused him to be incapacitated in some way. Before she left, he made arrangements with his financial consultant at Neuberger and Berman to transfer $300,000 into an account in both their names. He wanted the funds to be conservatively invested for maximum reliable income with minimum risk, and with all interest and dividends to be paid into Sigrid's personal account each month. As this amount would vary, Steinberg stipulated that she could draw on the capital as needed or wanted by sending a written request to the adviser, who would contact him to secure his permission. Steinberg's generosity gave her financial security, but the gesture did little to relieve the awkward tension between them.

Very few people knew that Sigrid had gone back to Africa, the assumption being that she was not seen with Saul because they were once again on the outs, or that she was in one of her bad periods, or, among the few who knew about Steinberg's cancer, that she had run away because she couldn't deal with his illness. In truth, she had planned the trip since late summer 1995, well before his diagnosis. She purchased her tickets and made her arrangements in early fall, and whether his illness had any bearing on her decision, she wanted to keep to her original travel schedule. When she returned at the end of February, Steinberg's depression was so severe that she could not break through his silence and withdrawal. She did not realize how deeply incapacitated it made him and blamed his behavior on the usual hard time and silent treatment she believed he gave her when he was angry about something she said or did. She was determined not to let what she mistook for his stubbornness offend or discourage her, for being in Africa was always a boost for her state of mind.

"What's the point?" she asked, wondering why the fact that she had come back safely did not cheer him up or at least make him "less gloomy." He was too depressed to respond, so she demanded to know, "Why can't you be proud of me for doing what I want to do well? I even started to speak the language and everybody in Gao is proud to be friends with me. They respect even admire and love me. I am sixty years old and their sister mother grandmother."

Sigrid and Saul were at an unfortunate impasse, two people who cared for each other, desperately wanting connection but drifting along in a miasma of miscommunication and misinterpretation. No matter what they did or said, they found themselves at cross purposes.

Putting money into an account for Sigrid to draw on no matter what happened to him was not enough to ease Steinberg's mind about what would become of her if anything should happen to him. He fully intended for her to inherit the greater part of his estate, but he worried about her erratic behavior and what she might do after he died if there was nothing or no one to constrain her. He had been talking to his lawyer, John Silberman, about how to ensure that his money and property were dispensed as he wanted, but the immediate question was how best to secure Sigrid's safety and well-being. Steinberg thought he needed to appoint some sort of trustee or guardian to watch over her.

His friendship with Prudence Crowther had strengthened during the past year, during which she had volunteered unwavering support and morale boosting. She accompanied him to a steady stream of medical appointments; saw that he got home safely, that his prescriptions were filled, and that he took them as directed; and, in conjunction with Josefine, made sure that his household was in order. In Hedda Sterne's words, "Prudence became the brick that got him through the really bad years." Steinberg thought Prudence would be the best person to help and advise Sigrid Spaeth, and he arranged for them to meet.

When he invited Prudence to visit them in Springs, he intimated but did not directly state that he wanted to give her an official role in overseeing his estate. She thought that Saul had hinted the same thing to Sigrid that he had hinted to her, that she would be "vaguely involved as an executor." Prudence spent the weekend in a motel and one afternoon went to the house, where Sigrid was waiting to meet her. At the time, Sigrid was sixty and Prudence was forty-eight. Prudence felt that in his oblique way, Saul worked hard to make the meeting "as gentle as possible," and after introductory pleasantries, he left the two women alone to get acquainted. Prudence thought the meeting must have been awkward for Sigrid, which was why she seemed at first "a bit noblesse oblige but gracious . . . working to impress upon me that she was also a person of imagination, not in a vain way, but out of uncertainty as to who I was and what I was doing there." Sigrid said something witty about the squirrels outside, and although Prudence thought it might have been a set piece she had used before, she gave her credit for being imaginative: "I am guessing that she would have already been privy to Saul's (mis)understanding of his medical circumstances, and therefore laboring under a terrible dread."

Even though his doctors assured Steinberg that his cancer was very slow-growing and would probably not be the cause of his death, he was convinced that it would be his killer and that he would die very soon. On November 5, 1996, he made a will in which he named his lawyer, John Silberman, and

his friend Prudence Crowther the executors of his estate. He also left signifi-
cant financial bequests to fifteen people. Aldo Buzzi was to receive $150,000,
and Ada Cassola Ongari was to receive an annuity that would pay her $12,000
a year for the rest of her life. His devoted housekeeper, Josefine Buttles, was
to receive $25,000, and his two studio assistants, Anton van Dalen and Gordon
Pulis, were each to receive $50,000. He left $50,000 each to Claire Nivola,
Ian Frazier, William Gaddis, Norman and Cella Manea, Karen van Lengen,
Mary Frank, Linda Asher, and Prudence Crowther. His cousin Henrietta's son,
Lawrence Danson, was also to receive $50,000. The remainder of Steinberg's
still considerable money and property (estimated at more than several million
dollars for each) was to be divided between his sister Lica's children, Dana and
Stéphane Roman. He left nothing to Sigrid Spaeth, because she committed
suicide on September 24, 1996.

NO ONE EXPECTED SIGRID TO TAKE HER LIFE, least of all Saul Steinberg,
for her previous attempts had seemed more a cry for help than a sincere desire
to succeed. Her most recent interactions with Steinberg had been unusually
quiet, both being so preoccupied with their individual depressions that they
never argued or fought, probably because they were both taking prescrip-
tion drugs and seldom had a genuine conversation. The summer drifted sadly
onward: "For an hour, in silence, Sigrid and I gaze at the landscape waiting for
the fox. Then lentil soup with potatoes and frankfurters, eating like hermits."

Steinberg kept a daily diary during the autumn of 1996, the first entry
starting the day he returned from Silver Hill. Because of the way he phrased
many entries, the document reads like something he wrote in one fell swoop
after everything had happened, as if he were trying to digest and make sense
of a seemingly senseless progression of events. On September 9, he wrote in
Italian, "Il mio dilemma, non io raggionare"—his problem was the inability to
think rationally—and therefore there was little he could do to control his own
behavior or his responses to Sigrid's.

He was still in the city on September 23, when he had his last conversation
with her: "Last time call Sigrid Papoose." The next day he wrote her name in
large horizontal block letters and next to it wrote "Papoose" vertically. He was
harkening back to the early years of their long relationship, when he had used
the loving nickname he and she gave to each other, a name neither one had
used in years except when they called the cat.

ON THE AFTERNOON OF SEPTEMBER 24, the sixty-year-old Sigrid Spaeth
went up to the roof of her fourteen-story building at 375 Riverside Drive and

jumped to the sidewalk below. The official death certificate listed the time she died as 4:15 p.m. and said that she died from multiple fractures and visceral lacerations, with blunt impact to her head, torso, and extremities. Her body was taken to the Garden State Crematory in North Bergen, New Jersey, where it remained until it was cremated on October 1.

Sigrid left two letters in her apartment, one for her sister, Ursula "Uschi" Beard, and one for Saul Steinberg. She began Uschi's letter in German, repeating the same sentence in English for Saul: "Please forgive me but I couldn't go on." In Uschi's letter, she switched to English to tell her sister to take what she wanted of her things and to "give away or sell or destroy and throw away [all the rest], especially my work." Her letter to Saul was more personal; she told him she could not go on living because "life was too painful. Only torture and agony. Please don't blame yourself in the least. You did more than what was possible for me and I never thanked you enough. It is my DEFECT that forces me to do this, please remember only the good things and that I love you. Your Papoose Sigrid. Please bury my ashes in the woods."

THE TWO WEEKS BETWEEN SIGRID'S SUICIDE and her cremation were devastating. As soon as Steinberg was notified, he called Hedda and asked her to inform a few close friends. The day after Sigrid's death, he made his own calls, starting early in the morning with Ruth Nivola. He said nothing about Sigrid but asked if the cleaning woman they both used happened to be in her house, and if not, did Ruth know how to reach her? Ruth said she would try to find the woman's number and would phone him back. She wondered why he was calling so early and with such a strange request, but she was trying to fulfill it when the phone rang again. It was Hedda, "her voice suffocated with tears," asking Ruth if she knew. Understandably, Ruth asked, "Knew what?" Sobbing, Hedda reverted to the name by which she had first heard of the existence of Sigrid Spaeth and said, "Gigi killed herself." Ruth wanted to rush across the road, but Hedda reminded her of Saul's strict instructions that he "did not want to be intruded upon" and no one, not even either of them, could arrive without his permission. In a state of emotional paralysis, each remained where she was.

Meanwhile, Saul was making other phone calls: to Sandy Frazier in Montana; to Dana and Stéphane Roman, in Paris and Nice respectively; to Aldo in Milan; to Uschi Beard in Ohio; to Sigrid's lawyer, Barry Kaplan, and his own, John Silberman, both in New York; and to Detective Brannigan of the local police precinct, who was in charge of the case. He also called the Riverside Memorial Chapel to arrange for the cremation and service, and he called two of Sigrid's friends whom he did not know personally. Then he made a note to

himself: "Tangible property—Hedda, Prudence. Leave to niece and nephew, leave house to niece and nephew." After that, he was "bedridden five days."

Although he told everyone who lived away from New York that they should not come, Sandy Frazier insisted that he had to be there, flew from Montana, and stayed with friends just in case Steinberg needed him. Steinberg remained alone in his apartment or took solitary walks that usually ended in Central Park, where he would use the pay phone in a men's room to phone Frazier, who explained, "Sometimes he'd say 'no, don't come,' sometimes he'd say 'yes, come over.'" If they met, they always walked back to Steinberg's apartment and sat at the big table in silence. "I can't talk," Steinberg told Frazier. "I can't say anything." But the telephone rang constantly with people who wanted to help, and Steinberg always answered it. Frazier remembered that he told his callers, "'Don't come over, —Sandy is here.' It reassured them that he was okay because he had someone with him."

Frazier was there when the funeral home telephoned to say that Sigrid's ashes were ready. Steinberg found a double shopping bag and they took a taxi to the West Side and sat in the waiting room until the attendant came to present them with the urn. Steinberg put the urn into the shopping bag and all the way back to his apartment and afterward repeated "Poor Sigrid" over and over as he cried.

SIGRID'S WILL BROUGHT ANOTHER ROUND OF shocks when Steinberg learned that she had changed an earlier version in which he was her executor to appoint her sister, Ursula Beard, and lawyer, Barry Kaplan, to replace him. She left the personal property within her apartment to Uschi, but she left the apartment itself, the one Steinberg had bought and paid for, with an estimated value then hovering around half a million dollars or more, to her analyst, Dr. Armin Wanner. Her personal property included a sizable collection of Steinberg's art as well as the works of others that he had given her, with an estimated value of $300,000. After her body was taken away, police sealed the apartment, and no one was allowed to enter until the executors applied for and received permission to remove all uninsured objects of value, starting with the art. Steinberg had to apply separately for permission to enter and remove the things he had given her, but by the time his permission was granted, Uschi Beard had followed Sigrid's instructions and everything of value was gone.

SAUL WAS STILL REELING WHEN HE phoned Ruth Nivola for the second time, again with an "almost inaudible deep voice." He told her he was "lost, in need of friends," and Ruth urged him to let her cross the road to be with him.

He said he would not see or speak to anyone until he could manage to "detach [himself] from the house in which Sigrid's spirit still dwells." Ruth asked her son, Pietro, to phone him later, and when he did, he told his mother that he feared "Saul was preparing himself for death and was soon going to die."

Although Saul was "practically catatonic with grief," he managed to get himself into the city to await Aldo and Bianca's arrival on October 5. Before he left Springs, he phoned Ruth and said "an amazing thing, something he had never said before in all the years I knew him. He said, 'Anytime you need something, call me.'" In the city, he stayed alone in his apartment, phoning Hedda multiple times every day and seeing only Aldo and sometimes Bianca, who discreetly absented herself so her husband could take care of his friend. Josefine did the shopping and cleaning, but Aldo prepared many of their evening meals, cooking the simple pasta dishes of their university days to try to tempt Saul to eat, as he had no appetite and was losing an alarming amount of weight.

Condolence letters poured in, and despite the writers' intentions to bring comfort, they only increased his pain. The letters fell into several general categories: Arthur Danto wrote that he hardly knew Sigrid but that whenever they spoke on the telephone she was so kind that it was like speaking to an old friend; Ben Sonnenberg said the relationship that endured for more than twenty-five years could not possibly have ended without great grief. Peter and Maria Matthiessen thought they were easing Steinberg's "remorse" (his word, not theirs) when they said they were long aware of what a tenuous hold Sigrid had on life, but instead of providing comfort, their letter provoked a tearful outburst of self-recrimination, as did many others. Ruth Nivola sent a note via Aldo saying that she respected Saul's wish not to see or hear from any of his friends, but she was "across the road" whenever he needed her. And Uschi Beard's letter was the most painful of all, because she enclosed with it a copy of Sigrid's earlier, outdated will, the one in which she wrote that she was leaving "everything to Saul Steinberg, who gave it all to me." Uschi's attached note said, "I feel for you . . . she must have been very desperate to do it to you. She must have been desperate."

SAUL, ALDO, AND BIANCA WENT TO Springs on October 16, in preparation for the private ceremonial burying of Sigrid's ashes the next day. That afternoon Saul called his niece, Dana, in Cachan to assure her that he would be all right, and then he allowed Aldo and Bianca to persuade him to cross the road and eat lunch and dinner in Ruth's warm and welcoming kitchen. When they arrived for lunch, Ruth was "frightened by the mood of all three, so dark and impenetrable." They were so silent that she wondered if "all three had forgot-

ten to use language" and conceivably had not exchanged one word on the long drive out from the city. Her way of offsetting the mood was to surround them with the foods they loved, from prosciutto and mortadella to her homemade cake. Ruth had to originate what little conversation there was, eliciting an occasional pleasantry from one of the Buzzis while Saul said "absolutely nothing." Afterward, Aldo literally had to guide Saul across the road to his house while Bianca stayed with Ruth. At dinnertime he led Saul back to Ruth's kitchen, where she served them roast chicken and loaded the table with everything from potatoes and salad to the luncheon leftovers. "A table with food can heal, and eventually Saul joined the conversation," she wrote in her diary. He talked about Italian food, "which he used as a shield for real emotions, but he did warm up and he did talk some more."

The weather was glorious for the entire week, and on the brilliant, crisp, and sunny October 17, Sigrid Spaeth's ashes were buried exactly where she wanted to lie. On July 16, 1994, she had taken a sheet of pink paper, written her wishes, and attached the paper to a little sapling she had planted three days earlier. It was not addressed to anyone, but it gave full instructions for her burial. Steinberg detached the note, put it away, and when the time came, honored it: "This is the place where I would like my ashes to be buried, under the little (or if I am lucky—by then big) tree I planted on July 13. Over a dead catbird. Among the catbirds and chipmunks and moles, etc., not far from where Papoose's soul is waiting in his tree. I know that when I die and go to heaven, Papoose will be waiting there and perhaps Papa and Mama and all those I loved."

She signed it, "Sigrid. Facing east toward Papoose and Africa."

Afterward, Aldo and Bianca had to help Saul into the car for the return drive to the city. Except for an occasional remark about the traffic, they were all silent. Aldo and Bianca were uneasy when they returned to Milan on the twenty-third, hopeful that Saul would soon be able to accept that he was powerless to have done anything to stop Sigrid from killing herself. It was reassuring to know that Hedda was on the phone with him several times each day, sometimes for more than an hour at a time. Afterward, Saul seemed to come briefly out of the haze that otherwise enveloped him, but it never lasted for long.

On November 7, with the assistance of Prudence, whom he had asked to help him find an analyst, Saul had his first and only appointment with one. By November 24 he felt strong enough to write his first letter to Aldo since Sigrid's death. They had talked on the phone, but Saul worked hard in his letter to assure Aldo that "the tragic depression, the constant and inexplicable terror, have passed for the moment." Then he added, "Perhaps they will return."

NATURE'S CHARITABLE AMNESIA

*I often surprise myself by awaiting [Sigrid's] return, and if I
survive, the summer will be difficult without flowers, bouquets,
even minuscule ones in the old ink bottles, and the silent strolls
in the woods, when she would point out the flowers visible only
to the eye of a small child.*

Steinberg spent Thanksgiving Day, the only holiday he truly enjoyed, all
alone in Springs, avoiding the "rich, noisy invitations" he was offered.
He thought of years past, when he would take his own wine to spare
himself "the local Beaujolais" at the houses of friends—James and
Charlotte Brooks, Muriel Murphy, Jean Stafford—"almost all of them gone"
now. He was content to be alone in his warm house and, thanks to his medi-
cations, was in one of his better moods on the dreary November day when
the postman delivered a dead leaf sent without an envelope but with stamps
affixed directly to it, as well as the address in Sigrid's hand, mailed from Key
West the last time they were there.

Sigrid had risen from her depression long enough to indulge in Steinberg's
little game of sending amusing objects through the mail without envelopes,
just to see if they would be delivered. He once sent a dollar bill to himself,
writing the address and affixing stamps directly onto the money, but that time
the postman spoiled his fun by putting it into a glassine envelope. Now, several
months after Sigrid's death, he was confronted by her leaf, which provoked
one of his recurring bouts of "profound sadness, and then, luckily, they pass,
nature's charitable amnesia."

He had had two rough months since Sigrid died. Often she came to him
in dreams that left him lying awake and yearning for interpretation. By spend-
ing his days puzzling over them he became ensnared in morbid depression,
forcing himself briefly out of it by accepting dinner invitations. His friends
were delighted to see him but discomfited by his unusual silence; he was so
afraid that he might break down in mid-monologue if he assumed his usual role

of commanding raconteur that he thought it "prudent" to listen rather than talk. "But where, then," he asked himself, "is the enjoyment?" He could not help but think of Sigrid, whose behavior he now praised as "honorable" as she refused to participate in what she had called social contracts requiring three hours of good behavior.

He was generally careful about which invitations he accepted and did not venture outside his comfort zone. Mary Frank was aware of his "tremendous fear of dirt and the smells of sickness" and invited him only for quiet suppers with herself, her husband, Leo Treitler, and occasionally another guest whom Steinberg knew and trusted, often their mutual friend Mimi Gross. Before Steinberg accepted Frank's first invitation after Sigrid's death, he warned her that he was depressed and had been on antidepressants for quite a long time and that none of his various medications seemed to be working. At a loss for how to comfort him, she said she admired his "tremendous will" and hoped that yoga and meditation would help. Later she did not remember whether he replied, only that he was exceptionally quiet when they were together.

He liked Jean Stein's dinner parties, where she always had a table of eight or ten interesting conversationalists and seated him next to her husband, Dr. Torsten Wiesel, a good friend who offered soothing medical counsel through casual and informal conversation. Steinberg also liked the small dinners Barbara Epstein gave, often for visiting European writers who brought the latest cultural news about many of his favorite places and friends. He met the exiled Romanian writer Norman Manea there, and in the beginning was "not thrilled to meet another Romanian." As the other guests vied to ask Manea about the political situation for Romanian writers, a quiet but also "sardonic and taciturn" Steinberg interrupted his reply with abrupt new questions: "How can anyone be a Romanian writer? Is there such a thing as Romanian literature?" These shut down conversation as all shocked eyes turned to Manea to await his answer. Perhaps because he did not know of Steinberg's reputation for acidly demolishing dinner companions, Manea became one of the few who survived and even surmounted the barbs Steinberg routinely tossed when he wanted center stage. He shot back with "When did you leave Romania?" When Steinberg confessed it was a good sixty years before, Manea expounded at length on Romanian intellectuals who had gone on to make international reputations, among them Steinberg's friends Eugène Ionesco and Emile Cioran. "Maybe, maybe," Steinberg answered grudgingly, admitting that he was "not up to date on Romania."

At first the friendship was "tentative," but as Steinberg learned that Manea was "an Austrian Romanian Jew, more refined than the usual Turkish Jews like

me," he seized the opportunity to recall and revisit his personal Romanian history. Every time Norman and his wife, Cella, told him they were planning a trip to Bucharest, Steinberg gave them detailed instructions about where to go for the historical postcards he wanted them to buy, particularly anything associated with Buzău. Steinberg may have called Romanian the language of police and thugs, but it still fascinated him. He had an enormous Romanian dictionary and would often telephone the Manea household to tell them of a word that struck his fancy or to ask their interpretation of a particular phrase or expression. Occasionally he hinted that he might like to accompany them on one of their visits to Romania, but if they invited him to join them, he always refused to make "an impossible return." He told them what he had told Christo several decades earlier, that it was better to retain one's memories in the mind than to revisit them in person.

However, no matter where Steinberg's conversations with Norman Manea began, they always became a diatribe about the plight of having been born a Jew in a hostile country. Steinberg ranted about authority, but Manea thought his primary obsession was "really nostalgia, for his family and for the language." Whenever they argued about the worth and value of Romanian literature, Manea offered to let Steinberg read Romanian editions of writers who were currently popular, but he always refused. Manea decided that Steinberg was not interested in the country's present or future; his only interest was nostalgia, which he expressed through a combination of melancholy and fury that had not softened during sixty years of self-imposed exile, a combination of "rage and magical feeling."

The magical feeling was for the boyhood neighborhood that was no longer there, most of the buildings having been razed by the ravages of war or the grandiose building projects of the Ceaușescu government. Steinberg yearned for the people he knew, the old shops in the old streets, and "particularly the smells," which he recalled with precision and tenderness time and time again. To Steinberg's immense delight, Prudence found a large-scale prewar map of Bucharest in the New York Public Library, and he spent happy hours making photocopies in various sizes for his friends, retracing his daily route from his house to his school and his walks to the homes of his aunts and the shops of his uncles.

"I'm passing my days walking those streets that don't exist anymore," he told Henri Cartier-Bresson. "My childhood lasted a long time, very intense. I recorded everything and now walking through the map of my childhood streets I see things consciously for the first time as if my mind has recorded everything and certain images are developed and printed only now after eighty years." He

also sent a copy of the map to the Maneas, with a note explaining his various peregrinations through the city. Although it began "*Dragii mei*" (dear friends) and ended "*Cu drag*" (affectionately), he wrote the body of the note in English, the salutation and the sign-off being the only words he ever wrote in their native language.

As Steinberg's friendship with Norman Manea deepened, another reason surfaced for his refusal to speak Romanian: his vocabulary remained that of an unsophisticated schoolboy, and he did not want to put himself in a position where he could be corrected or embarrassed. Instead he chose to feel sorry for Manea, "the poor guy, obliged to write in the despised Romanian and have his work translated." He sternly demanded that both Norman and Cella speak only English, for how else would they learn their new language? Although he could be scathing about current American politics and culture, he told them that he considered himself profoundly and deeply American and they must "never be frightened or ashamed" of being American themselves.

PRUDENCE ASKED STEINBERG TO JOIN HER for a Key West holiday in January, the first winter after Sigrid's death, but he declined. As she knew he had been there before with Sigrid, she thought he might be reluctant to return and did not press him to change his mind. Shortly after Prudence invited him, he received the news that Ada had died quietly on January 16, 1997, in her well-appointed rooms at the Casa Prina nursing home, felled by the various heart problems she had suffered for quite a few years. Her death was not a total surprise, for Saul telephoned her almost every time he spoke to Aldo, and as was her way, she chatted effusively and left out no details of her ailments and illnesses. He knew they were serious, but her death so soon after Sigrid's was still a terrible blow.

Prudence left for Key West on January 22, and by the twenty-ninth Saul had changed his mind and flew down to join her. She had rented Alison Lurie's house and cottage, two separate dwellings that were connected by a patio where a large kapok tree grew. Steinberg liked the tree so much he drew it several times, writing on one, "This tree looks too much like art." He stayed in the cottage, where he could have as much privacy as he wanted, and after Prudence returned to New York and her work as a copy editor at *BusinessWeek* magazine, he moved into the house to stay for two more weeks.

Key West was exactly what Steinberg needed, and from the moment he arrived, "he became as happy as a child, as if a miracle had happened, the sentence was lifted, and he had stepped clean away from his catastrophe." He liked everything about the town, especially the new friends, among them

the writers Harry Matthews, Robert Stone, and Ann Beattie. William Gaddis was there with his son, Matthew, and he saw them often. He and Prudence had lunch with someone Steinberg had always liked, Charles Addams's ex-wife, Barbara, who had subsequently married John Hersey. She took them to visit Shel Silverstein, the children's book author and illustrator who had long admired Steinberg.

What he loved most about the small town was the "strangeness more than anything else," which helped him to forget "almost everything." The tiny wooden houses that he passed on his mile-and-a-half morning walk to pick up the newspaper fascinated him, as did the famous writers and other celebrities who cherished their privacy during the day and came out only long enough to be convivial at night. He thought he was exceptionally lucky to have Prudence with him, as she enjoyed experimenting with the local food and could whip up dinner for six on the spur of the moment. He told Aldo that having her there was "a blessing I regard with feigned indifference." And he told Prudence that they should plan ahead to rent Alison Lurie's house again the next winter and that he wanted to invite Aldo and Bianca to join them, but in a separate house he would rent for them.

HE WAS IN A MORE BUOYANT MOOD in Key West than he had been in since Sigrid's death, but as March ended and the return to New York loomed, what he was now calling "the tragedy" sprang to the forefront of his mind, and he dreaded returning to the familiar places where he had been with her. The first onerous task was to persuade the crematorium to accept his check as payment, for the law stated that only Sigrid's heirs, her sister and Dr. Wanner, could authorize and pay for cremation. Eventually he prevailed. When he went to Springs and visited the grave site, he found it covered with green moss. He asked Gordon Pulis to construct a small fence to enclose it, and as soon as the weather permitted, although he had never shown much interest in gardening, he planned to plant her favorite flowers. He never did it, for he was so mired in depression that he was seriously considering suicide.

The long downward spiral began just after he returned from Key West and found himself crying over Sigrid day and night. He was afraid to see people during the day for fear he would burst into tears, and at night his dreams were so disturbing that he was afraid to let himself fall asleep. When he finally did, his rest was fitful and he awakened frightened and anxious, lying tightly curled in bed; if he slept until the morning light, he was afraid to open his eyes and face the day.

Searching for some explanation for his depression, he immersed himself

in rereading the novels of Thomas Bernhard, looking for comparisons between Bernhard's relentlessly negative prose and the rambling, disjointed, and disconnected ideas that swirled in his own head, all of which he was powerless to organize, let alone control. Steinberg invented other tenuous correspondences between himself and Bernhard: that the writer's death at the age of sixty was also a suicide, as Sigrid's had been at the same age, and that many of Bernhard's women characters expressly mirrored her troubled existence. Such vague connections led Steinberg to conclude that if he had been a writer rather than an artist, Bernhard was the author to whom he would most likely be compared. Once again, as he had done when he read the novels for the first time, he found similarities between Bernhard's fiction and Gaddis's, which he then extrapolated to the personalities of Gaddis and himself. Their earlier rupture had been mended in Key West, and on the eve of his departure for Germany, Gaddis came to Steinberg's house to say goodbye. After he left, Steinberg noted how Gaddis could not express the deep affection he felt for him, just as he, Steinberg, could never tell others how much he cared for them. It was a depressing reunion, as Gaddis was visibly ill; his emphysema was now in its endgame, and the symptoms of the prostate cancer that actually killed him a year later were barely manageable. Steinberg shuddered at how closely Gaddis resembled far too many of Bernhard's ill and dying characters.

STEINBERG LOOKED FOR DISTRACTIONS FROM THE illness and death that surrounded him by focusing on his Romanian years. He was always searching for new ways to inhabit his past, and this time he found them by reaching out to classmates from the Lycée Basarab and the University of Bucharest with whom he had had little or no contact since he had left for Milan. He went to see Bruno Leventer, who lived near him on Park Avenue, which made visiting easy and also let him make a quick exit using the pretext of another appointment. Leventer had had a stroke several years previously and could not speak, so Steinberg had to carry the conversation, which, in his depression, was too exhausting to keep up for long. When he learned that a casual friend, Eddi Fronescu, had retired as a physician in Los Angeles, he telephoned often—after he discovered that he reveled in having to speak Romanian because the man was almost deaf and could only hear his native language. At first Steinberg made excuses for speaking Romanian, but he found that he rather enjoyed it, and it was the same when he wrote in Romanian to Eugene Campus in Israel, inventing as the excuse for using his native language that he could not write in Hebrew or Yiddish.

Pursuing all things Romanian could not occupy his mind completely, nor

could such self-appointed tasks as making major repairs and repainting Sigrid's cabin. Just as suddenly as he started, he decided not to do it and turned instead to other projects, which he became too exhausted to finish. Even writing letters took too much effort, and he abandoned one to Aldo after three sentences, with the excuse that he had to telephone Hedda for another of the rambling conversations in which she tried everything she could to boost his spirits. Although he thought himself powerless to control or change his moods, he was a shrewd observer of the effect they had on others; he noted how what he was calling by another euphemism, his "friendship" with Hedda, was really a dependency that grew and strengthened every time they talked. He decided that the friendship stemmed from her unconditional love, which made him ashamed, embarrassed, and often sobbing over how much he needed it and how unworthy and undeserving he was.

His letters to Aldo were less frequent now because he picked up the telephone whenever he felt the urge to unburden himself, often through sobs and tears. The phone calls worried Aldo more than the depressing and repetitive letters, and in an effort to cut through Steinberg's haze of depression, he made him promise repeatedly not to phone unless he had something positive to say, and also to promise that he would be careful not to repeat himself time and again when he wrote—both to little avail. In one worrisome letter, Steinberg said that he was writing only to exercise his mind, as he had nothing to offer except continuing affection; he apologized for wallowing in self-pity on the telephone and promised to restrain himself in the future. His intentions were good, but he could not live up to them.

He became obsessed with Sigrid's suicide note and, almost as if he needed to justify to himself that he bore no blame for her action, made photocopies and sent them to Aldo and many other friends, sometimes more than once. Aldo's and Sigrid's birthdays were one day apart, she on August 9, he on August 10. Even though the better part of a year had passed, Steinberg commemorated both anniversaries by crying to Aldo in a phone call and writing in a letter how he still missed her every minute.

JUST WHEN HE SEEMED THE MOST DOWN, he became the most up he had been since Key West. He told Prudence to go forward with reserving two houses there for the following winter, Alison Lurie's for him and her, another for Aldo and Bianca. Even though he had not driven for the past several years, he decided that his old Chevrolet was becoming too dangerous to drive, and on Gaddis's recommendation he bought a Volvo. He was also making plans for new books, new exhibitions, and even new friendships. He expressed regret that he had not reached out over the years to the many interesting people he

had met at the dinner tables of others, and he regretted even more that he had always been a guest and never a host. He decided to give dinner parties of his own, but his teeth prevented him from doing anything immediately, and like many other good intentions, this one also drifted away.

So much that he did in his daily life became an homage to Sigrid, as he made litanies of her qualities and virtues that he had not sufficiently appreciated when she was alive. Preparing meals became a tribute to her as he made a fetish of seasoning his foods with the perennial herbs she had planted years before, convinced that they continued to grow so lavishly because it was her way of sending him greetings. By the autumn he was having such troubling dreams about her that he refused to describe them even to Aldo. Instead he compiled and mailed more lists of the flowers and herbs Sigrid had planted and then recited them on the phone to Hedda. Hedda and Aldo both worried when he described how he had awakened smiling from a nap because Sigrid was there and she invited him to take a walk in the woods with her and Papoose; he told them not to worry but to be serene, because Prudence had assumed all responsibilities for his care and there was very little he had to do except sit, sleep, and dream. He pretended to complain, but he was content to be relieved of the responsibilities for his daily well-being. Prudence worked in New York during the week, and when she went to Springs on the weekends to care for him, he was always filled with hope that "maybe the terror will disappear." Unfortunately, it never did.

For more than a month at the end of 1997, Steinberg was physically incapacitated by depression, unable even to write to Aldo or pick up the phone and call him. Like one of his favorite fictional characters, Goncharov's Oblomov, what he liked best was to pull the covers up over his head and let his still excellent memory revive past regrets and painful memories, because each time he did, he remembered something he had not been aware of at the time he had lived it. If friends who were not in his intimate circle wanted to visit, he put them off, saying that he was working and needed to be alone to concentrate for whole days at a time, but in reality he was afraid he would break down and cry in front of them. Just as he sometimes thought Sigrid was there with him, he thought Papoose was still alive and once took his flashlight out into the dark night to troll the underbrush looking for him. He bought a book about the destruction of Bucharest's old neighborhoods during the reign of Ceauşescu and wept over the photos of buildings and streets he remembered from his boyhood that were no longer there. Looking at the pictures made him unhappy, but they also provided an excuse to stay in bed and sleep off unpleasant memories.

His only happiness came when he was planning his escape to Key West for

January 1998, this time including a reunion with Aldo and Bianca. The holiday was everything his three friends could have hoped for in terms of seeing him cheer up, and indeed he did enjoy it. He mixed seemingly effortlessly with the local literary crowd at dinner parties and took pleasure in introducing his Italian friends to the locals. Ann Beattie gave several small dinners at which Steinberg held forth with monologues, almost but not quite as in days of old. What he enjoyed most was the pleasure he and his three companions took in each other's company and how the warmth and relaxation they found in the colorful setting permeated their affection.

BACK IN NEW YORK, HE WAS IMMEDIATELY beset by lethargy and despair. Steinberg regretted that he had been so happy in Key West that he had not taken Aldo aside to give him the details of what he was now describing generically as his "illness." He meant the term to include much more than the euphemism "melancholy" that he still substituted for depression. There were new problems with his teeth and continuing worries over the many visits to the doctors who supervised his still indolent thyroid cancer, and there was also a host of new aches and pains for which he consulted specialists. His neurologist recommended a physical therapist who visited regularly several times each week to put him through a routine of exercises. The main problem was that the antidepressants were not working, and he felt the need to see an analyst and begin therapy on a regular basis. He asked Prudence to help him find someone, and in early 1998 he began therapy with at least two or three analysts, none of whom he consulted for long.

Once again he was on the telephone, first to Aldo, until he realized how upsetting his unfocused ramblings were, then to Sandy Frazier in Montana. "Strange how the letters and telephone don't mix," he wrote. "Will I tell you the same things when I'll talk to you? Will I worry?" Frazier was indeed worried, for Steinberg asked him to buy a gun, specifically a .38-caliber Smith & Wesson revolver that he was familiar with from his time in the navy. Frazier tried to talk him out of it: "I took it as something crazy and said no, I wouldn't do it. All I could think of was that he would shoot himself in New York City with a gun that was registered to me in Montana. I told him I thought it was a crazy thing to do." Steinberg accepted Frazier's refusal and dismissed the subject by saying he wished he were Swiss, because all Swiss men had to serve in the army and "everybody there has a bazooka under the bed." Next he asked Prudence to buy him a gun, and she too refused. Shortly after, he decided that as nothing else was working, he would have electroshock therapy.

———

STEINBERG WAS "TIRED OF WAITING FOR SANITY TO RETURN," an expression he had used many years earlier when he made his return pilgrimage to Tortoreto in search of he knew not what. He knew he had to do something drastic, because panic and anxiety left him frightened to the point of paralysis most of the time, and depending on where he was, he was afraid to leave his house or apartment. When he could not avoid being with people, he had to make a superhuman effort to pretend that everything was normal, and when others treated him as if everything was as it always had been, he was both upset and amazed that no one could sense his despair or realize how troubled he was. His night fears were overwhelming, so he took Ambien to help him sleep. Sometimes it made him wake up happy, but the feeling never lasted for long.

By early December 1998 he feared that his depression was intractable and that he could do nothing to cure it, either alone or with the help of doctors and psychiatrists. Dr. Jerome Groopman had just become a staff writer on medical subjects for *The New Yorker*; he recommended that Steinberg consult his psychiatrist brother, Dr. Leonard Groopman, who was the first to suggest that Steinberg might benefit from electroshock therapy. When Arne Glimcher learned of Dr. Leonard Groopman's suggestion, he referred Steinberg to the psychiatrist Dr. Frank Miller, who agreed that it could be beneficial and then became the doctor who authorized the treatment. At first Steinberg dismissed the idea out of hand, but eventually he decided that he had no other option.

Prudence was so alarmed when he told her that he would have the treatment that she went to a medical bookstore and bought and read the only book in stock on the subject. The book's introduction gave the history of all the past horrors of shock treatment, but the text described the latest progress, explaining how treatments were much shorter and more controlled than they had been and were surprisingly effective for curing depression in older people. She was unexpectedly reassured by what she read and felt it made her better equipped at Steinberg's next appointment with Dr. Miller, to be "a less naive advocate, since Saul wasn't the type to do research or grill doctors."

The original plan was for Steinberg to have ten or twelve treatments, and originally he did not want anyone but Prudence to know. He changed his mind and told Aldo in a telephone call, but instead of calling Hedda directly, he asked Prudence to go to her house and tell her in person that she was not to worry. His internist, Dr. Tepler, and the psychiatrist, Dr. Miller, both told Steinberg that he would suffer a cumulative loss of short-term memory but would regain it entirely within six to eight weeks. Originally he was to go to the Payne Whitney clinic's psychiatric facility, perhaps as an outpatient, but someone, Prudence remembered, probably one of his doctors, thought he would

need greater privacy to be amenable to the treatment and he was admitted to the Greenberg Pavilion at New York–Presbyterian Hospital.

He was treated every other day from December 16 to December 24, 1998, and was discharged for a short break on Christmas Day. He began a second round of treatments as an outpatient on December 31 but was rehospitalized for further treatments every other day from January 4 to January 13, 1999. He was discharged again on January 15, and by that time, as Prudence remembered, "he was getting a little scrambled (not unpleasantly so) and they didn't want to push him into flat-out incoherence, is how I recall their putting it." She also remembered that Steinberg was "never not himself," and although he did not see anyone but her during the treatment, she did not think any of his close friends would have been able to tell that anything untoward had happened to him.

Prudence was waiting when he was brought back to his room after the first treatment. She was terrified to go in despite hearing from the nurse that he was fine, but the moment she saw him, she was astonished at the change in his expression. "I didn't know then the term 'mask of depression,' but it was simply gone. He fell immediately into easy banter and said he had to call Hedda immediately. And I knew just from the tender way he drew out *Hed-da-a-a*, as if it were the first word he'd ever learned to say and was savoring the syllables, that she would be instantly reassured. She told me later—I'm sure I would have gone there afterward so we could kvell together—that she hadn't heard his voice sound like that in ten years."

Almost immediately he felt so much better that he was able to joke. He was allowed day passes, and just before Prudence collected him to go to lunch in a nearby Turkish restaurant that he liked because the cuisine reminded him of Romania, the nurse took his temperature with a sonar instrument. Prudence had never seen one before and asked what she was measuring; without missing a beat, Saul replied, "Ego." He joked that even with no memory he could still make a bon mot. Dr. Torsten Wiesel came to visit, and the ever-courteous Saul said, "This is Prudence, and this is"—forgetting Torsten's name—"Virtue."

Prudence assumed that because Saul was never bedridden, he had been hospitalized both as a safety precaution because of his age and to make sure he stuck with the treatment long enough for it to be effective. He liked to go for walks around the neighborhood, noticing with pleasure that his physical vitality had returned. He looked at the street scenes with such expectation, as if he were plotting new pictures, and he was so joyful that it gave her joy to see him that way. As his treatments wound down and because it was January and bitterly cold and snowy, Dr. Miller thought it would be a good idea for him to

go somewhere where he could move around easily and consolidate the psychic and physical gains he had made. Prudence was surprised when Saul said he wanted to go to St. Bart's, for he had not been back there since the time Sigrid had had such a serious breakdown that she had to be airlifted back to New York under heavy sedation. She could only guess that he might be testing himself to see if he really had overcome the many emotions connected with Sigrid's suicide, but he may also have chosen St. Bart's because "it was warm, he knew the hotel and could predict the kind of anonymity he would enjoy. And maybe they'd been happy there the time before [her breakdown]." Just before they left, he wrote to Henri Cartier-Bresson, telling him that he thought he would never recover from Sigrid's death but (without mentioning the electroshock treatments) that he was slowly and timidly coming back to life. As he reread what he had written to his old friend, he was convinced that the worst was over.

THEY LEFT FOR ST. BART'S ON MARCH 7, and Steinberg was happy to be back in the same hotel in the same rooms, sitting on the same balcony and looking out at the beach. He sent Sandy Frazier a postcard praising the weather's "many degrees of perfection" and told him how much he was enjoying reading Lytton Strachey's *Elizabeth and Essex*. He particularly relished that she was seventy and Essex thirty-four when she had him decapitated. He was also reading G. M. Trevelyan's *History of England*, pleased with and sharing Trevelyan's liberal political interpretations.

They were there a week when the effects of the electroshock therapy began to wear off. He began to make notations about himself in his datebook on the day they arrived, and on the day after, March 8, he wrote, "Lost memory of part of life made of quarrel [sic] tears, pacify, forgive, no speak. Then again offense, etc." After that, his daily notations were about how his moods varied; how pleasure came from glancing through Prudence's copy of *Moby Dick* and rereading Solzhenitsyn, taking long walks on the beach, and enjoying the local food, but how easily pleasure was replaced by concern. He was carefully calculating his worrisome weight loss in both pounds and kilos and calling Hedda every day, more because he needed her to reassure him that he would stay well than because he simply wanted to talk to her. At the end of March, he was back in New York and summed up the vacation as leaving him "tired and disappointed."

As April began he made a careful note in his datebook about the times and quantities of the medications Ritalin, Dexedrine, and Adderall that he was supposed to take each day but did not. At the same time, Dr. Miller's office was telephoning to implore him to schedule a follow-up appointment and he

was stalling. On April 11, Dr. Miller sent a letter urging him to come to the office for an evaluation: "It is my opinion based on twenty-seven years of work that you will relapse within the year if you do not have either outpatient ECT or attempt to reintroduce an antidepressant." Dr. Miller put the risk of relapse within the year at 65 percent and within eighteen months at 85 percent, saying, "Obviously, this is a serious but avoidable prognosis. You may not appreciate fully the work and effort that went into your diagnosis and I don't want it wasted."

Still Steinberg did nothing. He blamed his increasing lethargy on his loss of appetite and the steady weight loss that resulted. During the last week of April 1999 he had lost so much weight that he consulted his internist, Dr. Tepler, who had him check into the hospital for several days of tests beginning on April 28. Prudence Crowther was at work on April 30, when Steinberg telephoned to say he was putting Dr. Tepler on the line. Dr. Tepler told her that Saul Steinberg had been diagnosed with pancreatic cancer and there was nothing to be done.

"And then I went to the hospital," Prudence recalled. "I don't know if Saul ever actually told anyone else, including Hedda." Although there was the possibility that one of his doctors told Hedda at an appropriate moment that the disease was fatal, Prudence thought it more likely that "maybe we just figured she'd realize soon enough what was happening."

THE ANNUS MIRABILIS OF 1999

The annus mirabilis of 1999. The year of my death—I would guess, calmly.

While he was in the hospital, Steinberg signed a second advance health-care directive naming Prudence Crowther as the person authorized to make decisions about his care and treatment if he became unable to do so himself. Nothing was necessary, as he was in full cognizance, but she organized all the details of his release and contacted the people she thought should know that his pancreatic cancer was so advanced that he would go home to hospice care for what might be a matter of days, a week at the most. By the time he was back in his apartment, Aldo Buzzi and Sandy Frazier were on their way to New York to help Prudence through the final vigil, or, more accurately, to help Prudence help Saul and Hedda get through it.

Sandy slept at a friend's apartment but spent long days at Saul's, while Aldo stayed full-time. He arrived on May 6 and went directly up to Saul's bedroom on the second floor of the apartment, leaving Prudence downstairs in the living area to hear something she had not heard for a very long time: Saul's deep and resonant laughter, a laugh that surely only a friend of such long standing as Aldo could have elicited. Aldo worked hard to make their meeting a joyous reunion, and his effort set much of the tone for how the people who loved Saul would behave as his last days unfolded.

When it came to stoicism, Prudence believed that Aldo could have given Marcus Aurelius lessons. By his own choice, he slept on the living room sofa, rising early to make his bed and clear away the evidence of his habitation and get things ready for the friends who came throughout the day. The apartment was perfectly constructed to hold a vigil for the dying, as Saul's bedroom was

quiet, tranquil, and secluded on the upper floor, while his friends downstairs could cook, talk, laugh, and sometimes cry without disturbing him. There were often many people floating about in the kitchen and dining room, as each of Saul's friends had an orbit of their own friends who wanted to make sure their needs were met while they ministered to his. Vita Peterson was there for Hedda, and among the others was an Italian-speaking friend of Prudence's whom she invited to give Aldo a respite from having to speak English all the time. In an effort to instill levity into the sadness of what was essentially a death watch, Prudence and Aldo agreed that living in a duplex was the best way to ensure a good end.

For the several days before the hospice attendants began their daily visits, Prudence and Aldo took care of Saul, doing everything from helping him sit up in bed to escorting him to the bathroom. Saul was resigned to his end, medications kept him relatively comfortable, and he relaxed in Aldo's care, reassured that Aldo knew what to do because he had had years of experience caring for his terminally ill mother.

On the afternoon of May 8, Prudence recorded in her datebook that the doctors had decided morphine was no longer necessary; she followed this with Aldo's observation that Saul no longer felt pain but his despair had returned. She also recorded some of Saul's remarks to her: "I'm dying, I can feel it—and of something so stupid. And I don't know what I'm dying for." Later that same day, he said, "I'm glad I don't have parents." And even later, when he was drifting in and out of sleep, he said something for which he seemed to want an answer: "a.m. Send everybody home." Prudence asked what about Hedda—should she still be allowed to come every day, and if not, what should she tell her? Saul said, "Tell her to stay home." Sometime later he said, "I want a Parisian doctor to tell me what I have." When he had periods of delirium, he sometimes talked to Sandy in Italian, a language Sandy did not speak; to Hedda in Romanian; once or twice to Aldo, whose mother was German, in what might have been garbled German but was more probably Yiddish. At other times he spoke coherently in English to Prudence.

No one who observed them could forget how tenderly Aldo cared for his dearest friend, particularly Prudence, who thought Aldo may have been suffering greatly inside but admired the way he could still be witty for Saul and enchanting to others. Aldo's demeanor helped to keep everyone on an even keel, and they were all grateful to him. During the week he was there, the only problem for Prudence and Sandy was the delicate one of how to ensure that Aldo and Hedda would be in each other's company only briefly and in passing, for in all the years they had known each other, they had never forged a friendship of their own and maintained cordiality only out of consideration for Saul.

Aldo had to return to Italy on May 10, and in their last encounter, Saul bid his old friend *addio*, an expression he did not use with anyone else, in the most moving and meaningful way. After Aldo was gone, Sandy and Prudence set up a schedule of shifts to make sure that someone would always be with Saul and so that Hedda could be alone with him whenever she wanted. Hedda always went to her own house to sleep, but during the day she stayed close to Saul, either watching him from the staircase while he was being attended medically or sitting at his bedside. Despite the anti-anxiety medications he still took, Hedda was convinced that Saul's sleep had been restless and fitful until Aldo was gone and she began to stay with him; as if sensing her presence, he slept quietly and deeply. But there was something puzzling about Hedda's behavior, as she gave an impression of growing anxiety to the others. At first Sandy and Prudence thought it had to do with Aldo's being there, but when her nervousness continued after he left, they were unsure about what to do until Vita Peterson told them why Hedda was so jittery and uncomfortable.

Saul had long before made Hedda promise that she would be holding his hands when he died, and Hedda had willingly agreed, but now the prospect terrified her, for several reasons: first because she was afraid that he would die at night when she was not there, and then because she feared she might break down in front of him and ruin his last moments of life. Her first fear was soothed soon after Saul was brought back to the apartment, when his doctors realized that the quick end they had envisioned was not going to happen as swiftly as they had predicted and that his death would probably happen in a matter of weeks instead of a few days. Although Prudence would have found a way to make private sleeping quarters for Hedda if she had wanted to move in, Hedda never asked, deciding on her own initiative to sleep at home and spend her waking hours at Saul's. Vita Peterson was the devoted friend who usually accompanied Hedda back and forth, and after Hedda broke down and confided her fears, Vita thought Prudence and Sandy needed to know so they could try to resolve Hedda's uneasiness. From then on, Prudence and Sandy worked out a sensitive and discreet collusion to ensure that someone would be downstairs and ready to run up to assist Hedda in any way she needed.

The last days unfolded with a certain structure imposed by the team of hospice personnel from Mount Sinai Hospital. Early each morning a nurse examined Saul and assessed his condition. Afterward, Prudence telephoned Hedda to give her the report and tell her to come whenever she wanted. Despite the inevitable recitations of daily decline, which were so sad for Hedda to hear, knowing how she would find him before she got there made it easier for her to assume the bedside vigils. She broke down only once, but gained control over herself and recovered quickly. It happened when Dr. Tepler came to examine

Saul while Hedda waited outside on the staircase; when he was finished, he assured her that Saul was not suffering and that he would have all the medication he needed to relieve his pain. She accepted what he said and seemed fine until shortly after, when the retired Dr. Fisch arrived out of friendship to pay his final farewell, at which time she burst into tears. She was more difficult to comfort and calm that time, until Dr. Fisch told her to take one half of one of Saul's anti-anxiety pills when she went home that night. She did, and slept for the first time in a very long time, and when she went back the next day there was a marked change in her ability to cope.

On May 12, the nurse overseeing Saul Steinberg's daily evaluations came downstairs and told the assembled friends that she thought he would die that day. Sandy had spent the night shift with him, and he stayed on while Prudence called Hedda and told her to come at once. They left Hedda alone with Saul, holding his hands to fulfill her promise, while they and some others gathered downstairs to wait for the end. As the day went on, someone asked Prudence if she thought she should go up to check on Hedda. When she entered the bedroom, Hedda, still holding Saul's hands, said, "I don't think he's breathing." Prudence called Sandy to come up, and the three of them sat quietly together for a very long time.

Hedda kept her promise to hold Saul's hands during his last moments, but he was not aware of it, as a morphine pump had been installed a day or two before and he was unconscious. At the time it was installed, Hedda recalled, Saul knew on some level that the end was coming. "I am dying," he told her. "I can feel it, but what am I dying for?" His last words to her were "I am still thinking. Can you hear me?"

"Yes," she told him, "yes."

THE UNCERTAINTY OF HIS PLACE

His choice of media, his use of humor, and his success at The New Yorker *contributed to the uncertainty of his place in the art world. After exhibits at Maeght, Janis, and the Whitney retrospective, people still asked "Is it Art?"*

Saul Steinberg was cremated and his ashes were buried next to Sigrid Spaeth's in the small plot enclosed by the white picket fence and beneath the tree she had planted.

Steinberg made his last will and testament on April 16, 1999, naming his attorney, John Silberman, as one of his two executors. He was the only person privy to the will's content until after Steinberg's death, when he informed Prudence Crowther that she was to be the co-executor. Before he died, Steinberg had told her that he planned to establish a foundation, but he was not specific about the degree of her involvement.

Silberman set up the Saul Steinberg Foundation, following Steinberg's directives as described in its mission statement: "a non-profit organization whose mission is to facilitate the study and appreciation of Saul Steinberg's contribution to 20th-century art." In his will, Steinberg also appointed two other trustees for the original governing board, John Hollander and Ian Frazier. He also heeded Hollander's advice that Yale University would make an excellent repository for his holdings, and the will stipulated that with the exception of a specific bequest of eight drawings to the Whitney Museum, his artworks were to be divided between Yale and the Steinberg Foundation: The university's Beinecke Rare Book and Manuscript Library received his archives and sketchbooks, all works smaller than fifteen by seventeen inches in size, and all the black-and-white *New Yorker* drawings; the foundation retained all works larger than those given to Yale as well as the copyright to all of Steinberg's texts and art.

Besides the generous financial bequests to his friends and associates, some of which he had changed from his 1996 will, Steinberg stipulated that

his residuary estate was to be divided between his niece and nephew, Dana and Stéphane Roman. They received the New York apartment, the property in Springs, and his personal art collection. He left the library in the New York apartment to Anton van Dalen. Hedda Sterne received her choice of whatever personal property had not been effectively disposed of through his other bequests, and Prudence Crowther was designated to distribute the balance of what remained.

All his wishes were either being attended to or were fully satisfied by the time his family and friends gathered for the memorial service on November 1, 1999, at the Metropolitan Museum of Art. The invitation featured a playful photo of Steinberg taken by Sigrid Spaeth in which he holds a large leaf that almost covers his face; the program featured another photo, taken by Evelyn Hofer, of an almost smiling Steinberg wearing one of his trademark tweed caps and posing in front of one of the antique postcards in his collection, a Russian street scene that he had enlarged to poster size.

Hedda Sterne chose not to attend the ceremony, but Steinberg's niece and nephew came from France, and the American cousins attended as well: his uncle Martin's descendants, Judith Steinberg Bassow and her family, came from Denver, and those of his uncle Harry came from the East and West Coasts. The ceremony began with Gioacchino Rossini's *Duetto buffo di due gatti* and ended with one of Steinberg's favorites (also by Rossini), *La Passeggiata.* Dr. Torsten Wiesel introduced the six speakers: Leo Steinberg, Norman Manea, John Hollander, Mary Frank, Ian Frazier, and Saul Bellow.

Bellow spoke last, following five moving personal accounts of what the speakers' friendship with Saul Steinberg meant to them. He was the only one who puzzled and dismayed some in the audience with remarks that seemed to be more about himself than about the man he was supposed to eulogize, offhandedly dismissing the friendship that Steinberg thought was one of kindred souls as little more than occasional meetings imbued with goodwill and cordiality. "Each of us wished the other well," Bellow said. "But when he . . . was seriously up against it I had no relief to offer him. I learned with astonishment that he had died of cancer."

The other tributes reflected the variety of relationships Steinberg had formed throughout his life and revealed many different facets of the man he was. Leo Steinberg described how some of the juxtapositions within Saul Steinberg's oeuvre were "the most biting satire arriving always in draftsmanship of sweet open-faced innocence, instantly loveable." Norman Manea offered insights into the friendship that had developed because of his and Steinberg's shared Romanian heritage, recalling a telephone conversation when Steinberg

asked how he was and Manea replied that he was well. Steinberg insisted that that was impossible: "We carry a curse, the place from which we come, we carry it inside us. It doesn't heal easily. Maybe never."

John Hollander spoke as the friend who was also a scholar and critic of Steinberg's work and of how difficult it was to define his place within the broad spectrum of twentieth-century art. Hollander remembered hearing, when he was a perplexed teenager, Steinberg dismissed as a cartoonist even as his work was being shown at MoMA. Hollander said that if the art world persisted in classifying Steinberg as a cartoonist, it might be as one like Daumier but more likely as one akin to William Blake, for like Blake, he was a "visionary intellectual satirist, rather than a narrowly political one."

Mary Frank came next, surprised by her invitation to speak despite the long and deep friendship with Steinberg that made her an obvious choice. Her remarks were the briefest and the most Steinbergian, to use the adjective that always gave its eponym enormous pleasure whenever he heard it. Frank listed the subjects of some of their conversations over the years: "the dreams of cubes," "rubber stamps of teeth used by dentists," whether horizons were "the future or the past," and "how at dusk, the day (which is painting), turns into night (which is graphics)." She praised Steinberg as "a profound visionary artist who was prophetic from so far back about this country and our lives." Her remarks touched the audience as she ended on a personal note: "Saul, in dreams I cry over you."

Ian Frazier evoked a similar response when he told how he found himself seeking the company of others who loved Steinberg just to be able to share memories of the man everyone agreed was "a marvel in nature." Frazier captivated the listeners as he told of Steinberg's adventures in teasing the U.S. mail delivery system, citing Hedda Sterne's contention that "reality accommodated Saul." Quoting Sterne, Frazier spoke of Saul's "great tenderness for the world" and of how he would suddenly turn to a friend, put out an arm, and demand, "Embrace me." "And you would embrace him," he concluded.

THE MEMORIAL SERVICE TOOK PLACE six months after Steinberg's death, but the tribute paid by his *patria*, *The New Yorker*, came a swift twelve days after he died, when the May 24 issue featured a cover drawing and a three-page spread accompanied by Adam Gopnik's tribute, which called Steinberg "the greatest artist to be associated with this magazine and the most original man of his time." His death, Gopnik concluded, "takes a world away."

The obituaries, articles, and other tributes were instantaneous and worldwide, laudatory but nevertheless equivocating, as, like John Hollander in his

memorial eulogy, they all addressed the question of where to slot Steinberg within the history of twentieth-century art. None seemed able to take a stand, let alone come to a decision. The Italian newspaper *La Repubblica* devoted an entire page to an obituary and three related articles that asked and then evaded the question by concentrating instead on Steinberg's Italian ties and his love of all things Milanese, especially the dialect. In France, *Libération* also allotted Steinberg a full page, arguing that his fame was such that it would be necessary to invent a special cenotaph in which to place him, while *Le Monde* agreed that despite his fame as an artist, he was nevertheless impossible to classify. In an appreciation in the *New York Observer*, Hilton Kramer praised Steinberg as one of the best-known and most admired artists of his time but wondered why, curiously, he was never written about or seldom mentioned in the many historical studies of twentieth-century art.

The question of what to call Steinberg and where to place him preoccupied those who wanted to lay him to rest in a tidy little time line and those who wanted to send him into artistic eternity with honor and praise. A prime example of the dichotomy appeared in the front-page obituary in the *New York Times*: the headline writer called Steinberg an "epic doodler," while the writer Sarah Boxer described him in her first sentence as the "metaphysically minded artist and cartoonist" who was solely responsible for raising illustrated comics to fine art. Michael Kimmelman echoed most others when he described Steinberg's "in-between status in the art world" and wondered why American cartoonists such as R. Crumb were considered major artists while Steinberg was ignored. Art Speigelman was more succinct as he evaded the debate entirely: "He was neither cartoonist nor painter. He was Steinberg." Boxer gave the most sustained attempt at categorization in her obituary when she repeated much that Harold Rosenberg had written in his essay for the Whitney retrospective catalogue. She noted how many comparisons had tried to place Steinberg among painters like Picasso and Klee, writers like Beckett, Ionesco, and Joyce, and even the film antics of Charlie Chaplin. But then she veered into what almost every other obituary would cite, if not actually stress: that he was known best of all as "the man who did that poster."

The critic Peter Plagens dubbed Steinberg's famous poster "the most iconic image in American art since Grant Wood's *American Gothic*," and if the many ways it was used in various media were proof of the contention, it certainly was. "Only he could have dreamed up the poster," Robert Hughes insisted, while Jean Lemaire called it quite simply "Steinberg's most famous composition," Steinberg himself often said he could have retired on that poster if royalties had been paid for all the rip-offs and knockoffs, but, as Boxer wrote, "They weren't, and he didn't."

———

BUT STILL, WHERE TO PUT HIM? The question proliferated in the years after his death until 2007, when a major retrospective of Saul Steinberg's art was organized by Joel Smith for the Frances Lehman Loeb Art Center at Vassar College. It then moved to the Morgan Library and Museum in New York before traveling for a full year to other museums throughout the United States. A major publication accompanied the exhibition, *Saul Steinberg: Illuminations*, and even though it was intended to be the first comprehensive study of Steinberg's contribution to twentieth-century art, it too raised the question—albeit obliquely—of how to classify Saul Steinberg and where to put him. The jacket copy described how the book was designed to show Steinberg's evolving vision through his many different kinds of artistic activity and stated the book's intention as one of raising "fundamental questions about the historiography of modernism and the vexed status of 'the middlebrow avant-garde' in an age of museum-bound art."

Steinberg's friend Charles Simic wrote a brief introductory essay for the volume that summed it up best: "Seven years after his death, Saul Steinberg is both a familiar name and an artist in need of discovery. This strange, posthumous fate would have puzzled him and confirmed his suspicion that the critics never had any idea what to do with him." Steinberg addressed this himself, way back in 1973, when he told a newspaper reporter, "I don't quite belong to the art, cartoon, or magazine world . . . they just say 'the hell with him.' They feel that he who has wings should lay eggs." He placed his work squarely in "the family of Stendhal and Joyce," with a half-nod toward Goya. Like them, his purpose was to provoke his audience into looking for something beyond mere perception. "That's what I'm playing with," he insisted, "the voyage between perception and understanding."

In the end, he was content that he had become what he wanted to be: "I am the writer who draws."

ACKNOWLEDGMENTS

When I began the research for this book, I contacted as many of Saul Steinberg's friends as I could find to ask them to tell me about their friendships. Almost every single time I received the same reaction: a radiant smile would cover their faces and the first thing they would say was usually something along the lines of "Dear Saul. What a wonderful man he was, and oh how I miss him!" They were delighted that a biography was underway and they all offered immediate and generous cooperation.

As we talked about Steinberg's work, I was particularly intrigued by the stories they told of memorable occasions they had shared, and of the spontaneous drawings Steinberg had made as gifts to commemorate them. They generously offered to let me use those drawings and anything else in their collections that I might need to tell their "Saul stories." How I wish I could have taken advantage of these vignettes of the friendships that made his life so rich and full. Instead, I had to content myself with writing about but not showing them, because I was constrained by the Saul Steinberg Foundation's decision to limit my use of his art to a total of thirty-five examples. I was able to secure these permissions through the generosity of Lisa de Kooning, who knew and loved Steinberg all her life and who provided a generous grant from the Willem de Kooning Foundation.

Six of the thirty-five examples of Steinberg's art were not under the Foundation's direct control. Three of the six came through the generosity of the trustees of the Hedda Sterne Foundation, all of whom were willing to grant me the use of as many images as I needed in order to tell the story of Saul and Hedda. I regret that the restrictions imposed by the Steinberg Foundation

meant that I could use only three. I am grateful to Hedda Sterne's trustees for their hard work on my behalf as they gathered photocopies of her work and allowed me to choose whatever I wanted. I express my deep gratitude to them: Sarah Eckhardt, Michael Hecht, Sanford Hirsch, Veronique Lindenberg, Gordon Marsh, and Karen Van Lengen. I wish especially to thank the late Hedda Sterne herself, whom it was a privilege and an honor to know. The friendship she gave me and the hours I spent with her in happy conversation will be one of the most important and lasting memories of my professional life.

Anton van Dalen, Steinberg's studio assistant for forty years, was a good friend to this book. He has most generously contributed the remaining three Steinberg drawings, and some of the photos here are from his private collection. He allowed me to roam at will through the books in Steinberg's personal library that were bequeathed to him, and he shared his memories and his archives.

Claire Nivola's collection of Steinbergiana is stunning in its originality and provides such a lovely history of the Nivola family's important friendship with Steinberg that I regret I could only write about it and not show it. I thank her and her husband, Gus Kiley, for their hospitality and support.

I wish I could write a mini-biography about each of the "friends of Saul" who shared their memories with me, but I must content myself with simply listing their names and assuring them of my gratitude. Among the Steinberg Foundation's trustees I thank Prudence Crowther, Ian Frazier, Jeffrey Hoffeld, and John Hollander for interviews; John Silberman and Donn Zaretsky for smoothing prickly paths. Steinberg's niece and nephew, Daniella and Stèphane Roman, in Paris, Nice, and East Hampton, were generous with family archives and gracious hospitality; so, too, were his cousins, Sol and Judith Steinberg Bassow, from their home in Colorado.

Among Steinberg's friends whom I wish to thank are: Ellen Adler, Roger Angell, Anna Aragno, Geraldine Aramanda, Dore Ashton, James Atlas, Marion Barthelme, Adam Baumgold, Ann Birstein, Aldo Buzzi, Gabriella Canfield, Ivan Chermayeff, Christo and Jeanne Claude, Arthur Danto, Richard Fadem, Russell Flinchum, Mary Frank, Nathan Garland, Mimi Gross, Elizabeth Hollander, Del Leu, Sabra Loomis, Lee Lorenz, George P. Lynes II, Norman and Cella Manea, James Marcus, Kevin Miserocchi, Eleanor Monro, Ruth Nivola, Vita Peterson, Mark Podwal, Gordon Pulis, Charles Simic, Benjamin Sonnenberg, Jeanne Steig, Jean Stein, Alexander Stille, Mario Tedeschini Lalli, Wendy Weil, Michelle White, and Drenka Willen.

Saul Steinberg left 177 boxes of archives to Yale University's Beinecke Library. These include personal and professional correspondence, tax returns

and financial documents, address books, daily appointment books and calendars, photos, objects collected in his travels and his postcard, stamp, comic book, and other collections. He saved everything, from takeout menus from his neighborhood restaurants to the baby bib crocheted by his mother. It took me almost six months of daily reading to go through these boxes, and as I did I gave thanks that I live in New Haven. The staff at the Beinecke Rare Book and Manuscript Collection was unfailingly kind, and I wish to thank Patricia Willis, Karen Nangle, and all those at the front desk who cheerfully grew muscles hoisting my boxes. Other research institutes that aided my research were the Archives of American Art at The Smithsonian Institution, the Tee & Charles Addams Foundation, the University of Chicago Special Collections, The Getty Research Institute Research Library, and the Menil Collection.

Writers are so lucky to have people in their personal life who do so much to ease the transition from scrawl to manuscript, and here again I'd like to write at length about all those who helped me, but I can only single out some. There are not enough thanks for the distinguished editor and dear friend John R. Ferrone, who gave me daily counsel, support, and friendship. I would have been lost without it. Aileen Ward has been a cherished mentor and one of the most important contributors to every aspect of my life and work. If a book can be said to have a fairy godmother, it is certainly Priscilla Morgan, who smoothed my path in too many crucial instances to mention here. Her indefatigable generosity of spirit was an inspiration. Kenneth and Roberta Nesheim gave me sound professional advice along with a personal friendship of so many years' standing we have all lost count. My friendship deepened with two good friends from my years in the world of Simone de Beauvoir: I had only to mention that I needed editing help for Mary Lawrence Test to step in and do it, and, in research, Myrna Bell Rochester always found what I needed. I had several unfortunate computer hacking incidents as I wrote, and my friend, neighbor, and computer guru Thomas Henderson bailed me out of every one of them. Allison Stokes expanded my world by taking me into hers; I counted on Sydney Stern, the "other Gem," for great book talk and interesting explorations along unusual byways.

Other friends contributed in so many ways: Lina Alpert, Neil Baldwin, Elissa Bruschini, Carol Chiodo, Lisa Corva, Nancy Cardozo Cowles, Patricia DeMaio, Jane Denning, Jay Edelman, Diane Jacobs, Laurence Lockridge, Elaine Lewis, Kenneth MacKenzie, Nancy MacKnight, Marion Meade, Jean Nathan, Patricia O'Toole, Joan Schenkar, Kenneth Silverman, Eoin and Maeve Slavin, Stephanie Steiker, Rosemary Sullivan, Beverly and Barry Wellman, and Lawrence Weschler.

At Nan A. Talese/Doubleday, I had the great good fortune to work with Ronit Feldman on editorial matters and Katherine J. Trager on legal issues. Emily Mahon designed the jacket, Pei Loi Koay was the interior designer, and Liz Duvall was the copy editor—all three were brilliant and I thank them. Our production crew included Roméo Enriquez, and for marketing and publicity, respectively, I thank John Pitts and Kristen Gastler.

Most of all, I must thank the inimitable Nan Talese, who makes beautiful books, and with this one—despite sometimes insupportable problems—produced one of her best. Her patience and support sustained me for several years, and it is my privilege to count myself as one of her writers. I say the same about my agent, Kristine Dahl, whose client I am privileged to be, and I thank Kris and her assistant, Laura Neely, who both make things happen in a flash.

Moving to the truly personal, I am fortunate to have such amazing adult children and I thank the talented four: Katney Bair, Vonn Scott Bair, my son-in-law Niko Courtelis, and my "Swedish son" Bjorn Lindahl. My granddaughter, Isabel Courtelis, continues to amaze and delight me, and now she fixes my computer (how lucky can you get?). This book is also for the memory of Lavon H. Bair.

My siblings give professional as well as personal support: my brother Vincent J. Bartolotta Jr., takes care of the legal, and his wife Judy, and my sister Linda Rankin, provide the medical. My cousins keep our large family united: Toni Jo and Archie Allridge, Leah Balliard, and all the Bartolottas: Joan and Bart, Camera, Devin, and our memory of Robin.

Finally, this book is dedicated to the patriarch of our family, my uncle Aldo L. Bartolotta, who makes everyone smile when he tells them he never had a bad day. "No wonder," says his wife, my Aunt Joan. "He gave them all to me."

NOTES

ABBREVIATIONS

Wherever possible, I have used the same abbreviations used by The Saul Steinberg Foundation.

ARCHIVES

AAA/DC: Archives of American Art, Smithsonian Institution, Washington, D.C.
HR/Getty: The Harold Rosenberg Papers, 1923–84, Getty Research Institute, Research
 Library, Accession 980048. Box and folder numbers are cited here.
SSF: The Saul Steinberg Foundation, New York. SSF holds artwork by ST, some original
 archival material, and other documentation related to the artist's life and work.
WMAA: *Saul Steinberg*, text by Harold Rosenberg. Publication of the 1978 retrospective at the
 Whitney Museum of American Art (New York, 1978: Alfred A. Knopf in association with
 the Whitney Museum of American Art).
YCAL: The Saul Steinberg Papers, Yale Collection of American Literature, Beinecke Rare Book
 and Manuscript Library, Yale University. ST bequeathed his papers, sketchbooks, and
 smaller artworks to the Yale University Art Gallery. As of 2011, YCAL Uncat. Mss. 126
 contained 133 boxes of papers and nearly forty boxes of drawings.

FREQUENTLY USED NAMES

AB: Aldo Buzzi
Ada: Ada Ongari Cassola
DB: Deirdre Bair
HS: Hedda Sterne
IF: Ian Frazier
MTL: Mario Tedeschini Lalli
PC: Prudence Crowther
SS: Sigrid Spaeth
ST: Saul Steinberg
TNY: *The New Yorker*

FREQUENTLY CITED WORKS

R & S: *Reflections and Shadows* by Saul Steinberg with Aldo Buzzi. Trans. John Shepley.
 New York: Random House, 2002.

R & S Outtakes: Unpublished portions of *Reflections and Shadows*
Romanian letters: Family letters in Romanian are in YCAL, boxes 5–8, 12, 14, 56, 67, and 86,
 mostly in correspondence folders. The letters were scanned, organized, and when neces-
 sary dated by Iain Topliss, who supplied a set of the scans to SSF. The translations made
 for SSF are by Emil Niculescu, © SSF. Hereafter "Romanian Letters," SSF.
S:I: *Saul Steinberg: Illuminations* by Joel Smith. New Haven: Yale University Press, 2007.
WMAA: *Saul Steinberg*, text by Harold Rosenberg. Publication of the 1978 retrospective at the
 Whitney Museum of American Art (New York, 1978: Alfred A. Knopf in association with
 the Whitney Museum of American Art).

CHAPTER TWO: A DECIDEDLY PECULIAR PLACE

3 **Romania, a half civilized:** Marie, Grand Duchess of Russia, *A Princess in Exile* (New
 York: Viking, 1932), p. 32.

3 **for him to be born there:** Paul Cummings, "Saul Steinberg Interviews, March 27,
 1973," Archives of American Art Oral History Program, Smithsonian Institution, Wash-
 ington, DC 20560, unpaginated transcript.

3 **His parents celebrated June 14:** Various sources supply different dates for the gradual
 adoption of the Gregorian calendar among the Catholic, Orthodox, and Greek Ortho-
 dox portions of Romania. When ST came to the United States, he celebrated with his
 closest friends on June 28, but he told everyone else the date was June 15. ST's niece
 and nephew, Dana and Stéphane Roman, both believe the family celebrated on June
 14, as did his wife, Hedda Sterne, but on June 28, 1994, he wrote that he was celebrat-
 ing his eightieth birthday: "b. June 15, 1914 in the old style (Julian Calendar, changed to
 Gregorian-new style by adding 13 days. 15 + 13 = 28." From spiral notebook, June 1994,
 YCAL, Box 95.

4 **Cuza proclaimed the founding:** Historical information comes from Mrs. Will Gordon,
 Roumania Yesterday and Today (London: Bodley Head, 1919), p. 62; Edward Behr, *Kiss
 the Hand You Cannot Bite* (New York: Villard, 1991), p. 35; and Barbara Jelavich, *His-
 tory of the Balkans* (Cambridge: Cambridge University Press, 1983), vol. 2, p. 4.

5 **forced emigration of Romanian Jews:** Edward Mandell House and Charles Seymour,
 eds., *What Really Happened at Paris: The Story of the Peace Conference, 1918–19, by
 American Delegates* (New York: Scribner, 1921), p. 220.

5 **served two terms:** ST, diary entry in spiral notebook, April 23–July 5, 1991, n.d. but it
 follows May 19, YCAL, Box 75.

5 **whose patronymic was never recorded:** A note on Moritz Steinberg's birth certificate,
 nr. 366/1877, issued by the Husi City Hall, states that his official name was Herscu Frid-
 man. In a document entitled "Genealogy—Rotman" (the original married name of ST's
 sister, later known as Lica Roman), copy SSF, there is mention of an authentic notarized
 document, nr. 719, of October 1918, from the Fourth Court in Bucharest, stating that
 Moritz Steinberg is the same person as Herscu Fridman. There is no mention of this
 name or its change or correction in any other official documents presently known (as
 of 2012) to ST's heirs or SSF, or in the family genealogy prepared by Judith Steinberg
 Bassow (Martin's granddaughter), who graciously made originals in her possession and
 copies available to me. Bassow prepared her genealogy with the cooperation of ST, and
 in one of the corrections and additions in his hand, he wrote that his grandmother Clara's
 name was sometimes given as Hinke and that she died in 1931. To write the family gene-
 alogy, I also consulted ST's letter to his niece, Daniela (Dana) Roman, February 9, 1991;
 ST's correspondence with AB, published in Italian as *Lettere a Aldo Buzzi, 1945–99*, ed.
 Aldo Buzzi (Milan: Adelphi, 2002); and an unpublished English translation by John
 Sheply (through 1977) and James Marcus (1978–99), made for SSF. Also *R & S* and *R
 & S Outtakes*. Some genealogical documents that are also in possession of SSF can be
 found in YCAL, Box 9.

5 **two of Moritz's brothers:** Berl Steinberg settled in Arizona. His son, Phil, became one of ST's favorite relatives and correspondents. For a photo showing Phil's uncanny resemblance to ST, see *S:I*, p. 263. Family correspondence (where appropriate in later chapters) will show that Harry Steinberg and his daughter, Henrietta Danson, were instrumental in bringing ST to the United States in 1941; that Martin Steinberg assisted; and that later, he and his son, Charles, joined ST in providing financial support for relatives who had settled in Israel.

6 **The Steinbergs had been Romanian:** ST occasionally joked (as he did in ST to AB, March 18, 1988) that he should have called himself Saul Tiraspol, for that was a better name for an artist than Steinberg.

6 **living in Walachia for at least six generations:** ST, diary entry in spiral notebook, n.d., but following May 19, 1991, YCAL, Box 75; Dana Roman, interview, January 7, 2008; Stéphane Roman, interviews, January 12 and 13, 2008. Unless otherwise noted, genealogical information comes from these interviews and from the Steinberg family genealogies prepared by Judith Steinberg Bassow.

6 **the family had taken the name Jacobson:** Iancu is the Romanian form of Jacob, Itic is Isaac. Norman Manea, interview, June 11, 2008, told me that Jacobson would be a logical Westernization of this name.

6 **"a peculiar sort of Romanian":** Cummings, "ST Interviews."

6 **"trussed [them] up":** Hannah Pakula, *The Last Romantic: The Life of the Legendary Marie, Queen of Roumania* (New York: Simon & Schuster, 1984), p. 116. Pakula is quoting in part Ethel Greening Pantazzi, *Roumania in Light and Shadow* (Toronto: Ryerson, n.d.), p. 77. The eye shadow information is from Norman Stone, *World War One* (New York: Basic Books, 2009).

7 **military figures that later populated his grandson's art:** See, for example, ST's commercial drawing for the jacket cover of Stephen Borsody's *The Tragedy of Europe* (New Haven: Yale Concilium on International and Area Studies, 1980). See also *R & S*, p. 8, for ST's father in uniform. Other examples of ST's art, particularly in the 1980s, are replete with military figures and are cited in later chapters.

7 **the pleasure of looking at girls:** ST to AB, May 24, 1996, SSF.

7 **When he wrote down:** Diary entry in spiral notebook, May 24, 1991, YCAL, Box 75.

7 **married there on December 6, 1911:** The name of Rosa Steinberg's father was inserted into hers on the marriage license. Diary entry in spiral notebook, n.d., but following May 19, 1991, YCAL, Box 75.

7 **was born prematurely:** This, and information that follows unless otherwise noted, is from a genealogy of the Steinberg/Roman family (Lica Steinberg married Ilie Roman in Bucharest on April 29, 1942) prepared by Judith Steinberg Bassow and annotated by ST, from versions of the ST/Bassow genealogy and others in SSF, from interviews and conversations with Daniela Roman, January 7, 2008, and Stéphane Roman, January 12 and 13, 2008, and from e-mails and telephone conversations with Judith Steinberg Bassow throughout 2010–11.

8 **Rosa kept him bedridden for six months:** Daniela Roman, interview, July 24, 2007, Amagansett, N.Y.

8 **"the General:"** Daniela Roman, in conversation, July 25, 2008, Amagansett, N.Y.

8 **began to feature Zia Elena:** Zia Elena first appeared in the Italian satirical newspaper *Bertoldo* when ST was a student in Milan. For examples, see *S:I*, fig. 12, pp. 26–27 and p. 87, fig. 2.

8 *sub rosa:* ST, diary in spiral notebook, May 19, 1991, YCAL, Box 75.

8 **a "horror" and a "terrorist":** These terms were used in interviews and conversations in 2007–8 with Dana and Stéphane Roman; HS, interviews and conversations, 2007–8; Ruth Nivola, interview, July 24, 2007; ST's YCAL correspondence and diaries (one example being YCAL, Box 75); ST's letters to HS at AAA/DC. In conversation, May 7, 2008, HS insisted that "you [DB] can never say too strongly how much Saul hated his mother. He despised her."

9 **Moritz told Rosa he had a daughter:** Dana and Stéphane Roman were unable to find genealogical proof to support a rumor in the Steinberg family that Moritz had been legally married to Sofia's mother, who died in childbirth, the date being variously given in family records as September 4 and September 11. They did verify that Sofia was raised by her mother's family, and a photo of her is in the Steinberg family album originally kept by Rosa and Moritz and now in possession of Dana Roman, copy in SSF. The photo caption states that Sofia Steinberg was ST's half-sister and gives her birth date as September 11. In diary entry in spiral notebook, n.d., but following May 19, 1991, YCAL, Box 75, ST writes of a possible early marriage in Braila and posits that the daughter's name may have been Rebeccah and her birth date September 4, 1911.

9 **Saul's memory of this family drama:** ST, diary entry in spiral notebook, n.d., but following May 19, 1991, YCAL, Box 75.

9 **There were many things she thought were her due:** HS, interview, September 9, 2007. All examples of Rosa's behavior are from this interview.

10 **"radar with mother":** ST gave "Examples of Radar with Mother" in a diary note, January 7, 1960, YCAL, Box 3. Norman Manea wrote of it in "Made in Romania," *New York Review of Books* 47, no. 2 (February 10, 2000).

10 **"the only taboo":** Cella and Norman Manea, interview June 11, 2008, New York.

10 **"the perfect intangibility of love":** HS, conversation, May 7, 2007.

10 **He was between six and eight months old:** ST, diary entry in spiral notebook, n.d., but following May 19, 1991, YCAL, Box 75. In ST to AB, November 1, 1988, ST writes that he lived in Râmnicul-Sărat for only six months "and then goodbye, off to [Bucharest]." He is vague and somewhat contradictory elsewhere about where they lived during his father's desertion, which makes it seem that they also lived in Buzău with him.

11 **"prehistoric monster":** ST to AB, September 29, and October 1, 1998.

11 **Saul's strongest memory:** ST to IF, Friday, July 10, 1998, copy in YCAL, Box 33.

11 **Goaded by Rosa:** ST to AB, October 2, 1988.

11 **Strada Soarelui:** Ibid.

12 **he strutted proudly:** Norman Manea, interview, June 11, 2008, and "Made in Romania."

12 **Rosa always managed to find fault:** HS remembered ST talking about these instances. Stéphane Roman verified memories of his mother saying the same. Dana Roman remembered how her grandmother constantly recalled earlier slights as if they were contemporary ones.

12 **"not such a great invention":** Robert Hughes, "The World of Steinberg," *Time*, April 17, 1978, p. 96; reprinted as "Saul Steinberg," in *Nothing If Not Critical: Selected Essays on Art and Artists* (New York: Penguin, 1992), pp. 260–61.

12 **"extremely high":** Hughes, *Nothing If Not Critical*, p. 260.

12 **"the smell of an artist's studio":** See, for example, *R & S*, pp. 4–7; ST's *Ex-Voto*, SSF 3341. ST's correspondence with AB also contains many such references.

13 **"the secret language of my parents, Yiddish":** Hughes, *Nothing If Not Critical*, p. 260. Other references to Yiddish include ST to AB, September 29, 1981, SSF; Jean Frémon, "Conversation avec Saul Steinberg," *Repères* no. 30, 1986 (Paris: Galerie Maeght Lelong), p. 17.

13 **"the *Thousand and One Nights*":** *R & S*, p. 17.

13 **Jacques's formidable wrath:** Ibid., p. 18.

13 **"Réveille-toi, Roumain":** ST to AB, October 7, 1990. ST was reading Cioran's *History and Utopia*, which he believed "amply explains the Romanians, including me." *R & S*, p. 18.

13 **one of the largest red-light districts:** *Pezzetti*, "Memories of Romania," mss. p. 52. ST made these remarks in an unpublished section of the ms. that became *R & S*. After his death, AB sent a group of outtakes to SSF, among them this one; all were translated by James Marcus and are cited as *R & S Outtakes*. A small selection was published as "Saul Steinberg: Portraits and Landscapes," *Paris Review* no. 195 (Winter 2010): 27–36.

13 **The activity was especially fascinating:** ST related the incident that follows to Mary Frank; Mary Frank, interview, January 25, 2009.

14 **"a fat lame man":** *R & S*, p. 20.

14 **adult penchant for casino gambling:** IF, interview, October 12, 2007; *R & S*, p. 19.

14 **"almost all of them thieves":** *R & S Outtakes.* The Marcovic family emigrated to Israel. Their name is written also as Marcovici in some of the family correspondence translated as Romanian letters, SSF. Reference is also to *R & S*, p. 17.

14 **he was content to pore over them:** HS, interview, May 8, 2007; ST, "Wartime Diary" (SSF renamed it "Journal, 1940–42"), now in YCAL, Box 89, Folder "Tortoreto 1940–42." Also, drawing bearing the date August 19, 1941, Ciudad Trujillo, YCAL, Box 20. Information also comes from interviews and conversations with HS throughout 2007.

15 **"thinking angel":** *R & S*, p. 12; see also SSF 2736–38.

15 **"suffering profession":** Cummings, "ST interviews."

15 **"a man on horseback":** "How I Draw," *R & S Outtakes.* Ferdinand I was king of Romania from 1914 to 1917. ST depicted the king, the queen, and their entourage in the 1966 drawing "Strada Palas," WMAA, p. 133.

15 **"Remember," he instructed himself:** Geert Mak, *In Europe: Travels Through the 20th Century*, trans. Sam Garrett (New York: Pantheon, 2007), p. 767: "Bucharest is a city of more than two million inhabitants, with an estimated 300,000 stray dogs. You see dogs everywhere, alone or in packs."

15 **Steinberg heard his mother and aunts:** ST to HS, May 10, 1944, AAA. See also *S:I*, "Bucharest in 1924," p. 180.

16 **Critics compared him:** These comparisons appear in a far-ranging series of taped conversations with Grace Glueck, which were eventually edited into her article "The Artist Speaks: Saul Steinberg," *Art in America*, November–December 1970, pp. 110–17. A copy of what appears to be the original tape transcripts is in the Archives of American Art, Smithsonian Institution. Several revisions by Glueck and ST were made later, and copies are in YCAL, Box 16, Folder "16: Correspondence 1967," and YCAL, Box 8, Folder 28.

16 **"Too many geniuses":** Sergio Zavoli, "Saul Steinberg: Intervista Televisiva con Sergio Zavoli," electronic file, Italian television network RAI, 1967. For comparisons with Klee, see also *S:I*, p. 82 and p. 236, n. 1; p. 168 and p. 245, n. 113.

16 **"To solve once and for all":** Glueck, copy of original transcript of unedited tape, pp. 19–20, AAA.

16 **"every explanation":** Ibid., p. 12.

16 **"a line is a thought that went for a walk":** Among them were HS, interview, November 13, 2007; Dore Ashton, telephone conversation, February 22, 2010; Dr. Mark Podwal, interview, July 10, 2008; Christo and Jeanne-Claude, interview, August 9, 2007. The actual quotation is "Die Linie ist ein Punkt, der spazieren geht" (a line is a dot that went for a walk).

17 **"the same one I acquired back then":** Glueck, early revised and edited transcript of "The Artist Speaks," YCAL, Box 8, Folder 28.

17 **Steinberg's earliest extant drawing:** The kindergarten photo is reproduced in *S:I*, p. 84; the photo itself is in YCAL, Box 20, Folder "Early Photos."

17 **Both are charcoal:** ST always insisted that he had never had formal training in art; he told Grace Glueck, "I never went to an art school or anything" (original transcript, p. 20), but he did attend drawing classes in high school and also had architectural drawing classes at the Politecnico, as discussed in subsequent chapters.

17 **One is a six-sided pyramid:** The pyramid is on a charcoal sheet, framed (probably by ST as an adult), 9½ x 11½ in. on laid paper, now in SSF; the portrait of Moritz is 38 x 28 cm (sight), framed, done before ST went to Milan in 1932, kept by his parents, and either given to or inherited by Lica Roman. It hung in her house in Cachan, France, and is now in the collection of Daniela Roman. Unfortunately, neither drawing is of reproduction quality.

17 **an aura about the portrait:** HS, conversations throughout 2007–8; Norman and Cella Manea interview, June 11, 2008; ST to AB, particularly letters written between 1996 and 1999; ST's diary writings, YCAL, Boxes 75 and 95.

17 **"pure Dada":** Dore Ashton, telephone conversation, February 22, 2010, in regard to a typed early version of the article "What I Draw Is Drawing," in *Saul Steinberg*, 7 Febrero–7 Abril 2002 (Valencia, Spain, Institute Valencia d'Art Modern), English translation, pp. 152ff.

CHAPTER THREE: A WUNDERKIND WITHOUT KNOWING IT

18 **Saul liked to tell the story:** HS, interview, April 18, 2007.

18 **"a culturally born Levantine":** Hughes, *Nothing If Not Critical*, p. 260.

18 **he too had to get out:** Norman Manea, "Made in Romania," and ST in conversation with Karl Meyer, then a reporter for the *Washington Post*, who was interviewing him for the feature story "Steinberg Looks at Washington," October 1978; also Karl Meyer, interview, September 1, 2007.

18 **an outsider and an observer:** These two words occur frequently throughout his correspondence with AB and were often told to me in interviews and conversations by (among many others) HS, Ruth Nivola, IF, Norman Manea, and Benjamin Sonnenberg.

18 **He received no feeling of normality:** *R & S Outtakes*, and mss. pages in YCAL, Box 38.

18 **"sewer" of a country:** ST to AB, unpublished portion of letter dated May 31, 1982, SSF.

19 **"most important and strongest memories":** Jacques Dupin, "Steinberg 1971," in *Steinberg: Derrière le Miroir*, no. 192, June 1971.

19 **It was only then:** ST to AB, unpublished portion of letter dated June 12, 1986; *R & S Outtakes* and YCAL, Box 38. As these letters have only been privately translated into English but not published by SSF, I do not distinguish here between the published and unpublished portions in the Italian book, because I have no way of knowing what may or may not eventually appear in an English publication.

19 **"Levantine people":** Cummings, "ST Interview," AAA.

19 **"Paris of the Balkans":** Behr, *Kiss the Hand*, p. 75.

19 **a study in contrasts:** Mak, *In Europe*, p. 771; Behr, *Kiss the Hand*, p. 75.

19 **"a mixture of honey and shit":** ST to AB, February 27, 1985. ST was referring to Philip Glazebook's *Journey to Kars*, which he praised.

19 **Strada Palas 9:** ST to AB, April 15, 1989. ST was mesmerized by television pictures of the wholesale destruction of entire neighborhoods by the dictator Ceauşescu.

19 **"a society with no mysteries":** *R & S*, p. 21; Cummings, "ST Interview"; HS, conversations, April 18, 2007; Daniela Roman, interview, January 7, 2008.

20 **as an elderly man was moved:** ST, diary, May 29, 1991, YCAL, Box 75.

20 **Even as a child he recognized:** ST, diary, n.d., but follows May 19, 1991, YCAL, Box 75.

20 **"identification and denunciation":** Manea, "Made in Romania." He made a drawing of himself in the school uniform, originally printed in *TNY*, "Cousins" portfolio, May 28, 1979; reproduced in Manea's article, and also as *LMB 566, 1968* in *Saul Steinberg: L'écriture visuelle*, catalogue for the exhibition of the same name at the Musée Tomi Ungerer, Centre International de l'Illustration, November 27, 2009–February 18, 2010.

20 **Those children were a hodgepodge:** Cummings, "ST Interview," AAA. Also ST to AB, February 3, 1988, where he writes that he is reading the autobiography of Elias Canetti, whose family "held the same ancient prejudices against the Sephardim, who at that time were considered inferior, a prejudice no one has held for sixty years."

21 **"a true native":** Cummings, "ST Interview," AAA.

21 **A decrepit American streetcar:** Ibid.: "probably from Philadelphia because they always ended up in places like Bucharest when they became obsolete."

21 **It suffused him with shame:** HS described these emotions in conversations throughout 2007.

21 **As an adult, Steinberg liked to use the word:** Cummings, "ST Interview," AAA.

21 **"an inferno of screams, slaps, toilets!":** ST to AB, ca. June 21, 1997: "The professor was named Ciupagea Emil? (almost seventy years ago! The good things must be remembered)."

21 **"extremely sophisticated":** Cummings, "ST Interview," AAA.

22 **"part of a civilization":** Ibid.

22 **"the minuteness of the German despoliation":** Herbert Hoover, *The Memoirs of Herbert Hoover: Years of Adventure 1874–1920* (New York: MacMillan, 1952), pp. 406–7.

22 **"urged and begged":** Charles J. Vopicka, *Secrets of the Balkans: Seven Years of a Diplomat's Life in the Storm Center of Europe* (Chicago: Rand-McNally, 1921), pp. 287–89.

22 **"whilst one cannot obtain":** Quoted in Pakula, *The Last Romantic,* p. 264.

22 **Steinberg's memory of wartime hunger:** ST, diary, n.d., YCAL, Box 75.

22 **"American Jews, bankers, and big businessmen":** Pakula, *The Last Romantic,* pp. 293, 395.

23 **the country was in disarray:** Sources for the following discussion include Jelavich, *History of the Balkans,* vol. 2, pp. 204–6; Eugen Weber, "Romania," in Hans Rogger and Eugen Weber, *The European Right: A Historical Profile* (Berkeley: University of California Press, 1966), pp. 541–42; Hugh Seton-Watson, *Eastern Europe Between the Wars, 1918–41* (New York: Harper & Row, 1967).

24 **"a social class revolution":** ST to HS, July 15 and 16, 1944, AAA.

24 **"a little like being a black":** *R & S,* p. 3.

24 **the "serious boys":** Eugen Campus, "Saul Steinberg, Portrayer of Our Times," *Minimum,* no. 10 (January 1988); translated from Romanian by Emil Niculescu. Campus became a literary critic, first in Romania and then after his immigration, in Israel. This quotation and information is from the "first set" of Campus articles published as "Iosef Eugen Campus, *Deschizând noi orizonturi: Însemnâri critice, Israel, 1960–2001* (Opening New Horizons: Critical Notes, Israel, 1960–2001) (Libra: Bucharest, 2002), vol. 1, p. 254.

24 **"my real world":** All quotations in this paragraph are from Hughes, *Nothing If Not Critical,* p. 261.

24 **The rigorous curriculum:** Mario Tedeschini Lalli, "Descent from Paradise: Saul Steinberg's Italian Years (1933–1941)," *Quest: Issues in Contemporary Jewish History,* no. 2 (October 2011), pp. 312–83, online at: http://www.quest-cdecjournal.it/focus.php?id=221. I am grateful to MTL, whose formidable research into ST's Italian years, particularly his university studies, supplemented my own 2007–8 inquiries into the archives of the Politecnico di Milano, Archivio Generale d'Ateneo (AGA), Fondo fascicoli studenti e Registri carriera scholastica, folder "Steinberg Saul," and Steinberg pages of the relevant *registro*. Among the documents are transcripts of ST's coursework at LMB, 1928–32.

25 **Music was one of his two best subjects:** Hughes, *Nothing If Not Critical,* p. 261.

25 **Despite his high grades:** That he scored so high in German is especially surprising, because even though he studied it for four years in the lycée and later at the Politecnico, throughout his life he claimed he could not speak or read the language, although he did admit to knowledge of it in his U.S. Navy papers. He told HS that he "did not know" German (conversations throughout 2007) and Leo Steinberg that he "could not read" German (interview, October 31, 2007). This appears to be another example of ST's habit of saying what suited him at the moment.

25 **He read avidly:** ST to AB, March 25, 1988, and September 26, 1986.

25 **when he became proficient in Italian:** ST to AB, September 25, 1986.

25 **"a language of beggars and policemen":** ST to AB, April 23, 1991.

25 **Uncle Harry visited:** ST to AB, November 20, 1987. A photograph taken during the

visit is in the family photo album in possession of Dana Roman, copies in SSF and YCAL, Box 2.

25 **"especially magic"**: ST, diary, n.d. but follows May 22, 1991, YCAL, Box 75.

26 **"I was different"**: Campus, "Elective Affinities (Conversations with Saul Steinberg)," p. 368.

26 **Two Romanian writers, Miron Costin and Dimitrie Cantemir:** A copy of the essay in the original Romanian and the English translation by Emil Niculescu are both in SSF.

26 **"a fictitious history"**: Cummings, "ST Interview," AAA.

27 **He was shocked by things he had not been taught:** Ibid.

27 **It was what Moritz liked best:** ST to AB, November 1, 1988.

27 **"without [electric] current"**: ST to AB, October16, 1985. ST was comparing damage inflicted by a recent hurricane on his East Hampton property to "a return to Bucharest in 1924." HS spoke in telephone conversations, March 19 and 22, 2007, of how she and ST compared their Bucharest experiences. She agreed that some of the worst privations were experienced around 1922–24 but said that ST also spoke of enduring similar privations after the move to Strada Justitie.

27 **he painted a telling portrait:** "Strada Palas," 1942; ink, pencil, and watercolor on paper, 14½ x 21¾ in., SSF; *S:I*, cat. 4, pp. 86–87.

28 **"wearing a name plate"**: *R & S*, p. 3.

CHAPTER FOUR: A SECURE TRADE

29 **"I accepted a kind of compromise"**: Campus, "Elective Affinities," pp. 367–71.

29 **This was the first-ever rejection**: Among the girls was one described only as "Ragazza Mehedinti," in "ST: Handwritten List of Addresses et al, 1932–41," YCAL, Box 2, Folder "Santo Domingo 1942." Jacques Ghelber, a cousin by marriage who was admitted to the Bucharest School of Architecture, wrote to ST from Tel Aviv, Israel, October 19, 1953, YCAL, Box 8, Romanian letters in folder "Correspondence 1953," joking that he had "more appreciation for Saul's [word not clear; possible translation is *skills*] than those at the School of Architecture in Bucharest. It's too bad they didn't also undervalue me. Then perhaps I [too] could have become somebody." To date, this is the single most direct comment that explains why ST went to Milan. MTL cites this as a possible reason in Mario Tedeschini Lalli, "Descent from Paradise: ST's Italian Years, 1933–41," *Quest: Issues in Contemporary Jewish Hisotry*, no. 2 (October 2011), pp. 316–17 and n. 14; online at http://www.quest-cdecjournal.it/focus.php?id=221. MTL cites as his source for this possibility Theodor Lavi's entry "Romania" in Numerus Clausus, *Encyclopaedia Judaica*, ed. Michael Berenbaum, Fred Skolnik, 2nd ed. (Detroit: Macmillan Reference, 2007), vol. 15, pp. 341–42.

29 **"for a young Romanian Jew"**: ST to Prudence Crowther, included in e-mail to DB, July 22, 2008.

30 **"an interesting, animated time"**: Arthur Segal, "Die neue Malerei und die Kunstler," *Die Action* 2 (Berlin, 1912); also in Tom Sundqvist, *Dada East: The Romanians of Cabaret Voltaire* (Cambridge, MA: MIT Press, n.d.), pp. 24, 187.

30 **No matter how ugly the building:** Luminita Machedon and Ernie Scoffham, *Romanian Modernism: The Architecture of Bucharest, 1920–1940* (Cambridge, Mass.: MIT Press, 1999), unpaginated preface.

31 **"chronicler of Romanian spirituality"**: Virgil Ierunca, introduction to G. M. Cantacuzino, *Scrieri* (Paris: Fundatia Regala Universitara Carol I, 1966), p. 9. Quoted also in unpaginated preface by Serban Cantacuzino, "On Being Romanian," in Machedon and Scoffham, *Romanian Modernism*. G. M. Cantacuzino was also the founder and editor of the annual journal *Simetria*, subtitled "notebooks of art and criticism" and published between 1939 and 1947. It is unlikely that ST read this influential journal at that time, and he did not have copies of it in his adult library.

31 **He also joined them to hike:** ST TO AB, April 2, 1985; Campus, "Elective Affinities: Conversations with ST," *Viaţa Noastră*, December 1981, pp. 12, 25.

31 **"rich Jews and Greeks":** ST to AB, July 7, 1998.

31 **He always insisted:** On August 7, 1998, ST sent AB a photocopy of a class photo taken during his last year at the Lycée Basarab, of classmates who joined him for a trip to "una rovina bizantina di Bucharest," on the back of which he wrote capsule biographies of his friends. For Leventi, whose name he sometimes wrote as "Leventer," ST remembered: "Leventer, ombre perfette, morto 4 anni fa ricco, moglio et figlio fedeli." In ST to AB, July 7, 1998, he wrote that he had forgotten the first name of Paraschevadis, his Greek classmate. He described Eugen Campus as "the first intellectual of my own age . . . who was my friend (more in my mind than in reality)." Campus organized the literary circle at his house, but none of the group wrote anything but short critical presentations. ST said "that's when I first began to understand the importance—which is essential for knowledge—of literature and critical study. The literary critic has the chance to confront concrete values, concretized life concepts." Campus graduated from Bucharest University and became a high school teacher and critic in Romania and later in Israel, where ST visited him starting in the late 1970s. ST and Leventer were classmates throughout their Bucharest years and their families were neighbors and friends within the local Jewish community. Leventer also graduated from the Regio Politecnico as an architect and had a lucrative and successful career in Bucharest until 1952, when he went first to Vienna and then to Israel before settling in New York on Cambridge Avenue in the Riverdale section of the Bronx and then on Park Avenue.

31 **This was where Steinberg first understood:** Information that follows is from writings by Eugen Campus, translated by Emil Niculescu for SSF. As I have not read the original Romanian texts, I give the original sources but use only English titles here: Campus's review of ST's show, "ST: Recent Work," Pace Gallery, New York, October 31–November 28, 1987, *Minimum* no. 10, January 1988; "ST—The Discovery of America Today," *Minimum* no. 77, August 1993, pp. 67–69; "Elective Affinities (Conversations with Saul Steinberg)," pp. 367–71, Tel Aviv, December 9–10, 1981, first published in *Viaţa Noastră*, pp. 12, 25.

32 **another Romanian Jew who had been:** Constantine I. Emilian, who wrote the first academic study on the Romanian avant-garde in 1931, quoted in Paul Cernat, *Avangarda romaneasca si complexul periferiei: primul val* (Bucharest: Cartea Romaneasca, 2007).

32 **"young emancipated Jewish writers":** Ibid.

32 **the vast majority of the avant-garde:** Tom Sandqvist, *Dada East: The Romanians of Cabaret Voltaire* (Cambridge, Mass.: MIT Press, 2006).

32 **Balkan absurdist writing:** Kirby Olson, *Andrei Codrescu and the Myth of America* (Jefferson, NC: McFarland, 2005), p. 40.

33 **"took pleasure from a city":** ST to AB, May 24, 1996.

33 **"gigantic head":** ST to AB, August 7, 1998. ST was describing himself as he looked in a photograph of his classmates.

33 **"timid and taciturn" personality:** Campus, "Elective Affinities," *Minimum* no. 10, January 1988.

33 **each one was "bigger than the next":** Sandqvist, *Dada East*, p. 99.

33 **Steinberg was one of four:** In ST's Romanian letters, Perlmutter is always referred to by his nickname.

34 **Steinberg began to think that going abroad:** Campus, "Elective Affinities," pp. 367–71.

34 **Steinberg's argument for going to the Regio Politecnico:** Information that follows is from interviews with Daniela Roman, Stéphane Roman, and HS; also from the Romanian letters, cited specifically where appropriate.

34 **What would happen to her:** As an adult, ST told friends, interviewers, and correspondents that he had never been called by a diminutive or a nickname, but it was not true, and neither was his similar contention in *R & S*, p. 19. Within his family he was Sauly,

Salitza, Saulica, or some other variant of his given name. In many letters, one or another of these is how his sister, Lica, addresses him.

34 **when it came to Milan:** It was a given that he would be accepted, for there was no entrance examination in Italian universities and only a high school diploma and transcript were required.

CHAPTER FIVE: THE PLACE TO GO

36 **at Viale Lombardia 21:** Conflicting documents give several addresses for ST's first residence in Milan. In "Handwritten List of Addresses," YCAL, Box 2, he wrote Ampero, but his official Politecnico documents give it as Ampère 46. Via della Sila appears to be the first fairly permanent room. He wrote Via [but the correct name is Viale] Lombardia for the room they moved into in early 1933. In a letter from Leventer, February 7, 1960 (YCAL, Box 5, Romanian letters, Folder "Correspondence chiefly 1960"), he writes of "the room and the terrace on Via Lombardia 21." He also refers to "our room" there in a letter of December 30, 1959 (YCAL, Box 5, Romanian letters, Folder "Correspondence, 1959–60"). From this point on in the Romanian Letters, ST usually writes Leventer's name as "Leventi." I shall do the same.

37 **a tiny balcony just big enough:** This is the room ST drew and titled "Milano—My Room—Bar del Grillo, 1937," Ink, 9 x 11⅜ in., YCAL, Box 20, "Photos."

37 **the *testa di cavallo*:** Bruno Leventi to ST, December 30, 1959, and November 27, 1956, YCAL, Boxes 14 and 8.

37 **he was officially enrolled:** YCAL, Box 73, folder "SS Biography."

37 **"skinny little fellow":** AB, interview, Milan, June 19, 2007.

37 **a rich correspondence:** AB edited the correspondence, which was published in Italian as *Lettere a Aldo Buzzi, 1945–1999* (Milan: Adelphi, 2002). The English translation of the published texts and summaries of the portions excised and unpublished were prepared for SSF by John Shepley (through 1978) and James Marcus (1979–99); typescript at SSF. As of 2012, the English translation remains unpublished.

38 **Tommaso Buzzi's distinguished reputation:** AB, interview, June 19, 2007. Tommaso Buzzi (1900–81) is regarded as one of the most important and interesting Italian designers of the twentieth century. He worked mostly in furniture and the applied arts and is probably best known today for the Citta Buzziana, a former convent that he converted into an "ideal city," and for his "autobiography on stone." Fantasy, irreverence, and the use of humanistic, literary, and classical quotations are found throughout his work. See also T. Buzzi, *Lettere Pensieri Appunti 1937–1979* (Milan: Silvana, 2000).

38 **"gigantic portions":** ST to AB, November 26, 1992.

38 **"terrible Jewish-Romanian cuisine":** ST, undated spiral notebook in his handwriting, YCAL, Box 69. This entry is entitled "Hunger."

38 **the first commission of Ernesto Rogers:** It was the first commission for the firm BBPR, founded in 1932 by Ernesto Rogers, Gian Luigi Banfi, Ludovico Belgiojoso, and Enrico Peressutti, all of whom became ST's friends at a later time. Sources consulted include Edoardo Persico, "Un bar a Milano," *Casabella*, January 1933, reprinted in Enzio Bonfanti and Marco Porta, *Città, museo e architettura. Il gruppo BBPR nella cultura architettonica italiana, 1932–70* (Florence: Vallecchi, 1973). Francesca Pellicciari also cites the Persico article in "Critic Without Words: Saul Steinberg e l'architettura," thesis, Instituto Universitario di Architettura di Venezia, 2004–5.

38 **iconic talisman:** ST to AB, April 6, 1987.

39 **"the best kind of propaganda":** Persico, "Un bar a Milano," p. A7.

39 **"the face of a Roman senator":** ST to AB, April 6, 1987.

39 **the most common slang word:** The *Dizionario Garzanti* and James Marcus, who translated the unpublished ST/AB letters into English, both agree that *grillo* means cricket and *grilletto* means trigger.

39 **"laboratory for modernity":** Hubert Lempereur, "Saul Steinberg: Une Vie Dans Les Lignes," *AMC: Le Moniteur Architecture*, September 2008, p. 97.

39 **Steinberg always insisted:** Although the term accurately describes his student years, ST used it only once, when he drew his "Autogeography" in 1966 (published posthumously in *TNY*, February 28, 2005, as an illustration for Roger Angell's "Map of Saul," pp. 56–57. This drawing appears also in Joel Smith, *Steinberg at The New Yorker* (New York: Abrams, 2005), pp. 220–21, and partially in *The Inspector*. Francesca Pellicciari also used the term in *Critic Without Words*, p. 25.

39 **"a particular neighborhood":** *R & S*, p. 25.

40 **Then it was back to the Grillo:** AB, interview, June 19, 2007.

40 **Saul insisted that the strongest memory:** *R & S*, p. 25.

40 **all things witty:** ST, spiral notebook, n.d., YCAL, Box 69.

40 **the "abundance" of women:** ST to AB, May 24, 1996.

40 **"symbol of reality":** ST, spiral notebook, n.d., YCAL, Box 69.

40 **"the first class noticer":** Roger Angell, interview, May 6, 1908.

40 **Steinberg's contention that he was always solitary:** AB supported this contention, interview, June 19, 2007.

40 **"the terrace of our villa":** Bruno Leventi to ST, November 27, 1956, Bucharest, in Romanian letters, YCAL. ST wrote: "I told [Lica] about our parties with del Castro and Ciucu." The same was true in the years when ST lived at Via Pascoli 64, in the room above the Bar del Grillo.

41 **"attached directly to his hand":** AB, interview, June 19, 2007.

41 **one of his favorite destinations:** San Lorenzo is reproduced in *S:I*, fig. 11; "Galleria di Milano" is dated 1951 and reproduced in WMAA, p. 78.

42 **His sole problem with women:** Gabriella Befani Canfield, interview, January 12, 2009; Sabra Loomis, telephone conversation, January 19, 2009; AB, interview, June 19, 2007; HS, telephone conversation, December 12, 2007.

42 **"chief interest":** *R & S*, p. 25.

42 **"marvelous training":** WMAA, p. 235.

42 **"cribbed Bauhaus":** Joel Smith, "Illuminations, or The Dog in the Postcard," *S:I*, p. 26.

42 **"the influence of Cubism":** WMAA, p. 235.

42 **Students often postponed:** MTL, "Descent from Paradise," p. 329.

42 **"places that don't belong":** *R & S*, p. 41. Pellicciari, "Indige Delle Immagini," in *Critic Without Words*, has a partial list of some of these drawings exemplified by "Milano via Pascoli in 1936, From Memory, 1974." Also SSF 5; *S:I*, cat. 70 and n. 157; MTL, "Descent from Paradise," p. 325 and figs. 6–8.

43 **which brought a "revelation":** AB to DB, June 7, 2008.

43 **what he called "documentary" drawings:** This was AB's word for the specialized internal drawings of a building, such as plumbing, heating, and electrical circuits. "Now most of this work is done on the computer but it was very useful for ST, especially during the journeys to Rome and Ferrara [field trips that students took]." AB, interview, June 7, 2008.

43 **Straight walls appear slanted and off-kilter:** This is apparent in, for example, *San Lorenzo* (ca. 1935), ink over pencil, *S:I*, p. 26; *Milano—My Room—Bar del Grillo*, 1937, ink on paper, YCAL, 3641, *S:I*, p. 252. Of his 1951 drawing of the Galleria di Milano done in similar style, WMAA, p. 78, Bernard Rudofsky commented that it "bears witness to both [ST's] formation as an architect and his understanding of the natural tendencies of Italians," in *Streets for People: A Primer for Americans* (New York: Doubleday, 1969). Roland Barthes saw this same drawing as fitting "the same definition as a labyrinth . . . a small autarchic universe," in "All Except You, Saul Steinberg," *Scritti* (Turin: Einaudi, 1976).

43 **"something about something else":** *R & S*, p. 71.

44 **Arturo Danusso:** Chimica generale ed applicata ai materiali costruzioni, Politecnico di Milano, folder ST and Registro.

44 **the confidence to be a snob:** Ivan Chermayeff, interview, March 5, 2009.

44 **"a very, very precise observer":** Ibid.

44 **He usually traveled by ships:** This information is from ST's folder with "extra chronologies" related to those he prepared for the WMAA 1978 retrospective, YCAL, Box 38. It is also one of the "Outtakes" from *R & S*, titled "Bucharest-Milan," YCAL, Box 38, and SSF.

45 **"pink, green, and blue box":** ST to Moritz and Rosa Steinberg, Milan, February 19, 1940, Romanian letters, YCAL, Box 12; AB, "L'architetto steinberg," *Domus*, no. 214, October 1946, p. 20.

45 **"just sort of appeared":** AB, interview, June 19, 2007, insisted that this happened during the autumn of 1936, but in a letter dated October 15, 1941, YCAL, Box 12, "Wartime Letters from Ada," she reminds ST of the "four years" they spent together, which would thus make early 1937 more likely.

45 **"tall, thin, angular":** AB's description differs from the photographs of Ada, all of which show a short, plump, and busty woman.

46 **Ada remained a major presence:** Information is from Loredana Masperi, director of the Casa Prina home in Erba, Como, Italy. YCAL documents show that ST paid $1,000 each month to the Bank of Como for her care there from the date she entered, February 2, 1990, until her death on January 16, 1997, with AB acting as executor and overseer.

46 **"mystery to the very end":** AB, interview, June 19, 2007, described how he and his wife took several trips with Ada throughout their lives and how Bianca tried in vain to get Ada to talk about herself. Bianca Lattuada never divorced her husband, but as she and AB, who were together for many years, always referred to each other as husband and wife, I pay them the courtesy here.

46 **"the little red-haired girl":** Ada to ST, Milano, November 12, 1941, YCAL, Box 12, "Wartime Letters from Ada."

46 **in this case she was so angry:** Ada to ST, "Mercoledi, May 21," YCAL, Box 12, "Wartime Letters from Ada."

47 **asking Saul to meet her:** Ada to ST, "Varazze 21–7," YCAL, Box 32. In a letter of October 10, 1941, she reminds him of the good times they had in Varazze, despite having to hide their relationship from friends who happened to be there at the same time. In YCAL, Box 12, "Wartime Letters From Ada." These letters are uncharacteristically dated, while most of her correspondence is not, so that I have had to use internal evidence to supply dates in other references.

47 **What she didn't tell him:** In one of the undated "Wartime Letters," YCAL, Box 12, Ada told ST that she had "known" him for forty-four years, but she had "been with Vincenzo Ongari" for fifty-five. In some of the letters that were cleared by the censor, she signs her name on the envelope simply "Ada." In others she uses her maiden name, and in 1940 (deduced from internal evidence, because she does not write the year), she begins to use Ongari and to speak of *he* or *him* (never using his name, which she sometimes gives as Giovanni). Also she writes of Ongari as if ST knew for quite some time that she was married. A "Stato di famiglia originario" of the Comune di Erba, Provincia di Como, states that Signora Ada Cassola moved there with her husband from Milan on April 4, 1973, where his name is "Giovanni [no middle name given] Ongari." He died in Erba on July 6, 1984. At her death she was listed as a widow. Carole Chiodo and Elisa Bruschini assisted me in acquiring these documents from the Municipality of Erba; other copies were provided by MTL to SSF.

47 **Leventer got tired of listening:** Information that follows is from BL to ST, November 27, 1956, Bucharest, Romanian letters, YCAL, Box 8.

47 **newspaper called *Bertoldo*:** To write about ST's *Bertoldo* years, I have consulted the following: Piervaleriano Angelini, "L'attivita italiana di Saul Steinberg," degree thesis, Universita di Pavia, 1981–82; Cinzia Mangini and Paola Pallottino, *Bertoldo e I suoi illustratori* (Nuoro: Glisso, 1994); Carlo Manzoni, *Gli anni Verdi del bertoldo* (Milan: Rizzoli,

1964); G. Mosca, "La conquista di Milano," *Corriere della Sera*, June 30, 1969; G. Mosca, *Non e ver che sia la morte* (Milan: Rizzoli, 1980); G. Guareschi, *Chi sogna nuovi gerani? Autobiografia* (Milan: Rizzoli, 1993); Carlotta and Alberto Guareschi, *Milano 1936–43: Guareschi e il Bertoldo* (Milan: Rizzoli, 1994); Pellicciari, *Critic Without Words;* G. Soavi, *Saul Steinberg: catalogo della mostra* (Milan: Mario Tazzoli, 1973); *Gli anni Trenta: catalogo della mostra* (Milan: Mazzotta, 1982); C. Zavattini, *Parliamo tanto di me* (Milan: Bompiani, 1977); MTL, "Descent from Paradise"; Tullio Kezich, *Federico Fellini: His Life and Work* (New York: Taurus, 2007).

47 **"I remember how stubborn you were":** BL to ST, November 27, 1956, Romanian letters, YCAL, Box 8. BL appended a postscript saying, "I still keep the rare edition of *Marc'Aurelio*."

47 **Guareschi was the managing editor:** Shortly after he met ST, Guareschi became editor in chief of *Bertoldo*. He was known for his biting wit and anti-Fascist satire, but his name was also on some of the most anti-Semitic articles. After the war he became internationally famous for his tales of the fictional priest Don Camillo (in *The Little World of Don Camillo*, among others).

47 **"a young man with a blond mustache":** Manzoni is probably the only person who remembered ST as blond; all others agree that his hair was dark brown, his mustache closer to black, and his eyes hazel tending toward brown.

48 **"the young blond man":** Carlo Manzoni, *Gli anni Verdi del Bertoldo* (Milan: Rizzoli, 1964), p. 28.

48 **"absurdity of the initial":** Mangini and Pallottino, *Bertoldo e i suoi illustratori*, p. 103.

48 **"I only discovered":** Quoted in Pierre Baudson, *Steinberg: The Americans*, exhibition catalogue (Brussels: Musées Royaux des Beaux-Arts de Belgique, 1967), pp. 1–2.

48 **In the cartoon titled "Darbe":** reproduced in Mangini and Pallottino, *Bertoldo e i suoi illustratori*, p. 95, fig. 138.

48 **the first of more than two hundred drawings:** The actual number has never been verified. MTL cites Angelini as having given an exact count, and Pellicciari also accepts it: "At least 204 cartoons in both *Bertoldo* and its supplement, *Archibertoldo*." MTL also writes that the number "may have been higher if the figure of '250 or more' . . . is correct." The uncertainty arises after 1939, because some that were published without attribution may now be housed in the Guareschi Foundation archives or with private collectors. The Guareschi Foundation has prepared an appendix to *Milano 1936–47: Guareschi e il Bertoldo*, pp. 491–92, in which they count 54 drawings among their holdings. In ST to AB, July 23, 1947, Steinberg claimed "250 or more that I did in one year for *Bertoldo*."

48 **"a public that almost immediately":** Mosca, "La conquista di Milano," my translation. At the time Mosca wrote this, he was attempting to gloss over the paper's acquiescent collaboration with the Fascist government, so the remark must be considered in that context. The novelist Italo Calvino wrote cartoon captions for a while, but it is not known if he provided any for ST's drawings. They did not seem to know each other until Calvino wrote the essay "Drawing in the First Person," *Derrière le Miroir*, no. 224, for ST's 1977 exhibition at Galerie Maeght, Paris.

48 **"fabulous graphics":** Attilio Bertolucci, *Umoristi del Novecento* (Milan: Garzanti, 1959), p. 12. Bertolucci collaborated with Cesare Zavattini (soon to be ST's lifelong friend) on the *Gazzetta di Parma*.

49 **"If Saul got money":** AB, interview, June 19, 2007.

49 **"making money out of something":** Robert Hughes, *Nothing If Not Critical*, p. 262.

49 **Steinberg still shared a room with Leventer:** Perlmutter had quit his architectural studies, moved back to Bucharest briefly, and then returned to Milan in search of a job. In 1940 he fled to Lisbon and eventually moved to Australia.

49 **"in wonder":** AB, interview, June 19, 2007.

50 **Steinberg normally sat in a corner:** Pellicciari, *Critic Without Words*, pp. 34–35,

citing Angelini, "L'attivita italiana di Saul Steinberg," p. 61, and Mangini and Pallottino, *Bertoldo e i suoi illustratori*, p. 96. Joel Smith touches upon this in *S:I*, pp. 26–27.

50 **One of his most successful creations:** See, for example, *S:I*, p. 26, fig. 12.

50 **It marked the beginning:** AB, cited in Pellicciari, *Critic Without Words,* p. 84, n. 13. AB repeated the anecdote to me (interview, June 19, 2007), insisting that it was "very important for any understanding of Saul."

50 **Flush with success:** ST to AB, July 6, 1991.

51 **"satirize attitudes and political mentalities":** Mangini and Pallottino, *Bertoldo e i suoi illustratori*, p. 178, n. 1. English translation by MTL.

51 **Publications that specialized in humor:** MTL, "Descent from Paradise," particularly pp. 320–22.

52 **"carried errors, bad taste, venial and mortal sins":** Oreste del Buono, *Bertoldo 1936* (Milan: Rizzoli, 1993), introduction; also quoted in MTL, "Descent from Paradise," pp. 321–22, n. 31.

52 **"a terrible idea, blackmail":** Angelini, "L'attivita italiana di Saul Steinberg," discusses this throughout; ST to AB, March 28, 1983.

52 **He was able to evade:** AB appended the following note to ST's letter of April 19, 1985: "Once he established himself in New York and at *The New Yorker*, the flaws and limitations of *Bertoldo* became clear to him: even its prose struck him as elementary, although it had charmed those readers whom Steinberg, recalling his schooldays, referred to as *matricole*, freshmen. He asked me to delete the occasional Bertoldian reminiscences scattered throughout his letters." However, AB retained a number of them and they are all negative, such as that of March 28, 1983, in which ST sympathizes with the recent suicide of a friend of AB's, saying he has an "identical weakness" which he calls "the *Bertoldo* in me."

52 **When the publisher Alberto Mondadori:** For a capsule history of *Settebello* (after 1939, *Ecco-Settebello*), see MTL, "Descent from Paradise," pp. 320–21, n. 29.

52 **"accomplish anything extraordinary":** Rosa Steinberg to Sali Marcovici, originally dated October 20, 1941, later changed by Iain Topliss to October 20, 1933, in Romanian letters, YCAL, Box 12.

CHAPTER SIX: THE BETRAYAL

53 **"I didn't want to accept":** ST to AB, June 26, 1995.

53 **"sovereign contempt":** Until late 1937, Mussolini mocked the German idea, Denis Mack Smith, *Mussolini: A Biography* (New York: Vintage, 1983), p. 221. Some of the other publications I have consulted to write about the racial laws are R. J. B. Bosworth, *Mussolini's Italy: Life under the Fascist Dictatorship, 1915–1945* (New York: Penguin, 2006); Ethan J. Hollander, *Italian Fascism and the Jews* (Berkeley: University of California Press, 2003); Giorgio Pisano, *Mussolini e gli Ebrei* (Milan: Edizioni FPE, 1967); MTL, "Descent from Paradise"; Joshua D. Zimmerman, ed., *Jews in Italy under Fascist and Nazi Rule, 1922–1945* (Cambridge: Cambridge University Press, 2005).

53 **new laws came thundering down:** The number of Jews varies depending on the source. Hollander, *Italian Fascism and the Jews*, gives 46,000; Smith, *Mussolini*, p. 221, gives as many as 70,000; MTL, "Descent from Paradise," p. 327, cites the official 1938 Italian census figure of 37,000 while relying on Michele Sarfatti's *Gli ebrei nell'Italia fascista*, whose figures are given on p. 327, n. 45, as 46,656 "actual" Jews, 37,241 of whom were Italian and 9,415 of whom were foreigners.

54 **"the usual: delaying":** Ada to ST, Milano, November 18, 1941, YCAL, Box 12, "Wartime Letters from Ada."

54 **he had exactly one year:** This is based on ST's student file at the Politecnico, corroborated by MTL, "Descent from Paradise, p. 329.

54 **he was almost entirely dependent:** ST's letters to his parents are not extant before 1940, but those that survive attest to both: "I'm fine and in good health and work a lot. At first opportunity I'll send some paintings of mine"; March 15, 1940, Romanian letters, YCAL, Box 12. Also AB, interview, June 19, 2007.

55 **One project that survives:** ST to AB, October 31, 1997. Pellicciari, *Critic Without Words*, found the drawings among the archives at Studio Boggieri and reproduces them on pp.123–25. She also points out the likeness to an unsigned drawing in *Bertoldo* in her fig. 69. The "Dynamin" clipping is in a collection of drawings titled "Vecchi disegni SS" at YCAL, Box 39, which contains other drawings that might have been commissioned at this time.

55 **unsigned drawings and cartoons:** MTL, "Descent from Paradise," p. 333, notes that at least 54 unsigned drawings in *Bertoldo* are listed in Guareschi, *Milano 1936–43*, while those ST made for *Settebello* and other papers are not documented as of 2011. See also Pellicciari, *Critic Without Words*, p. 84, n. 1.

55 **"could never become an architect":** Hughes, *Nothing If Not Critical*, p. 261.

55 **the last possible moment:** In 1938 he took the exams that had been postponed; from the middle to the end of February 1940, he took those for his current courses; on March 1–5 he took those relating to his thesis.

55 **he barely passed:** MTL prepared the document "Registri carriera scholastica" for SFF, which I have consulted and incorporated into my own Politecnico research for the discussion here.

55 **a special project that had to be designed:** ST to M & R Steinberg, March 6, 1940, Romanian letters, YCAL, Box 12: "I had to take a four-day final exam for which I wrote a diploma project, locked in the school."

55 **When his examiners asked why:** MTL cites the testimony of Vittorio Metz, an artist at *Bertoldo*, in Domenico Frassineti, "Steinberg," thesis, Facoltà di Lettere e Filosfia, Università di Roma, 1966–67, p. 333 and n. 65.

55 **"I did well":** ST to R & M Steinberg, March 6, 1940, Romanian letters, YCAL, Box 12.

56 **"a diploma of discrimination and prejudice":** ST made this remark in 1985 in notes made for Primo Levi when they exchanged "worthless" diplomas. YCAL, Box 38, Folder "Correspondence, 1985–87." In ST to AB, August 12, 1985, he called it "diploma *di Ebreo*—diploma of Jewishness."

56 **"symmetrical to yours":** Primo Levi to ST, Torino, July 18, 1985, YCAL, Box 38, Folder "Correspondence 1985–87." Levi also wrote that reading *Bertoldo* "was the event of the week. We all tried to imitate the drawings; we could do so more or less with Mosca's . . . but not with yours and this is an indubitable sign of nobility, as was later demonstrated."

56 **"Only Saul remains, son of Moritz":** In an interview with Robert Hughes, *Time*, April 17, 1978, ST used much the same language as he later wrote to Levi, concluding with "I am no architect. The only thing that remains is *razza Ebraica*!"

56 **"Dad writes that I'm avoiding":** ST to R & M Steinberg, February 19, 1940, Romanian letters, YCAL, Box 12.

56 **"to sleep and eat a lot":** ST to R & M Steinberg, March 6, 1940, Romanian letters, YCAL, Box 12.

56 **"pretty painful to have to part with 2,000 lire":** ST to R & M Steinberg, February 9, 1940, Romanian letters, YCAL, Box 12.

56 **Several weeks passed:** ST to R & M Steinberg, March 15, 1940, Romanian letters, YCAL, Box 12.

56 **He kept a partial list:** ST listed this in a diary/journal he kept during his incarceration at the Tortoreto detention center. YCAL, Box 89, Folders "Tortoreto 1940–42," and "Miscellaneous 1940–42."

57 **"other newspapers and magazines":** YCAL, Box 89, Folder "Tortoreto," December 30, 1940. *Bertoldo* continued to publish until September 8, 1943. On May 7, 1941, ST wrote

that he worked for *Bertoldo* until the "last issue, April 16," meaning the "last" before he left Milan.

57 **"a nice drawing":** MTL, "A Tragic Part of Life," n. 61. MTL posits that a pencil drawing containing bottles, flowers, and clocks, now in the possession of Margareta Latis, may have been a study for the Chiesa work. Pietro Chiesa was the artistic director of the interior design firm Fontane Arte, which is still in operation today.

57 **His friend Vito Latis:** Latis graduated from the Politecnico in 1935 and was an active member of a group of other graduates who advocated the modernist style. See also Maria Vittoria Capitanucci, *Vito e Gustavo Latis: Frammenti di città* (Milan: Skira, 2007).

57 **The commission Latis gave him:** ST, YCAL, Box 89, Folder "Tortoreto," May 7, 1941. MTL, "Descent from Paradise," p. 332, n. 60, writes that Bruno Coen Sacerdotti, son of the original owner, has the painting in his possession. ST later asked AB twice about the painting, on January 26, 1946, and May 29, 1947. In the latter, he thought the villa might have been in Viareggio rather than Rapallo.

57 **He never imagined:** Information about ST's passport(s) and travel visas are in YCAL, Box 89, folder "Tortoreto."

57 **Antonescu allied the country firmly:** Jelavich, *History of the Balkans*, pp. 226–27.

57 **"a year, two ago":** ST to R & M Steinberg, August 12, 1940, Romanian letters, YCAL, Box 12.

58 **there is no record that he ever tried:** ST to R & M Steinberg, April 23 and August 12, 1940, Romanian letters, YCAL, Box 12.

58 **"in terrible times":** Julian Bach to ST, March 4, 1971, YCAL, Box 103. Bach reminisced about their first meeting in a letter welcoming ST as a new client brought to his agency by Wendy Weil. Bach is probably referring to "Life in the 'Guatavir' Line," *Life*, May 27, 1940, pp. 14–15.

58 **ST's luck was better:** ST, diary, YCAL Box 20, Folders "Tortoreto 1940–42" and "Miscellaneous 1940–42," entry for December 18, 1940. The *Town & Country* article was entitled "The Shot Heard Round the Country." Besides the *Life* drawing in n. 33, Civita placed drawings in *Harper's Bazaar*, March 15, 1940.

58 **This was very good news:** ST to R & M Steinberg, December 20, 1940, Romanian letters, YCAL, Box 12. Some of his drawings listed in *S:I*, p. 29 and p. 237, n. 37, were sent to the Argentine publication *Cascabel* but may not have been published; others were published there on February 11 and June 3, 1942. Some were featured in the Brazilian journal *Sombra*, December 1940–January 1941. See also *S:I*, p. 27, n. 34, p. 237, and pp. 269–70. Also ST's correspondence with Gertrude Einstein (the Civita's administrative assistant in New York), YCAL, Box 1, Folder "1942 Correspondence" contains other references to South American publication.

59 **Harry, on behalf of his extended family:** Ada to ST, "lunedi September 22" (internal evidence suggests 1941–early 1942), YCAL, Box 12. Ada asks, "are you bringing your parents over?" the implication being to New York. Harry Steinberg to Moritz and Rosa Steinberg, July 5, 1941, YCAL, Box 12, writes, "Naturally his desire is to bring you over as well. May God help him to carry out this plan."

59 *Vagabonding with Vanderbilt:* Lawrence Danson (son of Henrietta and Harold), "An Heroic Decision," *Ontario Review* no. 53 (Fall–Winter 2000–2001): 59–60.

59 **The Denver and New York Steinbergs pooled their money:** Ibid., pp. 61–62.

60 **"expelled from the Kingdom":** In the Decree of June 15, 1940. *R & S*, pp. 25–33. See also Bosworth, *Mussolini's Italy*, pp. 414–18; Smith, *Mussolini*, pp. 220–22; MTL, "Descent from Paradise," p. 340.

60 **various friends . . . allowed him to sleep:** AB, interview, June 19, 2007, and interview with Carol Chiodo, August 2008. AB shared a studio with Luciano Pozzo on the Via dell'Annunciata; ST to AB, November 23, 1945. Also YCAL Box 78, Folder "Tortoreto," translated by Adrienne Foulke, pp. 1and 2.

60 **"The air in Milan was excellent":** *R & S*, p. 27.

60 **"like a real Sherlock Holmes":** Ibid., p. 32.

60 **While Steinberg was on the lam:** Danson, "An Heroic Decision," p. 60. Judith Steinberg Bassow provided information about her father Martin Steinberg's role in interviews and telephone conversations throughout the winter of 2010–11. ST to AB, September 12, 1945, and August 22, 1946, where ST refers to the "old debt"; ST to Cesare Zavattini, written at Ellis Island, July 4, 1941, copy SSF, thanking him for the "300 lire" and promising to "take care of that soon." ST to R & M Steinberg, Milan, December 20, 1940, Romanian letters, YCAL, Box 12, discusses money donated by H. & M. Steinberg and C. Civita.

60 **his application was rejected:** Cornelius Vanderbilt, Jr., April 23, 1940, YCAL, Box 89, folder "Miscellaneous 1940–42."

61 **the idea of using the Dominican Republic:** Cesar Civita to Lawrence Danson, n.d.; internal evidence suggests mid-June 1940. Copy at SSF.

61 **"a very talented and worthwhile resident":** Quoted in Danson, "An Heroic Decision," p. 60. Copies of the extant correspondence are at SSF and scattered throughout uncatalogued YCAL boxes.

61 **The Washington consul's reply:** Information that follows is from YCAL, Box 20, Folders "Tortoreto 1940–42" and "Miscellaneous 1940–42."

61 **purchase a ticket in his name:** Letter dated May 11, 1940, from Director da Policia de Vigilancia e Defesa do Estado, V. da Cunha, to the Portuguese Consul in Milan at the Ministerio dos Negocios Estrangeiros en Lisboa, received there on May 15, 1940, and referring to ST's file #552.1.

61 **Portugal was being flooded:** Alberto Dines, "Black Friday," *Serrote* no. 1, 2009, pp. 69–72; cited in MTL, "Descent from Paradise," p. 338, note 79.

61 **He never learned the real reason.** Information that follows is from Documento confidencial do secretario-general da Policia de Vigilancia e Defesa do Estado manifestando surpresa, em 07.09.1940, and memorando de 11.05.1940; Dines, "Black Friday," and MTL, "Descent from Paradise," p. 338, n. 79.

62 **Undeterred, he contacted the Portuguese consul:** For details of the flight, see Danson, "An Heroic Decision," pp. 61–62; Memorando confidencial da Policia ve Vigilancia e Defesa do Estado (PVDR), to the Ministerio dos Negocios Estrangeiros, Lisboa, September 7, 1940.

62 **"another Steinberg":** Danson, "An Heroic Decision," p. 61. Although this was never verified, ST did repeat the story to HS, who said "it was one he liked to tell," interview, October 24, 2007.

62 **As long as he had to stay in Rome overnight:** ST, "Wartime Diary," Milan, December 12, 1940, YCAL, Box 20, Folder "Tortoreto 1940–42."

62 **a cryptic diary-journal:** Examples of the diaries he wrote at various times are in YCAL boxes and are cited where appropriate.

62 **"most dramatic disaster":** ST to Leo Steinberg, September 7, 1984, SSF: "44 years ago! Will tell you about it someday." LS, October 31, 2007, says ST never did.

63 **"I am anxious right now":** ST, "Journal, 1940–42," Milan, December 7, 1940, YCAL, Box 20, Folder "Tortoreto 1940–42."

63 **"a great and fine book":** Ibid., December 7 and 18, 1940.

63 **"I would not treat a friend":** Ibid., December 8, 1940.

64 **To further complicate his life:** Ibid., between December 8, 1940, and April 26, 1941.

64 **"not really alone":** ST to R &M Steinberg, January 7, 1941, Romanian letters, YCAL, Box 12.

65 **"Gentile kindness":** M & R Steinberg to ST, February 12, 1941, Romanian letters, YCAL, Box 12.

65 **Jews were still allowed to read newspapers:** R & M Steinberg to ST, May 1, 1941, Romanian letters, YCAL, Box 12. Historical information from Jelavits, *History of the Balkans*, pp. 225–27.

65 **"a certain Captain Vernetti":** "San Vittore e Tortoreto" typescript manuscript, p. 2, YCAL, Box 78, Folder "Tortoreto, translated by Adrienne Foulke."

65 **He wrote in his diary:** ST, "Journal, 1940–42," December 25, 1940, YCAL, Box 20, Folder "Tortoreto 1940–42."

65 **There must have been other foreign students:** Information that follows is from Prefect of Milan to the Ministry of the Interior, February 21, 1941, in ACS, MI, PS, AG. Cat. A 16; draft of Ministry of the Interior to Prefect of Milan, February 27, 1941; Prefect of Milan to the Ministry of the Interior, March 12, 1941; Ministry of the Interior to the Prefects of Milan and Teramo, March 31, 1941. These documents were found in the Archivio Centro dello Stato, Rome, by MTL, who generously made them available to me.

66 **By the time Steinberg received this decree:** ST, "Journal, 1940–42," May 7, 1941, Tortoreto, YCAL, Box 20, Folder "Tortoreto 1940–42." Unless noted otherwise, information that follows is from the "Wartime Diary."

67 **The next day he was transferred:** He gave a far more romantic version of this in *R & S*, p. 33, saying his first cellmates were "bicycle thieves," and the second was "another political detainee, or perhaps a false detainee who was there as a stool pigeon or for some other reason."

67 **The two major categories of detainees:** Among them was his old friend Giovanni Guareschi, from *Bertoldo*. See also Guareschi's "How I Got Like This," introduction to *The Little World of Don Camillo*.

67 **On May 1 at 9 a.m., he was taken down:** ST, "Journal, 1940–42," May 1, 1941, YCAL, Box 20, Folder "Tortoreto 1940–42."

67 **Aldo was waiting:** Dr. Pino Donizetti was a radiologist and, after the war, the author of a medical quiz published in the magazine *Tempo Medico*. ST originally met him through AB and stayed in touch from time to time thereafter.

68 **They went from Bologna to Rimini:** In *R & S*, pp. 34–35, ST describes the trip as if he were the only prisoner on the train, and the landscape as one of "perilous mountains . . . with the train going . . . along the edge of the abyss." In "Descent from Paradise," MTL writes that the route from Milan to Ancona "is actually very flat."

68 **"constantly on the road":** ST to R & M Steinberg, Ancona, May 1, 1941, Romanian letters, YCAL, Box 12.

68 **Steinberg was in the one called Tortoreto Alto:** Information that follows is from Costantino Di Sante, "Dall'internamento alla deportazione," *I campi di Concentramento in Abruzzo (1940–41)* (Milan: F. Angeli, 2001), part II, pp. 2–15. See also Italia Iacoponi, *Il fascismo, la resistenza, I campi di concentramento in provincial di Teramo: cenni storici* (Colonnella: Grafiche Martintype).

68 **"a truly romantic prison":** ST to HS, March 25, 1955, AAA, written when he made a pilgrimage to the internment camp. I am grateful to Ms. Sterne for allowing me to quote from this letter and all others written to her by ST, which were restricted during her lifetime.

69 **"as an allowance":** *R & S*, pp. 38–39.

69 **"romantic young man":** Elena Zanoni, *Alba Adriatica e la sua gente: Un secolo di eventi e di ricordi* (Rome: Pioda Imaging, 2006), pp. 151–60, as quoted in MTL, "Descent from Paradise," p. 351, n. 127.

69 **before she coined the lover's nickname:** Ada's correspondence is scattered throughout the YCAL boxes, and every letter begins with "*mi olino caro.*"

69 **The violinist Alois Gogg:** For futher information, see MTL, "Descent from Paradise," p. 352, n. 131.

69 **made a tongue-in-cheek drawing:** MTL provides extended provenance for various copies of this document in "Descent from Paradise," p. 381, fig. 18. Only a cover letter from the Prefect of Teramo is extant in ST's file with "seen by the Duce" noted in the margin.

70 **"Tom Sawyer takes off his hat":** ST, "Journal, 1940–42," entries for May 6–10, 1941, YCAL, Box 89, Folder "Tortoreto 1940–42."

70 **"die of heartbreak":** ST, "Journal, 1940–42," May 21, 1941, YCAL, Box 20, Folder "Tortoreto 1940–42."

72 **his stark pencil drawings:** MTL, "Descent from Paradise," p. 382, fig. 20.

72 **a more dramatic story:** His obituary in the *New York Times* carried this story: Sarah Boxer, "Saul Steinberg, Epic Doodler, Dies at 84," May 13, 1999. His passport with all the travel visas and affidavits is in YCAL, Box 89, Folder "SS Romanian Passport 1939."

72 **he had all the proper travel documents:** MTL notes that Mondadori's assistant, Mathilde Finzi (another Jew in perilous circumstances who survived the war and became a successful literary agent in Milan), gave ST 2,214 lire ($73.80). In YCAL, Box 1, Folder 1, Cesar Civita's "Statement Account" up to March 1, 1942, notes that Arturo Civita and AB each lent 2,000 lire ($66.66). Undated letters from Ada refer to "money orders" she sent to Tortoreto. ST to AB, June 26, 1996, cites "Signorina Finzi" as one of the persons who aided his escape from Italy.

72 **Henrietta Danson noticed sadly:** Danson, "An Heroic Decision," p. 63.

72 **They also supplied him:** Ibid.

73 **"They've brought me everything":** ST to R & M Steinberg, July 2, 1941, Romanian letters, YCAL, Box 12.

CHAPTER SEVEN: TO ANSWER IN ENGLISH — A HEROIC DECISION

74 **"He is now in the Dominican Republic":** James Geraghty, art editor, *TNY*, 1941 memo to Ik Schuman, *TNY* administrative editor; reprinted in Ben Yagoda, *About Town: The New Yorker and the World It Made* (New York: Scribner, 2000), p. 178.

74 **When it finally docked:** ST to R & M Steinberg, July 16 and 25, 1941, October 20, 1941, Romanian letters, YCAL, Box 12, Folder "Letters from Milano and Santo Domingo."

74 **He drew his room:** ST to Henrietta Danson, Ciudad Trujillo, August 25, 1941. Original in possession of Lawrence Danson, copy in SSF.

75 **By October he had still not recovered:** ST to "Henrietta and Harold [Danson]," October 1, 1941, copy in SSF.

75 **he had generated more good ideas:** ST to Henrietta Danson, October 12, 1941, copy in SSF.

75 **"much primitive":** ST, "Journal, 1940–42," October 22, 1941, YCAL, Box 12. On November 20, he spent the "evening at Godesteanu's and his wife."

75 **the real excitement came:** There is a notebook in YCAL, Box 2, Folder "Santo Domingo 1942," of lists and sketches of work ST was doing for U.S. magazines, plus ideas for drawings. Almost all of it is in Italian, with the occasional English word.

75 **"the very goods English":** ST to H & H Danson, November 17, 1941, copy in SSF.

75 **"like a x-ray picture":** ST to H & H Danson, October 12 and November 17, 1941, copy in SSF.

76 **No matter how sick, tired, or depressed:** ST to R & M Steinberg, July 16, 1941, Romanian letters, YCAL, Box 12.

76 **The only unvarnished truth:** ST to R & M Steinberg, October 20, 1941, Romanian letters, YCAL, Box 12.

76 **After the United States entered the war:** Harry Steinberg to R & M Steinberg, January 7, 1942, Romanian letters, YCAL, Box 12.

77 **Aldo did reply:** AB to ST, "22 Aug.," YCAL, Box 12, "Wartime Letters from Ada"; also AB to ST, July 22, 1941, YCAL, Box 12.

77 **"He makes it clear":** ST, "Journal, 1940–42," October 1, 1941.

77 **"She writes bullshit":** ST, "Journal, 1940–42," October 16, 1941. The word is either *put-tanate* (bullshit) or *puttana* (whore). Whichever, ST is angry with Ada.

77 **"feel rancor toward Aldo":** Ada to ST, n.d., YCAL, Box 12, "Wartime Letters from Ada."

77 **Ada tried to explain:** The account that follows is based on internal evidence from undated "Wartime Letters from Ada," YCAL, Box 12.

78 **Aldo did not like Ada:** When I asked him about this in June 2007, he became angry and said that he was "finished" talking about Ada because "she is not very interesting and she bores me."

79 **several days later when Ada sent a photo:** ST, "Journal, 1940–42," October 17, 1941.

79 **From then on, her letters referred casually to her husband:** Ada to ST, "Wartime Letters from Ada," YCAL, Box 12.

79 **On any particular "today":** ST, "Journal, 1940–42," various entries from October 20, 1941, through February 11, 1942.

79 **"Dear Adina, poor little thing":** Ada to ST, Milano, October 30, 1941, "Wartime Letters from Ada," YCAL, Box 12; ST, "Journal, 1940–42," various entries, October 17–20, 1941.

79 **"in great fear":** ST, "Journal, 1940–42," November 21, 1941.

79 **he moved again:** Estrelleta 42 (Altos), to H. & H. Danson, December 19, 1941; Gavino Puello 9, to H. & H. Danson, April 22, 1942.

80 **a book jacket for Simon & Schuster:** ST, undated letter to H. & H. Danson, probably November–December 1941. In "Journal, 1940–42," December 7, 1942, he wrote that he sent ten drawings to Simon & Schuster on December 6.

80 **the Valentine's Day spread:** "Don't Ever Marry These Guys," *Mademoiselle*, February 1942.

80 **"silence from New York":** ST, "Journal, 1940–42," January 18, 1942.

80 **"I continue confusedly":** ST, undated letter to H. & H. Danson; also "Journal, 1940–42," December 7, 1941.

80 **He was pleased with his success:** ST to H. & H. Danson, January 15 and March 16, 1942; Danson, "An Heroic Decision," p. 64; ST, "Journal, 1940–42," January 15, 1942. L. Danson posits that the painting reproduced on the cover of the issue of *Ontario Review* in which his article appears may be one of the three. It is reproduced in *S:I*, cat. 3, and cat. 4 is another painting done in Santo Domingo. In "Journal, 1940–42," November 24, 1941, ST describes a "neoclassical tempera. Framed picture came out well."

80 **"Is a pity":** ST to H. & H. Danson, January 19, 1942, and March 16, 1942.

80 **"other, Communist" Steinberg:** ST to H. & H. Danson, n.d.; internal evidence suggests early 1942.

81 **"is better don't mention":** ST, undated letter to H. & H. Danson; internal evidence suggests October 1941. Letter to Harry Steinberg, October 12, 1941. In a letter to AB, April 19, 1985, while reading a novel by Gadda, who wrote in the Milanese dialect, ST disparaged his "ancient association with *Bertoldo*, and other nonsense of that era."

81 **Civita also furnished a statement of ST's earnings:** Ik Schuman, *TNY* administrative editor, sent a memo to editor Harold Ross and art editor James Geraghty saying they should all "avoid seeming to say we guarantee ST work as this would be a violation of law prohibiting labor contracts with prospective immigrants; we should say that we feel his talents would enable him to get work." November, 21, 1941, TNYR, Box 366. Letters from these publications to various officials and addresses at the U.S. State Department begin with the date of February 3, 1942, and are in YCAL, Box 1, Folder "Correspondence 1942."

81 **directed his letter to a high-level contact:** Cornelius Vanderbilt, Jr., to Mr. A. M. Warren, March 25, 1942, copy in YCAL, Box 1, Folder "Correspondence 1942."

81 **"I have seen his work on the editorial pages":** Smith, *Steinberg at The New Yorker*, p. 16, notes that "cartooning under watchful Fascist eyes had taught Steinberg to poke

fun at war in general rather than condemn its opponents; in fact, the first set of drawings he published in America [*Harper's Bazaar*, March 15, 1940] had satirized, of all things, French defense efforts."

82 **"very much to our interest":** Geraghty, 1941 memo, reproduced in Yagoda, *About Town*, p. 178.

82 **Even better was the agreement Civita arranged:** Ik Schuman contract letter form to Cesar Civita, as "attorney or agent" for ST, May 15, 1942; Cesar Civita to Ik Schuman, July 1, 1942, spelling out details of an agreement "valid for two years from July 1, 1942," making "Victor Civita (brother) and Charles Civita (father)" ST's lawful attorneys. They were to receive a 40 percent commission on anything sold, with the remaining 60 percent to go to ST. Both documents are in YCAL, Box 1, Folder "Correspondence 1942."

82 **His application had been approved:** In 1978, when his work was featured on the cover of *Time*, ST received a letter from Paul Radin saying that what may have been the best gesture he ever made was to "sign a paper sponsoring your entry into the US." ST never forgot Radin's gesture: in 1953 he sent one of his false diplomas and in 1979 a signed copy of his latest book. Radin's letter is dated April 14, 1978, YCAL, Box 22.

82 **He had his visa in hand:** ST to H & H Danson, May 16 and May 26, 1942; Gertrude Einstein to ST, June 1, 1942.

82 **admitted that it was "stupid":** ST to Harold Danson, May 26, 1942.

83 **"There is not the slightest danger":** Gertrude Einstein to ST, May 25, 1942, YCAL, Box 1.

83 **"I'm wasting my time here":** ST to Harold Danson, June 17, 1942.

83 **"Traveling by bus, if you manage":** *R & S*, pp. 53, 55.

83 **And that was how he got his first view:** *R & S*, p. 55.

CHAPTER EIGHT: IN A STATE OF UTTER DELIGHT

84 **"Who the hell knows":** ST to HS, January 18, 1944, AAA.

84 **He trained his European eye:** *R & S*, pp. 56–57.

84 **"in a state of utter delight":** HS, interview, April 18, 2007.

84 **The "Cubist elements" that became his lifelong totems:** Some of these are referred to in Jacques Dupin's essay, *Derrière le Miroir*, no. 192, June 1971.

84 **"a flying Indian":** In *R & S*, p. 57, ST confuses the Pontiac with the DeSoto, which had a stylized head of the explorer Hernando DeSoto as its hood ornament.

84 **"the sort of red":** Diary 1991, n.d. but following May 30, YCAL, Box 75. Internal evidence suggests that some of the undated pages may have been written at a later time and inserted; very few (if any) seem to be a continuation of the dated page.

84 **In later years, he regretted:** ST to AB, December 15, 1984. The rest of the sentence said that photographers "like Walker Evans were already making the rounds."

85 **America was "disarming":** These observations about what he thought of American architecture and culture were made in notes at the end of a 1953 calendar/diary, YCAL, Box 3.

85 **"Speaking primitive English":** Diary, n.d. but following entry for June 4, 1991, YCAL, Box 75.

85 **"Who the hell knows":** ST to HS, January 18, 1944, AAA.

85 **the first street he knew in the United States:** He gave his address as 412 6th Avenue on his application for a commission in the navy, BNP953, Revised 1942, YCAL, Box 20.

85 **"Sixth Avenue was very luminous":** Diary, n.d., entry following Friday, May 31, 1991, YCAL, Box 75.

86 **Tino was filled with a zest for life:** ST to HS, May 25, 1944, AAA.

86 **"everybody brought something":** Ruth Nivola, interview, September 22, 2007.

86 **"no curiosity about the USA"**: HS, interview, March 29, 2007; Ruth Nivola, interview, September 22, 2007.

86 **"true friendship"**: ST to AB, January 26, 1946.

86 **"one beautiful room with big windows"**: Ruth Nivola, interview, September 22, 2007. In a prior interview on July 24, 2007, she expressed regret at having to leave the mural on the wall, but she still had the initial sketch for it, made by ST on the back of another painting.

86 **It was signed by Ik Schuman:** Contract letter from Ik Schuman to Cesar Civita, "attorney or agent" for ST, May 15, 1942, YCAL, Box 1.

87 **It gave them power of attorney:** Contractual letter from ST to Cesar Civita, July 1, 1942, YCAL, Box 1. This document continued an earlier agreement, "Statement Account Steinberg up to March 1, 1942," also in YCAL, Box 1, Folder "1942 Correspondence." ST to H & H Danson, May 16, 1942: "Maybe you know the good news that Miss Einstein is negotiating an agreement with the *New Yorker*. That would be wonderful."

87 **More work soon followed:** George H. Lyon, OWI, to ST via Cesar Civita, July 11, 1942, YCAL, Box 1, "Correspondence 1942."

87 **By November he was a consultant:** ST from OWI Overseas Operations Bureau, Overseas Publications Graphic Arts Division, Art Section, NY; YCAL, Box 1, "Correspondence 1942."

87 **He also responded:** "To Our Artists" from the *New Yorker* editors, July 2, 1942, YCAL, Box 1, "Correspondence 1942."

87 **Several weeks later a second memo arrived:** "To Our Artists" from the *New Yorker* editors, August 4, 1942, YCAL, Box 1, "Correspondence 1942."

87 **he wanted to see the Pacific Ocean:** HS, interview, March 29, 2007: "He was a natural-born traveler. When he came to the U.S. from Santo Domingo he was totally broke . . . but the kind of man he was, he got on a bus."

87 **He took advances:** HS, interview, May 8, 2007.

87 **here he was helped by Harold Ross:** Ross and Cook letters are January 7, 1942; Ross to McGuiness is January 6, 1942, as are general delivery to ST; YCAL, Box 1.

88 **Steinberg took the southern route:** Information that follows is from diary, undated entry following June 4, 1991, YCAL, Box 75.

88 **From his earliest days:** HS, interview, May 8, 2007.

88 **"the back side of cities":** *R & S*, pp. 52–53.

89 **"character . . . with a lot of influence":** Dupin, interview, *Derrière le Miroir*.

89 **"Damn!":** ST, January 1, 1943, YCAL, Box 20, Folder "Tortoreto, 1940–42."

89 **"invited him to lunch":** Throughout 2007 I conducted interviews and had many conversations with Hedda Sterne. As stated earlier, she allowed me to read her restricted letters from ST in the Archives of American Art, and she showed me many other documents, letters, paintings, and drawings in her house on 71st Street in New York. HS made four recordings to answer questions asked by Claire Nivola in 2005, on May 21, June 4 (two tapes), and September 26, which Claire Nivola generously made available to me. These sources provide much of the account that follows.

90 **"all energetic [over]achievers":** Joseph M. Stafford, e-mail to DB, August 1, 2008. I am grateful to Mr. Stafford, a nephew of Fred Stern, who (along with HS) provided much of the information about his uncle that follows.

90 **"learned how to deal":** Joan Simon, "Hedda Sterne: Patterns of Thought," *Art in America*, February 2007, p. 161; hereafter Joan Simon interview.

91 **As one example among many:** Quotations are from Stacy Schiff, *Saint-Exupéry: A Biography* (New York: Holt, 2006), p. 370. Also personal communication with Stacy Schiff, May 17, 2009; HS interviews with DB, 2007; Joan Simon interview.

92 **"You explained to me by phone":** ST to HS, January 18. 1944, AAA.

93 **"a big house, a happy home":** HS, interview by Phyllis Tuchman, December 17, 1981, p. 11, AAA; hereafter Tuchman interview.

93 **She enrolled in the University of Bucharest:** HS told Tuchman that she completed two years, and Sarah Eckhardt, p. 117, only one. In interviews and conversations with DB, she said she "attended but did not graduate."

93 **"to this day, it was":** Tuchman interview, p. 10; HS on Claire Nivola tapes, May 21, 2005.

94 **"advocating a synthesis":** Sarah Eckhardt, *Uninterupted Flux: Hedda Sterne, A Retrospective* (Urbana-Champaign: Krannert Art Museum, University of Illinois, 2006), p. 117 and p. 3, fig. 3; *Victor Brauner: Surrealist Hieroglyphs*, catalogue for the exhibition, October, 2001–January, 2002, Menil Collection, Houston (Ostfilden: Hatje Cantz, 2001), p. 151, fig. 87.

94 **"world of the comic press":** HS, interview with DB, April 18, 2007; HS on Claire Nivola tapes, May 21 and June 4, 2005.

94 **When she was seventeen:** After she married ST, he and HS became friendly with Léger, but during her time in Paris, Léger never came to the studio and she never saw or met him.

94 **"it was the place of strangers":** Joan Simon interview; HS on Claire Nivola tapes, May 21 and June 4, 2005.

94 **"I was like a real good little Jewish girl":** Tuchman interview, p. 13.

94 **"super-primitive":** Tuchman interview, p. 18; HS interviews with DB; HS on Claire Nivola tapes, May 21, June 4, and September 21, 2005.

95 **"as a girl, a woman":** ST to HS, January 18, 1944, AAA.

95 **"the products of refusals":** HS, interview, March 29, 2007.

CHAPTER NINE: GOING OFF TO THE OSS

97 **"This applicant has about everthing disqualifying":** VCNO is an abbreviation for Vice Chief of Naval Operations. Documents quoted are from Bureau of Naval Personnel, New York Office of Naval Officer Procurement, "Report of Investigation, Form N Nav 544, Restricted: Saul Steinberg, applicant for appointment in USNR, January 26 & 28, 1943." Documents are in the National Archives, Washington, D.C., with copies in SSF.

97 **he spoke Romanian and Italian fluently:** Despite the several years he studied German, he never admitted that he spoke it, and in his "Officer's Qualification Report, May 25, 1945," he did not list it. YCAL, Box 20.

97 **Efforts were under way:** Memorandum for the Assistant Chief of Naval Personnel from Captain A. P. Lawton, USN, February 20, 1943. Subject: Exemption from Indoctrinal Training Course: "exempted . . . because he possesses specialized skill or knowledge and his services are desired for assignment in a specialized billet where the time for such training would hamper and restrict the war effort." National Archives and SSF.

98 **He found all this activity slightly puzzling:** Notices of Alien's Acceptability from Local Board No. 17, 412 6th Avenue, NY. The 4F classification was dated August 24, 1942; the 1A was dated January 21, 1943.

98 **"going off to the OSS":** HS, interview, March 29, 2007.

98 **"completion of naturalization be waived":** W. R. Purnell, "Memorandum for CNO," FF1/P14/00, January 20, 1943, National Personnel Records Center (NPRC), St. Louis, copy at SSF.

99 **no mention of any mental disorder:** Report of Physical Examination (First Examination), January 21, 1943; Report of Physical Examination and Induction (2nd Examination), February 16, 1943. Both refer to the reports of his Selective Service Examination, August 21, 1942, and his classification as 1A on August 24, 1942, NRPC, copy at SSF.

99 **"the special circumstances":** From Director of Naval Officer Procurement New York to CNO, Washington, re: ST, applicant for appointment in USNR, January 26, 1943; NPRC, copy in YCAL, Box 20, and SSF.

99 **The rush was on:** His commission in the Naval Reserve was officially dated February 20, 1943, and a certificate stated that he was sworn in on February 25. However, these documents were prepared after the fact and the true date was February 19; YCAL, Box 20, Folder "Navy" (1 of 2).

99 **received orders to report for duty:** Memorandum for the Passport Division, Department of State, BuPers 2324-ELI, signed by Randall Jacobs for CNO RAdm. Ernest J. King, March 9, 1943; NPRC, copy at SSF.

99 **"God knows how your knowledge":** James Geraghty to ST, August 18, 1943, YCAL, Box 1.

99 **He was in a frenzy:** A copy of his life insurance policy from the Travelers Insurance Company, Hartford, Connecticut, June 29, 1942, and a letter to Harry Steinberg, April 4, 1943, are both YCAL, Box 1.

99 **the navy was not sending him to China immediately:** BuNavPers to ST, "order to report to CNO, DC, for temporary active duty, under instruction," February 23, 1943; YCAL, Box 20, Folder "US Navy."

100 **The first time he felt ready:** HS, interview, April 18, 2007.

101 **Margaret C. Scoggin:** Her publisher, Alfred A. Knopf, sent payment checks to Civita on behalf of "Lt. Paul Steinberg," a mistake the navy also occasionally made. A canceled check for $300 is in YCAL, Box 1, along with ST's tax return for 1943. His income was $1,909.62 and he paid $355.27 in taxes. The following year, while he was on active duty, the navy paid him $576.35 and he earned $5,446.50 from his art, for a total of $7,019.66. He paid $660.74 in taxes.

101 **an easily recognizable Hermann Göring:** *TNY*, March 6, 1943; reproduced in Smith, *Steinberg at The New Yorker*, p. 18, fig. 8.

101 **Hedda took to them at once:** HS, interview, April 18, 2007. HS became the godmother of Claire Nivola, the Nivolas' second child.

101 **the reviews for "Drawings in Color":** Among them, *New York Herald Tribune*, April 18, 1943, and *Time*, April 26, 1943.

101 **"Each week":** HS, interview, May 8, 2007.

101 **Through her they formed:** I have repeated here the list of artists compiled by Sarah Eckhardt in *Uninterrupted Flux*, pp. 119–20, with the exception of Jackson Pollock, whom they met through Peggy Guggenheim. I have also added the names of others whom Eckhardt did not name.

102 **"Bill and Elaine lived at night":** HS, interview, April 18, 2007.

102 **"never at the Cedar Tavern":** HS, interview, March 29, 2007.

102 **She had known Peggy Guggenheim:** Eckhardt, *Uninterrupted Flux*, p. 118, writes that Arp encouraged Victor Brauner to send them to Peggy Guggenheim at Guggenheim Jeune in London, and that "one of these may have been included in *Exhibition of Collages, Papiers-Collés and Photo-Montages* at the show, Nov. 4–26, 1938." HS, interview, March 29, 2007, insisted that Peggy Guggenheim had shown her work at Guggenheim Jeune.

102 **When Hedda arrived, she reintroduced herself:** HS, interview, March 29, 2007.

102 **"all these male artists":** HS, interview May 8, 2007.

102 **"four hundred to five hundred people":** HS, interview March 29, 2007. She was quoting ST's remarks on the night he told her he would not go to any more of PG's parties.

102 **"Back home for me":** ST to HS, July 27, 1943, AAA.

102 **"there was always someone":** HS, interview, May 8, 2007.

103 **It was something she found:** HS interview, September 9, 2007.

104 **he told Civita to proceed:** ST to HS, November 17, 1943, AAA.

104 **"was leaving":** ST, recollecting the quarrel in letter to HS, January 9, 1944, AAA.

104 **He was assigned instead:** ST's Officer Personnel File (OPF), February 20, 1943, YCAL, Box 20, and ST file in the National Personnel Records Center (NPRC), copy in SSF. In a document dated 5/29/45: Officer Qualifications, YCAL, Box 20, ST mistakenly gave his

time in D.C. as "3/43 to 6/43," when he was there only during the months of April and May.

104 **Mostly he learned:** A page about these details is in YCAL, Box 1.

104 **Much of the time he spent sitting in the corridor:** Norman D. Atkins, "Steinberg's Wartime Cartoons: Anti-Nazi Propaganda Found at the Archives," *Washington Post*, June 30, 1984.

104 **On weekends he took the train to New York:** A young girl who shared his seat, Susan Ingraham, described her encounter in an e-mail written August 12, 1999, after his death, now in YCAL, Box 73. She still had the copy of the magazine.

105 **"scotch & wine & apple pie":** ST to HS, November 27, 1943, AAA.

105 **The pamphlet covered everything:** The pamphlet contains no identifying information about when it was compiled or by whom. A copy is in YCAL, Box 1. Another pamphlet, entitled "China Theater: An Informal Notebook of Useful Information for Military Men in China," is in YCAL, Box 73.

105 **He was given eight days:** Change of Duty Orders is in YCAL, Box 20.

CHAPTER TEN: MY HAND IS ITCHING FOR DRAWINGS

106 **"Lt. Steinberg states":** Interview with Lt. (j.g.) Steinberg of MO by Major (AUS) Carleton S. Coon, November 8, 1944, Declassified document 84s099, YCAL, Box 48, Folder "Nato Anthology, Algiers Vol. II."

106 **"a very unromantic sickness":** ST to HS, November 6, 1943, AAA.

106 **lumbered across the equator:** ST's handwritten notes on the first page of a pamphlet distributed on board troopship *Nieuw Amsterdam*, YCAL, Box 20.

106 **"Tunnies on Sundays":** ST to HS, May 1, 1944, 1943. AAA: "Today is exactly one year since I left San Francisco."

106 **he had lost all his money:** Ibid. ST liked to gamble, and in ST to HS, January 20, 1944, AAA, he boasted that he lost over $900 before he left China.

107 **"not a good place to live in":** ST to HS, July 3, 1943, AAA.

107 **clear sight of the Himalayas:** The Hump was the name given to the eastern end of the Himalayan Mountains, over which Allied planes flew after April 1942, when the Japanese blocked the Burma Road. It was the main supply route from India to China. ST drew the plane trip for a lithographed pamphlet, no. 69895, "China Theater: An Informal Notebook of Useful Information for Military Men in China," put out by the Reproduction Branch OSS. It was later reprinted in *All in Line* and *TNY*, February 5, 1944, p. 20. ST gave his copy of the pamphlet to his studio assistant, Anton van Dalen, in October 1979. A copy is in SSF.

107 **"perspiring like a waterfall":** ST to HS, July 20, 1943, AAA.

107 **even though there were only chopsticks:** ST's first *TNY* cover, January 13, 1945, depicts soldiers eating with chopsticks in a Chinese restaurant. He gave the original drawing to a SACO colleague, Cmdr. Ray Kotrla, and signed it "To Cmdr. Kotrla, Happy 1945, S. Steinberg." Copy in YCAL, Box 9, Folder 12.

107 **"the extraordinary Chinese diarrhea":** *R & S Outtakes*; "Chinese diarrhea" [AB # 37].

107 **he would have been lost:** ST to HS, July 24, 1943, AAA.

108 **he drew his for Hedda:** ST's drawings are in Milton E. Miles, USN, *A Different Kind of War: The Unknown Story of the U. S. Navy's Guerrilla Forces in WW II China* (Garden City, N.Y.: Doubleday, 1967), photo insert, pp. 8–9. Some of these drawings, in slightly different form, are in *All in Line*.

108 **"a table, two chairs":** Captain Frank Gleason, e-mail to Sheila Schwartz, November 29, 2005, SSF.

108 **the little English bulldog:** John Horton to ST, September 25, 1991, YCAL, Box 87. Horton wrote that they spent part of the summer of 1943 in Chungking and that he

brought "the small white bulldog, Skipper, there from Perth." He asks if ST still has the drawing of the men on the veranda with their feet on the railing and Skipper sleeping in the background. He wants to use it for a memoir and asks ST to draw another if he no longer has the original. Another copy of this letter is in YCAL, Box 69.

108 **he had everything he desired:** ST to HS, July 24, 1943, AAA.

108 **he was despondent:** ST to HS, August 2, 1943, AAA.

108 **"a special mood":** OSS Pamphlet no. 69895, p. 14; reproduced in *All in Line* and *TNY*, January 15, 1944, p. 18.

108 **"the atmosphere is quite different":** ST to HS, August 2, 1943, AAA.

109 **"the Rice Paddy Navy":** To write this account of ST's China service, I have benefited from (among many others) the following sources: Miles, *A Different Kind of War*; Charles Barton, Capt. USN (ret)., "The Rice Paddy Navy," *The Retired Officer*, January 1989; Lou Glist, *China Mailbag Uncensored* (Houston: Emerald Ink, 2000); John Ryder Horton, *Ninety-Day Wonder: Flight to Guerrilla War* (New York: Ivy, 1994); Clayton Mishler, *Sampan Sailor: A Navy Man's Adventures in WWII China* (New York: Macmillan, 1994); Samuel Eliot Morison, *History of United States Naval Operations in World War II*, Vol. XII, *The Liberation of the Philippines* (Boston: Little, Brown, 1959), pp. 301–2; Michael Schaller, *The U.S. Crusade in China, 1938–45* (New York: Columbia University Press, 1979), and "SACO! The United States Navy's Secret War in China, 1938–45," *Pacific Historical Review* 44, no. 4 (November 1975): 527–33; Roy Stratton, *SACO: The Rice Paddy Navy* (Pleasantville, N.Y.: C. S. Palmer Publishing Co., 1950); Frederic Wakeman, Jr., *Spymaster: Dai Li and the Chinese Secret Service* (Berkeley: University of California Press, 2003). I am grateful to Del Leu for correspondence about his father Donald Leu's service in SACO, and whose information can be found at www.delsjourney.com/saco/saco.htm. Del Leu's website will lead the interested reader to many more sources for information about SACO.

109 **useful for an Allied invasion:** Miles, *A Different Kind of War*, p. 137.

109 **"psychological warfare artist":** From Officer Qualifications Questionnaire, 5/29/45, YCAL, Box 20.

109 **the somewhat puzzled Saul:** SACO correspondence, YCAL, Box 9; Miles, *A Different Kind of War*, index, p. 621.

109 **Surprisingly, it worked:** Miles, *A Different Kind of War*, p. 137.

109 **"one of China's most mysterious":** "Generalissimo's Man," *Time*, April 8, 1946.

110 **Miles was effectively marginalized:** Miles, *A Different Kind of War*, p. 159: "Looking back now, I do not understand why we did not see from the beginning that the OSS was trying to bypass the Chinese, and why we did not recognize the fact that in order to do it they had to get rid of me."

110 **"politically checked":** Ibid., pp. 138–39.

110 **A third banner at the bottom:** The first two banners are from Les Hughes's article "SACO (Naval Group, China)," http://www.insigne.org/SACO-I.htm, 10.23/2007. Steinberg's drawing is in YCAL, Box 9, Folder 14, and is reproduced in *S:I*, p. 31. There is also extensive correspondence in Box 9 between ST, Mrs. Miles, and fellow officers Henley Guild and Ray Kotrla. On May 23 and July 27, 1989, Guild asked Steinberg to verify that he made the drawing so it could be auctioned at a SACO reunion. ST apparently replied that the drawing was a fake because he would not have surrounded the figure with "cross hatching." Guild replied that of course it was not cross-hatching but the ubiquitous mosquito netting, and that it had to be authentic because it bore ST's "distinctive signature." He also writes on November 9, 1989, "Mrs. Miles showed me the Happy Valley drawings which you have given to her husband and told me of the John Ford film she has of you attempting to eat Thanksgiving dinner with chopsticks. This film is now on videotape and available for showing at SACO reunions."

111 **On December 8 he told Hedda:** ST to HS, December 8, 1943, AAA.

111 **"some excitement":** ST to HS, January 1, 1944, AAA; ST's handwritten itinerary is in

YCAL, Box 20, and his navy pay statements are in YCAL, Box 1. Information that follows is from these sources.

111 **"curious outfit":** ST to HS, January 6, 1944, AAA.

112 **He was even more noticeable:** ST to HS, January 1, 1944, AAA.

112 **At work, he had problems:** NATO Anthology, ST interview conducted by Major Carleton S. Coon, November, 8, 1944, YCAL, Box 48, Folder 2.

112 **Most of the agents were transplanted Europeans:** Edward Lindner, interview with Sheila Schwartz, September 17, 2002, SSF.

112 **"dropped in millions of copies":** Peter M. F. Sichel, e-mail to Sheila Schwartz, August 27, 2002, SSF. Sichel served with ST in Algiers throughout 1943 and 1944.

112 **"publisher, editor, and lover":** ST to HS, "Africa," January 20, 1944, AAA. The following information comes from this source.

112 **"happy, happy, happy":** ST to HS, January 22, 1944, AAA.

113 **"sick of being attached to the Army":** ST to HS, January 24, 1944, AAA.

113 **"this war is a war of pants":** ST to HS, "Monday Feb 14 44," AAA.

113 **the orders he had been hoping for:** Allied Force Headquarters official orders, February 23, 1944, YCAL, Box 20.

113 **he would be in Naples such a short time:** ST to HS, April 2, 1944, AAA.

113 **"I was really scared":** ST to HS, March 1, 1944, AAA.

113 **Most likely he was in Bari:** The 2677th was also in Siena for part of 1944–45, but ST was not there.

113 **"I'm finally here":** ST to HS, February 24, 1944, AAA.

113 **"some of the real war":** ST to HS, March 11, 1944, AAA.

113 **"this sort of scenery":** ST to HS, March 20, 1944, AAA.

114 **"In Italy, I used to be":** ST to HS, March 11, 1944, AAA.

114 **"silly and sad":** ST to HS, March 30, 1944, AAA.

114 **"coming attractions":** ST to HS, April 24, 1944, AAA.

114 **off by himself to buy postcards:** ST to HS, April 27, 1944, AAA.

115 **"almost cried for days":** ST to HS, May 10, 1944, AAA.

115 **gave up on reaching Rome:** ST to HS, letters of May 12, 19, and 22, 1944, AAA.

115 **"I don't know what's wrong":** ST to HS, May 25, 28, and 31, 1944, AAA.

115 **He also had to censor:** From "List of Officer[s] of the Day, August 13, 1944, YCAL, Box 20.

115 **news of the Normandy invasion:** ST to HS, June 7, 1944, AAA.

116 **"running around and busy as hell":** ST to HS, June 15, 1944, AAA.

116 **"a bastard who ate him":** ST to HS, July 1, 1944, AAA. In ST to HS, March 20, 1944, he enclosed a drawing of the baby goat visiting him as he sits in a chair examining his feet.

116 **"frightened villages":** The notebook is in YCAL, Box 3.

116 **"entire cities completely forever destroyed" :** ST to HS, July 1, 1944, AAA.

117 **"accumulated for days":** ST to HS, July 21 and 22, 1944, AAA.

117 **"fancy beds in fancy houses":** ST to HS, July 1, 1944, AAA.

117 **"I'm very much disgusted":** ST to HS, n.d. but internal evidence suggests August 1944, AAA.

117 **If he saw nothing but the ugly side:** ST to AB, September 5, 1945, New York.

117 **"I changed in many ways":** ST to HS, August 4, 1944, AAA.

117 **One old friend he met by happenstance:** ST to HS, n.d. but internal evidence suggests late August 1944, AAA. In the letter, ST identifies Stille by his birth name, Mikhail Kamenetzki, misspelled as Kamenetsky. ST writes: "I invited for lunch today Kamenetsky and his new wife."

117 **two of his *Bertoldo* friends:** ST to HS, August 4, 1944, AAA.

118 **A furlough to Bucharest:** Walter M. Ross to ST, April 22, 1978, YCAL, Box 22. Ross was the lieutenant-colonel chief of the OSS in Bucharest. He handled ST's request and

visited the Steinberg family: "I went to see them and wrote you that they were well, happy, and in no need of monetary assistance which you had authorized me to supply." He thought they were "a lovely couple." Ross took two officers who spoke French and Romanian to verify the conversation, and he remembered that ST sent a thank-you letter afterward. This letter was inspired, like so many others from military friends and colleagues, by the WMAA retrospective and the cover story in *Time*.

118 **To let her know he was back in Rome:** ST to HS, August 2, 1944, AAA.

118 **"in a neighborhood":** ST to HS, n.d. but internal evidence suggests the last half of August 1944, AAA.

118 **"the exciting news":** ST to HS, August 16, 1944, AAA.

118 **his assignment was to deliver:** Letter from Eugene Warner, Chief MO, to Lt. j.g. Robbins, USN, PRO, re: Saul Steinberg, September 11, 1944, copy in YCAL, Box 20.

118 **some of the most important information:** In "Prologue," *OSS Records*, Spring 1991, p. 15, William J. Casey, head of the OSS Secret Intelligence (SI) Branch in Europe during the war and later the director of the CIA, described how the two field offices between which Steinberg shuttled "gathered intelligence on everything, down to the location and condition of every last pillbox or pylon."

118 **King Michael of Romania staged a royal coup:** Jelavich, *History of the Balkans*, p. 254.

118 **Steinberg learned that an American plane:** Travel orders signed by "Col. Glavin," September 15, 1944, YCAL, Box 67. Lt. j.g. USNR Frederick Burkhardt wrote to ST on March 22, 1962, YCAL, Box 16, describing how both men were assigned to OSS in Italy: "I happened to be assigned to operation 'Bughouse' which took me to Bucharest ostensibly to arrange for the evacuation of our air crews shot down during raids on Ploesti but actually to assess the damage done to the oil refineries by our attacks . . . You came to see me [in Caserta] to find out if I could get you to Bucharest . . . I did succeed in cooking up some reasons for sending you." Burkhardt reminded ST that he had promised to give him a drawing after the war was over, but they never saw each other again. He was writing in 1962 to ask for a drawing, which ST sent. Also, Iosef Eugen Campus, *Deschizand noi orizonturi, Insemnari critice, Israel, 1960–2001* (Opening New Horizons: Critical Notes, Israel 1960–2001), vol. I (Libra: Bucharest, 2002), translated by Emil Niculescu as "Nature and Art (Conversations with Saul Steinberg)," pp. 54–56, first published in *Viata Noastra*, December 1981, pp. 12, 15, from conversations with ST in Tel Aviv, December 1981. Copies in SSF.

119 **he was back in the homeland:** ST to HS, September 3, 1944 (in Romanian), AAA.

119 **He knew that his parents:** From a genealogy of the Rotman/Roman family prepared by Ilie Roman, copy made available by Dana Roman; additional copy SSF. Dana Roman said the family had changed the name from Rotman to appear "less Jewish," even though Jews were less likely to be deported or harassed as long as Germans controlled the capital; but a cloak of invisibility was still advisable.

119 **he had managed to get to Bucharest:** ST to AB, September 12 and November 23, 1945.

119 **"caricature of Prince Charming":** Campus, "Nature and Art (Conversations with Saul Steinberg)," *Viata Noastra*, December, 1981, pp. 12, 25, trans. Emil Niculescu.

120 **"a closed chapter":** ST to AB, December 27, 1955.

120 **a printing plant had been commandeered:** For complete documentation of the kind and quantity of work produced at the Stabilimento Aristide Staderini, see Herbert A. Friedman, "The American Propaganda Postcards of World War II," *German Postal Specialist*, February 1987, p. 55ff.

120 **probably the most sustained and valuable contribution:** Information that follows (unless noted otherwise) is from DB interview with Barbara Lauwers Podoski, January 30, 2008; Sheila Schwartz transcript of telephone conversation with Barbara L. Podoski, September 11, 2002, SSF; correspondence from Barbara L. Podoski to Sheila Schwartz,

September 2, 2002, SSF; Elizabeth P. McIntosh, *Sisterhood of Spies: The Women of the OSS*, (Annapolis: U.S. Naval Institute Press, 1998); Sheila Schwartz, interview of Elizabeth P. McIntosh, September 11, 2002, SSF; "Prologue," *OSS Records*, Spring 1991, pp. 13–14.

120 **"straight out of [journalism's] Central Casting":** Edward Lindner, who was a member of the unit, interview with Sheila Schwartz, September 17, 2002, SSF.

121 **The deception succeeded so well:** Norman D. Atkins, "Steinberg's Wartime Cartoons," *Washington Post*, June 30, 1984.

121 **determine which could be persuaded to assist the Allies:** Lindner became an advertising executive after the war. Williams was born Willi Haseneier and was a graduate of the Dusseldorf Art Academy; he later became a well-known artist in the Washington, D.C., area. See also Robert A. Erlandson "The Artist of Military Intelligence," *Baltimore Sun*, April 13, 1955; untitled typescript version of "Operation Sauerkraut" article, National Archives, McIntosh, *Sisterhood of Spies*, chapter 6, pp. 6off.

121 **One of his more imaginative creations:** Copies are reproduced in *OSS Records*, pp. 13–14.

122 **The subterfuge was so credible:** McIntosh, *Sisterhood of Spies*, p. 65; "German Soldiers on Leave from the Front Have Only to Wear a Heart on their Uniform," *Washington Post*, October 10, 1944; Herbert A. Friedman, "Propaganda Ricocheted 'Round Both Sides," *American Philatelist*, November 1985, p. 1018. Copy in YCAL, Box 9, Folder 6.

122 **Steinberg was able to indulge:** Information that follows is from Edward Lindner, interview with Sheila Schwartz, September 17, 2002, SSF. Photos of ST's works are in Friedman, "American Propaganda Postcards."

122 **all of which showed the new turn:** ST to AB, November 23, 1945. ST writes that he has not used a pencil "in ages."

123 **Around this time, he began to decorate his letters:** ST to HS, August 10, 1944, AAA.

123 **After the war, he took delight in telling:** The story appeared in *P.M.*, March 11, 1946, among many other places. Hedda Sterne verified that it was apocryphal in several conversations.

123 **a group execution he had witnessed:** ST to HS, February 14, 1944, AAA.

123 **"just kids 16, 17 years old":** ST to HS, n.d. but internal evidence suggests late September 1944, AAA.

124 **Steinberg feared that the Italy he knew:** YCAL, Box 67, 2 pp. in ST's hand, interview with "Marchi, born 1925."

124 **After the war, he wanted:** Undated letter to HS.

124 **"Give me all your Tootsie Rolls":** Information that follows is from DB interview with Barbara Lauwers Podoski, January 30, 2008.

125 **Sichel wondered how much:** Peter Sichel, interview with Sheila Schwartz, September 13, 2002; Sichel, e-mail to Sheila Schwartz, August 27, 2002; both SSF.

125 **Lindner remembered how Steinberg hid under a desk:** Edward Lindner, interview with Sheila Schwartz, September 17, 2002, SSF.

125 **"had a lot of *Weltschmerz*":** Edward Lindner to ST, December 1, 1988, YCAL, Box 9, Folder 6.

125 **nostalgic for the work of "the Miles organization:"** Correspondence in YCAL, Box 67, Folder "Correspondence 1944," includes postcards wishing Captain Bob Corrigan "Ding-hao" greetings for the New Year and thanks for "the lift over the Hump." Cards to Lt. Henry Gibbins were returned to ST with the envelope marked "deceased." He wrote about it to "McGonigle" and asked him to "drop me a line about what's new." Phil Talbot's letter filled him with "nostalgia" when he wrote from Chungking to tell how Gibbins's plane had been ambushed by Japanese fighters.

125 **this became his first cover:** January 13, 1945.

126 **was proud to be in "the society service":** This appellation is one that is often applied to the Navy.

126 **he continued to wear:** There are photos of him wearing these clothes in East Hampton with Tino Nivola as late as 1948–49. The photo of him in full uniform with HS was taken at a time when he was authorized to wear civilian clothes.

126 **he was interviewed by an intelligence officer:** Information that follows is from "Interview with Lt. j.g. Steinberg of MO, 8 November, 1944," National Archives (declassified), copy in YCAL, Box 9, and SSF.

127 **it arrived safely at Hedda's:** HS, interviews throughout 2007, listed these things at various times. Also, many of them are distributed throughout YCAL boxes.

127 **Some of the elaborate engravings:** These too are distributed throughout the YCAL boxes.

128 **"splendid teamwork":** Eugene Warner to ST, November 20, 1944, YCAL, Box 20; Brig. Gen. William J. Donovan to all MO Personnel, 2677th Regiment, November 3, 1944, YCAL, Box 20.

128 **"a difficult officer to appraise":** Officer's Fitness Report, December 1, 1945, National Personnel Records Center (NPRC), Officer Fitness File (OFF); copies in YCAL, Box 20, Folders "US Navy," 1 and 2.

128 **he had to secure permission:** ST to Commandant Third Naval District, August 28, 1951, YCAL, Box 20.

129 **"I don't want two weeks leave":** ST to HS, n.d. but internal evidence suggests September 1944, AAA.

CHAPTER ELEVEN: STARTING AGAIN IN THE CARTOONS RACKET

130 **"I'll have a hard time starting again":** ST to HS, n.d. but internal evidence suggests January 1944, AAA.

130 **Saul left for China:** HS, interview, April 18, 2007: "I couldn't make up my mind what name I wanted to use in those days, so it was pretty confusing."

131 **"that horrible drawing":** ST to HS, December 2, 1943, AAA; *TNY*, October 30, 1943; *All in Line*, not paginated.

131 **"I want [to see] the proofs":** They appeared in *TNY*, January 15 and February 5, 1944.

131 **"I act like a photographer":** ST to HS, n.d. but internal evidence suggests January 1944, AAA. All quotations are her remarks.

131 **"that triple name publisher":** ST to HS, January 12, 1944, AAA.

132 **"of no concern to us":** HS to ST, YCAL, microfilm of HS letters. Three other YCAL letters (HS to ST) make reference to Knopf's offer: January 26 and 29, 1944, and (by internal evidence) February 1944.

132 **"It was the sad time of my residence in Santo Domingo:"** ST to HS, January 12, 1944, AAA.

132 **She was outraged:** HS, interview, April 18, 2007.

133 **Hedda said Steinberg told her he "knew anti-Semitism":** IF, interview, October 12, 2007. Other versions of this incident are in Smith, *Steinberg at The New Yorker*, p. 227, n. 30.

133 **Saul trusted her judgment:** ST to HS, February 2, 1944, AAA.

134 **Steinberg didn't really like it:** HS to ST, YCAL, microfilm reel, "February 15 [1944]."

134 **"the kind of silly cheap stuff":** ST to HS, February 19, 1944, AAA.

134 **"getting madder and madder":** ST to HS, February 24, 1944, AAA.

135 **He did not blame Hedda:** ST to HS, March 29, 1944, AAA.

135 **Meanwhile, at *The New Yorker*:** ST to HS, April 20, 1944, AAA.

136 **"eventually [the] same one":** ST to HS, May 31, 1944, AAA.

136 **"something like 'c/o Postmaster'":** ST to HS, June 3, 1944, AAA.

136 **Geraghty was so eager:** ST to HS, n.d. but internal evidence suggests Summer 1944, AAA.

137 **Divorcing Fred Stafford:** The following account is based on interviews and conversations with Hedda Sterne throughout 2007.

137 **"very lovely true girlfriend":** HS, interviews, April 18 and September 9, 2007.

137 **"When he was in the navy":** HS, interview, September 9, 2007.

137 **"He wanted to get married":** HS, interview, March 29, 2007.

137 **Their courtship by mail gradually eroded:** HS letters to ST are on microfilm at Beinecke Library, YCAL, reels 144–45. She seldom dated them, usually writing only the day of the week.

137 **"the ideas of other people":** ST to HS, January 23, 1944, AAA.

137 **"in all the years of our relationship":** HS, interview, September 9, 2007.

138 **Through them she met the artists:** Eckhardt, *Uninterrupted Flux*, pp. 119–20.

138 **"after the show":** HS, YCAL microfilm reel, internal evidence suggests early 1944. HS usually used dashes for punctuation. I have supplied some periods and commas where appropriate.

138 **"without their even knowing it":** HS, YCAL, microfilm reel, p. 3 of letter dated "Monday 28"; internal evidence suggests early 1944.

139 **Geraghty wanted to nurture and promote:** HS, YCAL microfilm reel, n.d. but internal evidence suggests May–June, 1944.

139 **"All I desire now":** ST to HS, March 29, 1944, AAA.

139 **"in a studio":** ST to HS, April 5, 1944, AAA.

140 **"trying to be very 'good and heroic'":** HS, YCAL, microfilm reel, undated letter with her quotation marks; internal evidence suggests April 1944.

140 **"I feel lousy":** HS to ST, YCAL, microfilm reel, V-mail dated "19 June."

CHAPTER TWELVE: THE STRANGER SHE MARRIED

141 **Steinberg arrived in New York:** Jeanne Steig, quoting her late husband, William Steig, interview, May 19, 2007.

141 **"where his services are desired":** ST, Officer Personnel File (OPF), National Personnel Records Center (NPRC), copies in SSF folder "War Service—Archival Documents."

141 **"the first of Saul's phony documents":** HS, interview, October 11, 2007. By "phony documents," she is referring to ST's false diplomas and other official-appearing drawings.

142 **"always made Saul weep":** Ibid.

142 **"indispensible as a teacher":** Diary entry, n.d., following entry for June 4, 1991, YCAL, Box 75.

142 **"de facto art director":** Yagoda, *About Town*, p. 106.

142 **became one of Steinberg's best friends at the magazine:** Lee Lorenz, interview, September 12, 2007, recalled that "Saul loved Carmine. He was a kid off the street with no art training, but eventually became assistant to the layout guy and then he took over. Every time Saul came in, he would stop in the makeup department, which was on the floor below the art department. He loved Carmine and he loved it there."

142 **He and Saul bonded:** HS, interview, October 11, 2007.

142 **It was, in fact, such a deep friendship:** Leo Steinberg, interview, October 31, 2007. The book was given to Perelman by Aline Bernstein and was signed by her as well. At his death, ST left the book to PC, who in turn gave it to Leo Steinberg, whose estate has it as of this writing. See also PC, "On S. J. Perelman," *The Company They Kept* (New York: New York Review of Books, 2006), p. 179.

142 **She spent the whole evening caressing:** IF, interview, October 12, 2007; HS, interview, October 11, 2007. ST told this story to IF sometime after 1978.

142 **Hedda thought he was like a little boy:** IF's remark, made during a discussion with DB of ST's and HS's memories of their wedding dinner, October 12, 2007.

143 **"rather proud of himself":** HS, interview, September 9, 2007.

143 **"idea of marriage"**: HS, interview, October 24, 2007.

143 **"To know Hedda through Saul"**: IF, interview, October 12, 2007.

144 **"ordinary superstitious Romanian fatalism"**: IF, interview, October 12, 2007; AB, interview, June 19, 2007; Stéphane Roman, interview, January 12, 2008.

144 **Saul told him fiercely:** Norman Manea, interview, June 11, 2008, New York.

144 **After he started to work:** ST's letters to AB throughout 1945 mention food, clothing, and sums of money that he has sent to him and Ada. On November 18, 1945, he promises to send food at least eight times per month and asks AB to give half to Ada. On January 26, 1946, he tells AB that Ada is now in Rome so there is no further need to divide the CARE packages with her.

144 **"trained for a future overseas assignment"**: ST, Officer Fitness File, NPRC, January 25, 1945, copy SSF. His fear of recall is also mentioned throughout the 1945 letters to AB.

145 **"alive and well"**: ST to AB, September 5, 1945.

145 **Saul resumed contact with her:** Internal evidence in her YCAL correspondence verifies the resumption of the correspondence, as does HS, interview, October 24, 2007.

145 **"get up every morning"**: ST to AB, November 18, 1945.

145 **"Those were the years"**: ST, diary entry, n.d. but following May 19, 1991, YCAL, Box 75.

145 **"title for book"**: ST, appointment book, January 7, 1945, YCAL, Sketchbook 3074. The page is reproduced in *S:I*, p. 238, n. 58.

146 **Fan mail poured in to the magazine:** Reader responses are in YCAL, Box 57, and TNYR, Box 62.

146 **Steinberg's success coincided:** For descriptions of this historical moment at the magazine, see Smith, *Steinberg at The New Yorker*, pp. 19–20; Yagoda, *About Town*, pp. 168–81; Brendan Gill, *Here at The New Yorker*, pp. 167–68. My brief comments here rely on their full and authoritative discussions.

147 **"wordless dispatches"**: Smith, *Steinberg at The New Yorker*, pp. 19–20.

147 **"may have been embarrassed"**: ST to Kurt Vonnegut, n.d. but internal evidence shows that it was written in 1989, YCal, Box 94, folder "Correspondence 1989."

147 **"the problem of identity"**: Harold Rosenberg, "Saul Steinberg's Art World," HR/Getty; this was translated into French for "L' 'Art World' de Steinberg," in *Steinberg: Le Masque: textes par Michel Butor et Harold Rosenberg; photographies d'Inge Morath* (Paris: Maeght Editeur, 1966).

147 **because the artists who were his friends:** "The Rose Is from the Cabbage Family," *R & S Outtakes*, copies at SSF and YCAL, Box 38.

147 **"milk that huge cow"**: Alain Jouffroy, "Visite à Saul Steinberg," *Opus International*, December 1971, English edition, pp. 117–18.

148 **"it contains the two most important"**: ST, "Ginza 1964," *R & S Outtakes*, copies at SSF and YCAL, Box 38.

148 **"Owing to "political circumstances"**: When the Romanian-Soviet armistice treaty was signed, Romania agreed to pay reparations of more than $300 million to bear all costs of the Soviet occupation. This followed the plunder and looting by the departing Germans so that the total amounted to three and a half times the national income from the last prewar statistics, gathered in 1938. See Jelavich, *History of the Balkans*, p. 320; Paul Lendvai, *Eagles in Cobwebs* (New York: Doubleday/Anchor, 1969), p. 245.

148 **Neither money nor certified mail:** Harry Steinberg to R. and M. Steinberg, October 2, 1945, Romanian letters, SSF.

148 **Armed with the official approved list:** ST to R & M Steinberg, June 7, 1946, Romanian letters, SSF.

148 **When medicines were finally approved:** ST to HS, February 2, 1947, AAA.

149 **"he didn't want them here"**: HS, interview, March 29, 2007.

149 **"No matter how much loneliness and suffering"**: ST, diary, n.d. but following May 19, 1991, YCAL, Box 75.

149 **Miller's approach was to select artists:** Dorothy C. Miller, "Foreword" to *Fourteen Americans*, pamphlet, pp. 7–8 (New York: Museum of Modern Art, 1946): "The question of age was not considered, still it may be of interest to look at the exhibition from that point of view. Five of the fourteen are between twenty and thirty years of age, two of them under twenty-five . . . Youth happens to be in the majority."

150 **Steinberg was the only one of the fourteen:** ST's contribution appears in *S:I*, p. 112, as "Artist's Statement for 'Fourteen Americans,'" 1946, ink on paper, 3½ x 7¼ in. (9.5 x 20 cm.), formerly collection of Dorothy C. Miller, now private collection.

150 **"to create a complicity":** ST to Katherine Kuh, November 9, 1961, YCAL, Katherine Kuh Papers, Box 2, Folder 28; published in *S:I*, p. 249.

150 **"There is an inside discipline":** Newsweek, "The Job of Being Absurd," July 5, 1945, p. 97.

150 **"from the military point of view":** ST to AB, November 23, 1945, SSF.

150 **At various times he gave them to friends:** Some of his handwritings, pamphlets, and books are scattered throughout YCAL boxes; others are in the collection of books in his personal library that were given to Anton van Dalen. Some are shown in *S:I*, pp. 112–15. His letter from Primo Levi, July 18, 1985, is in YCAL, Box 38.

151 **"a safe guess":** Howard Devree, "It's Funny—But Is It Art?," *New York Times*, September 8, 1946.

151 **Glaser thought him the only visual artist:** Robert Hughes, "The World of Steinberg," *Time*, April 17, 1978, p. 96.

151 **"He was somehow not treated":** Mary Frank, interview, January 25, 2009.

151 **"felt safe with him":** HS, interview, March 29, 2007.

151 **Steinberg had become an "AA" artist:** *S:I*, p. 36.

152 **Sam Cobean:** ST was devastated by Cobean's early death in an auto accident in 1950.

152 **"different pay scales":** Lee Lorenz, interview, September 12, 2007.

152 **When Steig learned of it:** Jeanne Steig, interview, May 19, 2007; HS, interview, September 9, 2007; Lee Lorenz, interview, September 12, 2007; Frank Modell, interview, September 24, 2007.

152 **"a quiet and elegant man":** ST, memorial tribute to Charles Addams, November 18, 1988, Tee and Charles Addams Foundation, Wainscott, N.Y., copy in SSF.

152 **Addams helped Steinberg buy his first car:** Smith, *S:I*, p. 35, writes that ST's first car was a used Cadillac convertible bought from Igor Stravinsky, but HS, interviews, 2007, insisted that the Cadillac was their second car, bought after they sold the Packard; Ruth Nivola, interviews, 2007, agreed with HS. In the folder "Travel Related Items," YCAL, Box 35, there is a New York State vehicle registration dated June 12, 1947, for a 1941 Cadillac. A bill of sale for the car dated the same month is in YCAL, Box 57. ST made a drawing of a Cadillac, reproduced in *S:I*, p. 35, original in SSF 4513.

152 **"We went up there":** HS, interview, May 8, 2007; Ruth Nivola, diary, September 10, 1999, and interview, September 22, 2007. RN was the mother of a toddler, Pietro, and pregnant with her second child, Claire. ST made "Abcedarian(s)," alphabet booklets, for each child, choosing images and people that had personal meaning to represent each of the letters. In a telephone conversation, April 28, 2008, Claire Nivola said Pietro's was "mostly political because he was born in 1944: A is for anarchy as one example," while hers (born 1947, booklet made by ST in December 1954) was "more personal: H is a drawing of Hedda astride a horse and she is painting." Originals in the ST collection of Claire Nivola.

152 **"was a bad driver":** HS, interview, May 8, 2007.

152 **In their many road trips:** Alexander "Sasha" Schneider rented the Packard that summer, then later bought it. ST to HS, n.d., AAA.

152 **"fine, fat, I eat":** ST to AB, November 23, 1945, SSF.

153 **Once his position at *The New Yorker* was firmly cemented:** HS, interview, May 8, 2009. Examples of all this work and correspondence relating to them are in the uncata-

logued YCAL boxes at the Beinecke Library, and a still incomplete listing is in the
"Features" section of "Selected Bibliography," *S:I,* pp. 169–272.

154 **"toward streamlined bad taste":** ST to AB, January 26, 1946, SSF.

154 **Drawing for it made him feel:** "The Rose Is from the Cabbage Family" and "Drawings
for *The New Yorker,*" *R & S Outtakes,* YCAL, Box 38, and SSF.

155 **"the absence of Fascism":** ST to AB, January 26, 1946, SSF.

155 **"a clever pirate":** ST to AB, November 18 and 23, 1945, SSF.

155 **"better than ever":** ST to AB, June 15, 1946, SSF.

155 **Joseph Mitchell's writing:** ST to AB, January 26, 1946, SSF.

155 **Most of all when he read:** ST to AB, April 29, 1946, SSF.

155 **"an old woman being decapitated":** Ibid.

155 **In June, while spending the summer:** ST to Bianca Lattuada, June 8, 1946, and ST to
AB, June 15, 1946, SSF.

156 **These were the years when every glittering name:** ST's calendars, datebooks, and
address book are all in YCAL, Box 3.

156 **a habitué at Del Pezzo:** Belinda Rathbone, *Walker Evans: A Biography* (Boston:
Houghton Mifflin, 1995), p. 228.

156 **He enjoyed conversations:** ST shared Evans's vision of postcards as "lyric documenta-
ries." In YCAL, Box 75, diary entry for May 29, 1991, after seeing Evans's biographer,
Belinda Rathbone, ST wrote of "postcards (love of) my connection with W.E. Postcards
are haikus of geography." See also Roberta Smith, "Main Street Postcards as Muse," *New
York Times,* February 6, 2009, p. C29.

156 **Steinberg was entranced with the laconic:** HS, interview, September 9, 2007; "The
Rose Is from the Cabbage Family," *R & S Outtakes,* YCAL, Box 38, and SSF. ST
described Giacometti as "a dear friend whom I always enjoyed talking to. Until the end,
he remained what I would call adolescent, meaning curious, free and easy."

156 **"Things never clicked for us with them":** HS, interview, September 9, 2007.

157 **"the Jews had survived":** "The Rose Is from the Cabbage Family," "Sartre" [AB #6],
R & S Outtakes.

157 **When they saw each other:** HS, interview, September 9, 2007.

157 **she should have snubbed Sartre:** ST to HS, n.d., AAA.

157 **"she figured it out":** ST to AB, August 22, 1946, SSF.

157 **They resumed their affair:** HS, interview, July 15, 2007.

157 **"Goring and company":** ST to AB, August 22, 1946, SSF.

158 **Among them were John Stanton:** John Stanton to Simon Michael Bessie, January 20,
1955; forwarded by Bessie to ST, now in YCAL, Box 7, "Correspondence 1955."

158 **Otherwise, everything he saw:** ST to AB, August 22, 1946, SSF.

158 **"I was in Nuremberg":** ST to M & R Steinberg, November 21, 1946, Romanian letters,
SSF.

158 **"pointless misery and destruction":** ST to AB, September 26, 1946, SSF.

158 **They had been in Europe for six months:** ST to AB, January 15, 1947, SSF.

159 **It was Aldo's wife:** HS, interview, July 15, 2007. She added, "There were often sub-
stantial sums of money given on a fairly regular basis, whenever Aldo was in a spot of
difficulty." Letters throughout various boxes at YCAL bear out her contention. When I
asked directly about "the intensity of the friendship and the possibility of homosexuality"
between AB and ST, HS said, "I am too discreet to go any further." In my research,
I found no evidence that it was anything other than a close friendship.

159 **He was a guest at the elegant Gramercy Park mansion:** Benjamin Sonnenberg,
e-mail to DB, November 2, 2007. At the time, ST was making a life drawing of Sonnen-
berg, Sr., for Geoffrey Hellman's *TNY* profile, which eventually appeared on April 8,
1950, and that and others are probably those found in SSF 5154. Sonnenberg Jr. added,
"When [ST] was doing my picture in January 1991, he showed me the several life
sketches of my father which he'd done in preparation for the *New Yorker* caricature.

They were altogether naturalistic and they showed my father as humane, approachable, even charming, which he certainly could be. By contrast, the *New Yorker* drawing shows a man totally preoccupied with his objects, his clothing, his public presentation."

159 **At their first meeting they discussed:** One drawing of a man holding his detached nose appears in *The Inspector*; a series of drawings featuring the nose in various manifestations is in *Le Masque*, both unpaginated; a brown-paper-bag figure holding a detached nose is on the 1969 poster ST created for the Spoleto Festival at the request of his friend Priscilla Morgan.

159 **"wonderful Saul Steinberg":** Brian Boyd, *Vladimir Nabokov: The American Years* (Princeton, N.J.: Princeton University Press, 1991), pp. 511–12. For a special issue of *TriQuarterly*, April 1969, celebrating Nabokov's seventieth birthday, ST contributed a diploma, p. 332.

160 **"much bigger and more serious":** ST to AB, August 4, 1947, SSF.

160 **He made a preliminary visit:** ST, datebook for 1946, YCAL, Box 3; HS, interview, March 29, 2007, said, "It was no picnic to drive that big thing; it was hard work."

160 **Aldo declined:** ST to AB, May 29, 1947. When finished, the mural was 80 feet long.

160 **The industrial designer Henry Dreyfuss:** The murals were featured in an article in *Interiors*, December 1948. A caption read: "Reproduced on Varlar, a formidable product developed by the United Wallpaper company, the murals will undoubtedly outlast the ships, come sea, lipstick, or alcohol," which they did. ST created murals for four ships which, some years later, were sold by American Export Lines. Henry Dreyfuss and ST were both members of the Century Assocation, and Dreyfuss gave the club the original book that contained a page about ST's murals plus the separate blueprints pertaining to them. In 2007, when the Century was deaccessioning the materials, they were given to me, and I in turn gave them to SSF. Serendipitously, at the same time, one of the ships was scuttled outside Galveston, Texas, where it was subsequently used as a training facility for the Texas Maritime Academy. The mural was still intact as of 2012.

160 **"The trouble is that these things":** ST to AB, August 4, 1947.

161 **As was usual with Steinberg, however:** ST to AB, December 5, 1947.

161 **the Russians were threatening to close:** ST to AB, December 5, 1947, and February 24, 1948; Lica Roman to ST, February 19, 1950, Romanian letters, YCAL, Box 56, copy in SSF.

161 **He was in such a bad mood:** ST to HS, partial letter, n.d. but internal evidence suggests end of 1947 or January 1948, AAA.

161 **He told Aldo that it was no small matter:** ST to AB, February 24, 1948. For a time there was the possibility that one of ST's aunts and her son might go with Moritz and Rosa, but in the end they decided to go to Israel instead.

162 **"always looked for ways to escape":** ST to AB, December 17, 1955, after spending Christmas with Sandy and Louisa Calder at their home in Roxbury, Connecticut.

CHAPTER THIRTEEN: SLAVING AWAY WITH PLEASURE

163 **"To work, I must isolate myself":** "Berenson," *R & S Outtakes*.

163 **He wanted to join her in France:** ST makes references to his refusal to fly throughout undated 1948 letters to HS, AAA. He says he will do so only if he can't get ship reservations. In ST to HS, April 25, 1949, he chastises HS for flying to Paris via London on Pan American Airlines: "I won't let you fly again. I worry too much."

163 **At night the building was full of noises:** ST to HS, February 6, 9, 13, 14, 17, 24, 28, and 29, 1948, AAA.

164 **"highly interesting, occasionally wonderful":** HS, interview, March 29, 2007.

164 **his only nod to discretion:** Some examples from YCAL, Box 2, 1948: "D" in a circle with "10–11"; "D 10"; "D 10:30."

164 **"In a way, sex was his life":** HS, interview, April 18, 2007.

164 **Worried that she might retaliate:** ST to HS, February 9, 1948, AAA.

164 **He went out almost every night:** To write about Richard Lindner, I have consulted the following sources: Dore Ashton, *Richard Lindner* (New York: Abrams, 1969); Matthew Baigell, "Richard Lindner," *Dictionary of American Art* (New York: Harper & Row, 1979); Klaus D. Bode, ed., *Richard Lindner: Paintings, Works on Paper, Graphic* (Nuremberg: Bode Galerie/Edition GmbH, 2001); Lee Hall, *Betty Parsons: Artist, Dealer, Collector* (New York: Abrams, 1991); S:I. Interviews with HS, Priscilla Morgan, and Dore Ashton were very useful.

164 **Within minutes:** ST, draft of his 1978 "Tribute to Richard Lindner," YCAL, Box 75.

165 **In 1953 he put his friends:** "The Meeting," oil on canvas, 60 in. x 6 ft. (152.4 x 182.9 cm). MoMA, anonymous gift.

165 **"proto-pop [art] color sense":** Smith, in *S:I*, p. 35 and p. 238, n. 63, writes that Lindner "got an early jump on Pop Art in America by seeing that color in America . . . had nothing to do with nature; its keynotes were fresh paint and packaging." Betty Parsons, quoted in Hall, *Betty Parsons,* p. 110, differed: "[Lindner] was an original . . . Later they said he was the first Pop artist. He wasn't that either but that helped sell his paintings . . . Later, when everybody got interested in Pop art, they thought Lindner was a Pop artist and then he sold very well and got a lot of attention."

165 **Saul was a dedicated poker player:** Sometime in the late 1940s, ST began to make drawings on musical notation paper, one of which appeared on Schneider's LP album. They made their first gallery appearance in the 1952 Parsons/Janis dual exhibitions.

166 **he had just done a series of drawings:** ST to HS, February 17, 1948, AAA. "A pity the *Vogue* drawings didn't come out well."

166 **"something corny":** ST to HS, February 29, 1948. Although he did a number of covers on political themes in later years, this one was not accepted.

166 **"forced by necessities":** ST to HS, undated, internal evidence suggests Spring 1948, AAA.

166 **He was pleased when he taught himself:** ST to HS, February 14, 1948, and undated "Sunday," AAA.

166 **"sad bunch of snobs":** ST to HS, February 29 and March 1, 1948, AAA.

167 **Because his teeth gave him his worst "real hell":** ST to HS, n.d. but evidence suggests the end of April 1948.

167 **Steinberg took Constantino Nivola:** For a capsule description of the mural's history and provenance, see *S:I*, p. 239, n. 83. See also YCAL, Box 57, Folders 1947 and 1948; ST to AB, August 4, 1947, and February 24, 1948.

167 **"silence from the upper classes":** ST to HS, n.d. but internal evidence suggests March–April 1948.

167 **When Steinberg compared the murals for the ships:** ST to HS, n.d. but internal evidence suggests mid-April 1948, AAA.

168 **Monroe Wheeler invited him:** Lynes wrote "A Man Called Steinberg" for *Harper's Magazine*, 1946, and it was the beginning of a long and close friendship. Copy in YCAL, Box 62, folder "Clippings 1946." Lynes did needlepoint and covered a chair with a canvas ST designed for him. His brother was the photographer George Platt Lynes, who took photos of ST and HS.

168 **After a dinner at Ben Baldwin's:** ST knew Ben Baldwin from the navy. Baldwin was now an interior architect with Skidmore, Owings & Merrill and was influential in the Cincinnati murals commission. For a capsule description of the friendship and professional relationship, see *S:I*, p. 239, n. 83.

168 **"Very important," Saul declared:** ST wrote MoMA in the letter, but he probably mistook it for the Whitney Museum, where HS was included in the "Annual Exhibition of Contemporary American Painting," December 16, 1949–February 5, 1950. Eckhardt, *Uninterrupted Flux*, pp. 120–21, lists this show and two others for 1949: "The 21st Bien-

nial Exhibition of Contemporary American Paintings, Corcoran Gallery of Art, Washington, D.C. (March 27–May 8)," and "Painting in the United States, Carnegie Institute, Pittsburgh (October 13–December 11)."

169 **He told Hedda he could not bear:** ST to HS, "Wednesday," internal evidence suggests late April 1948, AAA.

169 **"on the biggest and noisiest honeymoon":** ST to HS, n.d. but internal evidence suggests early May 1948, AAA.

169 **Saul told her not to worry:** ST to HS, "Wednesday" to "Dear Rabbit," n.d. but internal evidence suggests early May 1948, AAA.

169 **"a lot of bad art":** ST to AB, June 10, 1948, Paris. SSF.

169 **Saul and Hedda started out:** AB was working on Lattuada's film *Il Mulino del Po*. A photo of ST and AB is in *Lettere*, p. 31, captioned "ST e AB al cantiere del 'Mulino del Po,' a Mantova." Also ST to AB, June 10, 1948, and note, SSF.

169 **"indifferent and stupid":** ST to AB, Biarritz, July 28, 1948, SSF.

170 **"big Romanian cloud":** ST to HS, February 28, 1948, AAA.

170 **"it's no small matter"** ST to AB, New York, February 24, 1948, SSF. His parents were two; Lica and her husband and son made five; he was including two of his Aunt Sali's children but they ultimately went to Israel. Initially, ST was responsible only for his parents; although he supported his sister and her family as much as he could, he did not become totally responsible for them until they were permitted to leave in 1957.

170 **Still, it got so that he hated:** ST to HS, February 28, 1948, AAA.

170 **"ate bad meals":** ST to AB, New York, October 13, 1948, SSF. The vulgar phrase is more correctly translated as "enough of playing the faggot," but SSF prefers the more refined alternative translation offered by James Marcus, "enough fooling around."

170 **He wanted to put off:** ST to AB, December 27, 1948.

170 **"slaving away at it":** Ibid. From 1949 until the mid-1950s he produced designs for Patterson, and later Stehli and Greef, on a fee-plus-royalty basis, which earned him significant sums of money. Some of the designs were titled "Views of Paris," "Paris Opera," "Gendarmes," "Trains," and "Cowboys." Examples are in *S:I*, pp. 44–45.

171 **He began the new year:** ST to AB, February 4, 1949, SSF.

171 **the first large-scale work:** See *S:I*, 1949 Chronology, p. 255 and p. 239, n. 86. In the end, ST made twenty-four drawings, which are now in the collection of the Detroit Institute of Art (DIA); the mural was destroyed when the DIA show closed.

171 **"the best design (in their opinion)":** ST to AB, June 1, 1949, SSF.

171 **Girard was sorry to relay:** Alexander Girard to ST, November 5, 1951, YCAL, Box 56, "Correspondence from 1950."

171 **"bunch of cartoons":** ST to AB, December 27, 1948.

171 **work was "therapeutic":** ST to AB, December 27, 1948, SSF.

172 **For a short time he liked:** ST to HS, n.d. but internal evidence suggests early spring 1949, AAA.

172 **"an old and honored title":** ST to AB, June 1, 1949, SSF.

172 **the reception . . . was tepid:** Wendy Weil, ST's literary agent, provided information about the sales of his books in interviews and conversations, March 22 and 24, 2010.

172 **He complained of having to work:** ST to HS, May 20, 1949, AAA.

172 **Miss Elinor didn't last long:** To the end of his life, ST kept voluminous folders filled with letters from individuals or firms who wanted to commission a project imploring him to respond to the initial request. He may have done so on the telephone, but there is no written record that he ever did. These folders are scattered throughout the YCAL boxes.

172 **Steinberg thought Rogers was one of the tourists:** ST to HS, April 28 [1949], AAA.

173 **"I made up my mind":** ST to HS, May 20, 1949, AAA.

173 **A flurry of telegrams ensued:** ST to AB, November 9, 1948. A series of cryptic telegrams relating to the pregnancy is in ST to HS, May 20 through 31, 1949, AAA. Internal evidence in undated letters in ST to HS, AAA, are most likely June 1949.

173 **It was unpoken between them:** Information that follows is from interviews and conversations with HS, particularly October 11, 2007.

173 **"he works three hours a week":** ST to AB, September 26, 1949, SSF.

173 **Saul's incomprehension:** Ruth Nivola, interview, September 22, 2007; Claire Nivola, interview, July 2, 2008.

174 **"I brace myself":** ST to HS, May 31, 1949, AAA.

174 **"If it were not for the parents":** ST to HS, n.d. but internal evidence suggests June 2, 1949, AAA.

174 **"We really have to move to the country":** ST to HS, "Friday evening of Memorial Day weekend," 1949, AAA.

174 **their "really beautiful" daughter:** ST to HS, "Sunday night," n.d. but internal evidence suggests mid-June 1949, AAA.

175 **In a spurt of energy:** YCAL, Box 15, "Correspondence with Lindey" contains detailed information and contracts.

175 **"very trying evening":** ST to HS, "Monday evening" and "Thursday," n.d. but internal evidence suggests mid-June 1949, AAA.

175 **"drinking lightly":** ST to HS, "Friday," n.d. but internal evidence suggests end of June 1949, AAA.

175 **"an architect's own dream house":** ST to HS, "Monday" and "Wednesday," June 1949, AAA.

175 **"help their ignorant editors":** ST to HS, undated letters, probably June–July 1949, AAA.

176 **They entertained him:** ST to HS, "Monday morning after a Friday 13th," June 1949, AAA.

176 **"an architect called Saarinen":** Eero Saarinen was then the director of the Cranbook Academy of Art in Bloomfield Hills, Michigan, and at the beginning of his career as one of the twentieth century's most renowned architects.

176 **"most convincing letters":** ST to HS, "Saturday night," probably late June 1949, AAA.

176 **It was his introduction:** For many years ST contributed money and original artwork to the synagogue in Trumbull, Connecticut, one of the smallest and most local.

177 **"it's too late now":** ST to HS, "Saturday night," June 2949, AAA. The book was *Israel Without Tears* (New York: Current Books, 1950). ST designed the endpapers as well as the jacket cover.

177 **He was to sail on the *Queen Mary*:** Information that follows, until noted otherwise, is from ST to HS, undated letters whose internal evidence suggests June 15–22, 1949, AAA.

177 **Steinberg pulled out all his drawings:** ST to HS, "Thursday," probably between June 15 and June 18, 1949, AAA.

177 **He liked de Kooning:** ST to AB, December 7, 1949, SSF.

177 **As the date to sail approached:** At the cat's feeding time, ST always cut a circle in a paper napkin and put it over the cat's head to serve as a bib. Lindner always did the same when he kept it. Priscilla Morgan, interviews and conversations, 2010 and 2011.

177 **Russell Lynes gave a small dinner:** When ST gave Lynes a drawing of a naked woman similar to the one he made for Cartier-Bresson's bathtub and the Eameses' chair, Lynes reproduced it in needlepoint. The chair is in Lynes's New York townhouse, where his son, George Lynes, now lives with his family.

178 **To his great surprise (and delight):** In his appointment book for 1949, YCAL, Box 3, Folder 2: 1949, he made a list of all the images he wanted to use for the mural, many of which never made it into the final version. The description that follows is from ST to HS, dated "Wed.," but probably before June 15, 1949, AAA, when he sent Girard the first group of final drawings.

179 **After this, he veered back into repetitions:** The "6000 Avenue" where he lived when he first arrived in New York became a recurring symbol that he used repeatedly in

single drawings and longer, book-length works. An example is *Canal Street*, published in a limited edition in collaboration with IF, where many of the drawings either hint at or replicate earlier images of the street.

179 **"about the stupid boring results":** ST to HS, "Tuesday night," probably between June 18 and June 20, 1949, AAA.

180 **Families falling from roofs:** Information that follows is from interviews and conversations with HS, 2007.

181 **"tobacco poisoning":** ST to AB, September 26, 1949, SSF.

182 **"I'd rather lie awake at night":** ST to AB, December 7, 1949, SSF.

182 **"To *Vogue* 6 large":** ST, "Week At A Glance 1949," December 7 and 20, 1949, YCAL, Box 3, Folder 3.

182 **There were even more:** SSF has no record that ST ever fulfilled commissions for Stehli fabrics.

182 **"I thought afterwards":** ST, remarks, Alexander Calder memorial service, WMAA, December 6, 1976.

CHAPTER FOURTEEN: THE ONLY HAPPILY MARRIED COUPLE

183 **"As artists, the Steinbergs pursue":** "Steinberg and Sterne: Romanian-Born Cartoonist and Artist-Wife Ambush the World with Pen and Paintbrush," *Life* 31, August 27, 1951, pp. 50–54.

183 **At a party one night:** ST to HS, n.d. but probably early spring 1949, AAA.

184 **It became, for better or worse, their trademark:** Emily Genauer, "The Irascible Eighteen," unsigned editorial, *New York Herald Tribune*, May 23, 1950.

185 **"politically savvy about publicity":** HS, interview, May 8, 2007; Joan Simon, "Patterns of Thought," *Art in America*, February, 2007. HS painted portraits of Barnett Newman (oil on canvas, 1952, Frances Lehman Loeb Art Center, Vassar College) and Annalee Newman (oil on canvas, 1952, collection of Priscilla Morgan).

185 **If he was miffed:** HS, interview, May 8, 2007.

185 **Fleur Cowles was prominent:** ST, "Week At A Glance 1950," YCAL, Box 3.

185 **"in those days I signed":** HS, interview, May 8, 2007. Biala did not sign the letter of protest, but Louise Bourgeois, Mary Callery, and Day Schnabel did. In the interview, HS said that Biala and Bourgeois told her they dropped out of the ensuing publicity because they thought it best not to "offend the power" of the museum and they urged her to do the same. HS said it was her opinion that "they feared its power to influence their careers," whereas this was "unimportant to her." HS had no knowledge of why Callery and Schnabel were not in the photograph. James Breslin, in *Mark Rothko: A Biography* (Chicago: University of Chicago Press, 1993), p. 272, writes of some artists who refused to cooperate because *Life* "epitomized mass culture," and others who "feared being made to look foolish."

185 **"not a school":** HS, interview, May 8, 2007. Also, HS, interviewed by Steven Naifeh, n.d.; Steven Naifeh and Gregory White Smith, *Jackson Pollock: An American Saga* (New York: Clarkson Potter, 1989), p. 603; Simon, "Patterns of Thought."

186 **"In terms of my career":** HS, interview, May 8, 2007; Phyllis Tuchman, "Interview of Hedda Sterne," December 17, 1981, AAA.

186 **Despite the fact that her method and technique:** Selden Rodman, interviewing ST in 1960 for his book *Conversations About Art* (New York: Capricorn, 1961), p. 183, described HS as "one of the most gifted members of that school of painting [abstract expressionism]."

186 **Throughout the 1950s, when art historians:** Eckhardt, *Uninterrupted Flux*, pp. 7, 9.

186 **"Painting for me is a process":** Ibid., p. 9 and p. 11, n. 22. Eckhardt calls attention to the editing of Robert Goodnough, "who cut the original transcript" of the "Artists' Ses-

sion at Studio 35 (1950)," later published in Bernard Karpell, Robert Motherwell, and Ad Reinhardt, eds., *Modern Artists in America* (New York: Wittenborn Schultz, 1951).

186 **"ability to make ideas concrete":** HS, interview, March 29, 2007.

186 **they "were filled with ideas":** HS, interview, April 18, 2007.

187 **Immediately after *Life* singled out:** *Life*, March 20, 1950.

187 ***Vogue* followed by placing her:** *Vogue*, February 1950; copy in YCAL, Box 6, Folder 2: "Hedda Sterne Clippings." When ST and HS married, HS shaved five years off her age at ST's insistence, because he did not want anyone to know she was his senior. In an interview on October 11, 2007, HS said it was a "great relief after his death when I could reclaim my true age."

187 **Hedda set out to read Dickinson's poetry:** HS, interview, October 11, 2007.

187 **Another glowing review soon followed:** "Art Exhibition Notes," *New York Times*, February 16, 1950. Copy in YCAL, Box 6, Folder 2, "Hedda Sterne Clippings."

187 **"Your work interests me much, much more":** HS to ST, n.d. but internal evidence suggests late 1943, YCAL, microfilm reels 144–45.

187 **"poor little ambitions":** HS to ST, "Sunday night," internal evidence suggests 1958, YCAL, microfilm reels 144–45.

188 **However, the circumstances of the early years:** For a listing of articles and reviews about HS, see Eckhardt, *Uninterrupted Flux*, Bibliography 1950 and 1951, p. 130.

188 **In 1951 she and Saul were featured:** *Life*, August 27, 1951, pp. 50–54.

188 **Someone at Metro-Goldwyn-Mayer:** The MGM contract is dated June 30, 1950, YCAL, Box 45, Folder "1950." No documentation has yet been identified that could determine whose idea it was to use ST's hand.

188 **They rented the Bel Air home:** The lease was in the names of Annabella Powers and Hedda Sterne, for 139 W. Saltair, Brentwood, for July and August 1950; YCAL, Box 56, "Correspondence from 1950." Unsigned article in the *New York Herald Tribune*, June 30, 1950, "Gene Kelly Gets Top-Flight Ghost for His 'Drawings,'" notes that "Sol [sic] Steinberg, noted for his fine-line sketches for *The New Yorker,* has been signed by MGM to double for Kelly's artistic endeavor in the musical," YCAL, Box 62.

188 **He thought it was only his hand:** Unsigned letter to ST, on Metro-Goldwyn-Mayer Pictures letterhead, dated June 30, 1950, with a signature line for "Loew's Incorporated" at the end; copy in YCAL, Box 45, Folder "1950."

189 **"great promises of 'a free hand'":** ST to AB, September 11, 1950, SSF.

189 **The climate was so seductive:** ST to AB, August 10, 1950, SSF.

189 **He met such diverse personalities:** Wilder became one of Steinberg's most enthusiastic collectors—interestingly, one with such similar taste that the drawings Wilder most wanted to buy were usually the ones Steinberg liked best and wanted to keep for himself. In one example of several, Billy Wilder wanted to buy "baseball items" and hoped ST would change his mind and sell them.; Billy Wilder to ST, October 5, 1955, YCAL, Box 6, Folder "Correspondence 1954–55." Wilder also thanked him for "the splendid diploma you bestowed upon me. It is my prized possession and hangs by its lonely self in my office. I shall cherish it beyond all academy awards"; Billy Wilder to ST, October 9, 1950, YCAL, Box 56, "Correspondence from 1950."

189 **When Charles saw some of the drawings:** Charles Eames to ST, January 8, 1951, YCAL, Box 56, "Correspondence from 1951."

189 **He graced another with a naked woman's torso:** In exchange for ST's drawings on the chairs, Eames "crated two units" of plain chairs and shipped them to ST in thanks for those which he painted. Charles Eames to ST, May 25, 1950, YCAL, Box 56, "Correspondence from 1950."

190 **Naturally the local papers had a field day:** The chair, designed in 1948, was composed of fiberglass, reinforced plastic, metal, and rubber. The torso chair is now in the collection of Lucia Eames. ST's drawing is mistakenly dated 1952. He made it during his Hollywood stay in 1950.

190 **When he tried to describe what he had seen:** ST to AB, October 23, 1950, SSF.

190 **After that, he was careful to retain:** *S:I*, p. 256, and YCAL, Box 56.

190 **The filmmaker Carlo Ponti:** Information about Ponti and Naples is from ST to AB, April 6, 1951, SSF.

191 **Steinberg thanked Blow:** ST may have presented the diploma in 1951, but there is no firm evidence that it was. There are notations in ST's 1955 and 1963 datebooks of dinners with Blow, so he may have given it then, but the likelihood is that it was a 1951 gift. In 2009, Blow's diploma was presented to SSF as a gift from Douglas and Carol Cohen. According to Sheila Schwartz, ST kept a supply of diplomas and certificates on hand to give as gifts whenever the urge struck him. Corroborating this is a letter to HS, n.d. but probably March 1953, AAA, where he writes that Betty Parsons "wants a diploma. I forgot to leave it with her and I don't think I have any diplomas left in NY."

191 **Funds had to be funneled:** ST shipped via Liberty Packaging, according to frequent notations in YCAL, among them Box 7.

192 **Frequently the amount was greatly reduced:** Lica Roman to ST, January 17, 1951, Romanian letters, YCAL, Box 56, copy SSF, urging him to "file a complaint because I think they lost the package."

192 **"We are extremely stressed out":** Ibid.

192 **It was already a subject of general conversation:** Lica Roman to M & R Steinberg, February 19, 1950, Romanian letters, YCAL, Box 56, copy SSF.

192 **"a donut maker":** Jacques Ghelber to ST, May 20, 1951, Romanian letters, YCAL, Box 56, copy SSF. For the next several years, letters similar to this one followed, among them ones from Sali Marcovici, Solomon Steinberg, and Sylvia Haimovici.

193 **It was a house "filled with art"** Janine Di Giovanni, quoting Antony Penrose in "What's a Girl to Do When a Battle Lands in Her Lap," *New York Times Magazine*, October 21, 2007, p. 70.

193 **His first impression of London:** ST to HS, July 17, 1951, AAA.

193 **A side trip to Brighton:** ST to HS, n.d., but internal evidence suggests 1951 (although an unidentified hand has written "56" on the envelope), AAA.

194 **The next day he decamped:** ST to HS, from Hotel Pembroke, Lansdowne Road, Ballsbridge, Dublin, n.d., and *TNY* stationery from London, Saturday July 28, 1951, saying he is staying at the Euston Hotel.

194 **Dublin and Belfast had reminded him:** ST to AB, July 3, 1951, SSF.

194 **After Brussels, he took the train:** ST to AB, October 26, 1951, SSF. He added, "They're nice and for me, having suffered so much with visas and documents . . . "

194 **he was not officially discharged:** SecNav to ST, July 15, 1954, YCAL, Box 7, "Correspondence 1954–55."

195 **"frightful in its ugliness":** ST to AB, January 17, 1952, SSF.

195 **Penrose and Miller sent the prickly Sonia:** Roland Penrose and Lee Miller to ST, November 23, 1952, YCAL, Box 8, "Correspondence 1954."

195 **Fred Stafford . . . stepped in:** Stafford bought the house for HS and it was always in her name. A 1952 agreement shows that ST rented the second floor of the house at 179 East 71st Street to use as a studio from Mr. Frederick Stafford of 521 Park Avenue; YCAL, Box 56, "Correspondence from 1952."

195 **The house was one in a row:** The description of the house and how they used it comes from interviews and conversations there with HS throughout 2007.

196 **At the rear, French doors opened:** When HS was in her nineties, after suffering a stroke and when she was afflicted with macular degeneration, she used these two rooms as combination bedroom and studio. She kept the second floor for guests and rented the third as a separate apartment.

196 **Throughout the next decade, Steinberg filled the room:** Rodman, *Conversations with Artists*, p. 182.

197 **Saul took over the second floor:** ST took the billiard table with him when he left the

house in 1960. It eventually ended up in one of the storage sheds on the Nivola property in Amagansett.

197 **He thought he worked better:** ST to AB, November 30, 1953, SSF.

197 **"Saul's *New Yorker* people":** HS, interviews, March 28 and April 18, 2007. For a list of friends and guests, see also *S:I*, p 256, and YCAL, Box 3, ST's appointment books for 1952 and 1953.

197 **"two Irish rabbis":** May Tabak Rosenberg to ST, n.d., HR/Getty, Box 12, Folder 7.

198 **"rare gift for inventing":** ST, quoted in HR's *New York Times* obituary, July 13, 1978. Kurt Vonnegut to ST, October 17, 1985, wrote that he remembered ST telling him how much conversations with HR meant to him. In ST's undated reply (internal evidence places it in 1989), he talks about how HR's "friendship continues to make my life tolerable and who in the meantime has become younger than I for he died in '78 age 72 and I am now 75."

198 **Rosenberg was a towering presence:** May Tabak Rosenberg, from HR's memorial service.

198 **Steinberg, whose height was just below:** HS interview, April 18, 2007. After HR's death, ST hung his photo in what he called "the meditation room" of his 75th St. apartment. It is now in YCAL, Box 50.

198 **Steinberg saw him in New York:** ST to AB, March 31, 1952, SSF; ST, appointment book, March 18, 1952, notes a reception for De Sica "at museum"; YCAL, Box 3, Folder "Appointment Books 1951–52."

198 **"a marvelous guest":** This information is from interviews and conversations with HS throughout 2007 and 2008.

199 **One evening he sat glowering:** Priscilla Morgan, interview, May 31, 2007.

199 **The energy that Steinberg put into:** The Parsons-Janis show was the first of a two-year traveling exhibition in which new works were substituted as others were sold. Other venues included the Frank Perls Gallery, Beverly Hills, in December; the London ICA and the Museu de Arte in São Paolo, 1952; Galerie Maeght, Paris, Amsterdam and Dortmund; and the Virginia Museum of Fine Arts, all 1953. All arrangements were made by Janis. Information is from the exhibition notebook, SSF.

199 **He returned her generosity:** Calvin Tompkins, *Off the Wall: A Portrait of Robert Rauschenberg* (New York: Macmillan, 2005), p. 53.

200 **"I liked her":** From a telephone conversation with an unnamed interviewer, November 7, 1985, YCAL, Box 58.

200 **"gossipy and could be a treasure":** ST to HS, n.d. but written during the six-day voyage, April 18–24, 1952, AAA.

200 **It made him so nervous:** Information and all quotes that follow are from ST to HS, May 1, 1952, AAA.

200 **"jittery" days:** ST to HS, "Tuesday" and May 4, 1952, AAA.

201 **His consolation was:** ST to HS, "Wednesday evening," internal evidence suggests May 21, 1952, on stationery of Hyde Park Hotel, London, AAA.

201 **He found his parents:** ST to HS, "Monday," and "Thursday 8," AAA. Information and quotes are from these letters until noted otherwise.

202 **Unfortunately, neither director's ideas:** ST to AB, September 26, 1952, SSF.

202 **Otherwise, the Italian trip was disappointing:** ST to HS, n.d., on stationery of Hotel Plaza and de France, Nice.

203 **Rogers had several projects in mind:** ST to HS, "May 52," on stationery of Hotel France et Choiseul, AAA.

203 **The thirty-eight year old ST, who had never wanted:** ST to HS, "Sunday evening," on stationery of Hotel France et Choiseul, internal evidence suggests May 18, 1952. AAA.

203 **"personal letter, silly":** ST to HS, "Thursday," internal evidence suggests May 21, 1952, on stationery of Hotel France et Choiseul, AAA.

203 **He tried to explain to Hedda:** Smith, *S:I*, p. 48, notes how ST "certainly heard from readers" and how, in a 1952 memo to himself, he divides readers into "the far and the near-sighted." See also 1952 "Diary" and "1952 yearbook, March 11," YCAL, Box 3.

204 **"any fly by night plane":** ST to HS, "Monday," internal evidence suggests May 19, 1952, on stationery of Hyde Park Hotel, AAA.

CHAPTER FIFTEEN: THE DRAFTSMAN-LAUREATE OF MODERNISM

205 **"Your principal fear, I think":** HS to ST, n.d. but internal evidence suggests 1954, YCAL, microfilm reels 144–45.

205 **It was more than "a point of honor":** ST to HS, "Wednesday evening," internal evidence suggests late May 1952, on Hyde Park Hotel stationery, AAA. In his "Week in Review, 1952," YCAL, Box 3, ST notes "June 9: Boston." ST never specified what the Boston commission was, but there are several references that suggest it was for a department store mural that was never realized. In ST to AB, January 17, 1952, he refers to "a huge mural" he is doing. Astragal ["Notes and Topics" columnist], "Drawing the Crowds," *Architects' Journal* [London], May 8, 1952, p. 565: "At the end of this month he is hurrying back to America to do a mural in a Boston department store." "P Is for Prosciutto," *Time*, February 11, 1952, p. 70: "Current Steinberg projects incude a 400-foot mural for a Boston store." The article's title refers to an ABC booklet ST made for Claire Nivola when she was four years old. It is another example of ST's inventions, as in her book the letter *C* is for Cagliari, one of the three principal cities in Sardinia (her father's birthplace), and the *P* is for Picasso, who is depicted standing with one foot on and holding a sword that passes through the Louvre, which is small and on its side and which has blood pouring from a wound. E-mail from Claire Nivola, October 23, 2009.

205 **He stayed in New York just long enough:** Jerome Beatty, October 6, 1955, wrote on behalf of *Collier's Magazine* to ask if it could buy the drawings because *TNY* never published them. He also wanted to discuss ST's working directly for *Collier's*, but nothing came of it.

205 **Hedda went with him:** Three letters in YCAL, Box 56: to the reservations manager, Hotel Sherman, July 1, 1952, allowing ST and HS to occupy the room several days before the Republican convention began; from Harding T. Mason, associate editor, *TNY*, asking readers for assistance to ST in covering the convention; from Harding T. Mason, July 17, 1952, asking the same for coverage of the Democratic convention.

205 **"I must have seen 200 films":** ST to AB, November 30, 1952, SSF.

206 **Between the United States government:** Daniel Bueno, "Saul Steinberg e o Brasil: sua passagem pelo pais, publicacoes e influencia sobre artistas brasileiros" (Saul Steinberg and Brazil: his time in the country, publications and influence on Brazilian artists), *Revista de Historia da Arte e Arqueologia* no. 10 (July–December 2008): 126. Bueno, on pp. 129–30, writes that Bardi's original idea was not realized although ST filled several sketchbooks with Brazilian scenes, YCAL sketchbooks 3179 and 3201. Only two drawings were published: a hotel in Belém appeared in *Saul Steinberg* (New York: Whitney Museum of American Art), text by Harold Rosenberg; and a drawing of Recife appeared in *The Passport*, 1954. I wish to thank Eoin and Maeve Slavin for providing me with a copy of the 2011 exhibition catalogue, *Saul Steinberg: As aventuras da linha*, Roberta Saraiva, ed. (São Paulo: Instituto Moreira Salles), 2011.

206 **"invented a new world":** Bueno, *Saul Steinberg e o Brasil*, pp. 127–28.

206 **"You could stand a matchstick":** Flavio Motta, "Steinberg no Brasil," *Habitat* (São Paulo) no. 9 (1952): 17.

206 **"His bottle-end glasses":** Ibid., p. 17; Pietro Bardi, *Outros textos*, collected papers in MASP; both quoted in Bueno, "Saul Steinberg e o Brasil," pp. 128–29.

207 **When they went to stay in the House of Glass:** ST to AB, September 26, 1952; *S:I*,
p. 256; Bueno, "Saul Steinberg e o Brasil," p. 129.

207 **"tropical Bucharest":** ST to AB, September 26, 1952.

207 **He made drawings of these:** Among them Salvador, Manaus, Amazonas, Petropolis,
Bahia, Belém, and Recife. Many are in YCAL, Sketchbook 3201; Manaus is 4454.

207 **He needed thirty drawings:** ST, datebook, November 21, 1952, YCAL, Box 3, Folder
"Appointment Books 1951–52." His prices ranged from $250 to $300 for each of the
thirty.

207 **He had not done any lucrative work:** The container corporation was not identified by
name in YCAL, Box 56, and according to SSF it was never realized.

207 **"The general feeling . . . is that":** Hallmark Cards to ST, June 6, 1952, YCAL, Box 56.

207 **The incident was not resolved:** Hall to ST, June 9, 1952; Wheeler to Hall, June 16,
1952; Wheeler to Hall, June 30, 1952; all in YCAL, Box 56.

208 **Quite often Steinberg's name was dangled:** By the time of the 1978 WMAA retro-
spective, his collectors included Billy Wilder, Claude Bernard, Ivan Chermayeff, Max
Pahlevsky, Ernst Beyeler, Eugene Meyer, Carter Burden, Charles Benenson, Richard
Anuszkiewicz, Warner Leroy, and Gordon Bunshaft. From "List of Titles, Dates, and
Owners," HR/Getty, Box 45.

208 **"marketable mills":** This information comes from an interview with Eleanor Munro,
May 31, 2007, and from a conversation with HS immediately afterward on the same date.

208 **If one of them made a slightly barbed comment:** Multiple letters from Solomon
Steinberg, Jacques Ghelber, Sylvia Haimovici, R. Marcovici, and Sali Marcovici, all late
1953, Romanian letters, YCAL.

209 **And as his feelings of civic responsibility deepened:** ST told AB he was "defeated
by Ike" when Eisenhower won the presidential election; November 13, 1952, SSF. A
telegram from Nathan Straus invited him to be on television for a benefit for Mayor
Robert Wagner along with Senator Nicholas Lehman, FDR Jr., Averell Harriman, and
others. His uncatalogued papers at YCAL hold many requests from 1952 on from Jewish
charities, organizations, and congregations, to all of which he gave generously.

209 **Because more than half were small:** ST to Louis Gabriel Clayeux (Maeght's chief
administrator), February 4, 1953, copy SSF. A complete list of works in the show is in
Derrière le Miroir, no. 53–54, March–April 1953 (Paris: Editions Pierre à Feu, Maeght
Editeur).

209 **Maeght planned to dedicate an edition:** I am grateful to Mary Lawrence Test, who
explained that in actuality, the lithographs were offset lithographs (reproductions), and
in France it was not necessary to make the distinction between the offset lithographic
process and original lithographs.

209 **"eating chicken, drinking highballs":** ST to HS, March 2, 1953, AAA.

209 **Then he planned to check:** ST to HS, "Monday" 1953, AAA.

209 **During his two months in Paris:** Information that follows is from ST, datebook 1952,
YCAL, Box 3.

210 **Mme. la Baronne Elie de Rothschild:** Baroness Rothschild's invitation is in the form
of a phone message from his Paris hotel, YCAL Box 8, "Correspondence 1953." After
she gave ST her calling card, he began to collect cards from the members of the nobility
he met in France, Italy, and other countries, all of which he pasted into a scrapbook now
in YCAL. According to HS, interviews, September 9, 2007, and October 24, 2007, he
collected them because "he was a snob and wanted everyone to know that he was there,
he met them, these little duchessas and other royalty. He was a bit of a braggart, so he
told me how many of them he seduced. But what he loved most about the cards was
the print. His passion for the cards was not to whom they belonged but to the print they
chose to use."

210 **He went to the home of Meyer Chagall:** Jean Hélion to ST, January 4, 1960, YCAL,
Box 5, "Correspondence chiefly from 1960": "I also enjoyed talking to you. I felt that I

understood you, and that, wherever we went, we were keeping the same level and would always see each other clearly."

210 **In the short time he and Steinberg knew each other:** The uncatalogued YCAL boxes contain Hélion's many letters to ST.

210 **On this trip he was especially interested:** ST to HS, "Hotel de Crillon, Sunday 8," internal evidence suggests May 1953, AAA.

210 **"beautiful and civilized city":** ST to HS, May 24, 1953, AAA.

211 **"terrible":** Still, he immortalized the trip by making wooden furniture representations of the hotel rooms, among them the Konak in Istanbul, where he stayed from May 24 to May 28, 1953. He remembered the rooms thirty years later in the 1980s, when he made three that were featured in a show at Pace Gallery, January 11–February 9, 2008: SSF works 7252, 6300, and 6328. YCAL sketchbook 3146 is a record of the Athens-Istanbul trip; some of the drawings from this trip appeared in *Harper's Magazine*, February 1956, others in *TNY*, and still others in *The Passport*.

211 **The hardest part of the work:** ST to HS, on stationery of Hotel de Crillon, "Friday," (probably early June) 1953, AAA.

211 **"settle a book or two":** ST to HS, on stationery of Hotel France et Choiseul, n.d. (June 1953), AAA.

211 **He was actually relieved:** Daniel Keel to ST, June 1, 1953, YCAL, Box 8. Keel's firm, Diogenes Verlag in Zurich, had just bought the German rights for *All in Line* and taken an option for *The Art of Living* and all forthcoming books. Further correspondence between ST, Keel, and various American publishers and ST's lawyer, Alexander Lindey, show the difficulties that arose in Germany over rights, permissions, and copyright between Rohwolt and Diogenes.

212 **As he had left instructions:** ST to "Mlle. Claudine," n.d., 1953. She was in charge of handling accounts at the gallery and was following his instructions to settle his account of F Fr 13,980 with a French rare-book seller, and to send the rest, the sum of 517,918 francs, to Moritz Steinberg.

212 **Once again the commercial work interfered:** Correspondence relating to this show is in YCAL, Box 7.

212 **his lawyer had to prepare an affidavit:** ST to AB, November 30, 1953, and December n.d., 1953. Documentation concerning "In the matter of the application of Architect dr. Aldo Buzzi for a non-immigration visa to the U.S. for approximately 3 months" is in YCAL, Box 8, "Correspondence 1954." ST affirms that he will support AB and that his average gross salary for the previous five years was $25,000 except for 1952, when he and HS earned $30,000.

212 **He chose, for example, cartoons:** John I. H. Baur, *ABC for Collectors of American Contemporary Art*, with drawings by ST, distributed by the American Federation of Artists through Princeton Press, New York, 1954; E. H. Gombrich, the 1956 Mellon Lectures, Bollingen Series, Princeton University Press. Correspondence with William McGuire, YCAL, Box 8, indicates that it was he, not Gombrich, who made the request.

212 **"There must be an area":** James Geraghty to ST, November 10, 1954, YCAL, Box 8, "Correspondence 1954."

213 **It was frustrating to take time away:** Lee Lorenz, interview, September 12, 2007; Fred Model, interview, September 24, 2007; IF, interview, October 12, 2007; Roger Angell, interview, May 6, 2008; HS, interviews 2007.

213 **After Cartier-Bresson introduced him:** Dominique deMenil to ST, n.d. but internal evidence suggests spring 1954, YCAL, Box 8, "Correspondence 1954."

213 **Saul was nervously awaiting:** In the ST/AB letters, AB gives the dates of his visit as December 23, 1953, to March 31, 1954; in his datebooks for 1953 and 1954, ST gives AB's arrival as December 28 and departure as March 19, 1954.

214 **"The main thing":** HS interview, September 9, 1907.

214 **"It was always difficult":** HS, interview, October 11, 2007.

214 **"the second dinner":** HS, interviews, 2007.

214 **Architecture was very much on his mind:** In 1958, the Neutras sent their nineteen-year-old son, who was studying briefly in New York, to ST. YCAL, Box 8, "Correspondence 1958."

214 **Steinberg followed the debates:** Invitations from the Saarinens are in YCAL, Box 8.

215 **"the draftsman-laureate":** Girard to ST, correspondence in SSF.

215 **On the subject of architecture:** These notes may have been made in connection with the "Built in USA" feature in *Art News*, February 1953.

216 **"sad, mixed up, scared":** HS to ST, undated letter from YCAL microfilm; internal evidence suggests mid-1954.

CHAPTER SIXTEEN: BALKAN FATALISM

217 **"I've had and still have problems":** ST to AB, April 28, 1954, SSF.

217 **Just for fun, they were among:** Certificate from New York Airways, n.d., YCAL, Box 8, "Correspondence 1954."

218 **"too much stuff in it":** ST, datebook entries, March–May 1954, YCAL, Box 3.

218 **He expressed his interest:** From the catalogue of part of ST's personal library, SSF. The books are now in possession of Anton von Dalen.

218 **After every trip, his postcard collection:** The Long Island duck graced the *New Yorker* cover for the issue of May 11, 1987.

219 **"Whoever wants to know":** Jacques Barzun, *God's Country and Mine: A Declaration of Love Spiced with a Few Harsh Words of Reality* (Boston: Little, Brown,1954), p. 159. ST owned and read *The Baseball Encyclopedia*, 8th ed. (New York: Macmillan, 1990).

219 **"It just confirmed my suspicions":** Leo Steinberg, remarks made at ST's memorial service, "Remembering Saul, November 1, 1999," SSF.

219 **The first thing he did:** Information that follows is from HS, interviews, 2007.

220 **The players were intrigued:** Some of the drawings appear in *The Passport* (1954), others in *The Labyrinth* (1960).

220 **"an incredible individual spirit":** Karen van Lengen, interview, November 4, 2007.

220 **His pitcher stares down:** Billy Wilder wanted to buy all "the baseball items," but ST would not sell them. BW to ST, October 6, 1955, YCAL, Box 7, "Correspondence 1954–55."

220 **"an allegorical play":** ST, "Chronology," WMAA, p. 240.

221 **This summer he needed to work:** Lease for the house of J. Stanton Robbins, Wamphassuc Point, Stonington, Connecticut, from June 3 to July 22, 1954, YCAL, Box 8, "Correspondence, 1954."

221 **Hedda set up her studio and painted:** *The Concert* was first performed in 1956 by the New York City Ballet, revised in 1958 for the Spoleto Festival, and revived by the NYC Ballet in 1971.

221 **"What the hell":** E. Hawley Truax wrote to ST on March 29, 1956, YCAL, Box 7, to tell him about Kenneth Bird, an artist who drew for *Punch* and was then working on a book about the development of humor. Bird wrote about "pictorial puns—the confusion of one shape with another instead of one word with another. Just as one word may be identical with another but for a trifling variation in one syllable, so the outline of a flowerpot may be identical with that of a head, except that the former tends to turn out at the top instead of in. And just as a verbal pun depends on the aptness of the substitution, so does the pictorial pun, which is, of course, in essence literary rather than pictorial—and that is, probably, why it appeals to ST."

222 **"Our March 20 cover":** YCAL, Box 8, "Correspondence 1954."

222 **A nine-year-old from Brooklyn:** Jeddu Keil to ST, YCAL, Box 8, "Correspondence 1954."

222 **Many kept his lawyer busy:** Examples that follow are in YCAL, Box 8, "Correspondence 1954."

222 **"slightly more consideration":** Letter from Harvey M. Smith of Patterson Fabrics, April 27, 1954, YCAL, Box 8, "Correspondence 1954." The German firm Rasch & Co. Tapetenfabrik wanted to reproduce his designs for a mass market because "there are no wealthy people in Germany but there is a big demand for modern products." Letter to ST, December 21, 1954, YCAL, Box 7, "Correspondence 1954–55."

223 **For a variety of reasons:** Telegram, January 18, 1954, YCAL, Box 8, Folder 1954.

223 **It was a shock to everyone:** Arnold Saint-Subber to ST, March 11, 1954; telegram from Saint-Subber, July 8, 1954; YCAL, Box 8, "Correspondence 1954." YCAL, Box 62, contains an article from the *New York Times*, "Stiff Tests Start for Stage Design: Union Conducts 3-Day Exams for 72 Would-Be Members Expected to Know 26 Plays," June 5, 1954, which states that ST was assigned "The Palace Scene" in *King Lear*, for which he was to create a "Romanesque period." It quotes him as being "glum about his luck" and saying, "Why couldn't I have gotten something Turkish, or Egyptian?"

223 **Nor was he mollified:** NSMP to ST, April 24, 1954.

223 **Metro-Goldwyn-Mayer asked permission:** William D. Kelley, MGM Production Department, December 6, 1954, YCAL, Box 8.

223 **As Steinberg was striving to earn money:** All of these requests are in YCAL, Boxes 7 and 8, correspondence folders from 1954 to 1955.

224 **There were also requests from individuals:** Kay Halle, a colleague from ST's OSS days, n.d., YCAL, Box 8.

224 **"He thought this country":** HS, interview, 2007.

224 **The list of people he had to see:** Datebook for 1954, YCAL, Box 3.

225 **"very sick":** ST to HS, n.d. but internal evidence suggests August 22–23, 1954, AAA.

225 **For the next several days, he had to force himself:** I have relied on the sources named in *S:I*, p. 239, notes 89, 90, 91.

226 **"three incredible boys":** ST to HS, n.d. but internal evidence suggests between August 29 and September 3, 1954, AAA.

226 **On August 29 the partners in BBPR:** ST to HS, August 29, 1954, AAA.

226 **Most of the guests were:** ST to HS, September 3, 1954, Nice, AAA.

227 **"It was ok":** ST to HS, August 29, 1954, AAA. The film was *Elementary School*.

227 **He said he planned to see no one:** From the generally undated letters in YCAL, envelopes postmarked in the early 1950s bear Ada's married name, Ongari, and the address Viale Misurate 61, Milano.

227 **For the past several years:** In a letter of May 9, 1952, she berates him because she spent the evening waiting for his phone call, which never came. She complains that he is not being honest with her, nor is he taking her seriously.

227 **There had been three previous postwar encounters:** Ada to ST, April 5, 1955.

228 **She arranged for them to meet:** She was living at Viale Misurata 61 and receiving letters from him at her friend's postal box in her maiden name, A. Cassola. Ada to ST, Milano, May 5, 1952, YCAL, Box 7, Folder 8.

228 **When Ada wrote, it was usually to tell him:** I cite all the correspondence between ST and HS, YCAL and AAA, and ST & Ada, YCAL, Boxes 7 and 8, dating from 1952 to 1955, and in particular Ada's letter of April 5, 1955, YCAL Box 7, Folder 8.

228 **First she told him:** Ada to ST, Roma, December 11, 1954, YCAL, Box 8.

229 **As soon as she told him she was a teacher:** Senza Rete was a variety theater show directed by Carlo Alberto Chiesa and Vito Molinari. There is evidence that it was televised on October 31, 1954, on RAI. The writers were Alberto Bonucci, Paolo Panelli, and Zuffi, all of whom knew Steinberg.

230 **She was still angry:** Lica Roman to ST, January 6, 1952, Romanian letters, YCAL, Box 56.

230 **As far as Rosa was concerned:** Rosa Steinberg to ST, August 5, 1952, Romanian letters, YCAL, Box 56.

230 **Rosa was crafty enough:** Rosa Steinberg to HS, November 16, 1952, Romanian letters, YCAL, Box 56.

234 **"a striped suit":** ST to HS, Sunday, September 19, 1954, Connaught Hotel, London, AAA.

234 **Everything became formulaic:** Ibid.

CHAPTER SEVENTEEN: SOME SORT OF BREAKDOWN

235 **"I've been an inflated balloon":** ST to HS, "Sunday: [Hotel] St.James et d'Albany," internal evidence suggests Paris, spring 1955, AAA.

235 **There were two shows:** ST, 1955 calendar/datebook, entry for November 23–26, YCAL, Box 3. The San Francisco exhibition is not listed in SSF's exhibition history, and as there is no other information pertaining to it, it was most likely never realized.

235 **He was unable to sleep:** ST to HS, "Saturday," internal evidence suggests Paris, January–February 1955, AAA.

235 **His intention was to take a short trip:** "He always paid his fair share and never complained about it, but he was always on the lookout for deductions because he had so many people to support. He thought the money was better used directly by them than by Uncle Sam." HS, interview, 2007.

236 **"dangerous looking Beale Street":** Information about the trip to Tennessee, Mississippi, Alabama, and Georgia comes from a 1955 datebook/diary in YCAL, Box 3. Steinberg habitually walked out of any movie that did not hold his attention, and this one was such an unlikely film for him to watch that when he entered it into the pocket calendar he was using as a diary of the trip, he punctuated its title with an exclamation point.

237 **"sheer fun":** HS, interview and telephone conversations, spring 2007.

237 **She was stunned:** General information is from interviews with HS, and ST to HS, letters dated from early March through the end of April 1955, AAA.

238 **"Love is the only thing ":** Schopenhauer was one of her favorite philosophers, and her letters to ST hold frequent references and allusions to his philosophy. The letter is HS to ST, YCAL, microfilm reel 144–45, undated, but internal evidence places it in April 1955.

238 **Hedda told him to go:** HS to ST, April 12, 1955, AAA.

238 **"honesty or truth":** ST to HS, April 1, 1955, AAA.

239 **She intended to send him off:** HS to ST, YCAL, microfilm, n.d. but internal evidence is April 1955.

239 **"all sorts of sea monsters":** ST to HS, "Saturday" (March 18), 1955, AAA.

240 **"It's not a ham gesture":** ST to HS, "Monday Morning" (March 20, 1955), AAA.

240 **"It was bad":** ST to HS, "March 23 wed.," AAA.

240 **Although Steinberg had no faith in psychoanalysis:** Dream diaries are scattered throughout YCAL boxes and are cited specifically where appropriate. In this instance, they are in his HS letters, many undated (as this one is) but clearly 1955, AAA.

240 **The setting was always:** ST to HS, "Wednesday" (March 25, 1955), AAA.

241 **"There are—I didn't know—two Tortoretos":** In a 1955 datebook, he kept as a diary of the European trip, he identified the first as Tortoreto Lido and the "real" one as Tortoreto Nereto; YCAL, Box 3. In *R & S*, pp. 39–41, he gives the wrong date, 1957, and other recollections made almost thirty years later differ from those that are more reliable, made at the time in the datebook and the HS letters.

242 **"strange, that a place":** HS to ST, "Saturday p.m." Internal evidence suggests April 9, 1955, YCAL, microfilm.

242 **"a sign":** HS to ST, "Sunday evening 12:30," YCAL, microfilm reel 144–45. In the letter she put the phrase in quotation marks.

243 **"I'm terrorized":** ST to HS, "Saturday, April 2, 1955," AAA.

243 **With the exception of Alberto Moravia's:** The Flaiano novel deals with the Italian occupation of Ethiopia, which reminded ST of something he saw on a bus trip to the

nearby town of Forte de Marini: "I saw on the road a cart pulled by a donkey. Inside the cart there was a big white ox. The man was leading the little donkey, donkey pulling ox. It was funny for a moment till you realized that the ox was being taken to the abbatoir. There is some moral here somewhere. Maybe about collaborationism." ST to HS, Friday, April 1, 1955, AAA.

243 **"unbalanced and too sensitive":** ST to HS, "Viareggio, Tuesday," internal evidence suggests early April 1955, AAA.

243 **He accidentally ran into:** ST, datebook, April 5, 1955, YCAL, Box 3.

244 **He told his diary something different:** ST, datebook, April 4, 1955, YCAL, Box 3.

244 **She begged him to believe:** Ada to ST, n.d. but internal evidence suggests spring 1955, YCAL; "Milano, 1956," probably written at the end of 1955 to reassure him of her maternal feelings and send New Year's greetings for 1956.

244 **"I feel fine":** ST to HS, Friday April 1, 1955, AAA.

244 **The image was so intense:** The drawing is in his 1955 datebook between the pages for April 4 and 5, YCAL, Box 3.

245 **"sick with fear":** ST to HS, Tuesday, April 12, 1955, AAA.

246 **When she told him she was thinking:** ST to HS, "Wednesday night, April 13 [1955]," AAA.

246 **"half in doubt":** HS to ST, April 23 [1955], YCAL, microfilm.

246 **In her customary way:** HS to ST, n.d. but internal evidence suggests mid-April 1955, YCAL, microfilm reel.

246 **"I am living in a kind of atmosphere":** HS to ST, n.d. but internal evidence suggests late March–early April 1955, YCAL, microfilm reel.

246 **"the ghetto group":** Although Leo Lerman does not mention ST or HS in his published letters, he was a frequent visitor to their home during these years. HS writes: "Leo Lerman comes to lunch, he needs my help and advice." Sonia Orwell had become a closer friend to HS than to ST, and sent HS volumes of "early Proust" because of their mutual interest. Norman Mailer invited HS alone to parties and dinners.

246 **If she worried about anything:** She was right to worry: almost fifty years later she fell victim to macular degeneration, and this ended her painting career. References to the people she saw and parties she attended are from the YCAL microfilm letters, all undated, ranging between February and April 1955.

246 **When he asked her to tell him:** HS to ST, an undated letter attached to the previous undated one, written on the tiny sheets of pocket notebook paper that she favored for her philosophical ruminations. These are scattered throughout the YCAL boxes and are often not in coherent order.

247 **"with each meal I cook for you":** HS to ST, n.d., YCAL, microfilm reel 144–45, her emphasis.

CHAPTER EIGHTEEN: A DEFLATING BALLOON

249 **"I was his long-suffering, uninterruptedly betrayed wife":** HS, interview, September 9, 2007.

249 **"certainly one of the best":** ST to HS, "Wednesday night April 13 [1955]," AAA.

250 **"How horrible the mud splashes":** ST to HS, "Tuesday morning," (April 1955), AAA. His datebook for 1955, YCAL, Box 3, mentions one meeting with Hayter.

250 **"small fry abstracts":** ST to HS, "April 23, Sat. Nite" (1955), AAA.

251 **Making the selection created:** ST, diary, May 27, 1955, YCAL, Box 3. Eventually the book contained approximately 200 drawings.

251 **While choosing them and working:** ST to HS, "Thursday morning" (April 1955), AAA.

251 **At the same time, Robert Delpire:** "Labyrinthe," a prefiguration of the title given by ST to his 1960 book, *The Labyrinth*.

251 **"There may be trouble here":** ST to HS, "April 20 evening" (1955), AAA.

252 **"I don't want to be shown":** ST to HS, "Tuesday Morning," (mid-April 1955), AAA.

253 **Moritz added to Saul's confusion:** Moritz Steinberg to ST, Nice, January 26, 1955, Romanian letters, YCAL, Box 8.

253 **Brooding over the conflicting claims:** ST mentions dining with Giacometti on several occasions in the AAA correspondence; HS returned to this friendship many times throughout the 2007 interviews.

254 **"never one of those artists' wives":** HS, interview, 2007.

254 **"What about you?":** ST to HS, April 25, 1955, AAA.

254 **Hedda was fascinated by all the existentialists:** HS, telephone conversation, 2007.

255 **Wedged into their social program:** ST to HS, April 15, 1955, AAA.

255 **"On top of that, they are in Bucharest":** ST to HS, "April 20 evening" (1955), AAA.

256 **"after I troubled the whole Palestine":** ST to HS, April 27, 1955, AAA.

256 **"envied for a moment":** ST to HS, "April 15, 55," AAA.

256 **Eventually he and Gallimard agreed:** ST to HS, "Friday night" (April 1955), AAA.

256 **"kind of anthology":** ST to AB, December 27, 1955, SSF.

257 **"NO Stonington":** ST to HS, "Friday night" (April 1955), AAA.

257 **He spent his last days in Paris:** ST, diary, June 26–27, 1955, YCAL, Box 3.

257 **Most of his interaction had been:** ST had extensive correspondence with Hélion and Miro, to cite two examples. Their letters are currently uncatalogued and scattered throughout the YCAL boxes.

257 **"Note: alone":** ST, datebook, April 22, 1955, YCAL, Box 3.

258 **"What I learned from Artists":** ST, datebook, n.d. but probably early 1980s, YCAL, Box 38.

258 **Now, on the way home:** The most striking representation is his *TNY* cover of February 5, 1972, in which a figure of a man stands between two signs pointing in opposite directions. He is turned away from the one reading "before" and faces the one reading "after."

259 **If he read something he liked:** Among those to whom he wrote were Lore Siegel, Alice Munro, Veronica Geng, IF, and Donald Barthelme.

259 **"In order to become a fox":** ST, diary, November 25, 1955, YCAL, Box 3. Isaiah Berlin, *The Hedgehog and the Fox: An Essay on Tolstoy's View of History*, was originally published by Weidenfeld & Nicholson (London, 1953), and read by ST in that edition.

259 **While in Paris, he did buy:** ST to HS, "Friday night" (April 1955), AAA.

260 **Jim Geraghty took him to lunch:** ST did not become a member of the Century Association until 1965, proposed by Eric Larrabee and seconded by Sidney Simon. He resigned on October 19, 1975, in a letter to Russell Lynes, saying that he never used the club and saw no purpose in continuing his membership. I am grateful to Dr. Russell Flinchum, the Century archivist, for providing this information.

260 **He was still thinking about the self-knowledge:** Information that follows is from ST, datebook, September 9 to December 30, 1955, YCAL, Box 3.

260 **He was discreet:** ST, 1955 datebook, YCAL, Box 3; one of the Parisian encounters was "Marielouise L.," December 1954, Romanian letters, YCAL, Box 8.

261 **There was so much to do:** ST, National Diary Page-A-Day, January 3, 1956, YCAL, Box 3.

CHAPTER NINETEEN: A GRAND OLD-FASHIONED JOURNEY

262 **"I've made a grand old-fashioned journey":** ST to AB, April 13, 1956, SSF.

262 **There was much to do:** ST, 1956 National Diary appointment book, YCAL, Box 3.

263 **"the cruelest humorist":** "L'intransigeant," *Paris-presse*, February 2, 1956, p. 7C, YCAL, Box 70.

263 **"quiet Englishman":** ST to HS, February 17, 1956, AAA.

263 **He was also thankful:** ST to HS, February 18, 20, and 21, 1956, from Leningrad, AAA.

264 **He was assigned a woman guide:** Information from a second datebook for 1956 dedicated to ST's diary of the Russian trip, YCAL, Box 3.

264 **he insisted on seeing the Finland Station:** Edmund Wilson, *To the Finland Station: A Study in the Writing and Acting of History* (New York: Harcourt Brace, 1940). The Finland Railroad Station was the terminus for trains from Helsinki and Vyborg and was made famous when V. I. Lenin went through it on his return to Russia.

264 **"three horses galloping":** ST to HS, Tuesday, February 21, 1956, AAA.

265 **At this point, he didn't care:** He bought so many things that he had to find a Russian bank to cash $300 in travelers' checks. ST, Russian datebook, February 20, 1956, YCAL, Box 3; ST to HS, February 23 and 27, 1956, and cable February 27, 1956, all AAA.

265 **Everything in Moscow was "enormous":** Figure 49 in *S:I*, p. 51, shows vividly the vastness of the square and how it dwarfs the people in it.

265 **Much of the rest of his three days:** In his Russian datebook he wrote only the last names of the embassy people (Conant, Bohlen, White) or the reporters (Raymond of the *New York Times*, Levine of CBS, Schorr of the *Chicago Tribune*); YCAL, Box 3.

266 **He liked his interpreter:** His writing is unclear, and the name may have been Yonkin.

267 **"Turkish verandas":** ST, diary, March 4, 5, and 6, 1956, YCAL, Box 3.

268 **They went on to the Ivari Monastery:** In his diary, ST mistakenly calls it the Samtavro Monastery.

270 **the young historian:** Later known as Priscilla Johnson MacMillan, who wrote about Lee Harvey Oswald, the CIA, and other topics pertaining to modern Russia.

270 **"sensitive and brutal faces":** Vladimir Maximov was the dissident author of *Seven Days of Creation*, *A Train for Moscow*, and the memoir of his adolescence, *Adieu from Nowhere*. He was sent to a mental hospital, exiled to Paris, and later permitted to return to Moscow.

271 **Bohlen also arranged an interview;** ST mistakenly gives the name as "Shugnov" in his diary, YCAL, Box 3. *Voks* was the official U.S.S.R. journal published by the Society for Cultural Relations with Foreign Countries. Highly propagandistic, it was so thoroughly reviled abroad that in 1958 it was discontinued, reorganized, and reissued under another name and with more objective content.

272 **"whether [Averell] Harriman":** ST wrote this in a little notebook where he jotted things that struck his fancy, now YCAL, Box 95. According to PC, the contents of Box 95 were so important to ST that he kept them in his bedside table.

272 **He stole the telephone directory:** WMAA, p. 241.

273 **"Thank you my darling":** In an interview, April 18, 2007, HS said, "This was one of my favorite stories about Saul." In his 1956 datebook, ST gave the man's remark as "My darling, I must go!"

273 **"The smell of fear":** Jean Stein vanden Heuvel, "An Interview with Saul Steinberg," typescript, YCAL, Box 38, eventually edited into the article published in *Life*.

273 **"frozen snow, Bolshoi":** ST to AB, April 13, 1956, SSF.

273 **"a trip for my nose":** WMAA, p. 241.

274 **He worked from notes:** These notes are in YCAL, Box 7, and appear to be companions to his YCAL sketchbooks 199–202b, 4860, 4869.

274 **"Comments about buildings in USSR":** YCAL, Box 7.

274 **"the best reporting":** Arthur Caylor, *San Francisco News*, September 29, 1956.

CHAPTER TWENTY: COVERING 14,000 MILES

276 **"Back from Alaska":** ST to AB, September 17, 1956, SSF.

276 **A check had come in:** Statement in YCAL, Box 7, n.d.

276 **Added to all these:** Correspondence with Alexander Lindey, January 25, 1956 to March 7, 1956, YCAL, Box 7.

276 **"in consideration of the sum":** These contracts appear annually among ST's correspondence in the YCAL boxes; here, I refer specifically to the one sent by R. Hawley Truax with accompanying letter dated October 22, 1954.

277 **In that one, Steinberg drew:** Joel Smith corroborates ST's habit of recycling old work for other purposes in *S:I*, p. 44.

277 **"Operation Steinberg":** Manuel Gasser, "Steinberg as an Advertising Artist," *Graphis* no. 63–68 (January–December 1956): 376–85.

278 **In one ad for Noilly Prat:** Ibid., p. 381, cites research figures for 1956 that show Noilly Pratt "achieved the biggest sales success in its own or any other trade sector."

278 **For Schweppes, he created:** This drawing, like the ad he did for Postum in 1943, contains portions of subject matter used before. The most blatant examples of ST's recycling are in the designs for the firms Patterson and Greef for wallpaper and fabrics of European cityscapes, all of which he worked and reworked for several years. One example is his 1946 ad for D'Orsay perfume, which shows up later in the fabric designs, particularly those for Patterson. See also *S:I*, p. 44.

278 **Perhaps the most wildly imaginative print ads:** Winius Brandon Company Advertising, St. Louis, Missouri, YCAL, Box 7.

279 **"demands coincide with your aspirations":** James Geraghty to ST, November 10, 1954, YCAL, Box 8.

279 **a television commercial for Jell-O:** The ad, which was a huge success in 1955, came in for severe criticism on the post-feminist Internet in 2009, when it was described as a "grim animated commercial . . . It shows a haggard woman on a treadmill being assaulted by symbols. The look on her face is one of pure despair. The female narrator seems to be taunting her. The plaintive harmonica tune that's playing is both sad and intentionally insipid. At the woman's blackest moment, she gets covered up by a black scrawl . . . All is cured, of course, once she buys a box of Jell-O instant pudding." From www.boingboing .net/2009/08/12depressing-1950's-jel.html.

279 **"comic draughtsman":** From a statement prepared by Hallmark and used in its advertising, YCAL, Box 8.

280 **Unquestionably he had arrived commercially:** Because these requests are so many and can be found in almost every YCAL Box, I merely alert the scholar to their existence without naming any specifically.

280 **"Left by car":** ST, datebook, 1956, YCAL, Box 3, and HS, interviews, 2007.

280 **"the beauty of an eventless life":** HS to ST, "the 31 January," internal evidence suggests 1944 as it is in reply to his of "Jan 18," YCAL, microfilm letters.

280 **"some room, any room":** HS to ST, Reno, May 31 [1944], YCAL, microfilm letters.

281 **"an understanding between [two] people":** HS to ST, "Feb 23," probably 1943, YCAL, microfilm letters.

281 **"a rather bad attitude":** HS to ST, n.d. but internal evidence suggests May 1944, when she was en route to Reno for her divorce from Fred Stafford, YCAL, microfilm letters.

281 **In the Pacific Northwest:** Several years later, ST received a letter concerning things he bought on the trip. On November 25, 1958, YCAL, Box 6, Michael Train asked if ST was still interested in having rugs or serapes made to his design. The artist, a Native American whom ST had befriended, "is growing listless from lack of fresh designs to work on. He is a neurotic Indian who suffers in part from what used to be called 'artistic temperament' and when forced to continually turn out the so-called 'authentic designs' has a tendency to get drunk or spend all his time playing the saxophone . . . I consider it to my advantage to keep him busy." Train also offered to sell ST "sneeze powder, collapsing forks, dribble glasses, and squirting boutonnieres."

282 **Saul said that like Cornell:** Deborah Solomon, *Utopia Parkway: The Life and Work of Joseph Cornell* (New York: Farrar, Straus and Giroux, 1997), p. 134.

282 **Rothko's insistence that he painted:** James Breslin, *Mark Rothko: A Biography* (Chicago: University of Chicago Press, 1993), p. 243.

282 **When Hedda painted the Newmans:** References to Cornell, Rothko, and the Newmans which are similar to these quotes can be found in the undated letters of HS, internal evidence suggesting the early 1950s, in YCAL, microfilm letters. HS gave the paintings of the Newmans to Priscilla Morgan, who bequeathed them to Vassar College.

283 **On the other hand, Hedda often spoke:** Two such examples are HS to ST, "Reno, May 31," and "Monday 21" [probably 1944], YCAL, microfilm letters.

284 **"a disaster—everything was in poor shape":** Appraisal, YCAL, Box 7, Folder 20.

284 **"charming clients really":** Schuman, Schuman & Furman to Alexander Lindey, March 30, 1957, YCAL, Box 7.

284 **However, it still took both lawyers:** Alexander Lindey to ST, June 26 and July 29, 1957, YCAL, Box 7, Folder 17.

284 **"I enjoy chopping wood":** ST to AB, November 1956, SSF.

284 **"bad mood because I'm dissatisfied":** ST to AB, December 10, 1956, and March 10, 1957.

CHAPTER TWENTY-ONE: SIX PEOPLE TO SUPPORT

286 **"Latest news: sister out of Romania":** ST to AB, October 5, 1957, SSF.

286 **The scenery was not enough:** Information that follows is from interviews and conversations with HS; WMAA, p. 242; documents pertaining to the purchase and sale of the Citroën from YCAL, Box 7.

286 **"A gentleman of Madrid":** ST to insurance agent Michel H. Lobut, rue de Richelieu, Paris, June 25, 1957, YCAL, Box 7.

286 **On their way home:** On July 1, 1957, he deposited the proceeds of the sale, $1,745, in his account at Chemical Corn Exchange Bank, YCAL, Box 7.

287 **Richard Lindner, for example:** HS to ST, n.d. but probably from the mid-1950s, YCAL, microfilm, reel 144–45 .

288 **But the friendship with the Stilles:** Interviews and conversations with HS, Ruth Nivola, Claire Nivola, Alexander Stille; letters and documents cited where appropriate.

288 **Stille was educated:** Alexander Stille, in conversation on January 6, 2009, believed that both his father and ST may have been involved with Leo Longanesi's magazine *Omnibus*, but he was not sure they knew each other before the war, as they lived in different cities.

288 **Steinberg never gave up his love:** Letizia Airos Soria, "The Language of Ugo, Alexander, and Sam," *IADP i-Italy*, June 1, 2008, http://www.i-italy.org/2279/language-ugo -alexander-sam. See also Stille's "Steinberg Diario Italiano: Gli anni della formazione e della persecuzione razziale," *La Dominica di Repubblica*, August 10, 2008.

288 **Ugo often traveled for his job:** "Ugo Stille" was a pen name adopted in the 1930s when he wrote a column with the poet Giamme Pintor for the magazine *Oggi*. When Pintor was killed by the Germans during the war, Kamenetzki took the name Michael Ugo Stille in partial tribute to him. Stille's obituary in the (London) *Independent*, June 12, 1995, called him "one of the most famous Italian journalists of the last fifty years and one of the best editors of Italy's most authoritative newspaper, the *Corriere della Sera* of Milan. In Italy, he was recognized as the best of the Italian correspondents in the United States and the key point of reference for anyone wishing to understand that country."

288 **"avoid or postpone":** ST to AB, New York, December 30 [1957], SSF.

288 **He was "enjoying it a lot"** Ruth Nivola confused Claire's book with the one ST made for her son, Pietro.

289 **He reserved the letter *E*:** I am grateful to Claire Nivola for allowing me to see the *ABCedarian*, which is in her private collection of works by ST.

289 **"yanked her out of Cornell":** Alexander Stille, interview, January 6, 2009. Stille refers to the New Bauhaus School funded by Walter Paepcke that lasted one year, 1937–38,

after which it became first the School of Design (1939) and then the Institute of Design (1944).

289 **Their friends tried not to notice:** Priscilla Morgan remembered such parties at the Weiner house and the Betty Parsons Gallery, to name just two. She recalled conversations with René Bouché and Richard Lindner when they all expressed sadness over HS's determined stoicism and ST's rude disregard for her feelings.

289 **"the terror that grips the shoulders":** ST wrote this on "Sunday, May 19, 1991," YCAL, Box 75, after a visit to HS. He said she had it "during my tenure," which was the expression he used for the years they lived together as a married couple.

290 **The news that the Roman family:** Lica Roman wrote a memoir of the years when she and her family were trying to leave Romania. SSF has prepared an English translation, unpublished as of 2011.

290 **"managed to slip out":** Alexander Lindey to ST, February 14, 1957, YCAL, Box 7.

290 **"They leave on September 1st":** M & R Steinberg to ST, August 26, 1957, Romanian letters, YCAL, Box 8.

290 **"through an exchange of favors":** ST to HS, September 8, 1957, AAA.

290 **In Nice, his parents were "frantic":** Much of this correspondence, dated September 3 through 27, is in Romanian letters, YCAL, Box 8.

291 **"a duty, a responsibility":** ST to AB, October 2 [1957], SSF.

292 **He was in New York:** Moritz Steinberg to HS and ST, September 25, 1957, Romanian letters, YCAL, Box 8.

292 **"very cute":** Rosa Steinberg to HS, September 22, 1957, Romanian letters, YCAL, Box 8.

292 **"the different generations":** Lica and Ilie (Rica) Roman to ST, October 9, 1957, Romanian letters, YCAL, Box 8.

293 **On their own they made:** Lica Roman to ST, November 1957, Romanian letters, YCAL, Box 8.

293 **They dutifully began the process:** Ilie and Lica Roman to ST, Nice, October 9, 1957, Romanian letters, YCAL, Box 8.

293 **"a good act as an artist":** ST to AB, December 3 [1957], SSF.

293 **At the same time, more letters:** "Sali" [Marcovici] to ST, n.d.; Jacques Ghelber to ST, Tel Aviv, November 18, 1957; both Romanian letters, YCAL, Box 8; Ada Ongari to ST, n.d., YCAL.

294 **"I'm in trouble":** ST to AB, January 20 [1958].

CHAPTER TWENTY-TWO: A BITING SATIRE OF AMERICAN LIFE

295 **"If my life, or yours or others":** ST to AB, December 20, 1957.

295 **Rudofsky was the chief designer:** Rudofsky was in charge of the interior design and installation of exhibitions for Peter G. Harnden Associates. Correspondence about the mural between ST and BR is in YCAL, Box 8.

295 **his charge was to tell:** Felicity D. Scott, "An Eye for Modern Architecture," in *Lessons from Bernard Rudofsky: Life as a Voyage* (Basel: Birkhauser, 2007), p. 200.

295 **"pricks our complacency":** Ibid., p. 194.

295 **President Eisenhower was so disturbed:** Ibid., p. 203; F. D. Scott, "Encounters with the Face of America," in *Architecture and the Sciences: Exchanging Metaphors*, ed. Antoine Picon and Alessandra Ponte (New York: Princeton Architectural Press, 2003), pp. 256–91.

296 **Before he began to arrange:** "Statement for Murals for Brussels World's Fair," YCAL, Box 6.

296 **he had worked on perfecting:** ST described the technique in his letters to HS, "Tuesday 24 August" [1954] and n.d. (probably late August 1954), both AAA.

296 **"Bernard full of politics"**: ST to HS, March 15, 1958, AAA. For gossip, intrigues, and actual details about the murals, see also B. Rudofsky to ST, January 13 and March 1, 1958, and Peter G. Harndon to ST, March 14, 1958, all in YCAL, Box 8.

296 **"beautiful, like enamel"**: ST to HS, March 15 through April 12, 1958, AAA.

297 **In fact, his mural was the greatest:** Some of the many reviews include "ST at Brussels," *Newsweek International Edition*, April 28, 1958, p. 39; "Americans at Brussels: Soft Sell, Rage & Controversy," *Time*, June 16, 1958, pp. 70–75.

298 **"to show how we really"**: *New York Herald Tribune*, April 10, 1958.

298 **"a biting satire"**: Pierre Schneider, partial clipping in YCAL, Box 62, folder "Brussels Fair Reviews."

298 **"ugly dark blue"**: ST to HS, "Sunday on Pont royal p.m. April 18, 1958," AAA.

298 **He urged Hedda not to doubt:** HS was still deeply involved in the friendship with the Stilles, and in an undated letter, YCAL, microfilm letters, she tells ST that "Mischa [as they called Ugo] and Elizabeth" took her to " [Dwight] McDonalds after dinner."

298 **"Decisions, decisions"**: HS to ST, n.d. but just prior to the one quoted above, YCAL, microfilm letters.

299 **He refused an invitation to dinner:** Correspondence in YCAL, Box 8.

299 **"suggestions to reconsider"**: Correspondence concerning this book is dated April 26, 27, 28, and 30, 1959, and March 25, 1959, YCAL, Box 6.

299 **The project dragged on:** D. F. Bradley to R. Delpire, April 39, 1959, YCAL, Box 6.

299 **An unhappy resolution occurred:** HS sent a telegram to ST, April 15, 1958, telling him that William Shawn "wants many drawings of Brussels Fair for possibly several double spreads." On May 11, 1958, she sent ST an undated letter telling him that Shawn refused them all. Apparently, he did not think them suitable for the magazine. YCAL, Box 8.

300 **"I'd be horrible"**: ST to HS, "Genova April 27" [1958], AAA.

300 **Then he drove on to Rome:** ST received $500 for the front curtain, and Leland Hayward paid him $200 in royalties for the Robbins ballets performed at the Alvin Theater in New York. Correspondence concerning the 1958 Festival of Two Worlds, Spoleto, is in YCAL, Box 6.

300 **They invited him to name any price:** Letter from Gabor Associates of I. M. Pei, on behalf of "Mr. Fassio," owner of the company, YCAL, Box 6. Carlo Luigi Daneri was the architect and Gigi Fornasetti was the interior designer.

300 **"affamato artista e la sua pottente giaguar"**: ST to HS, Spoleto, May 3, 1958, AAA.

300 **" horror of the brutality"**: ST to HS, Grande Albergo Minerva, Rome, n.d. but most likely late April–early May 1958, AAA.

301 **Although he remained close:** His date and address books in YCAL, Box 3, attest to his meetings with those named in the text and many others.

301 **It was a shock to read:** Originally titled *Quer Pasticciaccio brutto de via Merulana*. ST to HS, "Sunday 11" internal evidence suggests May 1958, AAA. Also ST to AB, June 1, 1958: "The idea of using dialogue to describe a person—not in the dialogue—is brilliant." ST felt several empathies for Gadda: both were Politecnico graduates, but Gadda had been in engineering; Both considered themselves "intensely Milanese," and Gadda's innovative use of language in literature had parallels with ST's in art.

301 **"undesired role"**: ST to AB, June 1, 1958, SSF.

301 **In his influential 1915 essay:** Daniel-Henry Kahnweiler, *The Rise of Cubism* (New York: Wittenborn, Schultz, 1949), pp. 5–16; originally published as *Der Weg zum Kubismus* (Munich: Delphin, 1920).

301 **Earlier in 1958:** HS to ST, n.d. but internal evidence suggests early 1958, YCAL, microfilm letters.

302 **Picasso gave the paper:** ST merely mentions that he called on Picasso in ST to AB, June 1, 1958, SSF. In a note to the letter, AB writes: "The result, logically, was not an exceptional drawing but merely a pleasant souvenir of the meeting, which since it was done with a ballpoint pen, ST kept wrapped in dark paper so that it would not fade with

the passage of time. To ST, it signified above all that on that day Picasso had considered him his peer." SSF, in a comment to this note, said that AB is mistaken about the ball-point pen: that one of the drawings was done in pencil, the other in colored crayons; also that ST did not keep it wrapped but framed the two sheets together. One is currently at YCAL, the other is owned by Stéphane Roman; interviews, January 11 and 12, 2008. See also *S: I*, cat. 69, p. 192. On p. 246, n. 155, Joel Smith writes that *cadavre exquis* works make their earliest appearance in the brochure for ST's 1966 exhibition at the Sidney Janis Gallery and are also reproduced in *WMAA*, p. 193. ST played the conventional version of *cadavre exquis* with Picasso on May 16, 1958. One of the drawings was most recently shown at the Musée Tomi Ungerer, Centre International de l'Ilustration, Strasbourg, France, in the exhibition "Saul Steinberg: L'ecriture visuelle," November 27, 2009–February 28, 2010.

302 **"an old Jewish man":** Adam Gopnik, from the multiple drafts of "Talks with Steinberg," 1986–93, YCAL, Boxes 48 and 67.

302 **The work was steadying:** The following account is based on letters from Rosa and Moritz Steinberg and Lica and Ilie Roman to ST, from January 1958 through January 1959, Romanian letters, YCAL, Boxes 8 and 14.

CHAPTER TWENTY-THREE: CLASSIC SYMPTOMS

305 **"I'm a bit troubled and confused":** ST to AB, October 16, 1958, SSF.

305 **He said it needed further breaking in:** In WMAA, p. 242, ST writes that he went by bus and rented car. Undated letters from HS refer to his driving the Jaguar.

305 **"the ancestors of the Americans":** WMAA, p. 242.

305 **"Here's where they ought to":** ST to AB, July 30, 1958, SSF.

305 **"I hear you are rich":** ST to HS, "Sat Apr 12" [1958], AAA. The annual Whitney exhibition of sculpture, paintings, and watercolors was November 20, 1957 to January 12, 1958.

305 **She had four new shows:** For full details, see chronology in Eckhardt, *Uninterupted Flux*, p. 123.

306 **Such excessive delight:** HS to ST, n.d. but internal evidence suggests late 1958, YCAL, microfilm letters. Alexander Stille, interview, January 6, 2009, said, "I think he [ST] was infatuated with Elizabeth's kids. I think there was the fantasy of having a family, plus a ménage à cinq with Hedda. Hedda was very taken with Elizabeth's kids. There was something very strange about this."

306 **plunked his "ass on the chair":** ST to AB, June 1, 1958, SSF.

306 **Deep down, however, he knew:** ST to AB, July 30, 1958, SSF.

306 **"life . . . seen here":** WMAA, p. 243.

307 **"easily found, not easily selected":** Brian Appel, "Beauty and 'the Beats'—Robert Frank's "The Americans" (1955–56): Poised for New Highs in the Age of Bush?," p. 5, http://artcritical.com/appel/BAFrank.htm.

307 **Delpire, aware of Steinberg's enormous popularity:** In 2009, rare first editions of the 1959 Delpire publication were being offered over the Internet for upward of $50,000. Delpire recalled telling Frank, "'You can use a photo for the American edition' . . . but when I reprinted the book in 1986, I used a photograph because I had discovered, basically, that he was right." See "Dream Team," July 7, 2009, http://doublemoine.com/2009/07/dream-team/.

307 **He filled a sketchbook:** YCAL, Sketchbook 4891.

307 **He brought home numerous souvenirs:** WMAA, p. 242.

308 **He arrived in Copenhagen:** ST to HS, December 3, 1958, AAA.

308 **His hosts pulled out all the stops:** ST to HS, December 5, 1958, AAA.

308 **"interesting insane Dane-painter":** ST to HS, "Monday morning" (December 7, 1958), AAA.

308 **"another normality":** WMAA, p. 243.

308 **"Raskolnikoff quarters":** ST to HS, December 10, 1958.

308 **The children were happy in school:** ST to HS, "Thursday" (December, 1958), AAA.

309 **"Dear Sauly":** Ilie Roman to ST, November 15, 1958, Romanian letters, YCAL.

309 **"the usual. I see too many people":** ST to AB, January 8, 1959.

309 **The magazine was not yet ready :** Reproduced in Smith, *Steinberg at The New Yorker*, p. 65.

309 **Stanley Marcus bought the original:** Stanley Marcus to ST, February 4, 1959, YCAL, Box 6.

309 **A housewife in Berkeley:** This letter and those cited below are in ST's fan mail, YCAL, Box 6.

310 **It helped that his work:** One example of many: WMAA acquired "Railroad Station" through the generosity of Mr. and Mrs. Carl L. Seldon, YCAL, Box 6.

310 **He did continue to work:** Smith, *Steinberg at The New Yorker*, p. 6, notes that he contributed 89 covers, more than 600 independent cartoons and drawings, and nearly 500 that appeared within multipage features. There were also still-uncounted "spots" and "spot fillers."

310 **"very particular about his drawings":** HS insisted this was true, but others, all connected to the magazine, denied it: Roger Angell, interview, May 6, 2008; Lee Lorenz, interview, September 12, 2007; Frank Modell, interview, September 24, 2007.

311 **"noise and confusion":** Lee Lorenz, interview, September 12, 2007.

311 **"a perfect fit":** Roger Angell, interview, May 6, 2008.

311 **The latter concerned a promotion booklet:** Information that follows is from correspondence in YCAL, Box 6, between Gene Walz, art buyer for FCB; ST's lawyer, Alexander Lindey; and ST's letter of April 17, 1959 to Walz via Lindey.

312 **"could authorize anyone":** Robert H. Busler of Hallmark, April 17, 1959; ST to Hallmark, n.d. but shortly after; both YCAL, Box 6.

312 **He went so far as to promise:** Kepes to ST, August 6, 1959, YCAL, Box 6. Kepes was also professor of visual design at MIT's School of Architecture and Planning.

312 **"I find it impossible to write":** ST to AB, April 23, 1959.

312 **In early spring, Ruth and Tino:** Springs, East Hampton, and Amagansett have been used interchangeably to describe the location in various articles and interviews. Springs is a section within the Township of East Hampton, as is the village of Amagansett. ST's property is 433 Old Stone Highway, in the Springs section.

312 **The Nivolas had been in Springs:** Information that follows is from Ruth Nivola, interviews and conversations throughout 2007, and Claire Nivola, interviews, conversations, and private correspondence, 2007–10.

312 **In the decade since:** The size of the property is sometimes given as more than thirty acres; Claire Nivola confirmed that "quite a bit later," her parents bought an additional six acres.

313 **Inside the house:** LeCorbusier painted the mural in September–October 1950.

313 **The Nivola household had become:** For an engaging account, see Alastair Gordon, *Weekend Utopia: Modern Living in the Hamptons* (New York: Princeton Architectural Press, 2001), particularly pp. 43–57.

313 **He did, and several days later:** Henry Adler McCarthy, attorney and counselor at law, East Hampton, April 23, 1959, re: proposed contract from Jonathan A. Miller and Maude I. Miller to Saul Steinberg.

313 **Steinberg paid $12,500 cash:** Steinberg agreed to pay $12,500 for the house and seven acres. He originally planned to finance $5,000 with a GI Bill mortgage, but securing it was a protracted process involving mountains of paperwork and he wanted the house right away. A letter from the Chemical Corn Exchange Bank, where he had banked since 1942, attested that he was a "long and favorably known" client with accounts that averaged "in the medium five figures." Chemical Corn Exchange Bank to ST, May 21, 1959, YCAL Box 6; deed of sale is in YCAL, Box 39.

313 **"We're neighbors now":** ST to AB, January 8, 1960.

314 **And besides, he was used to:** ST, National Diary datebook, May 26, 1959, YCAL, Box 4.

314 **"Too bad it's full of children":** ST to AB, May 23, 1959.

314 **In August 1959, he was beset:** Information that follows is from his datebook, YCAL, Box 3, and from ST to HS, "Monday, August 16, 1959 from Tropicana, Las Vegas Nevada," AAA.

314 **"Traveling has been for me":** ST to AB, January 8, 1960.

315 **The major cause of his anxiety:** Alexander Stille, interview, January 6, 2009: "I am not sure what happened. My mother fell in love with him, or thought she did."

315 **But when Saul returned:** ST's datebook for November–December 1959 is filled with initials, times, and places; YCAL, Box 3.

315 **It created a tremendous personal crisis:** Alexander Stille, interview, January 6, 2009, and HS, interview, March 29, 2007: "He went to a Freudian, but he deprecated it and always spoke scathingly of Freudian analysis. In the last year or two he was with me, he drank too much. He had terrible hangovers and wanted to get rid of them and he said Freudian analysis freed him of them. He never admitted the main reason he went [to analysis], Elizabeth." In 2010, Claire Nivola consulted her mother's diary to see what she had written about her role in the affair and found that Ruth Nivola had torn those pages out and destroyed them.

315 **Ugo Stille seems not to have known:** Alexander Stille had a series of conversations with his mother during her final illness (she died in 1993). "I found out [about ST] because she told me, she talked about it. She was a pretty direct kind of person and the relationship mattered to her. She had none other like this one." Of his father: "I never talked to him about the [ST] relationship. He was not the kind of man who would discuss personal issues."

315 **Apparently they did not end the affair:** Throughout my interviews and conversations with HS, she made it clear that her lack of forgiveness was for this single incident and that she and Ruth Nivola remained friends for the rest of their lives.

316 **"She calls out to me":** ST, spiral notebook that begins April 29, 1984, YCAL, Box 95.

316 **"for some time I've been":** ST to AB, January 8, 1960, SSF.

317 **"I haven't written you":** ST to AB, August 7, 1960, SSF.

317 **"kicked him out":** HS, interviews and conversations, 2008.

CHAPTER TWENTY-FOUR: THE THIRTY-FIVE YEARS' WAR

318 **"If Saul wants pasta":** ST, diary, May 22, 1991, quoting Consolata Solarola Isola, YCAL, Box 75.

318 **She had asked him to leave:** ST, diary, May 19, 1991, YCAL, Box 75; HS, in a story repeated often throughout 2007 interviews and telephone conversations.

318 **Her fear was that if they did not behave:** HS to ST, n.d., YCAL, microfilm letters.

319 **He asked himself questions:** ST, pocket diary, February 25 and March 3, 1960, YCAL, Box 3.

321 **Rica Roman lost so much weight:** Lica Roman to ST, October 6, 1959, Romanian letters, YCAL, Box 14.

321 **She did not convince Saul:** ST to HS, "Pont Royal, Sat. April 1960," AAA.

321 **"Mom doesn't let go of money":** Moritz Steinberg to ST, September 23, 1959, Romanian letters, YCAL, Box 14.

321 **"What a scandal":** Moritz Steinberg to ST, November 14, 1959, Romanian letters, YCAL, Box 14.

322 **"I gave it to him":** ST to HS, "Southampton, April 17, 1960," AAA.

322 **"loss of time and fatigue":** ST to HS, "Pont Royal, Sat. Apr. 1960," AAA.

323 **Steinberg's disposition suffered further:** ST to Aimé Maeght, June 1, 1960, SSF.

Maeght commissioned the Giacometti scarves in 1960, but except for a number of sample copies he gave to family and friends, they were never sold. In 2009, LVMH commissioned a limited edition for its flagship Louis Vuitton stores in conjunction with the LVMH-sponsored exhibition of Giacometti's work at the Centre Pompidou in Paris.

323 **"better than usual":** ST to HS, "Nice May 5, 1960," AAA.

323 **"unbelievable complications":** ST to Aimé Maeght, June 1, 1960: "Les notaries et les agents d'immeubles après des complications incroyables m'ont enfin vendue une bonne maison avec jardin—en banlieue"; SSF.

323 **He left instructions with Rica:** R & M to ST, May 28, 1960, Romanian letters, YCAL.

324 **"Is this suitable for our age?":** R & M to ST, June 1, 1960, Romanian letters, YCAL.

324 **Cass Canfield had become his editor:** ST, pocket diary, 1960, YCAL, Box 3.

325 **He went home to 71st Street:** Barbara Daly Baekeland signed only her first name on the stationery engraved with her initials, BDB. Information that follows is from BDB to ST, n.d., YCAL, Box 14. In YCAL, Box 102, ST has a clipping from the *New York Times* about the slaying of Barbara Daly Baekeland on November 17, 1972, by her son, Antony, with whom she was allegedly in an incestuous relationship. Unlike other news stories and obituaries about people ST knew, most of which he annotated heavily, this one was filed without comment. Baekeland was probably the woman in Paris who signed her letters only as "Barbara" and with whom he had a long and highly neurotic affair throughout the 1960s. See also Natalie Robins and Steven M. L. Aronson, *Savage Grace* (New York: Morrow, 1985), p. 35, where ST is quoted: "Saul spoke of Barbara's *whiteness*, her white skin, her Irish skin, white lovely skin, red hair—her fresh marvelous look."

CHAPTER TWENTY-FIVE: CHANGES AND NEW THINGS

326 **"I haven't written to you":** ST to AB, August 7, 1960, SSF.

326 **On July 9, 1960, he wrote:** ST, National Diary, 1960, YCAL, Box 3. "Ala" was probably the architect Ala Damaz, who worked on his 75th Street apartment.

326 **"Catch 'em young":** From "The Girl in the Spotlight," by Victor Herbert and Richard Bruce.

326 **Those who were present at the start:** Among these were HS, Ruth Nivola, Vita Peterson, Dore Ashton, Benjamin Sonnenberg, and many others.

326 **When she told him she was planning:** In her "Life in Postcards" she writes that she did hitchhike to Provincetown; in other diary entries she describes how she took a train, and in a letter dated "p.m. Aug. 60," she says she is writing to him while on the train; YCAL, Box 110. Also calendar listing dates in Provincetown, YCAL, Box 108.

327 **When he listed his "engagements":** ST's memo to himself on a page titled "Engagements for the week," YCAL, Box 14, Folder "Correspondence 1959–61." Also ST, National Diary, July–August, 1960, YCAL, Box 3.

328 **"but I never got to see":** SS, "My Life in Postcards," YCAL, Box 110.

328 **And in the week following:** In the letter dated "p.m. Aug. 60," written on the train to Provincetown, SS tells ST, "When I find myself hanging on you like today, I want to dislike myself and I couldn't go home and do something. If I had some work I maybe would have made it." It is the first of her oblique requests that soon become overt when she asks him to help her find work. Among the friends ST consulted were Serge Chermayef, n.d., YCAL, Box 14, who tried to find work for her at Harvard and who contacted his counterpart at the University of Chicago Press, and Paul Rand, n.d., YCAL Box 14, who spoke to the designer Irving Miller and Allan Thurlbut, the art director at *Look*.

328 **"classically Nordic":** Descriptions of SS that follow are from interviews with (among many others) Richard Fadem, March 2, 2010; Dore Ashton, February 24, 2010; HS, March 29, 2007; Ruth Nivola, July 24 and September 22, 2007; Claire Nivola, July 2,

2008; Mimi Gross, March 9, 2010; and Benjamin Sonnenberg, telephone conversations, July 2007.

328 **"represented his idea of Eros":** HS, interview, March 29, 2007.

328 **She was born long after:** In a diary entry for April 15, 1992, YCAL, Box 111, she writes that she first went to Trier for "my brother's funeral," so she must have had two brothers, although no other mention is made of the one who died.

329 **She liked to joke:** From interviews with Ruth Nivola, Dore Ashton, Vita Peterson, and many others. HS, interview, April 18, 2007, said that "Sigrid's attitude about herself was that she was absolutely not to be forgiven for German Nazi behavior; she was filled with guilt over it." HS added that it was difficult "to know the true degree of Sigrid's German-ness."

329 **"terrible years of the war":** From an undated, untitled page of diary writing in YCAL, Box 108.

329 **"evil or bad":** SS, diary, "Tues. 21 91," which precedes the dated entry for May 22, 1991, YCAL, Box 111. According to SS, when her mother met ST for the first time she used these words to describe her daughter.

329 **"authority and establishment":** SS, diary, September 8, 1971, YCAL, Box 108. When she wrote this, she was describing ST, saying he had become "all I ran away from home from," and then she went on to compare his behavior to her father's.

329 **"It didn't work out":** SS, "My Life in Postcards," April 15, 1994, YCAL, Box 110. This is a collection of postcards on which she made biographical observations.

330 **She was later vague:** SS to Uschi, October 22, 1971, YCAL, Box 108.

330 **She never explained how:** Biographical information is from SS's "Synopsis" of her life in USA from 1958 to 1971, YCAL, Box 108.

330 **she was crashing in a friend's apartment:** SS, a single page of "Important Dates" in her handwriting, YCAL, Box 108. Her date for the first meeting with ST, July 11, differs from his, given above as July 9.

330 **"stupid and innocent enthusiasm":** SS, diary, May 9, 1970, YCAL, Box 112.

330 **Hedda called to ask his advice:** ST, National Diary, entries for August 23 and 27, September 2, 8, 14, and 16, 1960, YCAL, Box 3; HS, interviews and conversations, 2007.

330 **While he was dealing with police reports:** Lica Roman to ST, August 2, 1960, Romanian letters, YCAL, Box 14, Folder 1.

330 **The house had to be gutted:** Rica Roman's letter of July 30, 1960, gives the details of many of these expenditures; Romanian letters," YCAL, Box 14, Folder 1.

331 **Steinberg wrote checks:** Moritz Steinberg to ST, July 19, 1960, Romanian letters, YCAL, Box 14, Folder 1.

331 **"Mom doesn't feel very well":** Moritz Steinberg to ST, July 28, 1960, Romanian letters, YCAL, Box 14, Folder 1.

331 **"You can't imagine my pain":** Rosa Steinberg to ST, August 6, 1960, Romanian letters, YCAL, Box 14, Folder 1.

331 **Steinberg used his contacts:** Rica Roman to ST, August 20, 1960, Romanian letters, YCAL, Box 14, Folder 1. He learned that he was hired on December 22, 1960, to begin work at Schlumberger just after New Year's 1961.

331 **"either to remain in Nice":** Rica Roman to ST, August 20, 1960, Romanian letters, YCAL, Box 14, Folder 1.

332 **Lica had secured a job:** She left *L'Arche* shortly after to work for *La revue mensuelle du fonds social juif unifie (La revue du FSJU)*, to which ST took a subscription, YCAL, Box 13. In her letters, particularly September 17, 1960, Lica described her work on *L'Arche* as "in the *New Yorker*'s style" and asked ST to send a drawing for the magazine to use. There is no record that he complied with her request.

332 **"We loved each other":** Rosa Steinberg to ST, September 1960, Romanian letters, YCAL, Box 14, Folder 1.

332 **"like being on a permanent vacation":** Lica Roman to ST, September 17, 1960, Romanian letters, YCAL, Box 14, Folder 1.

332 **In almost every letter to Saul:** Rosa Steinberg to ST, November 22, 1960, December 28, 1960, and others, Romanian letters, YCAL, Box 14, Folder 1.

332 **"his idea of friendship":** HS, interview, October 24, 2007.

333 **"found it a little difficult":** HS, interview, May 8, 2007. She added: "After twenty or thirty years of separation, every now and again he would ask me if I still had something that he remembered and wanted now, and of course I always gave it to him. Sometimes I asked him for something. There was an occasional exchange of goods, but that's all."

333 **There was a fairly large group:** HS, interview, October 24, 2007. Among those she edited out were May and Harold Rosenberg, Evelyn Hofer and Humphrey Sutton, Ingeborg Ten Haeff and Paul Weiner.

333 **"I did that with or without":** Ibid. She refers to her two husbands, who supported her throughout her lifetime. Eleanor Munro interviewed HS for her book *Originals: American Women Artists* (New York: DaCapo, 2000). In an interview with DB, May 31, 2007, Munro said, "There was always something very ascetic about Hedda. How she suffered terribly after he left her! All those exercises she did to purify her mind; how rigorously she painted!" HS's "one unfinished love affair" was with Theodore "Teddy" Brauner, the younger brother of Victor, who lived with her in the New York house and who accompanied her to Venice during her Fulbright year. She added that she was "fifty-five or fifty-six" when she made the decision to become celibate.

333 **"I was a zombie":** SS, diary, January 9, 1963.

334 **Every now and again a commission:** John Hollander, *Vision and Resonance: Two Senses of Poetic Form* (New York: Oxford University Press, 1975). A folder of SS's book jackets are in YCAL, Box 111, and include Peter Gay's *Freud for Historians* and the *Oxford Anthology of English Literature, Volume I*. Most of her designs are for scholarly books and are fairly conservative, with neat lettering and little illustration. At a time before computers, when hand lettering was a skill publishers sought, SS was noted for her talent in creating or copying beautiful typefaces. Among the other writers whose covers she designed were Theodore Hershberg, Richard Sewell, Theodore Reik, and Joseph Epstein.

334 **"To you my darling":** SS to ST, n.d., YCAL, Box 13, Folder "Correspondence 1960–61."

334 **"relentless recorder of urban types":** Grace Glueck, YCAL, Box 13.

334 **"even greater inventiveness":** Phillip Day, "The Labyrinth," *Sunday Times*, May 20, 1961.

335 **To make sure that Steinberg had calmed down:** Cass Canfield to ST, January 17, 1961, YCAL, Box 13.

335 **The book sold around:** Cass Canfield to ST, April 1 and 21, 1965, YCAL, Box 15.

335 **Canfield planned to use the phrase:** The Wilson and Mumford information is from ST to HS, May 3, 1961; the Huxley from Cass Canfield to ST, January 17, 1961, YCAL, Box 13.

335 **"Let's face it":** Cass Canfield to ST, April 21, 1964, YCAL, Box 15.

335 **He was in Paris:** ST's reply to "Mr. Kunz" was actually to Professor Paul Grimley Kuntz, a member of the philosophy faculty of Emory University. Prof. Kuntz was active in the university's studies in law and religion and he was also cognizant of ST's drawings for Paul Tillich's *My Search for Absolutes*. ST's letter is May 7, 1966, YCAL, Box 15, Folder 1965–66. Eugene Freeman wrote to ST on May 27 to say that Professor Kuntz "was so pleased with your rebuke that . . . he wants to publish it."

336 **When she was trying to determine:** Meera E. Agarwal, Vassar College Senior Project, "Steinberg's Treatment of the Theme of the Artist: A Collage of Conversations," December 8, 1972, YCAL, Box 78.

337 **"suit that looks more":** SS to ST, May 19, 1961.

CHAPTER TWENTY-SIX: I LIVED WITH HER FOR SO LONG

338 **"Hedda and I have become friends":** ST to AB, March 16, 1961, SSF.

338 **"It now seems to me":** ST to AB, October 9, 1961, SSF.

338 **The house had always been in Hedda's name:** ST to HS, July 19, 1961, AAA: "As I paid the insurance for it in the past and now the company says that it should be transferred to me, I'll pay you $400 for it. A bargain. The car must be worth $25. I'll try to fix it properly and you'll use it any time. It's yours anyway. If you agree, please sign . . . sign Hedda Steinberg only."

338 **"got all he wanted":** HS, interviews, March 29 and May 8, 2007. In the latter interview, HS alluded to the "deep hurt" she felt when ST left her for SS. She said, "People can be wounded but will do what they need to do in order to keep a situation on an even keel." When we spoke of how many women assumed the role of stabilizer in disintegrating relationships, she became vehement and insisted that "this is the necessary thing to do, and I was right to do it."

339 **As for Steinberg himself:** Many people related this anecdote in interviews and conversations, among them Hedda Sterne, Dore Ashton, Cornelia Foss, Mimi Gross, Priscilla Morgan, and Daniela Roman. They and others, Richard Fedem and Ruth Nivola among them, also related how angry it made SS, because she did want marriage and children in their early years together.

339 **"Please take good care":** ST to HS, May 16, 1961, AAA, in which he mentions "Del Corso, Lattuada, and Aldo."

339 **And yet, even as he wished her:** ST to HS, July 19, 1961, AAA.

339 **"that having pleasure":** ST to HS, May 16, 1961, AAA.

340 **"It's now a mark of distinction":** ST to HS, June 29, 1961, AAA.

340 **He worked in Springs:** Unless otherwise noted, information that follows is from two 1961 datebooks, YCAL, Box 3.

340 **He had become close to Inge Morath:** Morath and Miller married on February 17, 1962. ST became a frequent visitor to their home in Roxbury, Connecticut. They were so close that ST was the only guest invited to stay in the Miller home during the festivities celebrating Arthur Miller's eightieth birthday; Inge Morath, note to ST, n.d., YCAL, Box 35.

340 **Eventually he let her capture him:** SS prepared a mock curriculum vitae sometime in late 1961 or early 1962, YCAL, Box 17, with topic headings such as "studied," "worked," "lives," "owns." Under "got rid of," she wrote first of his mustache, then "an attitude to be photographed preferably with paper masks." *Le Masque* was first published in conjunction with ST's 1965 exhibition at Galerie Maeght, with texts by Michel Butor and Harold Rosenberg, photos by Inge Morath (Paris: Maeght Editeur, 1966). Unrelated drawings to this show appeared in a *TNY* portfolio on May 5, 1962. See also *S:I*, pp. 149–50, and Catalogue, n. 93. The book *Saul Steinberg: Masquerade* was published by Viking Studio Books (New York: Penguin, 2002).

340 **He accepted the dinner invitation:** ST became litigious when the Vancouver, British Columbia, Festival bought the rights to the production and used his drawings. On October 4, 1961, Paul Feigay wrote to apologize for assuming that, having bought the entire production, they had also bought the rights to use ST's drawings. It was a genuine mistake and all ST's drawings were removed from use. Berghof wrote to ST from Rome, October 17, 1961, to apologize for "the flap and the mix-up" over his name, which he did not want "to color" their friendship. YCAL, Box 14.

340 **Morgan was the American associate director:** Morgan was responsible for ST's contributions during the next several years. The request to borrow the drawing came officially from MoMA in a letter of May 8, 1961, YCAL, Box 13.

341 **"wish to present something abstract":** Frank Metz to ST, April 21, 1961, YCAL, Box 13.

341 **"the usual Pont Royal":** ST to HS, "Monday 15 May" [1961], AAA. In YCAL, Box 3, ST's 1961 datebook shows that he was in Rome on June 1, in Venice on June 4, and in Milan on June 6, returning to Paris on June 9.

341 **"It's not fair":** ST to HS, August 20, 1961, AAA. The artist is identified only as "Ruth" in correspondence from this period.

342 **"I don't know what the cause"**: Rosa Steinberg to ST, April 28, 1961.

342 **This became her genuine attitude**: Daniela Roman, interviews and conversations, 2007, Amagansett and Paris.

342 **"all very glamorous"**: SS, "My Life in Postcards," YCAL, Box 110.

342 **He also learned to swim**: See *S:I*, pp. 175–76.

342 **He told Aldo that it was**: ST to AB, Amagansett, July 28, 1961, SSF.

342 **Their social life had been mostly with old friends**: Connie Breuer to ST, October 15, 1961, YCAL, Box 14. The Breuers wanted ST to meet Willy Staehelin, a Zurich lawyer for whom Marcel had built a house and for whom ST would later design a very personal Christmas card.

343 **he only went to the theater:** In an interview he gave to the Appleton, Wisconsin, *Post-Crescent* when he received an honorary degree in June 1962, he said, "The theater is mediocre. People here go to the theater to be seen—not to see anything"; YCAL, Box 14.

343 **When Sasha Schneider praised:** SS to ST, in care of Ernesto Rogers in Milan, December 8, 1961.

343 **"the appendage in this relationship":** Mimi Gross, interview, March 9, 2010; Cornelia Foss, interview, March 20, 2010.

343 **"I sit here all evening":** SS to ST, on the back of an envelope telling him his subscription to *Dissent* has expired, n.d., YCAL, Box 13, Folder "Correspondence 1960–61." The only punctuation SS used was dashes, which I have mostly replicated, adding the occasional period where I thought it appropriate.

344 **"so wrapped up in his 'art'":** SS wrote this on September 8, 1971, reflecting back on her first years with ST; YCAL, Box 108.

344 **As always, travel presented a way:** The mural was destroyed in 1997 when the house was torn down and a commercial building erected.

344 **While he was making preparations:** Information that follows is from Lica Roman to ST, September 7, 11, and 24, and October 1 and 10, 1961, Romanian letters, YCAL, Box 14, Folders 2 and 3.

345 **It was a difficult time:** Iancu Marcovici to ST, November 13, 1961, Romanian letters, YCAL, Box 14, Folder 2.

345 **"great changes and renewal":** Lica Roman to ST, April 14, 1962, Romanian letters, YCAL, Box 14, Folder 2.

345 **After he finished the Via Bigli mural:** SS to ST, December 8, 1961, YCAL, Box 14.

345 **He started to make lists:** ST, "List of Weekly Engagements, December 26, 1961," YCAL, Box 14, "Correspondence 1961–63."

345 **He was worried when she told him:** SS to ST, November 29, 1961, YCAL, Box 14.

345 **the first of the long series of psychoanalysts:** She was seeing June M. Barrack, M.S.S., several times weekly, and the bills were addressed to him. The rusting hulk of the Chevrolet is still behind his studio in Springs.

346 **In later years Max's Kansas City:** SS often invited Mimi Gross to join her and was undeterred when MG refused and asked her not to go either.

346 **Unfortunately, the trip was not all sunlight:** Repeated letters from *Sports Illustrated*, which ST did not answer, are in YCAL, Box 14.

346 **Lincoln Center wanted posters:** These are among the many in the burgeoning files in YCAL, Boxes 14 and 15.

346 **In Italy, Rizzoli wanted to publish:** Rizzoli Editore to ST, December 13, 1962; Feltrinelli Editore to ST, September 26, 1962, both in YCAL, Box 14.

346 **There were other foreign requests:** *Steinberg's Paperback* (Munich: Rowohlt, 1964).

346 **he still managed to produce:** The covers were April 2 and September 17, 1960; January 28, June 10, and September 9, 1961; May 19 and October 6, 1962.

346 **He had designed several book jackets:** They included endpapers for May Natalie Tabak (Rosenberg), *But Not for Love* (New York: Horizon, 1960); dust jacket for Erich

Kuby, *The Sitzkrieg of Private Stefan* (New York: Farrar, Straus, Cudahy, 1962); dust jacket and title page for Martin Meyerson et al., *Housing, People, and Cities* (New York: McGraw Hill, 1962). ST's covers included those for *Art in America* 49, no. 2 (1961); *Opera News* 25 (April 29, 1961); *JAIP* 27 (August, 1961). Jesse Reichek was also a professor of design at the College of Environmental Design, U.C. Berkeley. His letter to ST is September 11, 1961, YCAL, Box 14.

347 **"the man involved in his own history":** ST's letter to Katherine Kuh is reprinted in *S:I*, Appendix, p. 240; original is in KK Papers, YCAL, Box 2, Folder 28.

347 **He was grateful for invitations from women:** Elaine de Kooning asked him to contribute $100 for an ad in the *New York Times* to support an unnamed group taking "action for peace." All these invitations are YCAL, Box 14.

347 **"bellicose postcards":** Harold Rosenberg, homage to Ad Reinhardt, HR/Getty, Box 32, Folder 32/6.

348 **"740 Hindu priests in New Delhi":** Ad Reinhardt, undated postcard referring to February 4, 1962, YCAL, Box 14.

348 **Aldo Buzzi was passing through:** AB was depressed over financial difficulties, and ST arranged to give him money through Billy Wilder, who pretended to hire AB for a film consultation, after which he paid him with ST's money. Correspondence concerning Wilder's acting as intermediary in passing funds for the next several years is in YCAL, Box 15, Folder "Correspondence 1965."

348 **He did not take her to the dinner party:** ST, desk diary, 1962, YCAL, Box 3.

348 **"on a stand-by basis":** SS, diary, containing a long letter to "Dear Saul" written on January 5, 1971, when she was recapitulating their previous decade together and apart. YCAL, Box 108.

348 **He told her she could start:** ST, datebook, "Gigi Schule," February 12, 1962, YCAL, Box 3.

CHAPTER TWENTY-SEVEN: BOREDOM TELLS ME SOMETHING

349 **"I get slightly bored":** Transcript from a German TV show with no other identification except the broadcast year, 1968, YCAL, Box 100.

349 **Eventually she wound her way:** SS, "My Life in Postcards," YCAL, Box 110.

350 **When it was first offered:** President Douglas M. Knight to ST, January 22, 1962, YCAL, Box 14.

350 **"curious about the process":** *Post-Crescent*, June 8, 1962, partial clipping with a photo showing ST laughing, YCAL, Box 14.

350 **"artists of gesture":** ST, unedited typescript of interview with Meg Perlman, n.d., no provenance given, YCAL, Box 32.

350 **Among his old friends:** Richard Lindner and Isamu Noguchi were old friends with whom ST could talk about art, but Lindner had moved back to Germany and Noguchi was in Japan more than in New York.

350 **"girls, all are timorous":** ST to AB, January 10, 1963, SSF. Most likely he was referring to Mary Frank, whom he greatly admired; Joan Mitchell, whose raucous lifestyle intrigued him as much as her painting; and Helen Frankenthaler, who became entwined in his thinking with her then husband, Motherwell.

351 **Their closeness deepened:** Correspondence between SS and Harriet Vicente and between Esteban Vicente and ST is scattered throughout YCAL Boxes 108 through 111. On Dec. 28, 1970, YCAL, Box 108, "The Vicentes" sent a card saying that although they never see SS anymore, they miss her and wish her a happy 1971. This and the rest of their correspondence indicates that they were aware of the ups and downs in the SS-ST relationship.

351 **A decade later, in the 1970s:** ST, interview with Meg Perlman, YCAL, Box 32.

351 **Steinberg had a more formal relationship with Miró:** There are several letters from Van Velde in YCAL, but the correspondence with Hélion and Miró is more extensive and more likely to be useful to art historians and biographers of the two painters.

352 **"He is perhaps the only friend":** ST to AB, January 10, 1963, SSF. ST recommended two of HR's books for AB to read: *The Tradition of the New* and a biography of Arshile Gorky.

352 **"a writer of pictures":** WMAA, p. 10.

352 **"Irish rabbis":** May Natalie Taback Rosenberg to ST, n.d. but internal evidence suggests 1958, YCAL, Box 8.

352 **"suddenly trapped in the banality":** Leo Steinberg, "Remembering Saul Steinberg," memorial service, November 1, 1999; Leo Steinberg, interview, October 31, 2007: "Whenever Saul came to visit me, he would always tell the doorman to announce him as my cousin." Unless noted otherwise, quotes that follow are from this interview.

353 **Leo found it particularly grating:** Argawal, "ST's Treatment of the Theme of the Artist," ST said, "I am more a writer than an artist. I have all the elements of a writer. I am most like Joyce or Nabokov."

353 **When Saul did not reply:** In an interview with Grace Glueck, *Art in America*, November–December 1970, pp. 110–17, ST said, "They help me avoid the narcissistic pleasure of hand."

353 **Saul replied that even telling that much:** *S:I*, pp. 216–19, contains reproductions plus a listing of some of the books in ST's personal library.

353 **They had known each other casually:** James Atlas, in *Saul Bellow: A Biography* (New York: Random House, 2000), p. 141, dates the friendship to Bellow's Guggenheim Fellowship year in Paris in 1948. Although it is possible that the friendship began then, I found no reference to Bellow in ST's YCAL papers until several years later, in the 1950s.

353 **"something of a relative to him":** Saul Bellow, "Saul Steinberg," *Republic of Letters* no. 7 (1999).

353 **"discoveries, small epiphanies":** ST, diary, Sunday, May 26, 1991, YCAL, Box 75.

353 **Among Steinberg's archives, various drafts:** Among them are "Saul Bellow Draft, pp. 11 & 12," and "Saul Bellow Revised Article, pp. 19 & 22," both YCAL, Box 22. In YCAL, Box 75, in a letter dated December 28, 1982, Bellow discusses the differences between ST's Romanian childhood and his in Montreal. Also YCAL, Box 75, on February 4, 1983, Bellow sent ST a journal-ledger in which he wrote a story in longhand titled "Talking Out of Turn."

354 **Shortly after the great success of *Lolita*:** Smith, *S:I*, posits that Figure 60, p. 60, from sketchbook 2954, YCAL, of a demon holding a small girl on his lap, may have been inspired by conversations about *Lolita*, which was published a year later. In the novel, Humbert Humbert asks, "Is 'mask' the keyword?"

355 **"ripe with symbolism":** Stacy Schiff, *Véra: (Mrs. Vladimir Nabokov)* (New York: Random House, 1999), p. 198, quoting from an interview with ST, January 17, 1996.

355 **the text that resonated most strongly:** Vladimir Nabokov, *Nikolai Gogol* (New York: New Directions, 1959; corrected edition, 1961). ST was also intrigued by *Lolita*, which he puzzled over and used frequently in conversations to illustrate various points he wished to make, but he never listed it among his favorites.

355 **The story was especially resonant:** Tape transcription, "Side B #28404," p. 17A, SSF, published as "The Artist Speaks," *Art in America*, November-December 1970, pp. 110–17. A particularly striking example comes from a 1970 interview with Grace Glueck, in which Steinberg described Giacometti and Cézanne as having a "recognizable aroma." He admired Bonnard and spoke of looking at his paintings in museums, when he could sometimes "sniff" their aroma: "But it's not that I see it directly and recognize it as Bonnard's—it's something I call aroma, the smell of souvlaki in the streets of Athens, smell this combination of onion and cabbage and roses." As a nonclinician, I am reluctant to describe this as synesthesia, that is, the neurological condition in which a stimulus to

one of the senses creates a response to one or more other senses, so I merely call attention to the concept and leave the neurological research to other scholars.

355 **"version of the nose problem":** ST, "The Nose Problem," *Location* (Spring 1963): 37.

355 **"She left a very good taste":** Carol Strickland, "Betty Parsons's Two Lives: She Was an Artist, Too," *New York Times*, June 28, 1992.

355 **"surrounded by [Armenian] noses":** Lica Roman to ST, July 26, 1960, Romanian letters, YCAL, Box 6: "In Cachan there is a neighborhood made up only of charming Armenians, and a painter among them."

356 **"slimy, creeping, furtive things":** Nabokov, *Nikolai Gogol*, pp. 5, 3.

356 **"could raise unexpected questions":** Brian Boyd, *Vladimir Nabokov: The American Years* (Princeton, N.J.: Princeton University Press, 1991), pp. 511–12.

356 **"sadness or despair":** ST to AB, June 16, 1962, SSF.

356 **"Work derives from work":** From the German TV interview quoted in n.1 unidentified typescript, YCAL, Box 100.

356 **"to get her out of granny dresses":** HS, interview, October 24, 2007. The remark was echoed in much the same words in interviews with Dore Ashton, Vita Peterson, and Ruth Nivola. It can be found in undated correspondence between HS and May Tabak Rosenberg, HR/Getty, and in SS's diary writings, YCAL, Boxes 100, 105, and 110.

357 **Aldo needed money to pay:** ST to AB, June 26, 1962, SSF, where ST says he does not know what to do to console AB. He also asks if AB had been able to sort out "the Spanish girl." PC (undated comment on the mss.) stated that one of Bianca's daughters confirmed that her father "definitely helped support them."

357 **Also, Ada chose the moment:** Ada to ST, undated letters YCAL; ST to AB, June 26 and August 3, 1962, in which he chafes at his inability to persuade Ada to explain her ongoing difficulties with legal procedures that may or may not involve her.

357 **Dino De Laurentiis had wanted to work:** ST to AB, August 3 and 27, 1962, SSF.

357 **It was never realized:** ST to AB, August 27, 1962, SSF. Specific information about the project is not known.

357 **Aldo and Bianca were his guests:** Information that follows is from ST, 1962 datebook, YCAL, Box 3.

358 **One of his most pleasurable meetings:** Two letters from ST to Nicola Chiaromonte, dated June 10, 1964, and February 1, 1967, discuss terms and condition; Nicola Chiaromonte Papers, General Mss. 113, Beinecke Library, Yale University.

358 **On October 1 Steinberg flew to Tel Aviv:** ST to AB, August 27, 1962.

358 **"the poetic, romantic":** ST to AB, October 30, 1962, SSF.

358 **"surrounded by Jewish faces":** HS, interview, September 9, 2007; ST to HS, n.d., AAA.

359 **whenever a Jewish group:** One example among many is seen in correspondence with the Trumbull, Connecticut, Congregation B'nai Torah, which asked ST to contribute to their annual art exhibit, February 15, 1964, YCAL, Box 17. He sent a drawing and continued to do so for many years afterward.

359 **he always fasted on Yom Kippur:** HS, interviews, 2007; AB, interview, June 19, 2007. There are also many brief references to fasting in ST's diary jottings in YCAL, Boxes 75 and 95, and occasional allusions in his letters to AB.

359 **"work on command":** ST to AB, October 30, 1962, SSF.

359 **"in a comic way":** ST to AB, January 10, 1963.

359 **"This is a sad but very human story":** Unattributed typescript, YCAL, Box 17, Folder "Correspondence 1963." Internal evidence suggests that ST wrote it, alone or in collaboration with SS, who was a skilled typist. ST was in the habit of rereading *Finnegans Wake* both for pleasure and for inspiration, and he wrote to AB that it took him years before he truly understood it.

360 **"random biographies of obscure people":** ST to AB, January 10 and April 25, 1963. Dore Ashton, interview, February 24, 2010, said ST presented this document to her as an authentic diary. She studied it intently before concluding that there was "something

slightly off about it," and then ST laughed and confessed that he had made it. See also
S:I, p. 129, fig. 30.

360 **"sadder still":** ST to AB, March 4, 1962.

360 **Gigi told him she wanted to go:** SS, diary, YCAL, Box 110.

360 **"cubist collages":** ST to AB, June 17 and July 20, 1963, SSF.

CHAPTER TWENTY-EIGHT: THE TERRIBLE CURSE OF THE
CONSCIOUSNESS OF FAME

361 **"Impossible to recount things":** ST to AB, February 19, 1964.

361 **"I'm not working":** ST to AB, June 17, 1963.

361 **"absolute happiness":** ST to AB, July 20, 1963.

361 **And he did something else he disliked:** SS, "My Life in Postcards," YCAL, Box 110.

361 **Shortly after, he learned that:** Gray & Gray, CPAs, to ST, July 16, 1963, YCAL, Box 17.

361 **By the autumn, his money worries:** *TNY*, May 25 and October 12, 1963.

362 **Steinberg was further delighted:** Herbert Mitgang to ST, August 20, 1962, YCAL,
Box 17. A year later ST was still in correspondence with Mitgang, trying to satisfy his
request for a drawing; ST, "List of things to do," YCAL, Box 17, Folder "Correspondence
1963."

362 *Life* **and** *Time* **had infringed:** Alexander Lindey to ST, September 23, 1963.

362 **"I don't quite belong in the art":** Quoted in WMAA, p. 10; on p. 13, Rosenberg com-
ments that "the advantage of being a borderline artist is that it allows the decision to be
put off indefinitely."

362 **He believed such honors:** Jean Stein (vanden Heuvel), "From the Hand and Mouth of
Steinberg," *Life*, December 10, 1965, p. 60. See also WMAA, p. 29: "This monumental-
ization of people, this freezing of life, is the terrible curse of consciousness of fame."

362 **To accept would have meant:** Harold C. Schonberg, "Artist Behind the Steinbergian
Mask," *New York Times*, November 13, 1966, pp. 48–51, 162–69.

362 **"another glossy portrait":** Editor, *Celebrity Register*, to ST, n.d., YCAL, Box 17, Folder
"Correspondence, 1963." The photo used in the first issue was a publicity shot taken by a
professional photographer, and ST did not send the informal one the editor requested.

363 **"strange, silent world":** Alexey Brodovitch, *Portfolio* no. 1 (Winter 1950). The maga-
zine featured a brief identification of seven full pages of ST's cartoons.

363 **"a dialogue between a No. 5":** Stein, "A Cartoonist Talks About Himself." The quota-
tions here are taken from Stein's "Notes on an interview with ST," YCAL, Box 38. They
do not appear in the published version of the article in *Life*, published on December 10,
1965.

364 **"obsessed with the question mark":** Jean Stein (vanden Heuvel), "Notes on an inter-
view with Saul Steinberg," typescript, YCAL, Box 38. There are several edited versions
of her interviews and conversations with ST in YCAL, Box 69; internal evidence suggests
they were conducted throughout 1965.

364 **He depicted it lying in bed:** The 5 and the question mark in bed appeared originally
in *Du Atlantis* 26 (August 19, 1960): 602 and is reproduced in *S:I*, p. 153; the 5 as a tuba
is in Smith, *Steinberg at The New Yorker*, p. 117; the 5 as a cupboard is a *TNY* cover,
July 18, 1970.

364 **"so simple—I even give hints":** Glueck,"The Artist Speaks," p. 112.

364 **"Oh, that's easy":** From the unedited transcript of Glueck's interview for "The Artist
Speaks"; Anne Hollander, interview, December 5, 2009. ST said much the same about
the number 4 in a conversation with Ann Birstein, who asked about his July 5, 1969,
TNY cover, in which a 4 is shooting skyward from a firecracker. When she asked, "What's
going on here?" he replied, "Oh, Ann, you can never trust a 4"; Ann Birstein, interview,
December 10, 2009.

364 **"a problem, a weakness":** Stein, "Notes on an interview with Saul Steinberg," YCAL, Box 38.

365 **"the serious core":** Smith, "Thought and Spoken," *Steinberg at The New Yorker*, p. 100.

365 **Much of the fan mail:** Typical is a letter from the writer Judith Thurman, signed as Judith Ann Thurman, a high school senior in Flushing, New York, YCAL, Box 17.

365 **One group thought it was:** YCAL, Box 17, folder of fan mail for 1963.

365 **"make people jittery":** Glueck, unedited transcript of interview, pp. 110–17.

366 **"get a gig for a workshop":** Lee Hall, *Elaine & Bill: Portrait of a Marriage* (New York: Cooper Square, 1993), p. 235.

366 **"Call Elaine about museum":** Information that follows is from this list, YCAL, Box 17.

366 **"a fresh eye":** Glueck, unedited transcript of interview.

367 **He donated drawings as well as money:** Evidence can be found throughout his YCAL archives, but in this instance I cite YCAL, Box 17, for his activity in 1963, before and after the Kennedy assassination.

368 **He wanted to talk about this**: HS to ST, October 8, 1963, YCAL, microfilm letters.

368 **He accomplished everything he wanted to do:** Itinerary, YCAL, Box 3, Folder 1964–65.

368 **"mild pornography":** HS to ST, December 31, 1963, YCAL, microfilm letters.

368 **She joked that she would steal:** HS to ST, May 1964, YCAL, microfilm letters. She was asking if he wanted her to keep looking, as she had not yet found one she thought suitable.

368 **In a gossipy letter to Saul:** HS to ST, July 9 [1964], YCAL, microfilm letters, reel 144–45.

369 **In this instance, she hoped it would lessen:** HS to ST, December 31, 1963, YCAL, microfilm letters.

370 **On the spur of the moment:** The itinerary that follows is from YCAL, Box 3, Folder 1964–65.

370 **They inspired him to visit:** Angelini was in charge of the UNESCO restoration of a World Heritage site. ST speaks of "several visits" to Ethopia in Glueck, unedited transcript of interview. He writes of the first in the itinerary in YCAL, Box 3, and of the second in a letter to AB, March 28, 1970, SSF, where he wrote that the second visit with Angelini to Lalibela "was excellent and leaves a fine memory." He repeated that it was "especially beautiful for its location, the magical plateau."

370 **"a terrific plateau":** Glueck, unedited transcript of interview.

371 **He spent the next day:** ST, 1964 datebook, YCAL, Box 3.

371 **"I'm still confused":** ST to AB, February 19, 1964.

371 **He made another list:** List on the back of a bill from Alexander Lindey, January 31, 1964, YCAL, Box 17.

CHAPTER TWENTY-NINE: AUTOBIOGRAPHY DOESN'T STOP

372 **"The fact that stuff gets printed":** ST to AB, April 29, 1964, SSF.

372 **"rediscovering Cubism":** For representative examples of drawings that came to fruition in the early 1970s, see WMAA, pp. 224–26.

372 **She tried to joke that the patch:** HS to ST, April 3, 1964, YCAL, microfilm letters and Box 17; C. Bueno, accountant, to HS, March 19, 1964, noting that ST paid HS $300 per month. He was also transferring money into her account to pay the real estate taxes on her house, and he paid all their joint income taxes.

373 **Throughout the affairs:** Richard Fadem, interview, March 2, 2010.

374 **"needed a lot of hand-holding":** Wendy Weil, interview, March 22, 2010.

374 **"vulnerable to the stupidity":** ST to AB, April 9, 1965, SSF.

374 **"amorous delights and suffering":** ST to AB, April 6, 1964. SSF.

375 **he kept a dream journal:** ST, dream sequences, 9/17, 12/15, 12/16, in 1964 datebook, YCAL, Box 3.

375 **He transposed his next dream:** American Council of Learned Societies, *Newsletter,* February 1964.

375 **"at a crossroads":** ST to AB, July 16, 1964, SSF.

375 **One of his honors came:** Paul Rand to ST, January 28, 1964; Howard S. Weaver, acting secretary of Yale University, wrote to say that the Council of Residential College Masters had voted to offer a five-year appointment; YCAL, Box 17.

375 **He was flattered:** James Laughlin to ST, January 2, 1964. YCAL, Box 17.

375 **Steinberg was invited to join:** He contributed money, drawings, and the use of his name and was rewarded with an invitation to the 1965 inaugural activities; YCAL, Box 17.

375 **Jean Stein and William vanden Heuvel:** The invitation is in YCAL, Box 17; Robert Kennedy to ST, February 2, 1965, YCAL, Box 15.

375 **He did all these things alone:** ST used to joke that he could set up a mirror to be like a periscope and use it to look into Mimi Gross's bedroom, on the fourth floor front of her parents' house (now a museum); Mimi Gross, interview, March 9, 2010.

376 **"the Nivola family spectacle":** ST to AB, April 8, 1964, SSF.

376 **Ruth Nivola was one of a number of mothers:** Ruth Nivola, interview, September 22, 2007; Dore Ashton, interview, February 24, 2010; letter from an unidentified woman in YCAL, Box 75, who objected to ST's invitation to her fifteen-year-old daughter for a private lunch in Springs.

376 **He even had calling cards printed:** These objects remain in the personal collection of Claire Nivola.

376 **"She is fifteen":** Dore Ashton, interviews, January 20, 2009, and February 24, 2010.

376 **"put such temptation":** Mary Carr to ST, on *Mademoiselle* stationery, December 1, 1966, YCAL, Box 16.

376 **He did, however, frighten Anna:** Ricardo Aragno was the literature and culture correspondent for *La Stampa.* Information that follows is from an interview with Dr. Anna Aragno, December 19, 2007.

377 **The next day he drew her portrait:** Because of the limitation on the number of images of ST's art SSF permitted, I may not reproduce the "Portrait of Anna" here. In the December 19, 2007, interview, she said she was entirely unaware of ST's relationship with SS until I told her of it. She also said, "There was something inappropriate about him. His behavior was a sort of façade, a mask. You never really touched him; it was all surface."

377 **"smokey [Bear] hat":** ST, datebook, August 4, 1964, YCAL, Box 3. All information about the trip comes from this datebook, SS's diary in Box 110, and ST to AB, August 27, 1964.

378 **Several decades later, when she stopped:** Information that follows is from SS, "My Life and Travels in Post Cards, Part II, by Sigrid Savage," YCAL, Box 112. Although this is a continuation of "My Life in Postcards," she gave it a slightly different title in this continuation of her life with ST.

378 **"Tired now":** ST to AB, August 27, 1964, SSF.

CHAPTER THIRTY: I HAVE TO MOVE

379 **"I have to move":** ST to AB, September 6, 1965, SSF.

379 **He did nothing about renewing his lease:** NYU to ST, December 20, 1963; July 15, 1964; August 24, 1964; YCAL, Box 17.

380 **They flew home via Puerto Rico:** ST, 1965 date book, YCAL, Box 3.

380 **Before they left, Steinberg had mailed:** ST, January 1965, datebook, notation to com-

plete the drawings he sent to Maeght on November 11, 1964, YCAL, Box 3; ST to Aimé Maeght, November 12, 1964, copy at SSF.

380 **It was quickly apparent:** Quotes are from ST to Maeght, November 12, 1964. According to SSF, ST allegedly sent 33 photos but only 22 were used. SSF dates their beginning to 1959, with most of those published in 1961–62. The entire series can be viewed at http://www.magnumphotos.com by searching the terms "Inge Morath" and "Saul Steinberg."

381 **Even there, progress was hampered:** ST to Aimé Maeght, March 12, 1965, copy at SSF: "This has to be a very fine book."

381 **he wanted Maeght to ask:** ST to Aimé Maeght, September 13, 1965, SSF (my translation).

381 **"celebrities who wrote crap":** ST used the word *conneries*, which can be translated as stupidity or nonsense, but because it is not used in polite company, it usually deserves the harsher, slangier translation.

381 **Sartre and Nabokov both refused:** Beckett sent a polite letter saying that he had no competence to interpret Steinberg's work and could not risk serving badly an artist he much admired; Jacques Dupin to ST, January 3, 1966, YCAL, Box 15 (my translation).

381 **To soften the blow:** ST to Aimé Maeght, October 6, 1965, copy in SSF (my translation); correspondence in YCAL, Box 15, between Lindey, Maeght, and Robert Delpire, who wanted to make a documentary film about ST. Maeght said he wanted to publish the book under his own name and refused Delpire's offer to publish.

382 **In Paris he met Jean Folon:** Correspondence between ST and Folon pertaining to this and other projects Folon wished to pursue is in YCAL, Boxes 8, 15, and 16, among others.

382 **whose writing he admired:** Italo Calvino, "La Plume la Première Personne," *Derrière le Miroir* no. 224 (May 1977).

382 **On an impulse, he flew:** ST to Aimé Maeght, March 12, 1965, copy at SSF. ST wrote that he spoke to Hamish Hamilton in London and Harper in New York and both were interested, and he was sure that Rowohlt in Germany and Feltrinelli in Italy would also want the book.

382 **"milk the [paper's] exchequer":** Michael Davie to ST, December 8, 1964, and February 26, 1965, YCAL, Box 15. One of Cynthia Nolan's earliest letters to ST is dated August 1950, YCAL, Box 5.

382 **He was Gigi's witness:** SS to ST, February 20, 1965, YCAL, Box 109.

382 **Off he went to Florida:** ST, 1965 datebook, YCAL, Box 3.

382 **It irritated him:** Jeanne-Claude and Christo, interview, August 9, 2007.

382 **Steinberg liked even more:** ST, notes from conversation with Christo and Jeanne-Claude's biographer, Bert Chernow, n.d., YCAL, Box 123. Published in Chernow, *Christo and Jeanne-Claude*, pp. 47–48.

383 **Priscilla Morgan usually had eight:** Priscilla Morgan, interview, July 2008. At one of her dinners where ST was not the center of attention, he repeated a version—again to Jeanne-Claude and Christo—of what he had said in their home. Seated silently in an armchair in Morgan's apartment, he said he might as well go home because "everyone is talking and no one is listening to me."

383 **"more than enjoyable":** Jean Stein, interview, March 8, 2009.

383 **"Conversation seemed to make him awkward":** Bellow, remarks delivered at Steinberg's memorial service, copy in SSF and also in James Atlas's papers at the University of Chicago.

384 **For the next several months:** ST liked the acerbic Spark so much that he called on her frequently when he was in Rome. She sent a telegram to ST, care of Maeght, on February 25, 1966, asking if he wanted to visit her at the Silvretta Hotel, Klosters, Switzerland; YCAL, Box 15.

384 **In short, he was out:** Often, if the evening was particularly memorable, he also made a drawing and sent it to the hostess.

384 **She was so insistant that LSD:** The first mention of mescaline is in June 1955, in ST, datebook, YCAL, Box 3. Smith, *S:I*, p. 240, n. 134, posits that ST might have received the drug from Henri Michaux, who was a proponent of mescaline. I found no direct evidence to support this, nor did I find any concrete information about his supplier.

384 **"They wanted to see":** ST, typescript of interview with Adam Gopnik, filed as "Interview" in YCAL, Box 67. The conversation took place in 1993, and ST mistakenly said he took the LSD "in Connecticut."

384 **"something very important":** ST to AB, July 12, 1965, SSF.

384 **"certain differences and suspicions":** ST to AB, September 6, 1965, SSF.

385 **Gigi had never liked Greenwich Village:** ST, 1965 datebook, YCAL, Box 3; SS, "Synopsis: My Life in America," entry for September 23, 1965, YCAL, Box 108.

386 **Most of her lovers still wanted:** SS, correspondence in YCAL, Box 109.

386 **Bill de Kooning gave him:** Appraisers for the Pace Gallery gave de Kooning's drawing a value of $400,000 sometime in the 1980s; YCAL, Box 39.

386 **"well being doesn't count":** ST to AB, October 6, 1965, SSF.

387 **"look around for something":** George Plimpton to ST, n.d., YCAL, Box 15. The Byron Gallery, New York, thanked him for providing "original work for a poster," along with such artists as (among others) Jim Dine, Robert Indiana, Richard Lindner, Louise Nevelson, and Andy Warhol; YCAL, Box 15.

387 **He did, however, manage to contribute:** ST donated the drawing as a prize for a New Year's Eve benefit for Chamber Music in the Circle, Bleecker Street, NY, YCAL, Box 15. Schneider's letter is in YCAL, Box 61.

387 **Steinberg was never one to brood over:** HS, interview, October 11, 2007: "I always had the urge to share with him anything I read that mattered to me. ST used to laugh and say I always had to give the citation for anyone I quoted."

387 **Hedda always carried:** The notebooks and individual sheets of paper from them are found throughout the YCAL boxes but are not otherwise identified.

387 **Dore Ashton was "shocked":** Dore Ashton, interviews, January 20, 2009, and February 22, 2010; Dore Ashton to ST, "Wednesday," YCAL, Box 5.

388 **As he doodled:** ST, 1965 datebook, YCAL, Box 3; ST, "Notes on Writing," YCAL, Box 15.

CHAPTER THIRTY-ONE: THE DESIRE FOR FAME

389 **"I was doing so well":** ST to AB, August 17, 1966, SSF.

389 **"camouflaged as a cartoon":** Stein, unedited transcript of interview.

389 **"a form of brooding":** Ibid. ST continued: The doodle "contains only a combination of reflexes, a combination of things that the hand knows, the brain knows, but it's all half asleep and it's mechanical." He said doodling was responsible for what he called "mechanical drawings," such as the one in *The New World* on p. 13, which he called "A man reasons. The man thinks."

389 **"say something interesting":** ST, datebook, November 4 and 13, 1965, YCAL, Box 3.

389 **After this he wrote:** ST, datebook, January 20 and 30, 1966, YCAL, Box 3.

390 **He had met Tillich:** Invitations to meet Anshen in New York are in YCAL, Boxes 3 and 15; invitations for ST and SS to dine with Hannah Tillich in East Hampton begin in the autumn of 1965, shortly before Paul Tillich's death, YCAL, Box 15.

390 **All were asked to write:** This is a loose paraphrase of the jacket copy. All the contributors were men, but future contributors were to include Lillian Smith and Margaret Mead.

390 **Tillich was well suited:** Paul Tillich, *My Search for Absolutes*, edited by Ruth Nanda Anshen, with drawings by Saul Steinberg (New York: Simon and Schuster, 1967). The jacket copy describes Tillich and ST as "close friends." It is true that they knew each other and had tremendous affinity and rapport, but it is probably an exaggeration to

make the friendship any stronger than that. After Tillich's death, ST continued to call on his widow, and he remained friendly with her and with Anshen for many years afterward.

391 **"this game of autobiography"**: Stein, unedited transcript of interview.

391 **"in what might be called"**: Anshen, "Prologue," *My Search for Absolutes*, p. 20.

392 **"strong and penetrating"**: Hannah Tillich to ST, October 9, 1966; Hannah Tillich, Christmas card to ST, n.d. 1966; both in YCAL, Box 16.

392 **When Anshen sent Steinberg a copy:** Ruth Nanda Anshen to ST, September 5, 1967, YCAL, Box 16.

392 **"a great title which says nothing"**: ST, *The New World* (New York: Harper & Row, 1965); Jean Stein, undated edited version of 1966 interviews with ST, YCAL, Box 69.

393 **In preparation for the book's launch:** The interviews are collected as typescripts under the names of Jean Stein, Jean Stein vanden Heuvel, and Jean Vanden and are in YCAL, Boxes 15, 16, 38, and 69. In some of them, Harold Rosenberg is a participant and occasional interviewer. Portions of these interviews were published under the name Jean vanden Heuvel as "Straight from the Hand and Mouth of Steinberg." Some of Rosenberg's dialogues are in "Saul Steinberg's Art World," pp. 51–54, 67–68.

393 **Now he made the conscious decision:** ST to AB, August 17, 1966, SSF.

393 **"the biography of a man"**: Although the the book is unpaginated, ST worked from a paginated proof during this section of the interview and referred to this drawing as being on p. 93.

394 **In Steinberg's translation:** All quotations that follow, until noted otherwise, are from Stein, unedited transcript of interview, transcripts 10A and 10B, August 19, 1965, YCAL, Box 15.

395 **"some sort of idea"**: Glueck, transcript of interview.

397 **When it appeared in *The New Yorker*:** I refer here to the many letters scattered throughout the uncatalogued boxes of his archives.

399 **She was hurt:** SS, diary, YCAL, Boxes 108 and 111.

399 **He went alone to Paris:** ST to SS, February 23 and undated letters, 1966, YCAL, Box 109.

400 **"very hysterical"**: SS to ST, "wed. 9" [February 1966], YCAL, Box 15.

400 **All his friends were there:** A copy of a partial list of guests he personally invited is in YCAL, Box 15. It lists Alain, Buzzi, Barbara (Chase Riboud), Sandy (Calder), (Robert) Doisneau, (Robert) Delpire, Folon, Hélion, Hayter, Ionesco, James Jones, Knoop, Lica, Matta, Rowohlt, Michéle Rosier, Man Ray, Geer van Velde, Zao, Soulages, Max, (Jean) Riopelle, "Stella," and C. I. Roy. Véra Nabokov sent her regrets and her husband's, saying that he had too much work to finish before going away for the summer. She expressed "enormous pleasure" that ST had flown overnight on March 12 to Montreux to see them. A copy of his bill from the Montreux-Palace Hotel and her letter are in YCAL, Box 15.

400 **"I never fitted"**: SS, diary, 1987, YCAL, Box 111.

400 **Afterward, Saul went on alone:** Travel receipts are in YCAL, Box 15.

400 **Sigrid was mostly on her own**: On May 23, SS wrote to ST from Trier, calling her visit "a nightmare" and "brooding about what next"; YCAL, Box 15.

401 **"like an exam in a French Lycée"**: ST to Aimé Maeght, August 5, 1966; ST to Aimé Maeght, November 15, 1966; copies of both in SSF. My translation, with assistance from Mary Lawrence Test, Myrna Bell Rochester, and Catherine Portuges.

401 **The medal was conferred:** ST to Aimé Maeght, October 22, 1966, YCAL, Box 22. A reception was given for ST on September 29, 1966.

401 **"another medal of honor"**: *Vogue*, January 1, 1967, p. 136.

401 **"in that state of trance"**: ST to AB, October 23, 1966, SSF.

402 **"My fee today"**: ST, telegram to "Mr. Adams," director of the Cincinnati Art Museum, June 14, 1966, YCAL, Box 15.

402 **"I sold eighty pictures"**: ST to Aimé Maeght, January 4, 1967, copy in SSF.

402 **"paternal satisfaction"**: ST to AB, December 10 and December 30, 1967, SSF.

402 **"ready-made for a Saul Steinberg cartoon":** *Time*, April 15, 1966, p. 46.

403 **"an unsettling trip":** Pierre Schneider, "Steinberg at the Louvre: A Museum Tour," *Art in America*, July/August, 1967; reprinted in part in *Encounter* 30, no. 3 (March 1968), 48–54.

403 **Many interviewers came from Europe:** Some of the networks that filmed him include Raiuno (Italy), Suddeütscher Rundfunk and Bayerischer Rundfunk (Germany), Allan King Associates (England), and PBS and CBS (USA).

403 **In the United States, in the heyday:** Stein, "Straight from the Hand and Mouth of Steinberg," *Vogue*, January 1, 1967; Hilton Kramer, "The Comic Fantasies of Saul Steinberg," *New York Times*, December 4, 1966; Rosenberg, "Saul Steinberg's Art World."

403 **"the line philosopher-artist-cartoonist":** Mrs. Gerald A. (Edith) Kay to ST, Denver, n.d., YCAL, Box 16.

403 **The Romanian Socialist Republic:** YCAL, Box 16. Although ST never joined SACO, he always gave permission for his drawings to be used whenever anyone with whom he served wanted to reproduce them in books or articles. Prominent among them was Admiral Milton E. Miles's history-memoir, *A Different Kind of War*.

403 **He had never hidden his support for civil rights:** The SLC drawing was exhibited at MoMA from October 31 to November 3, 1968, YCAL, Box 32; the CORE documents are in YCAL, Box 16. Another group to which he contributed was Artists for SEDF (Scholarship, Education, and Defense fund for Racial Equality); see Robert Rauschenberg to ST, March 1, 1967, YCAL, Box 16. Elodie and Robert Osborn invited him to contribute to send young French filmmakers led by Gerard Calisti to North Vietnam, YCAL, Box 16. A letter from C. Conrad Browne, YCAL, Box 68, thanked him for a contribution of $260 that "helped make possible the termination of charges against the six campers arrested in the 1963 North–South work camp incident."

404 **When he ignored a letter from the Guggenheim Museum:** Second Street Workshop Club to ST, n.d., YCAL, Box 16; initial Guggenheim invitation, January 27, 1967.

404 **"I go on working":** ST to AB, December 30, 1966, SSF.

404 **"Come see me:"** ST to Aimé Maeght, January 4, 1967, copy in SSF.

404 **He was not as welcoming:** SS, nine handwritten looseleaf pages, the first entry dated October 22, 1965, YCAL, Box 68.

404 **By February she was begging:** SS to ST, "Feb 18" [1966], YCAL, Box 15; diary entries, YCAL, Boxes 99 and 111; SS to ST, February 8, 1965 to June 14, 1966, YCAL, Box 113.

405 **"It is a complex fate":** ST noted this in various YCAL boxes; in YCAL, Box 38, Charles Simic quoted it to him in regard to his own writing. The full quotation is from Henry James's letter to Charles Eliot Norton, February 4, 1872: "It is a complex fate to be an American and one of the responsibilities it entails is fighting against a superstitious valuation of Europe."

CHAPTER THIRTY-TWO: SUCH A DIDACTIC COUNTRY

406 **"The Washington experience is over now":** ST to AB, June 2, 1967.

406 **"Ah, America":** IF, interview, October 12, 2007.

406 **It was a blessing to be excused:** Charles Blitzer to ST, April 13, 1967, YCAL, Box 16.

406 **His stipend for the three months:** S. Dillon Ripley, Secretary of the Smithsonian Institution, to ST, February 23, 1967, YCAL, Box 16. In Owen Edwards, "Doodle Dandy," *Smithsonian*, May 2007, p. 41, ST's stipend was given as $11,000 and his acceptance letter is quoted as saying he would stay "for at least six months or perhaps a whole year." In *R & S*, p. 48, ST writes: "I was well paid, but I was determined not to save so much as a penny and even to pay a lot out of my own pocket so as not to feel too indebted to the government, and to uphold my honor as a guest of the Smithsonian."

406 **In an article about local celebrities:** Sunday "Potomac" supplement, *Washington*

Post, January 8, 1967, p. 7. The article featured ST's glasses with the caption "Artist Saul Steinberg moving to Washington as the Smithsonian's Artist in Residence."

406 **As soon as word got out:** From the folders of requests in YCAL, Box 16.

406 **"Smithsonian's Steinberg":** January, 1967, as quoted in Edwards, "Doodle Dandy," *Smithsonian,* p. 41.

407 **"an easy interview":** Karl E. Meyer, interview, May 27, 2010, in connection with "Steinberg Looks at Washington," *Washington Post,* March 15, 1970. Meyer interviewed ST in New York, where he was the paper's correspondent.

407 **"a subject of interest":** Mary Krug, managing editor of the *Smithsonian Torch,* to ST, March 6, 1967, YCAL, Box 16; the article was entitled "Enigmatic Steinberg Discusses Residency," April 1967, p. 3.

407 **"one of the elite of the elite":** ST, diary, YCAL, Box 78; HS, interview, October 11, 2007.

407 **"Norwegian Palace":** For a complete account of ST's time in Washington, see *R & S,* pp. 45–50. In WMAA, p. 245, ST calls the animals "gorillas."

407 **The library had an excellent collection:** ST to AB, March 30, 1967, SSF.

407 **The high living took a toll:** ST consulted Dr. Milton Gusack on April 17 and 18, 1967, for a complete "history and physical examination," which included a sigmoidoscopy and a glucose tolerance test. On May 4, Dr. Gusack prescribed a diet that followed an exchange pattern similar to Weight Watchers'. See YCAL, Box 16.

407 **He met so many people:** The notebook is in YCAL, Box 16.

408 **"bed w[ith] bells":** ST, datebook, March 28, 1967, YCAL, Box 3.

408 **"the famous daughters":** "Mr. and Mrs." Saul Steinberg were invited by President and Mrs. Johnson to a White House reception on June 7, 1966; YCAL, Box 69. ST did not attend.

408 **"the most admired diploma":** Letter to ST, YCAL, Box 16.

408 **He did not meet any of the Supreme Court justices:** ST, datebook, April 18, 1967, YCAL, Box 3; notebook of names, YCAL, Box 16.

408 **The one document that truly spurred his imagination:** *R & S,* p. 49.

408 **he left only thirty-six:** The drawings were made into the exhibition catalogue *Steinberg at the Smithsonian—The Metamorphosis of an Emblem* (Washington, D.C.: Smithsonian Institution Press, 1973), preface by John Hollander.

408 **He included the logo:** The dog on a cliff and the India ink bottle are reproduced in Edwards, "Doodle Dandy," pp. 41–42; the jug on a table is in WMAA, p. 245.

408 **thirty-foot-long scroll:** *R & S,* p. 49. Approximately 14 feet have survived, catalogued as SSF 7011. SSF also holds SSF 6186, a unique screen print that appears to be some kind of proof, possibly for a fabric design. In an e-mail, May 26, 2010, Sheila Schwartz wrote that to the best of her knowledge, the scroll was never exhibited. In WMAA, ST said that the scroll was "thirty or 40 feet long, a nice way of keeping a diary, ruined naturally by the boredom of a self-imposed commission."

408 **His output was steady:** *R & S,* p. 47, where ST insists he never wore formal dress again.

408 **He had to put the finishing touches:** "Steinberg: The Americans: Aquarelles, Dessins et Collages, 1955–67," Musées Royaux des Beaux-Arts de Belgique, Brussels; Museum Boymans-van Beunigen, Rotterdam; Hamburger Kunsthalle.

408 **There was the usual flood of requests:** "Steinberg: Dibujos y Acuarelas," Museo de Bellas Artes de Caracas, 1968; "Saul Steinberg: Watercolors and Drawings," J. L. Hudson Gallery, Detroit; solo exhibitions at Parsons and Janis galleries, all in 1969.

409 **"remote fishing, lumber, and farm communities":** Glynn Ross, Seattle Opera Association, to ST, November 21, 1966, YCAL, Box 16. Steinberg made the drawings and directed the painting of the screens but did not work on them himself. When the production ended, in March 1967, the screens were discarded. ST liked the project and wanted to do another, so he proposed Mozart's *The Magic Flute* for the following season. Glynn Ross wrote again, February 28, 1967, YCAL, Box 16, to say that it would not be staged.

409 **"nothing is ever created"**: Krug, "Enigmatic Steinberg Discusses Residency." See also *S:I*, pp. 166–67.

409 **Saul arranged for money to be deposited:** YCAL, Box 16.

409 **He planned not to return to New York:** Letter of protest written by Breiner and Bodan, accountants; directive for ST and HS to appear at District Conference, plus copy of their protest letters; YCAL, Box 16. They won the protest, but the IRS continued to audit ST regularly over the next decade.

409 **"Maybe I should take the hint":** SS to ST, n.d., YCAL, Box 16.

410 **Unfortunately, when he was there:** SS, diary, YCAL, Boxes 109, 111, and 113.

410 **"Why do you behave like a hysterical old woman?":** SS to ST, May 9, 1970 [most likely written for herself and not sent], YCAL, Box 112.

410 **"outrage":** Joel Smith uses this word in *S:I*, p. 170.

411 **He agreed with his old friend:** Ad Reinhardt, postcard to ST, n.d., YCAL, Box 20. The full text is quoted in *S:I*, p. 245, n. 124.

411 **Among the first to enlist Steinberg:** The collage was exhibited during the "Week of Angry Arts," January 29–February 4, 1967, YCAL, Box 16.

411 **From then on, Steinberg gave money:** A sampling of the exhibitions includes "Protest and Hope: An Exhibition of Contemporary Art," New School Art Center, New York; "Art for Peace," staged by various art galleries in New York and other cities; "Referendum 70," a benefit for antiwar congressional candidates. Scattered throughout the YCAL boxes are flyers, letters, posters, and other materials from various artist groups protesting the war.

411 **Instead of drawing the seals and stamps:** ST gave his drawings to William Cypel, of the Union Stamp Works and Printing Company, which was for many years on Broadway but then moved to East 12th Street. Some of the invoices are in YCAL, Box 8. Some of the stamps themselves are in YCAL, Boxes 19 and 20, and they fill YCAL, Boxes 52, 53, and 55.

411 **"to render space, nature, technology":** Glueck, "The Artist Speaks," p. 112.

411 **This posed a problem:** Joel Smith discusses this in *Steinberg at The New Yorker*, p. 41.

411 **"the cliché is the expression":** "Saul Steinberg Interview," YCAL, Box 67. This unidentified document is misidentified in *S:I*, p. 245, n. 126, as "June 1, 1968 interview." The correct date is assumed to be 1986, but the interviewer remains unknown.

412 **"greater social and political":** Richard Cohen, "Shawn's Letter from 43rd Street: 'We Are Not as Aloof as We Once Were,'" *Women's Wear Daily*, July 1, 1968. See also Yagoda, "A Time of Tumult: 1962–71," *About Town*, pp. 313–64.

412 **Many readers thought so:** Yagoda, *About Town*, chapter 6, discusses the debate.

412 **"He believed that most of his audience":** "Saul Steinberg Interview," YCAL, Box 67.

CHAPTER THIRTY-THREE: LIVING IN THE PAST

413 **"I work and see few people":** ST to AB, February 22, 1968, SSF.

413 **She told him to invite Aldo:** ST's datebook for 1968 is full of doodles on newspaper want ads and includes meetings with the realtor Alice Mason; YCAL, Box 3.

413 **When he heard that the eleventh (and top) floor:** The lease ran from April 19, 1968, to August 31, 1975. His application to use the premises for a residence in conjunction with an artist's studio was approved on November 4, 1968; YCAL, Box 22. Also, ST to AB, December 8, 1968, SSF.

414 **"Isn't it sumptuous?":** Eli Waldron, 1973 essay, YCAL, Box 32.

414 **He got as far as making a list:** His work was exhibited in 1968 at the Museo de Bellas Artes, Caracas; Hamburger Kunsthalle, Germany; Louisiana Museum, Humleback, Denmark; Moderna Museet, Stockholm; and Irving Galleries, Milwaukee, and was also part of a traveling exhibition that featured the Neuberger Collection, "An American Col-

lection: Paintings, Drawings, and Sculpture," which began at the Rhode Island School of Design and ended at the Smithsonian Institution.

415 **"the little house":** In a datebook diary, YCAL, Box 108, SS wrote that they moved the little house on May 27, 1968.

415 **"We're going through a nice period":** ST to AB, December 8, 1968, SSF.

415 **"Romanian winter":** ST to AB, March 11, 1969, SSF.

415 **"I function poorly these days":** ST to AB, September 16, 1969, SSF.

416 **They met for the first time:** The first meeting took place on September 12, 1965, according to ST's 1965 datebook, YCAL, Box 3. Information pertaining to van Dalen is from an interview with him, October 5, 2007.

417 **Steinberg asked van Dalen to walk:** "Steinberg would move through subject matter. Something would come up that fascinated him and he would work it through, follow it through. I just started at the east end [of Canal Street] and walked west and photographed everything I saw. I always wondered if he had a woman who lived down there because he was so fascinated with it"; Anton van Dalen, interview, October 5, 2007.

418 **"The true artist":** Mimi Gross, interview, March 9, 2010.

418 **She kept up with the literature:** HS, interview, October 7, 2007.

418 **The dunning letters:** These and copies of many other overdue bills are in YCAL, Box 8.

419 **Money became a concern again:** ST, Week At A Glance, 1969, YCAL, Box 3.

419 **He invested a good part of everything:** As of 1970, $20,978.35; see *TNY* annual report of participation trust from Morgan Guaranty Trust Company, YCAL, Box 8.

419 **"July 24: S. hits me":** Information that follows is from SS, diary, 1969, YCAL, Box 108.

419 **"such an extreme and extravagant change":** SS to ST, December 6, 1969, YCAL, Box 112.

420 **"hate and disgust":** SS to ST, January 1, 1970, YCAL, Box 112.

420 **Steinberg had wanted to return to Africa:** Information in this paragraph is from ST to AB, March 28, 1970.

421 **"crocodile man":** From what appears to be the earliest transcript of the conversations with Grace Glueck that became the article "The Artist Speaks," *Arts in America*, November–December 1970, pp. 110–17.

421 **He was speaking of Alistair Graham:** Alistair Graham, *Eyelids of Morning: The Mingled Destinies of Crocodiles and Men* (San Francisco: Chronicle, 1973–76; reissued 1990). Graham's correspondence with Steinberg is in YCAL, Box 8.

421 **Graham urged Steinberg to go:** Steinberg never visited Lake Rudolph. He sent a thank-you letter to Graham, who replied that ST's description of Murchison Falls "confirms my suspicion that your taste in Africa is as good as it is in wit"; Alistair Graham to ST, April 25 [1970], YCAL, Box 8.

421 **On his first day in Nairobi:** Bellow claimed they were both wearing American baseball hats, but this detail, like many others he allegedly recalled, is in dispute. See also "Saul Steinberg," *The Republic of Letters*, no. 7, November 1999; Saul Steinberg, "Saul Bellow in Uganda," *Saul Bellow Journal* 4, no. 2 (1985): 24–25.

421 **In an article Bellow wrote:** Bellow, "Saul Steinberg," p. 29.

422 **it is highly unlikely:** However, ST did tell Grace Glueck that he and Angelini "had a ball going around on donkeys and mules in cowboy hats, smoking hashish and seeing these—well, more than the churches."

422 **Steinberg observed how the biologist:** Information that follows is from Glueck, unedited transcripts of interviews, copies at SSF.

423 **He had accepted an extremely lucrative commission:** Harry Abrams prepared a portfolio of six lithographs with collage that guaranteed ST income in the range of $32,000 (if sold by dealers) to $40,000 (if sold directly by the publisher); YCAL, Box 8.

423 **"enter into investigative discussions":** These are among the many requests in YCAL, Box 8. ST did eventually send the paintings, which were exhibited in the fall at the Carnegie International Exhibition of Painting and Sculpture, Pittsburgh.

423 **Van Dalen also had to take care of:** Palm Springs Desert Museum donation, September 24, 1970; $100 to East Hampton Guild Hall, August 4, 1970; Guild Hall poster earned $500. All in YCAL, Box 8.

423 **Steinberg was against the war:** Lica Roman to ST, n.d., YCAL, Box 8.

423 **He did, however, contribute:** Manifesto, April 1970; Dolci invitation, n.d. Both in YCAL, Box 8.

423 **"closed up . . . into my shell":** ST to AB, November 8, 1970.

423 **Despite his silence, she sent:** The message read, "I wish I were there with you"; SS to ST, n.d., YCAL, Box 8.

424 **"less lonely here alone":** SS to ST, May 9, 1970, YCAL, Box 112.

424 **Gross and Grooms were so concerned:** Mimi Gross, interview, March 9, 2010.

424 **"It has been coming for a long time":** SS to ST, n.d. but internal evidence suggests fall 1970, YCAL, Box 8.

425 **"pretend the problem does not exist":** ST to AB, November 8, 1970.

CHAPTER THIRTY-FOUR: FURNITURE AS BIOGRAPHY

427 **"I go to work as though out of remorse":** ST to AB, April 12, 1971, SSF.

427 **"Here I've spent five days":** ST to AB, February 1, 1971, SSF.

427 **He had checked himself into:** Bills in YCAL, Box 6, show that his stay in the clinic, Keltenstrasse 48, Zürich, cost approximately $1,000. Before he entered the clinic he stayed at the Hotel Baur au Lac and afterward in the Dolder Grand Hotel. In 1974 he went to the Buchinger-Klinik am Bodensee, on Lake Constance, Switzerland, where he paid 2,000 DM to "take the cure" through fasting and to have medical tests done, primarily on his heart. YCAL, Box 40.

427 **he continued to smoke:** In a medical history he gave at Sloan-Kettering Hospital for a 1995 biopsy, he said he smoked one to two packs daily for thirty years but smoked his last cigarette in 1972.

427 **It was one of his two solo exhibitions:** Chicago: "Annual Works on Paper;" Corcoran Gallery of Art: "Seven Enormously Popular American Artists"; "Le Dessin d'humour," Bibliothèque Nationale.

427 **He was a judge:** Emily Genauer praised the show for not being "one more opportunistic theme show in this time of Women's Lib" and praised Steinberg and several others for "quality pieces that are, in several instances, surprisingly offbeat"; Emily Genauer, review of "She," *New York Post*, January 16, 1971.

428 **"a couple million scientologists":** Tom Solari to ST, August 4, 1971, YCAL, Box 101. He refers to L. Ron Hubbard's *The Fundamentals of Thought*.

428 **Storm clouds explode:** Anton van Dalen recalled that Warhol and Steinberg were "intrigued by each other" but he and ST were invited to visit the Factory only once, during the daylight hours, when no one was there to party. Van Dalen called Warhol "an incredibly polite guy and I think he was a fan of Steinberg's"; Anton van Dalen, interview, October 5, 1007.

428 **"left his study for the streets":** Smith, *Steinberg at The New Yorker*, p. 41; Anton van Dalen, interview, October 5, 2007.

429 **Some of Steinberg's ideas:** His collection is in YCAL, Boxes 91 and 92.

429 **"evidently lost all sight":** HS to ST, n.d., YCAL, microfilm letters.

429 **"on probation":** SS, calendar for 1971, in which she lists "Mistakes of summer '71," YCAL, Box 108; ST to AB, April 12, 1971, SSF.

429 **They returned home despondent:** SS, diary, April 13, 1971, YCAL, Box 108.

430 **He relished being in the distinguished company:** These names are found on the small scraps of writing in HS's hand throughout the YCAL boxes, often with her comments about the person's importance, beauty, or originality.

430 **Steinberg was inordinately proud:** ST to AB, November 11, 1971, SSF.

430 **"a writer's work is a lot more difficult":** ST to Aimé Maeght, October 6, 1971, copy in SSF.

430 **The euphoria dissipated abruptly:** ST to AB, January 24, 1973, SSF.

430 **He had flown to Zurich:** ST to Aimé Maeght, October 6, 1971, copy in SSF.

431 **The last decision was the most crucial:** ST to Sidney Janis, May 1, 1971, YCAL, Box 101. On January 4, 1972, ST thanked Maeght for sending him $50,000 as part of his earnings from prior exhibitions; ST to Aimé Maeght, copy in SSF.

431 **"sensational news":** ST to AB, March 17, 1972, SSF.

431 **"metemphyschosis":** ST to AB, March 17, 1972, SSF; Joyce has Leopold Bloom meditate upon metempsychosis, loosely translated as "the transmigration of the soul," in *Ulysses*, episode 8, "Lestrygonians."

431 **"Saul with warm blue scarf":** ST to SS, Überlingen, January 24, 1972, YCAL, Box 108.

431 **And because Sigrid felt the need:** Information that follows is from a list of their travels in a mini-planner kept by ST, YCAL, Box 102; and a MoMA pictorial diary 1971–72, YCAL, Box 3.

432 **One of her best paintings:** The painting, done in 1979, was 6 ft. x 6 ft., described by Rose Slivka as "pencil and thin oil of pink tans like skin tones, with greens here and there to indicate water and rivers on a large gray ground." It hung in ST's studio in Springs for many years and was the focal point of several exhibitions of SS's work, particularly the show at Ashawagh Hall in October 1986. See Rose C. S. Slivka, "From the Studio (Sigrid Spaeth)," *East Hampton Star*, October 9, 1986.

432 **Africa became the only place:** SS, diary, YCAL, Box 111.

432 **"of these absurd trips":** ST to AB, March 17, 1972, SSF.

433 **To Hedda, he said merely:** HS, interview, October 24, 2007.

433 **"like the previous collections":** ST to AB, June 1, 1972, SSF.

433 **To Aimé Maeght, he said everything was just fine:** ST to Aimé Maeght, April 7, 1972, copy in SSF.

433 **It had always been a very special holiday:** Throughout her diary writings in YCAL, Boxes 100, 101, 108, and 109, SS always notes if ST sent roses to commemorate the holiday or if he ignored it—a sign that they were estranged.

433 **"struggle against tobacco":** ST to AB, December 9, 1972, SSF.

434 **"beautiful and simple":** ST to AB, September 25, 1972, SSF.

434 **he now had a second studio assistant:** Gordon Pulis worked for ST for twenty-two years. In an interview, September 22, 2007, Pulis said, "We didn't hit it off the first time we met, at a dinner with [William] Gaddis and Muriel [Oxenberg Murphy] and Sigrid. Five years later, I told him about that first dinner. He said nothing that I can remember when I told him we had met before; I think he just stared at me." Before ST hired Pulis, he hired a woman whose name is not known to help with ink and color drawings. Pulis said, "She was totally incompetent, which is how he came to get my name the second time when he hired me."

434 **"a bit sinister":** ST to AB, September 25, 1972, SSF.

434 **Sometimes he found a remnant:** *S:I*, p. 40, fig. 31. See also figures of dog tag, datebook, and camera on p. 196.

434 **He began to make other objects as well:** Cartier-Bresson's camera is in the collection of the Fondation Cartier-Bresson, Paris. Helen Levitt's was in her possession at the time of her death in 2009.

434 **"the rather animal world of painters":** ST to AB, March 10, 1973, SSF.

434 **"I think there were too many":** ST hired Sig Lomaky in the 1960s for occasional help in constructing his wooden sculptures. He writes about Lomaky in *R & S*, pp. 90–94.

434 **He himself may have been unable:** The comment is by Gordon Pulis, interview, September 22, 2007. ST is shown making his own carved wood objects in the last half of the film *Du côté chez les Maeght*, October 1973. (The first half features Valerio Adami.)

434 **One of the earliest tables:** *S:I*, Catalogue 71, p. 196.

435 **At the top of the tableau:** ST often incorporated actual etching plates into the tables.

435 **Steinberg called one of the intriguing:** Wood assemblage with crayon and pencil, depicted in *S:I*, p. 216 bottom.

435 **Many were three-dimensional replicas:** He left them to Yale University and they currently make up YCAL, Boxes 134–72. The objects themselves were not in the YCAL bequest and are in SSF.

435 **Whether he referred to them:** Gordon Pulis, telephone conversation, June 29, 2010.

435 **Hedda Sterne thought it was because:** Ibid.; HS, interview, October 7, 2007; Daniela Roman, conversation, July 27, 2008. Sheila Schwartz confirmed that "Furniture as Biography," wood assemblage with crayon and pencil, was on the transparency from which the photo in *S:I*, p. 216, fig. 84, was made. She thinks the title "Grand Hotel" may have been given in the course of preparing the 1987 show and catalogue. According to Pace's records, the work was returned to ST on May 2, 1989, which is when he probably consigned it to the cellar beneath his studio. Schwartz does not know when or by whom it was disassembled, but she verified that several pieces of it are still extant, now owned by SSF.

435 **One of the most revealing wooden constructions:** Pencil and mixed media on wood assemblage, depicted in *S:I*, p. 216, fig. 84.

436 **"in fact, I'm preparing a show":** ST to AB, March 10, 1973, SSF.

CHAPTER THIRTY-FIVE: UP TO MY NOSE IN TROUBLE

437 **"All's well here":** ST to AB, May 4, 1974, SSF.

437 **"The show, yes, it went well":** ST to AB, March 10, 1973, SSF.

437 **"utterly captivated":** Philip Guston to ST, February 4, 1973, YCAL, Box 102.

437 **"the boring problems":** ST to AB, January 24, 1973, SSF.

438 **He found what he wanted:** ST to AB, June 28, 1973, SSF. He bought the apartment on May 31, 1973, from Edgar and Joan P. Stillman, for a total cost of $71,500. He did not get a mortgage but paid them $41,500 cash and they held a promissory note for $30,000. Documentation in YCAL, Box 39.

438 **"a talented, charming, reliable man":** Letters dated April 1973. Bodian was a partner in the CPA firm of Breiner & Bodian; YCAL, Box 103. In a legal document that "settled the rights and interests" of ST and HS, December 19, 1989, YCAL, Box 71, ST's net worth had risen to $4,669,000.

438 **It resembled all too closely:** Documents and photocopies of most of his memberships and awards, YCAL, Box 32.

438 **His dues were in arrears:** ST became a member in 1965, nominated by Eric Larrabee, Sidney Simon, and Brendan Gill. He resigned on October 19, 1975, because he never used the club's facilities. I am grateful to Dr. Russell Flinchum, archivist of the Century Association, for documentation concerning ST's membership.

438 **"Everyone . . . looked fabulous":** "Suzy," *New York Daily News*, March 20, 1974, YCAL, Box 32.

439 **The most oft-repeated story:** Among the many people who told versions of these stories in interviews were HS, AB, Vita Peterson, Ruth Nivola, and Christo and Jeanne-Claude. I had conversations with others who were guests on these occasions and claimed to have witnessed them firsthand but did not wish to be cited.

439 **He hired the architect:** Various documents concerning the renovation are in YCAL, Box 73. Floor plans for alterations, May 1978, are in YCAL, Box 32. PC, e-mail, July 20, 2010, provided details of the layout. In his veiled datebook notations, "Ala" had been appearing for the better part of the previous decade.

439 **He ended up living through:** ST to AB, June 28, 1973; Anton van Dalen, interview, October 5, 2007.

440 **Finally, everything was settled and approved:** ST to AB, November 12, 1973, SSF.

440 **The two housing decisions were momentous:** ST to AB, December 3, 1973, SSF.

440 **He thought the addition dwarfed:** ST to AB, February 1, 1974, SSF.

440 **"temporary . . . improvised":** ST to AB, June 12, 1974, SSF.

441 **"fucking patria":** ST wrote this in a diary entry on his seventy-seventh birthday, June 15, 1997, YCAL, Box 75. Immediately after, he wrote: "Unfortunately all my landscapes, smells, sounds, tastes, are there. Houses, courtyards, sky, mountain, snow."

441 **He wondered if his disposition:** ST to AB, September 25, 1972, SSF.

441 **"in harmony for the moment":** ST to AB, January 24, 1973, SSF.

441 **"a nightmare":** ST to AB, January 24, 1973, SSF.

441 **"depressing, disaster":** ST to AB, September 8, 1973, SSF.

441 **"biting its own tail":** Edith Schloss, "Around the European Galleries," *International Herald-Tribune*, October 27–28, 1973.

442 **Steinberg had occasionally used de Bloe:** After de Bloe bought several watercolors from the exhibition, Steinberg instructed him to send the $4,000 payment directly to Aldo, who was to keep $3,000 and send the remaining $1,000 to Ada. AB thanks ST, December 7, 1973, YCAL, Box 102, for money that brought tranquillity to a stressful financial period.

442 **Although the Internal Revenue Service:** Serge de Bloe to ST, December 18, 1973, YCAL, Box 102. He tells ST he sent the check per ST's instructions. Letters from the IRS and ST's tax accountants in YCAL, Box 101, verify that he was being audited, that he was late in paying previous years' taxes, and that he had applied for an extension of the April 15, 1973, deadline. The amounts ST contributed often exceeded the amount permitted as gifts.

442 **Until now he had never volunteered:** In an undated letter in YCAL, Box 101, Ada asks ST where the television he promised to send her is.

442 **"doing a good or bad thing":** ST to AB, December 3, 1973, SSF.

442 **Mary McCarthy came:** McCarthy thanked him for the dance in a letter, October 19, 1973, YCAL, Box 102. Information that follows until noted otherwise is from this letter.

442 **He sent almost the entire amount:** Mary McCarthy to ST, November 7, 1973, to thank him for the money, and again on December 12, 1973, to tell him of progress made; YCAL, Box 102.

442 **He was generous with his work:** Marten Bogner bought the McGovern-Shriver painting; Frances O'Brien, March 28, 1972, thanked ST on behalf of Spanish refugees. Both in YCAL, Box 102. On July 13, 1975, O'Brien wrote again to thank ST for a second contribution, an original four-color print; YCAL, Box 103.

442 **Judith Hope, who was running for reelection:** On June 18, 1985, Judith Hope wrote to tell ST that she wanted him to hear from her first that she was withdrawing from the campaign; YCAL, Box 103.

442 **He gave permission:** The work was from the May 25, 1968, issue, pp. 36–37, 40–41; the anthology was published by Dell.

443 **Shortly after, the group asked him:** National Emergency Civil Liberties Committee to ST, n.d., YCAL, Box 102; letter confirming his promise to create "only the front cover," May 8, 1975.

443 **But when the National Lawyers Guild:** The first letter is undated, the second is February 26, 1974, YCAL, Box 103.

443 **It was not a politically correct thing to do:** Letter of invitation, April 4, 1972, YCAL, Box 102.

443 **His work had always been of interest:** Agarwal, "Steinberg's Treatment of the Theme of the Artist," with several interviews beginning December 8, 1972, YCAL, Box 78.1; Ralph Neubeck, "A Biographical Critique of Steinberg's Work with Particular Emphasis on Its Relationship to the American Culture and Sense of Humor, with Particular Emphasis on the Humorous Content," PhD dissertation, University of Minnesota,

Department of American Studies, 1972; Ralph Neubeck to ST, January 20 and March 24, 1972, YCAL, Box 102.

443 **the cartoonist Garry Trudeau:** Garry Trudeau to ST, n.d., YCAL, Box 102.

443 **Steinberg's work even penetrated the Romanian Iron Curtain:** Nick Luddington of Associated Press to ST, October 21, 1974, YCAL, Box 103; Matty Aslan to ST, Bucharest, 2 ionie, 1974, YCAL, Box 103. To prevent government intervention, Luddington asked ST to send any replies to Aslan through him, and a brief exchange ensued between them. Examples of Rosa Steinberg's embroidery, including ST's bib from his 1914 birth, with his name in pink thread in chain stitch on ecru lace, are in YCAL, Box 71.

443 **He had met Susan Sontag:** According to the appeal, Sontag had a radical mastectomy in October 1975 and had no medical insurance to pay for it or money to support her son, David Rieff.

443 **He provided the jacket drawing:** Hollander was published by Oxford University Press; YCAL, Box 103.

443 **When Nora Ephron:** Nora Ephron to ST, March 26, 1975, YCAL, Box 103.

444 **Most recently he and Nabokov had disagreed:** ST wrote to AB, March 5, 1975, giving hints of his conversation with Nabokov about a biography of Courbet. Of the biography, ST wrote: "Writers of biographies understand only other writers (as shown in diaries, letters, etc.)." Of Courbet: "Poor Courbet. When he wrote a letter he showed only his worst. His originality or uniqueness was involuntary, that of an animal that by some miracle painted, with naturally the great refinement and precision of beasts."

444 **"maybe it could be done":** ST to AB, February 1 and 27, 1974, SSF.

444 **gave great care to nominating:** An example of his political discretion came when he wanted to nominate Christo: ST enlisted George Rickey to propose Christo, and he and Isamu Noguchi seconded. He and Saul Bellow worked to secure William Gaddis's membership. YCAL, Box 94.

445 **Awards and accolades from other institutions:** A list of ST's honorary degrees in SSF lists the following: Lawrence College, 1962; Harvard, 1976; Philadelphia College of Art, 1977; New York University, 1978; Royal College of Art, 1988; Yale, 1989. A photocopy without date, in Latin, is from "Moderamini Academiae Regiae Artium Nobilium in Urbe Hagana," which Sheila Schwartz believes is from the Royal Academy of Art, The Hague. In 1983 ST was nominated for election to the Accademia Internazionale d'Arte Moderna, Rome, but SSF has no record that he was elected or that he accepted. A partial list of other honors include Chevalier de l'Ordre des Arts et des Lettres, 1966; American Academy and Institute of Arts and Letters, 1968; Benjamin Franklin Fellow of the Royal Society for the Encouragement of Arts, Manufactures & Commerce, London, 1969; Die Bayerische Akademie der Schönen Künste, 1972; National Institute of Arts and Letters, Gold Medal for Eminence in Graphic Art, 1974; Skowhegan School of Painting and Sculpture, medal for drawing, 1976; AIA Medal, the American Institute of Architects, May 1976; American Academy of Arts and Sciences, fellow, 1978; [New York City] Mayor's Award of Honor for Arts and Culture, 1983.

445 **"impossible to witness":** ST to Mrs. G. Walter Zahn and Richard Seyffert, October 31, 1976, YCAL, Box 103.

445 **Philip Johnson was the presenter:** Philip Johnson Papers, I.109, Museum of Modern Art Archives, NY; published in *Proceedings of the American Academy of Arts and Letters*, New York, 1975, p. 21; copy in YCAL, Box 103.

445 **He was alarmed when one of the women:** ST to AB, May 4, 1974, SSF. The woman was known only as Erika.

446 **"What does this sadness mean?":** ST to AB, June 12, 1974, SSF.

446 **He kept in touch with Chiaromonte's widow:** Miriam Chiaramonte, articles and obituaries in YCAL, Box 102. In Box 22, letter of July 26, 1977, she thanks ST for signing a protest letter for Polish dissidents: "It's fine that you gave your name."

446 **His brother-in-law, Rica Roman:** ST to AB, February 27, 1974, SSF.

446 **Steinberg gave her the happy news:** ST to Lica Roman, May 14, 1975, YCAL, Box 22.

447 **He wondered if her low spirits:** ST to AB, May 24, 1975, SSF.

CHAPTER THIRTY-SIX: SADNESS LIKE AN ILLNESS

449 **"I've found and taken a good look":** ST to AB, October 9, 1975, SSF.

449 **Lica's death at the relatively young age:** ST to AB, July 19, 1975, SSF; Dana Roman and Stéphane Roman, interviews, January, 2008.

449 **"sadness was like an illness":** ST to AB, July 19, 1975, SSF.

449 **"depressed, scared in the morning":** ST to AB, March 5, 1975, SSF.

449 **All the while she had been with him:** ST to AB, May 24, 1975, SSF.

450 **A number of interesting projects resulted:** Some of SS's other commissions included Cynthia Griffin Wolff, *A Feast of Words: The Triumph of Edith Wharton*; Richard Eberhart, *Fields of Grace*; William H. Pritchard, *Lives of the Modern Poets*; and Peter Conrad, *Imagining America*. All in YCAL, Box 32.

450 **"ideas were more developed":** Letters of rejection from the Whitney's personnel department and from Barbara Toll, director of Hundred Acres Gallery, February 1973 and 1975, YCAL, Box 108.

450 **"Of course I still love you":** ST to SS, July 9, 1976, YCAL, Box 104, Folder "Paris Milano 1976 Jan 27–July 10."

451 **Before Anton could do the actual packing:** To help ST decide, Anton took photos of the studio so that ST could re-create various arrangements where he wanted them. The photos are in van Dalen's personal collection.

451 **"the brutal image of the end of life":** In an interview with Mark Stevens, *Newsweek*, April 17, 1978, pp. 124–26, in conjunction with his 1978 WMAA retrospective, ST is quoted as saying that he is "a voyeur of himself." Some of the stamps he collected include birds, JFK, and reproductions of art. These and various brochures are found in YCAL, Box 32, and also in some of the other uncatalogued boxes.

451 **He asked anyone traveling to Bucharest** ST to Bert Chernow, interview for *Christo and Jeanne-Claude*; W. D. Snodgrass to ST, October 13, 1973, YCAL, Box 22; "Humphrey" [Sutton?], photographs of Strada Palas, 1973, YCAL, Box 22; Norman Manea, interview, June 11, 2008.

452 **"an emotional orgy":** ST to Henri Cartier-Bresson, February 28, 1999, YCAL, Box 73.

452 **Ada's letter was especially poignant:** Ada to ST, n.d., YCAL, Box 38; ST to AB, May 24, 1975, SSF. Other letters from (among many) Sidney Janis, Cartier-Bresson, the Ionesco family, and Bram van Velde are scattered throughout YCAL boxes, among them 38 and 75.

452 **With Lica gone, he grew closer to Ada:** Lica's term is found throughout her correspondence with ST, SSF; Ada's *"olino"* is a diminutive of "Saulino."

452 **He stayed on in Springs:** ST to AB, November 10, 1975, SSF.

452 **"who keeps writing wonders":** ST to AB, March 8, 1975, SSF. ST was probably referring to Hammett's *The Big Knockover* (New York: Random House, 1966), edited by Hellmann, and to her first memoir, *An Unfinished Woman* (New York: Bantam Books, 1969).

453 **"Joyce's illegitimate son":** ST to AB, August 15, 1976, SSF. ST had just read *The Buenos Aires Affair*, which he called "a novel disguised as a detective story." He also recommended *Betrayed by Rita Hayworth* and later, in the 1990s, he liked *The Kiss of the Spider Woman*, both the book and the movie. Mainly he preferred European biography and fiction, such as the two novelists whose work he was currently exploring, Elsa Morante and Heinrich Böll.

453 **His recommendations often came:** Claire Nivola, "Menu," atop which ST has affixed two rubber stamp impressions of Millet's *Angelus*; collection of Claire Nivola.

453 **"more contemporary and more historical":** Claire Nivola, telephone conversation, April 29, 1908.

453 **His most recent suggestion:** ST to AB, May 10, 1976, SSF, in which he tells AB that Barthes is to write the introduction for the next *DLM* but that he had not yet read anything by Barthes. He planned to go to Paris in June 1976 specifically to meet Barthes and discuss what he would write. Although the two met as friends then and on other occasions, Barthes did not write for *DLM*, but he did supply the text for the 1983 book *All Except You*. In Claire Nivola to ST, May 17, 1975, she tells him that she forgot the title he wrote when he told her to read something of Barthes's so they could talk about it; YCAL, Box 104. On May 26, 1976, postcard in possession of Claire Nivola, he thanks her for an unnamed Barthes book: "—very difficult to understand. The obvious (to me) as explained by him—It's his art."

453 **This assertion led him to**: Roger Shattuck, *The Banquet Years: The Origins of the Avant-Garde in France, 1885 to World War I* (New York: Vintage Books, 1958), p. 208. ST's copy is in YCAL, Box 32. ST was also reading Shattuck's *Proust's Binoculars* (New York: Random House, 1963).

453 **"closed, complete":** ST to AB, March 8, 1975, SSF.

454 **"completely lost faith":** ST to AB, June 19, 1976, SSF.

454 **After not having a single cover:** ST to AB, October 23, 1976, SSF. The exhibition, "Steinberg Cartoons," opened on November 17 and ran through December 4 (Parsons) and 11 (Janis).

454 **"Manhattanite dystopias":** *S:I*, p. 67; see also fig. 69 on that page, for Steinberg, Papoose, and the wall of drawings. Note also that he has regrown the mustache he cut off shortly after he met Sigrid and she objected to it. The *TNY* cover for October 20, 1975, is a compilation of his grotesque head shots.

454 **He took renewed pleasure:** A collection of these drawings was published as *Dal Vero* (New York: Library Fellows of the Whitney Museum of American Art, 1983).

455 **While Ruth seethed:** This account is based on interviews with Hedda Sterne, Aldo Buzzi, Ruth Nivola, Claire Nivola, Dore Ashton, Ivan Chermayeff, Vita Peterson, and many others. Chermayeff offered the most succinct appraisal of the difference between the two men: ST "was a bit of a shit. He was a self-oriented guy and he was not nice. Tino and Saul were exact opposites. Tino was outgoing, friendly, encouraging to others, a great person. Saul behaved to lots of people in the same snotty manner as he treated Tino. Genius or not, [ST] was not a nice guy. He had certain things missing from his life, which is probably why he loved Tino and Ruth. They are sophisticated, too, but they are simple, warm, and direct people. I think Saul was envious of their ability to go forward and do their own work. I think Saul was jealous. He was aware of the life they led and that they represented something he was not capable of being."

455 **Tino invited Saul to help him hunt:** This was something ST and Nivola had done for many years: in a letter to Claire Nivola, October 25, 1976, in her possession, ST relates how they went mushroom hunting "across the dunes from the fish factory."

455 **"in boarding houses in Milan":** ST to AB, May 10, 1976, SSF.

455 **One of the things he liked best:** ST, diary, June 12, 1991, YCAL, Box 75. ST was also reading Nabokov's *Speak, Memory* and unnamed books by Wittgenstein and Canetti.

455 **"I'm following your advice":** ST to AB, August 15, 1976, SSF.

455 **To thank Aldo for his concern:** ST to AB, January 29, 1976. He also told AB that Rosa Esman, a gallery owner in New York, would be sending checks for $600; he was to keep half and send the rest to Ada, who had broken her arm. On March 25, 1976, he wrote again to tell Aldo that a $4,000 check would come to him; he was to keep $1,000 and the rest was to be sent to Lica Roman's children, Stéphane and Dana. On June 19, 1976, he wrote that he would tell Aldo about his "dependent niece and nephew."

455 **He was engaged by a text:** First published 1979 by Adelphi Edizioni, S.P.A. Milano; translated by Guido Waldman for Bloomsbury, New York, and not published until 2005.

Fourteen drawings by ST that he sent to AB from the 1950s on were all reprinted with permission from SSF.

456 **"I'm a little depressed":** ST to AB, October 23, 1976, SSF.

456 **"next year with pleasure":** ST, telegram to Aimé Maeght, September 1976, copy at SSF; ST to AB, October 23, 1976, SSF.

456 **Maeght instructed them to go to Springs:** ST to AB, November 16, 1976, SSF.

456 **He told Aldo he wanted:** ST to AB, January 19, 1976, SSF.

457 **But instead of cheering him up:** The YCAL boxes contain articles about how to have sex after ninety, medical folders about which positions to assume after hip surgery or if suffering from chronic arthritis, and, when he was in his eighties, numerous articles and pamplets about the use of Viagra. There are also many guarded references to women who probably rebuffed his advances, but he does not commit the actual details to paper.

458 **"many emotional reactions":** ST to AB, November 16, 1976, SSF.

458 **"comfortably and naturally":** ST, Alexander Calder memorial service, Whitney Museum of American Art, December 6, 1976, copy in SSF files.

458 **"getting tongue-tied":** ST to AB, December 12, 1976, SSF.

459 **He thought Calvino's preface:** ST to AB, March 24, 1977, SSF.

459 **The show was to open on May 11, 1977:** He referred to the adult children of his aunt Sali Marcovici, who were his contemporaries The Romanian letters in the YCAL boxes, copies at SSF, verify that he still sent them all regular financial stipends.

459 **"big worries":** ST to AB, April 1, 1977, SSF.

459 **"A retrospective usually comes":** Alexander Lindey to ST, May 1, 1978, YCAL, Box 61.

CHAPTER THIRTY-SEVEN: THE MAN WHO DID THAT POSTER

461 **"There is no frontier":** Undated transcript of a dialogue between ST and HR, catalogued as 7B-3 and 4, HR/Getty.

461 **"the man who did that poster":** Sarah Boxer, ST obituary, *New York Times*, May 13, 1999, pp. 1, B10.

461 **"one of the very rare times":** ST to Claire Nivola, March 6, 1967, in her archives. The anecdote was also used in *S:I*, Catalogue 65, pp. 184–85, and Smith, *Steinberg at the New Yorker*, p. 136.

461 **As she described her intentions:** Dorothy Norman, *The Heroic Encounter* (New York: Grove, 1958). The Willard Gallery exhibition was the same year.

462 **In 1966 he did a series of drawings:** Published on October 1, 8, and 15. The drawing where the artist is poised over the Pacific Ocean and looking at the city is reproduced in *S:I*, p. 70.

462 **Beyond the city, a sun peeked:** Reproduced in *S:I*, p. 71, fig. 77, discussed in Catalogue 75.

462 **There was only a power station:** For an idea of how the painting evolved, see *Saul Steinberg: Fifty Works from the Collection of Silvia and Jeffrey Loria*, pp. 41–49, figs. 18–23. The first drawing was colored pencil and graphite on paper; the last was colored pencil, crayon, watercolor, ink, and graphite on paper. All the drawings were signed lower right. For an extension of the idea expressed in "9th Avenue," see *Saul Steinberg: Drawing into Being*, catalogue, Pace-Wildenstein, New York, October 1–30, 1999, pp. 68–72, "Looking West," 1986, and "Looking East," 1986.

462 **In another version, "Jersey" showed up:** On a copy that he sent to his cousin Judith Steinberg Bassow, ST made a mark on a boulder where Denver, Colorado, might have been and wrote her name there, "Judy," followed by the comment: "This shows Judy on the mountain . . . love from Saul Steinberg 1976." I am grateful to Ms. Bassow for this and other photocopies of ST's work in her possession.

463 **Steinberg's ordinary "crummy" New Yorkers:** *S:I*, p. 241, n. 146, in which Joel Smith quotes an e-mail from PC, January 4, 2004; Smith, *Steinberg at The New Yorker*, p. 42.

463 **"glued to the television":** ST to AB, June 28, 1973, SSF.

463 **"Today you get from here":** Arne Glimcher, "Saul Remembered," in *Drawing into Being*, p. 5.

463 **"boring parties and primitive conversations":** ST to Claire Nivola, July 17, 1964, in her archives.

463 **"ruined by invasion of the rich":** ST to Claire Nivola, March 10, 1986, when the depression that began in the late 1970s was entering its deepest trough.

463 **"everyone has left":** ST to AB, September 5, 1974, SSF.

464 **As years passed, it became a kind of public shorthand:** The quotation is Sigrid Spaeth's, from a collection of her correspondence, 1993, YCAL, Box 34. Apparently the speaker confused 7th and 9th Avenues.

464 **Steinberg complained that he hated:** Accounts of ST's anger and dismay over the rip-offs come from (among many others) interviews and conversations with HS, Claire Nivola, Vita Peterson, IF, Anton van Dalen, and Gordon Pulis.

464 **Steinberg insisted that he did:** Examples abound in the YCAL boxes, but I cite in particular the one in YCAL, Box 61.

464 **After Steinberg paid his new lawyers:** Correspondence pertaining to the settlement is in YCAL, Box 11, Folder "Rembar & Curtis Correspondence, 1988." The case hinged on whether Columbia had infringed his intellectual property by reproducing buildings that Steinberg drew in his poster. In his deposition, YCAL, Box 64, Steinberg was asked if a building was "an actual building." Steinberg replied: "I doubt it. It's an invention based on a real building. I usually—the way a writer bases fiction on nonfiction—I took notes, sketches, and even a poloroid picture or two of the area in order to make the location probable." In 1993, the original drawing of the poster was sold at auction by Christie's as "Property from a New York Estate," no. 128. The original drawing, "provenance Janis," carried an estimate of $18,000–$22,000. On the catalogue ST wrote: "200,000; tax 22,500," and below that "225,000." The drawing did sell for $225,000, according to Christie's listing of sales for Wednesday, November 10, 1993.

465 **"I accepted, I have to do it":** ST to AB, July 19, 1977, SSF. His letters throughout 1977 contain similar remarks.

465 **"It all reads like a novel":** Henrietta Danson to ST, "Wed. Apr. 26" [1977], YCAL, Box 20.

465 **He came to Springs:** AB, interview, June 19, 2007.

465 **The first task was to select the pictures:** YCAL, Box 79, consists entirely of photos of ST's work, arranged chronologically year by year; probably assembled for the WMAA retrospective. See also ST to AB, August 13, 1977, SSF.

466 **Steinberg knew that was too many:** ST to AB, April 25, 1978, SSF.

466 **"the *Art Book* I've feared":** ST to AB, August 13, 1977, SSF (his emphasis).

466 **Part of his animus:** ST to AB, June 2, 1978, SSF.

466 **It paid off, and he thanked Aldo:** ST to AB, April 25, 1978, SSF (his emphasis).

466 **Also, although the museum staff was in charge:** Some of the collectors who were delighted to loan their paintings included Jean and Dominique de Ménil, "Soria of Milano," Hedda Sterne, S. J. Perelman, Jean Stein vanden Heuvel, Carter Burden, and Max Palevsky. A complete list is in YCAL, Box 21.

467 **One of her earliest duties:** Information and quotations that follow are from Sheila Schwartz, e-mail, June 8, 2010.

467 **"Most chronologies read like tombstones":** John L. Hochmann to HR, January 10, 1978, HR/Getty, Accession #980048, Box 45.

467 **He still had to complete the poster:** Some of the collectors who loaned pictures were Billy Wilder, Claude Bernard, Ivan Chermayeff, Ernst Beyeler, Max Pahlevsky, Eugene Meyer, Carter Burden, Charles Benenson, Richard Anoszkiewicz, Warner LeRoy,

Gordon Bunshaft, and Richard Lindner. Museums and galleries included Museo de Bellas Artes, Caracas; Housatonic Museum, Connecticut; Galeria de Milano; Hirshhorn Museum, D.C.; and Israel Museum.

467 **When Schneider phoned to ask about:** Alexander Schneider to ST, June 13, 1977, YCAL, Box 61. ST's pocket diary for 1978 shows that he attended Schneider's concert at the New School on October 21, 1978, YCAL, Box 82.

468 **Steinberg asked him not to come:** ST to AB, March 13, 1978, SSF.

468 **"classic way to show muscle":** ST to AB, April 25, 1978, SSF.

468 **"separated (but did not divorce)":** Enid Nemy, *New York Times*, April 15, 1978. The article featured a photo of ST with Jacqueline Onassis, Woody Allen, and Jean Stein vanden Heuvel.

468 **She was a genuine friend to Steinberg:** Dore Ashton, interviews, January 20, 2009, and February 24, 2010.

469 **So too did several others:** Vita Peterson was one among the several who told me of this incident in an interview, March 7, 2009.

469 **Her embarrassment was magnified:** Stefan Kanfer, *People*, May 29, 1978, pp. 79ff.

469 **In a diary entry from 1985:** The chronology of this collection of diary writings is confused, but in the sentence before this one, she says she is typing it on August 16, 1985. Also, she mistakenly attributes ST's interview with *People* to *Time*; YCAL, Box 111.

469 **"a dazzling gallery":** From a proof of the review, n.d., HR/Getty.

469 **"one of the best pieces":** Paul Goldberger, "Design Notebook," *New York Times*, May 25, 1978; Kim Levin, "A Spy in the House of Art," *ARTS*, June 1978 (she is referring to Anaïs Nin's *A Spy in the House of Love*).

469 **The *International Herald-Tribune*:** Alexandra Anderson and B. J. Archer, "The Swift Canonization of Cartoonist Steinberg," *International Herald-Tribune*, May 27–29, 1978, p. 7.

469 **Anatole Broyard wrote an article:** Anatole Broyard, "Books of the Times," *New York Times*, April 29, 1978, p. L21; reprinted in *Stars and Stripes*, May 15, 1978, p. 15.

469 **a devastating blow with a punch:** John Russell, "The Many Humors of Steinberg," *New York Times*, April 14, 1978. Scattered throughout the YCAL boxes are numerous letters from Steinberg's friends, fans, and total strangers who objected to Russell's review.

470 **"intentionally malicious":** Leo Steinberg to ST, November 22, 1987, YCAL, Box 69.

471 **They had been neighbors during the years:** Lindner's iconic painting of a group of friends, *The Meeting*, hangs in the Museum of Modern Art: It pictures ST and HS, Evelyn Hofer, mad King Ludwig of Bavaria, and Lindner's archetypal woman. Hilton Kramer, in an article in *New York Times*, Sunday, April 30, 1978, p. D 25, calls it "the key to his oeuvre as a whole."

471 **"a sad cemetery in the suburbs":** From two versions of ST's tribute to Richard Lindner, both in draft form, YCAL, Boxes 38 and 75.

471 **Ironically, John Russell wrote:** John Russell, HR obituary, *New York Times*, July 12, 1978, p. D16.

471 **Hilton Kramer posited:** Hilton Kramer, *New York Times*, July, 13, 1978.

471 **Indeed, for Steinberg it had:** ST to AB, July 19, 1977, SSF.

471 **"In my mind, the conversations with Harold":** The folder containing the various versions of the speech is in YCAL, Box 75.

471 **When he set up the meditation room:** The photo of HR is now in YCAL, Box 50. The caption reads "This hung in Saul's meditation room."

471 **He did not want to be alone:** ST to AB, June 2 & 13, 1978, SSF.

472 **Instead he created a series of portfolios:** Smith, *Steinberg at The New Yorker*, p. 43 and p. 228, n. 70. A description of some of ST's output in the next decade is also given on p. 43.

472 **And perhaps when he wrote:** ST, 1978 pocket diary, YCAL, Box 82.

CHAPTER THIRTY-EIGHT: WHAT THE MEMORY ACCUMULATES

473 **"Nothing is lost of what the memory accumulates":** ST, random notes of his life through 1978, probably an early version of the chronology prepared for WMAA, as corrected by "BS," n.d., YCAL, Box 38.

473 **his only fairly regular correspondence:** Judith Steinberg Bassow married a doctor and became a lawyer. One of her two daughters graduated from Brown and Brown Medical School and the other from Princeton, with a doctorate from Harvard. The Bassow family resides in Denver. Judith Bassow prepared the Steinberg family genealogy, for which she and ST exchanged correspondence and information throughout the 1980s. She has a personalized collection of art given to her by ST; she inherited one example of Lica Roman's art from Martin Steinberg, another was given to her by ST, and a third was given to her by Stéphane Roman.

473 **He formed a close friendship:** A copy of the Steinberg family genealogy is in YCAL, Box 9; related materials may be those classified as "miscellaneous" or "unidentified" in YCAL, Boxes 6 and 7. Correspondence between Judith Bassow and ST is scattered throughout these boxes and in some correspondence folders from the 1980s.

474 **Phil's letter was an honest:** Phil Steinberg to ST, June 28, 1978, YCAL, Box 22.

474 **"the mysterious cousin":** ST to AB, September 4, 1978, SSF. ST had just returned from a trip by plane and car to Monument Valley, Arizona; Logan, Utah (where he thought of living for several months); Idaho; and Wyoming.

474 **"a powerful desire to meet a cousin":** ST to AB, October 24, 1978, SSF.

474 **"These days," he told Aldo:** ST to AB, September 18, 1978. SSF; also "random notes" in YCAL, Box 38.

474 **"where dignity was the most important thing":** The drawing and its companions was first published in *The Passport*; the one in question appears on p. 23 of *The Catalogue*. ST drew the woman from a drawing by Lica Roman that she made from a photograph of Judith Bassow and told Bassow he meant it to be her; he also told her there was another portrait very like her in the book, but he did not identify which one. From Judith Steinberg Bassow's notes appended to photocopies of her collection for DB, February 14, 2011.

474 **Over the years he had amassed:** ST clipped advertisements from New York newspapers about the regular flea markets on 26th Street and some of the occasional ones that happened at various times of the year; YCAL, Box 32. In many of the other boxes there are business cards and advertisements for dealers in stamps, books, and photographs, all of whom he frequented.

474 **Eventually both his new drawings:** *TNY*, December 1978 and May 1979. A description of ST's technique is in "Old Photographs" [AB #4], *R & S Outtakes*.

475 **"He thinks he's funny":** ST to AB, May 15, 1979, SSF.

475 **"First and Second Class Reality":** ST to AB, April 25, 1978, SSF. The quotations that follow are from notes in YCAL, Box 38, in a folder titled "Notes and Dreams," n.d. but internal evidence suggests 1979.

475 **One of his most famous first- and second-class realities:** The photo is the frontispiece in *R & S*. In ST to AB, November 20, 1982, he writes that the rug came from a house in Barnes Landing owned by the descendants of Alexander Graham Bell. Bell's widow left the contents to her church when she died, to be sold at auction; ST attended and bought the rug for $100.

475 **During the fourteen years they had lived:** Information about Phil and Rita Steinberg and all quotations are from ST to AB, October 21, 1979, SSF.

476 **In the end he stayed there:** ST to AB, October 21, 1978, SSF. Many of his friends could not understand how ST could live in such a dark apartment, Mary Frank among them: "It seemed like a grim place to me. It was very dark, while Washington Square Village was very light and bright"; Mary Frank, interview, January 25, 2009.

476 **"playing it loudly":** ST to AB, December 9, 1979, SSF.

476 **"with admiration":** ST to AB, January 12, 1980, SSF.

477 **He made no reply:** Mary Frank, interview, January 25, 2009.

477 **He was disgruntled all evening:** ST to AB, November 19, 1980, SSF; Mary Frank, interview, January 25, 2009.

477 **"Johann Christian Bach":** ST to AB, January 12, 1981, SSF. In YCAL, Box 9, he notes the dates for lessons as October 28, 1980, through January 8, 1981.

478 **"made progress":** ST to AB, December 1, 1980, and April 4, 1981, SSF.

478 **He thought the structures were interesting:** ST to AB, January 12, 1980, SSF.

478 **Besides these renderings of buildings:** ST to AB, July 27, 1981, SSF, with brief remarks or allusions in other 1981 letters to AB.

478 **He caught Sigrid in many different poses:** ST to AB, August 13, 1978, SSF.

478 **He played with postcards:** ST to AB, January 12, 1980, SSF.

478 **He liked to use airmail envelopes:** ST to AB, August 25, 1982, SSF: he asks AB to stick some stamps on a fake letter and send it back to him; in ST to IF, April 28, 1983, he writes that he still gets "strong emotion at the sight of airmail envelopes with striped borders. What a cheerful invention!"

478 **In his almost frenetic search for pursuits:** ST to AB, February 4 and 25, 1980, SSF.

479 **"horror of hotels":** ST to AB, February 4, 1980, SSF.

479 **"periods of paranoia":** ST to AB, November 30, 1979, SSF.

479 **While he was visiting Phil in Tucson:** ST to AB, October 21, 1979, SSF.

479 **"greedy, avaricious characters":** ST to AB, November 30, 1979, SSF.

CHAPTER THIRTY-NINE: THE DEFECTS OF THE TRIBE

481 **"I realize that for many years":** ST to AB, June 7, 1980, SSF.

481 **"It's clear that the desire for stamps":** ST to AB, August 18, 1980, SSF.

481 **Steinberg believed that one of the best ways:** ST to AB, February 4, 1980, SSF; Mary Frank, interview, January 25, 2009.

481 **One of the first was his adult "mania":** Information about stamp collecting is from ST to AB, May 1 and 19 and June 7, 1980, SSF.

482 **"thin blonde WASP women":** SS, diary, n.d., YCAL, Box 111; HS, in conversation with DB and Karen van Lengen, November 3, 2007; Karen van Lengen, interview, November 4, 2007.

482 **He was not embarrassed to tell Aldo:** ST to AB, June 7 and 9, 1980, SSF.

483 **Perusing the postcards led him:** YCAL, Box 100.

484 **"Majorcan Pearl, Josefine":** ST to AB, August 18, 1980. There he puts the name "Josepha" in parentheses after her name, and in correspondence and diary jottings in YCAL she is alternately called Josefine and Josefa, but her legal name was Josephine Buttles. For consistency, I call her "Josefine" as that is how he usually wrote it. She kept such order in his household that he boasted of how she "lined up the socks like soldiers." When she became infirm and temporarily unable to work, ST supported her and her family with generous gifts on a regular basis.

484 **"as usual, full of qualms":** ST to AB, January 12, 1981, SSF.

484 **"love one another":** ST to AB, December 1, 1981, SSF.

484 **"symptoms similar to those":** ST to AB, April 4, 1981, SSF. He refers to Gaspare Guidice, *Luigi Pirandello* (Turin: UTET, 1963). Pirandello's wife, Antonietta Portulano, had severe psychological problems that eventually resulted in her institutionalization. ST was referring to incidents of catatonic depression, obsessive jealousy, and sometimes violent physical behavior toward herself and others.

484 **As they exchanged greetings:** Ellen Adler, interviews, May 4 and 5, 2010. Adler and Steinberg had been friends "sort of forever" because she was the daughter of Stella Adler and Harold Klurman, to whom ST was close for many years.

484 **"This is the tragedy":** On an undated file card in YCAL, Box 65, SS wrote: "Why (do you think) did I never have any friends?" She probably wrote it in 1986, because it is attached to an article on friendship from the *New York Review of Books* on which she has written "Jean de Florette. Depardieu," referring to the recently released movie.

484 **Although Saul begged Sigrid:** ST to AB, January 30, 1981, SSF.

485 **"drunk out of habit":** ST to AB, March 18, 1980, SSF.

485 **Among them were his dear friends:** Karl Flinker to ST, June 9, 1981; Ray Eames, n.d. 1981; both in YCAL, Box 60.

485 **He planned to stay in Los Angeles:** ST to AB, January 12, 1981, SSF. The *incisione* include engravings, etchings, drypoints, aquatints, etc.

485 **The only specialists whose names never appeared:** In YCAL, Box 110, SS lists the doctors she was seeing from the early 1980s through 1992: Arnold Rosen (psychopharmacologist), Armin Wanner (psychotherapist), Melvin Horwith (endocrinologist), Daniel Shapiro (neurologist), Martin Carmins (neurosurgeon), David Hendell (dentist). She has crossed out the name of Dr. George Feldman, gynecologist, adding the comment "arrogant bastard." In a separate note in YCAL, Box 111, she gives her first appointment with Dr. Wanner as October 30, 1984.

485 **He did, however, throw himself enthusiastically:** "Two Women," start date 1981, signature and publication dates 1993. One color black (copper-drypoint) etching, 53.3 x 50.8 cm. (21 x 20 in.), edition of 56 plus 10 AP. Other titles include images of "Gogol" (1–5), "Cedar Bar," "North Dakota," "Provincetown," and "Legs."

485 **"I do wish I had been more stoic":** Mark Rosenthal, *Artists at Gemini G.E.L.: Celebrating the 25th Year* (New York: Abrams, 1993); also *Both Art and Life: Gemini G.E.L. at 25*, exhibition catalogue for Newport Harbor Museum, Newport Beach, California, September 22–November 29, 1992.

486 **He ended negotiations:** ST to AB, April 4 and 26, 1981, SSF. The exhibition was probably the one proposed for the Walker Art Center; the Japanese venue is unknown. Correspondence pertaining to the Walker is SSF.

486 **"due to his avarice":** ST to AB, April 5, 1982, SSF. Betty Parsons had been incapacitated by a stroke in November 1981, and she died on July 23, 1982. Arne Glimcher represented ST at Pace-Wildenstein Gallery and then SSF at Pace Gallery.

486 **a series of "small disasters":** ST to AB, July 8, 1981, SSF; Claire Nivola to DB, October 8, 2010. Nivola is not sure that her mother had a television set at that time, "but maybe so."

486 **variations on the Japanese printmaker Hiroshige's bridge:** "Rain on Hiroshige Bridge," *TNY*, November 2, 1981.

486 **They, like so much else:** For a complete listing, see *The Complete New Yorker*, all issues and database on disks, 2005, published by *TNY* and distributed by Random House, New York.

487 **He stopped trying to analyze:** Both Gordon Pulis and Anton van Dalen said in separate interviews that they cautiously questioned ST about the wisdom of making so many, but he waved them off and continued to do so.

487 **"intimate language":** ST to AB, September 29, 1981, SSF.

487 **"regression, childish rages":** ST to AB, August 24, 1981, SSF.

488 **Alexander Lindey, died that same year:** Lindey's widow, Ella, in a letter dated December 14, 1981, YCAL, Box 60, wrote that she had given ST's files to Harold Daitch, the lawyer who represented her after her husband's death, and suggested he do the same. ST declined and on June 8, 1982, ST asked Daitch to transfer the files to John C. Taylor at Paul Weiss, Rifkind, Wharton & Garrison. Taylor represented him until John Silberman became his lawyer and after ST's death, an officer of SSF.

488 **Leo Steinberg sent a caustic:** Leo Steinberg to ST, March 21, 1980, YCAL, Box 58.

488 **"total disregard for [his] gift":** Information that follows is from HS to ST, n.d. but internal evidence suggests early 1980s, YCAL, Box 58.

489 **When Steinberg moved to 75th Street:** Muriel Oxenberg Murphy to ST, September 27, 1973, YCAL, Box 104.

489 **When Gaddis sent him work in progress:** According to ST's diary entry for January 21, 1991, YCAL, Box 76, the friendship became difficult over the ms. of Gaddis's *The Deposition*, for which ST did not make the appropriate comments. ST told this to AB, who repeated it in an interview, June 2007, and he wrote it in a letter of August 18, 1983, to IF. In an interview, October 12, 2007, IF said ST told him, "I liked Gaddis as a person but I never finished one of his books."

489 **He was largely responsible:** ST to Saul Bellow, n.d., YCAL, Box 99. He asks Bellow to be the conominator, with Kurt Vonnegut, Donald Barthelme, William Gass, and John Barth as seconders.

489 **Steinberg was one of the background figures:** Documentation pertaining to recommendations for the MacArthur "genius" award is in YCAL, Box 69.

490 **Steinberg and Saul Bellow had been good but casual friends:** Saul Bellow to ST, April 25, 1980, YCAL, Box 33.

490 **Whether it was a philosophical/political essay:** Two typescripts that have edits in Bellow's and Steinberg's handwriting are in YCAL, Box 22. Bellow sent a letter on February 4, 1983, YCAL, Box 75, along with a journal/ledger in which he wrote a story, "Talking Out of Turn," in longhand. It must have been meant as a gift, for there are no marginal comments by ST. There is also an early typescript of a story called "Cousins" in YCAL, Box 75.

490 **"even if his style is naturally witty":** ST to AB, December 2, 1982, SSF.

490 **And yet when she was dying:** PC, in notes to DB, 2011.

490 **"He could do this, just cut people":** IF, interview, October 12, 2007.

491 **Steinberg contacted Sandy Frazier:** "Dating Your Mom," *TNY*, July 3, 1978. ST cut the article out of the magazine and kept it in YCAL, Box 99.

491 **He did the same with Donald Barthelme:** Information that follows is from Marion Barthelme, interview, May 18, 2008.

491 **he became a frequent dinner guest:** ST liked Marion Barthelme so much that he created a special drawing to celebrate her wedding to Don. As of 2012, it is in her collection in Houston, Texas.

491 **He told the story of how Steinberg:** HS told this same story in several 2007 interviews, always marveling at how "the dead, needleless, slightly off-center branches of the pine tree resembled a Steinberg."

492 **He and Steinberg discovered so many parallels:** Saul Steinberg with IF, *Canal Street* (New York: Library Fellows of the Whitney Museum of American Art, 1990).

492 **At the time she was working:** Information that follows is from Karen van Lengen, interview, November 4, 2007.

493 **So too were the few people:** From interviews with HS, IF, Karen van Lengen, Dore Ashton, Ruth Nivola, Claire Nivola.

493 **Only once did Steinberg speak of it:** Mimi Gross, interview, March 9, 2010.

493 **"Poor Sigrid," Aldo said:** AB, interviews, June 19, 2007, and July 27, 2008; AB to ST, April 29, 1981, YCAL, Box 60.

CHAPTER FORTY: THE PASSION OF HIS LIFE

494 **"Saul truly loved her":** AB, interview, June 19, 2007.

494 **Perhaps Sigrid was not fated:** AB to ST, April 29, 1981, YCAL, Box 60.

494 **These phases of flamboyant behavior:** On a file card dated "May 3" in YCAL, Box 110, she wrote: "My recent hypo/maniac episode cost me," followed by a list of purchases that totaled $14,300. Bills to ST charged by "Mrs. Steinberg" and signed by SS appear occasionally throughout YCAL, Boxes 108–115, which contain SS's papers.

494 **Ruth and Tino Nivola invited her:** The following account is from Dore Ashton, interviews, January 20, 2009, and February 24, 2010; Ruth Nivola, interviews, July 24 and September 22, 2007.

494 **"not all that bad":** SS collected articles about the Holocaust, particularly how the Nazis tortured Jews and how women were required to add "Sarah" to their given names and men "Israel." She made a list of all the extermination camps and where they were located, and she collected articles about neo-Nazis and skinheads. She was also interested in the postwar rise of fascism in various countries, particularly Spain. All these articles are in YCAL, Box 110.

495 **"be with a Nazi's daughter":** Interviews with HS, Ruth Nivola, Dore Ashton, Vita Peterson, Ellen Adler, and others.

495 **"he was very sweet to her":** Cornelia Foss, March 20, 2010. Ms. Foss and her late husband, the composer Lukas Foss, were often part of "the three couples"—the Fosses, ST and SS, and Muriel Murphy and William Gaddis—mainly in East Hampton.

495 **Hedda Sterne said it was more than that:** HS, interviews and telephone conversations, 2007 and 2008.

495 **"Not bad, but fierce":** ST to AB, May 23, 1983, SSF.

495 **"The question is":** Numbers in ST's handwriting, comment in SS's, n.d., YCAL, Box 110. Unless noted otherwise, information that follows is from SS's diary writings in YCAL Boxes 110, 111, 112, and 113.

495 **"terrible loneliness":** This phrase was used by Claire Nivola and Gus Kiley in interviews, July 2, 2008; AB, interview, June 19, 2007; HS, various interviews throughout 2007, and many others.

496 **"She had very few friends":** Mimi Gross, interview, March 9, 2010.

496 **"two people living together":** These quotations are comments from interviews with (among others) Ellen Adler, Dore Ashton, Aldo Buzzi, Cornelia Foss, IF, Mimi Gross, Ruth Nivola, Dana Roman, Hedda Sterne, and Karen van Lengen.

496 **Even though she enjoyed:** She made a list of all the grudges she had against him, YCAL, Box 111: "It has become like living with Dana—you, being the spoiled brat—offended for my not pampering you more, looking for understanding everywhere else (consolation from Hedda, etc.) and me stuck and lonely, without friends, doing the dirty work."

496 **"I'd rather be like Hedda":** SS, from her 47-page typed diary for 1981–82, YCAL, Box 111.

497 **She felt she was worthy:** Richard Fadem, interview, March 2, 2010.

497 **What he did do was contact:** David J. Shewitz of Shewitz and Rosenhouse, CPAs, to SS, May 9, 1983, YCAL, Box 111.

497 **He also agreed to let his lawyers make:** Joseph S. Iseman and John C. Taylor III, from the firm of Paul, Weiss, Rifkind, Wharton, and Garrison, memorandum to ST, February 9, 1982. In this change, HS inherited one-third, his niece and nephew shared a second third, and SS was to receive the third portion. The change suggested (and accepted by ST) was that HS would receive the principal of the trust until her death, at which time it would be payable to Dana and Stéphane Roman, with the "only disadvantage" that they would not inherit until HS's death. On August 4, 2010, HS celebrated her hundredth birthday; she died on April 8, 2011.

498 **"not even the next ten days":** SS, diary, 1981–82, YCAL, Box 111. I have also relied on SS's correspondence with the Belgian photographer Pierre Cordier, whom ST befriended at the 1958 World's Fair. Cordier and SS became close; copies of his extensive correspondence and photographs of SS are at SSF.

498 **She recalled how she and her father:** SS to Pierre Cordier, March 24, 1982, SSF.

498 **Saul was worried about how the depth:** ST to AB, September 27, 1982, SSF.

498 **"when she got horribly depressed":** Cornelia Foss, interview, March 20, 2010.

499 **"nobody can live like this":** The following information is from a typescript dated "Sun-

day, Feb. 9," to which SS later added "Spaeth 1967," YCAL, box unidentified, copy in SSF. The text is a conversation/exchange between SS and ST.

499 **Her "valium summer" began:** SS, diary, writings beginning March 29 and ending sometime in mid- to late September 1983, YCAL, Box 111.

500 **"avoid the errors of the past":** ST to AB, July 20, 1983, SSF.

500 **"without drama":** ST to AB, July 12, 1983, SSF.

500 **He had been prompted to end:** ST, diary, May 30, n.d. but internal evidence suggests he is writing in the early 1990s and reflecting back to the early 1980s, YCAL, Box 75.

500 **He preferred distance on his own terms:** The following account is from SS, diary "Summer '83," August 6–10, YCAL, Box 111.

501 **Later he made a movie of her:** There are many nude photos of SS in the YCAL boxes, most of them in Box 23. Most were taken by ST, but others were taken by Evelyn Hofer, and there are unidentified photographs in which SS sits on ST's lap, nude, while he is fully clothed. Both stare intently and dispassionately at the camera.

501 **"nice weekend" together:** ST to AB, August 10, 1983, SSF.

501 **On her next visit, he relented:** The following account is from SS, diary "Summer '83," August 9, YCAL Box 111.

501 **He was confident that if things remained amicable:** ST to AB, references in letters of July 12 and 20, 1983; further clarification from AB, interview, June 19, 2007.

502 **When he returned, the holiday season:** IF, interview, October 12, 2007.

502 **"If I should die," she began:** SS to ST, December 2, 1983, YCAL, Box 111.

503 **"empty, boring":** SS to Pierre Cordier, postcard, October 24, 1984, SSF.

CHAPTER FORTY-ONE: "STEINBERGIAN"

504 **"A drawing from life reveals":** *R & S*, p. 72.

504 **"the racket, the hysteria":** ST to AB, January 16, 1984, SSF.

504 **"Bulletin: I stopped drinking":** ST to AB, dated by him as July 12, 1983, but internal evidence suggests September, SSF.

504 **He had checked himself into a Zen temple:** ST to AB, dated by him as July 20, 1983, but internal evidence suggests September, SSF.

504 **To acquire knowledge through practice:** YCAL, Box 69, contains addresses for the Zen Dharmacraft, Massachusetts; Samadhi, Vermont, Zen Center, New York; Zen Stitchery in Idyllwild, California. A letter from Paul Mocsanyi, October 28 (no year), tells him the best book for yoga is *Yoga and Health* by Selvarajan Yesudian and Elisabeth Maich. ST bought a copy.

505 **Usually pretending to be encapsulated:** ST to AB, April 2, 1985, SSF.

506 **"I am an amazing sight":** ST to IF, August 18, 1983; ST to AB, July 20, 1983, SSF.

506 **He found such euphoria:** ST, "The Bicycle as a Metaphor of America," 2 pp. of handwritten notes, YCAL, Box 115. ST drew a bicycle for the cover of *TNY*, July 8, 1985, and later used it for the cover of his 1992 book, *The Discovery of America*.

506 **"inside with oneself":** ST, diary, n.d., but ca. 1993, YCAL, Box 48.

506 **"elective austerities":** *S:I*, p. 73.

506 **"only the pleasure of having won":** ST to IF, February 6, 1983; IF, interview, October 12, 2007.

507 **"film exposed sixty years ago":** YCAL, Sketchbook 3323; see also *S:I*, p. 241, n. 154.

507 **"a person of impulse":** IF, interview, October 12, 2007.

507 **He was one of the few trusted friends:** ST, diary, YCAL, Box 75.

507 **"windowless studio":** ST to AB, May 31, 1982; ST, diary, Sunday May 26, n.d. but probably 1983, YCAL, Box 75. ST continued to see Dine, either in Vermont or New York, and at the end of his life was distressed that Dine liked the reproductions done by Graphic de France, to which he strongly objected.

508 **"perhaps a bit too garishly":** ST to AB, May 9, 1982, SSF.

508 **Both books contained texts:** Roland Barthes, *All Except You*, with drawings by Saul Steinberg; *Repères*, Editions d'Art, Galerie Maeght, s.a. 1983; *Dal Vero*.

508 **Steinberg and Barthes had known and respected:** Steinberg later used variants of some of the drawings in *The Discovery of America* and *Reflections and Shadows*, but the book *All Except You* is relatively unknown in his canon. An unofficial English translation of Barthes's text was made by William R. Olmstead, professor of humanities at Valparaiso University, who presented a copy to SSF in 2003. All references are from that work, with my gratitude to Professor Olmstead for permission to quote from it. Richard Howard, who is the official Barthes translator for Farrar, Straus, and Giroux, said in a telephone conversation, November 3, 2010, that he had no factual information about why Barthes's essay was never translated or published in any form after the original appearance, but that he had "long believed both parties [Barthes and ST] had various dissatisfactions with it" and that "both nixed it." He thinks that it is "a charming essay, worthy of Saul," and he knew from personal experience that "Barthes was always interested in Steinberg's work."

509 **"a collection of drawings that were unique":** John Hollander, interview, October 2, 2007.

509 **His studio assistants remember:** Anton van Dalen and Gordon Pulis were among the many observers of ST's ruthlessless in evaluating his own work. ST told Claire Nivola how angry he was when he was at the Smithsonian and his house servant told him how neighbors went through the trash can in search of his discards. He said the same thing to HS, and many of his friends in New York knew how careful he was when putting out the trash on 75th Street.

510 **"certain parts":** He wrote about this in *R & S*, pp. 72ff.

510 **It was in Springs that:** John Hollander, *Blue Wine* (Baltimore: Johns Hopkins University Press, 1979). Comments here are taken from p. 71. There is another poem inspired by an ST drawing, "Ave Aut Vale" (untitled, p. 34, collection of the artist), which shows a man, woman, and young girl standing in a doorway. Hollander asked ST "whether this was a scene of arrival or departure; he replied that he didn't know anything about the people in the drawing save that they were all dead"; John Hollander to DB, October 31, 2007.

510 **He had written about Steinberg:** John Hollander's publications are at www.ct.gov/cct/cwp/view.asp?a=2162&q=329210 .

510 **Steinberg told Hollander that throughout:** John Hollander, interview, October 2, 2007.

511 **The only other person besides Aldo:** He also submitted one of his generic buxom women with large thighs and feet that dissolve into stiletto-pointed boots. To make sure Hollander did not use it, ST send a photocopy as well as the declaration "This picture is OUT"; ST to John Hollander, August 24, 1983, collection of John Hollander.

511 **Eventually they settled on sixteen:** From an announcement promoting the publication: "Bound into each copy of the edition of 140 will be an original hard ground etching by Steinberg created exclusively for the publication." Copy in YCAL, Box 99.

511 **"brace ourselves for more surprises":** ST to AB, July 12, 1883. ST was miffed that the book made money for the publisher and not for him, but that was not something he dwelled on; rather, he concentrated on how well the book was received.

511 **His name had long been used:** Rodica Ionesco to ST, July 16, 1982, YCAL, Box 99.

511 **In New York, he graciously accepted:** YCAL, Box 64.

512 **He took Bellow's request:** YCAL, Boxes 33, 64, 95, 99, and 110.

512 **Steinberg gave them all gifts of drawings:** There is no documentation of the painting's title or any that shows ST ever accepted payment. Lee Eastman's letter is in YCAL, Box 64. A thank-you letter from Linda and Paul McCartney, n.d., from their home in East Sussex, England, is in Box 99. There is also no documentation pertaining to a second album cover.

512 **Michael Kennedy, Robert's son:** Michael Kennedy to ST, YCAL, Box 99.

512 **After he and Sigrid resolved the details:** SS, diary, March 10–17, 1984, YCAL, Box 111.

512 **"low-rent restaurants":** ST to AB, March 27, 1984, SSF.

513 **"magic—return to forty years ago":** ST to AB, June 26, 1984, SSF; undated letters from AB to ST in YCAL, Box 99, and from Ada to ST throughout the YCAL boxes, where internal evidence provides the information given here. Records of ST's financial bequests also appear in YCAL, Boxes 6, 7, 8, and 99, where statements from the Banco Lariano, Erba, credit ST with sending money to the account of Giovanni Ongari and Ada Cassola. Apparently Ada had resumed using her maiden name.

513 **She was always in pain:** SS, diary entries and medical histories, YCAL, Boxes 99, 110, and 111. The tumor was a filium terminale ependymoma, slow-growing and common in young women. The laminectomy was performed sometime later. In 1990, when she had severe pain, she had another MRI, which resulted in a second surgery to correct inflammation of the arachnoid.

513 **"quite lovely":** ST to AB, June 25, 1984.

513 **He certainly tried to be happy:** ST to AB, July 28, 1984, SSF.

513 **In a "gastronomical update":** ST to AB, August 7, 1984, SSF.

CHAPTER FORTY-TWO: WINDING UP LIKE MY PARENTS

515 **"I see with terror":** ST to AB, April 19 and July 2, 1985, SSF.

515 **The "mess" began:** ST to AB, November 14 and 29, 1984, and August 12, 1985, SSF.

516 **"We have to be careful":** ST to SS, August 7, 1985, YCAL, Box 34.

516 **Sigrid had her own use:** White paper plates with ST's drawings are scattered throughout the YCAL boxes; some with SS's messages are in Boxes 99 and 110.

516 **While the house was uninhabitable:** In a typed diary for 1984, YCAL, Box 111, SS writes that she went to Africa early in January, leaving Papoose with HS, and that she had a breakdown ("desperate. don't want to go to NY") at Orly airport on the way home. "March 1: NY breakdown." "March 10–17: Martinique, Barbados, Sanibel" (the islands from which they took short flights to Florida, and thence to New York).

516 **He told Aldo that making changes:** ST to AB, December 15, 1984, SSF. HS and Claire Nivola joked about ST's penchant "for adding a new room" on the interview tape she made, May 31, 2005.

517 **Instead of changing landlords, he changed:** ST to AB, December 15, 1984, SSF.

517 **"first class TWA":** ST, "Agenda 1984," YCAL, Box 73.

517 **The next day he went to Erba:** In a 1991 diary, YCAL, Box 75, ST writes: "Green ink! Pity. I can't help giving low marks for green ink." Also, he feels for Solaroli "a beautiful emotion of love, friendship, spirit, complete confidence, security. I didn't realize she is one of the few I trust."

517 **"the beneficent illusion of travel":** ST to AB, November 14, 1984, SSF.

517 **This one found him constantly replaying:** ST to AB, April 2, 1985, SSF.

517 **"We are the victims":** ST to AB, April 19, 1985, SSF.

518 **"excellent, pleasurable":** ST to AB, July 22, 1985. SSF

518 **It was not fair, she told him:** SS to ST, letter written but not sent, Monday, October 4, 1984, YCAL, Box 111.

518 **Through Evelyn Hofer:** SS, typed diary for 1984, YCAL, Box 111. Under October 30, she writes "See Armin Wanner first time." Dr. Wanner did not respond to my repeated requests for interviews except for one e-mail citing doctor-patient confidentiality. Information in this paragraph is from SS, diary entries, YCAL, Boxes 109, 110, and 111.

519 **If he also hoped it would inspire her:** SS, diary, 1987, YCAL, Box 111. She lists after his contribution $2,890 income from interests on savings and money market accounts.

519 **"Go fuck yourself":** SS to ST, November 18, 1989, YCAL, Box 111.

519 **Many of Steinberg's friends were so concerned:** I refer to letters from (among many others) Muriel Murphy, William Gaddis, Saul Bellow, and Peter Matthiessen in YCAL, Boxes 69, 75, and 99–111.

520 **"thin and whining":** ST to AB, October 16, 1985. SSF.

520 **"Too late," he concluded:** HS told me about this in an interview, October 11, 2007, as she described how he shuffled the obituary cards from the American Academy. The drawing was published in *TNY*, June 17, 1972, present whereabouts unknown.

520 **Two days before he died:** ST to AB, March 18, 1988, SSF.

520 **"very unexpected and complicated mind":** ST, memorial tribute to Jean Stafford, YCAL, Box 94.

520 **"poor timing for obits":** ST, undated diary notation, YCAL, Box 95.

520 **He underlined the sentence:** YCAL, Box 32. The folder of obituaries dates from the early 1980s, the handwritten list from the mid-eighties, and the article is June 2, 1993.

521 **"exaggerating, perhaps to avoid":** ST to AB, "January," 1986, SSF.

521 **Still, no one expected the shattering announcement:** Information about *TNY* is primarily from Yagoda, *About Town*, pp. 413–25.

521 **The staff hastily called:** Roger Angell, telephone conversation, December 8, 2010.

521 **"an act of self-delusion":** Yagoda, *About Town*, p. 415.

521 **"sad, hurt, infuriated":** ST to AB, January 18, 1987, SSF.

521 **And then he sent Roger Angell:** Roger Angell, telephone conversation, December 8, 2010.

521 **"unhappiness *does not*":** ST, diary, n.d. but probably early July 1991, YCAL, Box 75.

522 **No one is sure how it began:** Information that follows is from interviews with HS, Ruth Nivola, and Claire Nivola; the diary of Ruth Nivola; and HS's taped recordings of reminiscences made with Claire Nivola in 2005.

522 **Ruth thought it was the most intimate:** Diary of Ruth Nivola, undated entry.

523 **"the sole person I know with whom I can commiserate":** ST to AB, August 31, 1987.

523 **Among the closest to both men:** Henri Cartier-Bresson to ST, May 17, 1988, YCAL, Box 94.

523 **"Dear Saul":** ST to ST, April 24, 1990, YCAL, Box 69. I was the first person to open the folder and read the message.

523 **"Now for some sensational news":** ST to AB, June 27, 1987, SSF. Documents pertaining to *Steinberg v. Columbia Pictures Industries, Inc.*, 663 F. Supp. 706 (S.D.N.Y. 1987)," are in YCAL, Boxes 32 and 33.

524 **he was quite pleased when Gaddis:** William Gaddis to ST, January 23, 1987, YCAL, Box 64. Gaddis wanted to use the legal document as background material in a novel that would refer to what he called "the case of the dog Spot."

524 **The case generated a new friendship:** ST to PC, Friday, April 20, 1990; Judge Pierre N. Laval, U.S.D.J., to ST, August 7, 1987, and postcard, September 8, 1987. All in YCAL, Box 33.

524 **"Lo and behold":** ST to AB, August 31, 1987, SSF.

524 **"when Saul and I divorced":** HS, interview, October 2007.

524 **"trusted [her] to do the right thing":** Legal agreement dated and signed December 19, 1989; living will dated April 25, 1990. On December 7, 1995, he wrote a new living will that appointed PC as his agent; YCAL, Box 71.

524 **"dropped out of the limelight":** Henrietta Danson to ST, June 21 [the year is not clear, probably 1987], YCAL, Box 94. ST wrote to AB, November 20, 1987, that even though Danson lived near him in New York, he seldom saw her, because she was boring and always wanted to talk about art. He thought her younger sister, Gertrude, who lived in a large house with swimming pool in Los Angeles, was "extraordinarily dull."

524 **The Royal College of Art in London:** Convocation program, July 1, 1988, YCAL, Box 94.

525 **Steinberg broke his ban:** To represent the Steinberg family, he asked Henrietta's son,

Lawrence Danson, a professor at Princeton, and his wife, and his niece, Dana Roman, and her husband, Yan Richard. Aldo Buzzi and Bianca Lattuada topped his list of friends, followed by Bibi Eng, the daughter of Maryam Javaheri Eng and Robert Eng, who were also friends. From his professional life he invited his agent, Wendy Weil, the Glimchers, and the art historian Arthur C. Danto and his wife. He also invited the famed First Amendment lawyer who represented him against Columbia Pictures, Charles Rembar, and his wife; Sidney Felsen, the co-owner of Gemini G.E.L.,and his wife; and his accountant, Charles Blitzer. Obituaries of Rembar, including that in the *New York Times*, October 2000, mistakenly listed Rembar as ST's literary agent.

525 **"the pleasures of vanity":** ST to AB, May 30, 1989, SSF.

525 **Everyone else remembered:** From interviews with John Hollander, Arthur C. Danto, Wendy Weil, and personal friends of DB on the Yale faculty who were also fellows of Morse College.

525 **"How monstrous":** ST, diary, May 15, 1991, YCAL, Box 75.

525 **There were four major exhibitions: Paris:** Galerie Maeght Lelong, 1986, *Repères: Cahiers d'Art Contemporain* no. 30, 1986, with an interview of ST by Jean Frémon. ST, Paris: Galerie Adrien Maeght, 1988, catalogue with text by Eugène Ionesco.

525 **"a kind of personal payback":** ST to AB, September 29, 1987, SSF.

525 **However, essays by Italo Calvino:** ST, 4th Internationale Triennale der Zeichnung, Kunsthalle Nürnberg, 1988, catalogue texts by Italo Calvino and Curt Heigl.

526 **To head off their many attempts:** Arthur C. Danto, interview, September 5, 2007; IF, interview, October 12, 2007; Claire Nivola, interview, July 2, 2008 (among many others).

526 **"who understand nothing":** ST to AB, July 4, 1990, SSF.

527 **He moved immediately to take:** Loria and Loria, *Saul Steinberg;* catalogue for an exhibition at Arthur Ross Gallery, University of Pennsylvania, Philadelphia, and Yale University Art Gallery, New Haven, 1995–96.

527 **Jeffrey Loria asked the distinguished:** Nathan Garland, interviews, January 16, and July 31, 2007.

527 **"happy to be taken seriously":** ST to AB, November 6, 1992, SSF.

527 **"the title and drift":** John Updike to ST, June 19 and July 21, n.d., YCAL, Box 38. Updike refers to the help given by "the conscientious Mr. [Nathan] Garland" and also thanks ST for the gift of "your Swiss suicide." He adds that he hopes someday to persuade Jeffrey Loria to write an introduction to the catalogue of his own Steinberg collection.

CHAPTER FORTY-THREE: THE LATEST NEWS

529 **"What I do these days":** ST, galley of Gopnik, "A Conversation with Saul Steinberg," YCAL, Box 67. Because there are multiple copies of various typescripts there, for identification purposes this one bears the heading "Disk 10: gopnik A2 (steinberg)." The quote is from p. A2.

529 **Sometime in mid-June 1989:** ST to AB, July 15 1989, YCAL, Box 94; Gordon Pulis, interview, September 20, 2007, YCAL, Box 111.

529 **Saul thought he had become:** ST, diary, Sunday, May 26, 1991, YCAL, Box 75.

529 **And then he corrected himself:** ST, diary, Sunday, June 2, 1991, YCAL, Box 75.

531 **He began with Prozac:** Medical history and diagnosis of Jatin P. Shah, M.D., Memorial–Sloan Kettering Hospital, 1995, referring to medical history since 1990, YCAL, Box 71.

531 **"a perfect shit":** Arthur C. Danto, interview, September 5, 2007.

531 **His refuge was no longer the magazine:** ST to AB, October 15, 1989, SSF.

531 **"75th and Park":** ST to AB, February 26, 1991, SSF.

531 **He made a series of drawings:** *TNY*, June 8, 1992.

532 **"as dead as Wall Street":** ST, diary, "1991—April 25–July 5," YCAL, Box 75.

532 **a fulsome declaration of "devotion":** ST to AB, February 24, 1990, SSF.

532 **There was a momentary scare:** Tests conducted by Dr. Morton Fisch, February 1, 1991, copies in YCAL, Boxes 33 and 110.

532 **Although he continued to collect articles:** Several years later, when ST was filling out a medical questionnaire, he told PC they had "gotten together the previous June (a birthday reconciliation?"); PC, mss. comment, 2011.

532 **"chicken nuggets and French fries":** ST wrote this in a diary entry, May 30, 1991, after a dinner with Karen van Lengen, and he made similar comments after dinners with Maryam Javahiri Eng, YCAL, Box 75.

533 **"every day, long or short":** ST to AB, May 8, 23, and 27, 1991, SSF.

533 **"talk in shorthand":** ST, diary, April 25–July 5, 1991, YCAL, Box 75.

533 **When he finally got under way:** ST, *The Discovery of America* (New York: Knopf, 1992); ST to AB, May 3, 1990, SSF; ST to AB, July 4, 1990, SSF; Wendy Weil, telephone conversation, March 22, 2010; Wendy Weil, interview, March 24, 2010.

534 **Steinberg's previous books had never sold well:** Wendy Weil graciously made ST's contracts and sales figures available for all the publications she represented.

534 **None of his drawings gave him pleasure:** ST to AB, July 27 or 28, 1989, SSF.

534 **"50% in color":** ST to AB, June 5, 1990, SSF.

534 **He insisted passionately:** ST to AB, April 3 and July 30, 1990, SSF.

534 **Often he collapsed:** ST to AB, July 30, 1990, SSF.

535 **"What a mistake the book!":** ST, diary, April 25–July 5, 1991, YCAL, Box 75.

535 **"in the same surprising way":** ST to AB, September 29, 1990, SSF.

535 **He was among a select number:** Marshall S. Cogan to ST, May 29, 1986, YCAL, Box 99.

536 **Quietly and usually anonymously:** Committee to Reelect Holtzman to ST, October 18, 1989, YCAL, Box 94.

536 **Without being asked:** Israel Museum, Jerusalem, to ST, thanking him for his contribution, YCAL, Box 94.

536 ***The Discovery of America* was the most:** In the inscribed copy ST presented to Leo Steinberg, he wrote: "For Leo/this uneven book/L'amico Saul ST/Sept 92." The copy is now in SSF.

536 **By the time he collected:** "America's Book" is in YCAL, Box 121.

536 **"tougher, grittier, darker":** "And Bear in Mind," *New York Times Book Review*, December 13, 1992; *St. Louis Post-Dispatch*, November 29, 1992.

536 **one of the most perceptive:** Red Grooms, "The World According to Steinberg," *New York Times Book Review*, December 6, 1992, p. 7.

537 **"However playful":** Donald Kuspit, "Saul Steinberg at Pace Gallery," *Art Forum*, March 1992, p. 91.

537 **Although Arthur Danto's introduction:** In e-mails of August 16 and 18, 2007, Danto wrote that "*Discovery* was not a great success—DOA: dead on arrival," and that "things cooled between us" after the book was published.

537 **He was famed for writing letters of complaint:** ST to AB, June 23, 1992, SSF: "I'm making life difficult for the people at Knopf, corrections, last minute changes, but the worst is over."

537 **to persuade him to leave her:** Andrew Wylie, e-mail, March 21, 2010; IF, interview, October 2007; Wendy Weil, interviews, March 22 and 24, 2010.

537 **"way of going always":** Wendy Weil, interviews, March 22 and 24, 2010. In her letter of August 24, 1992, she told ST that she did not agree to his request that Andrew Wylie take over the properties she represented, "nor do I agree that he should collect the moneys involved. My office will continue representing them as agreed"; YCAL, Box 38.

538 **"real sorrows":** ST to AB, July 3, 1991, SSF.

538 **He could not stand the smell:** ST to AB, November 16, 1991, SSF.

538 **Not until the dreaded Christmas holidays:** AB, interview, October 2007; HS, interview, October 2007; Ruth Nivola, interview, September 22, 2007.

538 **"Every now and then":** ST to AB, December 23, 1991; ST, diary, Friday, May 24, 1991, YCAL, Box 75.

538 **She wanted to know if it was true:** PC to ST, February 14, 1984, YCAL, Box 64. In her letter of October 1, 1986, also YCAL, Box 64, PC asks ST if this was the copy signed by Aline Bernstein, given to her by Thomas Wolfe, who met James Joyce on several occasions. Perlman signed it before giving it to ST. ST gave it to PC, saying, "Because you will love it the most." After ST's death PC gave the book to Leo Steinberg, who had read it "about nine different times and in five editions and knew most of it by heart"; PC, e-mail, October 7, 2007. See also "Prudence Crowther on S. J. Perelman," in *The Company They Kept: Writers on Unforgettable Friendships*, edited by Robert B. Silvers and Barbara Epstein (New York: New York Review Collection, 2006), pp. 179–80.

538 **"an invaluable shortcut":** "PC on S. J. Perelman," p. 180. In a diary entry for June 4, 1991, ST reminisced about his first days in America: "First thing learn the clichés in order to avoid them (or worse, reinvent them). In his satires (of let's say Hollywood conversations) S. J. Perelman is indispensable as a teacher of pitfalls, common wisecracks, a hint of the fairly high level of popular sophistication."

538 **Saul discovered that he was comfortable:** PC to ST, April 18, 1997, YCAL, Box 38; PC e-mail to DB, October 7, 2007, mss. comment, 2011.

538 **Saul discovered that he was comfortable:** PC, e-mail, October 7, 2007; PC, mss. comment, 2011.

538 **When he began to see her more frequently:** ST to AB, June 17, 1996; PC, e-mail to DB, December 6, 2010.

539 **Saul attempted to work out:** The account that follows is from ST, diary, June 2, 1991, YCAL, Box 75. HS recounted this conversation in much the same language as that ST used in the diary and verified that the "P" he referred to was Prudence Crowther; telephone conversation October 23, 2007.

540 **"the crème de la crème":** ST to AB, November 29, 1991, SSF.

540 **"to universal surpise":** ST to AB, January 7, 1992, SSF; reproduced on p. 193 in *Discovery of America*.

540 **It was one of the drawings:** According to SSF, July 2011, these covers were printed not from original drawings but from color photocopies in *TNY* files. It appears that ST was publishing some things during Gottlieb's tenure—for example, the three covers plus the April 30, 1990, "Canal Street" drawing in conjunction with IF's book of the same name.

540 **After that, whenever he felt he had something:** The covers appeared on January 13, June 8, September 7, and November 30, 1992; May 17, 1993, and February 28, April 25, and October 10, 1994; all are reproduced in Smith, *Steinberg at The New Yorker*, p. 138.

540 **Tina Brown was so intent:** Smith, *Steinberg at The New Yorker*, p. 46.

540 **"such absurd one-dimensional publicity":** In ST to AB, December 12, 1992, ST writes that the four covers had already appeared in "that book," in which they had been "used by those thieves with more impunity than usual." The book was *Seasons at The New Yorker: Six Decades of Cover Art*, reprinted by the National Academy of Design, 1990. Tina Brown to ST, March 12, 1994, YCAL, Box 39.

541 **When he had drawings he wanted to submit:** For a description of how they worked, see Smith, *Steinberg at The New Yorker*, p. 47.

541 **"Whenever and wherever":** William Shawn to ST, December 8, 1992, YCAL, Box 32. For Shawn's misdating, see also ST to AB, December 12, 1992.

541 **He had to stop playing this mental game:** ST, diary, Thursday, May 30, 1991, YCAL, Box 75.

542 **"walking for two hours":** ST, diary, June 14, 1991, YCAL, Box 75.

542 **While he was there, she went:** SS's medical records regarding the depression and suicide attempt are in YCAL, Box 110. They give June 27, 1992, as the date she sought help

for "acute depression," and July 13 as the date she took an overdose of sleeping pills. In YCAL, Box 34, letter from SS to ST, December 27, 1992, she writes that "exactly six months ago, June 27" was the day she made the suicide attempt.

CHAPTER FORTY-FOUR: AFFIRMATION OF THINGS AS THEY ARE

543 **"Something else, too, came to me":** C. G. Jung, *Memories, Dreams, Reflections* (New York: Vintage, 1989), pp. 296–97. ST photocopied these pages and highlighted the paragraph with the passage quoted above; YCAL, Box 38.

543 **Steinberg found Sigrid:** The account that follows is from a diary entry by SS, mistakenly dated June 26, 1992, as this event did not happen until July 13, according to the admission date on the records of Southampton Hospital; YCAL, Box 110.

543 **"waking with his name":** Ibid. The account that follows is based on medical documents in YCAL, Boxes 34, 38, 58, 110, 111, and 112, and interviews, conversations, and e-mails with (among others) PC, IF, HS, Claire Nivola, and Vita Peterson.

543 **"for doing this awful thing":** SS, suicide note mistakenly dated June 27, 1992, YCAL, Box 110.

544 **"It's rather nice":** SS to ST, Friday, July 17, 1992, YCAL, Box 111.

544 **Once back in the city:** SS, living will dated August 18, 1992, YCAL, Box 112. It replaced a letter written July 26, 1989, YCAL, Box 110, to her lawyer, Barry Kaplan, in which SS wrote that she did not know the rules of New York State but she did not want life support: "I want to be put out of my misery quickly. Could you please add this to my will."

544 **She settled into her apartment:** SS, diary writings in YCAL, Boxes 110 and 111, and letter to ST from Southampton Hospital, July 17, 1992, also YCAL, Box 110.

544 **This worried Evelyn Hofer:** Evelyn Hofer to ST, n.d., 1996, written shortly after SS's suicide, YCAL, Box 58.

544 **In the letter she told Glimcher:** SS to Arne Glimcher (copy to ST), April 7, 1992, YCAL, Box 38.

545 **He was shocked and in despair:** Documents pertaining to the sale are in YCAL, Box 112.

545 **She sent him color photocopies:** The drawings were of the Hell Gate Bridge and some New York taxis; they and her note are in YCAL, Box 124. Sometime later, she sold a de Kooning drawing, but the date and the provenance are not clear. She alludes to this obliquely in diary writings in YCAL, Box 108.

545 **"From Steinberg: $30,000":** SS, assorted papers in YCAL, Box 110.

545 **"depression and recent hypo/manic episode":** SS, file card dated May 3, but probably misdated as there are other credit card listings with later dates in the name of "Mrs. Steinberg," YCAL, Box 110. Other bills and order forms are in YCAL, Boxes 69 and 109.

546 **"reflected the entire drama":** ST to AB, July 31, 1992, SSF. Dr. Morton Fisch was attached to Lenox Hill Hospital and had been ST's internist for more than twenty years. Later ST consulted Dr. Jeffrey Tepler, to whom he was referred by William Gaddis. Medical information from PC, e-mail, December 6, 2010.

546 **"powerful emotions":** ST to AB, July 31, 1992, SSF.

546 **"nobody dies of heartbreak":** ST, undated jotting in a small notebook he kept from April to May 1993, YCAL, Box 95.

546 **"I am the same age as Lincoln":** One of the obituaries she clipped was of Pierre Beregovy, prime minister of France, May 9, 1993; from her collection of suicides in YCAL, Box 110.

546 **She continued to see Dr. Wanner:** In an e-mail of November 13, 2007, Dr. Wanner, a Jungian analyst, said he had promised SS's family and her lawyer not to divulge information. I regret that all information about SS's treatment is one-sided, as it comes from her, ST, their friends and associates, and other information in the YCAL boxes.

546 **She photocopied many pages**: C. G. Jung to "Anonymous," March 9, 1959, in Gerhard Adler and Aniela Jaffé, eds., *C. G. Jung: Letters*, Vol. 2, *1951–1961* (Princeton, N.J.: Princeton University Press, 1953), p. 492. SS also read Anthony Stevens's and Joseph Campbell's writings but did not specify which. Photocopied pages in YCAL, Box 38; other information from YCAL, Box 110.

546 **"how extraordinary"**: SS to ST, December 27, 1992, YCAL, Box 34.

547 **"Everything is going so well"**: SS, writing on a copy of two printings of the name "Steinberg" in bold black type, YCAL, Box 38.

547 **She sent another worrisome signal:** The letter is Joseph J. Schildkraut, professor of psychiatry at Harvard Medical School, to the *New York Times*, Sunday, March 27, 1994, copy in YCAL, Box 110.

547 **"constantly worried"**: ST to AB, August 26, 1992, SSF.

547 **"removed from life"**: ST to AB, August 2, 1992, SSF.

547 **He saw the books she left lying around:** Jung, *Memories, Dreams, Reflections*, pp. 296–97. ST's photocopies are in YCAL, Box 38.

547 **As Steinberg read Jung's life story:** Jung, *Memories, Dreams, Reflections*, pp. 289–98; see also D. Bair, *Jung: A Biography* (Boston: Little, Brown, 2003), chapter 32, pp. 496–502.

548 **Jung never became one of the philosophers:** HS, telephone conversation, October 23, 2007, said she did not remember ST ever introducing Jung's name into conversation. She "may have done, once or twice," but not because she found his writings personally influential. There is no reference to Jung in any of ST's correspondence with AB, nor in any of ST's diary writings.

548 **"one does not meddle"**: Jung, *Memories, Dreams, Reflections*, p. 297.

548 **"I can't. It's my magazine"**: ST to AB, January 9, 1993, SSF.

548 **Miles wrote that the magazine:** Jack Miles, "What Has Happened to *The New Yorker?*" *Los Angeles Times Book Review*, April 25, 1993, p. 16.

548 **Steinberg put this piece into his:** YCAL, Box 121.

549 **"fine wine in an ugly"**: ST to AB, July 1, 1993, SSF.

549 **"he's one of those people"**: ST to AB, January 28, 1993, SSF.

549 **"remembers everything about the earlier days"**: ST to AB, April 16, 1993, SSF. On April 26, 1993, ST wrote that he had "done 4 or 5 Simics." ST told Simic that "you look like a good drawing." To AB, he wrote: "In reality, his eyes appear to have been painted on his glasses, like a sign at the oculist's." On September 6, 1993, YCAL, Box 87, he wrote to tell Simic he was sending one of his portraits, "pencil on wood . . . drawing on wood is like on skin, a tattoo. Lumber stays alive a long time."

549 **Playing with portraits and blocks of wood:** ST to Charles Simic, September 6, 1993, YCAL, Box 87.

549 **"young and well-nourished son"**: ST to AB, March 9, 1993, SSF.

549 **"at the home of his publisher"**: ST to AB, April 11, 1993, SSF.

550 **Eco's American editor:** Drenka Willen, interview, May 13, 2008.

551 **He especially liked the way:** ST to AB, February 15, 1993, SSF.

551 **"loyal love for the man"**: ST's undated draft of the letter he eventually sent is in YCAL, Box 87; Shirley Hazzard's reply is dated December 19, 1994, also YCAL, Box 87.

551 **"an experiment"**: PC, e-mail, December 14, 2010.

551 **"hidden surprises"**: ST to AB, December 7, 1992, SSF.

551 **"suspicious"**: ST to AB, April 26, 1993, SSF.

551 **"a discovery"**: ST to AB, July 1, 1993, SSF.

551 **For the next several years, Steinberg sent:** ST to AB, January 7, 1992; correspondence between ST and Munro, YCAL, Boxes 58, 65, and 75. On February 27, 1994, YCAL, Box 65, she wrote that she would not send her photo in exchange for the one that he sent her but would send a story instead, which would not be published anywhere but for a Canadian fund-raiser.

551 **Brian Boyd's biography:** ST to AB, January 14 and 25, 1992, SSF.

552 **"rivermaid's father":** Vladimir Nabokov, *Bend Sinister* (New York: Library of America, 1996), p. 168.

552 **This time, however, he wanted to be:** ST, notebook, n.d., April–May 1993, and small spiral notebook, May 1993, both YCAL, Box 95. In the published Italian edition of the ST/AB letters, p. 230, AB mistakenly inserts the word "Überlingen" after the "Buchinger Clinic."

552 **"blessed with invisibility":** ST to AB, Juy 20, 1993, SSF.

552 **The next day he and Dana:** ST to AB, May 24, 1993, SSF.

552 **"the rich live badly":** ST, undated jotting in April–May 1993 notebook, YCAL, Box 95.

552 **"miserable black slime":** ST to AB, May 24, 1993, SSF.

553 **"the companionship of one's selves":** ST to AB, June 13, 1993, SSF.

553 **Hedda sent a note:** HS to ST, YCAL, Box 22; HS, telephone conversation, October 23, 2007. In a letter to Saul Bellow, SS writes that ST's "private birthday is on June 27." His letter is dated June 1, 1987, and hers is a draft of her reply, YCAL, Box 110.

553 **"paradise":** ST to AB, July 31, 1993, SSF.

553 **"so worried and caring":** HS, interview, October 24, 1907.

553 **"the other important thing":** ST to AB, August 29, 1993, SSF.

553 **"added intensity":** ST to AB, September 18, 1993, SSF.

554 **"My happy memory of St. Barth":** ST to AB, March 12, 1994, SSF.

554 **"understand[ing] drawing":** ST to AB, March 4, 1994, SSF.

554 **"Of course Tina wants it for the noise":** ST to Saul Bellow, Friday, February 11, 1994, YCAL, Box 87.

554 **Bellow advised caution:** The pieces were not published until February 21–28, 2000 and are reproduced in Smith, *Steinberg at The New Yorker*, pp. 218, 222–23. On p. 221 there is a reproduction of ST's "autogeography," a map of his personal history that he made in 1966 but never submitted for publication. Correspondence between ST and Tina Brown, January 12 and March 2, 1994, YCAL, Box 65, indicates that negotiations about the "Jewish cover" were protracted and in the end ST and Brown concurred that it should not be published.

555 **"return to me all photocopies":** ST to Françoise Mouly, March 14, 1994, YCAL, Box 71.

555 **Steinberg called their collaboration:** ST to AB, April 30, 1995.

555 **"even dogs gazed at us":** ST to AB, September 26, 1993.

555 **"a terror mixed with curiosity":** ST to AB, September 28, 1993.

555 **"a man in the act of thinking":** ST to AB, January 7, 1994.

555 **Steinberg and Buzzi talked about:** AB, in an interview conducted by Carole Chiodo on July 29, 2008, verified that he and ST either talked about or actually worked or reworked the book's proposed content in the two decades before it was published in Italy. AB also verified that the book was eventually published because he wanted the publication and "could use the money, small though it was."

556 **"thought it over once more":** AB, "Foreword," *R & S.*

556 **"with pleasure, with surprise":** ST to AB, April 30, 1995.

556 **In 2002 it appeared in an English translation:** Originally published in Italian as *Riflessi e ombre* (Milan: Adelphi Edizioni, 2001); English translation by John Shepley, *Reflections and Shadows* (New York: Random House, 2002); French and German editions also 2002.

556 **"a man full of doubts":** AB, "Foreword," *R & S*, p. vii.

556 **"June 28, 1994":** ST, spiral notebook, June 1994, YCAL, Box 95.

556 **"keep quiet":** SS, note on cardboard tablet backing, Saturday, June 17, 1994, YCAL, Box 110.

557 **He had engaged professional photographers:** According to the "Preliminary List, 2004," YCAL, Uncat. Mss. 126, photographic material is primarily, but not exclusively, in

Boxes 19–30. Many that I have referred to are in Boxes 80 (binders filled with negatives of his work) and 81 (photos in a format suitable for cataloguing, all prepared by the same photographer).

557 **On his own initiative:** John Hollander to ST, July 29, 1994, YCAL, Box 38; ST to AB, November 8, 1993.

557 **"mostly because not having children":** ST to AB, December 18, 1955, SSF.

557 **"curiosity . . . searching":** ST to AB, July 31, 1993, SSF.

557 **"like a sleepwalker":** ST to AB, June 19, 1995, SSF.

558 **Steinberg felt sorrow that such a vital man:** ST to AB, June 29 and August 7 and 15, 1995, SSF.

558 **Steinberg's only acknowledgment:** IF, interview, October 12, 2007.

558 **He was constantly worried about Sigrid:** ST to AB, July 10, 1995, SSF.

559 **He exploded every time:** ST to AB, February 20 and 27, 1995, SSF.

559 **"absence of terror":** ST to AB, December 27, 1995, SSF.

559 **"This time," he told Aldo:** ST to AB, February 11, 1996.

CHAPTER FORTY-FIVE: WHAT'S THE POINT?

560 **"The tragic depression, the constant and inexplicable terror":** ST to AB, November 24, 1996, SSF.

560 **"definitely not malignant":** ST, note, May 1, 1993, YCAL, Box 95. In a note written by AB and published in Italian with ST's letter of March 30, 1998, AB writes: "During his final visit to Überlingen (1995), routine blood tests unexpectedly revealed the presence of tumorous activity . . . The doctors [in NY] called Steinberg's case 'indolent,' meaning that it was progressing very slowly. 'You will not die of this,' they told him."

560 **A second CT scan confirmed:** Reading of CT scan taken October 20, 1995, YCAL, Box 71; second CT scan taken October 27, 1997, YCAL, Box 90.

560 **"I have a feeling":** Medical diagnosis of Dr. Jatin P. Shah, M.D., copy in YCAL, Box 71.

560 **"medullary carcinoma":** Medical diagnosis of Dr. Jatin P. Shah, February 29, 1996, YCAL, Box 71.

562 **"He has had suicidal ideation":** Dr. Jeffrey Tepler, M.D., to Dr. Chaikowsky, August 6, 1996, copy in YCAL, Box 71.

562 **Although most of his close friends were aware:** I base this on interviews and conversations with HS, AB, Claire Nivola, Charles Simic, Drenka Willen, Cilla and Norman Manea, IF, and many others.

562 **"austerely private self":** Muriel Murphy to ST, January 4, 1990, YCAL, Box 87. Although written earlier, I cite it here as the best example of the concern that had been building among ST's friends throughout the 1990s.

563 **She made another journey to Mali:** A telegram from ST to SS in Bamako, Mali, tells her he read about "roads crowded with refugees from Nigeria. Please be wise. Come Home"; YCAL, Box 113.

563 **As this amount would vary:** ST to Neuberger & Berman, January 11, 1996, YCAL, Box 112.

563 **"Why can't you be proud of me?":** SS to ST, February 27, 1996, YCAL, Box 113.

564 **"Prudence became the brick":** HS, interview, October 24, 2007.

564 **Steinberg thought Prudence would be:** Information that follows is from PC, in documents prepared for this book, December 6, 2010.

564 **On November 5, 1996:** A copy of the last will and testament, dated November 5, 1996, with a letter from John Silberman dated November 12, 1996, is in YCAL, Box 70.

565 **He left $50,000:** William Gaddis predeceased ST, dying on December 16, 1998. ST wrote to his son, Matthew, on February 3, 1999, that he was honoring his initial bequest "in the name of friendship" by leaving the money to Gaddis's children. ST signed his letter "with strong emotion and love, Saul"; YCAL, Box 70.

565 **"For an hour, in silence":** ST to AB, July 9, 1996, SSF.

565 **Steinberg kept a daily diary:** YCAL, Box 82.

566 **The official death certificate:** Copy in YCAL, Box 113.

566 **Sigrid left two letters:** Copy of SS's letter to Ursula Beard and copy of her handwritten suicide letter, YCAL, Box 113. I have followed her spelling and punctuation. ST later made multiple photocopies of the letter and sent it to many of his friends. Other unsent copies are scattered throughout YCAL boxes and are in collections of his correspondence with (among others), AB and IF, both SSF, and Claire Nivola, in her possession. HS put her copy into the large dictionary where she stored "the things that are important to me."

566 **he called Hedda:** In a telephone conversation, September 22, 2007, HS said she remembered calling Muriel Murphy, William Gaddis, and Ruth Nivola.

566 **In a state of emotional paralysis:** Ruth Nivola, diary, September 25, 1996, and interview, September 22, 2007; Hedda Sterne, telephone conversation, September 25, 2007.

566 **He also called the Riverside Memorial Chapel:** ST, diary-datebook, September 25, 1996, YCAL, Box 82. The two unidentified names are "Caroline" and "Tad Soltesz."

567 **"Tangible property":** YCAL, Box 113, folder pertaining to SS's cremation.

567 **Although he told everyone:** IF, interview, October 12, 1997.

567 **Sigrid's will brought another round of shocks:** Copy of SS's last will and testament, March 15, 1989, YCAL, Box 113.

567 **Steinberg had to apply separately:** In a handwritten note to her lawyer, YCAL, Box 34, "Sigrid Folder," SS specified that ST's art should go to the New York Public Library. Since it was not witnessed, it did not override her official will and Ursula Beard retained possession of the art and other personal possessions. Beard tried to sell them through the Pace Gallery, which chose not to represent her. Subsequently, however, the Galerie Bartsch & Chariau in Munich and the Adam Baumgold Gallery in New York mounted shows. The Galerie G & B held the show "Sammlung Sigrid Spaeth, 45 Originalzeichnung 1950–84," September 13–November 8, 1997: Adam Baumgold's show, "Saul Steinberg," was December–February 1998. It was reviewed in *Artnews*, May, 1998, pp. 170–71. The review began: "When graphic designer Sigrid Spaeth died in 1996, her estate included more than 40 works by Saul Steinberg, dating from the early 1950s to the late 1980s. Collected here, they made for a small enchanting survey of Steinberg's career."

567 **"an almost inaudible deep voice":** Ruth Nivola, diary, September 26–October 24, 1996. All of Nivola's comments that follow are from this portion of her diary.

568 **"Saul was preparing himself":** Charles Simic, Drenka Willen, and Dore Ashton, in separate interviews, all used this expression. IF remarked that ST was "suicidal" after SS's death.

568 **"practically catatonic with grief":** AB, interview, June 19, 2008. Ruth Nivola used the same expression in her diary entry for October 16, 1996.

568 **Arthur Danto wrote:** Arthur C. Danto, November 30, 1996, YCAL, Box 59; Benjamin Sonnenberg, n.d., YCAL, Box 59.

568 **Peter and Maria Matthiessen:** Peter and Maria Matthiessen, n.d., YCAL, Box 65; information about ST's response from AB, interview, June 19, 2008.

568 **And Uschi Beard's letter:** Ursula Beard to ST, October 1, 1966, YCAL, Box 71.

569 **"This is the place":** SS, letter on pink paper, Saturday July 16, 1994, YCAL, Box 113.

569 **On November 7, with the assistance:** PC, in a mss. note, 2011, said she tried to arrange a session with Dr. Virginia Goldner but the meeting never happened. Instead, Dr. Goldner suggested a male colleague, whom ST saw only once.

CHAPTER FORTY-SIX: NATURE'S CHARITABLE AMNESIA

570 **"I often surprise myself":** ST to AB, December 31, 1996, SSF.

570 **"rich, noisy invitations":** ST to AB, November 28, 1996, SSF.

570 **"the local Beaujolais":** ST to AB, November 24, 1996, SSF.

570 **"profound sadness":** ST to AB, November 28, 1996, SSF.

570 **Often she came to him:** ST to AB, January 7, 1997, SSF.

571 **He could not help but think:** ST to AB, December 31, 1996.

571 **"tremendous fear of dirt":** Mary Frank, interview, January 25, 2009.

571 **He liked Jean Stein's dinner parties:** Jean Stein, telephone conversation, August 15, 2007.

571 **"not thrilled to meet":** Norman Manea, interview, June 11, 2008.

571 **"When did you leave":** Norman Manea wrote a version of this meeting in "Made in Romania," *New York Review of Books* 47, no. 2, February 10, 2000. I quote from his interview of June 11, 2008.

571 **At first the friendship was "tentative":** ST to AB, January 23, 1995, SSF.

572 **"an impossible return":** From "Un Dadaist?" (the Romanian version of Manea, "Made in Romania"), *Apostroph*, 10, no. 12 (1999), special issue, "In Memoriam Saul Steinberg," pp. 12–22. There were many cuts in the published English version, but the full text in a translation by Emil Niculescu is in SSF.

572 **The magical feeling:** ST's boyhood home was still there in 1972, according to a photo in YCAL, Box 22.

572 **Prudence found:** The map is reproduced in *S:I*, p. 267, along with a drawing ST made from it. It is also mentioned in ST to AB, February 4, 1999, SSF.

572 **"I'm passing my days":** ST to Henri Cartier-Bresson, February 28, 1999, YCAL, Box 73.

573 **"the poor guy":** ST to AB, January 23, 1995, SSF.

573 **"never be fightened or ashamed":** ST to AB, April 22, 1995, SSF.

573 **Ada had died quietly:** I am grateful to Elissa Bruschini, who found the Ufficio dello Stato Civile Certificato di Morte, Comune di Erba, Provincia di Como; to Signora Loredana Masperi, director of Casa Prina, who, although constrained by Italian privacy laws, was able to provide background information; to AB, interview, June 19, 2007. MTL provided a copy of the death certificate to SSF, which was also made available to me.

573 **He knew they were serious:** PC did not remember that he told her of Ada's death, but her datebook for January 16 contains a note saying "Saul" followed by "Dr. Brooks," who may have been one of the several psychiatrists Steinberg consulted that year; Prudence Crowther, e-mail, January 7, 2011.

573 **Steinberg liked the tree so much:** Ibid. The drawing was published in AB's article "Key West," *Raritan* 27 (Summer 2007): 160. Ann Beattie remembered ST's fascination with the tree in a conversation with DB, Brattleboro, Vermont, September 30, 2007. Four drawings of the tree are in YCAL, Sketchbook 4846, and are reproduced in *S:I*, p. 266.

574 **"strangeness more than anything else":** ST to AB, February 22, 1997, SSF.

574 **"a blessing I regard":** ST to AB, March 6, 1997, SSF.

574 **He asked Gordon Pulis to construct:** ST to AB, April 13, 1997; Gordon Pulis, interview, September 22, 2007.

574 **He was afraid to see people:** ST to AB, June 17, 1998, SSF.

574 **Searching for some explanation:** References to Bernhard are found throughout ST's letters to AB, 1997–98, SSF.

575 **At first Steinberg made excuses:** ST to AB, July 7, 1998, SSF.

576 **He decided that the friendship stemmed:** HS, conversation, December 11, 2008.

576 **The phone calls worried Aldo:** Internal evidence in ST/AB correspondence suggested this; AB verified it in an interview, July 28, 2008.

576 **Even though he had not driven:** The rusted body of his first Chevrolet, a 1953 model, is behind the garage of his property in Springs. In ST to AB, November 7, 1998, he wrote that Huang, his Vietnamese gardener, was clearing the underbrush that had been grow-

ing around it for many years. In a mss. note, 2011, PC affirmed that he bought the Volvo on Gaddis's recommendation.

576 **He expressed regret that he had not reached out:** ST to AB, June 17, 1997, SSF.

577 **He pretended to complain:** ST to AB, August 14, 1997, SSF.

577 **"maybe the terror will disappear":** ST to AB, September 10, 1997, SSF.

577 **For more than a month at the end of 1997:** ST to AB, October 14, 1997, SSF.

577 **Like one of his favorite fictional characters:** ST to AB, November 5, 1997, SSF.

577 **Just as he sometimes thought Sigrid was there:** ST to AB, December 12, 1997.

578 **Ann Beattie gave several small dinners:** Ann Beattie, conversation, September 30, 2007. She remembered that ST "smoked a little grass" and enjoyed it.

578 **What he enjoyed most was the pleasure:** PC, e-mail December 6, 2010.

578 **"Strange how the letters":** ST to IF, July 3, 1998, original in IF's possession.

578 **"I took it as something crazy":** IF, interview, October 12, 2007.

578 **Next he asked Prudence:** PC, mss. note, 2011.

579 **"tired of waiting for sanity to return":** ST to HS, "Monday morning" [May 20, 1955], AAA.

579 **Sometimes it made him wake up:** HS, interviews and conversations, September–November 2007.

579 **By early December 1998 he feared:** PC, e-mail, December 15, 2010. All information about ST's ECT therapy is from this correspondence.

581 **Just before they left, he wrote:** ST to Henri Cartier-Bresson, February 28, 1999, YCAL, Box 73.

581 **"many degrees of perfection":** ST to IF, March, 1999, SSF. ST wrote a similar message on a postcard to AB, March 10, 1999, SSF.

581 **"Lost memory of part of life":** ST, daily diary, March 8, 1999, YCAL, Box 82.

582 **"It is my opinion":** Dr. Frank T. Miller, M.D., to ST, April 11, 1999, YCAL, Box 71.

582 **During the last week of April 1999:** ST's last note in the daily diary for 1999, YCAL, Box 82, is dated April 27, when he wrote: "Sign proxy bldg 102; call Teppler."

582 **"And then I went to the hospital":** PC, e-mail, January 7, 2011.

CHAPTER FORTY-SEVEN: THE ANNUS MIRABILIS OF 1999

583 **"The annus mirabilis of 1999":** ST to AB, January 24, 1999, SSF.

583 **While he was in the hospital:** ST had named PC his health-care proxy sometime before his last hospitalization, when documents permitting her access to his medical records were drawn up by his lawyer, John Silberman. According to Crowther in mss. comments, December 6, 2010, where ST wrote "sign proxy" on April 27, 1999, YCAL, Box 82, he was referring to a duplicate required by the hospital. Information about ST's last days is from PC, e-mail December 6, 2010; IF, interview, October 12, 2007; HS, interviews and conversations, 2007–8; Vita Peterson, interview, March 7, 2009; and Claire Nivola, interviews and conversations, 2008–10.

584 **She also recorded:** All ST's remarks this paragraph are from PC's datebook, May 8, 1999, sent in an e-mail, December 6, 2010. Information about the various languages in which ST sometimes spoke is from interviews with the persons cited in the text.

584 **they had never forged a friendship:** HS verified this throughout our interviews and conversations and repeated it emphatically on December 11, 2008, after she had had a stroke. My impression was that she thought it was important for me to know this, and so I honor her intentions here.

586 **"I don't think he's breathing":** Ibid.

586 **"I am dying":** HS, interview, December 11, 2008. HS also told this to Claire Nivola, interview, July 2, 2008. PC, e-mail, December 6, 2010, questioned HS's memory, saying that ST had also said this to her; "Does anyone know Saul's last words? I don't believe so."

EPILOGUE: THE UNCERTAINTY OF HIS PLACE

587 **His choice of media, his use of humor:** Unsigned obituary, "Saul Steinberg," *East Hampton Star*, May 20, 1999, copy in YCAL, Box 88, "Obituaries" Folder.

587 **Steinberg made his last will and testament:** The last will and testament of Saul Steinberg, April 16, 1999, submitted by Attorney Lynn Saidenberg of the firm of John Silberman Associates PC, acting on behalf of Prudence Crowther and John Silberman as executors of the estate of Saul Steinberg, admitted to probate by the Surrogate's Court of New York County by decree dated June 23, 1999; copy in SSF. It replaced an earlier will dated November 6, 1996, a copy of which is in YCAL, Box 70.

587 **He was the only person privy:** PC, e-mail, December 15, 2010.

587 **"a non-profit organization":** The Saul Steinberg Foundation mission statement, http://www/saulsteinbergfoundation.org/. John Silberman and John Hollander left the board in 2008 and 2010, respectively, and were replaced by Megan Fox Kelley and Jeffrey Hoffeld. Sheila Schwartz was the original executive director and was serving in that capacity in 2012.

587 **The university's Beinecke Rare Book and Manuscript Library:** ST specified that besides the drawings 15 x 17 in. or smaller, his archives consisted of all his letters, bills, photographs, rubber stamps, notebooks, albums, manuscripts (whether by him or by others), plus all papers other than works of art, black-and-white cartoons created for *TNY*, and portraits or photographs of him by other persons. Yale received the papers, but all copyrights were retained by SSF. The archives were to be available only to scholars and researchers until 2009, after which the general public was permitted access to them. The university was not allowed to sell any drawings within the archives after 2009.

587 **Besides the generous financial bequests:** In the final 1999 will, ST made several changes: he gave $50,000 each to Aldo Buzzi, Josephine Buttles, Anton van Dalen, IF, Gordon Pulis, Norman and Cella Manea, Lawrence Danson, Karen van Lengen, Maryam Javaheri Eng, and Mary Frank. Prudence Crowther received $100,000. Provision was made for Ada Ongari to receive $12,000 per annum for life if she survived him, but as she predeceased him, that money remained with his estate.

588 **He left the library:** A note in Sheila Schwartz's handwriting, appended to SSF's copy of the article "The Artist as Collector," by Andre Emmerich, *Art in America* no. 2 (Summer 1958), notes on p. 26 that ST's collection of "a large group of turn-of-the-century doll-like bisque figurines," a "black magic figure of wrought iron from Brazil, and "a small clay jar representing the ancient Mexican Rain-God Tlaloc," are now [i.e., after his death] in possession of Anton van Dalen.

588 **the memorial service on November 1, 1999:** The ceremony was held in the Charles Engelhard Court in the American Wing at 11:00 a.m. I am grateful to Sol and Judith Steinberg Bassow for copies of the invitation and program. In ST to AB, April 11, 1988, ST wrote of his pleasure in having the postcards enlarged: "(to a meter across) . . . and when you look at them you enter into that world, shortly before our birth—which is a more attractive and comprehensible era."

588 **Hedda Sterne chose not to attend:** In an interview, October 11, 2007, HS said she chose not to attend "for a variety of reasons." After saying that she did not want to be a distraction or to draw attention to herself, she paused a long time before saying it would have been too emotionally difficult and she feared she would break down in public.

588 **Dr. Torsten Wiesel introduced the six speakers:** Copies in SSF. A handwritten note on the IF transcript indicates that transcriptions were made by PC.

588 **"Each of us wished":** Saul Bellow, untitled remarks, reprinted as "Saul Steinberg," *Republic of Letters*, no. 7, November 7, 1999; four untitled pages of Bellow's remarks are in the James Atlas papers, University of Chicago Library, Special Collections Research Center, Box 4, folder titled "Marbles," with portions of what became the article in *The Republic of Letters*. I am grateful to James Atlas for permission to read them, and to Julia Gardner, Reference and instruction librarian, for her prompt attention to my request.

588 **"the most biting satire":** Leo Steinberg, "Remembering Saul," November 1, 1999.

589 **"We carry a curse":** Norman Manea, "Memorial: Saul Steinberg."

589 **"visionary intellectual satirist":** John Hollander, untitled remarks, later incorporated into "Saul Steinberg, 1914–1999," read at the American Academy of Arts dinner meeting, November 10, 1999, published as "Memorial Tribute to Saul Steinberg," *Proceedings of the American Academy of Arts and Letters* no. 50, 2nd series (2000): 101–6.

589 **Mary Frank came next:** Mary Frank, interview, January 25, 2009; quotations taken from her untitled remarks transcribed from a tape by PC, SSF.

589 **"a marvel in nature":** IF, "Eulogy," reprinted as "Eulogy for Saul Steinberg," *McSweeney's* no. 6 (2001): 29–32. HS's remark about "reality" is also on Tape 4, September 26, 2005, "Conversations with Claire Nivola," and was repeated throughout HS's interviews with DB.

589 **"the greatest artist to be associated":** Adam Gopnik, untitled essay to accompany "Sketchbook by Saul Steinberg," cover and pp. 54–57, *TNY*, May 24, 1999.

590 **The Italian newspaper:** *La Repubblica*, May 14, 1999, copy in YCAL, Box 88, "Obituaries" folder. One of the articles, "Quando era inamorato di Gadda," was about Steinberg's particular enjoyment of Gadda's fictions because he wrote in the Milanese dialect, which for ST was "the language of love." In ST to AB, April 11, 1988, ST described the pleasure of reading Gadda's Milanese dialect: "I understand it better than I would have expected, as long as I read it out loud."

590 **In France, *Libération* also:** "Culture: 'Steinberg coupe sa ligne de vie'; 'le dessinateur et mort mercredi a New York'; 'il faudrait inventer un cenotaphe special pour Saul Steinberg,'" *Libération*, May 16 and 17, 1999; unsigned obituary, "Saul Steinberg," *Le Monde*, May 18, 1999. Copies of both in YCAL, Box 88, "Obituaries" folder.

590 **Hilton Kramer praised Steinberg:** Hilton Kramer, "Farewell, Saul Steinberg, a Mordant Comic Artist," *New York Observer*, May 23, 1999. Sheila Schwartz provided the example of H. W. Janson's *History of Art* (New York: Abrams, 1991), where ST is not in the index until the sixth edition and even then is discussed only briefly in an introductory section, "Looking at Art," where a 1960 *TNY* drawing is used along with three other cartoons by pure cartoonists to make a general point about the creative process; his work is not considered in the actual history of art text that begins in the next chapter. See *S:I*, p. 20 and n. 10, for further examples.

590 **"epic doodler":** Sarah Boxer, "Saul Steinberg, Epic Doodler, Dies at 84," *New York Times*, May 13, 1999, pp. 1, B10, copy in YCAL, Box 88, "Obituaries" folder.

590 **"in-between status":** Michael Kimmelman, "Art in Review: Saul Steinberg," *New York Times*, October 22, 1999; in conjunction with exhibitions at Pace Wildenstein Gallery and Adam Baumgold Fine Art Gallery.

590 **"He was neither cartoonist nor painter":** Franklin Foer (with Angie Cannon), "A Great View of the World: Saying Goodbye to Saul Steinberg," *U.S. News & World Report*, May 24, 1999, p. 65; copy provided by Judith Steinberg Bassow.

590 **"the man who did that poster":** Among the many obituaries that discuss "that poster" are Robert Hughes, "Fine, Indecipherable Flourishes," *Time*, May 24, 1999; Elaine Woo, "Saul Steinberg: Artist Best Known for Covers and Cartoons in *The New Yorker*," *Los Angeles Times*, May 14, 1999; "Saul Steinberg," *The Art Newspaper: In Memoriam*, June 1999, copy in SSF archives; Martin Plimmer, "Obituary: Saul Steinberg," *Independent* (London), May 18, 1999; Foer with Cannon, "A Great View of the World."

590 **"the most iconic image":** Peter Plagens, "Have Pen, Will Amuse," *Newsweek*, May 24, 1999, copy in YCAL, Box 88, "Obituaries" folder.

590 **"Steinberg's most famous composition":** Hughes, "Saul Steinberg," in *Nothing If Not Critical*, p. 259; Jean Lemaire, "An Appreciation," *Loria Collection*, p. 10.

591 **The question proliferated:** The exhibition itinerary listed in the book is as follows: Morgan Library and Museum, New York, November 30, 2006–March 4, 2007; Smithsonian American Art Museum, Washington, D.C., April 6–June 24, 2007; Cincinnati Art Museum, Cincinnati, Ohio, July 30–September 20, 2007; Frances Lehman Loeb Art

Center, Vassar College, Poughkeepsie, New York, November 2, 2007–February 24, 2008. The publication (cited throughout this book) is Joel Smith, *Saul Steinberg: Illuminations* (New Haven: Yale University Press, 2007).

591 **"fundamental questions":** Front flap copy, *S:I*. Smith wrote the jacket copy, which he discusses more fully in the introduction, p. 20.

591 **"Seven years after his death":** Charles Simic, "Steinberg's Bazaar," *S:I*, p. 17.

591 **"I don't quite belong":** J. R. Cochran, "He Seldom Lays Eggs," *New Haven Register*, July 1973.

ILLUSTRATION CREDITS

157 Courtesy of Saul Steinberg Papers, Yale Collection of American Literature, Beinecke Rare Book and Manuscript Library.

181 Courtesy of Saul Steinberg Papers, Yale Collection of American Literature, Beinecke Rare Book and Manuscript Library.

184 Saul Steinberg, *Untitled*, 1954. Ink on paper, 10 x 8 in. © The Saul Steinberg Foundation / Artists Rights Society (ARS), New York, courtesy Estate of Hedda Sterne.

196 Saul Steinberg, *Diploma for Hedda (Cooking)*, 1950s. Ink on paper, 28 x 22 ¾ in. (71.1 x 57.8 cm) © The Saul Steinberg Foundation / Artists Rights Society (ARS), New York, courtesy Estate of Hedda Sterne.

204 Saul Steinberg, *Untitled (Birthday Check to Hedda)*, n.d. Ink on blank check, 2 ¾ x 6 ⅜ in. (7 x 16.2 cm) © The Saul Steinberg Foundation / Artists Rights Society (ARS), New York, courtesy Estate of Hedda Sterne.

215 Courtesy of Saul Steinberg Papers, Yale Collection of American Literature, Beinecke Rare Book and Manuscript Library.

219 Courtesy of Anton van Dalen.

221 Courtesy of Saul Steinberg Papers, Yale Collection of American Literature, Beinecke Rare Book and Manuscript Library.

231 Saul Steinberg, *Untitled*, 1954. Ink on paper, 14 ½ x 11 in. (36.8 x 27.9 cm). Private collection. Originally published in *The New Yorker*, July 10, 1954 © The Saul Steinberg Foundation / Artists Rights Society (ARS), New York.

232 Saul Steinberg, *Untitled*, 1950. Ink on paper. Originally published in *The New Yorker*, October 21, 1950 © The Saul Steinberg Foundation / Artists Rights Society (ARS), New York.

232 Saul Steinberg, *Untitled*, 1954. Ink on paper. Originally reproduced in Steinberg, *The Passport*, 1954 © The Saul Steinberg Foundation / Artists Rights Society (ARS), New York.

263 Courtesy of Saul Steinberg Papers, Yale Collection of American Literature, Beinecke Rare Book and Manuscript Library.

297 Saul Steinberg at work on his *Americans* mural, Brussels World's Fair, 1958 © The Saul Steinberg Foundation / Artists Rights Society (ARS), New York, courtesy of Saul Steinberg Papers, Yale Collection of American Literature, Beinecke Rare Book and Manuscript Library.

316 Theodore Brauner, *Hedda*, c. 1963–65, The Estate of Theodore Brauner / Courtesy of the Janos Gat Gallery, New York, and the Hedda Sterne Foundation, New York.

320 Saul Steinberg, *Knight and Pineapple*, 1970. Lithograph, 22 ¼ x 30 in. (56.5 x 76.2 cm). The Saul Steinberg Foundation, New York © The Saul Steinberg Foundation / Artists Rights Society (ARS), New York.

327 Courtesy of Saul Steinberg Papers, Yale Collection of American Literature, Beinecke Rare Book and Manuscript Library.

354 Saul Steinberg, *The Nose Problem*, 1963. Ink on paper, 11 ⅛ x 14 ⅛ in. (28. 2 x 35.9 cm). Private Collection. Originally published in Location (Spring 1963) © The Saul Steinberg Foundation / Artists Rights Society (ARS), New York.

358 Courtesy of Saul Steinberg Papers, Yale Collection of American Literature, Beinecke Rare Book and Manuscript Library.

364 Saul Steinberg, *Untitled*, 1961. Ink on paper. Originally published in *The New Yorker*, July 29, 1961 © The Saul Steinberg Foundation / Artists Rights Society (ARS), New York.

383 Courtesy of Priscilla Morgan.

394 Courtesy of Saul Steinberg Papers, Yale Collection of American Literature, Beinecke Rare Book and Manuscript Library.

395 Saul Steinberg, *Untitled*, 1960. Ink on paper, 11 ½ x 14 ⅜ in. (29.2 x 36.5 cm). Saul Steinberg Papers, Beinecke Rare Book and Manuscript Library, Yale University. Originally published in *The New Yorker*, December 10, 1960 © The Saul Steinberg Founda-

tion / Artists Rights Society (ARS), New York, courtesy of Saul Steinberg Papers, Yale Collection of American Literature, Beinecke Rare Book and Manuscript Library.

396 Saul Steinberg, *Untitled*, 1961. Ink on paper. Originally published in *The New Yorker*, November 25, 1961 © The Saul Steinberg Foundation / Artists Rights Society (ARS), New York.

414 Courtesy of Claire Nivola.

416 Courtesy of Anton van Dalen.

447 Courtesy of Anton van Dalen.

448 Courtesy of Anton van Dalen.

499 Courtesy of Saul Steinberg Papers, Yale Collection of American Literature, Beinecke Rare Book and Manuscript Library.

505 Courtesy of Saul Steinberg Papers, Yale Collection of American Literature, Beinecke Rare Book and Manuscript Library.

506 Courtesy of Saul Steinberg Papers, Yale Collection of American Literature, Beinecke Rare Book and Manuscript Library.

530 Courtesy of Anton van Dalen.

550 Courtesy of Priscilla Morgan.

558 Courtesy of Claire Nivola.

561 Courtesy of Anton van Dalen.

INSERT

Saul Steinberg, *Autogeography*, 1966. Ink, gouache, and watercolor on paper, 29 ½ x 20 ¾ in. (74.9 x 20.8 cm). The Saul Steinberg Foundation, New York © The Saul Steinberg Foundation / Artists Rights Society (ARS), New York.

Saul Steinberg, *Galleria di Milano*, 1951 © The Saul Steinberg Foundation / Artists Rights Society (ARS), New York.

Saul Steinberg, *Techniques at a Party*, 1953. Ink, colored pencil, and watercolor on paper, 14 ½ x 23 in. (36.8 x 58.4 cm). The Saul Steinberg Foundation, New York © The Saul Steinberg Foundation / Artists Rights Society (ARS), New York, courtesy of Saul Steinberg Papers, Yale Collection of American Literature, Beinecke Rare Book and Manuscript Library.

Saul Steinberg, *Untitled*, 1979. Black pencil, conté crayon, ink, crayon, and pencil on paper, 11 x 15 in. (28 x 38.1 cm). Saul Steinberg Papers, Beinecke Rare Book and Manuscript Library, Yale University. Originally published in *The New Yorker*, May 28, 1979 © The Saul Steinberg Foundation / Artists Rights Society (ARS), New York.

Hedda Sterne, *Untitled [Circus]*, 1945. Oil on canvas, 39 x 34 in. © Hedda Sterne Foundation, New York.

Hedda Sterne, *New York, NY*, 1955. Oil on canvas, 36 x 60 in. Whitney Museum of American Art, gift of anonymous donor, © Hedda Sterne Foundation, New York.

Hedda Sterne, *Antro II*. Oil on canvas, 31 ½ x 51 in. Private collection, © Hedda Sterne Foundation, New York.

Saul Steinberg, cover drawing for dustjacket of *The Labyrinth*, 1960 © The Saul Steinberg Foundation / Artists Rights Society (ARS), New York.

Saul Steinberg, *Untitled*, 1969–70. Oil, ink, and rubber stamps on canvas, 22 ⅝ x 16 ¼ in. (57.6 x 41.3 cm). Private Collection. Variant of drawing for *The New Yorker* cover, June 6, 1970 © The Saul Steinberg Foundation / Artists Rights Society (ARS), New York.

Saul Steinberg, *Bleecker Street*, 1970. Ink, pencil, colored pencil, and crayon on paper, 29 ½ x 22 ⅜ in. (74.6 x 56.8 cm). Collection of Michael Ulick. Cover drawing for *The New Yorker*, January 16, 1971 © The Saul Steinberg Foundation / Artists Rights Society (ARS), New York.

Saul Steinberg, *The Politecnico Table*, 1974. Mixed media assemblage on wood, 28 ¼ x 23 ¼

in. (71.8 x 59.1 cm). Collection of Richard and Ronay Menschel © The Saul Steinberg Foundation / Artists Rights Society (ARS), New York.

Saul Steinberg, cover of *The New Yorker*, March 20, 1954. Cover reprinted with permission of *The New Yorker* magazine. All rights reserved © The Saul Steinberg Foundation / Artists Rights Society (ARS), New York.

Saul Steinberg, *Prosperity (The Pursuit of Happiness)*, 1958–59. Cover of *The New Yorker*, January 17, 1959. Cover reprinted with permission of *The New Yorker* magazine. All rights reserved © The Saul Steinberg Foundation / Artists Rights Society (ARS), New York.

Saul Steinberg, cover of *The New Yorker*, May 25, 1963. Cover reprinted with permission of *The New Yorker* magazine. All rights reserved © The Saul Steinberg Foundation / Artists Rights Society (ARS), New York.

Saul Steinberg, cover of *The New Yorker*, October 12, 1963. Cover reprinted with permission of *The New Yorker* magazine. All rights reserved © The Saul Steinberg Foundation / Artists Rights Society (ARS), New York.

Saul Steinberg, *Peacock Thanksgiving*, 1976. Colored pencil, ink, and collage on paper, 20 x 15 in. (50.8 x 38.1 cm). Private Collection © The Saul Steinberg Foundation / Artists Rights Society (ARS), New York.

Saul Steinberg, *View of the World from 9th Avenue*, 1976. Ink, pencil, colored pencil, and watercolor on paper, 28 x 19 in. (71.1 x 48.3 cm). Private collection. Cover drawing for *The New Yorker*, March 29, 1976 © The Saul Steinberg Foundation / Artists Rights Society (ARS), New York.

Saul Steinberg, *Corrugated Catcher*, 1954. Mixed media on cardboard, 29 x 20 in. (73.7 x 50.8 cm) © The Saul Steinberg Foundation / Artists Rights Society (ARS), New York, courtesy of Jason van Dalen.

Saul Steinberg, Dal Vero (Sigrid and Papoose), September 10, 1979, 1979. Pencil and colored pencil on paper, 14 x 17 in. (35.6 x 43.2 cm). The Saul Steinberg Foundation, New York © The Saul Steinberg Foundation / Artists Rights Society (ARS), New York.

Saul Steinberg, *Long Island Duck, on Highway*, 1979. Colored pencil and pencil on paper, 8 ½ x 11 in. (21.6 x 27.9 cm) © The Saul Steinberg Foundation / Artists Rights Society (ARS), New York, courtesy of Anton van Dalen.

Saul Steinberg, *Library*, 1986–87. Pencil and mixed media on wood assemblage, 68 ½ x 31 x 23 in. (174 x 78.7 x 58.4 cm). Collection of Carol and Douglas Cohen © The Saul Steinberg Foundation / Artists Rights Society (ARS), New York.

Saul Steinberg, *Zip Code Map*, 1994. Pencil, crayon, colored pencil, and collage on paper, 13 ½ x 11 in. (34.3 x 28 cm). Saul Steinberg Papers, Beinecke Rare Book and Manuscript Library, Yale University. Originally published in *The New Yorker*, February 21–28, 2000 © The Saul Steinberg Foundation / Artists Rights Society (ARS), New York.

Estate of Evelyn Hofer.

INDEX

Page numbers in *italics* refer to illustrations.